John Singleton Copley
in America

John Singleton Copley in America

Carrie Rebora and Paul Staiti
Erica E. Hirshler, Theodore E. Stebbins Jr., Carol Troyen

with contributions by
Morrison H. Heckscher, Aileen Ribeiro, Marjorie Shelley

The Metropolitan Museum of Art, New York
Distributed by Harry N. Abrams, Inc., New York

This publication is issued in conjunction with the exhibition "John Singleton Copley in America." The exhibition is made possible in part by grants from The Henry Luce Foundation, Inc., and the National Endowment for the Arts. It is organized by The Metropolitan Museum of Art, New York, and the Museum of Fine Arts, Boston, and held at the Museum of Fine Arts, Boston, from June 7 to August 27, 1995; The Metropolitan Museum of Art, New York, from September 26, 1995, to January 7, 1996; the Museum of Fine Arts, Houston, from February 4 to April 28, 1996; and the Milwaukee Art Museum, from May 22 to August 25, 1996.

Published by The Metropolitan Museum of Art, New York
Copyright © 1995 The Metropolitan Museum of Art, New York

John P. O'Neill, *Editor in Chief*
Carol Fuerstein, *Editor*
Bruce Campbell, *Designer*
Matthew Pimm, *Production Manager*

New photography at The Metropolitan Museum of Art by Katherine Dahab, Anna-Marie Kellen, Bruce Schwarz, Eileen Travell, the Photograph Studio, The Metropolitan Museum of Art, New York

Set in Aldus by U.S. Lithograph, typographers, New York

Printed on Cartiere Burgo R400, 150 gram
Separations by Arnoldo Mondadori, S.p.A., Verona, Italy
Printed and bound by Arnoldo Mondadori, S.p.A., Verona, Italy

Jacket/Cover illustration: Detail, *Nicholas Boylston* (cat. no. 31)
Frontispiece: *Portrait of the Artist* (fig. 25)

Library of Congress Cataloging in Publication Data
John Singleton Copley in America / Carrie Rebora . . . [et al.].
p. cm.
Exhibition catalog.
Includes bibliographical references and index.
ISBN 0-87099-744-0. — ISBN 0-87099-745-9 (pbk.) — ISBN 0-8109-6492-9 (Abrams)
1. Copley, John Singleton, 1738–1815 — Exhibitions. 2. United States — Biography — Portraits — Exhibitions. 3. Artists and patrons — United States — History — 18th century — Exhibitions. 4. Group identity in art — Exhibitions. 5. Social status in art — Exhibitions. I. Rebora, Carrie. II. Metropolitan Museum of Art (New York, N.Y.)
N6537.C6579A4 1995
759.13 — dc20

95-2520
CIP

THE PETITION.

Artful Painter, by this Plan
Draw a Female if you can.
Paint her Features bold and gay,
Casting Modesty away;
Let her Art the Mode express,
And fantastick be her Dress;
Cock her up a little Hat
Of various Colours, this and that;
Make her Cap the Fashion new,
An Inch of Gauze or Lace will do:
Cut her Hair the shortest Dock:
Nicely braid her Forehead Lock:
Put her on a Negligee,
A short Sack or Sheperdee
Ruffled up to keep her warm,
Eight or Ten upon an Arm;
Let her Hoop extending wide
Shew her Garters and her Pride,
Her Stockings must be pure and white.
For they are seldom out of Sight.
Let her have a high heel'd Shoe,
And a glittering Buckle too;
Other Trifles that you find,
Make quite Careless as her Mind,
Thus equipp'd she's charming Ware
For the Races or the Fair.

— *Boston Gazette*, March 15, 1756

Contents

Directors' Foreword

At The Metropolitan Museum of Art and the Museum of Fine Arts, Boston, exhibitions of John Singleton Copley's work seem to run in thirty-year cycles. In 1937 and 1938 our institutions mounted important shows to commemorate the two hundredth anniversary of the artist's birth. Nearly thirty years later the Metropolitan and the Museum of Fine Arts joined with the National Gallery of Art in Washington, D.C., to present the most extensive exhibition of Copley's work held to that date, on the occasion of the publication of Jules D. Prown's authoritative monograph on the artist. Now, after another thirty years have passed, continuing interest in Copley has inspired the Metropolitan and the Museum of Fine Arts to organize a third major exhibition, one that brings recent scholarship to bear on the painter and his oeuvre. *John Singleton Copley in America* diverges from the tradition of monographic exhibitions by focusing on the work Copley produced before he left America for England in 1774. The paintings, pastels, and miniatures he executed before the Revolution are unified by the circumstances of their production and are stylistically and culturally distinct from his English pictures. They are remarkable not only as superb works of art but also as documents of the artist's ability to express the social and cultural values of his colonial patrons.

Copley's career in America was a triumph. The painter's respect for exacting craftsmanship and his familiarity with the history of the visual arts made him the portraitist of choice for affluent New Englanders and New Yorkers. He appealed to the taste and aspirations of his sitters by depicting them in costumes made of expensive fabrics and surrounded by luxurious draperies and high-style furniture. He indulged his patrons' anglophile leanings by rooting his images in the tradition of British portraiture: yet he was also uniquely able to provide sitters with individualized likenesses, portraits that were psychologically penetrating at the same time they emphasized wealth and social position.

We are especially pleased that the Metropolitan Museum and the Museum of Fine Arts have jointly organized *John Singleton Copley in America* for display in 1995, the year each institution celebrates its 125th anniversary. Since both museums were founded in 1870, they have worked together on numerous projects. This exhibition and catalogue result from the collaboration of Carrie Rebora, Associate Curator of American Paintings and Sculpture at the Metropolitan Museum; Paul Staiti, Professor of Art History at Mount Holyoke College and J. Clawson Mills Senior Fellow in the Department of American Paintings and Sculpture at the Metropolitan; Theodore E. Stebbins Jr., John Moors Cabot Curator of American Paintings at the Museum of Fine Arts; Carol Troyen, Associate Curator at the Museum of Fine Arts; and Erica E. Hirshler, Assistant Curator at the Museum of Fine Arts.

We are gratified that the exhibition will travel to the Museum of Fine Arts, Houston, and the Milwaukee Art Museum after its appearance in Boston and then in New York. *John Singleton Copley in America* is made possible by generous loans from many public institutions and private collectors, which we appreciate deeply.

Philippe de Montebello
Director
The Metropolitan Museum of Art

Malcolm Rogers
Ann and Graham Gund Director
Museum of Fine Arts, Boston

Preface and Acknowledgments

John Singleton Copley in America presents new ideas about Copley's paintings, working methods, and relationship to the culture of pre-Revolutionary America, especially of Boston and New York. The approach upon which this project is founded came from Paul Staiti, who some time ago began to explore the extraordinary social eloquence of the artist's American pictures. In 1990 Staiti came as a senior fellow to The Metropolitan Museum of Art, where Carrie Rebora had begun to plan a Copley show. Their collaboration gave rise to this exhibition and catalogue. Theodore E. Stebbins Jr. expressed interest in the undertaking and proposed that the Museum of Fine Arts, Boston, coorganize it; in so doing he made his institution's exceptional collection of Copley's work available for study. Erica E. Hirshler and Carol Troyen at the museum in Boston soon joined the curatorial team. The results of our efforts reflect the scholarly energy that Copley inspires and the way his paintings delight the eye and sustain fresh investigation.

The last important Copley exhibition, the retrospective show organized by Jules D. Prown in 1965–66 and accompanied by his catalogue and two-volume monograph covering the artist's entire career, remains a landmark for American art studies that need not be reprised. For our own project we decided to bring together a selection of Copley's best paintings, pastels, and miniatures in order to reveal his achievement. Issues of connoisseurship and stylistic quality guided our choices because we felt that the exhibition should highlight Copley's most visually compelling and technically accomplished pictures. But we also wanted to engage methodological aspects of recent art history to examine the works in the context of the circumstances of their production and patronage.

We decided to concentrate on Copley's career before his departure for England in 1774 because the paintings from his American years—over three hundred all told—issued from a single, unified culture that was very different from the culture that framed his production in England. We selected approximately sixty representative paintings, most of them the three-quarter-length, 50-x-40-inch portraits favored by the merchant elite and landed gentry of Massachusetts and New York, and a group of his finest pastels and miniatures.

This show confronts issues beyond those of an artist and his pictorial talent alone. Central among these issues is our belief that Copley's work not only responded to but also helped to constitute pre-Revolutionary culture in America, that his paintings were key agents in late colonial expressions of identity, class, and character. Copley's portraits themselves, which saturated the market to a degree perhaps unprecedented in the history of art, contributed vitally to the forging of social identity for the American merchant class.

Finally, as a corollary of our exploration of Copley's effect on his cultural milieu, we want to convey the idea that the content of his pictures was in large measure market driven. He worked in a city that had a parodic relationship to England, for Boston grew increasingly anglicized in the twenty years before the Revolution. Elite consumers, often plagued by the anxiety that afflicts provincials, sought to conform to English taste in art and artifacts. As a result, imports from England to America doubled between about the mid-1750s and the mid-1770s, and local silversmiths, furniture makers, and painters such as Copley strove to mimic English forms. For example, Copley chose English mezzotints as the basis for poses, costumes, and settings in his portraits to satisfy his sitters' desire to express their Englishness.

Our approach to Copley and his work brings new critical methods to bear upon biography, iconography, style, and other traditional aspects of the study of portraitists and portraiture. Consequently, we have produced an exhibition and a book that diverge from the typical monographic treatment: our project concerns not the taxonomy of Copley's life and art but the anthropology of this artist and the people for whom he worked. One essay views the artist through historiography, scrutinizing published accounts of Copley's career throughout the nineteenth century and up to the present day in an investigation of critical attitudes and methods that have shaped, distorted, and established his reputation. Two texts draw upon theories of art, portraiture, anatomy, etiquette, consumerism, and fashion to examine the relationship between culture and capitalism as they intersect in

Copley's life and in the paintings he produced in America. Another discusses his artistic aspirations in the context of pre-Revolutionary Boston, considering the development of his American manner and the nature of portraiture itself. These four principal essays are followed by four specifically focused studies that treat Copley's use of fashion in his portraits; his painting of miniatures in oil on copper and watercolor on ivory; his career as a pastelist; and the frames he selected for his paintings and pastels. Like the exhibition, the catalogue presents paintings, drawings, miniatures, and pastels arranged chronologically to reveal the way Copley's work developed over time. The catalogue entries address how Copley's paintings reveal the social and economic status, as well as the ambitions, anxieties, deceptions, and desires of his patrons, and explain the various ways in which the artist gratified his prestigious sitters with expressive portraits that enhanced their social positions and sense of self. The bibliography is comprehensive and includes references of both general and specific interest.

Countless individuals at the coorganizing institutions contributed their diverse talents to this project. Philippe de Montebello, Director of the Metropolitan Museum, was enthusiastic about *John Singleton Copley in America* from the start, and its successful outcome is due in great measure to his unwavering support and abiding wisdom. Malcolm Rogers, Ann and Graham Gund Director of the Museum of Fine Arts, Boston, encouraged the idea that this exhibition should be a cooperative venture between our two institutions, as did his predecessor, Alan Shestack.

We are grateful to many staff members at the Metropolitan for their contributions. In the Director's office we are particularly indebted to Mahrukh Tarapor, who oversaw all preparations with the able assistance of Martha Deese and Sian Wetherill, and to Jennifer Russell, who counseled us on numerous occasions. Linda M. Sylling of Operations coordinated innumerable details. Emily Kernan Rafferty worked with Lynne M. Winter and Nancy McLaughlin in Development to secure funding for the exhibition. In the Counsel's office Sharon H. Cott was aided in handling legal matters by Lee White Galvis, James L. Kronenberg, and Douglass Fleming. Members of the Departments of American Art were extremely helpful. John K. Howat, Kevin J. Avery, Thayer Tolles, Peter M. Kenny, Alice Cooney Frelinghuysen, Amelia Peck, Frances Gruber Safford, and Catherine Hoover Voorsanger offered support and encouragment. Morrison H. Heckscher generously provided his expertise and taught us about Copley's frames. The late Dale T. Johnson, whose strength of character and mind inspired all who knew her, shared her knowledge of Copley's miniatures with us. We especially thank H. Barbara Weinberg, who gave shrewd advice, sound judgment, and collegial support so often and so generously. Julie Eldridge, Jeanie Wienke, Irene C. Papanestor, Ellin Rosenzweig, and Emely Bramson handled many details. Don E. Templeton, Gary Burnett, Edward Di Farnecio, and Sean Farrell were indispensable to the realization of the exhibition. Dorothy Mahon of Paintings Conservation, Antoine M. Wilmering and Pascal Patrice of Objects Conservation, Marjorie Shelley of Paper Conservation, and Chris Paulocik of Costume Institute Conservation prepared many works for the exhibition. Richard Martin and Harold Koda gave us access to the vast resources of the Metropolitan's Costume Institute, and Dennita M. Sewell and Joell Kunath of their staff offered indispensable assistance. Suzanne Boorsch, Eliot Bostwick Davis, and Catherine Bindman of Drawings and Prints also deserve our thanks. Doralynn Pines and her staff in the Thomas J. Watson Library facilitated our research.

In the Metropolitan's Registrar's office Herbert M. Moskowitz, Aileen K. Chuk, and Stephanie Wahlgren efficiently made the arrangements for the exhibition tour. Kent Lydecker and his Education staff, including Aline Hill-Ries, Linda Komaroff, Christopher Noey, Stella Paul, Nicholas Ruocco, Teresa Russo, and Alice Schwarz, designed programs and projects. Hilde Limondjian placed the resources of Concerts and Lectures at our disposal. Harold Holzer and Jill Schoenbach of Communications arranged publicity on our behalf. The installation of the exhibition at the Metropolitan was the splendid work of David Harvey, graphics were the responsibility of Sue Koch, and lighting design was by Zack Zanolli, Anita Jorgensen, and Jonathan Sprouse.

At the Museum of Fine Arts the exhibition was realized through the dedicated labors of numerous staff members. Former Deputy Director Morton J. Golden supervised loan negotiations, and in the Exhibition Planning office Désirée Caldwell, assisted by Joshua P. Basseches, tended to numerous crucial details. In the Development office Patricia B. Jacoby and Marjorie M. Saul worked to assure funding. Marianna Pierce of the Counsel's office provided her expertise. We extend very special gratitude to Janet L. Comey and Karen E. Quinn of the Department of Paintings for their superb research and myriad contributions to our enterprise, which include the writing of catalogue entries, and we also acknowledge their colleagues Deanna M. Griffin, Julia McCarthy, Maureen Melton, Harriet Rome Pemstein, Marci E. Rockoff, and Regina Rudser. Jonathan L. Fairbanks, Gerald

W. R. Ward, and Jeannine J. Falino in the Department of American Decorative Arts and Sculpture were unfailingly generous with assistance and made available many exquisite objects that greatly enhanced the exhibition. Anne L. Poulet of European Decorative Arts and Sculpture was a thoughtful reader of a number of catalogue entries. Trevor J. Fairbrother in the Department of Contemporary Art shared his considerable knowledge of Copley with us. Anne E. Havinga, Annette Manick, and Roy L. Perkinson in the Department of Prints, Drawings, and Photographs were exceptionally helpful, as were Marianne Carlano and Nicola J. Shilliam of Textiles and Costumes. Nancy S. Allen and the staff of the museum's William Morris Hunt Library supported us in the pursuit of our research.

Paintings conservators at the Museum of Fine Arts devoted monumental efforts to this project and made exciting discoveries about Copley's methods and studio practices. We are greatly indebted to James M. Wright, Rita P. Albertson, Irene Konefal, Rhona Macbeth, Patricia O'Regan, Brigitte R. Smith, and Jean L. Woodward, assisted by Deborah Squires, for their superb work in treating many pictures in the exhibition. Andrew Haines made invaluable contributions, researching eighteenth-century frames, as well as tending to their conservation. The fruits of the conservators' labors are apparent not only in the renewed brilliance of many of the museum's paintings but also in the catalogue, where their findings constitute substantial additions to scholarship.

In the Museum of Fine Arts Registrar's office Patricia Loiko orchestrated countless details. Gilian Wohlauer of the Education department was responsible for interpreting this project for the Boston audience. Robert Mitchell and his Public Relations staff skillfully publicized the exhibition. The beautiful installation in Boston was designed by Judith Downes.

We acknowledge with gratitude the enthusiastic cooperation of staff members at the Museum of Fine Arts, Houston, and the Milwaukee Art Museum, the third and fourth venues for the exhibition. The primary responsibility for the presentation at Houston was borne by Peter Marzio, Director, and Gwen Goffe, Associate Director, who depended upon David Warren, Michael K. Brown, George T. M. Shackelford, Ann Coleman, Karen Bremer Vetter, A. Thereza Crowe, and Clifford Edwards of their curatorial area. We would like to single out for special notice Emily Ballew Neff, who pursued research on behalf of the coorganizers prior to her curatorial appointment at Houston. She devoted her skill and energy to ensuring that everything that had ever been written about Copley was represented in our files and, when she

completed that task, stayed on to unearth material on the artist's New York sitters. Many others in Houston deserve our thanks for their contributions: Margaret Skidmore and Ashley Scott in Development; Charles Carroll, Thommy Chingos, and Chris Tice in the Registrar's department; Wynne Phelan and Steve Pine in Conservation; Kathleen Crain in Preparations; Beth Schneider, Kathleen O'Connor, and Margaret Mims in Education; Alison Eckman in Public Relations; Diane Planer Lovejoy in Publications and Graphic Design; Jack Eby in Design and Exhibition Production; Jeannette Dixon in the Hirsch Library; Marcia K. Stein in the Slide Library; and Suzanne Decker and Tom DuBrock in Photographic Services.

Director Russell Bowman of the Milwaukee Art Museum encouraged our project and worked with Cheryl Robertson, Curator of Decorative Arts, to realize it at his institution. We also thank Lucia Petrie in Development. The exhibition was designed for the Milwaukee galleries by John Irion. For supporting the exhibition at this venue, the Milwaukee Art Museum is grateful to John A. Puelicher, Layton Art Collection Trustee, to Northwestern Mutual Life Foundation, and Marshall & Ilsley Corporation and especially acknowledges James D. Ericson, President and CEO of Northwestern Mutual Life Insurance Co., and James B. Wigdale, Chairman of the Board and CEO of Marshall & Ilsley Corporation and M & I Marshall & Ilsley Bank.

Research for this publication was carried out by a team of assistants, students, interns, and volunteers, to whom we owe a great debt: Susan Barto, Sarah Elson, Danielle Hughes, Nanette Scofield, Shira Silverman, and Nancy Stula filled our files with rich material. Elizabeth Lamb Clark joined the project as a researcher and simply could not be allowed to leave when she completed her initial task, so valuable a colleague had she become; she remained to assist with virtually every aspect of the publication and of the installation at the Metropolitan. She almost single-handedly gathered the illustrations for the book, an enormous task made easier by the extremely helpful individuals in the rights and reproductions departments of the many institutions involved. We extend our appreciation to several people who went above and beyond their usual duties to fill our complicated orders for photographs: Barbara Bridgers and her staff in the Metropolitan's Photograph Studio; Deanna Cross in the Metropolitan's Photograph and Slide Library; Karen L. Otis and Mary Sluskonis, Museum of Fine Arts, Boston; Ita Gross, Art Resource, New York; Janice Reading and Claire Messenger, Department of Prints and Drawings, British Museum, London; Elisabeth Gombosi, Harvard University Art Museums,

Cambridge, Massachusetts; Claire Kelly, National Portrait Gallery, Smithsonian Institution, Washington, D.C.; Janice Dockery, Historical Society of Pennsylvania, Philadelphia; Suzanne Warner, Yale University Art Gallery, New Haven. We are also grateful to David Bohl, Benjamin Maggos, and Bruce Schwarz for special photography.

We relied upon the resources of numerous institutions and the expertise of many gracious colleagues: Susan Faxon, Addison Gallery of American Art, Phillips Academy, Andover, Massachusetts; Warren Adelson, Adelson Galleries, New York; Georgia B. Barnhill, American Antiquarian Society, Worcester, Massachusetts; Mary LeCroy, American Museum of Natural History, New York; Judith A. Barter and Kimberly Rhodes, The Art Institute of Chicago; Sona Johnston, The Baltimore Museum of Art; Frederick Hill, Berry-Hill Galleries, New York; Michael Wentworth, Trevor Johnson, Stephen Nonack, and Rodney Armstrong, Boston Athenaeum; Fred Licht and Mary C. Beaudry, Boston University; Carolyn Hughes, Karen Gausch, and Phillip Bergen, Bostonian Society, Boston; Lynne Harrell, J. Carter Brown Library, Brown University, Providence, Rhode Island; Mark Brown and Rita H. Warnock, John Hay Library, Brown University; Ellen Nelson, Cape Ann Historical Association, Gloucester, Massachusetts; H. Nichols B. Clark, The Chrysler Museum, Norfolk, Virginia; William H. Gerdts, Graduate School and University Center of the City University of New York; David Steinberg, The Cleveland Museum of Art; David Lubin and Lynn Marsden Atlass, Colby College, Waterville, Maine; Sarah Elliston Weiner and Hollee Haswell, Columbia University in the City of New York; Nancy Rivard Shaw, Detroit Institute of Arts; Philip Cash, Emmanuel College, Boston; Steven Dudley and Janet Howell, The First Religious Society, Newburyport, Massachusetts; John W. Tyler, Groton School, Massachusetts; Jeanne T. Newlin, Harvard Theatre Collection, Harvard College Library, Cambridge, Massachusetts; Richard J. Wolfe, Countway Library, Harvard Medical School, Cambridge, Massachusetts; Robin McElheny, Harvard University Archives, Cambridge, Massachusetts; Sandra Grindlay and Timothy A. Burgard, Harvard University Art Museums, Cambridge, Massachusetts; Stuart P. Feld, Hirschl and Adler Galleries, New York; Jennifer Saville, Honolulu Academy of Arts; Lawrence A. Fleischman, Kennedy Galleries, New York; Carol Bacon, Littlefield Library, Tyngsboro, Massachusetts; Aileen Susan Fort, Los Angeles County Museum of Art; Judith Anderson and Elizabeth Hunt, Marblehead Historical Society, Massachusetts; Peter Drummey, Virginia Smith, and Catherine Craven, Massachusetts Historical Society, Boston; Susan Danly, Mead Art Museum,

Amherst College, Massachusetts; Mary M. Gallant, Medford Public Library, Massachusetts; Alan Stein, Morristown National Historic Park, New Jersey; Clare Sheridan, Museum of American Textile Industry, North Andover, Massachusetts; Doreen Bolger and Ann Slimmon, Museum of Art, Rhode Island School of Design, Providence; Tony Mackle, Museum of New Zealand Te Papa Tongarewa, Wellington; Nicolai Cikovsky Jr. and Franklin Kelly, National Gallery of Art, Washington, D.C.; Elizabeth Broun, Richard Murray, and Margy P. Sharp, National Museum of American Art, Smithsonian Institution, Washington, D.C.; Ellen G. Miles and Linda Thrift, National Portrait Gallery, Smithsonian Institution, Washington, D.C.; David Dearborn and Scott Bartlett, New England Historical and Genealogical Society, Boston; Betsy Hamlin-Morin, New Hampshire Historical Society, Concord; Rupert Barneby and John Mickel, New York Botanical Gardens; Lynn Warner, New York Horticultural Society; Roberta Rainwater, New York Public Library; Bertram Lippincott III and his staff, Newport Historical Society, Rhode Island; Patrick Leehey, Paul Revere House, Boston; Dean Lahikainen and William La Moy, Peabody Essex Museum, Salem, Massachusetts; Sylvia Yount, Pennsylvania Academy of the Fine Arts, Philadelphia; Kevin Shupe, Richard M. Candee, Carolyn Eastman, Portsmouth Athenaeum, New Hampshire; Nicholas B. Bragg, Reynolda House, Winston-Salem, North Carolina; Gail Mohanty, Slater Mill House Museum, Pawtucket, Rhode Island; Richard Nylander, Lorna Condon, Anne Clifford, and Martha Pike, Society for the Preservation of New England Antiquities, Boston; Greg Colati, Susan Grigg, Rodney Rowland, Strawbery Banke Museum, Portsmouth, New Hampshire; Elizabeth C. Bouvier, Supreme Judicial Court, Archives and Records Preservation, Boston; Nancy Ames Petersen and Hal Fischer, Timken Museum of Art, San Diego; Stephen A. Mrozowski and Marcos A. Paina, University of Massachusetts, Boston; Robert Vose, Vose Galleries, Boston; Elizabeth M. Kornhauser, Wadsworth Atheneum, Hartford; E. McSherry Fowble, Joyce Hill Stoner, Wendy Samet, and Caitlin McQuade, Winterthur Museum, Delaware; Susan Strickler and Judy MacQueston, Worcester Art Museum, Massachusetts; Theresa Fairbanks, Yale Center for British Art, New Haven; Robin Frank, Helen Cooper, and Mark Aronson, Yale University Art Gallery, New Haven.

The exhibition and catalogue could not have been realized without the Copley works and related decorative arts, as well as information about them, made available to us by public institutions and private collectors alike. We express our appreciation to these generous lenders and also thank the fol-

lowing for special assistance: Carol Aiken, William Goodell Barnum, Michael Scott Barratt, Caroline Cabot, John H. Claiborne III, Grenville Clark Jr., Samuel Crocker, Katherine Eirk, Cynthia Fleming, James Leo Garvin, Jean K. Gridley, Philip Hanes, Edward Sprague Jones, June Waterman Lincoln, Michael Quick, Susan Ricci, Elizabeth Barnum Rose, John T. Sargent, Stanley P. Sax, Marc Simpson, Sarah Watkin, Erving and Joyce Wolf.

In the course of pursuing research in Great Britain, we were treated with kindness and hospitality by many individuals to whom we owe gratitude: Deborah Gage; Hazel Gage; Robin Gage; Lt. Colonel and Mrs. John Montresor; Jeremy and Belinda Morse; Thomas Woodcock, The College of Arms, London; Helen Watson, Scottish National Portrait Gallery, Edinburgh; Robin Hamlyn, Tate Gallery, London; the staff members of the British Museum Library and Department of Prints and Drawings, National Portrait Gallery, National Register of Archives, Public Record Office, Royal Academy Archives, and Victoria and Albert Museum Library, all in London.

For sharing her vast knowledge of eighteenth-century British and American costumes and fashion, we are most indebted to Aileen Ribeiro of the Courtauld Institute of Art, London, who not only flattered us by agreeing to write an essay for our book but also freely offered her insights and opinions on many occasions. We appreciate as well the advice we received on costumes from Claudia B. Kidwell, National Museum of American History, Smithsonian Institution, Washington, D.C.; Patricia Mears, The Brooklyn Museum, New York; Jean L. Druesedow; and Michele Majer.

This publication took shape in the Editorial Department at the Metropolitan Museum under the ever-watchful eye and expert guidance of John P. O'Neill. Barbara Burn was a great advocate for our book and took care of many administrative details related to it. Carol Fuerstein edited the manuscript superbly, smoothing over its rough edges and teaching the authors much about the art of writing. She was assisted in this monumental task by Barbara Cavaliere, Cynthia Clark, and Jean Wagner. Bruce Campbell designed the book with a brilliant sense of how to make the layout enhance the subject at hand. Matthew Pimm, Gwen Roginsky, and Chris Zichello saw the book through the stages of its production, and Steffie Kaplan carefully made the mechanicals.

We extend our sincere thanks to Jules D. Prown of Yale University, who shared his comprehensive knowledge of Copley with us frequently during the course of this project. We appreciate the generosity with which he opened his files to us, answered our questions, and encouraged our investigations. He inspired and emboldened us in our efforts to bring Copley scholarship up to date, and for that we are profoundly grateful.

The William Cullen Bryant Fellows of The Metropolitan Museum of Art supported this publication in its initial stages. The Henry Luce Foundation, Inc., and the National Endowment for the Arts made the exhibition possible in part through generous grants. To these benefactors we extend our deepest appreciation.

Carrie Rebora and Paul Staiti
Erica E. Hirshler, Theodore E. Stebbins Jr., Carol Troyen

Lenders to the Exhibition

American Antiquarian Society, Worcester, Massachusetts

The Baltimore Museum of Art 55

The Boston Athenaeum 37

British Museum, London 6

The Chrysler Museum, Norfolk, Virginia 72

The Cleveland Museum of Art 21

Columbia University in the City of New York 47

The Corcoran Gallery of Art, Washington, D.C. 63

Department of State, Washington, D.C. 39

Detroit Institute of Arts 71

Fine Arts Museums of San Francisco 64

President and Fellows of Harvard College, Cambridge,
 Massachusetts 30, 31

Historical Society of Pennsylvania, Philadelphia 9, 80

Los Angeles County Museum of Art 69

Marblehead Historical Society, Massachusetts

Massachusetts Historical Society, Boston 23

The Metropolitan Museum of Art, New York 4, 27, 41, 42,
 54, 68, 79

Museum of Art, Rhode Island School of Design, Providence
 8, 18, 34

Museum of Fine Arts, Boston 1, 7, 10, 12, 15, 19, 22, 25,
 26, 32, 33, 45, 46, 48, 58, 60, 61, 62, 65, 76, 81

Museum of Fine Arts, Houston 13, 57, 73

Museum of New Zealand Te Papa Tongarewa,
 Wellington 59

National Gallery of Art, Washington, D.C. 11, 74

National Museum of American Art, Smithsonian
 Institution, Washington, D.C. 20

National Portrait Gallery, Smithsonian Institution,
 Washington, D.C. 28, 29

New-York Historical Society

The New York Public Library, Astor, Lenox and Tilden
 Foundations

The Pennsylvania Academy of the Fine Arts,
 Philadelphia 40

Timken Museum of Art, San Diego 67

The Toledo Museum of Art 38

Wadsworth Atheneum, Hartford 52, 53

Winterthur Museum, Delaware 5, 70

Worcester Art Museum, Massachusetts 56

Yale Center for British Art, New Haven 66

Yale University Art Gallery, New Haven 14, 50, 51

Mason Bowditch and Courtenay Bromfield Cabot 17

John H. Claiborne III 35, 36

Gloria Manney 49

Stanley P. Sax 3

Erving and Joyce Wolf 16

Anonymous lenders 2, 24, 43, 44, 75, 77, 78

Contributors to the Catalogue

JLC Janet L. Comey
Research Assistant, Department of Paintings
Museum of Fine Arts, Boston

Morrison H. Heckscher
Curator of American Decorative Arts
The Metropolitan Museum of Art, New York

EEH Erica E. Hirshler
Assistant Curator of American Paintings
Museum of Fine Arts, Boston

KEQ Karen E. Quinn
Assistant Curator of American Paintings
Museum of Fine Arts, Boston

CR Carrie Rebora
Associate Curator of American Paintings and
Sculpture and Manager of The Henry R. Luce
Center for the Study of American Art
The Metropolitan Museum of Art, New York

Aileen Ribeiro
Professor of the History of Dress
Courtauld Institute of Art, London

Marjorie Shelley
Conservator, Paper Conservation
The Metropolitan Museum of Art, New York

PS Paul Staiti
Professor of Art History
Mount Holyoke College,
South Hadley, Massachusetts

Theodore E. Stebbins Jr.
John Moors Cabot Curator of American Paintings
Museum of Fine Arts, Boston

CT Carol Troyen
Associate Curator of American Paintings
Museum of Fine Arts, Boston

John Singleton Copley
in America

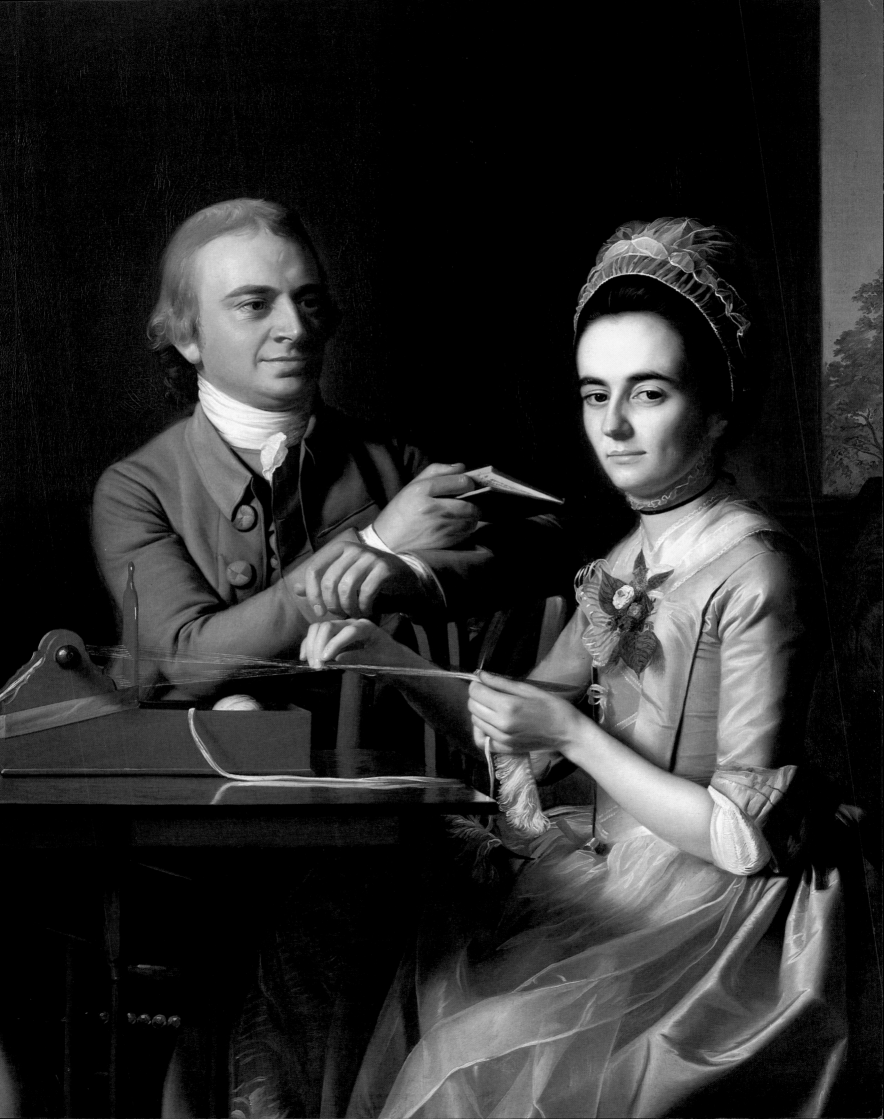

Copley and Art History: The Study of America's First Old Master

CARRIE REBORA

*It is a pleasing reflection that I shall stand amongst the first of
the artists that shall have led that Country to the Knowledge
and cultivation of the fine Arts.*

Copley, letter to Henry Pelham, Rome, March 14, 1775

It might be said that John Singleton Copley has been studied enough. The bibliography is voluminous, encompassing books, dissertations, and theses, as well as essays and articles in publications ranging from the *Gazette des Beaux-Arts* to *National Geographic* and *Vogue*, from exhibition catalogues to monographs and catalogues raisonnés. Few other American artists have been considered as frequently, yet the amount of material on Copley is deceptive, for few other well-known American artists are as little known.

Within the discipline of American art history, which has long been populated by scholars who have combed likely and unlikely repositories in pursuit of information, Copley has been an exemplary subject. His life and work have captivated an astounding number of authors; indeed, many of the principal historians in the field have written about Copley. They have discussed the sources of his compositions, his knowledge of art history, aesthetic theory, and iconography, the relationship of his drawings to his paintings, his working methods, his painting style, the costumes and other props in his portraits, his choice of frames, his patrons, his personality, and his family life. For more than a century these authors have made Copley's life in Boston, his life in London, and the identities of his sitters and patrons familiar to students and collectors of American art. They have qualitatively classified and quantitatively categorized his work, extensively studied matters of authenticity, dating, and style, and virtually completed the cataloguing of the oeuvre. One of a handful of early American artists who rank as masters

by almost any standard—and his paintings have been compared, justly or not, to paradigms of portraiture ranging from the Fayyum encaustics to Van Dyck and Velázquez—Copley has been the subject of at least one essay, book, or catalogue every year for over a century. The first checklist of his paintings was published in the early 1870s, and the first full-length monograph on the artist appeared within the next decade, and there were studies long before that.

The initial literature on Copley is full of praise based on little more than hearsay. Although they knew almost nothing of his life and less about his work, early-nineteenth-century commentators lauded Copley as an inspiration for all young American painters. In succeeding decades scholars reconstructed his biography from bits and pieces of documentation and recollections and compiled lists of his works—in fact, in 1888 the Boston critic William Howe Downes likened his researches on Copley to paleontology.[1]

Nothing approximating connoisseurship was undertaken by Copley's earliest biographers and cataloguers. His sitters and their appurtenances attracted more interest on the part of writers and public alike than did his painting style or technique; owners of Copley portraits, who usually were descendants of the sitters, cherished them more for whom they depicted than for the manner in which the subjects were depicted. When Copley's paintings began entering public collections during the late nineteenth and early twentieth centuries, however, curators and dealers started to pay attention to quality and to scrutinize their condition, and scholars pursued more focused studies, investigating individual paintings and specific aspects of his career.

As knowledge of the facts of Copley's life increased and

the record of his paintings and the appreciation of his technique grew, critical judgments about the work were more often made; the most common of these assessments involved a preference for and a concentration on the pictures produced in America, as opposed to those executed after Copley departed for the Continent and England in 1774. Nationalism or nativism came to underlie the attitudes of Copley scholars between the world wars, in the same way it determined the viewpoints of students of other American artists who had lived or worked abroad. This trend was succeeded in the 1960s by studies of Copley's full career grounded in formal and stylistic analysis and connoisseurship. In the most recent studies Copley's pictures have become the subject of cultural and ideological inquiry.

The Copley bibliography comprises as much anecdotal history and romantic narrative as factual material, as much formal analysis as interpretive examination; in short, it reflects changing attitudes toward what constitutes history and marks directions and methods in American art-historical scholarship. In this respect the record of Copley's life and work is no different from that of other American artist celebrities, such as Thomas Cole, George Caleb Bingham, Thomas Eakins, Winslow Homer, and Albert Pinkham Ryder; the painter and his work remain inexhaustible and relatively impenetrable despite the amount that has been written about them. This is not to say that the appreciation or interpretation of an artist can ever be complete, but that Copley, perhaps to a greater extent than most American artists, defies entirely satisfactory readings. The critic William Rankin wrote in 1905 that "the prevailing estimate of the artist . . . grants him a success of eminent esteem but no active immortality."[2] This essay, by reviewing the Copley literature and examining its ideological biases, speculates on the reasons Rankin's observation still applies today.

The literature on Copley began as mythology rather than historiography. Because he was one of the few Americans invoked during the early nineteenth century as an inspiration to other artists, Copley became an American art paragon even before his death. According to John Bogert, secretary of New York's American Academy of the Fine Arts, who wrote an essay on the fine arts in 1811, Copley's "eminence" certified the promise of American art.[3] Bogert knew little about Copley—he referred to him as Copeland—but a familiarity with his work apparently was not a prerequisite to endorsement. In fact, although Copley's work was generally unknown, his name was often put to service by nineteenth-

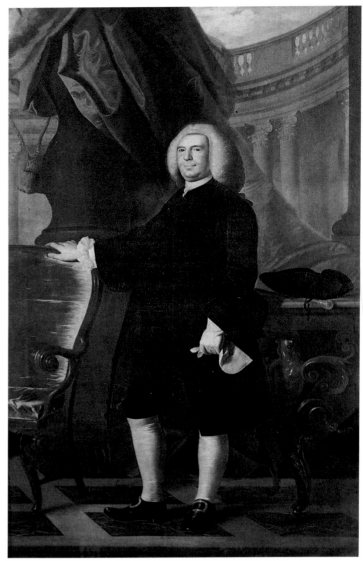

Fig. 1 *Thomas Hancock*, 1764–66. Oil on canvas, 95⅝ x 59½ in. (242.9 x 151.1 cm). Harvard University Portrait Collection, Cambridge, Massachusetts, Given by John Hancock, nephew of Thomas Hancock, to Harvard College, 1766

century commentators on the prospects for American art. His pictures rarely were exhibited publicly in the United States during the first decades of the nineteenth century. The history paintings that established his reputation in England and earned him respect in America as a successful native son who excelled in relation to foreign artists were known here only through engravings. There were many Copley portraits in America, but most hung in the private homes of his sitters' descendants. The one sizable public collection of Copley's work, which includes full-length portraits of Thomas Hancock, Thomas Hollis (figs. 1, 2), and Nicholas Boylston (fig. 135), half-lengths of Nicholas and other Boylston family members (fig. 187; cat. nos. 30, 31), was unknown to anyone who did not frequent the halls and meeting rooms of Harvard University.

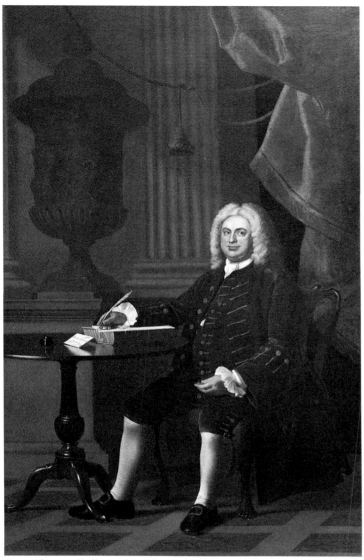

Fig. 2 *Thomas Hollis*, 1766. Oil on canvas, 94 x 58 in. (238.8 x 147.3 cm). Harvard University Portrait Collection, Cambridge, Massachusetts, Commissioned by the President and Fellows of Harvard College in 1765

[Phoenix Art Museum]), for few readers would have felt the need for such information. A Copley was a Copley, and a Copley was worthy of study. In 1817 a contributor to *American Monthly Magazine* referred to Copley as "one of the men who have made the United States to be considered as the birth place of painters" but, in lieu of presenting a discussion of his work, offered only that a certain Copley portrait of a lady on view in New York "has much to be admired."[7] Even Copley's second-rate paintings and paintings questionably attributed to him were accepted and admired. In 1833 a New York critic called a portrait of Gabriel Ludlow (Museum of the City of New York)—reattributed a century later to an unknown artist's hand—"a queer old picture" yet recommended it because it was thought to be by Copley.[8]

For most of the nineteenth century, knowledge of Copley's work rested upon portraits shown in newly established art galleries and exhibition halls in Boston, Philadelphia, and New York. As proprietors solicited loans from local collectors, the exposure of audiences to his paintings slowly increased. At the Boston Athenaeum, an institution in a neighborhood abounding with portraits in private homes, Copley was represented in annual loan exhibitions beginning in 1827. The inaugural presentation included five portraits by Copley, and there were eight in the 1828 show. The board of directors listed them in the catalogues that accompanied the exhibitions under the distinguished heading "Old Masters"[9]—thereby expressing its appreciation of the paintings, rewarding Copley's native-son status in Boston, and betraying American eagerness to link American art to a noble past full of respected traditions.

In Philadelphia Copley was known primarily for his portrait *Mr. and Mrs. Thomas Mifflin* (cat. no. 80), which was secured by Charles Willson Peale for the 1795 Columbianum exhibition and borrowed by the directors of the Pennsylvania Academy of the Fine Arts for its show of 1817. In New York Copley was exalted by both John Trumbull, acting in his role as president of the American Academy, and Trumbull's friend Elkanah Watson, who had sat for Copley in 1782. Trumbull touted Watson's portrait (fig. 3), which was lent to the American Academy in 1822, as "a specimen of the extraordinary attainment of one of the earliest and brightest ornaments of the age in which he lived." For his part, Watson told Trumbull that Copley considered the portrait "his chef d'oeuvre"; he also exacted a promise from Trumbull that in the event of fire or other disaster in his gallery, the portrait would be saved "in preference to any other object."[10]

That Copley's early reputation superseded the scant physical evidence of his talent disproved the artist's own pessimistic statement "that fame cannot be durable where pictures are confined to sitting rooms."[4] To be sure, his fame, rather than his pictures, perpetuated his fame—suggesting that Daniel Boorstin's remark that a "celebrity is a person who is known for his well-knownness"[5] is as relevant to the nineteenth century as it is to the twentieth. Viewers dazzled by Copley's name did not find that it was necessary to question or closely examine the work. In 1816 an editorialist for the *National Advocate* argued that artists should be granted free admission to an exhibition in New York because it included a Copley portrait of a man that was crucial for them to study.[6] He did not support his case by identifying or describing the portrait (it was *John Graham*, 1798

Unfavorable criticism of Copley was quite rare during the early nineteenth century, even though a number of respected American artists who had seen a good deal of his work in London knew that he was not consistently brilliant. For example, Samuel F. B. Morse, who visited Copley in London in 1811, recognized that his paintings from the 1770s and 1780s were "exquisite" but that his more recent ones were "miserable."[11] Gilbert Stuart complained that Copley was a tedious artist, although he knew how to "manage paint" better than anyone, and Thomas Sully, who also appreciated scrupulous technique, said Copley "had great force and breadth" but "was crude in colouring, and used hard terminations."[12] In 1829 the Philadelphia critic John Neal became one of the few dissenters among writers in the press when he dismissed *Elkanah Watson* as "about half as good a thing as [Copley] ought to have made of it, with a tenth of his power."[13] These informed opinions had little impact on contemporary understanding of Copley because they were recorded privately and also because the general audience held fast to arbitrary assessments of technique or skill where Copley was concerned.

Copley's reputation continued to expand during the nineteenth century, notwithstanding some harsh treatment of his work by artists and critics. Despite its negative point of view, William Dunlap's lengthy account of Copley's career, published in 1834, solidified his reputation as an artist worthy of honor and emulation. Dunlap's piece on Copley appeared in his *History of the Rise and Progress of the Arts of Design in the United States*, in which he profiled nearly three hundred artists in essays that were brief and factual or long and opinionated.[14] His biography of Copley was among his longest entries (although the texts on Trumbull, whom he despised, and Benjamin West, whom he idolized, and his autobiography were longer); it featured paragraphs of neutral narrative presenting the details of his life intertwined with disparaging commentary about him and his work. Dunlap compiled his biographies from a variety of sources, such as letters, published writings, and conversations. In Copley's case he relied heavily on short biographies by English authors Frances Lieber and Allan Cunningham.[15] Lieber, whose approach was encyclopedic, and Cunningham, who had access to some of Copley's letters and many of his history paintings, provided threads of information that Dunlap wove into a critical account of the artist's career; since both authors stressed Copley's years in England, Dunlap did the same. As was his custom, he quoted lengthy passages from both sources, including superfluous or inaccurate information. He then refuted the questionable material, thereby establishing his authority and critical position. He disabused his readers of the romantic idea, set forth by both Lieber and Cunningham, that Copley had emerged a great painter from "the wilderness" by explaining that artists' supplies as well as artistic inspiration were readily available in the American colonies. Twice he took issue with the notion that Copley was self-taught, and he disagreed with the characterization of him as a history painter, preferring to think of his historical compositions as "collection[s] of portraits." With the help of secondhand accounts—although he had seen the artist's work himself in London and New York—he portrayed Copley's technique as laborious and indecisive. He complained that Copley had become "a being of superior nature from those with whom he once associated," arguing that the painter, although talented, should not be "lost to the mass from which he is taken."[16]

Dunlap's commentary altered the criteria used to qualify Copley as a distinguished artist and, despite its contentious tone, influenced the way Americans thought about and discussed this particular painter and American art in general. He established a canon of American art history that persists in certain of its aspects to the present day, even though modern scholars understand that his opinions were, necessarily, formed by the biases of his own time. As Charlotte Adams explained in 1888 in the *American Magazine*, Dunlap's "chronicles of early American art have a classic value."[17] For his own generation of scholars and writers, however few there were, Dunlap invented a critical rhetoric that replaced the glowing, adulatory language of earlier writing on American art. By the late 1830s, thanks largely to Dunlap, Copley was no longer praised as the embodiment of the national genius and promise. In his book Dunlap had drawn attention to the existence of many noteworthy American painters, to whom he devoted individual chapters, and this sort of accolade was meaningless in a country where numerous artists worked and prospered. His message was that American art must be represented not by the accomplishments of one or two individuals who were praised out of proportion but rather by the myriad achievements of the entire community of American artists. And Copley, he maintained, should be remembered simply as a very talented portraitist.

Indeed, during the mid-nineteenth century, Copley was championed above all by portraitists and connoisseurs of portraits. G. P. A. Healy thought of Copley as "the greatest portrait painter of the last century."[18] In 1855 Rembrandt Peale included Copley's name in a short list of America's best painters, and Horatio Greenough proudly related that the

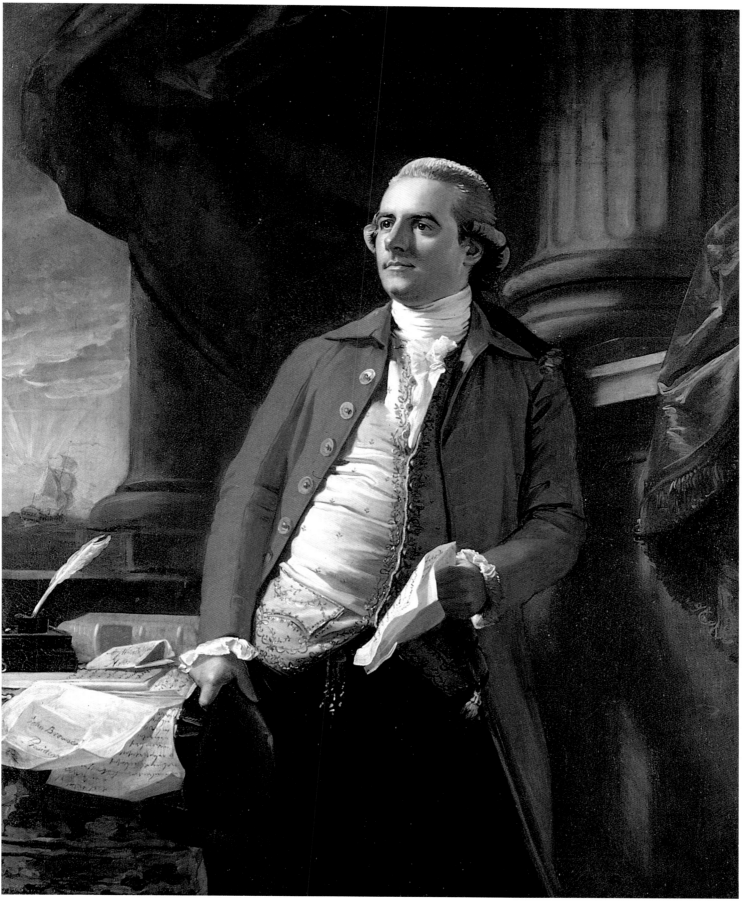

Fig. 3 *Elkanah Watson*, 1782. Oil on canvas, 58⅝ x 47⅝ in. (149 x 121 cm). The Art Museum, Princeton University, Presented by the Estate of Josephine Thomson Swann

excellence of Copley's portraits had astonished Sir Joshua Reynolds.[19] At about the same time, *Putnam's Monthly* published the "Confessions of a Young Artist," the journal of an unidentified fledgling painter whose teacher, Mr. Ochre, set him on the right course of study by recommending Copley's work. The youth considered Copley's portraits "old fashioned" and told Mr. Ochre that he had selected a "fancy head" by Sully to copy, whereupon the teacher, irritated that his pupil did not "know better . . . after all my instructions," led him to a Copley portrait.[20] Even the critic James Jackson Jarves, who castigated Copley's portraits in *The Art Idea* of 1864 as "cold in color and aristocratic in type" and therefore ill-suited to Americans, found something to recommend in his painting: it had, he noted, "precisely the qualities of coloring and design to please Londoners of rank and fashion."[21]

Copley's most influential advocate at midcentury was Henry T. Tuckerman, who introduced his chapter on the painter in his *Book of the Artists* of 1867 with a brief discourse on portraiture. Portraits, Tuckerman wrote, "are useful and attractive not only as connected with the affections, or as meritorious works of art, but as symbols of departed races and ages." In the spirit of post–Civil War nationalism, he advanced the idea that Americans interested in the history of their country and in their native ancestry should take note of portraits of men and women who lived during the Revolutionary era, and he finally introduced his central subject with the remark that possession of a Copley portrait "is an American's best title of nobility." He waxed enthusiastic about the bygone era that Copley portrayed, a time when "the distinction of gentle blood was cherished . . . [and] the patrician element still carried honorable sway in the New World."[22] Whereas Copley had worried that his portraits would be "regarded only for the resemblance they bear to their originals,"[23] Tuckerman was especially drawn to their verisimilitude. He must have seen many of Copley's portraits in private collections and public galleries as he prepared his book, for he devoted a good deal of space to listing their owners.

Tuckerman provided the most fact-filled biography of his subject to date, relying upon Dunlap yet taking issue with that author's "indignant" tone. Despite their differences, Tuckerman's *Book of the Artists* and Dunlap's *History* fall into the same category of eyewitness, Vasari-influenced historical enterprise and served basically the same function: one corroborated the other in securing Copley's place in the canon of American art history. But it was Tuckerman who most powerfully buttressed Copley's reputation for audiences of the late nineteenth century, when American art of the present was prized over that of the past, when landscape and narrative subjects were considered worthier than portraiture, and when European-trained American artists were usually favored over their self-taught countrymen. Tuckerman implied that Copley's work should not be viewed in the same way as contemporary art. He offered critical and aesthetic judgments and suggested that interpreters might usefully bring to their task a reverence for the past. For example, he considered the treatment of "the familiar and the imaginative" and "the beauty of the execution" in Copley's portrait of his half brother, Henry Pelham (cat. no. 25), while indulging a nostalgic bent: Pelham's clothing, he said, was "so much more picturesque than that of the present day."[24]

A few years after Tuckerman's book appeared, Augustus Thorndike Perkins published the first catalogue of Copley's paintings. Perkins, a member of the Copley family by marriage and a descendant of a Copley sitter, began his work on the artist as a service to his relatives and in honor of all of Copley's sitters and their families. In the preface to his book, which was published privately in 1873, Perkins told Copley's life story as it emerged, year by year, paragraph by paragraph, by implication from the list of people he painted. This was a sentimental and personal project: Perkins's research involved interviewing and corresponding with Copley's descendants and his sitters' descendants. He spoke, moreover, of the portraits as embodiments of their subjects and described his own mission in almost mystical terms, explaining that in his catalogue "husbands and wives, brothers and sisters . . . will be brought together in close companionship" and that friends and acquaintances would, he hoped, be "reunited."[25] Perkins's focus on Copley's subjects to some extent anticipated modern patronage studies that bring knowledge of Copley's sitters to bear upon the artist and his work. As an art historian working in the 1870s, Perkins could not, of course, have pursued this progressive methodology, but his catalogue of Copley's extant work is a significant achievement on its own terms, presenting valuable material upon which others built and elaborated.

Perkins, however, offered little information that would have persuaded the critic Clarence Cook that Copley was a great painter. Cook took note of Copley's portraits in his *New York Daily Tribune* review of the art display at the Philadelphia Centennial Exposition of 1876 and found nothing of inherent interest in them: "the monstrous deal of hard work and patience by which most of his pictures were produced would rather dampen a scholar's ardor in the contem-

plation than blow it to a flame," he maintained. But he understood the contemporary viewpoint that Copley could best be appreciated in terms of his important position in history and rather begrudgingly recommended that his portraits be treated "with tolerance at least, if not with positive respect," even though he had "no pupils and no imitators."[26]

The immediate successor to Perkins's volume was the first full-length biography of Copley, written by Martha Babcock Amory in 1882 and previewed in excerpts in *Scribner's Monthly*. Amory, who was the artist's granddaughter, explained that she had noticed "a deep and general interest in Copley" and so had undertaken to reconstruct his life. In the tradition of many other contemporary authors of monographs on artists, she began her book like a fairy tale: "A century and a half ago an humble boy, of quiet habits and untiring industry, with a rare love of art, was born in the little town of Boston, Mass. Without instruction or master he drew and painted and 'saw visions' of beautiful forms and faces . . . till his name and portraits began to be known in the staid Puritan society of the place."[27] She drew her material primarily from original letters owned by her mother, Copley's daughter. Interweaving anecdotes and hearsay with transcriptions from these letters, Amory narrated the story of Copley's modest and extraordinary youth, his felicitous and loving marriage, and the birth of his son who later became Lord Lyndhurst. A memoirist concerned with the human-interest aspect of her subject, she favored domestic matters over artistic ones, relating all she knew about Copley's taste in clothing, his manners, and his personality. The few writers who criticized Amory regretted that she had not written more about Copley's work; a reviewer for *Lippincott's Magazine*, for example, wished that she had taken her reader "into the painting-room" instead of forcing him to "content himself in the family drawing room."[28]

Amory was unfalteringly respectful of her subject, and her treatment of him, if it did not meet the approval of discriminating readers, was in perfect keeping with the contemporaneous colonial revival. Responding to scholarly and popular interest in America's early days, this movement was characterized by deep reverence and nostalgia for things colonial—furniture and simple artifacts such as household utensils, as well as portraits—and was well served by Amory's biography. The growing popularity of genealogy, which some Americans in the grip of the colonial revival hoped would help them trace Anglo-Saxon roots, also created a climate that welcomed studies of colonial portraiture, such as Amory's, that were rich in biographical material and weak in the areas of connoisseurship and aesthetics. It is to

be expected, then, that other essays on Copley published during the late nineteenth century also took the sympathetic and romantic tone of reminiscences. The author of a short essay titled the "Life of John Singleton Copley" that appeared in *Magazine of Art* in 1879 proposed that "his only teacher was his own observation, his only class-room the fields and lanes around his parents' house."[29] Charlotte Adams described the way Copley's "radiant, mobile Irish face sparkled,"as if she might bring the artist to life, in an article she wrote for *Art Interchange* on the occasion of the 1893 World's Columbian Exposition, which included Copley's work.[30]

By the turn of the twentieth century, Copley's portraits could be viewed in museums in New York (in Brooklyn as well as in Manhattan), Boston, Worcester, Hartford, Chicago, Cleveland, Detroit, and St. Louis, and essays on him appeared regularly in a variety of magazines, newspapers, and books. The texts that celebrated acquisitions of Copley's works by museums typically offered biographical information about the sitter, a few laudatory sentences on the artist, and a conclusion that the painting or pastel in question filled a conspicuous gap in the collection.[31] Most American museums had been established in the late nineteenth century with holdings of antiquities and European art and needed to build representative collections of American art that included paintings by the greatest American artists; in this context it was unnecessary for writers to explain why a painting by Copley was a desirable and necessary acquisition. Thus, commentaries that attempted to elucidate Copley's talents were rare and, indeed, unexpected, and so it is surprising to encounter an essay of 1908 that suggests that his portraits of Mr. and Mrs. Isaac Smith (cat. nos. 50, 51) reveal the artist's "power to perpetuate the character and manners of his time."[32]

Perhaps it is unavoidable in portraiture that the characteristics of the sitters seem to overwhelm the other qualities of the paintings. As Richard Brilliant recently explained, "It is as if the [portraits] do not exist in their own material substance but, in their place, real persons face me from the other side."[33] This perception was especially evident during the late nineteenth and early twentieth centuries, when writers often encumbered their interpretations of Copley's portraits with mawkish visions linked to America's olden days and with attributes of their own invention. Characteristically, one critic said in 1918 that *Mrs. Michael Gill* (fig. 4) reminded him of "bumper Thanksgiving dinners, of pumpkin pie, and clear wines of home vintage."[34] Downes, who knew more about Copley and his work than most, wrote in

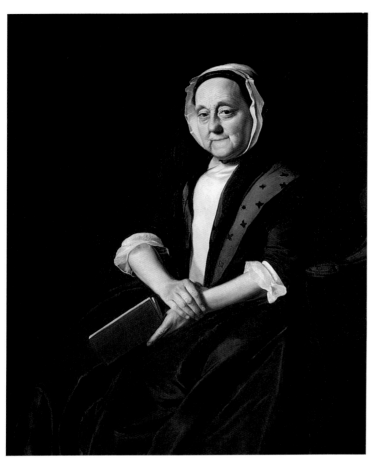

Fig. 4 *Mrs. Michael Gill (Relief Dowse)*, 1770–71. Oil on canvas, 50 x 40 in. (127 x 101.6 cm). The Tate Gallery, London

1886 that Copley's paintings were easily identifiable: "the smirking, self-satisfied looking colonists . . . are always on such good terms with themselves."[35] On another occasion Downes described the "punctilious" manners of John Hancock as portrayed by Copley (cat. no. 22) and declared that the portrait of Mrs. Thomas Boylston (cat. no. 30) was "so quiet, so well bred," as if the painting and the woman were one and the same.[36] This latter remark was not a simple case of confusion between sitter and picture but a typical indication of the nature of Copley scholarship near the turn of the century. As Downes perceptively noted in the *Boston Evening Transcript*, "[Copley] enjoyed the distinction of having been a sort of court painter to the Boston of the eighteenth century; but possibly the very people who were proud of owning his portraits often failed to realize how much of a master he was."[37]

Changes in the state of Copley literature began to occur when, during the very early twentieth century, Tuckerman and Dunlap, biographers of American artists and chroniclers of the history of American art, were succeeded by comparatively systematic and detached surveyors of the subject. Sadakichi Hartmann, in his seminal *History of American*

Art of 1901, summed up Copley's career in less than two pages, calling his American work "meritorious" for what it recorded about "the costume and character of his time."[38] Samuel Isham wrote in his *History of American Painting*, which appeared in 1905, that he found most compelling the "two pretty sharply marked divisions" of Copley's career and incumbent stylistic change. Although he singled him out for study in an individual chapter, thus maintaining the traditional canon and perpetuating the idea that Copley was incomparable, Isham judged him an artist of "respectable talents," not genius.[39] The same year that Isham's volume was published, Charles Henry Hart produced an essay on *Mr. and Mrs. Thomas Mifflin* (cat. no. 80), which he paid the high compliment of likening to "paintings by Vermeer." In the context of his commentary on this particular portrait, he proposed "a reconstruction of our theories" about Copley that would increase appreciation of his work based upon examination of the many works "heretofore unknown" that had come out of "hiding" in recent years.[40] In *The Story of American Painting* of 1907 Charles Caffin described Copley's American success in relation to the economic and religious climate of pre-Revolutionary Boston. It was, he remarked, "precisely these altered social conditions which had much, perhaps most, to do with Copley's achievement." And he wrote at length about Copley's portrait *Mrs. Theodore Atkinson Jr.* (fig. 163), which he deemed an exemplification of the artist's ability to paint a "personal document" for his sitters.[41]

Guernsey Jones's discovery in London's Public Record Office of abundant Copley manuscripts, most of which were published by the Massachusetts Historical Society in 1914 as the *Letters and Papers of John Singleton Copley and Henry Pelham, 1739–1776*, provided a wealth of new information that dramatically changed the scope of research on the artist and inspired a number of fresh projects over the succeeding decades.[42] In 1915 Frank Bayley, proprietor of the Copley Gallery in Boston, published a biography of Copley and an annotated checklist of his oeuvre that expanded upon Perkins's book and incorporated material from the artist's letters into its catalogue notes.[43] In 1918 the artist James Britton began work on two books that he promised would take advantage of the newly discovered letters and adopt "the point of view proper to an artist and not merely a historical or biographical essay." Downes reported in the *Boston Evening Transcript* that Britton's volumes (which were never published) would do away with the idea of Copley "as the remote person who painted 'our' very much esteemed grandmothers."[44] Within the next decade Ruth de Rochemont

read Copley's portraits of women as expressive of female character and struggle in colonial America, and Susan La Follette took an even wider frame of reference, describing the economic and social circumstances of Boston in the mid- to late eighteenth century as the context for Copley's production.[45]

By 1930 the roster of those who had written on Copley included the artist's family members, curators, genealogists, fashion reporters, college professors, novelists, and museum curators, and the material produced was as varied as the authors' backgrounds and disciplines. In terms of the facts of his life and the inventory of his extant work, Copley was better known and had received more thorough attention than most American painters, especially those of the generations that immediately preceded and succeeded him. But other American artists were made known and made famous simultaneously, whereas Copley had become famous before he and his work were well known. And, to a remarkable extent, Copley had achieved his fame on the strength of evidence that was fragmentary and imperfect. As Theodore Bolton and Harry Lorin Binsse put it in 1930, "There is a discouraging paucity of definite information [on Copley]… [and yet] there is really too much to say about [him]."[46]

Bolton and Binsse, who collaborated on a biography of Copley and a checklist of his work, articulated what they thought to be the problem in Copley studies: his pictures had not received the sort of inquiry they deserved. What was missing from the Copley literature, they said, was connoisseurship. "It was [Copley's] misfortune to be born American," they wrote, "and thus to have interested only historical and genealogical scholars with no eye for fine painting." American art, especially that of the colonial period, was esteemed primarily for its historical value and subject matter—for what it revealed about the cherished and unimpeachable things of American life—and not for its value as fine art. Thus, Bolton and Binsse speculated, earlier writers on Copley had in common one important characteristic: none subjected the artist to any visual test or analysis. As a result, they explained, "artistic scholarship has largely passed [Copley] by."[47] In this respect, Copley was no more neglected than any other American artist. Writers on Copley were entirely in tune with mainstream art-historical studies of the day, for the history of American art had not yet become a defined discipline, as had, for example, the history of Italian or Northern Renaissance art or French painting. Connoisseurship was absent not only from Copley studies but also from the literature on the broader subject of American art and especially from the field of American portraiture.

This state of affairs persisted through the 1930s, a decade that, as far as Copley was concerned, opened with Bolton and Binsse and closed with retrospective exhibitions of his work at the Metropolitan Museum in New York in 1937 (figs. 5, 6) and the Museum of Fine Arts in Boston in 1938. Together the shows included hundreds of paintings, many from private collections and many from abroad that had never been seen in public, and they generated a good deal of commentary. Reviewers and scholars discussed Copley's preeminence in portraiture and the important role he had played in recording American life. Several writers marveled that he had achieved high success despite his lack of formal training: as Malcolm Vaughan, art editor of the *New York American*, expressed it, people were fascinated by the "golden mystery" of his early artistic education.[48]

Two topics generated by the shows received especially marked attention. One concerned the year of Copley's birth, a detail, according to one New York newspaper, that had caused "the Metropolitan Museum['s exhibition to] be marred by controversy." The Metropolitan's curators had scheduled their exhibition, supposedly a bicentennial celebration, based on speculative evidence that Copley had been born in 1737, while the Museum of Fine Arts held its own bicentennial display of Copley's work in 1938, two hundred years after his actual birth date.[49]

The second issue that attracted considerable interest involved the differences between Copley's early and late paintings. The curators of the New York and Boston exhibitions preferred Copley's American work. Said Charles C. Cunningham, who was responsible for the Boston show, the American paintings "illustrate better than his English work the real personality of the artist."[50] Most critics agreed and plainly stated their preference for the work Copley produced in America, although some of them disparaged his English pictures. The *New York Post* complained that the English paintings were "pompous canvases in which we cannot discover the man for the sumptuous trappings and farbellows"; the *New York Times* rebuked Copley "for not having rested content with his comparatively meager colonial lot"; and *Travel*, which might have been expected to approve of Copley's journey abroad, called him a "victim" of the Grand Tour.[51] The *Boston Evening Transcript* reported that Copley was "utterly lost" when it came to painting his English grand-manner portraits and historical scenes, and a critic for the *New York Times* speculated that Copley must have pined for American "countenances . . . when he had a mere lord or some frivolous my lady in front of him."[52] The scholar John Hill Morgan, who delivered a paper on Copley

Fig. 5 *An Exhibition of Paintings by John Singleton Copley,* The Metropolitan Museum of Art, New York, December 22, 1936–February 14, 1937

Fig. 6 *An Exhibition of Paintings by John Singleton Copley,* The Metropolitan Museum of Art, New York, December 22, 1936–February 14, 1937

at the Walpole Society during the run of the Boston exhibition, despaired of "what ruin Rome brought to Copley's genius."[53] Royal Cortissoz conferred a left-handed compliment upon the English paintings when he declared that Copley's change in style had not completely "obliterate[d] his basic virtues."[54] When William Germain Dooley, critic for the *Boston Evening Transcript*, remarked that the Boston exhibition made Copley's "faults clearer," he was referring to his English paintings.[55] Lloyd Goodrich explained that Copley had "exchanged the integrity of his American style for the graces of a decadent tradition," and Marsden Hartley described his English paintings as having "a kind of compromising softness."[56]

Cunningham's exhibition coincided with the publication of Barbara Neville Parker and Anne Bolling Wheeler's museum-sponsored catalogue raisonné of Copley's American work.[57] In this enterprising and seminal volume, one of the first such projects devoted to an American artist, Parker and Wheeler built upon Perkins's and Bayley's work, adding provenances, bibliographic references, and exhibition histories. A fully illustrated catalogue of Copley's extant paintings completed before the artist left Boston for England in 1774, it includes a brief biography and a short account of his style and technique. As such, the book perfectly represents the taste and needs of its time: Copley's biography was so well known that it could easily be summarized, there was limited concern for his manner of painting, and the vast majority of writers, scholars, and students agreed that the American work rather than the English deserved attention. Parker and Wheeler did not necessarily disdain Copley's English production but did not include it, they explained, because they could not undertake the requisite travel and spend the necessary long hours ferreting out paintings in private homes in England.[58] Nevertheless, their catalogue effectively validated critical bias in favor of Copley's American work.

The preference for Copley's American work expressed in response to the bicentennial exhibitions was not surprising, as it followed a tradition that began less than a decade after the artist's death. This tradition not only favored the American production but also insisted upon Copley's unshakably American identity. In 1824 a commentator for the New York *Daily Advertiser* wrote that Copley "painted much better before he went to Europe."[59] Dunlap asserted, "Copley was, when removed to England, no longer an American painter in feeling."[60] By the mid-nineteenth century one of the most frequently repeated stories about Copley involved his portrait of Elkanah Watson (fig. 3) and the afterthought that in-

spired his decision to add an American flag on the ship in the background. As told by Watson's son in the *Crayon* and reiterated by Tuckerman, the tale portrayed Copley as a fervently patriotic artist, who boldly applied "a master touch" to the composition to mark the Americanness of his subject and himself.[61] In 1892 the editor of the *Collector* dubbed Copley's American paintings "marvels," as opposed to his "conventional" English works, in which there is only "a certain suggestion of his early natural . . . force."[62] Respected authors of early-twentieth-century surveys of American art, such as Isham and Caffin, preferred Copley's American work. Alan Burroughs, who wrote the important *Limners and Likenesses* in 1936, was of the opinion that Copley "turned sour" when he left America, only to become "the most stilted painter in England."[63]

The New York and Boston exhibitions had barely closed when some writers' biases in favor of Copley's American career became so extreme that they began to attack not only the English paintings but also the artist for disloyalty to his native country. Indeed, the kind of criticism that merges artist and work, always common, was especially prevalent in studies of American art during and immediately after World War II, when writers felt the need to demonstrate that the story of American art could be told without reference to European tradition or influence. In 1939 Forbes Watson reviewed *Life in America*, an exhibition at the Metropolitan Museum that included seven American portraits by Copley, and a show at the Museum of Fine Arts in Boston chronicling European and American life, and concluded that Copley was an "outstanding American" who had been "swallowed up by England."[64] In 1942 Cunningham said that Copley's failings were "not so much those of the artist as those of the man," and in 1943 Esther Forbes maintained that "Copley was as New England as stone walls and sumac bushes, and seemingly as hard to transplant."[65]

Yet as early as 1942 E. P. Richardson spoke out boldly against the prejudices of his colleagues that made Copley "the object of a savage criticism" on grounds "of nationalism" rather than "upon artistic considerations."[66] He acclaimed Mrs. Gordon Dexter's gift of two of Copley's English works, *The Red Cross Knight* (fig. 7) and *Sir Robert Graham*, to the National Gallery of Art in Washington, D.C., and made note of their high quality and strong appeal. A few kindred spirits took a stand for Copley's English work. Ruth L. Benjamin, for one, reminded readers of the *Gazette des Beaux-Arts* in 1944 that the "homespun, forthright quality" that contemporary critics found in the pictures of Copley's colonial years and prized as inherently American was

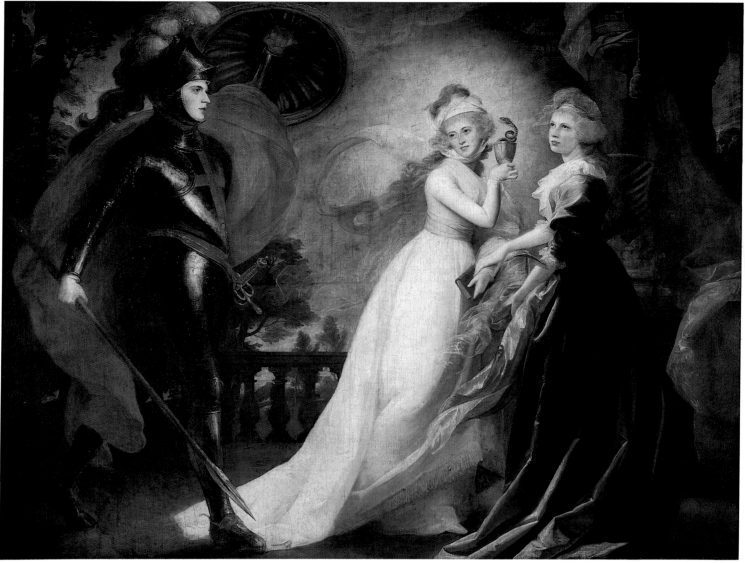

Fig. 7 *The Red Cross Knight*, 1793. Oil on canvas, 84 x 107½ in. (213.5 x 273 cm). National Gallery of Art, Washington, D. C., Gift of Mrs. Gordon Dexter 1942.4.2

entirely idiosyncratic and hardly certified the artist for greatness outside of the vacuum of American-art studies.[67] Similarly, in her review of the 1946 Tate Gallery, London, exhibition *American Painting from the Eighteenth Century to the Present Day*, Helen Comstock expressed the opinion that "it is a common failing . . . to seek Americanism and to exalt its manifestations as virtues in themselves." She explained, "Too often crudity and ineptness, in antiques as in paintings, are hailed as American characteristics and admired for their own sake."[68]

In his introduction to the catalogue for *American Painting from the Eighteenth Century to the Present Day*, in which Copley was represented by three American and four English works, John Rothenstein, the Tate's director, predicted that the show would "lead to a revived appreciation" of the English paintings.[69] To propose that such a limited display of

Copley's pictures in England could provide the antidote to American animosity toward the artist's English work was possibly unrealistic. Or perhaps Rothenstein's remarks were made only to produce an effect. In any event, his forecast proved accurate in the sense that the Tate exhibition created a certain degree of interest in Copley's English paintings, if not a revival. To be more precise, the burgeoning interest was not focused exclusively on the English work but was also directed toward a reassessment of Copley's entire career. Thus, in his monograph of 1948, James Thomas Flexner paid equal attention to the American and British pictures, giving balanced accounts of them, despite his rather over-dramatized telling of Copley's life story.[70] Oliver Larkin wrote in his *Art and Life in America* of 1949 that a hallmark of Copley's practice, regardless of when and where he painted, was his free and extensive borrowing of ideas from

other artists and his transformation of them into a personal, expressive "visual truth."[71] Larkin's attitude was extremely rare but not unique in the study of American art. Comstock noticed "a disposition to form a new view of Copley" attributable to English critics and historians who were taking an interest in Copley for the first time; his work at the Tate attracted more commentary than that of almost any other artist and, in a tally of critical opinion, he was ranked among the top five American painters, along with James McNeill Whistler, Mary Cassatt, Eakins, and Ryder.[72]

Over the course of the next several years, a few scholars attempted to reconcile the two distinct phases of Copley's career by seeking the Englishness in his American work and, to a lesser extent, the Americanness in his English work. For example, Frederick A. Sweet, curator at The Art Institute of Chicago, published a groundbreaking article in 1951 on British mezzotint sources of American colonial portraits, in which he showed that Copley's American work relied on such prototypes and therefore was not purely American after all.[73] Six years later Waldron Phoenix Belknap confirmed Sweet's hypothesis in his more extensive study of the same subject.[74] In 1954 Benedict Nicolson wrote an essay for *Burlington Magazine* in which he drew parallels between Copley's American portraits and the work of Gericault, and two years thereafter, in his seminal *Painting in America*, Richardson proposed that Copley's American paintings were expert examples of *portraits d'apparat* that derived their style from Rococo prototypes.[75] Nevertheless, even Larkin scorned Copley for going off to paint wealthy English sitters while his fellow Bostonians "climbed to their roofs to see Charlestown burning."[76]

Goodrich's legendary essay "What Is American—in American Art?" of 1958 acclaimed Copley as America's "greatest artist," one of the four most American of American artists, along with William Sidney Mount, Homer, and Eakins. In a quest to define the national self-image in American art in terms of subject matter, style, and intellectual content, he identified Copley's "primitive virtues" and "richness of substance" as the qualities that made him supremely American.[77] Whether or not scholars agreed with the answers he framed for the question he posed, his article clearly and directly confronted one of the issues that had dominated American-art history for over three decades. And, paradoxically, even though his text posed questions about the characteristics of Americanness that were not answered to the satisfaction of all readers, it is remembered as among the most eloquent and definitive words on the subject. With serious discussion of the issue no longer necessary, Allen

Guttman made sport of it in an article in *American Quarterly* in 1959; here he reviewed the ongoing study of Copley's American and un-American traits in light of recent USIA investigations and censures and concluded that the artist had been "improperly assaulted" and should not be under suspicion for anti-American behavior.[78]

By the early 1960s a number of historians had decided that concentration on the Americanness or Englishness of Copley's work was not useful as a framework for study. For example, in 1961, on the basis of his consideration of a number of English Copleys formerly attributed to Nathaniel Dance that had come to light recently, Charles Merrill Mount proposed that it was Copley's achievement in both America and England that made him "the greatest individual genius in the history of American painting."[79] And in 1963 John McCoubrey attended to the strictly formal aspects of Copley's work and argued that his gifts did not depend on his nationality but rather on his ability to portray his subjects indirectly through polished planes, networked lines, and arrangements of color and form.[80]

The scholar most responsible for showing that the nativist debates surrounding Copley and the decades-long disparagement of his English work had obscured important aspects of his artistic abilities and personal life was Jules Prown. Prown devoted his Harvard University doctoral studies to what he called a "balanced view" of Copley's art. He also wrote *John Singleton Copley*, a two-volume monograph, and organized a retrospective exhibition of Copley's work for the National Gallery of Art in Washington, D.C., which opened in 1965 and traveled in 1965–66 to The Metropolitan Museum of Art and the Museum of Fine Arts in Boston (figs. 8, 9).[81] For his monograph Prown undertook the extensive search through private homes and public galleries in England that Parker and Wheeler years before had said was necessary for the study of Copley's English career; indeed, Parker cooperated with him on many aspects of his research. In *John Singleton Copley*, Prown did not merely supply the companion volume to their book but rather catalogued the artist's English work, recatalogued his American work, and wrote a narrative of Copley's life that was more object based and less anecdotal than any previous biography: his goal, he declared, was to put "this sadly bifurcated Copley back together again."[82] This study and its visual companion, the 1965–66 exhibition, at once highlighted the striking contrast between Copley's American and English paintings and revealed the talents that remained in force throughout his career.

Together, Prown's book and exhibition, which charted the

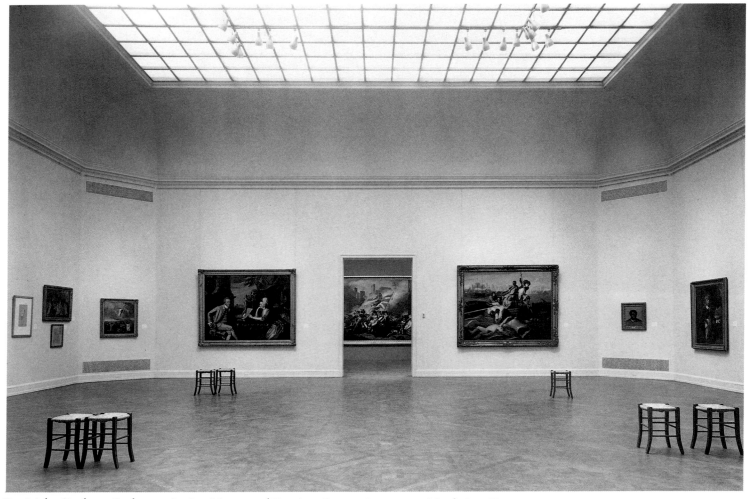

Fig. 8 *John Singleton Copley: 1738–1815*, Museum of Fine Arts, Boston, January 22–March 6, 1966

political affiliations of Copley's American sitters, the evolution of his style and technique, and the exhibition history and auction record of his work, were highly influential. Prown examined the pictures, weeded out false attributions, and established the oeuvre as we know it today. His approach to Copley's paintings was grounded in connoisseurship and enhanced with genealogical and other primary-source research and as such appealed to other scholars and critics of American art, who often felt the need to defend or apologize for the aesthetic quality of the subjects they chose to study.[83] The writers who commented on the Copley exhibitions of 1937 and 1938 and on Parker and Wheeler's book had sought the antiquarian or historical value of Copley's work; by contrast, reviewers of the 1965–66 exhibition focused on aesthetic or cultural issues and praised Copley's ability to alter the way in which he painted to suit a different set of circumstances as the key to his genius. They liked his "dual moods" and the exhibition's "double view."[84] John Canaday of the *New York Times* praised Copley as "the artist who

lived twice," and Barbara Novak wrote about the fascinating continuity of expression that characterized his "schizoid" nature.[85]

Prown established that the study of Copley did not have to be an either/or enterprise by demonstrating that it was a skilled consistency within his "bifurcated" work that qualified him as a great artist. Yet, at the same time, he deliberately perpetuated the tradition of studying Copley in two parts, albeit without the chauvinistic prejudice of years past, for he believed that an attempt to make the artist's life and work seamless was contrary to stylistic and historical evidence. Prown not only published his book in two volumes, one on Copley's work in America and the other on his work abroad, but also applied a different approach and methodology to the study of each part of Copley's career: visual analysis of the American paintings and biographical investigation of the American sitters—with the help of a Fortran database—in the absence of any other substantial evidence bearing upon his life and career before 1774; and for the

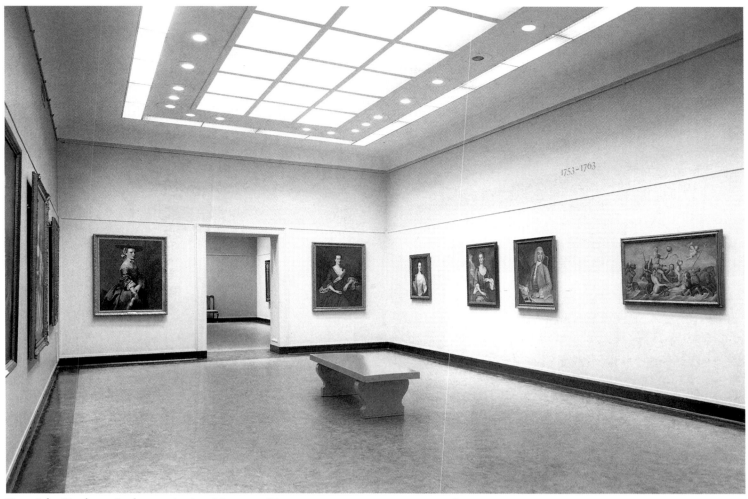

Fig. 9 *John Singleton Copley: 1738–1815*, Museum of Fine Arts, Boston, January 22–March 6, 1966

English paintings historical research based upon primary archival and manuscript sources documenting his career after 1774.[86]

Prown's most substantial contribution, in addition to drawing attention to the English career, was his rigorous compilation and accessible presentation of information in charts, lists, and genealogical trees. In both volumes he examined selected works, assembled a wealth of material about them and their subjects or patrons, and proposed that analysis of this material would illuminate Copley and his art. (This was an approach that foreshadowed the methodology he later devised for the study of material culture in which the work of art is subjected to painstaking visual scrutiny and empirically analyzed before theoretical methods are applied and outside sources are consulted.)[87] His informationally and methodologically clear book set the parameters for the study of Copley over the next three decades. Prown's *John Single-ton Copley* remains the definitive source for any scholar interested in the artist. But far from discouraging additional

research, as comprehensive monographs often do, his publication, especially the volume on Copley's American work, was organized to invite further study.

For Prown's contemporary Barbara Novak, who published a chapter on the artist as a prolegomenon to her book of 1969 on nineteenth-century American painting, the empirical data surrounding Copley's work was of little use. Her own theoretical bias led her to adapt her review of Prown's 1965–66 exhibition, in which she had described Copley's "essentially conceptual vision" and reliance on certain specific formulas, for an essay dealing with the roots of "the unique relation of object to idea" that she believes characterizes American art as a whole. Prown offered information on artists active in America during the early eighteenth century and speculated about which of them may or may not have influenced Copley; however, Novak discussed his artistic sensibility as a phenomenon that derived more from his own "conceptual bias" than from what he may have learned from one predecessor or another, using formal analysis to

17

support most of her hypotheses. She identified "Copley's realism as a unique union of object and idea," comparing him to the theologian Jonathan Edwards, who relied on the clarity of "things" in his preaching as Copley did in his painting. This clarity of things, Novak proposed, was, and still is, at the core of the American experience, and she attributed Copley's greatness to his invention of means of conveying weight, volume, texture—the "thereness" or "being" of people and objects—and his reconciliation of conceptual and empirical experience.[88]

The coincidence of Prown's book and Novak's essay on Copley was a crucial historiographical moment for Copley studies, when skilled scholars, employing positivist and conceptualist approaches, illuminated the artist's life and work from different but complementary viewpoints. Since that moment, over the past three decades, writing on Copley has continued apace; few authors, however, have taken advantage of either Novak's essentialist theories or Prown's statistical analysis. One notable exception is G. B. Warden, who had collaborated with Prown in compiling and computing facts about the religious, political, and economic backgrounds of Copley's sitters and who published an article in 1970 that reasserted the value of Prown's work and showed how his raw data might be put to use. Warden argued that Copley's work satisfied his patrons' puritanical tastes for realism and their anglophile tastes for sophistication and that his style and expressive content changed in subtle ways according to the religious, political, and economic status of his sitters.[89] Most historians who worked on Copley during the 1970s and 1980s tended toward taxonomic problem solving and fact gathering. Examples of material produced in this vein are Barbara Ward and Gerald Ward's study of the frames Copley selected for some of his paintings, Richard Klayman's dissertation on Copley's early education, Trevor Fairbrother's article on new evidence of his use of mezzotints, and J. William Shank's technical analysis of his method of painting.[90]

Copley's work has also been investigated in a variety of exhibitions and accompanying publications since the 1965–66 retrospective. In 1976 Jonathan Fairbanks mounted Copley paintings alongside those of Stuart and West in a presentation that compared this triumvirate to their provincial colleagues. Five years later Michael Quick and William H. Gerdts placed Copley's full-length portraits at the head of the American tradition of grand-manner portraiture when they examined the subject in an exhibition; their texts in the related catalogue were among the first to consider the ways in which he fashioned identities, rather than strictly recorded likenesses, for his sitters. Shortly thereafter six of Copley's

American portraits, together with an array of other paintings selected to represent the best of American art before 1910, toured France in the show *A New World*. Most recently, Copley was considered "the rising star" in *American Colonial Portraits, 1700–1776*, an exhibition curated by Richard H. Saunders and Ellen G. Miles that explored and clarified how artists in this country grappled with aesthetic and professional issues before the Revolution.[91]

The common denominator in these disparate texts and exhibitions of the last thirty years, as well as in the hundreds of articles and books and shows that preceded them, is the assertion of Copley's unassailable position in the story of American art. From Dunlap and Tuckerman to Perkins and Amory, from Parker and Wheeler to Prown and Novak and beyond, although more facts have come to light and the methods of study have changed, the scenario remains the same: Copley is consistently described as a wondrously skilled native-born painter who rose from the mire of a wharf in colonial Boston to surpass his artistic predecessors in his hometown and then moved on to the international stage, where his portraits and history paintings won him acclaim. There has never been a need for writers to defend their decision to study his work, even during the late nineteenth century, when colonial painting fell from favor among collectors and scholars. As Isham wrote in 1905, Copley "occupies securely a little niche in the temple of Fame which shields him against oblivion."[92] Hyperbole accompanies Copley almost everywhere he figures in art history. After John Adams judged Copley "the greatest master that ever was in America," other writers called him "the greatest artist of Colonial America," "one of the greatest masters of the eighteenth century," and "the greatest individual genius in the history of painting."[93] In 1975 he was termed "not only the best and greatest of American painters of the Colonial period . . . [but also] the greatest and best painter that America has yet produced," and in 1983 it was said that Copley "painted far better than his society had any right to expect."[94] Critics notice Copley's inexpert passages and praise them: John Russell has admired his "sovereign awkwardness" and Canaday his "yankee plainness."[95] Even Novak, who utilized a network of sophisticated theoretical methods to locate and comprehend Copley's paintings according to a philosophically rational and art historically solid framework, stated, after all, that she simply found his American works "wonderful."[96] Copley is now to us as he was to Trumbull in 1772—"dazzling."[97]

Recently historians and scholars have begun to adopt a variety of new methodologies to elucidate Copley's work and

Fig. 10 *The Death of Major Peirson, 6 January 1781*, 1782–84. Oil on canvas, 99 x 144 in. (251.5 x 365.8 cm). The Tate Gallery, London

the specific circumstances of his extraordinary production. Art historians relying upon the disciplines of social history and structural analysis have started to situate Copley within the worlds of pre-Revolutionary New England and Georgian England. In 1986 Wayne Craven investigated the religious, economic, and political status of some of Copley's American sitters and concluded that he "proved himself a master at capturing those social and cultural elements at the heart and core of his patrons' existence."[98] In his 1990 study of likeness in eighteenth-century American consumer society, T. H. Breen suggested that Copley was a key agent in his sitters' self-fashioning; he was an inventor of images rather than a strict recorder or portrayer and, as such, a commentator not only on his patrons but also on himself and the society in which he worked.[99] In 1992 Novak reformulated and elaborated upon her original ideas about Copley in the context of psychoanalytic theory in order to explore the extent to which information about the artist's interior life is encoded in his

paintings or, more specifically, in his portrayals of others.[100]

Many recent essays closely examine individual American and English paintings by Copley as a way of historicizing the artist and his work. Lois Dinnerstein analyzed the portrayal of household industry in *Mr. and Mrs. Thomas Mifflin* (cat. no. 80), Carol Troyen considered the portrait of Nathaniel Sparhawk (cat. no. 19) as a ceremonial image for private display, Saunders discussed the orchestration of history in *The Death of Major Peirson* (fig. 10), and Margaretta Lovell illuminated the interpretation of familial relationships in the paintings of the Isaac Smiths (cat. nos. 50, 51) and the Isaac Winslows (cat. no. 81) and also wrote on the intersection of the artist's and patron's ambitions and values in *Sir William Pepperrell and Family* (fig. 11).[101] By far the most popular subject for study among Copley's paintings has been *Watson and the Shark* (fig. 12), the focus of attention of scholars, including Ann Uhry Abrams, Albert Boime, Hugh Honour, Irma Jaffe, Ellen G. Miles, and Roger Stein, who have em-

Fig. 11 *Sir William Pepperrell and Family*, 1778. Oil on canvas, 90 x 108 in. (228.6 x 274.3 cm). North Carolina Museum of Art, Raleigh, Purchased with funds from the State of North Carolina

ployed various approaches, primarily grounded in social history, with provocative, informative, and sometimes contradictory results.[102]

This book and the accompanying exhibition follow Prown's model by examining paintings unified by the circumstances of their production and patronage but draw on a wider range of methodologies by synthesizing direct examination, social history, anthropology, structural analysis, biographical interpretation, and formal inquiry, as well as other disciplines and modes of investigation. In the years since Prown published his volumes, research has added new material to the wealth of facts and statistics he compiled. This material is highly relevant to the social environments in which Copley's work must be situated, but until now it has remained virtually untapped for answers to a plethora of questions about the artist's practice and relationship to his patrons. How were his paintings shown or used by the people who commissioned them? Did he charge portraits with social and political meaning? Where did he find his materials, and how did he learn to use them? Did mezzotints merely provide compositional precedents, or were they the ideological key to his production of fashionable likenesses? How did he find his market? Did the market find him? What was the portraitist's role in colonial American society, and to what extent did his work contribute to social consciousness? Did he paint according to a different set of aesthetic conventions for people of different economic classes?

It might be said that Copley has not been studied nearly enough.

1. [William Howe Downes,] "Boston Painters and Paintings," *Atlantic Monthly* 62 (July 1888), p. 92.
2. William Rankin, "An Impression of the Early Work of J. S. Copley," *Burlington Magazine* 8 (Oct. 1905), p. 68.
3. John G. Bogert, "American Academy of Arts," *New York Evening Post*, Mar. 29, 1811, unpaged; reprinted in *Monthly Recorder* 1 (Apr. 1813), pp. 40–43.
4. Copley, letter to Captain R. G. Bruce, 1767, quoted in Allan Cunningham, *The Lives of the Most Eminent British Painters and Sculptors* (New York, 1868), vol. 4, p. 140.

Fig. 12 *Watson and the Shark*, 1778. Oil on canvas, 72½ x 90¼ in. (184.2 x 229.2 cm). Museum of Fine Arts, Boston, Gift of Mrs. George von Lengerke Meyer 89.481

5. Daniel J. Boorstin, *The Image: A Guide to Pseudo-Events in America* (1961; reprint, New York, 1987), p. 57.

6. An Artist, "Communication," *National Advocate*, Nov. 8, 1816.

7. "American Academy of the Fine Arts," *American Monthly Magazine and Critical Review* 1 (July 1817), p. 201.

8. "American Academy of the Fine Arts," *American Monthly Magazine* 1 (Aug. 1833), p. 402.

9. Mabel Munson Swan, *The Athenaeum Gallery, 1827–1873* (Boston, 1940), p. 21.

10. Minutes of the American Academy of the Fine Arts, Oct. 6, 1821, pp. 112–13, New-York Historical Society.

11. *Samuel F. B. Morse: His Letters and Journals*, ed. Edward Lind Morse (Boston and New York, 1914), vol. 1, pp. 46–47, 102.

12. Thomas Sully quoted in Dunlap 1834, vol. 1, p. 125.

13. John Neal, "American Painters—and Painting," *Yankee; and Boston Literary Gazette*, n.s. 1 (July 1829), p. 49.

14. Dunlap 1834, vol. 1, pp. 103–30.

15. Frances Lieber, ed., *Encyclopaedia Americana*, vol. 3 (Philadelphia, 1830); Cunningham, *Lives of British Painters and Sculptors*, vol. 4.

16. Dunlap 1834, vol. 1, pp. 105, 108.

17. Charlotte Adams, "The Belles of Old Philadelphia," *American Magazine* 8 (May 1888), p. 31.

18. George P. A. Healy, letter to his wife, Louisa Phipps Healy, Sept. 3, 1845, quoted in Mary Healy Bigot, *Life of George P. A. Healy* (Chicago, 1915), p. 52.

19. Rembrandt Peale, "Reminiscences," *Crayon* 1 (Jan. 10, 1855), p. 23; Horatio Greenough, "Remarks on American Art," *Crayon* 2 (Sept. 19, 1855), p. 178.

20. "Confessions of a Young Artist," *Putnam's Monthly* 3 (Jan. 1854), p. 41.

21. James Jackson Jarves, *The Art Idea* (1864; reprint, Cambridge, Mass., 1960), p. 169.

22. Tuckerman 1867, pp. 71, 72, 76.

23. Copley, letter to Captain R. G. Bruce, 1767, quoted in Cunningham, *Lives of British Painters*, vol. 4, p. 140.

24. Tuckerman 1867, p. 77.

25. Perkins 1873, p. 13.

26. Clarence Cook, "Features of the Fair: Fine Art Department, American Pictures (Fourth Notice)," *New York Daily Tribune*, June 9, 1876, p. 1.

27. Amory 1882, p. 1. See also Martha Babcock Amory, "John Singleton Copley, R. A.," *Scribner's Monthly* 21 (July 1881), p. 759.

28. Review of *The Domestic and Artistic Life of John Singleton Copley*, *Lippincott's Magazine*, May 1882, pp. 526–27.

29. "Life of John Singleton Copley, R. A." *Magazine of Art* 2 (1879), p. 94.

30. Charlotte Adams, "John Singleton Copley," *Art Interchange* 31 (Aug. 1893), p. 27.

31. See, for example, "Colonial Portraits [at Ehrich Galleries]," *New York Times*, Apr. 15, 1905, p. 5; "A Pastel by Copley," *Bulletin of The*

Metropolitan Museum of Art 3 (Feb. 1908), p. 37; "Mrs. Harriman Buys Copleys," *New York Times,* Jan. 19, 1912, p. 6; H. M. L., "Early American Portraits," *Bulletin of the Worcester Art Museum* 6 (July 1915), pp. 2–14; James Britton, "Copleys in Brooklyn," *American Art News* 14 (Nov. 27, 1915), p. 9; Mr. Dana, "The Vassall Portraits," *Massachusetts Historical Society Proceedings* 50 (Mar. 1917), pp. 200–203; M. B. W., "Portrait of Brass Crosby," *Bulletin of the Art Institute of Chicago* 16 (Sept. 1922), pp. 66–67; C. H. B., "A Portrait by Copley," *Bulletin of the Detroit Institute of Arts* 9 (Mar. 1928), pp. 69–70; and J. B. M., "A Portrait by Copley," *Bulletin of the City Art Museum of St. Louis* 14 (Oct. 1929), pp. 42–43. Cuthbert Lee (*Early American Portrait Painters* [New Haven, 1929]) based the Copley chapter (pp. 67–78) upon works in public collections.

32. "Three Portraits by Copley on Loan," *Bulletin of The Metropolitan Museum of Art* 3 (Mar. 1908), p. 56.

33. Richard Brilliant, *Portraiture* (London, 1991), p. 7.

34. "A Resurrected Copley," *American Art News* 17 (Oct. 26, 1918), p. 1.

35. [William Howe Downes,] "Boston Notes," *Art Interchange,* July 31, 1886, p. 1.

36. [Downes,] "Boston Painters and Paintings," pp. 92–93.

37. [William Howe Downes,] "The Fine Arts: Vogue of Copley," *Boston Evening Transcript,* July 1, 1918.

38. Sadakichi Hartmann, *A History of American Art* (Boston, 1901), vol. 1, pp. 18–21.

39. Samuel Isham, *The History of American Painting* (New York, 1905), pp. 30, 19.

40. Charles Henry Hart, "Thomas Mifflin and Sarah Morris Mifflin, Painted by John Singleton Copley, 1771," *Art in America* 5 (June 1905), pp. 200–205.

41. Charles H. Caffin, *The Story of American Painting* (New York, 1907), pp. 16–18.

42. Jones 1914.

43. Bayley 1915. See also Frank W. Bayley, *Sketch of the Life and a List of Some of the Works of John Singleton Copley* (Boston, 1910), upon which the 1915 book elaborated.

44. [Downes,] "Fine Arts: Vogue of Copley." Britton's papers and manuscripts are on restricted-access microfilm at the Archives of American Art, Smithsonian Institution, Washington, D.C.

45. Ruth de Rochemont, "Fashions in Feminine Portraiture," *Vogue* 67 (Feb. 1, 1926), pp. 62–63; Susan La Follette, *Art in America: From Colonial Times to the Present Day* (New York, 1929), pp. 45–52.

46. Theodore Bolton and Harry Lorin Binsse, "John Singleton Copley: Probably the Greatest American Portrait Painter, Here for the First Time Appraised As an Artist in Relation to His Contemporaries," *Antiquarian* 15 (Dec. 1930), p. 76.

47. Ibid., p. 79.

48. Malcolm Vaughan, "Copley from Windsor's Gallery to Be Shown at Metropolitan," *New York American,* Dec. 21, 1936.

49. On the controversy surrounding Copley's birth date, see Edward Alden Jewell, "Copley Portraits to Be Shown Here," *New York Times,* Dec. 21, 1936, p. 18; "An Exhibition of Early Boston Master's Paintings Shows Division of Periods" [unidentified newspaper clipping], Jan. 2, 1937, Copley Papers, Archives of American Art, Smithsonian Institution, Washington, D.C.; and Henry Wilder Foote, "When Was John Singleton Copley Born?" *New England Quarterly* 10 (Mar. 1937), pp. 111–20.

50. Charles C. Cunningham, *John Singleton Copley (1738–1815): Loan Exhibition of Paintings, Pastels, Miniatures, and Drawings in Commemoration of the Two Hundredth Anniversary of the Artist's Birth* (exh. cat., Boston: Museum of Fine Arts, 1938), p. 7.

51. "Loan Exhibition of John S. Copley at Metropolitan," *New York Post,* Dec. 26, 1936; Edward Alden Jewell, "In the Realm of Art," *New York Times,* Dec. 27, 1936, p. 9; Frank E. Washburn Freund, "Exploring the Art World of New York," *Travel* 68 (Feb. 1937), p. 44.

52. "Boston Exhibit Hails Copley's Bicentennial: Colonial Aristocracy Lives Again in Unusual Display at Museum," *Boston Evening Transcript,* Feb. 18, 1938; R. E. Turpin, "Copley Keeps Alive Our Pre-Revolution Age," *New York Times Magazine,* Feb. 13, 1938, p. 19.

53. John Hill Morgan, "John Singleton Copley," *Walpole Society Note Book,* 1938, p. 39.

54. Royal Cortissoz, "The Traits of Our Early Portraiture," *New York Herald Tribune,* Feb. 13, 1938, p. 8.

55. William Germain Dooley, "Copley in Retrospect After 200 Years of American Art," *Boston Evening Transcript,* Feb. 5, 1938, p. 4.

56. Lloyd Goodrich, "Our Greatest Colonial Artist," *Talks* 2 (1937), p. 33; Marsden Hartley, "The Six Greatest New England Painters," *Yankee* 3 (Aug. 1937), p. 14.

57. Parker and Wheeler 1938.

58. Ibid., p. vii.

59. "American Academy of Fine Arts," *Daily Advertiser,* June 4, 1824.

60. Dunlap 1834, vol. 1, p. 117.

61. Charles M. Watson, "Letters," *Crayon* 5 (July 1858), p. 201; Tuckerman 1867, p. 74. See also "Gleaning and Items," *Crayon* 4 (Mar. 1857), p. 92.

62. [Alfred Trumbull], "John Singleton Copley," *Collector* 3 (Sept. 15, 1892), p. 295.

63. Alan Burroughs, *Limners and Likenesses: Three Centuries of American Painting* (Cambridge, Mass., 1936), p. 69.

64. Forbes A. Watson, "My Country 'Tis of Thee," *Magazine of Art* 32 (June 1939), p. 334; Forbes A. Watson, "Exhibition Reviews," *Magazine of Art* 32 (Sept. 1939), p. 544.

65. Charles C. Cunningham, "The Karolik Collection—Some Notes on Copley," *Art in America* 30 (Jan. 1942), p. 35; Esther Forbes, "Americans at Worcester—1700–1775," *Magazine of Art* 36 (Mar. 1943), p. 87.

66. E. P. Richardson, "*The Red Cross Knight* by Copley," *Art Quarterly* 5 (Summer 1942), pp. 267–69.

67. Ruth L. Benjamin, "American Art Through Foreign Eyes," *Gazette des Beaux-Arts* 25 (May 1944), p. 299.

68. Helen Comstock, "American Painting in London," *Antiques* 51 (Feb. 1947), p. 127.

69. John Rothenstein, *American Painting from the Eighteenth Century to the Present Day* (exh. cat., London: Tate Gallery, 1946), p. 7.

70. James Thomas Flexner, *John Singleton Copley* (Boston, 1948).

71. Oliver Larkin, *Art and Life in America* (1949; rev. ed., New York, 1960), p. 60.

72. Helen Comstock, "Some Unpublished Drawings by John Singleton Copley," *American Collector* 16 (July 1947), p. 6; John Walker, "American Painters and British Critics," *Gazette des Beaux-Arts* 30 (Oct.–Dec. 1946), pp. 331–44.

73. Frederick A. Sweet, "Mezzotint Sources of American Colonial Portraits," *Art Quarterly* 14 (Summer 1951), pp. 148–57.

74. Waldron Phoenix Belknap, "Mezzotint Prototypes of Colonial Portraiture," *Art Quarterly* 20 (Winter 1957), pp. 407–68.

75. Benedict Nicolson, "The Raft from the Point of View of Subject Matter," *Burlington Magazine* 96 (Aug. 1954), pp. 241–49; E. P. Richardson, *Painting in America* (New York, 1956), pp. 72–73.

76. Larkin, *Art and Life in America,* p. 64.

77. Lloyd Goodrich, "What Is American—in American Art?" *Art in America* 46 (Fall 1958), p. 21.

78. Allen Guttman, "Copley, Peale, Trumbull: A Note on Loyalty," *American Quarterly* 11 (Summer 1959), p. 183.

79. Charles Merrill Mount, "A Hidden Treasure in Britain, Part II: John Singleton Copley," *Art Quarterly* 24 (Spring 1961), pp. 33–54.

80. John W. McCoubrey, *American Tradition in Painting* (New York, 1963), pp. 17–20.

81. Prown 1966.

82. Ibid., vol. 1, p. 4. See also Jules David Prown, "John Singleton Copley: A Balanced View," *Antiques* 89 (Mar. 1966), pp. 380–83.

83. See the following discussions of this matter: Jules David Prown, "Art History Vs. the History of Art," *Art Journal* 44 (Winter 1984), pp. 313–14; Wanda M. Corn, "Coming of Age: Historical Scholarship in American Art," *Art Bulletin* 70 (June 1988), pp. 190–91; Ursula Frohne, "Strategies of Recognition: The Conditioning of the American Artist Between Marginality and Fame," in *American Icons: Transatlantic Perspectives on Eighteenth- and Nineteenth-Century American Art*, ed. Thomas W. Gaehtgens and Heinz Ickstadt (Santa Monica, 1992), pp. 211–12.

84. "Copley's Dual Moods," *Connoisseur* 154 (Nov. 1963), pp. 204–5; Frank Getlein, "Hand Across the Sea," *New Republic* 153 (Oct. 9, 1965), p. 32.

85. John Canaday, "The Artist Who Lived Twice," *New York Times*, May 1, 1966, p. 7; Barbara Novak O'Doherty, "Copley: Eye and Idea," *Art News* 64 (Sept. 1965), p. 58.

86. On Prown's application of computer analysis to his study, see Jules David Prown, "The Art Historian and the Computer: An Analysis of Copley's Patronage, 1753–1774," *Smithsonian Journal of History* 1 (1966), pp. 17–30.

87. Jules David Prown, "Style As Evidence," *Winterthur Portfolio* 15 (Autumn 1980), pp. 197–210; Jules David Prown, "Mind in Matter: An Introduction to Material Culture Theory and Method," *Winterthur Portfolio* 17 (Spring 1982), pp. 1–19.

88. O'Doherty, "Copley: Eye and Idea," p. 24; Barbara Novak, *American Painting of the Nineteenth Century* (New York, 1969), p. 15.

89. G. B. Warden, "John Singleton Copley's Boston," *Apollo* 91 (Jan. 1970), pp. 48–55.

90. Barbara M. Ward and Gerald W. R. Ward, "The Makers of Copley's Picture Frames: A Clue," *Old-Time New England* 67 (July–Dec. 1976), pp. 16–20; Richard Klayman, "The Education of an Artist: The American Years of John Singleton Copley, 1738–1774" (Ph.D. diss., University of New Hampshire, Durham, 1981); Trevor J. Fairbrother, "John Singleton Copley's Use of British Mezzotints for His American Portraits: A Reappraisal Prompted by New Discoveries," *Arts* 55 (Mar. 1981), pp. 122–30; J. William Shank, "John Singleton Copley's Portraits: A Technical Study of Three Representative Examples," *Journal of the American Institute for Conservation* 23 (Spring 1984), pp. 130–52.

91. Jonathan L. Fairbanks, *Copley, Stuart, and West in America and England* (exh. cat., Boston: Museum of Fine Arts, 1976); Michael Quick and William H. Gerdts, *American Portraiture in the Grand Manner, 1720–1920* (exh. cat., Los Angeles: Los Angeles County Museum of Art, 1981); Theodore E. Stebbins Jr., Carol Troyen, and Trevor J. Fairbrother, *A New World: Masterpieces of American Painting, 1760–1910* (exh. cat., Boston: Museum of Fine Arts, 1983); Richard H. Saunders and Ellen G. Miles, *American Colonial Portraits, 1700–1776* (exh. cat., Washington, D.C.: National Portrait Gallery, 1987), p. 230.

92. Isham, *History of American Painting*, p. 19.

93. John Adams, letter to Abigail Adams, Aug. 21, 1776, quoted in Dorothy G. Wayman, "Copley's Portraits Part of Boston," *Boston Globe*, Feb. 20, 1939; Goodrich, "Our Greatest Colonial Artist," p. 30; Alfred M. Frankfurter, "J. S. Copley, American Master," *Art News* 35 (Dec. 26, 1936), p. 12; Mount, "Hidden Treasure in Britain," p. 51.

94. Stuart P. Feld, *American Portraits by John Singleton Copley* (exh. cat., New York: Hirschl and Adler Galleries, 1975), p. 3; Stebbins, Troyen, and Fairbrother, *New World*, p. 34.

95. John Russell, "The Human Comedy of Copley Portraits," *New York Times*, Dec. 5, 1975, p. 52; John Canaday, "Yankee Honesty—the Strength of Copley's Portraits," *New York Times*, Dec. 14, 1975, p. 39.

96. O'Doherty, "Copley: Eye and Idea," p. 58.

97. *The Autobiography of Colonel John Trumbull*, ed. Theodore Sizer (New Haven, 1953), p. 11.

98. Wayne Craven, *Colonial American Portraiture: The Economic, Religious, Social, Cultural, Philosophical, Scientific, and Aesthetic Foundations* (Cambridge, 1986), p. 352.

99. T. H. Breen, "The Meaning of 'Likeness': American Portrait-Painting in an Eighteenth-Century Consumer Society," *Word and Image* 6 (Oct.–Dec. 1990), pp. 325–50.

100. Barbara Novak, "Self, Time, and Object in American Art: Copley, Lane, and Homer," in *American Icons*, pp. 61–91.

101. Lois Dinnerstein, "The Industrious Housewife: Some Images of Labor in American Art," *Arts Magazine* 55 (Apr. 1981), pp. 109–19; Carol Troyen, "John Singleton Copley and the Grand Manner: *Colonel Nathaniel Sparhawk*," *Journal of the Museum of Fine Arts, Boston* 1 (1989), pp. 96–103; Richard H. Saunders, "Genius and Glory: John Singleton Copley's *The Death of Major Peirson*," *American Art Journal* 22 (1990), pp. 4–39; Margaretta M. Lovell, "Reading Eighteenth-Century American Family Portraits: Social Images and Self-Images," *Winterthur Portfolio* 22 (Winter 1987), pp. 243–64; Margaretta M. Lovell, "To Be 'Conspecuous in the Croud': John Singleton Copley's *Sir William Pepperrell and His Family*," *North Carolina Museum of Art Bulletin* 15 (1991), pp. 30–43.

102. For the bibliography of essays on *Watson and the Shark*, see Ellen G. Miles, *John Singleton Copley's Watson and the Shark* (exh. pamphlet, Washington, D.C.: National Gallery of Art, 1993). See also Louis P. Masur, "Reading Watson and the Shark," *New England Quarterly* 67 (Sept. 1994), pp. 427–54.

Accounting for Copley

PAUL STAITI

A portrait painter must understand Mankind, and enter into their characters, and express their minds as well as their faces. And as his business is chiefly with people of condition, he must think as a gentleman, and a man of sense, or 'twill be impossible for him to give such their true, and proper resemblances.

Jonathan Richardson, 1715

Unexpectedly, John Singleton Copley illuminated Boston's colonial sky. The child of poor, uncultured parents, and only briefly the stepson of artist Peter Pelham, he became by 1760, as if by Providence, the port city's supreme artist, and he retained that position until his departure for London in 1774. His swift ascent and sustained eminence were understandably the result of an innate ability to handle paint and produce images that in their proficiency eclipsed anything created by his predecessors in America. But as Jonathan Richardson, the eighteenth-century artist and theorist, claimed in the passage above, an accomplished portraitist must do more than exhibit technical skill. He must also internalize the values of those he paints. That was Copley's other extraordinary skill. He could not have achieved his imperial position as portraitist to Boston's merchant elite had he not thought as gentlemen do, had he not, in other words, entered into and incorporated the social, economic, and political habits of his patrons. In an era of accelerating class divisions and political upheaval, Copley flourished. He did so by closely identifying with those who expressed the prevailing ethos of the city and, until their world collapsed, by capturing and confirming their values and hopes.

The present essay attempts an exploration of that connection between the artist's life and the distinct social, economic, and political circumstances under which he lived in Boston. What exactly was Copley's urban environment? Where was Copley positioned within it? How did it affect the course of his remarkable career and the manner in which

he painted? In what specific ways was he complicit with—or did he dissent from—the values and practices of those he served? How, and to what degree during his American years, were social ethics in accord with his pictorial aesthetics?

FAMILY AND CITY

Few documents remain to detail Copley's birth. It is known that he was born in Boston to Irish parents, Mary Singleton and Richard Copley, who immigrated to America sometime in the mid-1730s. The date of their only child's birth was July 3, 1738.[1] The Copleys were near the bottom of the city's economic spectrum, living frugally in a house on Long Wharf, from which they sold tobacco. Their simple home consisted of three rooms—a kitchen, a "green chamber," and a "yellow chamber"—the last containing, in addition to curtains, chairs, and feather bed, a group of six unidentified "prints and pictures."[2] Richard Copley died of unknown causes at some point in the mid-1740s, but his widow and son continued to live on the wharf until 1748.

Although those spare facts do not predict Copley's artistic destiny, the geographic site of his childhood (fig. 13) begins to illuminate the basis for his exceptional ability to gratify the taste of Boston's elite. His birthplace and first home, Long Wharf, was built by merchants in 1710. It was the most prominent commercial structure in colonial America, reaching an audacious 2,000 feet into the harbor. The wheelhouse of Boston's merchant economy, the 150-foot-wide wharf accommodated warehouses, shops, and residences, and daily received hundreds of people who staffed and serviced as many as five hundred ships that typically cleared 24,000 tons of shipping annually.[3] When Long Wharf was constructed, Boston was responsible for 40 percent of the total volume of colonial American shipping.[4] Codfish, lumber, pitch, tar, beef, pork, and furs were the city's most important exports. Textiles, ceramics, glass, flour, sugar, rum, tea, nails, tools, and paper were the major imports. Framed by headlands at its north and south ends, Long Wharf was at the center of a safe, deep, spacious, U-shaped harbor. From it Copley would

Detail, James Carwitham after William Burgis. *A South East View of the Great Town of Boston in New England in America* (fig. 13)

Fig. 13 James Carwitham after William Burgis. *A South East View of the Great Town of Boston in New England in America*, ca. 1764. Colored engraving, 11¾ x 17¾ in. (29.8 x 45.1 cm). The New York Public Library, Astor, Lenox and Tilden Foundations, I. N. Phelps Stokes Collection, Miriam and Ira D. Wallach Division of Art, Prints and Photographs

have had dramatic views of numerous coves spiked with fifty-seven lesser wharves and twenty-seven shipyards, and, beyond them, of the bay and ocean, punctuated by hundreds of islands and rocky outcroppings that sheltered the harbor from storms and invasion.

Long Wharf was at the center of Copley's economic world-view. There, surrounded by the most intense commodities traffic in America, he would have acquired daily schooling in the dynamics of the marketplace. Although his formal education remains a mystery, it is certain that on Long Wharf Copley was exposed to the mechanisms of commercial trade and observed the operations of markets that intricately connect producers to merchants and merchants to consumers.[5] Copley could not have avoided noticing how the most savvy and efficient merchants, those with the keenest sense of popular consumer taste, were motivated by profits to offer Bostonians an ever-expanding array of desired commodities. Long Wharf and the merchants, shopkeepers, and laborers who populated it were his school yard and teachers, the inspiration for a life as a commercial artist.

The economic landscape of Copley's youth expanded westward, away from the harbor, toward the city (fig. 14). In that direction he would have seen the Boston peninsula in a three-mile panorama, extending from the marshy neck that connected the city to Roxbury on the far left of his view to the spire of Christ Church (later, Old North) on the far right. Interrupted by three principal hills and plagued by poor soil, Boston was unsuitable to every economy except trade.

Walking up Long Wharf toward shore, Copley would have entered the inner circle of the city's mercantile trade (fig. 15). Merchants Row was at the end of the wharf. King Street ran straight ahead, leading to Boston's commercial, political, and artisanal heart, which was marked by the Town-House, the site for meetings of the House of Commons, the Court of Justice, and the City Council. Artisans, booksellers, printers, cloth sellers, tea merchants, tavern owners, and other shopkeepers were located on the crowded, narrow streets around the Town-House. To the right of Long Wharf was the North End, where there were secondary wharves and the mansions

Fig. 14 John Smibert. *Vew* [sic] *of Boston*, 1738. Oil on canvas, 30 x 50 in.
(76.2 x 127 cm). Childs Gallery, Boston

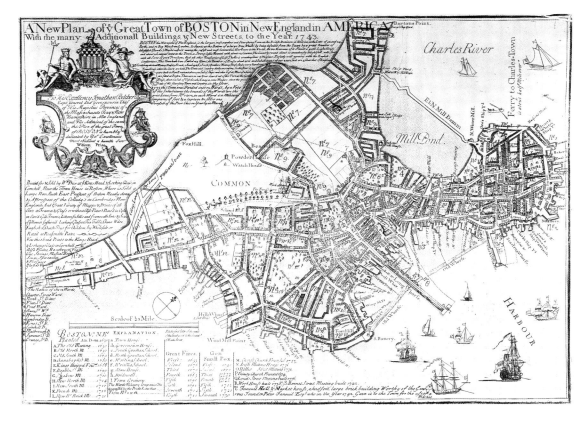

Fig. 15 Francis Dewing after John
Bonner. *A Plan of Ye Great Town
of Boston in New England in
America*, 1743. Engraving, 17⅝ x
24⅛ in. (44.8 x 61.2 cm). The
New York Public Library, Astor,
Lenox and Tilden Foundations,
I. N. Phelps Stokes Collection,
Miriam and Ira D. Wallach
Division of Art, Prints and
Photographs

of some of the city's wealthiest merchants. Toward the South End were tertiary wharves, shops, and taverns. Only to the far west did the economic city abate, in the pastoral Common and Beacon Hill. Together, by 1765 these districts housed a population of about 15,600, of which roughly 900 were African-American. A total of 20 percent of the families owned slaves. Between 35 and 40 percent of the population that paid taxes were artisans; about a quarter were traders and shopkeepers; another quarter were laborers; only 4 percent were professional men; the remainder were farmers and tavern keepers.[6] There were approximately 1,700 tightly clustered private homes in 1765, most of them timbered and sheathed with clapboard, the rest built of brick and mortar. The majority of the city's seventy-eight streets and lanes were narrow and hugged the harbor in winding disarray.

Copley moved to the center of Boston when his widowed mother married the émigré English artist Peter Pelham (1695–1751) on May 22, 1748. Pelham, an engraver and schoolteacher who arrived in America in 1727, had been married twice before and had four sons and a daughter of his own by 1748, when he was fifty-five. His house on Lindel's Row, up from Long Wharf, near King Street and the Town-House, became Copley's new home, as well as home to Copley's half brother, Henry Pelham, born in 1749. Though Lindel's Row was only a half mile away from Long Wharf, the move there shifted the focus of ten-year-old Copley's education to the realm of small-business men, who were socially and economically one step higher than the seamen and laborers who constituted his earlier environment.

Here Copley was surrounded by the studios and shops of the city's artisans, who sold the products of their own skilled labor. Some of them, for example Paul Revere Sr. and Jacob

Fig. 16 Advertisement for Mary Copley, *Boston Gazette*, July 12, 1748, Massachusetts Historical Society, Boston

Hurd, who both worked in shops behind the Town-House, had distinguished reputations, their silver being signature goods, the eighteenth-century version of modern name-brands. But, for the most part, the mercantile economy of Boston was not defined by that sort of exceptional artisan. More typical than Revere or Hurd was the minor goldsmith Zechariah Brigden, "opposite the west Door of the Town House," who sold to the trade scales, tongs, shears, vises, blowpipes, scorpers, and gravers, and to the public children's whistles, shoe buckles, buttons, seals, bosom brooches, teapots, sugar dishes, ladles, thimbles, rings, and many other metal goods.[7] His advertisements in Boston newspapers were representative of those of the average artisan, listing as many as a hundred specialized crafted objects provided by a single shop.

Within a few blocks of Copley's new home there were about a hundred shops of carvers, joiners, japanners, clock-makers, printers, clothing makers, and upholsterers. Nearly half of the city's adult males were employed in selling a world of goods, both homemade and imported, to the members of an insatiable consumer culture—the first of many in American history—that craved novelty, variety, and high quality. Pottery, for example, could be found in earthenware, Delft, flintware, yellowware, china, stoneware, and tortoiseshellware.[8] Fabrics were offered in broadcloth, linen, ticking, mohair, duck, wool, silk, and lace. One fabric shop, Thomas Trowell's, sold "Rich Morrello Tabbies, Florence Satteens, A blue Ground Brocade, English damasks, Handkerchiefs, Fine Norwich Mourning Crapes, Brilliants, Superfine Silk Camblets, Brocaded Stuffs, Cloth-coloured Padusoys, Italian Mantuas, strip'd Ducapes, White English Pealong, Allamode, Bird's Eyes, Plain black-Thread Satteens, Burdetts, Black Bombazene, Callamancoes, &tc."[9]

The cornucopia of available goods extended to the art-supply shops on King and Queen Streets that carried imported supplies, among them the basics: brushes, knives, palettes, and pigments in numerous shades of every hue. But they also stocked exotic items, such as alum, argol, five different kinds of black pigment, seven whites, pastel crayons, bronze, and London crown glass. Nathaniel Warner, an importer, advertised mezzotint engravings of William Pitt, the king of Prussia, the four seasons, the five senses, and the idle and industrious apprentice, and sets of William Hogarth's *Harlot's Progress* and *Rake's Progress*.[10] At the corner of Brattle Street and Cornhill resided John Smibert (1688–1751), the leading artist in Boston during Copley's childhood. The ambitious late Baroque pictures (241 painted in Boston) of this Scottish émigré, who arrived in Boston in

Cottonus Matherus
S. Theologiæ Doctor: Regiæ Societatis Londinensis Socius.
et Ecclesiæ apud Bostonum Nov-Anglorum nuper Præpositus.
Ætatis Suæ LXV. MDCCXXVII. *P. Pelham ad vivum pinxit & fecit Boston.*

Fig. 17 Peter Pelham. *The Reverend Cotton Mather*, 1728. Mezzotint,
14¾ x 10¾ in. (37.5 x 27.3 cm). The Metropolitan Museum of Art,
New York, Bequest of Charles Allen Munn, 1924 24.90.14

1729 after pursuing a moderately distinguished career in London, set a new standard of excellence for colonial artists. Smibert was also important for the goods he brought to America, which included a library of professional artists' materials, theoretical texts, European prints, and plaster casts after the antique. Moreover, like his neighbors, he was a salesman, opening in his studio on Queen Street a lucrative color shop where he sold brushes, papers, colors, grounds, oils, frames, and, for a week in 1735, his personal collection of old master prints.[11]

Copley's mother and stepfather were each active merchants in this commercial city, selling both goods and services. An advertisement in the *Boston Gazette* (fig. 16) reveals that Mary Singleton Copley Pelham continued after her remarriage to deal in "the best *Virginia* Tobacco, Cut, Pigtail and spun, of all Sorts, by Wholesale, or Retail, at the cheapest Rates."[12] To judge by that wording, she was determined to be not only an industrious shopkeeper, filling her shelves with an attractive variety of raw materials cus-

tomized to local tastes, but also an avid competitor, enticing customers with good prices and individualized services. Pelham also advertised, offering instruction in English manners, reading, writing, arithmetic, needlework, dancing, painting on glass, and French.

The one skill Pelham did not advertise was engraving. Yet it was the basis for his lasting reputation as an artist. He had achieved prominence in London for his work in mezzotint, a difficult print medium that generates form in tonal areas rather than in lines. Because it allows the production of half-tones, mezzotint is more illusionistic than other print media and thus similar to painting in its suggestion of finely gradated three-dimensional form.

Before he died from unknown causes in 1751, Pelham introduced his stepson to the mezzotint. Copley's initial artistic effort was a mezzotint portrait of the Reverend William Welsteed (cat. no. 1), printed in 1753 from the re-scraped plate his stepfather had used to produce his own portrait of the Reverend William Cooper (fig. 152) ten years earlier. Pelham also introduced Copley to the artistic culture of England and Europe. He did so by offering him, either orally or through his library, his knowledge of art and art theory. It is not surprising, given Pelham's own English training, that Copley's first paintings were mythological works (*The Forge of Vulcan* [cat. no. 3], *Galatea* [fig. 157], and *The Return of Neptune* [cat. no. 4]), all based on European prints and more consistent with Baroque English taste than the traditional American taste for portraiture.

Pelham probably taught Copley a progressive view of the artist in society. Though economic necessity forced him to teach a subject as utilitarian as etiquette in America, Pelham would have remembered the more exalted social responsibilities of the artist in England. Maturing artistically in the orbit of Lord Shaftesbury, the English philosopher and follower of John Locke, Pelham himself had been educated in a culture that believed the fine arts were a form of civic humanism. He may well have passed on to his stepson the principle that Copley's career bore out: an artist could be an active agent shaping society and promoting public virtue.[13]

In addition to instructing him in artistic technique and theory, Pelham probably taught Copley the art of entrepreneurship. This is not documented but is clearly implied in each man's ability to manufacture desire for his own artistic products in the commodities-obsessed culture of America. Though Pelham was at the end of his career when he became Copley's stepfather, he would still have exemplified an artist-merchant for the boy, as he printed and also promoted seven final mezzotints between the time of his remarriage and his

death. Like most household producers in colonial Boston, Pelham had to be a marketing tactician. The first print he made in America, from a plate scraped a year after he arrived in 1727, was a mezzotint of the Reverend Cotton Mather (fig. 17), the aging patriarch of Puritan theology. Not only did Pelham render the most accomplished and arresting image produced in Boston to that date, he also marketed it cleverly. In choosing Mather as his first American subject, he was riding the coattails of the most prominent clergyman in New England, the last in a dynasty of renowned ministers. And when it came time to sell the print, Pelham bought advertising that enticed subscribers with assurances of the truthfulness of the likeness. Moreover, he was an effective salesman, offering an appealing plan for financing: "three shillings down, and two shillings at the delivery of the print." Thinking as a producer in a market, Pelham also offered a bonus for bulk purchases: "those who take twelve shall have a thirteenth gratis."[14] He continued to his death to find ways to shape his various talents to the demands of consumers. But he did more than satisfy a market. He created one. Because there was no market for mezzotints before Pelham, he must also be regarded as an entrepreneur who successfully stimulated desire for a new, nonutilitarian service.[15]

ECONOMICS AND CULTURE

Copley's success, as well as that of master artisans, such as Paul Revere, was made possible by a merchant and professional class that was ascendant in the early eighteenth century and that was, moreover, motivated to commission from artists the highest quality goods that could be produced in America or imported from London. More than 60 percent of Copley's pictures were painted for merchants, large landowners, lawyers, and physicians. Though these men constituted a small fraction of the city's total population, their presence in it was dominant. This dominance, however, was not derived solely from the fact of their status as elites, as would be the case in a European aristocracy. It was also based on their bourgeois identity.

Boston's elite had all the properties of modern bourgeoisie: a combination of economic, political, and social power that operated in a stratified society. Instead of remaining separate from society, in the manner of aristocrats, they were engaged citizens. They variously occupied positions in local government, exerted extrastate political influence through their professional associations, controlled trade, challenged British policy by smuggling and boycotting, and imposed

their own cultural aspirations and tastes on the rest of society by means of their patterns of conspicuous consumption. They may not have constituted a ruling class in the European sense, but they were powerful enough to maintain an autonomy from the state if they wished to do so. This special position made their agency highly influential and allowed them to act upon society in a way that would have been impossible for a traditional aristocracy.

During Copley's youth, the strength of the commercial and professional class notwithstanding, the merchant economy of Boston was in frequent jeopardy. After 1720 the port began to lose shipping traffic to New York and Philadelphia. By 1740 inflation was rising, the middle class was eroding, wages were dropping, and population was starting to decline, from 16,528 in 1742 to 15,500 in 1765.[16] The Anglo-Spanish War of 1739, the King George's War of 1744 to 1748, and the Seven Years War of 1755 to 1763 reinvigorated the economy through the shipbuilding contracts and munitions trade attendant upon them. But the relief generated by each war was temporary, and the city slipped into economic depression marked by widespread poverty, especially after 1763.

The depressions of the eighteenth century, however, had relatively little impact on the arts. Indeed, they might have stimulated interest in painting. When Boston was at its economic nadir in the mid-1760s, Copley was at the peak of his popularity, boasting in 1765 of "a large room full of pictures unfinished, which would engage me these twelve months."[17] He was earning three hundred pounds a year in the late 1760s and again in 1771, when a very high annual income was one thousand pounds. In comparison, the best lawyers in town might earn two thousand pounds yearly, whereas a professional weaver could earn forty pounds.[18]

Copley was able to flourish because the depressions concentrated what money there was into the hands of a few families. Money migrated upward to the merchant oligarchy, a process that was the result of an American consumer revolution that was motivating members of the middling and lower classes to buy goods omnivorously on credit, in spite of the overall economic decline of Boston. Paper currency and specie were rare, and most monetary transactions were registered on paper in the large debit ledgers that Copley occasionally included as symbols of power in his portraits of merchants. Thus, the only real capital was property, both real estate and goods. The middling and lower classes that depended on the merchants for their own goods were, consequently, in perpetual debt, with wealth held in gridlock by those at the top of the economic pyramid.

Though there had always been marked economic class dif-

Fig. 18 Attributed to Paul Revere. *Trade Card of William Jackson*, 1765–70. Engraving, 7⅝ x 6¼ in. (19.4 x 15.9 cm). American Antiquarian Society, Worcester, Massachusetts

Fig. 19 *Trade Card of Joseph Welch*. London, 1760–65. Engraving, 6⅝ x 5⅜ in. (16.8 x 13.7 cm). The Metropolitan Museum of Art, New York, Gift of Mrs. Morris Hawkes, 1927 27.100.3

ferences in America, by midcentury in Boston the poor were getting poorer and indigency was epidemic. Meanwhile the rich were getting much richer, and there were fewer of them. The statistics vary from one economic analysis to another, but there is general agreement that approximately the richest 15 percent of the taxpayers owned about 66 percent of the city's total wealth by 1770, the top 5 percent owned 44 percent, and the lower 50 percent owned less than 10 percent. The upper 25 percent controlled 90 percent of the port's shipping. Whereas real estate assessments in 1687 ranged only between two and ten pounds, by 1770 valuations had polarized dramatically and ranged from twelve to two hundred pounds. Though the economy as a whole was failing, more than half of Copley's patrons earned over five hundred pounds a year, and about a quarter over one thousand pounds, which was more than the salary of the royal governor. If the perspective is reversed to examine the opposite end of the economic scale, the figures are bolder: the number of people who did not own any property had increased 400 percent between 1687 and 1770, and by the latter year 35 percent of those who died had neither property nor other possessions and left no estate.[19]

Because it was achieved at the expense of almost everyone else, the economic and social triumph of the merchants led to class antagonisms that, some historians argue, were as important a catalyst for the Revolution as the desire for political and economic independence from England.[20] The merchants themselves were of varying political persuasions, but, as consumers and participants in the rituals of their class, they cohered as a group. Their power, based on exceptional wealth and uncommon political enfranchisement, made them modern merchant princes, "great men," in the language of cultural anthropology. They were interconnected by a web of business alliances and, to an astonishing degree, by blood relation and marriage.[21] By 1763 their awareness of their own extraordinary status prompted 146 of them to establish the exclusive Merchants Club, its members forming a network of economic and political power throughout the city.[22]

But spending power alone did not provide sufficient motivation for the merchants to become patrons of artists or to shower as much money as they did on Copley, who became, as a result, a merchant prince in his own right. Equally important was a romantic sense of themselves and their place

in transatlantic British society. Their consumption of art was a matter not just of their economic capital, then, but also of their new social capital. Their voracious acquisition of luxury items stemmed not merely from an ability to buy inessential cultural goods but also from a new willingness to do so.[23] They could have salted their money away, as they had done as recently as 1720, eschewing things as superfluous as portraits. But now they flaunted their wealth, especially in acts of consuming luxury objects, among them Copley's sensational paintings.

Why such a change of cultural conduct? Why were the elite more willing than before to patronize an artist such as Copley? First, in the middle of the eighteenth century most Americans were becoming more self-consciously British than ever before, and they were willing to spend money as their transatlantic cousins did, especially on objects that expressed their Englishness. Indeed, the cultural act of anglicization expanded to include virtually all material objects and also to encompass social customs. During the city's early history, colonists had an interest in visually—as well as legally and institutionally—defining their separateness from London. But now, distanced from a Puritan past when luxury, leisure, and indulgence were subjects of conflict, the new, unharnessed bourgeois merchant society—and the middling and lower classes that imitated it—had an unabashed taste for all things English.[24]

The new anglicization, which cut across political differences, was evident in shifts that recently had taken place in artistic and architectural taste. For example, Bostonians discerned the differences between American and foreign art. On display in the Town-House were English portraits of Charles II, James II, William, Queen Mary, George II, and Queen Caroline, as well as American portraits of the colonial governors.[25] That was to be expected in a colony. What was surprising, however, was the response to the likenesses of the governors. Painted by Americans, these pictures—"little miserable likenesses" to John Adams—seemed to Bostonians of anglophile taste no more than weak provincial echoes of early- eighteenth-century English art.[26] Anglicization also affected Boston's cabinetmakers, silversmiths, engravers, and japanners, all of whom typically borrowed from or copied English sources.[27] Revere, for instance, adapted or copied his copperplates, certificates, bookplates, trade cards, and illustrations from English models (see figs. 18, 19).

The growing preference in Boston at mid-century for English forms—a cultural shift astutely perceived and exploited by Copley, whose American career can be read as an effort to acquire an English manner—was apparent in the most sig-

Fig. 20 Hancock Mansion, Boston, from *Massachusetts Magazine* (July 1789)

nificant architectural additions made to the city during Copley's early life. Thomas Hancock, the most important merchant in New England, built a grandiose Georgian-style mansion on Beacon Hill in 1737 (fig. 20). The window glass, hearths, fireplace tiles, wallpaper, and most of the customized furniture came from London. The seeds and seedlings for his magnificent garden of fruits and flowers also were imported from England, and what there was of American manufacture was crafted in the English style. When the house and grounds were finished, Hancock boasted that "the Kingdom of England don't afford so fine a Prospect as I have."[28] As thoroughly English was King's Chapel (fig. 21), designed in 1749 by Peter Harrison, the English émigré architect. Rejecting the brick and painted wood exterior that had been the hallmark of churches in Boston, Harrison unabashedly based his design for the dark gray granite chapel on James Gibbs's Saint Martin-in-the-Fields in London (fig. 22).

Behavior was equally anglicized. For the most part, Bostonians tried, often with a self-consciously provincial anxiety, to dress, walk, talk, drink tea, garden, and entertain like the English. So much so that a visiting Englishman, Daniel Neal, observed the imprint of England in every aspect of Boston's culture. "A Gentleman from England," he observed, "would almost think himself at home in Boston when he observes the number of people, their Houses, their Furniture, their Tables, their Dress and Conversation, which perhaps, is as splendid and showy, as that of the most considerable Tradesmen in London."[29]

The cultural trajectory of America was overwhelmingly toward Britain, not away from it. This was a trajectory clearly apparent in the rapid but visually obvious transformation of colonists from seventeenth-century Puritans who

Fig. 21 Peter Harrison. King's Chapel, Boston

Fig. 22 James Gibbs. Saint Martin-in-the-Fields, London

vehemently opposed King Charles into mid-eighteenth-century merchants who had Copley paint them holding King Charles spaniels in their laps. "On the eve of the American Revolution," writes historian James Deetz, "Americans were more English than they had been in the past since the first years of the colonies."[30] Culturally, Boston was the parodic mirror of London, with its middling and elite classes now willing to buy pictures because that was what their counterparts did "at home." Bostonians' inflated sense of self-worth encouraged them to ape English aristocrats at the same time that insecurity about their provinciality intensified cravings for culturally identifying forms that validated their transatlantic status.

American silversmiths, furniture makers, and portrait painters strove to produce goods that gratified the new taste for things English. In order to appeal to an anglophile elite, artists and artisans learned the most modern procedures, designs, and iconographies used by their English counterparts. Copley made a strenuous effort to familiarize himself with the poses, postures, attitudes, settings, and accessories found in contemporary English art, many of which he managed to make use of by basing his own pictures on mezzotints after English paintings. The pose, costume, and setting of his portrait of Mrs. Daniel Hubbard (fig. 23), for example, is modeled on John Faber's mezzotint after Thomas Hudson's portrait of Mary Finch, Viscountess Andover (fig. 24).[31]

Art historians usually have interpreted Copley's mimetics as motivated by a desire to be a more proficient artist. What they have overlooked is his drive to be a more proficient producer. His use of English mezzotints as templates for his own pictures may indeed indicate a striving for technical self-improvement. But Copley was an astute and relentlessly competitive businessman who knew he needed to please his clients, and, given the anglophilia of the upscale Boston market in the 1760s, he also knew that he had to be able to offer them a catalogue of compelling images that could fulfill their fantasies of themselves as English aristocrats. Using that market strategy, Copley acquired mezzotints as models from which he and his sitters could begin to fashion the spaces they might inhabit, the objects they wished to possess, and, most importantly, the attitudes they wanted to strike.

The other factor that impelled cultural largesse in Copley's time was the first modern consumer revolution, which just then was sweeping Britain and its colonies. Goods were being imported into America and acquired at a frantic pace by midcentury. Beginning in the 1740s—during Copley's childhood—the importation rate had exploded, so that British objects overflowed the counters of Boston's

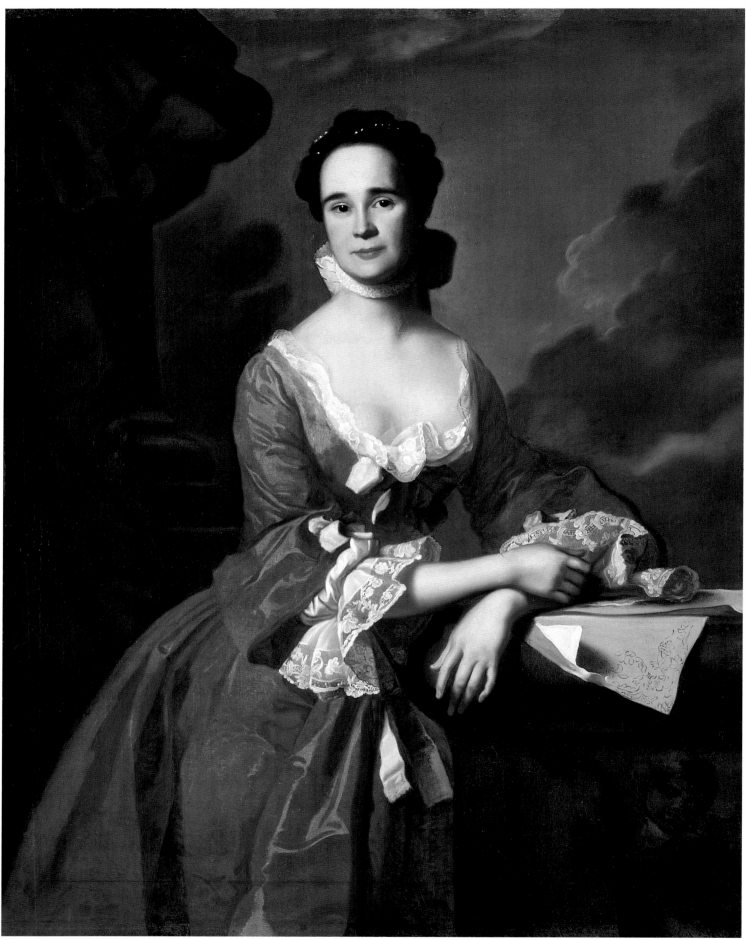

Fig. 23 *Mrs. Daniel Hubbard (Mary Greene)*, 1764. Oil on canvas, 50¼ x 39¾ in. (127.6 x 101 cm). The Art Institute of Chicago, Purchase Fund 1947.28

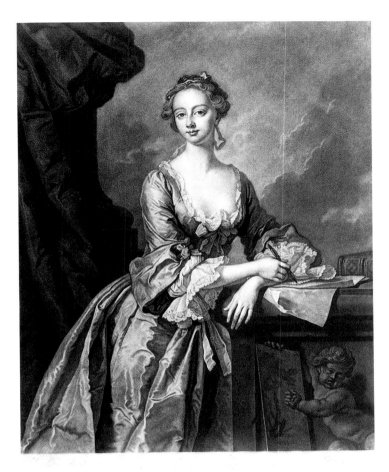

Fig. 24 John Faber after Thomas Hudson. *Mary Finch, Viscountess Andover*, 1746. Mezzotint, 12¼ x 9⅞ in. (31.1 x 25.1 cm). The Trustees of the British Museum, London

Merchants sought, as they never had before, portraits that offered a plausible fiction of themselves. Though the represented person in a portrait held emotional value, the actual possession of works of art, especially English-style pictures, and in particular those by an artist as accomplished as Copley, who rivaled his English counterparts, was of immeasurable social value in Boston. And that value, that ability of the object to calibrate status, was amplified if the picture was filled with coveted consumer objects—furniture, silks, pearls, rugs, columns, and the like.

For the elite, patronizing Copley was an active part of their developing sense of self. In the eye of a socially ambitious, commodity-driven, English-oriented merchant in Boston, a Copley portrait, which in 1771 cost twenty guineas, was the site of dreams. The picture's utility might be perceived, in such a worldview, to lie in its power to capture the individual's projected illusion of himself, the commissioning and acquisition of the portrait offering some promise of the dream's realization. Thus the descriptiveness of Copley's images, given the elite's attempts at self-fashioning, was not intended to be understood as representing a faithful transcription of actual lives. Instead, descriptiveness was a rhetoric that allowed his pictures to acquire credence, *as if* they were a reality.

Copley's unmatched success as a producer in a culture of consumption was built on his ability to sell dream material that told consumers in visual terms what it was possible for them to believe about themselves. In his portraits Copley helped make concrete the pleasurable dramas that clients had already enjoyed in their own minds. By so doing, he became an indispensable producer during a consumer revolution, satisfying the demand for anglicized cultural goods that helped the elite define who they were, for both themselves and others.

SELF AND SOCIETY

Copley thought he was looked upon by Bostonians as a provider—a social resource more than a thinking artist. When he complained in his famous letter of about 1767 that "the people generally regard [painting] no more than any other usefull trade, as they sometimes term it, like that of a Carpenter tailor or shew maker, not as one of the most noble Arts in the World,"[36] he was lamenting his position in a culture that thought of everything as a commodity and everyone as a producer and could not distinguish its best artist from a maker of shoes. Yet Copley's view of Bostonians as philistines did not deter the enterprising artist from avidly

shops, offering consumers unprecedented choices.[32] America was Britain's largest market, imports increasing 1,400 percent, and their annual value growing from £50,000 to £750,000 between 1700 and 1750.[33] However tense their fluctuating political relationship may have been, England and America were fused by trade, prompting Adam Smith to refer to the colonies as "a nation of customers."[34]

Utility alone did not provide the root motivation for the new consumer ethic that came to include works of art among objects craved. Elites were using luxury consumer goods to define themselves as members of a class. In the words of historian T. H. Breen, elites were trying "to establish clear markers separating themselves from all the others who were clambering up the social ladder. Consumer goods became the props in a new public theatre of self-fashioning."[35] According to the logic of mid-eighteenth-century American consumerism, the elite of Boston did not seek satisfaction from works of art themselves so much as pleasure from the illusory effects that they constructed from the associative meanings of objects. Objects defined and validated status manifestly.

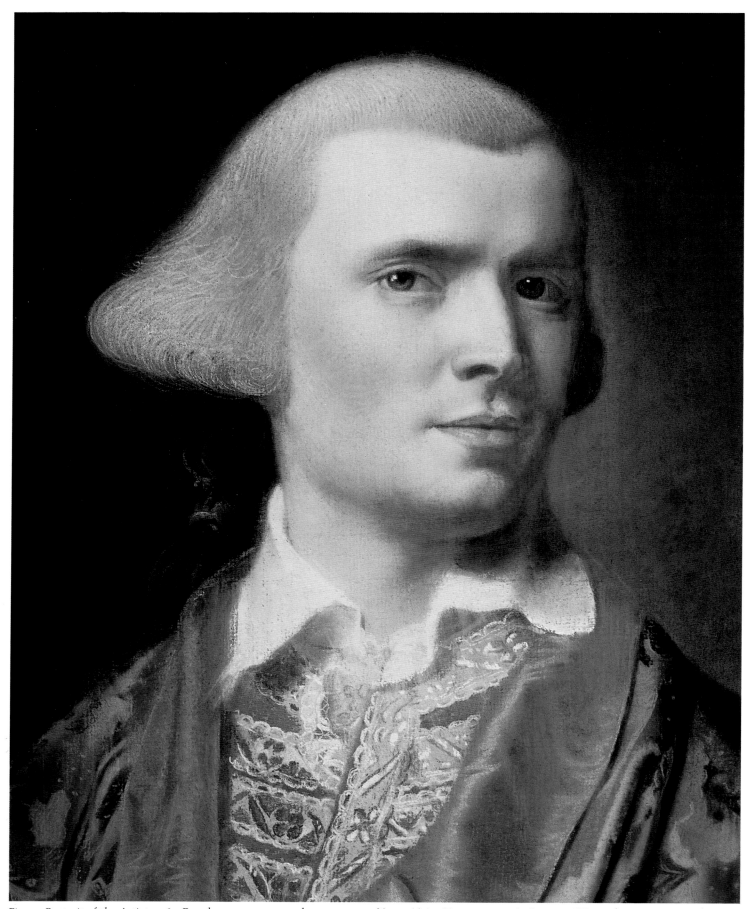

Fig. 25 *Portrait of the Artist*, 1769. Pastel on paper mounted on canvas, 23¾ x 17½ in. (60.3 x 44.5 cm). Courtesy Winterthur Museum, Delaware

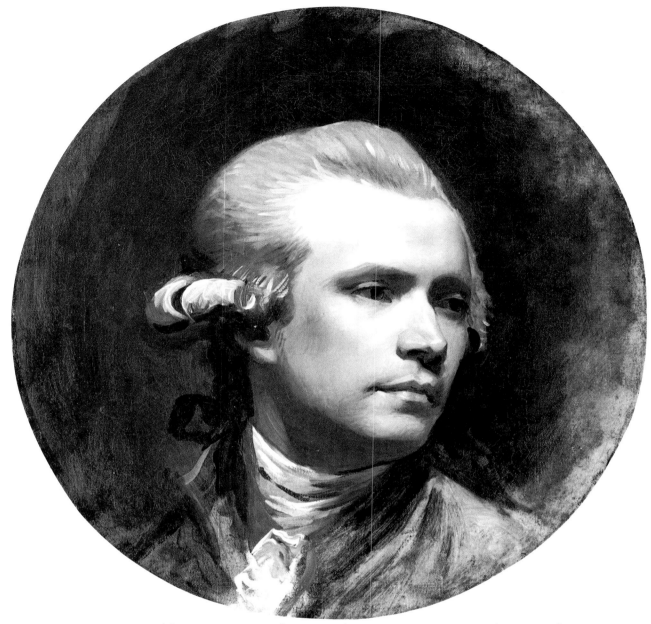

Fig. 26 *Portrait of the Artist*, 1780–84. Oil on canvas, diam. 18 in. (45.5 cm). National Portrait Gallery, Washington, D. C., Gift of the Morris and Gwendolyn Cafritz Foundation and matching funds from the Smithsonian Institution NPG.77.22

participating in the consumer marketplace. Though conflicted about his situation, Copley not only understood but also internalized the values of a society that cherished luxurious commodities, conspicuous consumption, and dreams of upward mobility.

Copley's internalizing affected his personal life and his visual language. Consider the way he perceived himself in his pastel self-portrait of 1769 (fig. 25), when he was the supreme portraitist in America. He wears a waistcoat heavily trimmed in gold and covered by a blue and green silk damask banyan, a high-style dressing robe usually worn by

elites at leisure moments. His collar is open, reinforcing the image of leisure, and he wears a stylish bob wig. Elegant, fashionable, and gentlemanly, his is the image of an English aristocrat. Erasing every reference to his trade as an artist, he represented himself the same way he represented Jonathan Jackson (cat. no. 45), the wealthy Newburyport merchant.

Though Copley's origins were poor, as an adult he fashioned himself as an aristocrat (fig. 26), to the degree that authors and diarists remarked on it. When young John Trumbull (1756–1843) made a pilgrimage to Boston in 1772

to visit the thirty-four-year-old Copley, he encountered someone more like an English baron than a working artist: "We found Mr. Copley dressed to receive a party of friends at dinner. I remember his dress and appearance—an elegant looking man, dressed in a fine maroon cloth, with gilt buttons—this was dazzling to my unpracticed eye!"[37] And Copley is described near Rome in 1774, having just left America, wearing

> one of those white French bonnets, which, turned on one side, admit of being pulled over the ears: under this was a yellow and red silk handkerchief, with a large Catharine wheel flambeaued upon it, such as may be seen upon the necks of those delicate ladies who cry Malton oysters: this flowed half way down his back. He wore a red-brown, or rather cinnamon, great coat, with a friar's cape, and worsted binding of a yellowish white; it hung near his heels, out of which peeped his boots: under his arm he carried the sword which he bought in Paris, and a hickory stick with an ivory head. Joined to this dress, he was very thin, pale, a little pock-marked, prominent eye-brows, small eyes, which, after fatigue, seemed a day's march in his head.[38]

The explicit details in the description are telling, for they speak of Copley's obsession with elite fashion and the highly differentiated goods that were a hallmark of the consumer revolution.

His effort to fashion himself along the lines of his merchant clients—to "think as a gentleman," as Richardson phrased it—was elementally expressed by his marriage in 1769 to Susanna Farnham Clarke. Affectionately known as Sukey, she was the daughter of Richard Clarke, the Boston agent for the British East India Company and one of the wealthiest, most influential, and anglophilic merchants in the city. The Clarke family was Congregationalist, not Anglican, and belonged to the Brattle Square Church. This was the most theologically liberal Congregational church in Boston but also the one that boasted the most socially exalted and affluent membership. Copley and Sukey were married by her family's minister, the Reverend Samuel Cooper.[39]

In the same year Copley began acquiring land on Beacon Hill, adjacent to the estate John Hancock inherited from his uncle Thomas. Far removed socially and psychically from Long Wharf, he eventually accumulated twenty acres and three houses (fig. 27). Mount Pleasant, as he called this complex, gave him a new perspective, over, no longer up to, the city. Here he would live with his mother, half brother, Sukey, and their American-born children, John Jr., Mary, and Eliz-

abeth. With an annual income from painting that made him the richest artist or artisan in the city, he converted the main house into a small European mansion, adding turned balusters, carved chimney breasts, and piazzas. The flood of letters Copley wrote to his half brother, who tended to his affairs while he painted portraits in New York in 1771, indicates that he spared no expense in constructing his estate. He wanted a lime-tree walk that would connect his property to Hancock's and, assuming a perfect imitation of the mentality of Boston's anglicized consumers, mailed exacting specifications for a china closet, Chinese architectural decoration, "venetian" doors, fifty-one fruit trees, corbeled classical arches, imported wall paints, and Connecticut stone hearths, all done "in the best Manner."[40]

Copley's internalization of his elite patrons' values in terms of his career was evident in his effort to make his pictures look English. His aspirations to English style were already embodied in the mythological pictures of 1754 (fig. 157; cat. nos. 3, 4), painted about three years after his English stepfather's death. As a mature artist in the 1760s he turned to European, not American, artists for advice. In 1762, for example, he wrote to the Swiss artist Jean-Étienne Liotard, requesting a set of pastel crayons, "the very best that can be got."[41] In 1764 he asked the New Haven portraitist William Johnston for a biography of the seventeenth-century Dutch artist Jan Steen.[42] He owned and, judging by the evidence of his letters, actively interrogated major European art treatises: Francesco Algarotti's *Letters upon Painting*, Charles Dufresnoy's *De Arte Graphica*, Roger de Piles's *Principles of Painting*, Horace Walpole's *Anecdotes of Painting in England*, Daniel Webb's *An Inquiry into the Beauties of Painting*, George Turnbull's *A Treatise on Ancient Painting*, and James Gibbs's *Book of Architecture*.[43] From those sources Copley learned the conventions of European composition, figuration, and expression and the ranking of categories of painting, from history painting at the top to genre and still-life painting at the bottom. In addition, he familiarized himself with human anatomy from the idealized plates in European texts rather than from live models, which were unacceptable in America.[44] And, as has been noted above, he based many of his compositions on English and European prints.[45] Like his fraternal silversmiths and furniture makers in Boston, Copley, of course, was determined to match his goods to those current in London.

Most important to Copley's acquisition of an English manner was his exchange of pictures and letters with artists in England, which began in 1765 when he shipped his portrait of Henry Pelham (fig. 28; cat. no. 25), his most accom-

Fig. 27 Sidney L. Smith after Christian Remick. *A Prospective View of Part of the Commons*, 1902, from a drawing of 1768. Engraving, 15¼ x 19½ in. (38.7 x 49.5 cm). Courtesy Concord Museum, Massachusetts

plished work to date, to London for exhibition at the Society of Artists. Captain R. G. Bruce, a friend of Copley's, relayed Sir Joshua Reynolds's opinion of the portrait. He praised Copley's talent—"the picture was *a very wonderfull Performance*"—but sounded a warning: if Copley remained on this path, he would never achieve an English manner. Presuming that was Copley's goal, Reynolds announced to the artist, whom he viewed as a provincial, that correction was needed "before your Manner and Taste were corrupted or fixed by working in your little way at Boston." He cited "a little Hardness in the Drawing, Coldness in the Shades, An over minuteness."[46] In what amounted to a correspondence course in English art, Copley also received the advice of Benjamin West (1738–1820), who had left America in 1760

and settled in London in 1764. Though West heaped praise on Copley, at the same time he criticized the picture of Pelham "as being to liney, which was judged to have arose from there being so much neetness in the lines."[47] Concentrating on the picture's sharp contrasts, large color zones, invisible brushwork, and minute details, West said, in twisted prose, that great painters feather the ends of strokes and avoid what Thomas Sully would later refer to as Copley's "hard terminations." Any further progress toward an English manner, West concluded, would require "a viset to Europe for this Porpase for three or four years."[48]

Copley must have attended keenly to West's advice, since it came from an artist who was also an American yet already completely versed in English taste. Feeling, as virtually every

39

Fig. 28 Detail, *Boy with a Squirrel (Henry Pelham)* (cat. no. 25)

Fig. 29 Detail, *Young Lady with a Bird and Dog* (cat. no. 38)

American did in the 1760s, a combination of awe, envy, and mortification in the shadow of English culture, Copley promised West that his next submission would be more acceptable. In 1767 he sent to London a portrait of a girl (fig. 29; cat. no. 38), hoping that this time his correspondents would find signs of congruency between his style and the English. But they thought Copley missed the mark again. The defects now were considered more severe than before. In part, West said, the problem was the "disagreeable" girl, an apparent reference to her squeamish expression. Also troubling to West were the opacity and brightness of the colors, and, most egregiously, the allover quality of the picture, "Each Part," he explained, "being . . . Equell in Strentgh of Coulering and finishing, Each Making to much a Picture of its silf, without that Due Subordanation to the Principle Parts, viz they head and hands."[49] In this latter regard he cited the overly conspicuous dog and carpet, and he closed by urging Copley to come "home" to London, an admonition reiterated by Captain Bruce, who added, before "your Genius is weakened, and it may be too late for much Improvement," as if talent had a shelf life when left exposed in America.[50]

Throughout the course of this correspondence, all parties, including Copley, agreed that English theory unquestionably exercised aesthetic jurisdiction over Copley's art. Copley could only make apologies for not living up to his advisers' expectations of mimesis.[51] Thus he began a provincial lament, again referencing English culture as authority. "In this Country," he pointed out, "there [are] no examples of Art, except what is to be met with in a few prints indifferently executed, from which it is not possible to learn much." He came to write, "I think myself peculiarly unlucky" to be in America.[52] Americans, he ranted, are "entirely destitute of all just ideas of the arts."[53]

Ironically, Copley's inability to make his art look fully English was never a liability in Boston, where the Englishness of an object was a highly regarded attribute. If his hard lines and preference for mass over volume were sure signs of a non-English touch, why was he so popular, receiving commissions for 350 American pictures? The answer is that patrons of painting in Boston were not familiar with British academic standards and in this way Copley was safe. Most colonial craftsmen had to compete with and therefore imitate the products of their English counterparts. Foreign sil-

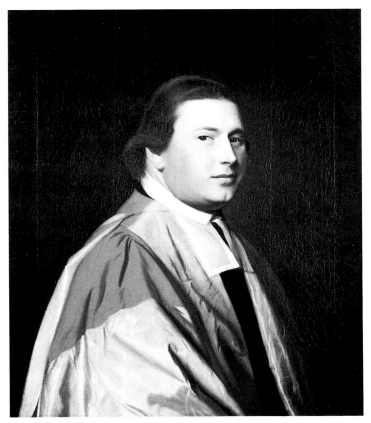

Fig. 30 *Myles Cooper* (cat. no. 47)

Fig. 31 Sir Joshua Reynolds. *Self-Portrait in Doctoral Robes*, 1773. Oil on canvas, 30 x 25 in. (76 x 63.5 cm). Private collection

ver, furniture, and architectural patterns were all widely available in America and served as their models of fashion. But paintings, alone among cultural goods, were not widely imported.[54] The primary patterns for American painters were prints that said nothing about color and touch. If anything, prints spoke in the linear, allover pictorial language that Copley employed in painting. Though a broad goal in the culture of mid-eighteenth-century America may have been the eradication of difference between domestic and English products, this was a goal virtually impossible to achieve in painting.

What could be imitated, however, was the English taste for owning large, flashy paintings. And sometimes an authentically English picture could be acquired in Boston if an actual English artist was imported. For example, the English Rococo portraitist Joseph Blackburn established himself in Boston and ruled the city's market in the late 1750s, in effect setting standards for taste and price. When Blackburn or his like appeared with a new, flamboyant English manner, it became incumbent upon American artisans to meet the challenge he posed. Copley did this in the case of Blackburn, first by imitating him and then, by 1760, by surpassing him, so that

there was no longer any need for the Englishman himself.

This isolated instance notwithstanding and despite his strenuous efforts at becoming as English as he could possibly be, by reading theory, copying prints, and sending pictures to London for critique, Copley's efforts remained, by academic British standards, provincial: descriptive, harsh, and linear, that is, without the lusciousness or atmospherics of English painting. The difference between his art and that of the English is demonstrated by comparing Copley's crisp, lustrous portrait of the Reverend Myles Cooper (fig. 30; cat. no. 47), which implicitly claims that surfaces are all-important, with Reynolds's soft, mottled self-portrait (fig. 31), which stresses depth and ambiguity. Nothing, except cultural expectation, required Copley to paint in an English fashion. If, for a moment, he could have released himself from self-imposed English criteria, he might have perceived in his own style the riveting visual definition that captured viewers in ways compellingly defiant of English aesthetic theory.

By 1765 Copley's manner was fully ingrained in him. He was aware of it, and even lamented it, yet he found that it was good for business. Much as he craved foreign instruction and accepted as his aesthetic yardstick the poetic softness and

41

dramatic brushwork of English painting, Copley did not have to alter his style to be a successful artist at home. Though he never quite hit the English aesthetic mark, according to Reynolds and West, he squarely hit the American, and thus actually profited from his divergences from English standards: Copley's visual inventories of people and their possessions fit the values of Boston's materialistic merchants, and, given his lack of competitors and the local ignorance of international art, his pictures stood unchallenged as paragons of fine taste.

Copley had molded himself so well to his local environment that his painting was as much a cultural practice as it was a stylistic form. In Boston descriptiveness was a force. Copley's visual language articulated, in the most arresting ways, how an American merchant thought, how he structured experience. The merchants loved facts and numbers and money. Theirs was a society in which exchange value dominated cultural thinking and behavior. Because any transaction involving the exchange or acquisition of objects, the rendering of a service, or the hiring of labor required an entry in a ledger, merchants were in the mental and mechanical habit of quantifying everything they encountered. And virtually everything could be converted into quantitative equivalences. Rye, pork, molasses, tea sets, tree cutting, and book repairs were rarely bartered or sold for cash. They were instead recorded in accounts, in books with vast pages, like the one John Hancock proudly displays in his portrait (cat. no. 22), in which every monetary transaction involving goods, services, and people is set out in columns across the sheet.[55] Hancock's experience when he opened that ledger of 1765 must have been like reading a diary that summarized into numerical icons what he did, with whom he did it, and how much it cost.

Copley structured his pictorial economy like a merchant's ledger. His allover technique, in which he articulated and arranged pictured objects with equal emphasis, from buttons to eyes, was analogous to the accounting methods of Boston's merchants. Copley's things, like the notations in the merchants' ledgers, were not set into a hierarchy determined by the importance of the individual objects but merely assigned positions of equivalent value on a surface (recall West's complaint that there was a problem in Copley's pictures with objects "being . . . Equell . . . Each making to much a Picture of its silf, without that Due Subordanation to the Principle Parts").[56] Just as Hancock tabulated things, Copley, following the same cultural logic, parceled out objects legibly and nonhierarchically in articulate vertical and horizontal columns like bookkeeping entries. It is in this re-

lentless enumerating and stacking of visual elements that the characteristic concerns of Copley's colonial realism emerge. A panoply of enunciable parts is syntactically arrayed in linguistic sequence. As in most realist enterprises, there is a concentration on parts that leads to the proliferation of parts. Viewers are left, as a result, with pictures that are more assembled than united, individuals who are more apportioned than engaged.

EMIGRATION AND REVOLUTION

Copley's portraits mirror antimetaphysical, materialist, provincial, elitist, mimetic, consumerist values of the late colonial society he served. His numerical aesthetics that turned individuals into account sheets presenting semiotic displays of personal assets were predictable for an artist who worked toward seamless congruency with his culture. In the role of entrepreneurial portraitist he had accomplished the dream of every American merchant: he had cornered a market. Yet, as his despairing letters to West indicate, he was self-conscious about being marginalized by the very culture in which he had succeeded. Moreover, he was also aware that his colleagues in England, by contrast, were considered gentlemen and treated as intellectual princes. His frustration occasionally boiled over into anger, for while the Boston elite were the people he understood so well, and with whom he shared so much, and who made him rich, they were the same people who kept him in his place. For all his accomplishments as an artist and as a respectable person, for all his entrepreneurial success and social aspiring, he was still a man who worked with his hands, an artisan who served a self-indulgent upper class. His work was all bespoke. That is, it was done on commission for clients and therefore never independent of patronage. Writes historian Gordon Wood about eighteenth-century American class structure, "Nobody who continued to work for a living, especially with his hands—no plowman, no printer, no artisan—no matter how wealthy he became, no matter how many employees he managed, could ever legitimately claim the status of gentleman."[57] Thus Copley, no matter what he achieved in America, would always be beholden to the wealthy individuals on whom his livelihood depended.

For this reason, and because he wished to see at first hand the artistic models in whose superiority he believed, he long dreamed of visiting or moving to England, a step he would finally take in 1774. As early as 1766 he wrote to his stepbrother, Peter, in Barbados of the "happy effect of leaving ones native Country," of breaking "shackles," and traveling

to Europe to be "heated with the sight of the enchanting Works of a Raphael, a Rubens, Corregio [sic] and a Veronese."[58] He told West of the "inexpressible pleasure" he would feel studying the old masters and living in the orbit of the Royal Academy.[59] He glorified Europe. He complained of the parochial American obsession with likenesses and of how difficult it was to perceive English art through the distorting lens of the Atlantic. He even confessed, in a letter of 1767 in which he accepted his election to the Society of Artists of Great Britain, to feeling deprived in a country with "neither precept, example, nor Models."[60] He recorded his thoughts about emigrating in a letter written in 1768, the year before he married. Here he detailed the conflicts he faced at this juncture, considering and then rejecting the idea of selling his property, moving with his elderly mother and his half brother, and living with less income:

> I should be glad to go to Europe, but cannot think of it without a very good prospect of doing as well there as I can here. You are sensable that three hundred Guineas a Year, which is my present income, is a pretty living in America, and I cannot think You will advise me to give it up without a good prospect of somthing at least equel to it, considering I must remove an infirm Mother, which must add to the dificulty and expenciveness of such [a] Voyage. And what ever my ambition may be to excell in our noble Art, I cannot think of doing it at the expence of not only my own happyness, but that of a tender Mother and Young Brother whose dependance is intirely upon me.[61]

Copley's marriage in 1769, the birth of children, and his acquisition of substantial new properties must have further anchored him in Boston.

At the same time that Copley's claim of duty as a family man was holding him back from Europe, an economy destabilized by revolutionary politics was pushing him abroad. The destabilization had begun with the Stamp Act of 1765 and the disruptive nonimportation movement, and it continued with the Townshend Acts of 1767. The Stamp Act and the Townshend Acts, which imposed a tax on imported goods, primarily glass, paper, and tea, became rallying points for Americans seeking economic and political autonomy. Consumer goods were the focus of the acts and of the rebellions against them, which included a boycott of English imports. The boycott impelled American consumers to turn to American craftsmen for products. But Copley did not benefit from this. He was not in competition with English artists and so could not inherit their clients. Indeed, the boycott

threatened his business, which depended on merchant patrons who needed English trade to fill their wallets.

The whole economic environment, as well as the social and political fabric, of Boston was in disarray after 1767. Harassment of customs officials and Tory merchants, some of whom were Copley's patrons, was rife as a result of the boycott, and there were threats of armed resistance against the British. Finally, the economic and political crisis provoked by the Townshend Acts culminated in the Boston Massacre of March 9, 1770.

Copley's in-laws became directly involved in pre-Revolutionary politics in 1772 and 1773. The Clarkes were Tories and their firms were Massachusetts consignees for the British East India Company, the colossus of English commodities trade, which planned to ship a half million pounds of tea to America in 1773. The family's income and status were dependent on that trade, and especially on the importation of tea, which, because it remained taxable after the repeal of the Townshend Acts in 1770, was an icon of British economic control of the colonies. Specifically inflammatory to Bostonians about the Clarkes' business was their unbrokered access to British East India tea, a right that allowed them to undersell other colonial merchants who had to pay the tax and middlemen.

In November of 1773 an infuriated mob stormed the home of Richard Clarke demanding that he resign as consignee.[62] In fear of their lives, Clarke and his two sons fled to Castle Island, in the harbor, where British troops had been stationed since the massacre. After the tea ships arrived on November 28, Samuel Adams held two mass meetings to consider what actions should be taken on the issue of the tax and the position of the Clarkes. Copley conspicuously attended in order to defend his in-laws. "I made use of every argument my thoughts could suggest to draw the people from their unfavourable oppinion of [the Clarkes]."[63] He claimed that the Clarkes were not in collusion with the royal governor and would have gone to the meeting themselves, were it not that "the People had drawn the precise Line of Conduct that would sattisfy them."[64] Though he thought the worst was past, on December 20, after eight thousand Bostonians listened to the exhortations of Samuel Adams at South Church, a group of activists disguised as Mohawk Indians boarded the tea ships and dumped all 342 casks of Richard Clarke's tea into the harbor.

The Boston Tea Party traumatized the Copley and Clarke families. The city became hostile territory for them. Traditional social relations broke down as the lower classes ceased to defer to the elite. All economic activity came to an end in

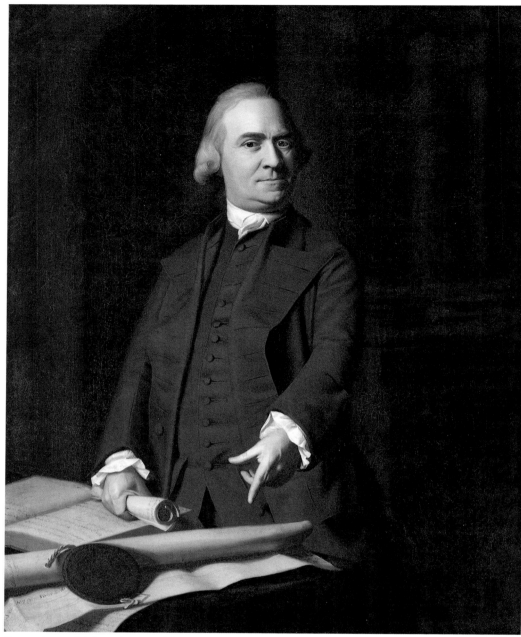

Fig. 32 *Samuel Adams* (cat. no. 62)

an atmosphere of fear and uncertainty under the retaliatory Coercive Acts and Boston Port Bill. British warships began filling the harbor. And craft groups, such as Paul Revere's Mechanicks, were converted into espionage rings.

Though Copley was intimately linked with the Loyalist Clarkes, his own position on revolutionary matters is hard to identify. Copley himself was not altogether unsympathetic to dissent. He attended a Sons of Liberty meeting in Dorchester on August 14, 1769.[65] Moreover, he worked for Whigs, painting John Hancock and Samuel Adams, the latter the most radical revolutionary in America. The portrait of

Adams (fig. 32; cat. no. 62) was executed sometime between the Boston Massacre and the Tea Party, when the sitter was at the apex of his political life. Here Copley depicted him as a firebrand, angrily pointing with one hand to the charter and seal of Massachusetts granted by King William and Queen Mary and with the other grasping a petition submitted by aggrieved citizens.[66] While he painted this picture on commission, and thus according to its patron's specifications, Copley nonetheless was allowing some of its political aura to hang on himself. It *was* Adams. It hung in John Hancock's Whig home and eventually in Faneuil Hall as a sym-

bol of dissent. And Copley must have realized that everyone knew it was he who had painted it.

But Copley never labeled himself politically and rarely expressed a clear political opinion. During the Stamp Act crisis, for example, he merely referred to the "noise and confusion" caused by the arrival of the stamps and dispassionately described the way the mob demolished the houses of Thomas Hutchinson and two of his sitters, Martin Howard and Benjamin Hallowell.[67] Sometimes he seemed to feel it was necessary to distance himself altogether from revolutionary politics. Thus, when John Wilkes, the British journalist and radical member of Parliament, offered to exhibit a portrait by Copley of the four-year-old son of a friend

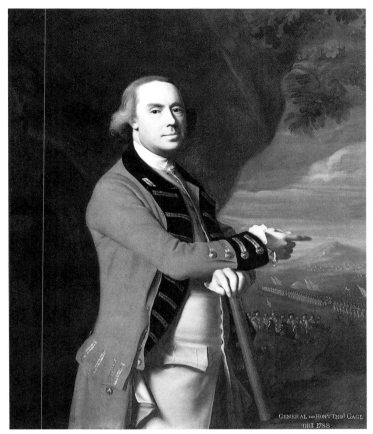

Fig. 34 *Thomas Gage* (cat. no. 66)

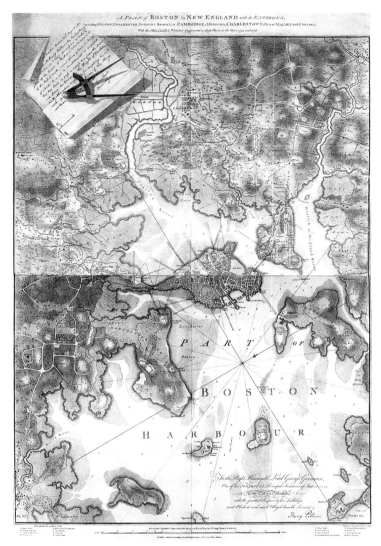

Fig. 33 Francis Jukes after Henry Pelham. *A Plan of Boston in New England*, 1777. Etching and aquatint, two sheets, each 21 1/2 x 28 1/2 in. (54.6 x 72.4 cm). The New York Public Library, Astor, Lenox and Tilden Foundations, I. N. Phelps Stokes Collection, Miriam and Ira D. Wallach Division of Art, Prints and Photographs

at the Society of Artists, the painter fretted about accepting the invitation because of the possible political consequences:

The party spirit is so high that what ever compliments the Leaders of either party is lookd on as a tassit disapprobation of those of the other; and tho I ought to be considered in this work as an Artist imploy'd in the way of my profession, yet I am not sure I should be, and as I am desireous of avoideing every imputation of party spir[it], Political contests being neighther pleasing to an artist or advantageous to Art itself, I would not have it at the Exibition on any account what ever if there is the Least room to supose it would give offence to any persons of eighther party.[68]

Publicly, Copley seems to have wanted to appear neutral. The only public office he held, clerk of market, allowed him to take the role of mediator, safely insulated from political extremism. Copley clearly was not a radical Whig in the camp of Samuel Adams, who had no tolerance for English intervention in the day-to-day life of Americans. Neither was he a wholehearted Loyalist like his in-laws, for he did not support English taxation and military rule. In fact, he in-

gratiated himself with and painted pictures for members of both Tory and Whig factions. But, despite that lack of strict partisan identification, he was not without political opinion. He felt threatened by the revolutionary climate and wished the clock could be turned back to 1760, when America was under the invisible benefaction of English rule. He claimed to dissociate himself from partisan politics in the higher name of Art, which itself represented a political position.[69] And perhaps most importantly, he as much as anyone was responsible for making Boston British, by creating politically resonant images of an American aristocracy.

Understandably, activists in Samuel Adams's circle identified Copley and his pictures with the Tory elite in the early 1770s. After all, he had married into a prominent Tory family and his half brother was a Loyalist who made military maps (see fig. 33) for Thomas Gage.[70] Moreover, he had painted Gage (fig. 34; cat. no. 66), British commander in North America and colonial governor of Massachusetts from 1774 to 1775. Perhaps Copley thought he was being politically circumspect by representing Gage as a gentleman in the portrait; though he showed the general in a political environment, on a military field, and dressed in full British military regalia, his approach is nonpolemical: he takes no partisan position, neither making references in support of nor alluding to the benefits of British occupation. But the very image of General Gage, even though portrayed neutrally, was politically charged. And the very fact that Copley painted Gage constituted a political statement, about the general and the artist. Copley agreed to paint him, take his money, and represent him in a dignified manner that reinforced his authority in America.

Copley claimed to be nonpartisan, but partisans pursued him nonetheless, because of his associations with Loyalists. In 1774 he told a harrowing story of being awakened at midnight by men looking for George Watson, a Tory mandamus counselor who had been visiting and whom he had painted in 1768. The intruders interrogated Copley about how he came to be friends with "such a Rogue and Villin." Not satisfied with the artist's equivocating answers, they responded with an "Indian Yell" and a threat, warning him that if he was not telling the truth, his blood would be on his own head.[71] Not only the man but also his work became the object of suspicion. In 1769, during the Townshend Acts crisis, for example, radical activists cut the heart area out of his portrait of Governor Francis Bernard, which was hanging in the dining room of Harvard Hall in Cambridge. Copley was called upon to repair the damage, prompting the *Boston Evening Post* to comment sarcastically that "our American

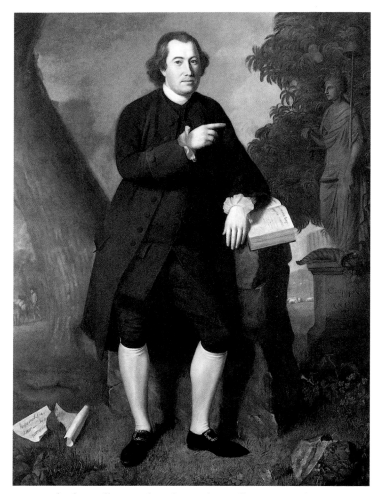

Fig. 35 Charles Willson Peale. *John Beale Bordley*, 1770. Oil on canvas, 79⅛ x 58¼ in. (201 x 147.6 cm). National Gallery of Art, Washington, D. C., Gift of the Barra Foundation, Inc. 1984.2.1

limner, Mr. Copley, by the surprising art of his pencil has actually restored as *good a heart* as had been taken from it; tho' upon a near and accurate inspection, it will be found to be no other than a false one."[72]

The artist must have been astonished by this attack on his portrait, for his goal seems to have been to keep his images scrupulously clear of partisan political taint. Mr. and Mrs. Isaac Winslow, for example, were robust Tories who fled the colonies, and Mr. and Mrs. Thomas Mifflin were radical Whigs—Mr. Mifflin, in fact, became one of George Washington's top aides. Yet Copley's visual language is the same in his portraits of the two couples (cat. nos. 80, 81), and the sitters' political affiliations, consequently, are indistinguishable. His effort is focused on fashioning character and class through icons of material wealth. In these pictures—as in the portrait of Gage and the other works of the era—Copley refused to preach revolutionary sermons or present Loyalist tracts. He effaced the dangerous American environment. His placid bodies and complacent, self-satisfied faces can be

seen as reassuring emblems for a merchant elite caught in the throes of unnerving change. The world, as depicted in Copley's late American portraits, is of the interior, closed off from the confusion outside, sealed, and shielded from the threat of dislocation. The serenity of his sitters is a functional illusion, however, a rhetorical insurance policy against change, an assurance of continuity and stability. It seems that the more hostile Copley's world became, the greater the premium he placed on acts of political erasure.

But political identification transcended artistic style in the climate of British occupation in the early 1770s. A Tory was a Tory, no matter what his or her clothing or expression. Copley's precarious balancing act in a precariously unbalanced world was simply impossible to maintain. As Henry Pelham understood, "The People in the Country have made it a Rule for a long time Past to brand every one with the Name of Tory and consider them as Inimical to the Liberties of America who are not will'g to go every length with them in the Scheems however mad or who show the least doubt of the justice and Humanity of all their measures, or even entertain an Idea that they may not produce those salutary effects they profess to have in View."[73] Neutrality was not a tenable public position in pre-Revolutionary America. There was no artisan who was not, as historian Gary Nash observes, "wielding his tools in a social and political context. The distance between workbench and street was very small. The relationship of craftsmen to their clientele had political and social dimensions, and, as American society developed, craftsmen became more and more involved in life beyond their shop doors."[74]

Charles Willson Peale, Copley's counterpart in Philadelphia—and in some respects his diametric opposite—epitomized the engaged artist who was eager to wield his tools in a social and political context. Peale was vividly political. Only two years younger than Copley, he was a soldier in the Revolutionary army, a member of numerous activist committees, and an effective propagandist who spouted radical rhetoric. In his painting he did not shrink from political content. For example, for a portrait of his patron John Beale Bordley (fig. 35) he constructed a polemical allegory on independence. Here he showed the sitter leaning on an open book with a Latin inscription that reads, "We observe the laws of England to be changed," and pointing to a statue of English Law that is overgrown by a poisonous Maryland jimson weed. In the distance are horses loaded with American wool, a reference to the boycott of English goods. Where Peale embraced political affiliation and moral definition, Copley chose political neutrality and class definition. Where

the Revolution was for Peale an artistic opportunity, for Copley it was the end of opportunity.[75]

When he boarded ship for London on June 10, 1774, Copley still believed that America belonged safely in benign British hands and that a "Civil War," as he termed it, was an evil greater than English taxation or control of American affairs. He departed alone, and perhaps suddenly, for he later lamented not seeing his mother before leaving.[76] The city he left behind was described by his half brother: "Four Regiment[s] and the Artillery are quietly encamped on the Common. . . . The Common wears an Entire new face. Instead of the peacefull Verdure with which it was cloathd when you left it, it now glows with the warlike Red. The fireing of Cannon, the Rattling of Drums, the music of the fife, now interrupt the pleasing silence which once rendered it so peculiarly deligh[t]full. But still all this Noise all this confusion are incomparably to be preferred to the infernal Wistle and shout of a lawless and outragious rabble."[77] What had been a prosperous port city at the beginning of Copley's career was, in the spring of 1775, a place where "thousands are reduced to absolute Poverty. . . . Business of any kind is entirely Stop'd."[78]

Sukey, who was expecting their fourth child, remained in the disintegrating city, surrounded by relatives at Mount Pleasant: Copley's mother and Henry Pelham and her embattled father and brother, who paid the expenses. Copley, meanwhile, fretted about the safety of his family and spent a month and a half in England before traveling to Paris and then Rome. In May of 1775, war having broken out, Sukey, three children, and the Clarkes departed for London, leaving behind Mary Singleton Copley Pelham, Henry Pelham, and the infant Clarke Copley, who would die a year later. In his safe haven in Europe, the artist mused about the Revolution; writing to his half brother from Parma in August of 1775, he foresaw, with astonishing accuracy, the dimensions the war would take, as well as its outcome: "I think that the people have gone too far to retract and that they will adopt the proverb, which says, when the Sword of Rebellion is Drawn the Sheath should be thrown away; and the Americans have it in their power to baffle all that England can do against them. . . . Ocians of blood will be shed to humble a people which they never will subdue . . . and after [the English] have with various success deludged the Country in Blood the Issue will be that the Americans will be a free independant people."[79]

In November Copley joined his wife, his children, and his in-laws in London, an event he commemorated in a family portrait of 1776–77 (fig. 36). There he was protected from

47

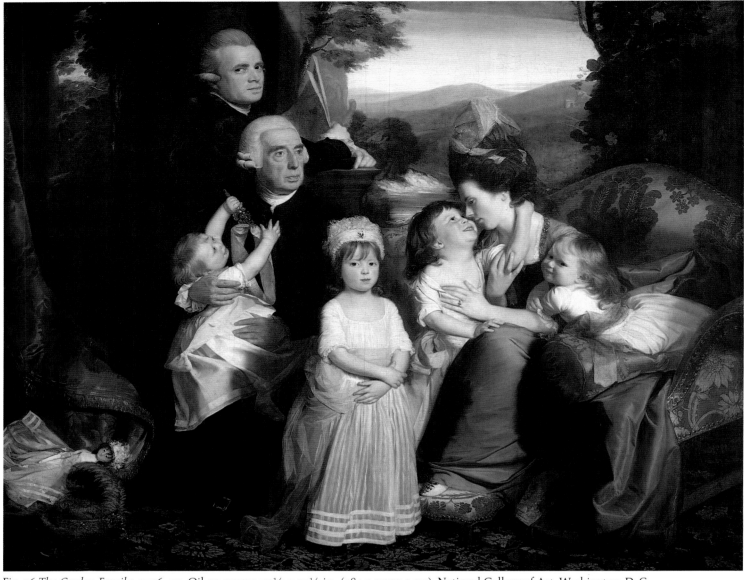

Fig. 36 *The Copley Family*, 1776–77. Oil on canvas, 71½ x 90¼ in. (184.1 x 229.2 cm). National Gallery of Art, Washington, D. C., Andrew W. Mellon Fund 1961.7.1

the political, military, and economic chaos of America. He was also released from the mimetic culture of Boston. He exchanged bespoke work, executed in an American paternalistic system, for life as an independent producer dedicated to self-interest in a competitive, laissez-faire English market. At that he excelled.[80] In London he could again enjoy the benefits of working in a "polite" society. On the road to becoming a republic, America was losing its gentility. Monarchies, observed John Adams on the eve of independence, produce "Taste and politeness . . . Elegance in Dress . . . Balls and Assemblies." But the emerging United States, he asserted, "will produce Strength, Hardiness, Activity, Courage, Fortitude

and Enterprise," in short, a cluster of civic attributes that are foreign to Copley's canvases.[81] The language of Revolution condemned luxury, idleness, avarice, and other new profanities that had formed the bedrock of the merchant culture of Boston and, by extension, the foundation of Copley's polite American imagery. In their place, industry, frugality, and a host of other neo-Puritan virtues became part of the new antimaterialist, republican ethos of the 1770s. What Copley left in 1774 was an American culture in rapid transformation. It was a new world that, at least for a time, radically politicized all people and all objects and that would not have had much patience with Copley's nonpartisan, elitist art.[82]

The author appreciates the good advice offered at various stages of the preparation of this essay by Joseph Ellis, Donald Weber, Debbora Battaglia, David Jaffee, Susan Rather, and Laura Quinn. I thank the ten students in the senior seminar at Mount Holyoke College who forced me to articulate my case for Copley intelligibly. And I appreciate the support, camaraderie, and good cheer provided by my colleagues in this project: Carrie Rebora, Theodore E. Stebbins Jr., Carol Troyen, Erica E. Hirshler, and Morrison H. Heckscher. I was fortunate to have received a research grant from Mount Holyoke College and to have fellowships from the National Endowment for the Humanities at the Winterthur Museum, Delaware, as well as the J. Clawson Mills Fellowship at The Metropolitan Museum of Art.

The epigraph is from Jonathan Richardson, *An Essay on the Theory of Painting* (London, 1715), p. 25.

1. There has been some debate over the year of Copley's birth; see Henry Wilder Foote, "When Was John Singleton Copley Born?" *New England Quarterly* 10 (Mar. 1937), pp. 111–20.

2. Suffolk County, Docket no. 8979, Archives, Supreme Judicial Court, Boston.

3. Nathaniel Shurtleff, *A Topographical and Historical Description of Boston* (Boston, 1871), p. 199. For a detailed analysis of Boston's maritime economy, see James Shepherd and Gary Walton, *Shipping, Maritime Trade, and the Economic Development of Colonial North America* (Cambridge, 1972).

4. Curtis Nettels, "The Economic Relations of Boston, Philadelphia, and New York, 1680–1715," *Journal of Economic and Business History* 3 (1930–31), pp. 185–215.

5. There are no records of any formal education Copley may have received; it is possible, however, that he attended one of Boston's two grammar schools or three writing schools, which were free and public.

6. Jackson Turner Main, *The Social Structure of Revolutionary America* (Princeton, N.J., 1965), pp. 38–39.

7. *Boston Gazette*, Nov. 19, 1764.

8. T. H. Breen discusses the spectrum of imported consumer goods in "'Baubles of Britain': The American and Consumer Revolutions of the Eighteenth Century," *Past and Present*, no. 119 (May 1988), pp. 73–104.

9. *Boston Gazette*, Mar. 18–25, 1734, quoted in George Francis Dow, comp., *The Arts and Crafts in New England, 1704–1775* (Topsfield, Mass., 1927), p. 155.

10. *Boston Gazette*, Nov. 5, 1759.

11. *Boston Gazette*, June 5, 1735.

12. Ibid., July 11, 1748.

13. See John Barrell, *The Political Theory of Painting from Reynolds to Hazlitt* (New Haven, 1986), pp. 1–68. For the situation in America, see Neil Harris, *The Artist in American Society: The Formative Years, 1790–1860* (New York, 1966), pp. 2–25.

14. *Boston Gazette*, Feb. 19–26, 1728.

15. My thinking on the subject of the operations of markets in pre-Revolutionary Boston follows the theory presented in Colin Campbell, *The Romantic Ethic and the Spirit of Modern Consumerism* (Oxford, 1987). I have also been influenced in general by the Hegelian theory offered by Daniel Miller in *Material Culture and Mass Consumption* (New York, 1987).

16. Alan Kulikoff, "The Progress of Inequality in Revolutionary Boston," *William and Mary Quarterly* 28 (July 1971), p. 393.

17. Copley, letter to Thomas Ainslie, Feb. 25, 1765, in Jones 1914, p. 33.

18. See Main, *Social Structure*, pp. 68–114; and Steven J. Erlanger, *The Colonial Worker in Boston, 1775* (Washington, D.C., 1975).

19. For this discussion of economics I am depending on Gary B. Nash, *The Urban Crucible: Social Change, Political Consciousness, and the Origins of the American Revolution* (Cambridge, Mass., 1979); James A. Henretta, "Economic Development and Social Structure in Colonial Boston," *William and Mary Quarterly* 22 (Jan. 1965), pp. 75–92; and Kulikoff, "Progress of Inequality," pp. 375–412. For a dissenting view, see G. B. Warden, "Inequality and Instability in Eighteenth-Century Boston: A Reappraisal," *Journal of Interdisciplinary History* 6 (Spring 1976), pp. 585–620. For a study of large economic forces, see Carole Shammas, *The Pre-Industrial Consumer in England and America* (Oxford, 1990). For a review of the bibliography on this subject, see "Wealth and Social Structure," in James A. Henretta, *The Origins of American Capitalism: Collected Essays* (Boston, 1991), pp. 148–97.

20. This is a prevailing theme in Nash, *Urban Crucible*.

21. Jules David Prown graphed the web of intermarriage in Prown 1966, vol. 1, pp. 153–99.

22. See Henretta, "Economic Development and Social Structure," p. 89.

23. Eric L. Jones, "The Fashion Manipulators: Consumer Tastes and British Industries, 1660–1800," in *Business Enterprise and Economic Change*, ed. Louis P. Cain and Paul J. Uselding (Kent, Ohio, 1973), pp. 198–226. For the sociology of consumption in the eighteenth century, I am indebted to the writings of Colin Campbell, especially his *Romantic Ethic and Spirit of Modern Consumerism*; to Neil McKendrick, John Brewer, and J. H. Plumb, *The Birth of a Consumer Society: The Commercialization of Eighteenth-Century England* (Bloomington, Ind., 1982); Grant McCracken, *Culture and Consumption: New Approaches to the Symbolic Character of Consumer Goods and Activities* (Bloomington, Ind., 1990); and Gordon Vichert, "The Theory of Conspicuous Consumption in the Eighteenth Century," in *The Varied Pattern: Studies in the Eighteenth Century*, ed. Peter Hughes and David Williams (Toronto, 1971), pp. 253–67.

24. For anglicization, see T. H. Breen, "An Empire of Goods: The Anglicization of Colonial America, 1690–1776," *Journal of British Studies* 25 (Oct. 1986), pp. 467–99. See also Gordon S. Wood, *The Radicalism of the American Revolution* (New York, 1992), pp. 11–24; and John J. McCusker and Russell R. Menard, *The Economy of British North America, 1607–1789* (Chapel Hill, 1985), pp. 277–94.

25. References to these pictures in the Boston newspapers are quoted in Dow, *Arts and Crafts in New England*, pp. 5, 40.

26. English and American portraits on display in Boston are discussed in Richard H. Saunders and Ellen G. Miles, *American Colonial Portraits, 1700–1776* (exh. cat., Washington, D.C.: National Portrait Gallery, 1987), pp. 53–58. Pierre Eugène Du Simitière commented on the portraits he saw on a trip to Boston in 1767: "Paintings in Boston New England," ms. 1767, Du Simitière Papers, Library Company of Philadelphia. Adams, writing in 1817, was recalling the impression he had of these pictures (*The Works of John Adams*, vol. 10 [Boston, 1856], p. 249).

27. See John T. Kirk, *American Furniture and the British Tradition to 1830* (New York, 1982); and Francis J. Puig and Michael Conforti, eds., *The American Craftsman and the European Tradition, 1620–1820* (exh. cat., Minneapolis: Minneapolis Institute of Arts, 1989).

28. W[illiam] T. Baxter, *The House of Hancock: Business in Boston, 1724–1775* (Cambridge, Mass., 1945), p. 67.

29. Quoted in Harold Perkin, *The Origins of Modern English Society, 1780–1880* (London, 1968), p. 222.

30. James Deetz, *In Small Things Forgotten: The Archaeology of Early American Life* (Garden City, N.Y., 1977), p. 38. See also Breen, "Empire of Goods," pp. 497–99; Wood, *Radicalism of the American Revolution*, p. 12; and John M. Murring, "Anglicizing an American Colony:

The Transformation of Provincial Massachusetts" (Ph.D. diss., Yale University, New Haven, 1966).

31. For the appropriation of English designs in American crafts, see Barbara M. Ward, "The European Tradition and the Shaping of the American Artisan," in *American Craftsman and European Tradition*, pp. 14–22. For Copley's print sources, see Trevor J. Fairbrother, "John Singleton Copley's Use of British Mezzotints for His American Portraits: A Reappraisal Prompted by New Discoveries," *Arts Magazine* 55 (Mar. 1981), pp. 122–30.

32. See Breen, "'Baubles of Britain.'"

33. Bernard Bailyn, "1776: A Year of Challenge—a World Transformed," *Journal of Law and Economics* 19 (Oct. 1976), p. 447; Erlanger, *Colonial Worker*, p. 9.

34. Adam Smith, *An Inquiry into the Nature and Causes of the Wealth of Nations*, ed. Edwin Cannan (New York, 1937), p. 626. See also Ralph Davis, "English Foreign Trade, 1700–1774," *Economic History Review*, ser. 2, 15 (Aug. 1962), pp. 290–92.

35. T. H. Breen, "The Meaning of 'Likeness': American Portrait Painting in an Eighteenth-Century Consumer Society," *Word and Image* 6 (Oct.–Dec. 1990), pp. 325–50.

36. Copley, letter to unnamed correspondent, ca. 1767, in Jones 1914, pp. 65–66.

37. *The Autobiography of Colonel John Trumbull*, ed. Theodore Sizer (New Haven, 1953), p. 11.

38. Quoted in Dunlap 1834, vol. 1, p. 113.

39. For Cooper, see Donald Weber, *Rhetoric and History in Revolutionary New England* (New York, 1988), pp. 113–32. Sometime in the early 1770s Copley moved to Trinity Church, which was Anglican.

40. Henry Pelham, letter to Copley, Aug. 25, 1771, in Jones 1914, p. 148.

41. Copley, letter to Jean-Étienne Liotard, Sept. 30, 1762, in Jones 1914, p. 26.

42. William Johnston, letter to Copley, Sept. 14, 1764, Copley-Pelham Papers, Public Record Office, London.

43. See Janice G. Schimmelman, *A Checklist of European Treatises on Art and Essays on Aesthetics Available in America Through 1815* (Worcester, 1983), pp. 106, 126, 145, 162, 163, 166.

44. Prown 1966, vol. 1, pp. 16–17.

45. For a summary of Copley's use of print sources, see Fairbrother, "Copley's Use of Mezzotints."

46. Captain R. G. Bruce, letter to Copley, Aug. 4, 1766, in Jones 1914, pp. 41–42.

47. Benjamin West, letter to Copley, Aug. 4, 1766, in Jones 1914, pp. 43–44.

48. Quoted in Dunlap 1834, vol. 1, p. 125; Benjamin West, letter to Copley, Aug. 4, 1766, in Jones 1914, p. 45.

49. Benjamin West, letter to Copley, June 20, 1767, in Jones 1914, pp. 56–58.

50. Captain R. G. Bruce, letter to Copley, June 25, 1767, in Jones 1914, p. 60.

51. On the relation of cultural margins to centers, in particular the voice of those on the margins, see Gayatri C. Spivak, "Can the Subaltern Speak?" in *Marxism and the Interpretation of Culture*, ed. Cary Nelson and Lawrence Grossberg (Urbana, 1988), pp. 271–313.

52. Copley, letter to Benjamin West, Nov. 12, 1766, in Jones 1914, pp. 50–51.

53. Copley, letter to Captain R. G. Bruce, ca. 1767, in Jones 1914, p. 64.

54. There were a few foreign pictures in Boston, especially in the Town-House, where portraits of English kings and queens hung. Occasionally someone had a portrait painted in England that was subsequently shipped to America. Such was the case with Governor William Shirley of Massachusetts, whose portrait was painted by Thomas Hudson in England in 1750 and then sent to Boston (National Portrait Gallery, Washington, D.C.).

55. For accounting practices, see W[illiam] T. Baxter, "Accounting in Colonial America," in *Studies in the History of Accounting*, ed. A. C. Littleton and B. S. Yamey (Homewood, Ill., 1956), pp. 272–87. On exchange economy, see Michael Merrill, "Cash Is Good to Eat: Self-Sufficiency and Exchange in the Rural Economy of the United States," *Radical History Review* 4 (1977), pp. 42–71; and Wood, *Radicalism of the American Revolution*, pp. 64–65.

56. West, letter to Copley, June 20, 1767, in Jones 1914, p. 57.

57. Wood, *Radicalism of the American Revolution*, p. 38. See also Richard L. Bushman, "'This New Man': Dependence and Independence, 1776," in *Uprooted Americans*, ed. Richard L. Bushman et al. (Boston, 1979), pp. 79–96.

58. Copley, letter to Peter [Pelham], Sept. 12, 1766, in Jones 1914, pp. 47–48.

59. Copley, letter to Benjamin West, Nov. 12, 1766, in Jones 1914, p. 51.

60. Copley, letter to Francis M. Newton, Nov. 23, 1767, in Jones 1914, p. 63.

61. Copley, letter to Benjamin West, Jan. 17, 1768, in Jones 1914, p. 68.

62. Regarding the Clarkes, see Benjamin W. Labaree, *The Boston Tea Party* (New York, 1964), pp. 33, 50–51.

63. Copley, letter to Jonathan and Isaac Winslow Clarke, Dec. 1, 1773, in Jones 1914, pp. 211–12.

64. Ibid., p. 212.

65. Hiller B. Zobel, *The Boston Massacre* (New York, 1970), p. 145.

66. The other documents on the table are illegible. The portrait may have been commissioned as a statement of revolutionary fervor by John Hancock, since it hung in his house; this would explain Copley's inclusion of such uncharacteristically political content.

67. Copley, letter to Captain R. G. Bruce, Sept. 10, 1765, in Jones 1914, p. 36.

68. Copley, letter to [Benjamin West], Nov. 24, 1770, in Jones 1914, p. 98.

69. It has been presumed that Copley linked politics and art in the political print *The Deplorable State of America*, 1765 (Library Company of Philadelphia). I reject the attribution to Copley of this work, however. Though Copley's name is on it, it is not in his handwriting and there is, moreover, no internal evidence to suggest his hand.

70. During the early years of the Revolution, Henry Pelham ridiculed those he called the "Rebels" and consulted with General Gage about producing a map of Charlestown.

71. Copley, letter to Isaac Winslow Clarke, Apr. 26, 1774, in Jones 1914, pp. 217–19.

72. *Boston Evening Post*, May 8, 1769, quoted in O. M. Dickerson, *Boston Under Military Rule, 1768–1769, As Revealed in a Journal of the Times* (Boston, 1936), p. 78. Mutilations of Copley's portrait of Benjamin Hallowell—four gashes near the head—may have occurred during the sacking of his house on Hanover Street by a rebellious mob on August 26, 1765. As comptroller of the Port, Hallowell was one of a number of Tory officials who were under violent attack during the Stamp Act crisis; see Wendy Watson, *Altered States: Conservation, Analysis, and the Interpretation of Works of Art* (exh. cat., South Hadley, Mass.: Mount Holyoke College Art Museum, 1994), pp. 56–59.

73. Henry Pelham, letter to Copley, May 1775, in Jones 1914, p. 316.

74. Gary B. Nash, "A Historical Perspective on Early American Artisans," in *American Craftsman and European Tradition*, p. 1.

75. For Peale in this specific period, see Joseph Ellis, *After the Revolution* (New York, 1979), pp. 41–71.

76. Copley, letter to Susan Clarke Copley, July 9, 1774, in Jones 1914, p. 224.

77. Henry Pelham, letter to Copley, July 17, 1774, in Jones 1914, pp. 232–33.

78. Henry Pelham, letter to Copley, May 16, 1775, in Jones 1914, p. 320.

79. Copley, letter to Henry Pelham, Aug. 6, 1775, in Jones 1914, pp. 348–49.

80. Nash, "Historical Perspective," p. 6. For a discussion of the differences between capitalistic and pre-capitalistic economies, see "The Transition to Capitalism in America," in Henretta, *Origins of American Capitalism*, pp. 256–94; and E. P. Thompson, "Patrician Society, Plebeian Culture," *Journal of Social History* 7 (Summer 1974), pp. 382–405.

81. John Adams, letter to Mercy Otis Warren, Jan. 8, 1776, in *Warren-Adams Letters, Being Chiefly a Correspondence Among John Adams, Samuel Adams, and James Warren . . .* , vol. 1 (Boston, 1917), pp. 201–2.

82. For this transformation, see Edmund S. Morgan, "The Puritan Ethic and the American Revolution," *William and Mary Quarterly* 24 (Oct. 1967), pp. 3–43.

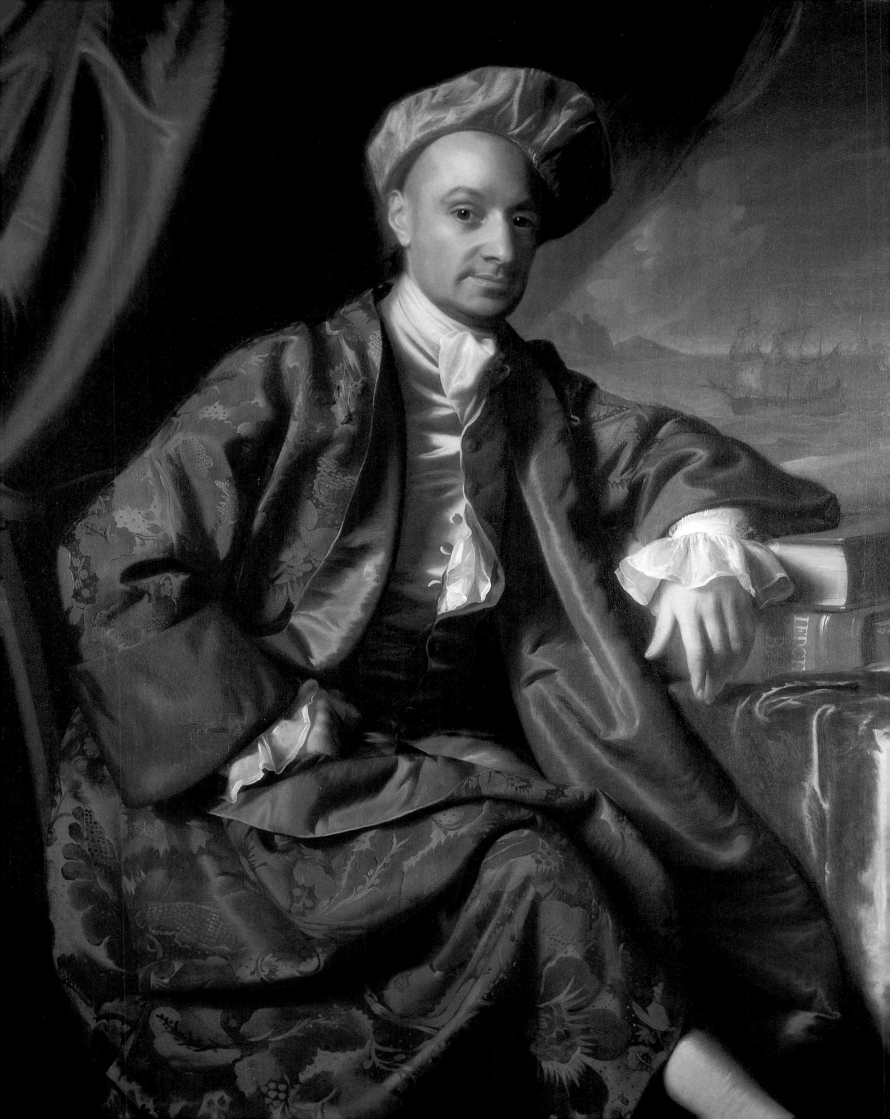

Character and Class

PAUL STAITI

There are two ways of understanding portraiture — either as history or as fiction. Charles Baudelaire, 1846

[Copley's portraits] illustrate the men and women of a day when pride, decorum, and an elegance, sometimes ungraceful but always impressive, marked the dress and air of the higher classes. . . . It appears to have been a favorite mode either with the artist or his sitters, to introduce writing materials, and to select attitudes denoting a kind of meditative leisure. The otium cum dignitate is the usual phrase. A rich brocade dressing-gown and velvet skullcap — a high-backed and daintily carved chair, or showy curtain in the background, are frequently introduced. "Sir and Madam" are the epithets which instinctively rise to our lips in apostrophizing these "counterfeit presentments."

 Henry T. Tuckerman, 1867

Henry T. Tuckerman understood the anthropology in portraiture. Throughout the lead biography in his landmark history of American artists, he saw registered in John Singleton Copley's 350 American portraits the social habits and desires—the "air," as he phrased it—of colonial elites.[1] In the passage above he mentioned some of the visual signs that made a Copley portrait socially effective: the display of clothing, furniture, manners, and leisure. He could have gone on to list more of the objects that draped, landscaped, and decorated the eighteenth-century portrait, for they too were specific sites where character and class were made manifest. The turn of a hand, the cut of a dress, the breed of an animal, the species of a flower, and the color of hosiery were all signs that allowed viewers to be persuaded of the social attainment of a Jeremiah Lee (cat. no. 52), the Orientalizing sexuality of a Margaret Kemble Gage (cat. no. 67), or the antimaterialist discipline of an Eleazer Tyng (cat. no. 74).

In writing about Copley as a society painter, Tuckerman argued, in effect, that it is insufficient to consider this artist's stature in the history of American art merely as a matter of exquisite technique.[2] Certainly, Copley's appeal had something to do with his unprecedented skill in transcribing material things onto canvas: he could make paint look like polished mahogany or clear glass or reflective satin. But that descriptive ability, for which he was justly renowned, does not adequately account for why the merchant and professional classes so avidly sought his services in the two decades before the Revolution.

In addition to dazzling descriptions, Copley, before Charles Baudelaire put it in words, offered the elite persuasive fictions. With his deft hands and social perspicacity he fashioned sitters into the personae they wanted to project. Copley adroitly choreographed bodies, settings, and objects into visual biographies—"counterfeit presentments," in Tuckerman's phrase—that had the power to calibrate social position in graphic ways that were legible to a community. As a result, patrons came to Copley for portraits that were venues where they might avouch a sense of themselves in the hierarchical and circumscribed social theater of colonial Boston. Typically displayed in the halls, parlors, and dining rooms of homes decorated with Chippendale-style furniture, Rococo tea sets, and other objects selected for the purpose of self-articulation, Copley's portraits became centerpieces in the stagecraft of the eighteenth-century persona.[3]

Copley's pictures were authenticating narratives. That is, they not only derived from but also helped constitute class in Boston, and to a lesser extent in New York, during the late-colonial period. With that expanded purview in mind, a number of questions will be raised in the pages ahead that all have to do with how a person was measured visually. How did the artist fashion a merchant, a wife, a dowager, a betrothed, a minister, an artisan, a girl? Through what visual codes were character and class read? Why and how were particular objects used in the interpretive program of a visual biography? What, in short, was portraiture's contribution to the production of social identity in the consumer society of late-colonial America?[4]

Detail, Nicholas Boylston (cat. no. 31)

To the discerning eye of John Adams, Nicholas Boylston's home was a dazzling visual domain composed of luxurious material possessions. Though Adams had gone to Boylston's on a late-winter evening in 1766 with the Stamp Act crisis on his mind, his diary entry for that visit only fleetingly refers to the dinner debate that took place over Parliament's right to tax the colonies. Most of the entry instead catalogues Boylston's riches in detail and in animated and explicit language: Turkey carpets, chimney clocks, crimson dyes, marble-top tables, and damask curtains and counterpanes. After admitting to silently tabulating the breathtaking cost of the furniture as he walked from room to room, Adams revealed the linkage between objects and social identity in late-colonial Boston in an astonishing sentence. Here he concluded that such a magnificent setting was not merely appropriate to a rich merchant but surely also was a sign that Boylston was the "noble Man" and the "Prince" whom he thought he encountered that night.[5]

When Copley painted Boylston in 1767 (cat. no. 31; frontispiece, this essay), he, like Adams, represented the person on the basis of things, the quality and dimensions of personhood rising and expanding as the quality and abundance of the objects displayed proliferate. In the picture Boylston's face is largely inscrutable as a bearer of meaning. But everything else is telling.[6] The source of the merchant's livelihood is indicated by the large ship sailing on turbulent seas and by the book marked "LEDGER" that literally buttresses his arm and metaphorically sustains his extravagant habits of living, details that lay concrete claim to elite status. Boylston's refined tastes and extraordinary wealth are declared by his banyan made of expensive English silk damask and by his turban, both of which would be worn when the sitter was at leisure at home. Elegantly posed and lavishly dressed, looking more like a sultan than a businessman, he is not encumbered by the vicissitudes of work. Yet the material benefits of his business—regal leisure and costly fabrics—are abundantly displayed in this presentation of the

achieved self. Boylston is meant to be judged on the basis of these elements. Viewers' eyes are to caress the silks and weigh the ledgers; they are to notice the right arm opening the banyan to show a magnificent vest that is unbuttoned for the gratuitous display of even more expensive fabric underneath. These things are the inanimate markers that are supposed to reflect well on the "essential person."

Copley and Adams were not alone among eighteenth-century Americans in equating luxury goods with character and social status.[7] For everyone understood that the path to high enfranchisement in pre-Revolutionary Boston was studded with emblematic expressions of being.[8] The merchants, and the artisans who served them, everywhere read the visual signs that announced exalted class: Georgian houses, export ceramics, silk fabrics, Chippendale furniture, chased silver, flower and fruit gardens, polite behavior, ample food, and even body fat. This was a face-to-face society that monitored things. It loved objects and facts and numbers and money. And with a quarter of a patrician's income spent on items handcrafted for one's home or one's back or one's portrait, material goods and the display of those goods became the outward signs of the quest for prestige and power. This practice of equating things and people exemplifies what anthropologists and consumer historians call the power of goods to transform the self.

Who a person was—or seemed to be—was a matter of reading what that person possessed. Objects in Copley's portraits thus were not emblems in the traditional iconographic sense of the word, for their interpretation was not strictly codified or explicitly determined in written texts, such as books of emblemata.[9] Instead, they were props fashioned by the artist into images that fulfilled the desire of elite clients who wanted to assert their position and social identity in materially potent ways that were visible to eighteenth-century viewers. Gentlemen and gentlewomen needed signs that collectively were the index of the social self: social graces, eating skills, proper carriage, body control, knowledge of the arts, informed taste in fashion, carved furniture, and powdered wigs. As agents in an interpretive system, the signs Copley presented were not merely bystanders in a picture, for these things had the cultural power to personify, to endow a sitter with the social, civic, or personal attributes he or she sought. And all forms of visual display in eighteenth-century British North America, from pictures to teapots, were bearers of identity and class definition.[10]

With a few notable exceptions that are discussed below, it is not known whether Copley's sitters owned the clothing, dogs, fruits, jewels, fountains, flowers, vases, and columns

Fig. 37 Detail, *Miles Sherbrook* (cat. no. 72)

Fig. 38 Detail, *Nathaniel Allen*, 1763. Oil on canvas, 50 x 40 in. (127 x 101.6 cm). Honolulu Academy of the Arts, Frank C. Atherton Memorial Fund Purchase, 1976 4376.1

Fig. 39 Detail, *James Allen*, 1768–70. Oil on canvas, 30⅛ x 25 in. (76.5 x 63.5 cm). Massachusetts Historical Society, Boston, Gift of Mrs. Susan Allen, widow of James Allen, Esq., 1836

Fig. 40 Detail, *Epes Sargent* (cat. no. 11)

with which they are shown in their portraits. Knowledge of such facts of ownership might be revealing insofar as it would indicate the degree of a painting's deviation from reality and thus the degree of its fictionality. But this knowledge or the lack thereof has no bearing on an essential assumption about Copley's portraiture: namely, that his pictures are not and ought not be construed as visual probate records.[11] Instead, the objects in the portraits, owned by the sitters or not, should be understood as metonymic, in the sense that they are sites into which character and class have been displaced. They are the rhetoric—not the record—of self-representation in eighteenth-century America.[12]

To be effective in a materialist culture—to acquire a social voice—those objects had to be taxonomic as well as metonymic. That is, they had to be classifiable and legible,

both individually and collectively, for interpretive reckoning by eighteenth-century viewers. A study of a few classes of objects should indicate how they operated in an interpretive system that was the result of collaboration between Copley, his sitters, and contemporary viewers.

The object most visible in Copley's emblematic language is the body itself, for its condition and control reflected the status of gentlemen and gentlewomen.[13] Copley frequently focused on distinctive markings as attributes that served to individualize a person. He did nothing, for example, to hide physical anomalies, such as the smallpox scars on Miles Sherbrook's face (fig. 37; cat. no. 72), the hairy wen on Nathaniel Allen's cheek (fig. 38), the bend in Henry Pelham's earlobe (cat. no. 25), the scar on Thomas Mifflin's forehead (cat. no. 80), the moles on the faces of Elizabeth Lewis

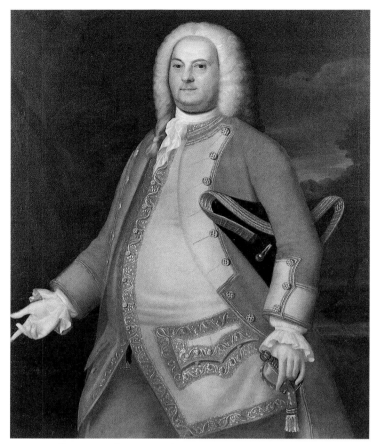

Fig. 41 *William Brattle*, 1756. Oil on canvas, 49½ x 39¾ in. (125.7 x 101 cm). Harvard University Art Museums, Cambridge, Massachusetts, Gift in part—Mrs. Thomas Brattle Gannett. Purchase in part through funds from Robert T. Gannett, an anonymous donor and the Alpheus Hyatt Fund 1978.606

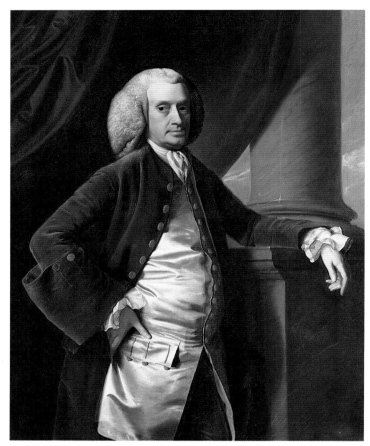

Fig. 42 *John Gray*, 1766. Oil on canvas, 49½ x 39⅜ in. (125.6 x 99.9 cm). Detroit Institute of Arts, Founders Society Purchase, Gibbs-Williams Fund 43.30

Goldthwait (cat. no. 60) and James Allen (fig. 39), the fleshiness behind Myles Cooper's ear (cat. no. 47), or the swollen tissue of Epes Sargent's old right hand (fig. 40; cat. no. 11). On the contrary, he made a spectacle of these features by centralizing them in compositions and placing them in bright, descriptive light.[14] "Warts and Moles," as John Dryden wrote in his introduction to Copley's edition of Charles-Alphonse Dufresnoy's *De Arte Graphica*, were capable of "adding a Likeness to the Face" and were "not therefore to be omitted."[15] Marks on the body had the power to endow pictures with the stamp of authenticity. William Carson of Newport pointed this out to Copley in 1772 upon seeing the artist's portrait of his wife: "I discover new beautys every day, and what was considered as blemishes, now, raises the most exalted Ideas of the perfection of the Painter 'and painting to the life.'. . . Strange objects strongly strike the senses, and violent passions affect the mind."[16]

In a similar way, fat was a marker of individuality and struck the senses strongly in many of Copley's portraits of wealthy men, but it was also a class marker. The vast stomachs of William Brattle (fig. 41), Moses Gill (cat. no. 18), Thomas Hollis (fig. 2), Jeremiah Lee, and Robert Hooper (cat. nos. 52, 40), to name a few of Copley's overweight subjects, proudly strain against waistcoats and overload narrow shoulders and diminutive legs. Copley often opened overcoats and latched hands, like Gill's, onto broad hips in order to amplify the appearance of corpulence. Fat, on these pictorial occasions, is the leitmotif of a composition that expands outward from the volume of a stomach, its curvature articulated and exaggerated by ripples of shining satin fabric cinched together by waistcoat buttons. On some of these occasions, in portraits of Nathaniel Sparhawk (cat. no. 19) and John Gray (fig. 42), for example, pentimenti indicate that Copley may have inflated a belly artificially in what amounts to a pictorial equivalent of the prosthetic stomach pads and calf pads that were sometimes used to reshape the anatomies of English and American gentlemen.

Fat in these portraits would have been read in the eighteenth century as salutary. It was perceived as protecting the body from injury, preserving the muscles, and filling inter-

stices of the torso in such a way as to give shape, symmetry, and beauty.[17] Moreover, it was a sign of wealth, for only the well-to-do had sufficient and rich enough food to produce fat.[18] A laborer's meals centered on bread, but the diet of prosperous merchants and landowners was more varied, including meats and sugar, and more abundant. Indeed, in the decades before the Revolution, as American elites became less provincial and more anglicized, they indulged in great dinners in the English style and constituted the largest market in the world for imported English foods.[19]

Because the conduct, as well as the condition, of the pictured body was the site for the inscription and enactment of values of status, in painting the elite Copley's job was to present men and women comporting themselves in a visually elegant manner that spoke like an official biography of their refinement and high moral character.[20] Increasingly in the middle decades of the eighteenth century, appropriate comportment for colonial elites meant behaving as they thought English aristocrats behaved. And so Copley's figures for the most part reflect idealized contemporary codes of conduct, despite the notoriously angular legs and awkward hips that are the products of an artist who was an autodidact. Guided by polite society's almost theatrical art of bodily demeanor, Copley chose to depict his sitters as moderate and pleasing by presenting their bodies in a controlled, graceful, and composed way, radiating ease and serenity, and avoiding what one etiquette master called "odd motions, strange postures, and ungenteel carriage":[21] hence Theodore Atkinson Jr.'s easy walk, the Royall sisters' relaxed arms and hands (cat. nos. 8, 10), Epes Sargent's and Thaddeus Burr's graceful leaning postures (cat. no. 11; fig. 43), Nathaniel Hurd's self-contained outline, and Mary Charnock Devereux's serene, contemplative repose (cat. nos. 21, 59). Few of Copley's figures sit or stand "bolt upright," at one extreme, or "too negligent and easy," at the other, for the true eighteenth-century man of fashion "makes himself easy, and appears so, by leaning gracefully, instead of lolling supinely."[22]

Copley knew firsthand the codes of polite behavior because he was himself trained by his English-born stepfather, Peter Pelham (1695–1751), who taught classes in manners in Boston. Pelham, in turn, would have been familiar with, and sensitive to, the contemporary English behavioral theory that reached its culmination in Lord Chesterfield's *Letters to His Son*.[23] Pelham, Chesterfield, and other etiquette masters in this period viewed manners as social theater acted out for peers and inferiors. Unconcerned with the moral imperatives that motivated traditional courtesy literature, contemporary writers used manners as a form of

self-fashioning that was a conventionalized fiction of the self calculated to profit the individual more than society. In Copley's visual culture, the body was another agent of social persuasion, another piece of capital equipment to be exploited.

Under Pelham's tutelage, Copley would have learned recent theories not only of bodily carriage but also of facial etiquette. According to the new courtesy literature, the ideal facial expression should be "moderately cheerful" and should affect the whole face, especially the mouth, which should be trained to have a "gentle and silent smile."[24] True to that theory, Copley's sitters as a rule veer neither into melancholy nor gaiety. Instead, their slight smiles, full eyes, and generally placid faces that are devoid of incident project a genteel sense of inner peace, confidence, grace, and moderation.

Remarkably, even in the years immediately before the Revolution, when radical politics were rupturing society in Boston, Copley continued to produce polite and placid images of his sitters' lives. High Tories, men such as Sylvester Gardiner (cat. no. 75), John Newton (fig. 44), and Isaac Winslow (cat. no. 81), remain cheerful and composed in the

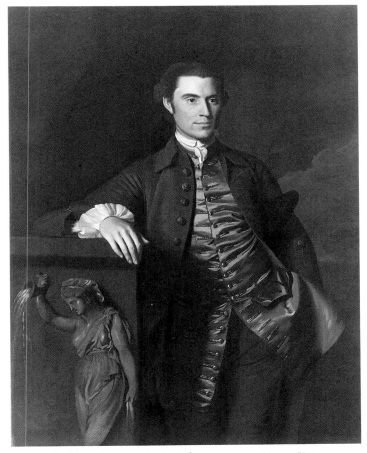

Fig. 43 *Thaddeus Burr*, 1758–60. Oil on canvas, 50⅝ x 39⅞ in. (128.6 x 101.3 cm). St. Louis Art Museum

Fig. 44 *John Newton*, 1772. Oil on canvas, 30¼ x 25¼ in. (76.8 x 64.1 cm). Berkshire Athenaeum, Pittsfield, Massachusetts

pictures Copley painted of them during these years, their carriage and attitudes suggesting, even insisting, that portraiture perpetuate social stability and continuity in a troubled time, when social disruption threatened the lives and livelihoods of Anglo-Americans.

Though Copley's overarching aim with regard to the body and the face was the display of the new ideal of polite deportment, the painter did show a concern with divergent bearing in exceptional portraits. Striking, in light of the flood of polite behavior in Copley's pictures, are the rare sitters who are not graceful, relaxed, and cheerful. One of these is John Bours (cat. no. 56); with his legs attenuated and his thoughts apparently occupied with a passage he has just read in the book in his right hand, he is, according to the conventions of etiquette, too supine, informal, unregulated, and melancholic to seem a gentleman. An American version of Alexander Pope, he is the very image of the sickly poet set appropriately against a turbulent sky.

Copley portrayed other attitudes and details of facial expression that emerge as unconventional when sorted by the codes of polite behavior: the rigid pose of Eleazer Tyng (cat. no. 74), whose body is wound like a clockspring; the grim-

ness of radical politician James Otis (fig. 76); the tight-lipped resolve of the Calvinist minister Edward Holyoke (fig. 45); the parted, conversational lips of Copley's half brother, Henry Pelham (cat. no. 25); the ferocity of lawyer Richard Dana (private collection); the operatic gesture of Henry Marchant (private collection); the studied casualness of Sarah Sargent Allen (fig. 46). Perhaps furthest removed from the standards of conventional gentlemanly deportment is the electrifying Samuel Adams (cat. no. 62), the political crusader whose coiled right and emphatic left hand, both cast in brilliant light, are markers of an angry orator.

The cloth that draped and enfolded the bodies of Copley's sitters, like the bodies themselves, was a potent sign of personhood. When Copley painted the young, wealthy Portsmouth official Theodore Atkinson Jr., he made such a spectacle of the brocaded waistcoat that the garment subsumes the man's slight body and claims the picture. Copley seems deliberately to have pulled Atkinson's arm back and plunged his hand, almost awkwardly, into a pocket, purely for the sake of showcasing the vest's opulent fabric, which might well have cost as much as a Chippendale chest.

Fig. 45 *Edward Holyoke*, 1759–61. Oil on canvas, 50½ x 40½ in. (127.6 x 102.9 cm). Harvard University Portrait Collection, Cambridge, Massachusetts, Given to Harvard College by Mrs. Turner and Mrs. Ward, granddaughters of Edward Holyoke, 1829

Fig. 46 *Mrs. Nathaniel Allen (Sarah Sargent)*, ca. 1763. Oil on canvas, 49½ x 40 in. (124.3 x 106 cm). The Minneapolis Institute of Arts, The William Hood Dunwoody Fund 41.3

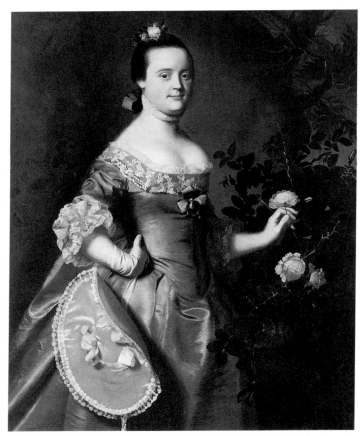

Fig. 47 *Hannah Loring*, 1763. Oil on canvas, 49¾ x 39¼ in. (126.4 x 99.7 cm). Detroit Institute of Arts, Gift of Mrs. Edsel B. Ford in memory of Robert H. Tannahill 70.900

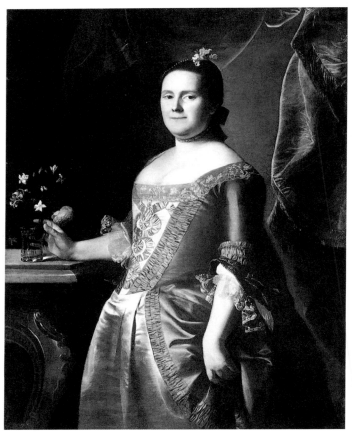

Fig. 48 *Mrs. Benjamin Blackstone (Eleanor Phipps)*, ca. 1763. Oil on canvas, 48⅛ x 37⅛ in. (122.2 x 94.3 cm). Mead Art Museum, Amherst College, Massachusetts, Bequest of Herbert L. Pratt, Class of 1895 1945.13

The year after he portrayed Atkinson, Copley painted Mary and Elizabeth, the daughters of Isaac Royall (cat. no. 10), the extraordinarily successful rum merchant from Medford, enveloping them in luxurious materials. The picture, the largest and most ambitious of the artist's early canvases, is about fabrics as much as faces. Dozens of yards of imported English satins cascade upon them, wrapping their bodies, furniture, and space in what Royall undoubtedly hoped would be read as a pageant of his family's wealth.

Fruits and flowers, as well as fabrics, were active agents in Copley's staged presentations of character and class. Copley sometimes used flowers as simple adornments to the hair or the décolletage of a dress, as in the portrait of Mary Sherburne Bowers (fig. 93). But he more frequently and more prominently featured flowers by representing women engaged in aspects of horticulture. Mercy Otis Warren (cat. no. 15), for example, turns only her head away from a nasturtium that she is tending, and she delicately holds the blossoms of the plant as if urging the viewer to inspect them. Hannah Loring (fig. 47), right arm pridefully akimbo,

similarly solicits the admiration of the audience for the flowers in her charge by holding out the branch of a rosebush. Eleanor Phipps Blackstone (fig. 48) and Elizabeth Oliver Watson (cat. no. 20) do not merely stand beside vases of flowers, they actively push them toward the viewer. In an early masterwork, *The Gore Children* (cat. no. 5), a girl holds a porcelain basket of white jasmine presumably clipped from a garden, while her sister displays one rose. In their portraits Rebecca Boylston, Sarah Sherburne Langdon (cat. nos. 33, 36), and Judith Sargent Stevens (private collection) play the role of mock gardeners, uncorseted in wrapping gowns, carrying freshly cut flowers, either in a fold of fabric or in a wicker gathering basket. And in other portraits Rhoda Cranston (private collection), Anne Fairchild Bowler (fig. 49), and Dorothy Murray (Harvard University, Cambridge, Massachusetts) proudly present garlands and wreaths they have arranged.

Copley also called attention to the horticultural craftsmanship of the women he depicted with fruits. In his portrait of Sarah Erving Waldo (private collection), for example, the

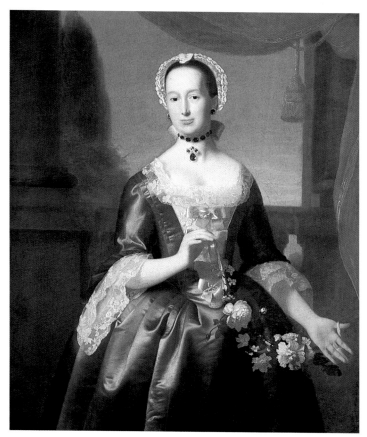

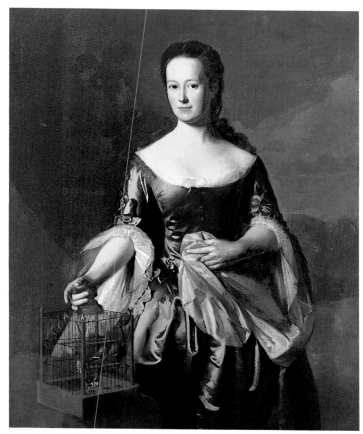

Fig. 49 *Mrs. Metcalf Bowler (Anne Fairchild)*, ca. 1763. Oil on canvas, 50 x 40 in. (127.2 x 102.2 cm). National Gallery of Art, Washington, D. C., Gift of Louise Alida Livingston 1968.1.1

Fig. 50 *Mrs. Metcalf Bowler (Anne Fairchild)*, ca. 1758. Oil on canvas, 50 x 40 in. (127 x 101.6 cm). Colby College Museum of Art, Waterville, Maine

painter arranged a cherry branch so as to display the fruit and leaves but also and more pointedly to show that the stem is cut precisely, suggesting that she has been grafting or experimenting with hybrids.[25] Similarly, the fruit and cut branch that Hannah Fayerweather Winthrop (cat. no. 79) offers the viewer is associated with scientifically managed cultivation: it is from a nectarine, which in the eighteenth century was typically grafted onto peach stock.[26]

It is not known whether all of the women Copley portrayed with flowers and fruits gardened. But certainly Copley himself must have been an accomplished gardener. He had Newton Pippin apples and New York watermelons on his Beacon Hill property and was advised to consult John Hancock next door about acquiring trees for his estate.[27] And certainly some of his sitters had renowned gardens.[28] Thomas and Lydia Hancock, for example, planted their acreage on Beacon Hill with plum, peach, apricot, nectarine, pear, mulberry, cherry, and gooseberry trees imported from England and available in Boston shops that boasted of "hundreds of grafted and inoculated English fruit trees."[29] Moses

and Rebecca Boylston Gill, the latter painted by Copley with majestic potted lilies (cat. no. 34), laid out elaborate gardens on their estate.[30] Anne Fairchild Bowler, whose portrait includes freely interpreted blossoms that may be roses, jasmine, buttercups, narcissus, carnations, or peonies, and her husband kept eleven acres of gardens and greenhouses of exotic plants in Portsmouth, New Hampshire.[31]

Whenever cultivated flowers and fruits were shown in a portrait, they were meant to be understood as the product of a woman's discipline, science, handiwork, and thus character. Women did not merely grow flowers, they reared them, much as they did children, or as they themselves had been raised.[32] Such a linkage between gardening and moral education grew out of the writings of John Locke, who claimed that fine character is nurtured, not innate.[33] A child, in his sensationalist theory, comes into the world a tabula rasa that, like a plant, is cultivated into an adult. "Moral Seeds," wrote Richard Steele, a follower of Locke's, "produce the novel Fruits which must be expected from them, by . . . an artful management of our tender Inclinations and first

Spring of Life."[34] In his pictures Copley portrayed women in terms of a Lockean analogy, defined with and by plants, nameable by genus and species, and cultivated or grafted according to horticultural science. The plants, like their gardeners, were elite species, and, as gems of the colonial garden, they were metaphors for their owners, who understood the ties between the social order and natural law.[35] Gardens, and the cultivated flowers they produced, were analogous to civilization and the superior character it nurtured.

Copley used flowers and fruits as gendered objects that express feminine accomplishment, virtue, and class distinction. He displayed masculine prowess with a different set of gendered objects: business ledgers, transatlantic ships, and quill pens. Animals, however, were the province of both men and women, though a particular species of animal was often assigned to one sex or the other. For example, birds usually accompany women sitters. They are exotic, typically parrots and hummingbirds, which trumpeted class privilege because they were imported from the Caribbean and Latin America.

Almost invariably Copley showed birds in transaction with women, the objective being the display of the sitter's, not the bird's, skill.[36] For example, Anne Fairchild Bowler actively and proudly brings a caged bird to the viewer's attention (fig. 50). Eunice Dennie Burr (St. Louis Art Museum) points to a parrot she has trained to sit uncaged on a tree branch. An anonymous young lady (cat. no. 38) is captivated by the parrot she has taught to perch on a ribbon. Most audacious among the demonstrations of female skill of this sort are the portraits in which birds have alighted on their mistresses' hands: Elizabeth Ross (fig. 51) has a white dove that balances itself on her finger by raising its wings, and Mary Boylston Hallowell (fig. 52) is fearless as a large rock dove perches on her bare hand.

The trained bird, like the cultivated flowers and fruits in Copley's pictures, reflected, by means of a Lockean analogy, on the semblance of the essential woman. Though Locke was not widely read in midcentury America, his theory penetrated the behavioral pedagogy of the colonies. For instance,

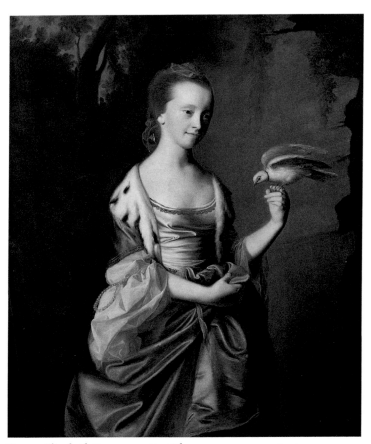

Fig. 51 *Elizabeth Ross*, ca. 1767. Oil on canvas, 50 x 40 in. (127 x 101.6 cm). Museum of Fine Arts, Boston, M. and M. Karolik Collection of Eighteenth Century American Arts 39.248

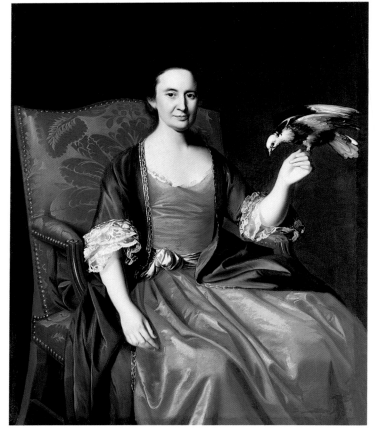

Fig. 52 *Mrs. Benjamin Hallowell (Mary Boylston)*, ca. 1766–67. Oil on canvas, 47 x 37½ in. (119.4 x 95.3 cm). Detroit Institute of Arts, Founders Society Purchase, Gibbs-Williams Fund, Dexter M. Ferry, Jr., Fund, Robert H. Tannahill Foundation Fund, and Beatrice W. Rogers Bequest Fund 71.168

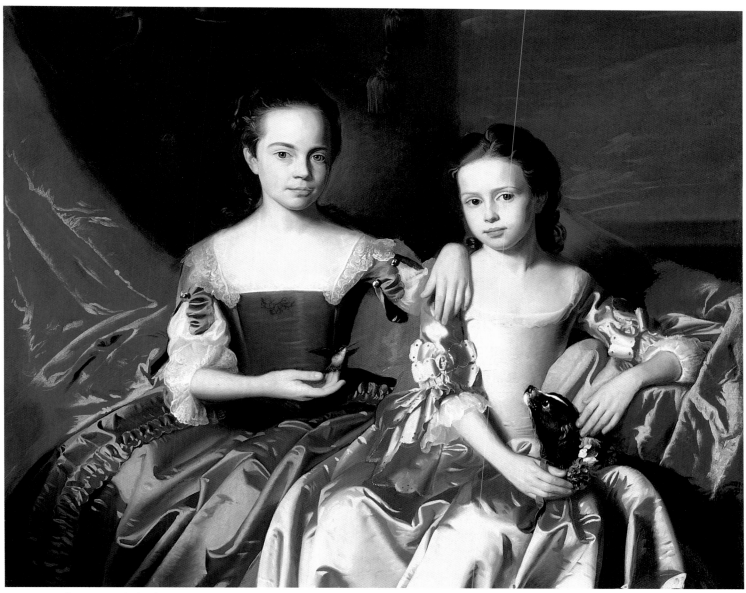

Fig. 53 Detail, *Mary and Elizabeth Royall* (cat. no. 10)

polite girls and young ladies in America were encouraged as part of their education to train birds. Writing in 1777 in *The Young Ladies School of Arts*, Hannah Robertson recommended a number of activities that would improve character. She offered detailed instructions on how to make gum flowers that imitate "roses, tulips, anemonies, ranuculas, plainthos, daisies, auriculas" and on how to clean shells from India and the Red Sea and arrange them into decorative grottoes. She also gave instructions on the keeping and care of tamed birds, detailing how young Americans could breed, cage, nest, and feed canaries and even how they might wean chicks away from a mother hen.[37] Copley's Mary MacIntosh Royall (fig. 53; cat. no. 10) clearly was one of the young girls of the era who was trained according to a Lockean method

like Robertson's. The viewer observing Miss Royall calmly balance a quivering ruby-throated hummingbird on a fingertip is meant to understand that exceptional stunt as a sign of the young lady's exceptional character. Even though Mary may never have conducted such an impressive trick, in the fictional spaces of Copley's picture the bird serves to lay claim to the sitter's moral accomplishment.[38]

Dogs also figured in Copley's vocabulary of Lockean tropes on the character of women. All of the dogs he depicted are house pets that are objects of affection, rather than laboring or sporting animals: for instance, the dog that nestles in Mary Sherburne Bowers's lap, the one that wears a floral necklace and admires Elizabeth Royall, and the inquisitive creature that watches an anonymous young lady

(cat. no. 38). The dogs in these three portraits are all King Charles spaniels, which were exported to America and considered symbols of high status.[39] In England spaniels and also hounds and greyhounds were breeds whose ownership was restricted by law to the aristocracy. Though that law did not apply to America, in the colonies the King Charles spaniel was nonetheless associated with the English court and the seventeenth-century Cavalier rulers, Charles I and Charles II. Ironically, these kings had epitomized profligacy and unseemly luxury for the original American Puritans, but in the 1760s the nonutilitarian dog named for the second Charles was a potent emblem for elite American women who sought ways to declare their privileged and leisured status through images that spoke of pampering and training animals.[40]

As spaniels were the province of upper-class girls and women, squirrels were the sport of privileged children, usually boys. "Boys frequently nurse this beautiful and active animal," stated an eighteenth-century encyclopedia.[41] Unlike dogs, they were not born and bred as fully domesticated house pets but instead were wild animals brought into a civilized state through training, which again, following Lockean pedagogy, in turn improved the trainer. In Copley's portraits all the squirrels, like their masters, have been civilized. Yet the rodents are nevertheless held in check with training collars and chains. Frances Deering Atkinson (fig. 163) and Henry Pelham (cat. no. 25), for example, loosely hold chains to "easily trained"[42] flying squirrels that nibble on the meat of nuts, the shells of which litter polished tables. More spectacular are the squirrels in the portraits of Daniel Verplanck (cat. no. 68) and John Bee Holmes (fig. 55). Each animal, performing for the viewer by holding onto its master's leg or hand, apparently without inflicting pain, serves to demonstrate each boy's moral attainment.

The chains attached to pet squirrels were themselves tropes applied to childhood. In 1784 Benjamin Franklin wrote a parodic epitaph on the squirrel Mungo, who led a luxurious life and was fed daily "the choicest viands by the fair hands of an indulgent mistress." But in his quest for more freedom, the squirrel wandered away, only to be met by "the merciless fangs of wanton cruel Ranger," a dog. Franklin ended his tongue-in-cheek story with a parable that sheds some light on the broad meaning of Copley's chained squirrels. "Who blindly seek more liberty," Franklin wrote, "whether subjects, sons, squirrels or daughters, that apparent restraint is real liberty, yielding peace and plenty with security."[43] Both Franklin and Copley, writing and painting in the tradition of Locke, understood the powerful

Fig. 54 Detail, *Boy with a Squirrel (Henry Pelham)* (cat. no. 25)

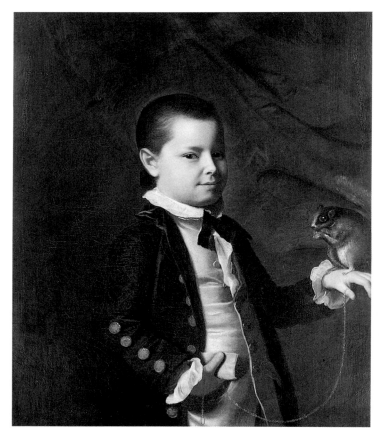

Fig. 55 *John Bee Holmes*, 1765. Oil on canvas, 29½ x 24½ in. (74.9 x 62.2 cm). Private collection

linkage in America between the methods of training animals and the moral development of children. Restrained yet free, like their squirrels, Henry Pelham, Daniel Verplanck, and John Bee Holmes have faces that radiate the peace that is the reward of the new Enlightenment belief in the nurturing and protection of youth.

The squirrels, dogs, fruits, flowers, and fabrics in Copley's portraits all could have been owned by his sitters. Though it cannot be documented that Daniel Verplanck had a pet squirrel or that Rebecca Boylston tended her flowers, it is known that squirrels and flowers were found in the homes of the elite in Boston, New York, and other cities and towns before the Revolution. But sometimes in picturing a person Copley created a situation that was overtly fictional by using props that could not have been owned by his subject. In these works fictional objects set a theatrical stage for a sitter's role-playing. In his eight-foot portrait of Nathaniel Sparhawk (fig. 56; cat. no. 19), for example, Copley configured this justice of the Inferior Court of Common Pleas in a superior pose set against uncommon architecture.[44] A merchant from Kittery, Maine, Sparhawk had experienced mixed fortunes despite his marriage into the wealthy Pepperrell family in 1742. At one point, in 1758, he had to put up his property for auction, the colonial equivalent of bankruptcy. However, the following year he was rescued by the death of his father-in-law, William Pepperrell, an English peer, who left his fortune not to Sparhawk but to Sparhawk's wife and their son.

Nonetheless, Copley's grand portrait commemorates Sparhawk's ascendancy to the apex of the class structure, social position, and wealth. Its extraordinary scale and size must reflect a conscious effort on the part of Copley and Sparhawk to challenge—and surpass—John Smibert's monumental painting of Sir William Pepperrell (fig. 180), one of five portraits of the heroes of the siege of Louisburg, which took place during King George's War of 1740 to 1748.[45] In fact, a total of three of the great Louisburg portraits, originally commissioned from John Smibert and Robert Feke to be placed in civic spaces, were hanging in Sir William's house in Kittery when he died and therefore would have been familiar to Sparhawk.

Compared to those pictures, which glorify civic disinterestedness and military acumen, Copley's *Nathaniel Sparhawk* is purely self-congratulatory. It exalts only the class ambitions of the sitter, to the degree that some passages veer into the preposterous. Dressed in expensive silk velvet and arranged in a pose based on an English mezzotint by James McArdell, Sparhawk leans against the plinth of a

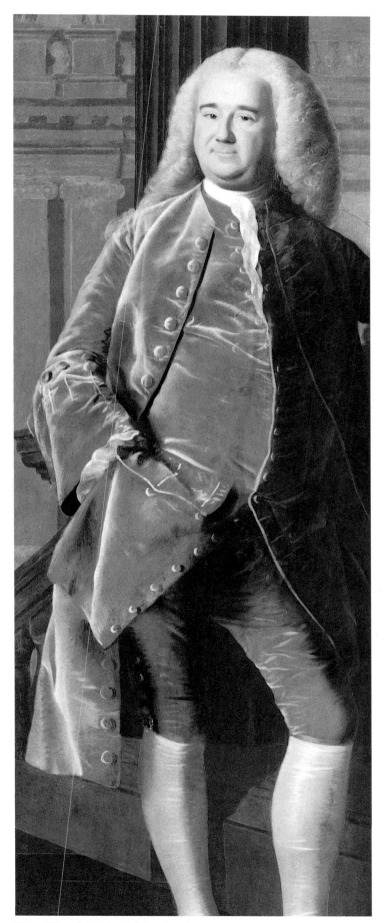

Fig. 56 Detail, *Nathaniel Sparhawk* (cat. no. 19)

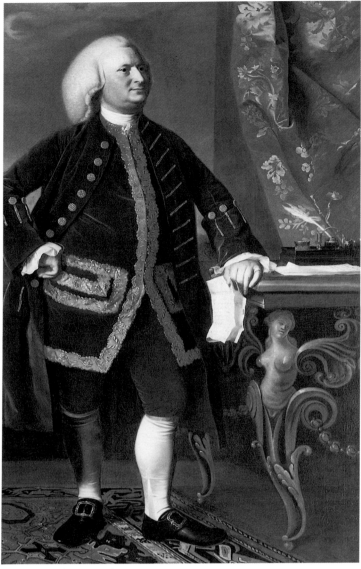

Fig. 57 Detail, *Jeremiah Lee* (cat. no. 52)

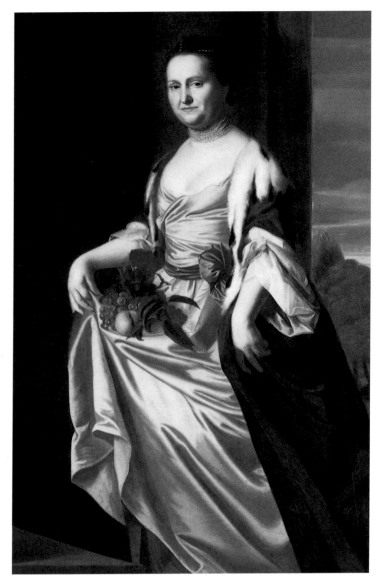

Fig. 58 Detail, *Mrs. Jeremiah Lee (Martha Swett)* (cat. no. 53)

colossal fluted column unknown in America.[46] Pentimenti show that the buttons of his waistcoat were moved to the right in order to inflate the curve of his stomach, converting a skinny man into the preferred image of a fat squire who has the taste, in mimicry of the English, as well as the means and the appetite to eat like a king. In his left hand he holds an architectural drawing for some grand building that cannot be identified.[47] And, most audaciously, he stands before a stunning classical arcade far more reminiscent of sixteenth-century Italy than eighteenth-century Maine.[48] It is the implausibility of Sparhawk's pictorial circumstances that speaks to his real desire to be perceived as a gentleman in the manner of his aristocratic father-in-law, Sir William.

Copley invented an even more regal format for his eight-foot portrait of Jeremiah Lee (fig. 57; cat. no. 52), the wealthy grandee of Marblehead, in which the pose of the sitter and

the composition are both patterned on English mezzotints.[49] There is nothing extraordinary about that imitative procedure, for Copley often resorted to it and must have had a stock of British mezzotints that both artist and client consulted in the early stages of shaping portrait images. What makes the portrait of Lee so fanciful is the marble-slab-top pier table with which he is pictured and which may be based on a table in a mezzotint by John Faber Jr. after John Vanderbank's portrait of Queen Caroline or, more likely, is a composite of the many Rococo pier tables that appear in Batty Langley's pattern book of 1740, *The City and Country Builder's and Workman's Treasury of Designs*.[50]

The gilt pier table is distinguished from, say, the Axminster carpet on which Lee stands by its implausibility, for such tables were unknown in eighteenth-century America. Lee could have owned that carpet or ones like it, since Axmin-

sters were common in the colonies. But the pier table is baldly fictional and must have been meant to be read as such. Demonstrably it was not an object owned by the sitter; a visitor to the Lee mansion would not have been able to find such a table anywhere in the house[51] or in any other colonial house. The fictive pier table exists in the picture because it was used exclusively by the European elite and therefore had the power to insinuate Lee's wealth and class visually.

This monumental canvas was but one element in the stagecraft of Lee's house, in the public spaces of which real and simulated materials were mixed. Lee's imposing mansion in Marblehead, completed a year before the portrait was painted, was built of wood that was cut to masquerade as stonemasonry. His dining table and chairs were based on designs published by Thomas Chippendale in *The Gentleman and Cabinet-Maker's Director* of 1754, and the breastplate over his chimney was patterned on plates LI and LIII in Abraham Swan's *British Architect* of 1745.[52] Though Lee would seem to have had no need for prosthetic riches, he nonetheless must have had enough anxiety about how he was perceived to hire craftsmen such as Copley to enhance the circumstances of his already extravagant life.

Whereas Copley converted Jeremiah Lee into a Marblehead prince, he confected Mrs. Lee (fig. 58; cat. no. 53), carrying a harvest of grapes and peaches in the folds of her gown, as an American incarnation of a mythological Pomona or Flora.[53] Placed against classical architecture set in an ideal landscape and ascending worn stone steps, she is far removed from her native Marblehead. Instead of wearing the rigidly corseted dress that in real life would have girded her body, she is unbound, like a goddess. Her caftan, a product of the eighteenth-century Turkish occupation of Greece that represents the incorrect English idea of ancient dress, might displace her culturally, were it not for her ermine-trimmed wrap and the pearls terracing her hair and tiering her neck, which betray her as a clearly modern woman playing an exotic role.

Copley used the same trope in his stunning portrait of Margaret Kemble Gage (fig. 59; cat. no. 67), wife of Thomas Gage, who was commander in chief of the British army in North America. Uncorseted and wrapped in a brilliant red taffeta caftan, she is composed, even more explicitly than Mrs. Lee, as an exotic Turkish woman.[54] Copley embellished the Oriental metaphor by adding to the costume a silk hair scarf that looks like a turban and a blue belt that is cinched high and embroidered in a floral design. Moreover, along the same Orientalizing line, he constructed a languid sexuality for his sitter, manifested in her dreamy eyes and in her

glossy brown hair that escapes the loosely fitted scarf and cascades sensually over her shoulder and chest. It is a sexuality situated in the gesture of the left hand that holds the dress and presses up against her thigh; in the sinuous curves of the camelback sofa, itself a furniture form from west Asia; and in a lolling pose so relaxed and expressive of idleness and self-indulgence as to challenge contemporary codes of polite bodily conduct.

Like its closest English counterpart, George Willison's painting of the renowned mistress Nancy Parsons (fig. 208), Copley's portrait of Mrs. Gage calls up the notion of the courtesan.[55] Yet it is clear that the pictured persona of the harem woman has nothing to do with Mrs. Gage's normal conduct or dress: her turban is lightly attached, as if a studio accessory; a proper eighteenth-century chemise peeks through the openings of the caftan; and a fine, brass-tacked American sofa of circa 1770 frames her performance. Mrs. Gage plays her role lightly.[56] Like the character Charlotte in George Colman's play of 1776, *Man and Wife*, she might, in anticipation of her performance in a costume party, be prepared to slip "on [her] dress, which is a blue Turkish habit, directly after dinner, and in that . . . shall expect you about seven o'clock."[57]

It was understandable that Mrs. Gage might wish to be portrayed in *turquerie*, for that was the thing to do in England. In English elite culture going Turkish had been and

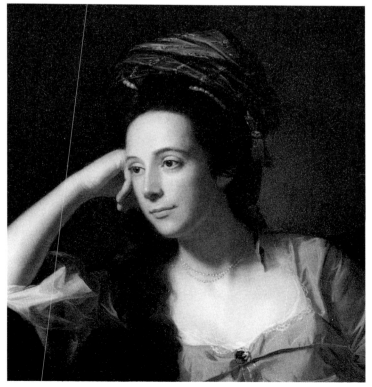

Fig. 59 Detail, *Mrs. Thomas Gage (Margaret Kemble)* (cat. no. 67)

was a custom best exemplified by the portraits of and writings by Lady Mary Wortley Montagu, who occasionally played the role of an Oriental woman in public.[58] It was also popular to act out Turkishness in the context of another English elite custom, the masquerade, at which the harem woman was a popular disguise because, of all the identities that a woman could assume, it offered the most exotic and erotically liberating possibilities.

But in America actually assuming Turkish dress and taking part in masquerades would have been daring if not impossible.[59] Margaret Kemble Gage could not walk the streets of New York with such bodily or sartorial abandon, nor could she entertain at home that way. Nor could she attend the sexually liberating masquerades that were available to her contemporaries in England.

Nonetheless, she was an elite Englishwoman by marriage and continued to think of herself as such. And that is where Copley entered. His project was to construct for her an imagined self, a desired role, a public face that American social practice could not condone but that representational practice could. In the fictive spaces of Copley's portrait, a faux sultana could participate, if only two-dimensionally, in the intoxicating English vogue for masquerading, dressing up, and role-playing.

At stake in the portrait was one of Mrs. Gage's social identities. Here Copley fashioned for her an image meant to gain purchase not only with the guest in her home but also, however tacitly, with the sitter herself and, undoubtedly, with the society in which she was situated. This image was the tool Margaret Kemble Gage used to connect with a social group from which she was distanced. It made the portrait a material artifact that could generate a social discourse that otherwise did not exist for her. It was one of the masks she wore in the dramaturgy of social life.

Instead of playing the part of a Turkish woman like Mrs. Gage, Hannah Hill Quincy was Peter Paul Rubens's wife in the portrait Copley most likely painted at the time of her marriage in 1761 to Samuel Quincy, a lawyer (cat. no. 12). Copley based Mrs. Quincy's pose and costume on a portrait by Rubens of his wife, Helena Fourment (fig. 170). Copley's contrivance of a Flemish fantasy for Mrs. Quincy may have been motivated in part by his search for formal schema among mezzotints—the Rubens portrait had been engraved often by the time Copley painted her, most recently in 1746 by McArdell.[60]

But the use of the sensual Flemish portrait type represents more than an episode in Copley's quest for artistic form. It was the fashion among the English elite of the mid-

eighteenth century to have women portrayed in the Flemish style of the seventeenth century. Thomas Hudson, Allan Ramsay, and Arthur Devis were a few of the many artists who regularly depicted women as Rubens's wife. Moreover, dressing and behaving as Rubens's wife was a frequent practice at masquerades. Typically, "the Rubens' wives, the Mary of Medicis . . . les Filles de Patmos. . . . shone conspicuous" at one fete in 1768.[61] Mrs. Quincy, with her plain, almost homely features, never had to worry about being too closely identified with the wry sexuality of Rubens's subject; she could, however, be gratified that she was represented à la mode, for the image that Copley constructed of her is not so much an allusion to a painting by Rubens as it is a reference to the social habits, milieu, and disguises of fashionable Englishwomen of the eighteenth century.

Clearly Copley's painted props contribute to an extraordinary degree to the visual identity of Mrs. Quincy, Mrs. Gage, the Lees, Sparhawk, the Boylstons, and the other sitters discussed so far; yet they are equally remarkable for erasing dimensions of character. In his portraits of men, for example, objects are not, for the most part, signs of professional title (Paul Revere [cat. no. 46] is an obvious exception). That is not to say that Boylston's merchant business is not adequately expressed by his ledgers and transatlantic ship, or that Martin Howard's status as a judge is not evident in his legal robes (fig. 60), or that the Reverend Thomas Cary's possession of a divinity degree is not apparent in his collar and books (cat. no. 65). These are obviously portraits of a merchant, a lawyer, and a minister but not portraits of trade, law, and religion. What the sitter did in life, while it is an important individualizing factor, hardly ever becomes a universalized value on its own in Copley's pictures.

Though the professional identity of Copley's sitters is incidentalized, their consumer identity and corresponding socioeconomic status are fully present, for it is the consumer object that tends to take precedence over the vocational object in the portraits. For example, in portraits of Thaddeus Burr, Mrs. Gage, Howard, Sparhawk, Boylston, and the Lees, the lavishness of the material goods becomes the very essence of the picture. The quantity, shine, and texture of luxurious fabrics are fundamental agents for Copley in his strategic interpretation of a sitter. As a result, a portrait by Copley tends to represent a class position via consumer objects while rarely declaring boldly the sitter's office within that class.

It is clear that in each of his paintings Copley could have said more about an individual's character or professional merits. Imagine how different Boylston would be if he were

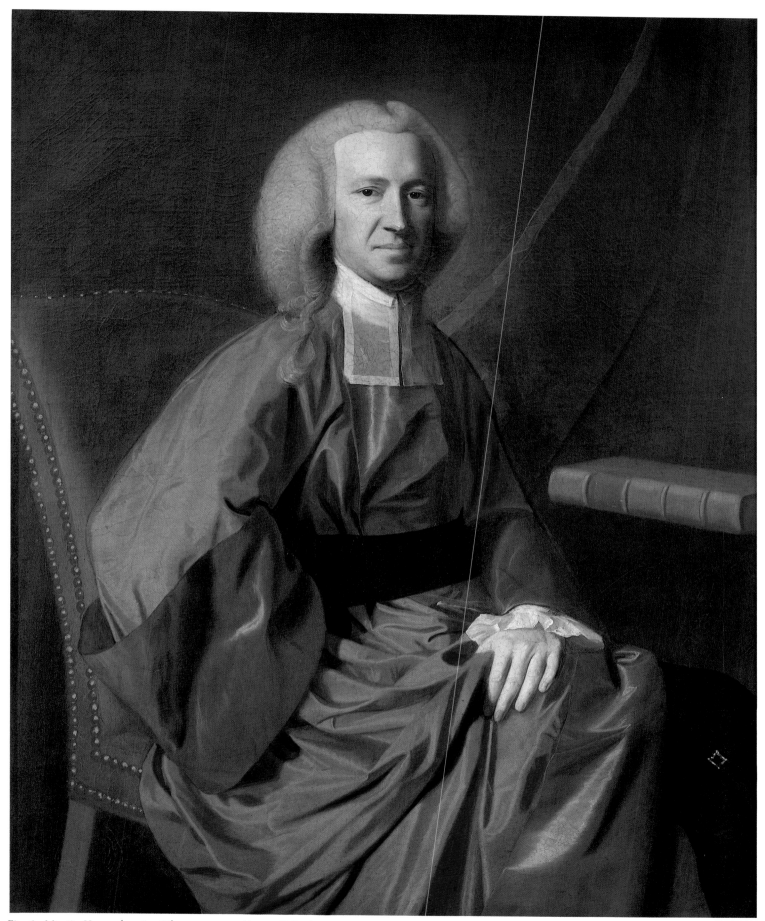

Fig. 60 *Martin Howard*, 1767. Oil on canvas, 40½ x 39¾ in. (125.7 x 101 cm). Museo Thyssen-Bornemisza, Madrid

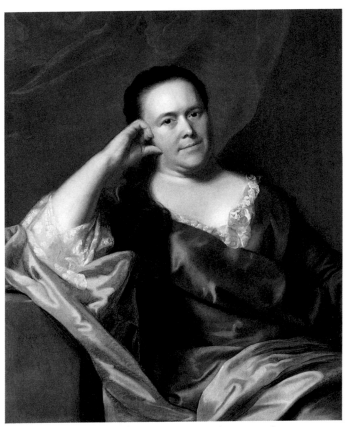

Fig. 61 *Mrs. John Scollay (Mercy Greenleaf)*, 1763. Oil on canvas, 35 ¼ x 28 in. (89.5 x 71.1 cm). Private collection

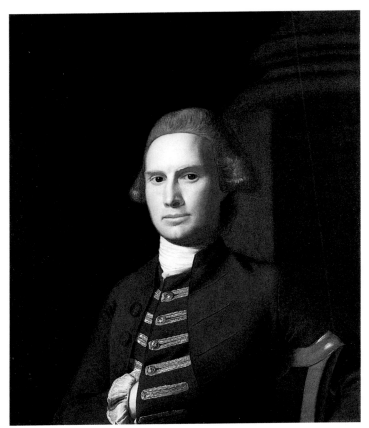

Fig. 62 *Jabez Bowen*, ca. 1771–74. Oil on canvas, 29 ⅞ x 24 ⅞ in. (75.9 x 63.2 cm). Private collection

painted together with his mother, Mrs. Thomas Boylston, Howard if studying law books, or Mrs. Gage if shown as a mother with pictures of her family prominent on a rear wall. Such depictions would require enhancement with objects, but they would be objects outside the arena of consumer goods.

There are, of course, significant exceptions to the rule that Copley usually concentrated on things and the consequent consumer identity they suggest. Many of his most compelling portraits—those of James Allen, James Richards, Thomas Amory II (cat. no. 63), and Mrs. John Scollay (fig. 61), for example—are unadorned. The absence of embellishing objects in some paintings may have been merely a matter of economics. Copley did little to ornament his ministers, military officers, and middle-class officials, small merchants, and lawyers, and their wives—men such as the Reverend Myles Cooper (cat. no. 47) or Jabez Bowen (fig. 62)—who, it seems, could afford no more than simple likenesses on a modest scale (as a rule 30 x 25 inches) or in miniature.

In other portraits plainness surely was adopted in support of a form of role-playing, the denial of ostentation being as

telling as its opposite. Copley's portrait of Eleazer Tyng (cat. no. 74), for instance, is brutally unadorned. Yet the sitter was a wealthy landowner who had inherited his family's seventeenth-century estate on the Merrimac River. Why would he not engage in the lavish anthropological display that was the pictorial convention of his class? Probably because Tyng, who was Puritan and eighty-two years old at the time the portrait was painted, came from an older, more modest, less flamboyant, less anglicized culture than the Boylstons, Lees, and Gages.

Moreover, Copley and Tyng seem to have declared plainness a virtue, for the astringency of the sitter and his accoutrements contradicts the values that inform, say, Copley's portrait of Jeremiah Lee. This is an astringency evident in the green Windsor chair on which Tyng is posed, a simple country piece far removed from the Rococo furniture in high English style in Copley's more lavish pictures. Tyng's suit, too, is simple, made of homely wool broadcloth, not silk or velvet. His stockings are black, instead of the more fashionable white. His full white shirtsleeves are those of a loose-fitting worker's smock, similar to the one worn by Paul Revere in his portrait. And, to complete the image of

a workingman from a simpler time, there is dirt under his fingernails.

Copley's project in his portrait of John Hancock (fig. 63; cat. no. 22) carried the act of simplification into the realm of politics. The written accounts of Hancock's life tell a consistent story: he was among the most fashionable, socially flamboyant, and politically ambitious figures in pre-Revolutionary Boston. In the year Copley painted his portrait, Hancock inherited his uncle Thomas's fortune, his mansion on Beacon Hill (fig. 20), and the House of Hancock, the largest trading firm in the port city.[62] In Boston Hancock was conspicuous for wearing lavender suits, driving in a bright yellow carriage, and exercising an extravagantly expensive taste for English goods.[63]

Yet Copley's Hancock is an ascetic man. He wears a stylish but simple dark blue wool frock coat, the plainness and practicality of which sharply contrast with the opulence and frivolity of the brightly colored velvet garments that he favored. He sits on an outdated Queen Anne chair of about 1740. His environment is devoid of any markers that might reveal him as a leisured person—he is not at home, surrounded by the luxurious things that he admired and owned. Most startling, given Hancock's reputation for ignoring the financial details of his uncle's sprawling business, he is portrayed tending the account books, holding a quill pen, with an inkstand nearby, ready to make entries in his ledger or just finished with the task (fig. 64).

In the context of a culture that viewed luxury objects as signs of elite class, Hancock's portrait would seem to deny his true status in the community. The open ledger that is filled with entries represents a numerical itemization of his mercantile activity. But otherwise the picture says little about his status, almost every material index of his social position having been omitted. Compared to his ultrarich merchant peers, such as Nicholas Boylston (cat. no. 31; frontispiece, this essay), who are presented as princes in their sumptuous portraits by Copley, Hancock looks like a minor trader, a small-business man who tends his own books and is proud to be shown as such.

What would have motivated Copley to fashion Hancock into a modest, unadorned, disciplined man who has denied himself the trappings of wealth and class that were available to him and were deemed essential elements of portraiture by current representational practice? Why, in the year of his promotion to the summit of wealth and class structure in Boston, would Hancock approach Copley for a portrait that fraudulently presents him as the house accountant?

One can only speculate. It is possible that his choice of this guise was politically motivated. Hancock was beginning to seek public office in the mid-1760s. At a time when demagogues such as Samuel Adams were launching blistering attacks on privilege and when populist mobs were demolishing the houses of Thomas Hutchinson, Andrew Oliver, and other elites in power, the politically ambitious and materially flamboyant Hancock was particularly vulnerable to shifting public opinion. Adams, for example, called for the disempowerment of the elites at the precise moment they were extravagantly flaunting their wealth by indulging their taste for great urban mansions, ornate furniture, elaborate weddings, grandiose portraits, and a ceaseless and, to radicals, seemingly grotesque mimicry of the English, financed by the exploitation of workers and the poor.[64]

The situation was perilous for Hancock, but he was a brilliant tactician. In the disintegrating Boston of 1765 he presented himself as a self-sacrificing man of the people. He participated in the boycott of English goods, at the risk of ruining his own trading firm. And he spouted radical rhetoric, calling for the beheading of all holders of royal office. Unlike many of his ever-more isolated elite peers who became increasingly wrapped up in the social rituals of an earlier, safer era, Hancock anticipated how he might be a leader in a new political era by publicly identifying with the laboring classes. Through both verbal and visual rhetoric this patrician was able to project an image of republican virtue, frugality, and simplicity.

Privately he believed in class structure, distrusted those he thought beneath himself, rebuked the mobs for sacking Hutchinson's house, retained all the perquisites of his class, and was more concerned with his commercial interests than with individual rights.[65] Nonetheless, his crafty political gambits worked, winning him immense popularity and election to the General Court in the midst of the Stamp Act crisis of 1766 and later to the positions of governor of Massachusetts and president of the Continental Congress.

The gulf between the private and public Hancock, between the elegant patrician and the man of the people, is bridged by the critical agency of Copley's portrait. Why did Copley portray Hancock as a worker, unadorned and almost old-fashioned? Because of Hancock's self-protective yet self-promotional need in 1765 to be seen as a new representative man. Hanging in Hancock's politically resonant home, the site of countless political events, the portrait surely identified him as a wealthy man, even though no luxurious objects are included in it. The very large size of the picture (50 x 40 inches) and the thick ledger filled with numbers that is displayed in it indicate this status. Set in his house amid an ex-

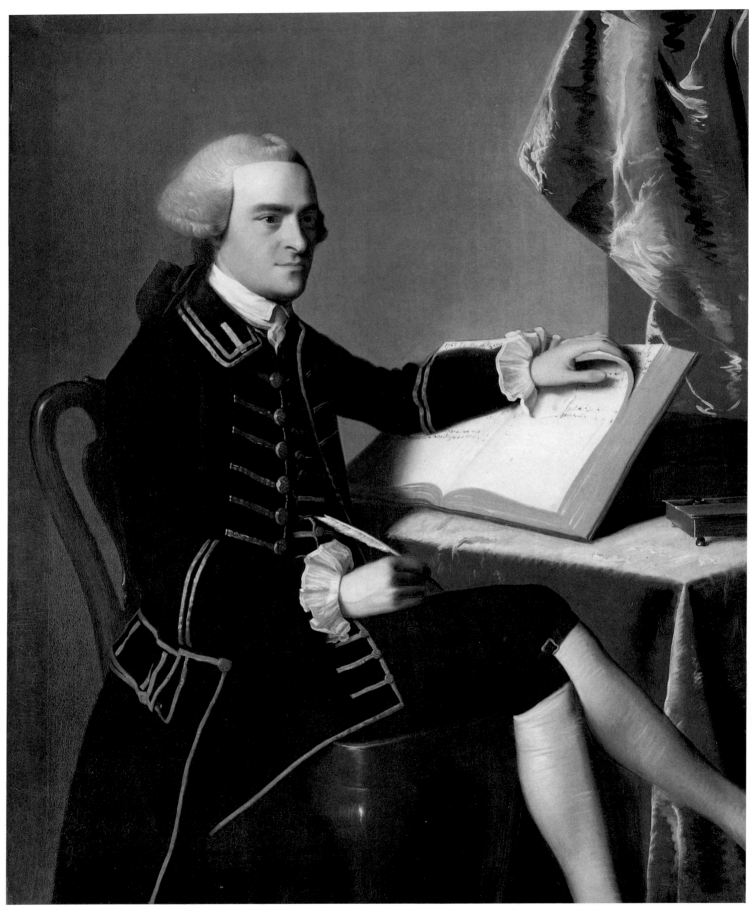

Fig. 63 *John Hancock* (cat. no. 22)

Fig. 64 Detail,
John Hancock (cat. no. 22)

traordinarily rich ensemble of the finest American and English decorative arts, however, the picture must have seemed out of place. With its disciplined forms, astringent composition, simple props, and workingman's ethos, it speaks in the ethical and aesthetic language of the antimaterialist, neo-Puritan, nascently republican culture that sprang up and began to find a voice in 1765 and propelled a revolution a decade later.

Until 1765 Hancock had been a politician manqué who coveted high office. But that year, when he contemplated running for one of four seats on the General Court, Hancock commissioned a portrait from Copley that expresses a new kind of virtue, crafted from republican wool. The picture can be considered an agent in his populist gambit, which took many forms. He made the decision, honored only temporarily, in 1765, to cease acquiring foreign goods. He had his ship

carry the order that overturned the Stamp Act to Boston, where he personally announced the news of the repeal to the public. He mounted fireworks in celebration of the repeal on the lawn of his mansion and provided glasses of Madeira for the crowds there. And he chose the visual motif of a working elite for himself in Copley's portrait, which, in the demonology of John Hancock, is the equivalent of a log-cabin myth. These acts of antimaterialist purification, these self-congratulatory rituals of self-conscious denial, were the manifest signs of what the new public man in America would become.

Copley's portrait of Hancock and his pictures of other colonial men and women epitomize Tuckerman's notion of the "counterfeit presentment." Whether fashioning the image of a simple man such as Hancock or a grandee such as Jeremiah Lee, arranging Mrs. Gage's masquerade, or con-

73

structing a Lockean analogy between the cultivation of flowers and of women, Copley was engaged in the audacious tooling of identity for those elite American men and women who felt compelled to be perceived as more than they were. As Jonathan Richardson claimed in his *Theory of Painting* in 1715, this ability to "raise the character; to divest an unbred person of his rusticity, and give him something at least of a gentleman," to, in other words, fashion, embellish, and even distort while retaining the likeness, "is absolutely necessary to a good face-painter; but it is the most difficult part of his art, and the last attained."[66]

Visual certification of character and class was especially important in a colonial society in which position could not be secured by inherited title. "In Europe," wrote Benjamin Franklin, one's birth "has indeed a Value; but it is a Commodity that cannot be carried to a worse market than that of America."[67] In Boston elites somehow had, literally, to earn status and authority by accumulating wealth and other forms of accomplishment and had to prove their power on a daily basis by displaying the kinds of things and images that emblematized class. With traditional sources of status "surrounded and squeezed," as Gordon Wood puts it, colonial Americans were measured "by cultivated, man-made criteria having to do with manners, taste, and character."[68]

These material attributes, which allowed for the deduction of character and class, were exactly the meritocratic criteria that lent themselves to manipulation in the hands of Copley, who was the master imagist of eighteenth-century America.[69] His artistic genius lies not merely in an inexplicable ability to teach himself how to paint as well as he did or to make his art look modern but also in his peerless understanding of the codes of patrician representation that were current in Boston and, by extension, in London. He, as no one before and few afterward, could provide clients with what they wanted and, sometimes, provide them with even more than they could imagine they wanted.

Copley understood implicitly an early modern condition according to which the material appearance of character becomes the demonstrable proof of character.[70] He postulated, de facto, that personality could be made available from the details of personal affectations, that character was immanent in material appearances, and that the reading of the things assembled in a portrait was tantamount to knowing the essential person who was pictured. His project in portraiture was not the creation of accurate likenesses but the production of authenticating narratives about people. As such, he was part of a perceptual conspiracy, also enacted by other craftsmen of his period, which presented the artifices of body form and luxury objects as natural representations of character.[71]

Since it claimed identity through an assemblage of discrete elements, Copley's representation of a person's character could be disassembled by a viewer into an inventory of an individual's appearances and possessions. Copley's interpretive method assumed that personal identity is visible and additive, instead of concealed and ineffable, that status was a projection, not just a possession. It assumed, moreover, that viewers had the ability to scrutinize, to make distinctions between objects and thus between individuals. Copley must have realized that in his culture this was the analytical means by which people evaluated one another, by which, to invoke the mercantile language of the era, individuals audited individuals. This was Copley's method. And surely it was the method that John Adams used to assess Nicholas Boylston's character that evening he visited him in the winter of 1766.

This emphasis on the field of semantic display was Copley's radical contribution to the anthropology of personhood in pre-Revolutionary America. When he was at his best in assembling the signs of a person, in his portraits of Nicholas Boylston, Nathaniel Sparhawk, and Margaret Kemble Gage, for example, he pushed the codes for the representation of character into realms previously unknown in America. It is not his descriptive technique alone but Copley's unsurpassed ability to reify the bourgeoisie's mythic perception of itself that is the critical basis for the claim that he is the supreme portraitist of the colonial era.

The first epigraph is from Charles Baudelaire, "Salon of 1846," in *Art in Paris, 1845–1862: Salons and Other Exhibitions Reviewed by Charles Baudelaire*, trans. and ed. Jonathan Mayne (1965; reprint, New York, 1981), p. 88. The second is from Tuckerman 1867, pp. 75–76.

1. Gordon Wood defines the elite as the class of gentlemen and gentlewomen, "the better sort," as they were called then. People who were mechanics, artisans, laborers, and those without property were "the lower sort" (Gordon S. Wood, *The Radicalism of the American Revolution* [New York, 1992], pp. 24–42).

2. Much of the literature on Copley as a "realist" artist reminds me of Lionel Trilling's essentialist claim that "in the American metaphysic, reality is always material reality, hard, resistant, unformed, impenetrable, and unpleasant" (Lionel Trilling, *The Liberal Imagination: Essays on Literature and Society* [New York, 1978], p. 12). For a discussion of historiography in the literature on Copley, see Carrie Rebora, "Copley and Art History: The Study of America's First Old Master," in this publication.

3. Probate inventories in Suffolk County, Massachusetts, for instance, overwhelmingly place family portraits in the semipublic spaces of the first floor of a house.

4. I admire the critical language and interpretive methods of Marcia

Pointon's *Hanging the Head: Portraiture and Social Formation in Eighteenth-Century England* (New Haven, 1993). I am using the words *character* and *social identity* interchangeably. By those words I mean to follow the definition of Colin Campbell of "character as the name for that entity which individuals consciously strive to create out of the raw material of their personhood. It is thus not equatable with personality, as that term usually covers the sum total of an individual's psychic and behavioural characteristics, nor is it something which can simply be understood as the unproblematic outcome of dominant cultural patterns of processes of socialization. On the contrary, character covers only that portion of the conduct of individuals which they can be expected to take responsibility for, and is the entity imputed to underlie and explain this willed aspect of their behaviour. As such it has an essentially ethical quality not possessed by the concept of personality" (Colin Campbell, "Understanding Traditional and Modern Patterns of Consumption in Eighteenth-Century England: A Character-Action Approach," in *Consumption and the World of Goods*, ed. John Brewer and Roy Porter [London, 1993], p. 45).

5. *Diary and Autobiography of John Adams*, ed. Lyman H. Butterfield (Cambridge, Mass., 1961), vol. 1, p. 294.

6. Pointon discusses this briefly in *Hanging the Head*, pp. 6–7.

7. Polly Wiessner concisely states the anthropological premise of this essay: an object "is one of several means of communication through which people negotiate their personal and social identity vis-à-vis others, whether it be to project a certain image, to mesh an aspect of identity, or to raise questions about a person's identity" (Polly Wiessner, "Style and Changing Relations Between the Individual and Society," in *The Meanings of Things: Material Culture and Symbolic Expression*, ed. Ian Hodder [London, 1989], p. 57). In discussing the relationship between luxury goods and social differences, I am following the theoretical and historical writings of a number of scholars, particularly Pierre Bourdieu, *Distinction: A Social Critique of the Judgement of Taste*, trans. Richard Nice (Cambridge, Mass., 1984); see especially his chapter "The Dynamics of the Field," pp. 226–56. I have also been influenced by the sociological theory of Colin Campbell, *The Romantic Ethic and the Spirit of Modern Consumerism* (Oxford, 1987); as well as by Richard Sennett, *The Fall of Public Man* (Cambridge, Mass., 1976); and Erving Goffman, *The Presentation of Self in Everyday Life* (Garden City, N.Y., 1959). Mihaly Csikszentmihalyi and Eugene Rochberg-Halton concisely state the premise at work in this essay: "All people can, and presumably most people do, use symbolic objects to express dimly perceived possibilities of their selves to serve as models for possible goals" (Mihaly Csikszentmihalyi and Eugene Rochberg-Halton, *The Meaning of Things: Domestic Symbols and the Self* [Cambridge, 1981], p. 28). Anthropologists Mary Douglas and Baron Isherwood equate the symbolic value and the use value of objects in *The World of Goods: Towards an Anthropology of Consumption* (New York, 1979). Grant McCracken calls goods "tokens in the status game" in his *Culture and Consumption: New Approaches to the Symbolic Character of Consumer Goods and Activities* (Bloomington, Ind., 1990), p. 17. The most intelligent overviews of the theory of objects and status are Jean-Christophe Agnew, "Coming Up for Air: Consumer Culture in Historical Perspective," in *Consumption and the World of Goods*, pp. 19–39; and Ann Smart Martin, "Makers, Buyers, and Users: Consumerism As a Material Culture Framework," *Winterthur Portfolio* 28 (Summer–Autumn 1993), pp. 141–57. T. H. Breen writes specifically about the relationship between goods and identity in eighteenth-century America; see his excellent essays "'Baubles of Britain': The American and Consumer Revolutions of the Eighteenth Century," *Past and Present*, no. 119 (May 1988), pp. 73–104; "An Empire of Goods: The Anglicization of Colonial America, 1690–1776," *Journal of British Studies* 25 (Oct. 1986), pp. 467–99; and "The Meaning of 'Likeness': American Portrait Painting in an Eighteenth-Century Consumer Society," *Word and Image* 6 (Oct.–Dec. 1990), pp. 325–50. See also Terence H. Witkowski, "Colonial Consumers in Revolt: Buyer Values and Behavior During the Nonimportation Movement, 1764–1776," *Journal of Consumer Research* 16 (Sept. 1989), pp. 216–26; Stephanie Grauman Wolf, "Rarer Than Riches: Gentility in Eighteenth-Century America," in *The Portrait in Eighteenth-Century America*, ed. Ellen G. Miles (Newark, Del., 1993), pp. 91–101; and Robert A. Gross, "Gentlemen Prefer Swords: Style and Status in the Eighteenth-Century Portrait," in *Portrait in Eighteenth-Century America*, pp. 116–20. Wayne Craven rightly calls attention to the significance of "paraphernalia" and the need to "decode it," though I disagree with his claim that a portrait "records" a sitter's biography ("Colonial American Portraiture: Iconography and Methodology," in *Portrait in Eighteenth-Century America*, pp. 102–3).

8. Richard L. Bushman believes that viewers in the eighteenth century were able to read a person's character cumulatively, through one visual opportunity after another (Richard L. Bushman, *The Refinement of America: Persons, Houses, Cities* [New York, 1992], pp. 61–99).

9. Roland E. Fleischer has attempted to read the portraits in the traditional, iconic way in "Emblems and Colonial American Painting," *American Art Journal* 20, no. 3 (1988), pp. 2–35. The most compelling discussions of iconic portraiture in the eighteenth century are Richard Wendorf, *The Elements of Life: Biography and Portrait-Painting in Stuart and Georgian England* (Oxford, 1990); and Ronald Paulson, *Emblem and Expression: Meaning in English Art of the Eighteenth Century* (Cambridge, Mass., 1975).

10. Wood, *Radicalism of the American Revolution*, p. 32.

11. Pointon repeatedly interrogates the fallacy that portraits document appearances in this manner. For example: "In a narrow line of enquiry the portrait is assumed to be a direct and unmediated equivalent for the self, and the clothing and personal accoutrements re-presented are assumed to be those worn by the subject in a given combination, a precise effect on a particular day" (Pointon, *Hanging the Head*, p. 111).

12. I am consciously avoiding the issue of likeness in Copley's portraits, since my claim in this essay is that what is at stake in the assessment of the person in a picture has more to do with situation and things than with expression and emotion. For the idea of likeness, see Nadia Tscherny, "Likeness in Early Romantic Portraiture," *Art Journal* 96 (Fall 1987), pp. 193–99; and E. H. Gombrich, "The Mask and the Face: The Perception of Physiognomic Likeness in Life and in Art," in E. H. Gombrich, Julian Hochberg, and Max Black, *Art, Perception, and Reality* (Baltimore, 1970), pp. 1–46.

13. Elizabeth Wilson discusses the body as object and artifact in *Adorned in Dreams, Fashion, and Morality* (Berkeley, 1987).

14. This was a method other artists also used. For example, John Wollaston very prominently showed a man's mole with curly hair growing out of it in *Family Portrait*, ca. 1750 (Newark Museum).

15. Quoted in Kenneth Silverman, *A Cultural History of the American Revolution: Painting, Music, Literature, and the Theatre in the Colonies and the United States from the Treaty of Paris to the Inauguration of George Washington, 1763–1789* (New York, 1976), p. 23.

16. William Carson, letter to Copley, Aug. 16, 1772, in Jones 1914, pp. 187–88.

17. See Thaddeus Harris, "Fat," in Thaddeus Harris, *The Minor Encyclopedia; or, Cabinet of General Knowledge* (Boston, 1799), vol. 2, p. 250.

18. See Richard Osborn Cummings, *The American and His Food* (New York, 1970), pp. 25–42. See also Bushman, *Refinement of America*,

pp. 74–78; Roy Porter, "Consumption: Disease of the Consumer Society?" in *Consumption and the World of Goods*, pp. 58–81; Jonathan Benthall and Ted Polheumus, eds., *The Body As a Medium of Expression* (New York, 1975); Anne Scott Beller, *Fat and Thin: A Natural History of Obesity* (New York, 1977); Carole Shammas, *The Pre-Industrial Consumer in England and America* (Oxford, 1990), pp. 121–56; Sara F. McMahon, "Provisions Laid Up for the Family: Toward a History of Diet in New England, 1650–1850," *Historical Methods* 14 (Spring 1981), pp. 4–21; and David Klingman, "Food Surpluses and Deficits in the American Colonies, 1768–1772," *Journal of Economic History* 31 (Sept. 1971), pp. 553–69.

19. There were no English cookbooks in America before 1742, but nine were in use between 1742 and 1772. See Waldo Lincoln, "Bibliography of American Cookery Books," *American Antiquarian Society Proceedings* 39 (Apr. 1929), pp. 85–92. For a later period, see Barbara Carson, *Ambitious Appetites: Dining Behavior and Patterns of Consumption in Federal Washington* (Washington, D.C., 1990).

20. The best recent study of manners is in Bushman, *Refinement of America*, pp. 30–60, 63–69. Bushman points out that the self-conscious control of the body was the most visible way in which a gentleperson expressed himself or herself. See also Arthur Schlesinger, *Learning How to Behave: A Historical Study of American Etiquette* (New York, 1946); John Kasson, *Rudeness and Civility: Manners in Nineteenth-Century Urban America* (New York, 1990); Christina Dallett Hemphill, "Manners for Americans: Interaction Rituals and the Social Order, 1620–1860" (Ph.D. diss., Brandeis University, Waltham, Mass., 1988); E. P. Thompson, "Patrician Society, Plebeian Culture," *Journal of Social History* 7 (Summer 1974), pp. 382–405; George C. Brauer, Jr., *The Education of a Gentleman: Theories of Gentlemanly Education in England, 1660–1775* (New York, 1959); and Jan Bremmer and Herman Roodenburg, eds., *A Cultural History of Gesture* (Ithaca, 1992).

21. Lord Chesterfield [Philip Dormer Stanhope], *Letters to His Son*, 3d ed. (New York, 1775), vol. 1, p. 39, quoted in Hemphill, "Manners for Americans," p. 191.

22. Chesterfield, *Letters to His Son*, vol. 1, p. 86, quoted in Hemphill, "Manners for Americans," p. 192.

23. Chesterfield was first published in America in 1775, but his influence had permeated Anglo-American society before then; see Bushman, *Refinement of America*, p. 36.

24. Chesterfield, *Letters to His Son*, vol. 1, p. 86, quoted in Hemphill, "Manners for Americans," p. 193.

25. The American cherry had been an inedible native fruit that was "ordered," or improved, by inoculation with the English sweet cherry in the eighteenth century. See Ann Leighton, *Early American Gardens: "For Meate or Medicine"* (Amherst, Mass., 1986), p. 271. See also Ann Leighton, *American Gardens in the Eighteenth Century: "For Use or For Delight"* (Boston, 1986).

26. Mrs. Winthrop's son, James, chronicled the dates his nectarines bloomed and fruited in Cambridge; see Leighton, *American Gardens*, p. 235.

27. Henry Pelham advised his half brother that Hancock "can supply you with every Fruit Tree, flowering Tree except the Tul[ip] shrub or Bush, that you want" (Henry Pelham, letter to Copley, Sept. 10, 1771, in Jones 1914, p. 158).

28. For these gardens, see Bushman, *Refinement of America*, pp. 127–31; and Rudy J. Favretti, *New England Colonial Gardens* (Stonington, Conn., 1964).

29. For the Hancocks, see W[illiam] T. Baxter, *The House of Hancock: Business in Boston, 1724–1775* (Cambridge, Mass., 1945), p. 67. The advertisement comes from the *Boston News-Letter*, Oct. 22, 1772.

30. Alice G. B. Lockwood, *Gardens of Colony and State: Gardens and Gardeners of the American Colonies and of the Republic Before 1840* (New York, 1931), vol. 1, pp. 106–7.

31. See Metcalf Bowler, *A Treatise on Agriculture and Practical Husbandry* (Providence, 1786); and Lockwood, *Gardens of Colony and State*, vol. 1, pp. 215–16.

32. For the idea of rearing, see Mrs. Anne Grant, *Memoirs of an American Lady, with Sketches of Manners and Scenery in America As They Existed Previous to the Revolution*, 2 vols. (London, 1808). Passages of Grant's book are reprinted in Lockwood, *Gardens of Colony and State*, pp. 297–98.

33. Both Locke and Jean-Jacques Rousseau repeatedly used the metaphor of cultivating plants to describe the proper pedagogical approach for the raising of gentlemen and gentlewomen. See Jay Fliegelman, *Prodigals and Pilgrims: The American Revolution Against Patriarchal Authority, 1750–1800* (Cambridge, 1982), pp. 31–35.

34. Richard Steele, *The Spectator* (London, 1950), vol. 3, p. 406. Americans had been introduced to the metaphorical association of gardening and moral education directly by Locke's writings, particularly his *Some Thoughts Concerning Education* (London, 1693), and indirectly through popular English literature in eighteenth-century America, including Daniel Defoe's epic on the subject of education, *Robinson Crusoe* (1719).

35. Mark P. Leone, "The Georgian Order As the Order of Merchant Capitalism in Annapolis, Maryland," in *The Recovery of Meaning: Historical Archaeology in the Eastern United States*, ed. Mark P. Leone and Parker B. Potter Jr. (Washington, D.C., 1988), pp. 235–61.

36. The only portrait of a male by Copley that includes birds is *Thomas Aston Coffin*, ca. 1758 (Munson-Williams-Proctor Institute, Museum of Art, Utica, New York). Though this picture seems to negate a thesis of gendered emblems, when he was painted Coffin was only about five years old, unbreeched, and thus not yet a subject for full masculine imagery.

37. Mrs. Hannah Robertson, *The Young Ladies School of Arts* (New York, 1777), p. 125. In addition, Robertson wrote "On the Nature and Signification of Colours," advising on the appropriate use of color in drapery, for example, "azure, signifies constancy" (p. 25); and "On Emblems," for example, "The Dove is mild and meek, clean of kind, plenteous in increase, forgetful of wrongs, for when their young ones are taken from them they mourn not" (p. 27).

38. For birds symbolizing civility, see Grant, *Memoirs of an American Lady*, vol. 1, pp. 166–68.

39. King Charles spaniels are now known as English toy spaniels. See Mary Forwood, *The Cavalier King Charles Spaniel* (London, 1967).

40. The dogs were described in affectionate, recreational terms. They sometimes were known as "comforters" because they kept people—like Mrs. Bowers—warm in chill weather. American encyclopedia entries of the era typically opened with a social, rather than a biological, definition of the dog discussed: for example, "an animal well known for its attachment to mankind" (Harris, *Minor Encyclopedia*, vol. 2, p. 135). Another announces the dog to be "an animal remarkable for its natural docility, fidelity, and affection for its master; which qualities mankind are careful to improve for their own advantage" and goes on to discuss in detail their care as domestic animals (*Encyclopaedia; or, A Dictionary of Arts, Sciences, and Miscellaneous Literature* [Philadelphia, 1798], vol. 7, p. 78). The mutual adoration Copley represented between patrician women and their dogs in his pictures corroborates the affectionate language used in the classified section of colonial urban newspapers, which contained countless requests for information on lost lap dogs with names like Beauty and Flora. Frequently the owner con-

fessed to being bereft over the loss and, as if the dog were a missing child, might be moved to offer a reward for information leading to the animal's return. An example of a typical announcement is: "Lost, Yesterday morning, in the New Market, a little young Spaniel Dog, entirely white—whoever brings him to No. 213, South Second Street, will receive three dollars reward" (*Pennsylvania Packet*, Nov. 20, 1797). A collection of similar clippings is in the Prime files, Winterthur Library, Delaware.

41. *Encyclopaedia; Dictionary of Arts*, vol. 10, pp. 712–13.

42. Ibid., p. 713.

43. Benjamin Franklin, "Epitaph on Miss Shipley's Squirrel, Killed By Her Dog," *Pennsylvania Gazette*, Nov. 10, 1784.

44. For a thorough discussion of the picture, see Carol Troyen, "John Singleton Copley and the Grand Manner: *Colonel Nathaniel Sparhawk*," *Journal of the Museum of Fine Arts, Boston* 1 (1989), pp. 96–103. See also Wayne Craven, *Colonial American Portraiture: The Economic, Religious, Social, Cultural, Philosophical, Scientific, and Aesthetic Foundations* (Cambridge, 1986), pp. 337–39.

45. The others by Smibert were of Sir Peter Warren, 1746, Captain Richard Spry, 1746 (both Portsmouth Athenaeum, New Hampshire), and William Shirley, 1747 (location unknown); the one by Feke is of Brigadier General Samuel Waldo, ca. 1748 (Bowdoin College Museum of Art, Brunswick, Maine). Peter Pelham made engravings of the Pepperrell and Shirley portraits; see Ellen G. Miles, "Portraits of the Heroes of Louisbourg, 1745–1751," *American Art Journal* 15 (Winter 1983), pp. 48–66. In 1760 Joseph Blackburn also painted a lifesize portrait of New Hampshire Governor Benning Wentworth (New Hampshire Historical Society, Concord). Other lifesize portraits were within Copley's view. The most prominent were of Charles II, James II, and George III in the Council Chamber of Boston's Town-House; another, of George II, was in Faneuil Hall; see Pierre Eugène Du Simitière, "Paintings in Boston New England," ms. 1767, Du Simitière papers, Library Company of Philadelphia.

46. Copley also used the colossal column in his portraits of Sarah Gerrish Barrett, ca. 1758 (private collection), James Warren (fig. 173), Thomas Hancock (fig. 1), Woodbury Langdon (cat no. 35), Richard Dana, ca. 1770 (private collection), and Elizabeth Lewis Goldthwait (cat. no. 60).

47. See Troyen, "Copley and the Grand Manner," n. 15. For the houses associated with Sparhawk, see John Mead Howells, *The Architectural Heritage of the Piscataqua: Houses and Gardens of the Portsmouth District of Maine and New Hampshire* (New York, 1937), pp. 6–13, 38–41.

48. Troyen notes its similarity to the scenographic displays in painting by Veronese, as well as the probability that Copley could have known of such architecture through eighteenth-century English prints or the plates in James Gibbs's *Rules for Drawing the Several Parts of Architecture* ([London, 1732], pls. 32, 39; see Troyen, "Copley and the Grand Manner," p. 100).

49. For a discussion of the pictorial sources, see the entry for cat. no. 52 in this publication.

50. For a later edition, see Batty Langley, *The City and Country Builder's and Workman's Treasury of Designs* (1756; reprint, New York, 1967).

51. This is confirmed by the Lee inventory at the Probate Court of Essex County, in Salem. It cannot be determined whether or not Lee owned the Axminster carpet on which he stands, for the Lee probate inventory is not detailed enough to allow identification of this specific example. For Axminsters in America, see Sarah B. Sherrill, "Oriental Carpets in Seventeenth- and Eighteenth-Century America," *Antiques* 109 (Jan. 1976), pp. 142–67.

52. Thomas Chippendale, *The Gentleman and Cabinet-Maker's Director*, 3d ed. (1762; reprint, New York, 1966); Abraham Swan, *The British Architect; or, The Builder's Treasury of Stair-Cases* (1758; reprint, New York, 1967).

53. Wayne Craven proposed that she is represented as Pomona or Flora in *Colonial American Portraiture*, p. 345.

54. See Aileen Ribeiro, "Turquerie: Turkish Dress and English Fashion in the Eighteenth Century," *Connoisseur* 201 (May 1979), pp. 17–23; and Pointon, *Hanging the Head*, pp. 141–57.

55. The Englishwoman posing as Turkish courtesan is discussed in Ross Watson, "Portrait of a Courtesan," *Apollo* 89 (Mar. 1969), pp. 184–87.

56. Terry Castle, *Masquerade and Civilization: The Carnivalesque in Eighteenth-Century English Culture and Fiction* (Stanford, Calif., 1986), pp. 4–5.

57. George Colman, *Man and Wife*, in *The Plays of George Colman* (London, 1777), act 2, p. 31.

58. On Lady Montagu, see Pointon, *Hanging the Head*, pp. 141–57.

59. See Bruce C. Daniels, "Sober Mirth and Pleasant Poisons: Puritan Ambivalence Towards Recreation and Leisure in Colonial New England," *American Studies* 34 (Spring 1993), pp. 17–28; and Bruce C. Daniels, "Frolics for Fun: Dances, Weddings, and Dinner Parties in Colonial New England," *Historical Journal of Massachusetts* 21 (Summer 1993), pp. 1–22.

60. See Ellen G. Miles, *Thomas Hudson: Portrait Painter and Collector, 1701–1779* (London, 1979), nos. 12, 14, 15, 16.

61. Reginald Rawdon Hastings, *Hastings Manuscripts*, ed. F. Bickley (London, 1928), vol. 3, p. 150, quoted in Aileen Ribeiro, *The Dress Worn at Masquerades in England, 1730 to 1790, and Its Relation to Fancy Dress in Portraiture* (New York, 1984), p. 146.

62. The most analytic treatment of Hancock's business is provided in Baxter, *House of Hancock*.

63. On the subject of wealth and poverty in Boston, see Gary B. Nash, *The Urban Crucible: Social Change, Political Consciousness, and the Origins of the American Revolution* (Cambridge, Mass., 1979); and Jackson Turner Main, *The Social Structure of Revolutionary America* (Princeton, N.J., 1965).

64. Nash, *Urban Crucible*, p. 123.

65. As Nash puts it, in 1765 Hancock was not "risking his life and fortune for a return to arcadian simplicity" (ibid., p. 224).

66. Jonathan Richardson, *An Essay on the Theory of Painting* (London, 1715), p. 172.

67. *The Writings of Benjamin Franklin*, ed. Albert Henry Smyth (New York, 1907), vol. 8, p. 605.

68. Wood, *Radicalism of the American Revolution*, p. 32.

69. My claim throughout has been that Copley was an emblematic rather than an expressive artist in the way that, say, Rembrandt was, and thus his pictures require their own hermeneutic tactics for reading. Joseph Koerner says that Rembrandt "installs the face at the center of our vision," whereas other artists, such as Cézanne and, I argue, Copley too, engaged in the "radical demystification of the face" (Joseph Koerner, "Rembrandt and the Epiphany of the Face," *Res* 12 [Autumn 1986], p. 18). Copley's faces, because they are only mildly expressive, serve all the more to weight meaning onto objects, fabrics, fashions, poses, and other markers of character.

70. See Sennett, *Fall of Public Man*.

71. Pointon eloquently claims that objects were "components in a language, in a vast repertoire of signifiers. . . . The subject of the portrait participates in the production of meanings that are not defined by reference to standards of likeness" (Pointon, *Hanging the Head*, p. 112).

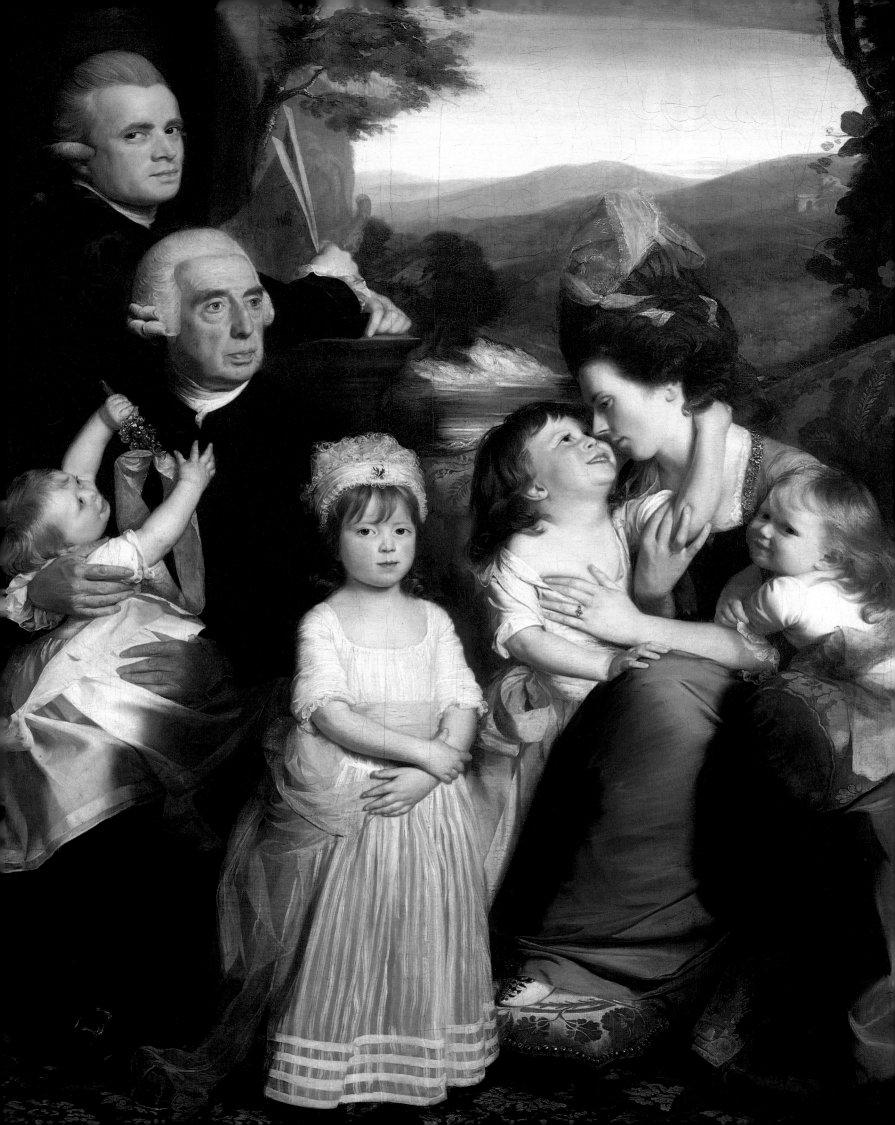

An American Despite Himself

THEODORE E. STEBBINS JR.

In August 1776 John Adams, the Boston lawyer and politician who would become the second president of the United States, took time out from the important work of the Continental Congress, less than three weeks after signing the Declaration of Independence, to visit the Philadelphia studio of Charles Willson Peale. Having admired his paintings, Adams wrote to his wife, Abigail, in Boston that Peale "has a variety of Portraits—very well done. But not so well as Copley's Portraits. Copley is the greatest Master that ever was in America. His Portraits far exceed West's."[1]

I

John Singleton Copley attracted attention, admiration, and extensive patronage from the people of his native Boston and surrounding towns in Massachusetts, as well as from the residents of other colonial cities, including Halifax, Portsmouth, New York, and Philadelphia, from the time he began to paint in about 1753 until he left for England in June 1774. The twenty-one years of Copley's American career were followed by fourteen months of study, travel, and painting on the Continent, largely in Italy, and then by a highly successful second career of some forty years as a portrait and history painter in London. Copley developed a new style in Rome and London in accordance with the demands of his new clients and with the methods of the leading British painters, whose works he now saw in the original for the first time, but his set of mind, his view of himself as an artist, remained the same as it had been in the colonies. From his beginnings as an artist at about the age of fifteen in Boston, he had seen himself not as an American working in a new way but rather as a painter who from his position at the periphery aimed to join the mainstream of Western tradition. He imagined himself an heir to the Renaissance masters and especially to Raphael (one of whose pictures, in print form, hung in his Boston bedroom). For three and a half formative years, between the ages of ten and thirteen, he had the benefit of having as his stepfather Peter Pelham (1695–1751), a successful English engraver and painter who was also a teacher of writing, dancing, and arithmetic. And he had learned everything he could from the portraits of the recently deceased John Smibert (1688–1751), whose Boston studio still boasted Smibert's own collection of books, drawings, and prints, as well as his copies of "the best statues and . . . the best paintings" in Rome. In Boston he also studied the portraits of Robert Feke (ca. 1708–1751), John Greenwood (1729–1792), and Joseph Blackburn (fl. 1752–ca. 1778), the last a well-trained English painter who arrived in the city in 1755. As Jules Prown points out in his monumental and still indispensable monograph on Copley, the young painter was familiar with many of the period's leading English, French, and Italian books on painting, architecture, and art theory.[2]

Copley's high aspirations even as a teenager are evidenced by his earliest works, which treat historical themes and include such mythological paintings as *The Forge of Vulcan* and *The Return of Neptune* (cat. nos. 3, 4), both of whose compositions he took from European prints. He learned to draw and attempted to master human anatomy (which would never become his strength) through studying medical treatises and by making a book of his own anatomical drawings (cat. no. 6), based on earlier European sources. And in composing one of his first portraits, *Mrs. Joseph Mann* (fig. 65), he turned to a British mezzotint engraving—a portrait of an English princess (fig. 66)—for a suitable pose to use in his own picture;[3] he would continue to use British and other European prints to guide and inspire him for years to come.

Perhaps the most important element of Copley's American education, however, was the unique course in self-improvement that he developed through correspondence with leading European artists, a course that evolved naturally from his earlier efforts at teaching himself from books, prints, and other sources. Copley had undertaken this innovative program at least by 1762, when he wrote to the eminent Swiss pastelist Jean-Étienne Liotard (1702–1789) for advice and materials. In his letter the young American spoke as had no colonial painter before him; admitting his provincialism while proclaiming his ambition to improve himself, he told the European master, "However feeble our efforts

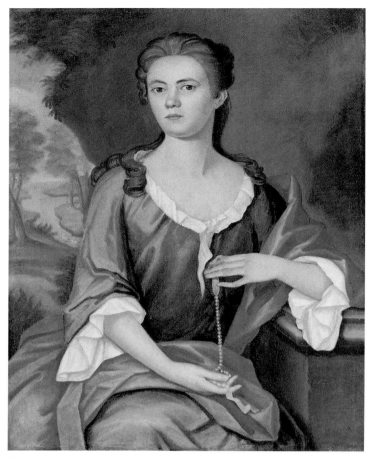

Fig. 65 *Mrs. Joseph Mann (Bethia Torrey)*, 1753. Oil on canvas, 36 x 28¼ in. (91.4 x 71.7 cm). Museum of Fine Arts, Boston, Gift of Frederick H. and Holbrook E. Metcalf 43.1353

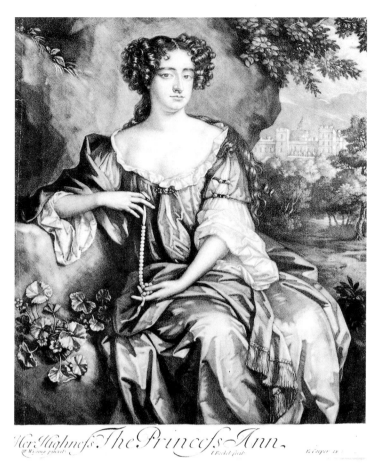

Fig. 66 Isaac Becket after Willem Wissing. *Princess Anne*, ca. 1710–30. Mezzotint, 13⅞ x 9⅞ in. (35.2 x 25.1 cm). Courtesy Winterthur Museum, Delaware

may be, it is not for want of inclination that they are not better, but the want of oppertunity to improve ourselves."[4] Determined as he was to better himself, Copley yearned not only for high-style European training but also for the chance to exhibit his productions in London alongside the best works of the day; what is truly remarkable is the extent to which he realized these goals while he was still in Boston. Beginning in 1765 with *Boy with a Squirrel (Henry Pelham)* (cat. no. 25), he executed a series of pictures that he sent to London for exhibitions at the Society of Artists over the next six years, hoping to elicit the comments of Sir Joshua Reynolds, Benjamin West, and other leading painters in London. There followed the now famous series of letters between Copley and various correspondents abroad who offered their opinions; they ranged widely, from "*a very wonderfull Performance*" for his first effort, to "so disagreable a Character . . . disliked by every one," "too brilliant and highly finished," and "a little want of Propriety in the Back Ground" for the second.[5] Copley responded graciously, even obsequiously, to good reviews and bad, all the while making explanations, offering excuses (regarding his picture of Mr.

Rogers, which he sent in 1768, he said, "if it is not liked you must blame him for all the Defects you find in it"), and lamenting his well-paid existence in Boston; to West he wrote: "I think myself peculiarly unlucky in Liveing in a place into which there has not been one portrait brought that is worthy to be call'd a Picture . . . which leaves me at a great loss to guess the style that You, Mr. Reynolds, and the other Artists pracktice."[6]

Despite all his striving and the help he received, Copley in America never did succeed in "guessing"—as he put it—current English style. During his Boston years he remained a colonial painter, a provincial one, an American despite himself. Then, just as the new nation was being born, he finally went abroad and saw the works of Reynolds and Thomas Gainsborough, of Raphael and Leonardo, of Mengs and Batoni, for the first time. He subsequently adopted English style quickly, thoroughly, and seemingly effortlessly.

The present exhibition is based on the belief that Copley's American paintings constitute a discrete body of work eminently deserving of intensive new study. Painted as they were on the eve of the American Revolution, these objects

shed light on American history and culture during a formative period and on some of its major personalities. Moreover, they inform us about the ways in which style is transmitted from a sophisticated cultural center to a distant province, about the development of an American manner, and about the nature of portraiture itself. To say that Copley's American pictures are a distinct entity is not necessarily to agree with the views of the critic William Dunlap, who in 1834 opined that they were in some ways "better" than his London portraits, while noting parenthetically that Copley in England was "no longer an American painter in feeling."[7] However, Dunlap's general view of the superiority of the American work held the field until the 1960s and even beyond. For example, Samuel Isham, one of the most eminent of historians of American art at the turn of the century, recast Dunlap only superficially in writing that Copley's European work "is far more skilled and complete technically" but then concluding that "it is the earlier work, the long series of portraits of our colonial dignitaries . . . which is most interesting . . . and which gives him his peculiar importance."[8] Isham believed that the painter's surroundings "forced upon him a greater sincerity" in America than in England and that the earlier pictures "put before our eyes the very age and body of the time."[9] A half century afterward E. P. Richardson, a leading historian of his own day, admired the "concentrated and imaginative realism" in Copley's American portraits, while finding the London ones "never so happy in characterization."[10] In 1969 this argument was taken further in Barbara Novak's important book *American Painting of the Nineteenth Century*, the first sentence of which reads: "The roots of an enduring American vision were first put down with the mature paintings of John Singleton Copley . . . from about 1765 to 1774."[11] For her part, Novak far preferred the American work, in which she believed the painter's "intent was to record reality as clearly and accurately as possible."[12] Finally, a decade later, Joshua Taylor again celebrated Copley's American portraits, declaring that "his candidly recorded likenesses stood out so sharply in what seemed to be a piercingly clear light that his Boston patrons found themselves confronting a vision of reality never before encountered in America."[13]

Historians now would be hesitant to express such views, as Copley in England—especially during his first two decades there—while working in a very different culture with its own expectations and patronage, produced a number of extraordinary works, including *The Death of Major Peirson* and *Watson and the Shark* (figs. 10, 12). In his 1966 monograph Prown devotes one volume to the American

paintings and the other to the English; he takes no position on which body of work is "better" but instead discusses the intrinsic qualities of each. As he makes clear, there is no doubt that the American pictures are very different from the English ones and that they stand as a unified body of work of great importance.

II

Copley's roots lie in the Renaissance, in attitudes and style transmitted to him through many intermediary sources, and his work must be understood in this light. Crucial for the development of the portrait was a new parity between the human and the sacred that emerged after the Middle Ages; as Max J. Friedländer says, "The portraits of donors in the Ghent Altar . . . are, dimensionally speaking, equivalent to the holy figures and are not inferior to them in significance."[14] Also important for the art of the new humanism was the development of the three-quarter-profile view (typically employed by Copley), which was first "successfully achieved when artists learned to master perspective foreshortening that went with it" and which provided the picture with "the illusion of movement, of action, of life."[15] The studies of Friedländer, John Pope-Hennessy, and other more recent writers outline the contradictory forces inherent in the new genre, including the ever-present dialogue between subject and painter involving the former's demand for a flattering or realistic likeness as opposed to the latter's wish to create a work of art; the conflict between objectivity and social convention; and, especially significant, the need for each portrayal to provide a picture both of the individual, suggesting his or her aspirations, and of the ideal being behind every person that exalts the nobility and constancy of the species.[16]

By means of the literature, prints, and copies, and through his stepfather, Copley was aware of the legacy of the Renaissance, and it is surely no coincidence that early in his career when he came to paint the young Hannah Hill Quincy (cat. no. 12), daughter of a distiller, on the occasion of her marriage to the rising young lawyer Samuel Quincy, he gave her not only a hat taken from a well-known painting by Rubens but also the slight smile and folded hands used in Leonardo's *Mona Lisa* (fig. 67). Similarly, Copley's *John Hancock* (cat. no. 22) echoes Quentin Massys's portrait of Erasmus at work in his study (fig. 68), while the Boston merchant and official Ezekiel Goldthwait (cat. no. 61) turns to his left and looks up from his work in the same manner as the sitter in "*Titian's School Master*" by the Venetian Giovanni Battista Moroni (fig. 69). By the same token, when Copley

Fig. 67 Leonardo da Vinci. *Mona Lisa*, ca. 1503–5. Oil on wood, 30¼ x 20⅞ in. (76.8 x 53 cm). Musée du Louvre, Paris

Fig. 68 Quentin Massys. *Erasmus of Rotterdam*, replica, 1517. Oil on panel. Galleria Nazionale, Rome

came to compose grand portraits of seated men, such as *Thomas Hollis* (fig. 2), he would have had in mind Van Dyck's magnificent painting of Cardinal Bentivoglio (fig. 70) in Florence, which he would have known through Smibert's copy. Example after example could be suggested, for Copley's American pictures rely heavily on his knowledge of Renaissance and Baroque portraiture and portrait theory.

Copley did more than borrow poses from earlier art; he did his best to adopt the attitudes, the traditions, and the aims of humanism. As a colonial Englishman, he would have turned naturally to the writings of Jonathan Richardson, whose *Essay on the Theory of Painting* of 1715 and other works served several generations of English-speaking artists. For Richardson one goal of portraiture was "to exalt our species." He believed that the painter must omit the awkward or the ugly from any picture of "a man made in the image of a perfect and simple God" (as Barbara Maria Stafford puts it), and he described a good portrait as being "from whence we conceive a better opinion of the beauty, good sense, breeding, and other positive qualities of the person."[17] Reynolds, the renowned London painter and theorist of the generation following Richardson's, also postulated

that art should imitate the ideal. He believed that the work of art, in Walter Jackson Bate's phrase, "should represent the *ethos*, or the fixed and universal character, rather than the *pathos*, or feeling, which is fluctuating and individual," but, as Bate points out, in later Discourses he suggested that "the highest art should perhaps possess a union of the two."[18] Reynolds advised the portraitist to "raise and improve" his subject by approaching it as a "general idea"; the painter who follows his prescribed path, he said, "leaves out all the minute breaks and peculiarities in the face, and changes the dress from a temporary fashion to one more permanent." But Reynolds acknowledged that the portraitist faced a special problem in cases in which sitters insisted on having true likenesses; he admitted that such demands made it nearly impossible for the painter to "enoble the character of a countenance."[19]

Copley had to deal with this conflict in the colonies, where the painter's traditional goal of showing the nobility of sitters was greatly tempered by his subjects' desire for likenesses. There is little question that American patrons required accurate representations. On one occasion Copley wrote to an English correspondent that "the likeness" con-

Fig. 69 Giovanni Battista Moroni, *"Titian's Schoolmaster,"* ca. 1575. Oil on canvas, 23 x 18⅛ in. (58.4 x 46 cm). National Gallery of Art, Washington, D. C., Widener Collection

Fig. 70 Anthony Van Dyck. *Cardinal Guido Bentivoglio*, 1623. Oil on canvas, 77⅛ x 57⅛ in. (196 x 145 cm). Palazzo Pitti, Florence

stituted "a main part of the exellency of a portrait in the oppinion of our New England Conoseurs." On another a patron offered the painter "great honour" in reporting that his fifteen-month-old son was completely fooled by Copley's portrait of himself and tried to speak to it.[20] Furthermore, when the painter John Greenwood commissioned his mother's portrait (cat. no. 59) from abroad, he explicitly charged Copley with supplying a picture that would show him how the lady now looked.[21]

Judging from fairly scant evidence, it seems likely that Copley's portraits represent the features of his sitters reliably. In most cases his portrait provides the only known contemporary representation of a given sitter, so it is seldom possible to corroborate his accuracy with visual evidence. However, Benjamin Blyth drew the Reverend Thomas Cary in pastel (fig. 205) at about the time that Copley painted him (cat. no. 65), and Cary's rather unusual, elfin face looks very similar in both pictures. In addition, in a few instances Copley portrayed a sitter on two different occasions, and the resulting efforts generally confirm his ability to produce likenesses. Henry Pelham, the subject of an oil sketch of about 1760 (cat. no. 24) and then of *Boy with a Squirrel* in

1765, and John Hancock, who commissioned a three-quarter-length portrait in 1765 and a bust portrait about seven years later (cat. no. 23), are recognizably the same people, and older, in the later pictures. Rebecca Boylston, who was painted as a single woman in 1767 and then as Mrs. Moses Gill in 1773 (cat. nos. 33, 34), bears an altered appearance from one picture to the other; here too the painter was able to record a change in his sitter's looks.

Does the fact that Copley's portraits were designed in large part to represent likeness accurately mean that it is useful to consider them simply as realistic works of art, or is there evidence suggesting that it would be fruitful to think of them in other terms? Can we read in them anything about the American character or about individual personality? And what can we learn from the paintings about the quality of the culture and of life in Boston during the two decades preceding the American Revolution? In the past a number of critics have seen Copley's portraits as literally truthful, expressing verifiable, historical facts about the character of the sitters and their society. For Homer Saint-Gaudens, for example, Copley painted "the salient aspects of an exquisite culture in a delightful social order," while more

recently Wayne Craven theorized that Copley's American works reflect "the process of rational analysis and presentation of the physical world, described without idealization or sentimentality."[22] These views seem naive today in light of recent scholarship on portraiture in general and Anglo-American painting in particular. Such students of the field as Richard Brilliant, Richard Wendorf, and Marcia Pointon have found the making of a portrait to be richer and more complex than the mere creation of likeness. As Pointon writes, "Portraiture is . . . an interactive dynamic resulting in portraits . . . that can be understood only as part of a process involving the bridging of the conscious and the unconscious, the historical and the actual, the real and the imagined."[23] For his part, Brilliant warns that portraiture is a "deceptively accessible genre," and Pointon echoes this, demanding that its students "interrogate imagery as representation, not accept it as mimesis."[24] It is now clear that we must not take Copley's portraits at face value.

T. H. Breen posits that in colonial portraiture the postures and faces of the subjects sometimes were less important, to both painter and sitters, than the clothing, fabrics, and other appurtenances—the consumer goods—with which they were shown.[25] This observation reminds us that Copley lavished equal attention on all parts of his composition, and that his skill at rendering materials played a major role in the way he constructed each painting. As Breen points out, in terms of value the most important British export to America in the eighteenth century was cloth: half of all colonial imports were textiles, and by Copley's era dozens and dozens of fabrics, including every kind and color of satins, velvets, brocades, poplins, cottons, and woolens, had become available.[26] If the portrait was, at least in part, "an object, a thing, an article of commerce, an ornament to be displayed with other possessions" in colonial America, as Breen maintains,[27] then the vast swags of luxuriant fabric that appear in Copley's portraits from the time of his earliest efforts, such as *Charles Pelham* and *Mary and Elizabeth Royall* (cat. nos. 2, 10), become understandable as representations of wealth and social position. Curtains had been used in portraits since the Renaissance, both for decorative purposes and to suggest interior spaces adjoining the sitter's space, and English painters of the generation of Thomas Hudson (1701–1779) employed them regularly; but they became nearly ubiquitous in Copley's portraits during the 1760s, joining an array of other materials. He typically placed a curtain on one side of the background or the other in his pictures of both men and women, and often included either a draped table or an upholstered chair—all in addition to the fabrics of the rich,

complex costumes in which his sitters were dressed. Here as in other details Copley missed the mark in terms of contemporary British usage, for by the 1760s Reynolds, Gainsborough, Allan Ramsay, and the like had long since given up such extensive display of fabrics. Copley's reliance on fabrics was made possible by the settings he utilized, which most often represented either interiors or ambiguous porchlike areas, while the British painters by this time had moved their sitters largely to the out-of-doors.

Much as Copley attempted to render the "general air of grandeur" that Reynolds recommended, by posing his sitters with great columns and other lavish props, and much as he may have tried to avoid minuteness (which for Reynolds constituted "the most dangerous error"),[28] especially after this quality was criticized in *Boy with a Squirrel*, in Boston he was unable to paint in a true English style. Yet his work does come close in spirit or manner to the occasional high-style English painting of the previous generation by a Hudson (see fig. 71) or a Joseph Highmore, or to a picture of Copley's own time by such London painters as Ramsay and Francis Cotes, or by one of their provincial colleagues, such as Joseph Wright of Derby, Mason Chamberlin the elder, or Tilly Kettle (see fig. 72). These analogies have been little explored and warrant a thorough study of the kind that John Kirk has given to American and British furniture and that Morrison Heckscher and Leslie Bowman have applied to the Rococo style.[29] However, enough work has been done to suggest that despite the increasing anglicization of American taste in the pre-Revolutionary years, when consumers, craftsmen, and painters such as Copley were all looking to London for guidance, remarkably enough there emerged in the arts of the colonies what Kirk concludes was "an American aesthetic," an aesthetic that frequently exhibits conservative, elegant, linear characteristics.[30] Copley's American work thus relates to the paintings of Reynolds and Gainsborough in much the same way that American silver and furniture of the period relate to high-style luxury products made in London.

Recent scholars usefully speak of portraits as being "self-fashioned," that is, as collaborative efforts of painter and sitter. We know of the pressure on Copley to produce likenesses, but there is relatively little evidence about the other demands or hopes of his patrons. That sitters sometimes played active roles in creating the image is occasionally documented, however. Captain John Small, for example, commissioned both a pastel portrait and a miniature of himself; later, when he ordered a replica of the pastel, he was very specific about requesting changes in the composition.

Fig. 71 Thomas Hudson. *Charles Pinfold*, 1756. Oil on canvas, 50 x 40 in. (127 x 101.6 cm). Yale Center for British Art, New Haven, Paul Mellon Collection B1981.25.368

Fig. 72 Tilly Kettle. *Portrait of a Man*, ca. 1764–69. Oil on canvas, 50 x 40⅜ in. (127 x 102.5 cm). Yale Center for British Art, New Haven, Paul Mellon Collection B1973.1.32

He asked the painter to place his face higher in the composition and to add more of his body and more drapery, and he expressed the hope that Copley could include his hand holding some papers, a detail for which he would pay extra.[31]

There is a paucity of information about how Copley and his sitters actually went about the fashioning of images. However, the reappearance of the same curtains, table coverings, tables, and chairs in various portraits leads us to believe that these elements often represented the painter's studio props rather than the subject's own possessions. Surprisingly perhaps, especially for those who have seen Copley as very much the literal realist, this also seems to be the case regarding many of the costumes. In her essay that follows, Aileen Ribeiro tells us that a third or more of the women Copley painted appear in fanciful costumes, dresses that did not actually exist but were invented by artist or sitter for the portrait. Copley learned to concoct costumes from West, who advised him to "take your Subjects from Nature" but cautioned, "dont trust any resemblanc of any thing to fancey, except the dispositions of they figures and they ajustments of Draperies, So as to make an agreable whole."[32] Other female subjects are portrayed in dresses copied from print sources. Three similarly posed Copley sitters of about 1764, for example, wear exactly the same brown dress taken from a mezzotint after a painting by Hudson, a dress neither they nor the painter would have seen.[33] A year or so earlier Copley pictured Mercy Otis Warren (cat. no. 15), Mrs. Benjamin Pickman, and Mrs. Daniel Sargent (figs. 73, 74) in the same fashionable blue dress; each of these women is posed differently, so that the dress is seen from a different angle in each painting, suggesting that it was painted from nature and that one of the models might have owned it.

Andrew Wilton makes the point that in British portraiture men were most often shown in the garb of their professions or avocations, or with unmistakable references to such, while women were not, and thus there is likely to be a "stronger element of sheer make believe in female portraiture."[34] The same observation holds true for American portraiture in general and for Copley's work in particular. American pictorial conservatism usually kept Copley from overtly posing female sitters as Diana, Venus, or Chastity, or in theatrical roles, guises commonly employed by his British counterparts; yet colonial practice, like the English, nonetheless apparently encouraged more use of fantasy in women's portrayals than in men's. In contrast to the women, Copley's men are all dressed in real costumes, ones that might have belonged to them. Fantasy, in the case of Copley's portraits of men, is confined to elements other than clothing.

Fig. 73 *Mrs. Benjamin Pickman (Mary Toppan)*, 1763. Oil on canvas,
50 x 40 in. (127 x 101.6 cm). Yale University Art Gallery, New Haven,
Bequest of Edith Malvina K. Wetmore 1966.79.3

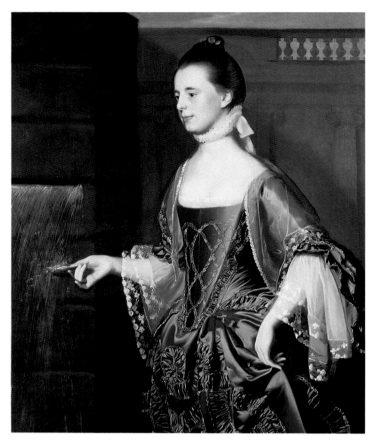

Fig. 74 *Mrs. Daniel Sargent (Mary Turner)*, 1763. Oil on canvas,
50 x 40 in. (127 x 101.6 cm). Fine Arts Museums of San Francisco,
Gift of Mr. and Mrs. John D. Rockefeller 3rd 1979.7.31

These fantastic elements, in his paintings of women as well as of men, coexist with plausible things, for Copley's pictures—like all Western portraits—present a combination of the plausible and the imaginary, of the observed and the conventional, of fact and aspiration. In Renaissance portraits, as Lorne Campbell writes, "objects placed in the sitter's hands, or close to him, might indicate his real or assumed status or interests."[35] Similarly, in Copley's paintings subject after subject, men and women alike who had never left Portsmouth or Boston, pose near Roman columns, balustrades, and fountains as if on the Grand Tour, and some, like Nathaniel Sparhawk, are given entire villas. Many sitters of both sexes are portrayed holding books (reflecting the high value placed on literacy in colonial culture and the related fact that Boston boasted some thirty bookstores in Copley's time), but only men hold letters or pens. This latter might seem surprising in view of how important letter writing was for both men and women in eighteenth-century America; instead it indicates once again how wedded Copley was to venerable pictorial traditions and to the telling of fictions, for the sword, walking stick, and pen were "key attributes of the Renaissance gentleman" and had long been

reserved as male symbols.[36] At the same time, the portraits of certain male sitters include attributes that are real, that is, demonstrably appropriate to those men. Two of Boston's wealthiest merchants, John Hancock and Nicholas Boylston (cat. nos. 22, 31), are shown with their giant ledgers, and behind Boylston and several other businessmen are ships that presumably represent their overseas interests. In addition, Copley painted a handful of men with objects uniquely associated with their own professions or avocations: we think of Paul Revere with his silver teapot (cat. no. 46), Dr. Joseph Warren, later to die at Bunker Hill, with drawings of a skull (fig. 75), the pioneering astronomer John Winthrop with his telescope (fig. 225), and, of course, Samuel Adams with the Massachusetts Charter (cat. no. 62).

Copley attempted to cast his women in an idealized mode, as called for by English practice, by generalizing them more than his male sitters, picturing them in luxuriant fashions, and seldom giving them specific, unique attributes representing their own individual interests or lives. Beginning with his earliest portraits, Copley showed women with what he knew to be traditional feminine emblems: his subjects display jewelry, they stand near fountains and gesture to-

ward falling water, they hold shells or fans. Even more often they are presented with flowers or fruit, symbols Copley surely knew had long been associated pictorially with the Virgin, Flora, and other female figures from history and myth. For example, Hannah Hill Quincy holds a sprig of larkspur, Mercy Otis Warren gestures toward growing nasturtiums, and Rebecca Boylston holds a basket of cut flowers in the first portrait Copley painted of her, when she was unmarried, and then in her second likeness, after she became the wife of Moses Gill, she stands next to a profusely blossoming pot of lilies. Apparently, at least the last subject, both as Miss Boylston and Mrs. Gill, really did have charge of extensive gardens; however, given the lack of information about the individual commissions, it is impossible to know whether Copley included flowers in her portraits and others as markers of a given sitter's specific interests or simply as generalized emblems appropriate to her station in life. Among the women the artist portrayed with fruit are Hannah Fayerweather Winthrop (cat. no. 79), who grasps a nectarine branch; Elizabeth Storer Smith and Martha Swett Lee (cat. nos. 51, 53), who hold grapes in their laps (the latter somewhat implausibly, as she is also climbing stairs); and Elizabeth Lewis Goldthwait (cat. no. 60), who reaches out to touch a dish of ripe apples and peaches. All four of these

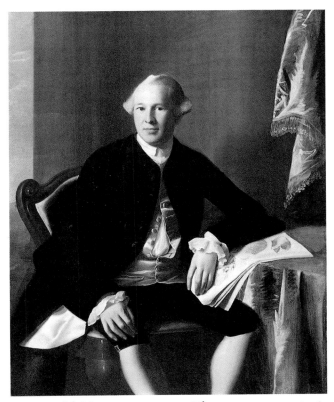

Fig. 75 *Joseph Warren*, ca. 1772–74. Oil on canvas, 50 x 40 in. (127 x 101.6 cm). Museum of Fine Arts, Boston, Gift of Buckminster Brown, M. D., through Mr. Church M. Matthews Jr., Trustee 95.1366

women had children, and we inevitably wonder whether Copley incorporated fruit in their portraits in order to allude to his sitters' fecundity. He may well have, but it should be noted that he also depicted a young boy and several mature, childless women carrying fruit, which suggests that artistic convention may have played a more powerful role for the artist than personal iconography in the choice of women's attributes.[37]

Copley's portraits of women have yet to receive intensive study but deserve scrutiny, for they should throw light on both the artist and his culture. Nearly half of all Copley's sitters were women. In addition, just under 50 percent of all of his portraits represent a man or a woman whose spouse he also painted—that is, one of a pair of images of a couple.[38] His handling of husband-and-wife pendants reveals the evolution of a distinctive interpretation of women, wherein he came to reject the conventions of marriage portraiture as it had been practiced since the Renaissance. In seventeenth-century Dutch pairs, for example, the man is often pictured in a deeper and more open space than the woman, who is frequently shown indoors, suggesting the limitations on her freedom.[39] Similarly, Dutch wives typically make subtle but well-understood gestures of deference or submission; thus, in many paintings they seem ready to listen, while the husband seems about to say something. Copley's pairs of the 1750s reflect the European tradition; representative are the pictures of Mr. and Mrs. James Otis (figs. 76, 77), in which Mr. Otis looks as if he is about to speak his mind or perhaps to read from his open book, while Mrs. Otis has closed her book and appears to await his words. However, the balance begins to shift in his pendants of the early to mid-1760s, such as the portraits of Mr. and Mrs. Daniel Hubbard, 1764 (The Art Institute of Chicago; fig. 23), in which the woman takes the customary masculine standing position and holds papers; Mrs. Hubbard strikes us as ready to take charge, and her husband sits and waits. During the very late 1760s and the 1770s, in *Isaac Smith* and *Mrs. Isaac Smith* (cat. nos. 50, 51) and other paintings of couples, Copley's women increasingly seem capable, independent people who look boldly out of the paintings, their eyes meeting ours.

Copley's earliest pictures are relatively conventional and somewhat repetitive, but by the mid-1760s he was painting members of both sexes more as individuals and less as generalized figures, and the change is particularly evident in the portraits of women. The new approach emerged beginning about 1763 with *Mrs. James Warren* (cat. no. 15), in which we sense under all the trappings of fashion and conformity a human being, an individual with dignity and intelligence,

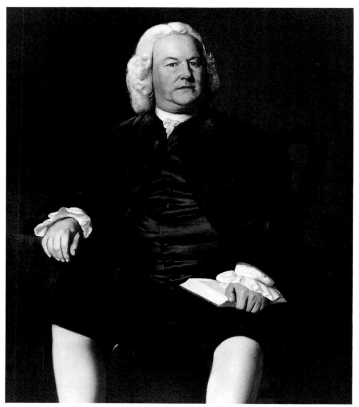

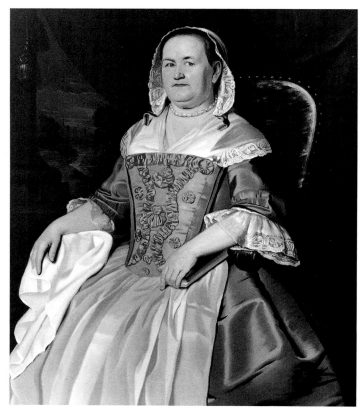

Fig. 76 *James Otis*, ca. 1758. Oil on canvas, 49½ x 39½ in. (125.7 x 100.3 cm). Wichita Art Museum, Kansas, Roland P. Murdock Collection

Fig. 77 *Mrs. James Otis (Mary Alleyne)*, ca. 1758. Oil on canvas, 49½ x 39½ in. (125.7 x 100.3 cm). Wichita Art Museum, Kansas, Roland P. Murdock Collection

and one who knows she looks awkward in her borrowed dress. Very different is Gainsborough's *Lady Carr* (fig. 78), painted at just this time, for the English sitter's distant, preoccupied attitude and her pose seem perfectly at one with her artificial-looking dress and flowers. Copley's *Mrs. William Coffin* (fig. 202) is one of a series of old women, begun about 1763, who are at once frail and strong and who are painted powerfully and directly, in contrast to English usage. *Mrs. Moses Gill* too stands apart from English convention: though the subject looks slightly more at home in her elegant dress than Mrs. Warren, there is still a gap, one that never exists in a Reynolds or Gainsborough portrait, between the luxuriance of the costume and surroundings on the one hand and the straightforwardness, accessibility, and reality of the sitter herself on the other.

Even more telling in their realism and psychological penetration are two paintings of men and a related sequence of portraits of women that Copley executed. In 1763 he portrayed Mrs. Nathaniel Appleton (Harvard University, Cambridge, Massachusetts), apparently lost in thought, resting her head against one hand; in 1768 he painted Paul Revere (cat. no. 46) in creative contemplation, his chin in his hand; and about the same time he depicted John Bours (cat. no. 56) during a poetic reverie, with one hand to his face and the

other holding a book he seems to have been reading. The attitudes of all three sitters are based on the traditional poses of men of genius, recalling Van Dyck's picture of Henry Percy, from about 1636, in which Wizard Earl's head rests on his right hand, or the similarly posed likenesses of Handel by Philip Mercier, Alexander Pope by Charles Jervas, and Reynolds's portraits of such cultivated figures as Horace Walpole and Laurence Sterne (figs. 79, 80). This format had been reserved for creative men of an exalted sort—for poets, painters, musicians, and philosophers. However, Copley broke with the convention, employing it first for a woman and subsequently for a mere craftsman, a silversmith whom most would have thought worked only with his hands, and a contemplative merchant. Then, between 1771 and 1773, he used this pose signifying introspective genius for a remarkable series of portraits of women. First was the elderly Mrs. Devereux (cat. no. 59), shown seated at a fragile gateleg table with a polished surface that mirrors her arms and the quiet internal reflection expressed on her face. She rests her chin in her right hand in a pose that echoes Revere's. Mrs. Devereux's picture was followed by a portrait of Mrs. Thomas Gage (cat. no. 67), who is presented reclining on a sofa, and then by *Mrs. Richard Skinner* (cat. no. 76) and *Dorothy Quincy* (fig. 224), in which the subjects sit at the same table

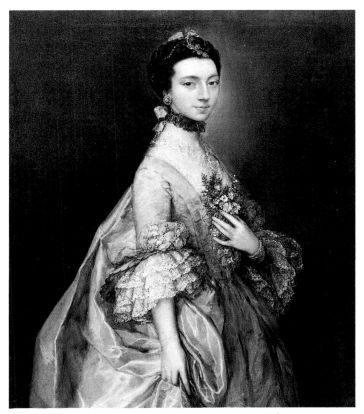

Fig. 78 Thomas Gainsborough. *Lady Carr*, ca. 1763. Oil on canvas, 50 x 40 in. (127 x 101.6 cm). Yale Center for British Art, New Haven, Bequest of Mrs. Harry Payne Bingham B1987.6.2

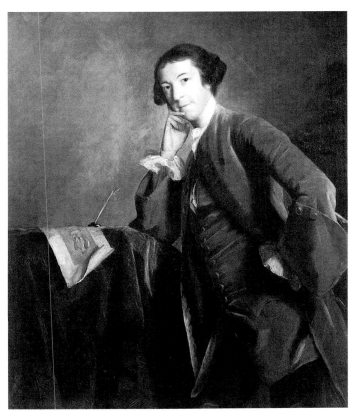

Fig. 79 Sir Joshua Reynolds. *Horace Walpole*, 1756. Oil on canvas, 50 x 40 in. (127 x 101.6 cm). Art Gallery of Ontario, Toronto, Bequest of John Paris Bicknell, 1952 51/32

that appears in *Mrs. Humphrey Devereux*. Mrs. Gage, Mrs. Skinner, and Mrs. Quincy all gaze thoughtfully into space, each with a hand to her head, yet the composition in which each is portrayed differs from the others in its specific details and coloring, and from each painting we gain the impression of a strong, memorable individual. Though these women are sumptuously dressed, and Copley spares nothing in the rendering of materials, the artist has replaced the columns, curtains, and outdoor vistas of earlier pictures with dark backgrounds like those in *Paul Revere, John Bours*, and other portraits of men from his last years in America. The bland materialism of the earlier pictures has given way to a mood of quiet introspection, a mood Copley finds as appropriate for women as for men.

Copley's respectful and sympathetic late portrayals of women were largely unprecedented in American or English art, yet his evolving attitude reflects the stirrings of change in colonial America. These stirrings were expressed not only in Copley's paintings but also by the voices of other colonials who shared his advanced perception of women as intelligent, thinking, equal beings. As we have noted, Copley placed books in as many female hands as male; this he did despite the fact that colonial women were far less likely to be literate than men, due to their vastly inferior educational oppor-

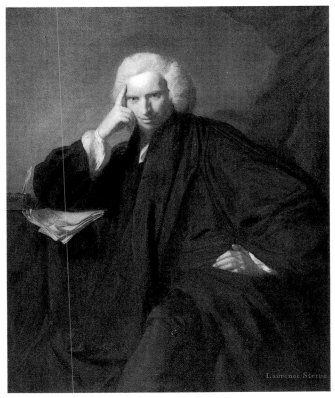

Fig. 80 Sir Joshua Reynolds. *Laurence Sterne*, 1760. Oil on canvas, 50⅛ x 39½ in. (127.3 x 100.4 cm). National Portrait Gallery, London

tunities. The issue of women's learning clearly was in the wind: we find Abigail Adams complaining to her husband during the 1770s, "I regret the trifling narrow contracted education of Females in my country. You need not be told how much Female education is neglected, nor how fashionable it has been to ridicule Female learning."[40] Women lacked many rights in colonial society; for example, they were ineligible for public office and could not vote, their property was transferred to their husbands' control when they married, and they were effectively restricted from seeking divorce.[41] However, in 1764, about a year after Copley painted Mercy Otis Warren, her brother James Otis Jr. asked in a pamphlet entitled *The Rights of the British Colonies Asserted and Proved*, "Are not women born as free as men? Would it not be infamous to assert that the ladies are all slaves by nature?"[42] Moreover, in 1773 two women won the first divorces granted on the grounds of adultery in Massachusetts, and Massachusetts became the first colony to institute a divorce statute.[43] And, as Carl Degler tells us in his valuable study of women and the family in America, there is considerable evidence that greater affection and love between spouses, along with increased freedom and equality for women within marriage, were beginning to emerge just at this time.[44] There is more than a hint of this enhanced feeling and status in Copley's two magnificent late double portraits of married couples, *Mr. and Mrs. Thomas Mifflin* and *Mr. and Mrs. Isaac Winslow* (cat. nos. 80, 81). In the portrayal of the older couple, the Winslows, the wife folds her hands, defers in the conventional way, and averts her glance from the viewer and toward her husband, who boldly faces front; nonetheless a strong sense of affection and respect between the two is conveyed by their harmonious gestures and their physical closeness, with their hands and legs nearly touching. However, in the rendition of the young Mifflins, a new kind of relationship is encountered, for here it is the husband who gazes toward his wife, who in turn glances up forthrightly from her work and looks out of the picture to make contact with the external world.

Copley's women lack the haughty, distant, to-the-manor-born look of Reynolds's or Gainsborough's more generalized subjects, despite the American's best efforts to adopt English style. (They even make the female sitters of Cotes, the English artist who emphasized decorative details in somewhat the same way Copley did and who himself never achieved the atmospheric, overall effects of Reynolds, look vapid and unreal by comparison.) Copley's intense male sitters bear much the same relationship to English portrait subjects. Despite his ongoing problems with drawing and foreshorten-

ing, especially when it came to arms and legs, Copley gave us men who are memorable as particular people; when we see his Samuel Adams or his Eleazer Tyng or Thomas Cary, we see the individual, not the type. Like their female counterparts, Copley's men look increasingly uncomfortable the more dressed up they get, the more their props and surroundings are idealized. The artist succeeded in making a Nicholas Boylston look haughty and rich perhaps because he *was* haughty and rich; but when he pictured Nathaniel Sparhawk or Mr. and Mrs. Jeremiah Lee in royal trappings and impossibly grand settings, they look ludicrous—and they look as if they know it.

III

Many scholars have remarked that Copley's subjects do not betray any reaction to the political, social, and economic realities of their time. Indeed, in presenting images of a genteel and complacent elite, Copley surely was creating deliberate fictions, as Paul Staiti writes in this volume. Copley's Boston was beset by economic hardship and by social strife and political upheaval that threatened the minority of its citizens, Whigs and Tories alike, who were his patrons and enjoyed material abundance. Boston's merchant class, which accounted for about half of Copley's patronage throughout his career, went into a decline after reaching its apogee in 1760.[45] A fire brought devastation in 1760, and "recovery from [it] had scarcely begun at Boston when harder times than that stricken city had ever known descended." Crime was on the rise: "gangs of thieves looted shops and warehouses with impunity," and highway robbery had become such a problem that in 1761 Massachusetts passed a law making it punishable by death.[46] A smallpox epidemic that raged in 1761 was followed by a more serious one three years later, when 170 people died and many fled the city in terror. Bostonians had a wide choice of houses of ill repute and in 1768 saw several hundred camp followers arrive from Halifax in the wake of the British troops that occupied the city in October. Carl Bridenbaugh goes so far as to speak of Boston's "moral and economic collapse" after the French wars.[47] Yet Copley's contemporary portraits offer no hint of disturbance.

Boston's economic problems set the stage for the city's emergence as a center of political protest during the 1760s and as a crucible for the events that led up to the final, drastic break with Great Britain in 1776. The powerful merchants and their friends and family members who were Copley's sitters played key roles in the ongoing struggles, and it is difficult to imagine how any of them had time to

commission a portrait during these tumultuous years. But, as we have seen, commission they did: over his twenty-one-year career in Boston, Copley painted at least 350 portraits, an average of nearly 20 annually.[48]

Copley had attained a full-fledged, mature Baroque style by about 1763, as evidenced in a series of elegant portrayals of young couples, including the Benjamin Pickmans, the John Murrays, the Daniel Sargents, and the James Warrens. Significantly, 1763 marked the beginning of the Revolutionary era, according to many historians, and, equally significantly, all of the subjects in these portraits look prosperous and untroubled. By the same token, there is no reflection of turmoil in the work of 1764, judging from the full-length portrait of the richly attired Nathaniel Sparhawk (cat. no. 19) or the likenesses of other confident, complacent merchants, such as Epes Sargent II and Moses Gill (cat. nos. 16, 18), although this was a year fraught with problems.

During the period of crisis and escalating anger at the British that followed the passage of the Quartering Act and the Stamp Act, Copley continued to seek aesthetic guidance from English artists more determinedly than ever. His achievement reached new heights as he painted both the *Boy with a Squirrel* (cat. no. 25) and perhaps his most important commission to date, *John Hancock* (cat. no. 22). In portraying his young half brother in the *Boy with a Squirrel*, Copley perfected his techniques for rendering a wide range of textures and materials—the shiny tabletop, the pink satin collar fit for a prince, the gold chain and the squirrel's coat, the boy's downy hair and his convincingly rendered right hand. Then, in his portrait of Hancock, whose Beacon Hill neighbor he would become just four years later, he presented the inheritor of Boston's greatest fortune and possibly its most ambitious young man. Copley interpreted the future president of the Continental Congress as a somewhat ambivalent personage, important, proud, handsome, yet also nervous, uncertain, and distant. Hancock holds a large pen, which would become a wonderfully appropriate symbol for the man after he gained fame for signing the Declaration of Independence with a bold hand, and wears an elegant blue jacket with gold buttons and gold piping. Ironically, in view of the sitter's political position, this garment represented the height of London style, for an almost identical jacket appears in Reynolds's portrait of the fashionable Warren Hastings (fig. 81), painted a year or two after *John Hancock* was completed. Hastings, like Hancock, sits with his gaze averted in front of a red curtain; but the space he inhabits, unlike Hancock's, is believable, and unlike Hancock, he looks both relaxed and authoritative. When he executed *John Hancock*,

Copley seems to have realized, perhaps for the first time, that, despite the limitations of his training and patronage, he could express not only formal concerns but also cultural and subjective ones; he knew, therefore, that he was a true painter and not merely a craftsman, like the carpenters, tailors, and shoemakers in whose company he was mortified to have been placed by his countrymen.[49]

Copley would go on in the later years of his American career to produce some of his most telling portraits—in the face of an ever-worsening political situation. Indeed, an extreme crisis point was reached when two regiments of British troops landed in Boston in 1768, and there followed in the city "a virtual state of siege for eight long years."[50] It was just about the time the siege began that Copley painted Paul Revere (cat. no. 46), the silversmith and patriot courier, and Thomas Gage (cat. no. 66), the British commander, men at opposite ends of the political spectrum, but both rendered highly effectively. Copley clearly responded better to some sitters than to others; yet, as is demonstrated here, even the most extreme political views and activities of his subjects were irrelevant to the results he achieved. As the artist would write to West in 1770, "I am desireous of avoideing every imputation of party spir[it], Political contests being neighther pleasing to an artist or advantageous to the Art itself."[51] However, regardless of Copley's intentions, *Paul*

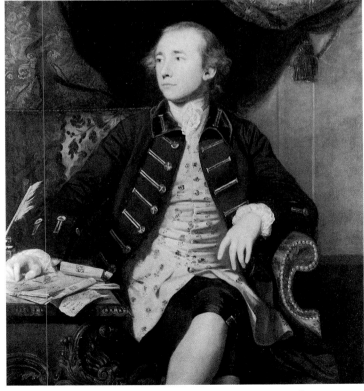

Fig. 81 Sir Joshua Reynolds. *Warren Hastings*, 1766–68. Oil on canvas, 50¼ x 40⅛ in. (127.5 x 102 cm). National Portrait Gallery, London

Revere was a political work, and his most important one to date, for it was nothing less than a painting of America's future. In his almost contemporaneous pastel *Portrait of the Artist* (fig. 25), Copley portrayed himself as a gentleman in silks, while he pictured Revere as a craftsman dressed informally in an open-necked shirt (in his only finished work that shows an artisan so attired). But it was Copley who left the colonies for England and Revere who stayed in America. The upper class that Copley had joined would largely be ruined by the Revolution, whereas the middle class—as represented by Revere in shirtsleeves—would build the new nation.[52]

Although tensions between the colonists and the British troops exploded in the so-called Boston Massacre of March 5, 1770, when five civilians were killed by shots from the soldiers, a period of relative calm ensued in 1771 and 1772. During this peaceful moment patriot leaders Samuel Adams and John Hancock temporarily became opponents; their reconciliation after a few months may have provided the occasion for Hancock's commissioning of Copley to paint a portrait of Adams, a likeness unique in the artist's oeuvre in terms of its treatment of time. In his astute study of British portraiture, Wendorf writes that the painter must decide either to "capture a distinct and significant moment" in his subject's life or to "suspend time, by creating an idealized portrait in which the subject is released by temporal contingencies."[53] Copley chose the latter alternative in nearly all of the pictures he executed before about 1764, painting his subjects as if time did not exist. He then discovered another possibility, one that recalls the practice of Hals, and began to portray a number of his subjects—among them Paul Revere, Nicholas Boylston, and Mr. and Mrs. Ezekiel Goldthwait—as real people, who are on the verge of speaking or moving. The time in which each exists is both of the instant and eternal; the moment chosen is not historically significant but is important because it is the one selected collaboratively by painter and sitter and because it is the moment in which we come to know the sitter. *Samuel Adams,* however, is the one painting in which Copley captured a truly "significant moment" in Wendorf's sense of the term, for it records Adams's confrontation with Lieutenant Governor Thomas Hutchinson after the Boston Massacre, when the patriot spoke for the rights of the people of Massachusetts.

The renewed struggles of 1773 were capped on December 16, when Samuel Adams's followers threw the English tea on board the *Dartmouth* into Boston Harbor. The chief consignee of the shipment was Copley's father-in-law, Richard Clarke, primary agent for the East India Company in Boston.

The crisis had now become both acute and personal for Copley, and the artist developed what one of his contemporaries called a "sudden determination" to make the European trip he had been considering for a decade.[54] He apparently painted very little, if at all, during the first months of 1774 and sailed for England in June of that year, never to return to America.

Copley's keen instincts told him to leave Boston, and he escaped just months before the collapse of the merchant society that he had painted so successfully. In September 1774 the first Continental Congress convened in Philadelphia and voted approval of the Suffolk Resolves, which had been written in Boston by Joseph Warren and carried on horseback to Philadelphia by Revere. Early in 1775 the Massachusetts Provincial Congress, under the leadership of Hancock and Warren, began to prepare the colony for war, and in April, Gage, now governor, ordered seven hundred British troops to march on Concord in order to seize colonial war supplies there. One of the earliest casualties of the developing conflict was Copley's subject Jeremiah Lee, the proud and prosperous Marblehead merchant, who fled from an inn in Menotomy (now Arlington), Massachusetts, on the arrival of British troops on April 18 and spent the night hiding in a cornfield; as a result of the exposure he suffered, he developed a violent fever and died a few weeks later.[55] On that same evening of April 18 Revere made his famous ride to Lexington to warn Adams and Hancock of the approach of the British. The Battles of Lexington and Concord followed later in April, the Battle of Bunker Hill (where Warren perished) in June, and in March 1776 the British evacuated from Boston. A thousand Loyalists left with the British fleet for Halifax, including Copley sitters Mr. and Mrs. Isaac Winslow, Sylvester Gardiner, and young Henry Pelham.

The Revolution further damaged Boston's already faltering economy, ending the role the elite, anglophilic merchant class played in it. Boston's population plummeted to no more than 3,500 in 1776.[56] The war completely disrupted the world that Copley had known, although he himself had the good luck to be reunited in London with his wife, Susanna, and three of his four children, along with his father-in-law, in October 1775; but he never again saw his youngest son, who did not survive infancy, or his mother, who remained in Boston, where she looked after his property until her death in 1789.[57] Others encountered less happy fates, as the war divided the families and destroyed the fortunes of many wealthy colonists, both Patriot and Loyalist. Tory Samuel Quincy, for example, fled to London, while his wife, Hannah Hill Quincy, stayed in Boston. John Hancock, on the other

side of the political fence, went on to high political office but lost most of his fortune in the process.

In any case, it is perhaps irrelevant to cite the political allegiances of those who suffered, for several historians, including John W. Tyler, have recently made the important point that most colonists cannot be classified simply as Patriots or Tories, good people on the right side and misguided ones on the wrong side.[58] In reality, the politics of Boston during the years Copley flourished there, especially in the final decade of his American career, were in constant flux, as economic circumstances, political crises, and ambitious personalities on both sides of the Atlantic interacted. Except for British government officials such as Gage or Hutchinson and the most ardent defenders of colonial rights such as Samuel Adams, few had fixed or extreme positions until the final years or perhaps months before the Revolution erupted. Most historians believe that even Adams did not envision the goal of independence until the late 1760s. Moreover, as Richard L. Bushman makes clear, colonial society had an enormous stake in polite behavior, and the genteel observance of the rules of manners and decorum was more important than politics until the very end.[59] Political opponents continued to dine together almost to the moment the first shots were fired. Thus the merchant, bon vivant, and diarist John Rowe (himself a cautious Whig who nonetheless was supportive of his son-in-law John Linzee, commander of a British warship) recorded that he had dined in Ipswich as late as June 17, 1772, with zealous patriots Jeremiah Lee, John Adams, and Samuel Calef, as well as with Epes Sargent II, a devoted Loyalist.[60] (So extreme, in fact, was Sargent's position that the residents of Gloucester would boycott his business and drive him from town.)

IV

Why did so many people, located at all points on the political scale, in and around Boston, and in New York during the seven months the painter worked there in 1771, commission portraits from Copley? How can we explain why, in this fragile (and largely doomed) merchant society, men and women under intense political and economic pressure made significant commitments of time and money in return for painted likenesses? It was surely not because they agreed with Copley and appreciated painting as "one of the most noble Arts."[61] Rather, anglophilic colonial Americans commissioned portraits because doing so was a customary part of their English cultural heritage. In Boston there were many British portraits hanging in private homes and public buildings to remind colonists of this legacy, and since the 1670s

prominent families in Boston and its environs had forged their own tradition of ordering likenesses. Well versed in the procedure, these families would have instinctively known the right occasion for commissioning a portrait: an engagement or a marriage (*Ann Tyng, Mrs. Samuel Quincy, Mrs. Moses Gill* [cat. nos. 7, 12, 34]), a grand new house moved into (the series of Boylston pictures, *Woodbury Langdon* and *Mrs. Woodbury Langdon* [cat. nos. 35, 36]), an inheritance gained (*John Hancock, Reverend Thomas Cary* [cat. nos. 22, 65]), or perhaps graduation from Harvard (*Theodore Atkinson Jr.* [cat. no. 8]). Older couples such as the Isaac Smiths, the Jeremiah Lees, or the Ezekiel Goldthwaits (cat. nos. 50, 51, 52, 53, 60, 61) apparently had themselves painted simply to celebrate their prosperity or perhaps because of the "craving for fame" or immortality that Friedländer suggests is the basic motive of all portrait sitters.[62] We have little or no idea why Copley portrayed craftsmen Nathaniel Hurd (cat. no. 21) and Paul Revere; we can guess that Hancock ordered a picture of Samuel Adams for political reasons. It has often been suggested that likenesses were frequently recorded so that they could be "sent to loved ones far away,"[63] but few full-size portraits seem to have been ordered for this practical reason, *Mrs. Humphrey Devereux* being a notable exception. More were painted after the death of the sitter, to celebrate a noble life or a generous benefaction, as demonstrated by the posthumous full-length portraits of Thomas Hancock, Thomas Hollis (figs. 1, 2), and Nicholas Boylston (fig. 135).

As Carrie Rebora suggests in her essay in this publication, despite all the research that has been done on the period, there is a great deal about Copley that we do not know. The lack of information as regards the commissioning process is striking. Not a single sitter left a written record that survives, in a letter, a diary, or any other source, explaining why a portrait was wanted in the first place, how Copley was selected, or what discussions took place about choice of costume, pose, mood, or palette for a painting. One thing we can be fairly certain about: Copley was a slow worker, and sitting for him must have been extremely tiresome. According to Dunlap, the painter Henry Sargent remembered that his mother, Mrs. Daniel Sargent, "told me that she sat to [Copley] fifteen or sixteen times! six hours at a time!!"[64] Other accounts confirm the painter's tedious, painstaking approach. For example, Copley himself declared, "I find . . . that [my portraits] are almost allways good in proportion to the time I give them provided I have a subject that is picturesk." On another occasion he wrote to Henry Pelham from New York: "It takes up much time to finish all the parts of a Picture

when it is to be well finishd, and the Gentry of this place distinguish very well, so I must slight nothing."[65]

Another subject that is largely undocumented and invites conjecture involves the prominent citizens who chose not to sit for Copley. Why did certain members of the merchant and political elite refrain from having their likenesses recorded by the leading portraitist of the era, and what separated them from the men and women who were his eager patrons? As we have seen, Copley painted many of the most talented and prominent people in his community, including the Revolutionary leaders Samuel Adams, John Hancock, and Joseph Warren, the writer and historian Mercy Otis Warren, the engraver Nathaniel Hurd, and the silversmith-patriot Paul Revere, as well as the British General Gage and his wife, and such Loyalists as Mr. and Mrs. Isaac Winslow, the Reverend Myles Cooper, and Andrew Oliver. Indeed, no other American master has ever portrayed such a concentration of leaders from a population at the center of historic events. (Only Thomas Eakins, who in the late nineteenth century painted Philadelphia's intellectual and creative elite, most of whom have been forgotten today, is remotely comparable.) Yet Copley did not paint the majority of Bostonians—certainly not of the middle class and even of the elite stratum. We wonder why Governor Hutchinson, for example, the future president John Adams, the gifted Abigail Adams, the radical James Otis Jr., and the diarist Rowe did not have their portraits painted by Copley, when so many of their friends and contemporaries were doing so.[66] Rowe is a particularly surprising case, for it would have seemed natural for such a wealthy and sociable merchant to commission a likeness from Copley.[67]

It is easier to guess why John Adams did not see fit to have Copley paint him in Boston. Adams's values were far stricter and more puritanical than those of the conspicuous consumers, such as the Boylstons, who were Copley's best customers, and Adams probably considered those who sat for portraits self-indulgent. In 1770 he criticized a friend's wife who "longs to be genteel, to go to dances, assemblies, dinners, suppers, etc." and remarked that he despised such "fribbling Affectation of Politeness, which is to me completely ridiculous."[68] On another occasion, in January 1766, he noted that he "laughed at the great expenses for furniture, as Nick Boylston's carpets, tables, chairs, glasses, beds etc.," and concluded that "The highest taste and newest fashion would soon flatten and grow old."[69] Later in the same year Adams asked himself rhetorically, "Who are to be understood by the better sort of people?"; he answered in a way that many of his contemporaries among the wealthy merchant class

would have found peculiar but which the citizens of the future American democracy would understand: "those of real merit."[70] Thus Adams stood apart from the self-selected group that constituted Copley's patrons, that distinct minority even among the elite, with the means, the requisite vanity, and the materialistic values that led them to sit for the painter.

Another eminent figure we might wish Copley had painted was the Boston-born Benjamin Franklin, who, with the possible exception of Thomas Jefferson, was the most broadly talented American of the eighteenth century. Franklin certainly had the vanity needed to motivate him to commission a portrait, for he sat for a number of other painters, but he had left Boston well before Copley emerged. As Barbara Novak suggests, Copley and Franklin deserve comparison in many ways. Both were pragmatists, and both were products of the Enlightenment. Copley and Franklin both loved money and success, and as artists each of them borrowed heavily from the best English sources, one for his painting, the other for his writing.[71] Moreover, Franklin's *Autobiography*, one of the greatest works of eighteenth-century American literature, shares with Copley's great paintings a clear, distinct, unambiguous style as well as what one critic calls the characteristic of being "not notably accurate."[72]

Perhaps Copley's hard-pressed patrons were willing to spend money on "unnecessary" things such as portraits because the portraits themselves helped assure the sitters and their circle that their world was stable, daily evidence of drastic change to the contrary. Breen suggests that for the upper class "fear of losing place—as much as the dream of upward mobility—spurred additional purchases."[73] Thus the colonial elite went on commissioning portraits almost until the moment of the Revolution, in the same way they persisted in giving the lavish dinners, lunches, anniversary celebrations, and other parties that Rowe described. The merchant aristocracy had a vested interest in continuity and tradition and thereby maintaining its own ruling status. When Hancock and Lee and their fellow Whig merchants protested against British taxes in the years before the Tea Party, they were arguing for their rights as Englishmen, just as Copley was casting himself as an Englishman painting in the English tradition. Bostonians of all parties saw nothing inconsistent in drinking toasts on each anniversary of the repeal of the Stamp Act as well as on the birthdays of the king and queen.[74] Copley and his sitters were much involved in the tumultuous events of the day, but his portraits themselves gave no indication of the crisis until the late 1760s, by

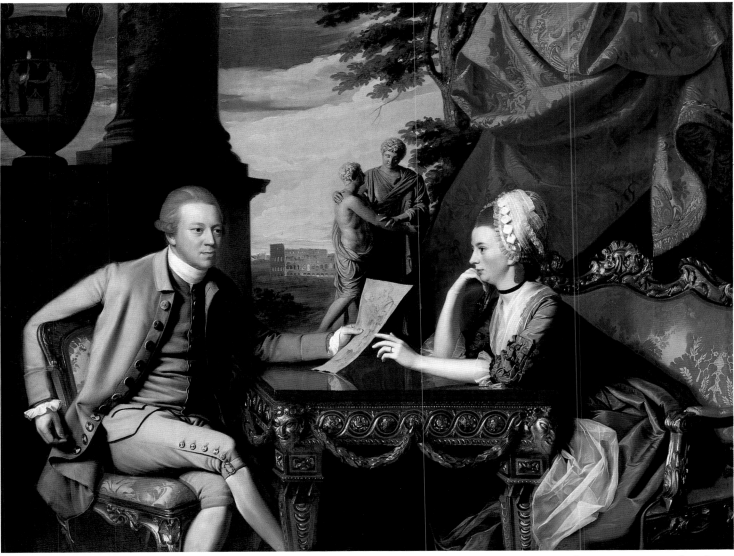

Fig. 82 *Mr. and Mrs. Ralph Izard (Alice Delancey)*, 1775. Oil on canvas, 69 x 88½ in. (175.3 x 224.7 cm). Museum of Fine Arts, Boston, Edward Ingersoll Browne Fund 03.1033

which time it had become acute and unavoidable; even then, any stylistic changes are relatively restrained and subtle. This reminds us how deeply unrealistic these portraits are in literal terms but underscores how well they demonstrate the colonial culture's fierce attachment to status and convention. As Bushman wrote of this era in America, "Gentility hid what it could not countenance and denied whatever caused discomfort."[75]

How much about the quality of the times can be read in the late pictures? As numerous writers have observed, the portraits became increasingly sober with the approach of the Revolution. And certainly Copley himself had every reason to feel concern not only for the whole of genteel society but also for his own livelihood and the welfare of his family. His commissions fell off considerably after 1770, and only the mining of a new group of customers in New York in 1771

saved him from hard times.[76] Beginning in 1767 or 1768, as Boston came under siege, Copley muted his colors—surely in response to the grim spirit in the air—turning to a virtually monochromatic palette in many pictures, such as *Paul Revere* and *Mrs. Humphrey Devereux*.

A comparison of two portraits of Nicholas Boylston measuring 50 x 40 inches, the first executed in 1767, the second perhaps two years later, provides telling evidence of the evolution of Copley's color treatment. The earlier picture (cat. no. 31) is a study in reds (the curtain, the drape on the table, Boylston's hat) and blues (his robe), with a yellow note at the center of the composition (his exquisite vest). Copley by this time had become a sophisticated colorist (a little-studied aspect of his work) and now was able to use color not only for decorative purposes but for psychological ones as well. Thus, using the three primaries in fairly intense tones, he

Fig. 83 *Winslow Warren*, 1785. Oil on canvas, 30 x 25 in. (76.2 x 63.5 cm). Museum of Fine Arts, Boston, Gift of Winslow Warren 57.708

here created a cautiously optimistic image. However, in the second version (cat. no. 32) he presented a very different impression. Although he made each color relate closely to the others, as in the first portrait, he substituted secondary and tertiary hues for the bright primaries: the elegant robe is now an unlikely but very beautiful brown, the yellow vest has become dark purple, and the curtain is dark blue-green. The result is a picture that is more somber and pensive than the earlier one; the sense of serenity and well-being has been drained from the image, just as confidence and complacency were evaporating from the painter and his society.

Copley's two interpretations of Hancock reveal a similar change of attitude. When he painted Hancock in 1765 (cat. no. 22), he pictured him in a large-format portrait surrounded by trappings of wealth and power, such as red velvet curtains and tablecloth and business ledgers that suggest his financial empire. But when he portrayed him a second time, between about 1770 and 1772 (cat. no. 23), he fashioned an image on a modest scale and showed little but the sitter's face, half in shadow, emphasizing his worried expression. Copley's choices here are representative of the approach he adopted by 1770. In the portraits of this time the backgrounds are likely to be dark and empty of the rich curtains, columns, and vistas of the earlier compositions. Copley now concentrated on the head—indeed, it seems on

the mind and the thoughts—of each individual. The material and materialistic world means less and less in these works, as an intense mood of awareness and concern arises to take its place.

The observer who doubts that Copley's late American paintings reflect the tenor of the times in Boston need only contrast them with the portraits that the artist executed in Italy in 1775 and in England in 1776 and thereafter. Material things overwhelm the young American couple in Rome who are the nominal subjects of *Mr. and Mrs. Ralph Izard* (fig. 82), Copley's major painting of 1775. Mrs. Izard, chin resting on her hand, leans on a table with a reflective surface; thus, her pose (which Copley rarely used again) echoes those shown in *Mrs. Richard Skinner* and *Mrs. Humphrey Devereux* in form but not in feeling. By focusing on lavish possessions rather than on the people who owned them, Copley suggested that Mrs. Izard and her husband had wealth, sophistication, and even learning but offered no indication that they were like the real, resolute, vulnerable Americans at home. Such pictures reveal that though the painter's technique may not have changed significantly, his view of the world had, and they show that he was able to effect an extraordinarily quick change in style in response to his new environment abroad.[77]

A revealing example of Copley's new manner is the portrait he painted in London of the American Elkanah Watson (fig. 3). Watson strikes much the same pose assumed by many of Copley's earlier American sitters, and he is decked out with similar luxurious dress, curtains and columns, inkwell and letters. But the tension between the sitter and his pose, between his real self and his material surroundings visible in the earlier pictures, has evaporated. Unlike the Americans Copley painted in Boston just a few years earlier, Watson seems completely at one with his setting, as he looks nobly into the distance, bland but handsome, in a portrait that Reynolds himself might have approved. A few years after he painted Watson, Copley received a commission from Winslow Warren Jr. of the Warren family of New England. Winslow was the son of Mercy Otis and James Warren and nephew of Joseph Warren, all of whom the painter had portrayed in Boston. The uncertain, genial, and open expressions of the Warrens pictured in Boston (cat. no. 15; figs. 75, 173) have been replaced in the likeness of the Warren painted in London by a forgettable face that has been given the time-honored British look of rank (fig. 83); the Bostonian in London has much of London and little of colonial Boston in him. Copley had finally succeeded in learning not only English style but also English attitude.

Observers have argued for centuries about whether character can be read in human appearance and especially in facial expression and whether the painter can suggest the individual personality of a sitter. William Hogarth advised that successful portrait painters needed "an exact external eye and much practice with very little speculation"[78]—implying that it was in the artist's best interests not to press the investigation of character too far. Reynolds came to much the same conclusion, on one occasion writing that a portrait subject should simply be given "that expression which men of his rank generally exhibit" and on another speculating about the limitations of the painter: "The habits of my profession unluckily extend to the consideration of so much only of character as lies on the surface, as is expressed in the lineaments of the countenance." He went on to say that "an attempt to go deeper and investigate the peculiar colouring of his mind" would be presumptuous at best.[79]

Scholars of Copley's work have differed on the question of whether his portraits successfully investigate character. Indeed, this issue is a major focus of Staiti's essay "Character and Class" in the present publication. In 1956 E. P. Richardson called Copley "a penetrating master of human character," but Prown, writing a decade later, concluded that rarely in the American portraits (and even less often in the English ones) was his primary emphasis on character or personality.

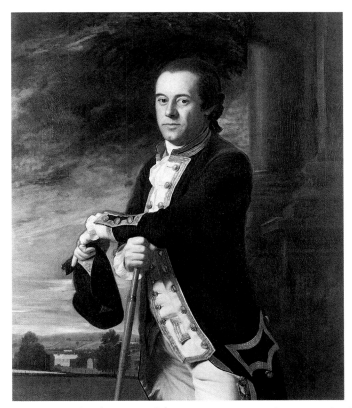

Fig. 84 *James Gambier*, 1773. Oil on canvas, 50 x 40 in. (127 x 101.6 cm). Museum of Fine Arts, Boston, Gift of Miss Amelia Peabody 37.1208

Prown sees Copley as stressing the "externals," the "physical appearance of the sitter and the objects that symbolize his station in life."[80] There is no question that eighteenth-century Americans were endowed with a distinctive attitude and character, as John Adams suggested when he wrote that the English "know not the character of Americans."[81] And there is also no question that Copley succeeded in telling us something important about his time and its distinctive people, though, like every portraitist, he was constrained by the limitations of his art. Rejecting the strictures of Jonathan Richardson and Reynolds, however unconsciously, he sought truth as he understood it. From the best of his work we gain an impression of life, a sense that each sitter possesses an individual character even if we cannot read it fully; these paintings lead us to feel what Ernst Gombrich calls "the illusion of seeing the face behind the mask."[82] We know that we are likely to project our own values onto any work of art, and that portraits in particular lend themselves to multiple interpretations. In addition, we surely understand (as eighteenth-century men and women did) that people are multidimensional, that everyone has good and bad traits, attractive habits and less appealing ones; in our own time especially we doubt "whether the elusive psyche can . . . be captured by pursuing superficial appearances," as one scholar has put it.[83]

Copley's American portraits, particularly those of the period 1763 to 1773, speak as a group to the existence of an American character that was stalwart, confident, direct, and clear minded. Moreover, Copley seems frequently to offer us something of his own subjective reaction to the people he painted. On occasion—whether by chance or intent—he illuminated something of an individual's personality. It is impossible to know whether Copley's interpretations of character are accurate or not; judging living people whom we know very well is difficult enough. But sometimes Copley's image does coincide with, and is perhaps corroborated by, judgments recorded by other witnesses. Thus, John Adams described his cousin Samuel Adams as "zealous, ardent, and keen in the cause," which is exactly as Copley painted him.[84] John Adams is one of the few Americans of the colonial era who has left us a very personal view of contemporary figures; most letter writers and diarists of the time were more refined or indirect and thus less useful to posterity. Adams, for example, particularly disliked the high Tory Sylvester Gardiner and described him as having "a thin Grashopper voice, and an affected squeak; a meager visage, and an awkward unnatural complaisance."[85] We would never discern such characteristics from viewing Copley's portrait of

Gardiner (cat. no. 75) alone, but if we look at it after reading Adams's remarks, we sense that the painter may have been hinting at his sitter's affectations in the awkward and asymmetrical way he posed him. Similarly, when we look at Copley's likenesses of the Isaac Smiths, we are not surprised by Adams's description of the evening he dined with them in 1766: "No Company, no Conversation."[86]

However, Copley was aware of who was paying for his pictures and whom he served, and he could not afford to allude too often to his sitters' unpleasant characteristics; thus, if he agreed at all with Adams's description of the merchant Thomas Boylston ("a perfect Viper—a Fiend . . . —a Devil"), there is no indication of it in his portrait of the man (fig. 187).[87] Finally, in this context, we might note that Copley himself is very hard to know, as he kept his personal reactions to things and people closely guarded in both his art and his letters. Both make us aware of his acuity, his abilities, and his ambitions. Some who knew him thought him "a peevish and peremptory man," but others described him as "mild and unassuming."[88] His beautiful pastel *Portrait of the Artist* (fig. 25) tells something different. In this image, in which Copley surely aimed to aggrandize himself, we can discern a quality the artist may not have intended, for it presents the very picture of vanity.

Copley possessed an enormous artistic intelligence, and he was very fortunate besides. In the colonies he could have risen to the heights he attained only in Boston, with its strong pictorial tradition, and in Boston his talents and ambition probably could have been shaped only in Peter Pelham's household. He generally has been well treated by historians. Extraordinarily, most of his oeuvre survives intact, a credit both to the way his paintings have been cherished by their owners and to Copley's own solid, well-crafted technique. His intuition, or perhaps chance, led him to consider and then to reject the idea of painting the silversmith Nathaniel Hurd in informal garb; as a result the portrait he would later produce of Paul Revere in shirtsleeves remained his only likeness of an artisan in such attire and became a unique icon of America and patriotism. Similarly, he fortuitously pictured Hancock in what would prove to be an eminently appropriate pose, with pen in hand. And remarkably he intuited enough of English style and his own future to paint such prominent Englishmen in America as Thomas Gage and Captain James Gambier (fig. 84) in a style more

Fig. 85 Thomas Gainsborough. *John Eld of Seighford Hall, Stafford,* ca. 1772. Oil on canvas, 93 x 60 in. (236 x 152.5 cm). Museum of Fine Arts, Boston, Special Painting Fund 12.809

Fig. 86 Sir Joshua Reynolds. *Sir James Esdaile, Lord Mayor of London,* 1789. Oil on canvas, 50 x 40 in. (127 x 101.6 cm). Washington University, St. Louis

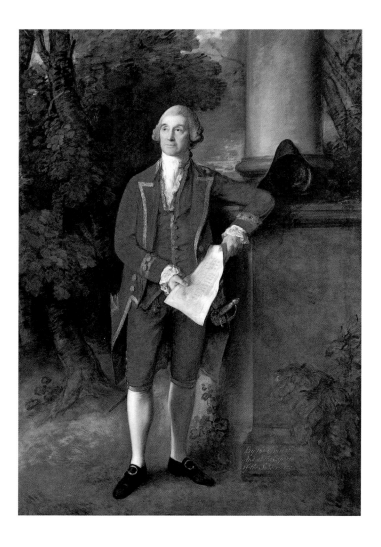

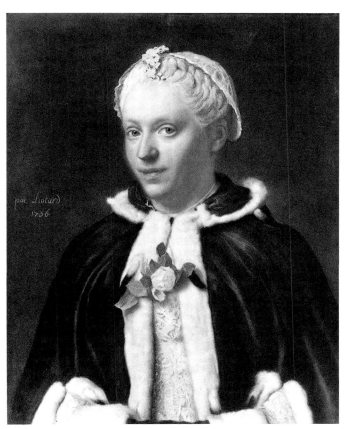

Fig. 87 Jean-Étienne Liotard. *Madame Pieter van Bleiswijk (Geertruida Antonia)*, 1756. Pastel on paper, 23¼ x 18½ in. (59 x 47 cm). Musée d'Art et d'Histoire, Geneva

generalized and more British than the one he was using contemporaneously for American sitters. He was prescient also in the advanced way he portrayed women. And he was fortunate to marry Susanna Clarke; Copley's devotion to her and to her Loyalist family led him finally to flee the city that was hostile to them and to make the trip to Italy and England he had been pondering for years. His decision to leave came at exactly the right time. The Revolution drove portraiture and the impulse toward patronage from the minds of Americans for a decade or more, and both Copley and his work surely would have suffered as a consequence had he remained. During the course of his first decade in England, however, he learned to paint in the English style to which he had always aspired, and he won the international recognition he had always hoped to achieve.

Copley's failure to become a true English painter in America lies behind his unique accomplishment. He devoted great attention and many sessions to clothing and other props, with which he aimed to indicate his subjects' status and aspirations. He probably dedicated as many sittings to painting their faces, matching "with his palette-knife a tint for every part of the face, whether in light, shadow, or re-

flection" before he even touched the canvas.[89] He hated being considered a mere craftsman, but he went at his portraits like someone making a teapot from an ingot or a high chest from rough-hewn boards. Never able to create a proper English atmosphere in his American pictures, never willing either to idealize or to focus his main attention on the face to the extent that Richardson and Reynolds demanded, he painted portraits that were strange and unbalanced according to English standards.

Reynolds or Gainsborough tells us more about status and wealth but less about likeness or individual personality than Copley does, as is clearly revealed by a comparison of Gainsborough's *John Eld* (fig. 85) with *Nathaniel Sparhawk* (cat. no. 19), or of Reynolds's *Sir James Esdaile* (fig. 86) with any number of Copley's pictures of seated merchants. Without knowing it, Copley altered the mix in attempting to emulate English style, and he frequently tells us a good deal about the character of his fellow Americans. As we have seen, in Copley's portraits there is often discord between the subjects' costumes and their faces, between their settings and their expressions. Luxurious jackets and dresses rendered in great detail often conflict directly with the seemingly modest, plain people who wear them. From *Mary and Elizabeth Royall* to *John Hancock* to *Jeremiah Lee*, yards and yards of expensive material seem more substantial and more real than the arms and legs and torsos of the sitters. Moreover, the bodies are often unconvincing in terms of both their proportions and the way they inhabit space; they frequently seem as independent from the sitters' faces as the curtains, the fountains, and the columns. Copley's figures have been accurately described as "often unbending, inexpressive, awkward, if not grotesquely out of proportion."[90] But the images are honest. Though Copley was politically impartial and painted Whig and Tory alike, he could not be bought, any more than Samuel Adams or Isaac Winslow could. A Jeremiah Lee, a Sparhawk, or a Hancock could never pay enough to buy a truly noble-looking characterization, while others who may have been less rich or less important, a Dorothy Skinner or an Eleazer Tyng, are portrayed as if they have real flesh and blood and soul.

Whatever their distortions or shortcomings as English-style portraits, Copley's pictures clearly pleased his patrons. He was able to get away with them because the sitters were more provincial than he; this painter of the desperate correspondence course may have known better, but his subjects did not. As Fred Licht has written, "Copley begins his career at just the moment in history when the premises which had made portraiture an important category of art began to lose

their validity."[91] In a sense, Copley made a significant break with the portrait tradition established during the Renaissance—in which he was rooted and which flowered in England with the work of Van Dyck and later with that of Reynolds and Gainsborough. The disjunction in Copley's portraits between costume and character, the lack of atmospheric continuity, and the equal treatment of every part of the picture—the qualities that make them so memorable—are exactly the qualities that West and Reynolds found so objectionable. Similar traits appear in the work of Liotard (see fig. 87) and, on occasion, of other eighteenth-century artists; they are magnified in Goya's portraits, in which elegant costumes contrast with the empty, mean faces of the Spanish elite. During the nineteenth century, portraiture—along with the values it represented—slowly died. Copley's portraits may thus be seen as an intuitive early expression of the rejection of humanism and of the crisis of identity and loss of established values that have become central issues of the twentieth century.

In writing this essay I relied on the superb research assistance given by Janet L. Comey and Deanna M. Griffin at the Museum of Fine Arts, Boston; I am especially grateful to Marci Rockoff for her patient skill at the word processor. I am also enormously indebted to Fred Licht, Paul Staiti, Carrie Rebora, Carol Troyen, and Erica E. Hirshler for their thoughtful comments and especially to Susan C. Ricci for her excellent suggestions. Finally, I am indebted to Carol Fuerstein for her very skillful editing of the manuscript.

1. John Adams, letter to Abigail Adams, Aug. 21, 1776, in *Adams Family Correspondence*, ed. Lyman H. Butterfield (Cambridge, Mass., 1963), vol. 2, p. 103. In 1773 the connoisseur and traveler John Morgan wrote: "Mr. Copley may justly be looked upon as the greatest Painter we have ever yet had in America" (John Morgan, letter to Isaac Jamineau, Nov. 24, 1773, in Jones 1914, p. 210).

2. Miles Chappell, "A Note on John Smibert's Italian Sojourn," *Art Bulletin* 64 (Mar. 1982), p. 133; Prown 1966, vol. 1, p. 16.

3. See Prown 1966, vol. 1, p. 19 and n. 10; and Trevor J. Fairbrother, "John Singleton Copley's Use of British Mezzotints for His American Portraits: A Reappraisal Prompted by New Discoveries," *Arts Magazine* 55 (Mar. 1981), pp. 122–30.

4. Copley, letter to Jean-Étienne Liotard, Sept. 30, 1762, in Jones 1914, p. 26.

5. Captain R. G. Bruce, letters to Copley, Aug. 4, 1766, June 11, 1767, and June 25, 1767, in Jones 1914, pp. 41, 53, 59; Benjamin West, letter to Copley, June 20, 1767, in Jones 1914, p. 57. Copley sent five oil paintings and one pastel to London. The oils were: *Boy with a Squirrel (Henry Pelham)* (cat. no. 25); *Young Lady with a Bird and Dog* (cat. no. 38); *Portrait of a Gentleman (Mr. Rogers)*, 1768 (location unknown); *Mrs. Humphrey Devereux* (cat. no. 59); and *Mrs. Thomas Gage* (cat. no. 67). The pastel portrait was of an unidentified woman.

6. Copley, letter to [Captain R. G. Bruce], [ca. Jan. 17, 1768], in Jones 1914, p. 70; Copley, letter to Benjamin West, Nov. 12, 1766, in Jones 1914, p. 51.

7. Dunlap 1834, vol. 1, pp. 112, 117.

8. Samuel Isham, *The History of American Painting* (New York, 1905), p. 30.

9. Ibid., pp. 33, 30.

10. E. P. Richardson, *Painting in America* (New York, 1956), p. 73.

11. Barbara Novak, *American Painting of the Nineteenth Century* (New York, 1969), p. 15.

12. Ibid., p. 18.

13. Joshua Taylor, *The Fine Arts in America* (Chicago, 1979), pp. 23–24.

14. Max J. Friedländer, *Landscape, Portrait, Still-Life: Their Origin and Development* (New York, 1963), p. 238.

15. Ibid., p. 236.

16. See John Pope-Hennessy, *The Portrait in the Renaissance* (Princeton, N.J., 1966); and Diane Owen Hughes, "Representing the Family: Portraits and Purposes in Early Modern Italy," *Journal of Interdisciplinary History* 18 (Summer 1986), pp. 7–38.

17. Jonathan Richardson, "The Theory of Painting," in *The Works* (1773; reprint, Hildesheim, Ger., 1969), p. 247; Barbara Maria Stafford, "'Peculiar Marks': Lavater and the Countenance of Blemished Thought," *Art Journal* 46 (Fall 1987), pp. 185, 186.

18. Walter Jackson Bate, *From Classic to Romantic: Premises of Taste in Eighteenth-Century England* (New York, 1946), p. 81.

19. Sir Joshua Reynolds, *Discourses on Art* (1797), ed. Robert R. Wark (New Haven, 1975), Discourse 4, p. 72.

20. Copley, letter to [an English Mezzotinter], Jan. 25, 1765, in Jones 1914, p. 31; Thomas Ainslie, letter to Copley, Nov. 12, 1764, in Jones 1914, p. 30.

21. John Greenwood, letter to Copley, Mar. 23, 1770, in Jones 1914, p. 81.

22. Homer Saint-Gaudens, *The American Artist and His Times* (New York, 1941), p. 5; Wayne Craven, *Colonial American Portraiture: The Economic, Religious, Social, Cultural, Philosophical, Scientific, and Aesthetic Foundations* (Cambridge, 1986), p. 312.

23. Marcia Pointon, *Hanging the Head: Portraiture and Social Formation in Eighteenth-Century England* (New Haven, 1993), p. 9.

24. Richard Brilliant, "The Limitations of Likeness," *Art Journal* 46 (Fall 1987), p. 172; Pointon, *Hanging the Head*, p. 9. See also Richard Wendorf, *The Elements of Life: Biography and Portrait-Painting in Stuart and Georgian England* (Oxford, 1990).

25. See T. H. Breen, "The Meaning of 'Likeness': American Portrait-Painting in an Eighteenth-Century Consumer Society," *Word and Image* 6 (Oct.–Dec. 1990), pp. 325–50.

26. Ibid.

27. Ibid., p. 340.

28. Reynolds, *Discourses*, Discourse 4, pp. 61, 58.

29. See John T. Kirk, *American Furniture and the British Tradition to 1830* (New York, 1982); and Morrison H. Heckscher and Leslie Greene Bowman, *American Rococo, 1750–1775: Elegance in Ornament* (exh. cat., New York: The Metropolitan Museum of Art, 1992).

30. Kirk, *American Furniture*, p. 159.

31. John Small, letter to Copley, Oct. 29, 1769, in Jones 1914, pp. 77–78.

32. Benjamin West, letter to Copley, Aug. 4, 1766, in Jones 1914, pp. 44–45.

33. See Breen, "The Meaning of 'Likeness'"; the identical dress is worn by Mrs. John Murray (Worcester Art Museum, Massachusetts), Mrs. Daniel Hubbard (fig. 23), and Mrs. John Amory (Museum of Fine Arts, Boston).

34. Andrew Wilton, *The Swagger Portrait: Grand Manner Portraiture in Britain from Van Dyck to Augustus John, 1630–1930* (exh. cat., London: Tate Gallery, 1992), p. 38.

35. Lorne Campbell, *Renaissance Portraits* (New Haven, 1990), p. 128.

36. David R. Smith, *Masks of Wedlock: Seventeenth-Century Dutch Marriage Portraiture* (Ann Arbor, Mich., 1982), p. 16. Smith writes that almost as many women as men are recorded in Dutch portraiture; this, he maintains, is a "uniquely Dutch phenomenon" (ibid., p. 2).

37. See, for example, *Thomas Aston Coffin* (Munson-Williams-Proctor Institute, Utica, New York); and *Mrs. James Smith* (Museum of Fine Arts, Boston).

38. Prown estimates that 51 percent of Copley's sitters were men, 45 percent women, and 4 percent children (Prown 1966, vol. 1, p. 129). Taking Prown's "Statistical Data for 240 Portraits" (pp. 101–16, 132) and eliminating pictures of children, double portraits, and paintings of deceased subjects, we are left with a pool of 221 sitters. Of these 46 were unmarried. Thus of the remaining 175 paintings of married adults, we find that 114 sitters had a spouse who was also painted by Copley and 61 had spouses who were not painted by him. It should be noted that Copley frequently painted one spouse a number of years after the other. See Deanna M. Griffin, Janet Comey, and Theodore E. Stebbins Jr., "Copley's American Portraits: Further Statistical Analysis," typescript, 1994, Curatorial Files, Museum of Fine Arts, Boston.

39. See Valérie Plat, "Copley's Pair Portraits: In the Stream of Tradition," seminar paper, Boston University, 1994; and Smith, *Masks of Wedlock*.

40. Abigail Adams, letter to John Adams, June 30, 1778, in *Adams Family Correspondence*, vol. 3, p. 52.

41. Linda K. Kerber, *Women of the Republic: Intellect and Ideology in Revolutionary America* (Chapel Hill, 1980).

42. James Otis Jr., quoted in ibid., p. 31.

43. Carl N. Degler, *At Odds: Women and the Family in America from the Revolution to the Present* (New York, 1980), p. 17; Kerber, *Women of the Republic*, p. 31.

44. Degler, *At Odds*, p. 16.

45. According to Prown, 55 percent of Copley's known male sitters were "big business and landed gentry" (including merchants, shippers, and landowners), and merchants commissioned 46 percent of all portraits, or five times as many as the next strongest groups of patrons, ministers (9 percent) and government officials (9 percent) (Prown 1966, vol. 1, p. 129).

46. Carl Bridenbaugh, *Cities in Revolt: Urban Life in America, 1743–1776* (New York, 1955), pp. 228, 301.

47. Ibid., p. 303.

48. See Prown 1966, vol. 1, pp. 97–100.

49. Copley, letter to [Benjamin West or Captain R. G. Bruce?], [1767?], in Jones 1914, pp. 65–66.

50. G. B. Warden, *Boston, 1689–1776* (Boston, 1970), p. 193.

51. Copley, letter to [Benjamin West], Nov. 24, 1770, in Jones 1914, p. 98.

52. In about 1765 Copley began a portrait of the silversmith Nathaniel Hurd in shirtsleeves (fig. 184) but for unknown reasons left it unfinished; he then painted Hurd elegantly though informally dressed, as a gentleman (cat. no. 21).

53. Wendorf, *Elements of Life*, p. 15.

54. Prown 1966, vol. 1, pp. 91, 92.

55. Parker and Wheeler 1938, p. 123.

56. Bridenbaugh, *Cities in Revolt*, p. 216.

57. Prown 1966, vol. 2, pp. 341, 295, vol. 1, p. 33.

58. See John W. Tyler, *Smugglers and Patriots: Boston Merchants and the Advent of the American Revolution* (Boston, 1986), passim.

59. Richard L. Bushman, *The Refinement of America: Persons, Houses, Cities* (New York, 1992), passim.

60. *Letters and Diary of John Rowe, Boston Merchant*, ed. Anne Rowe Cunningham (Boston, 1903), p. 229.

61. Copley, letter to [Benjamin West or Captain R. G. Bruce], [1767?], in Jones 1914, p. 66.

62. Friedländer, *Landscape, Portrait, Still-Life*, p. 231.

63. Prown 1966, vol. 1, p. 79.

64. Dunlap 1834, vol. 1, p. 126.

65. Copley, letter to [Captain R. G. Bruce], [ca. Jan. 17, 1768], in Jones 1914, p. 70; Copley, letter to Henry Pelham, Nov. 6, 1771, in Jones 1914, p. 174.

66. Copley did, however, refer to "the drawing" he had made of Hutchinson "some years since" (Copley, letter to Henry Pelham, Aug. 25, 1774, in Jones 1914, p. 242).

67. Rowe mentions the painter just once in his diary, in his entry for April 23, 1767, where he reveals that he knew of his work: he records having dined with a group of Copley sitters who included Ezekiel Goldthwait, the Michael Daltons, and Mrs. Robert Hooper. The conversation must have turned to Copley, for Rowe notes that he learned that "Mrs. Hooper went to Copley to have her picture drawn as did Capt. Dalton and wife" (*Letters and Diary of Rowe*, p. 129). Despite his pretensions, Copley seems never to have quite attained the social level of his sitters, for he is rarely cited as a guest at their dinners or other gatherings.

68. *Diary and Autobiography of John Adams*, ed. Lyman H. Butterfield (Cambridge, Mass., 1961), vol. 1, p. 358. It should be noted that both Abigail and John Adams were the subjects of modest pastel portraits by Benjamin Blyth, dating about 1776 (Massachusetts Historical Society, Boston), and also that Copley finally did paint Adams in London in 1783 (Harvard University, Cambridge, Massachusetts). Adams paid Copley 100 guineas for his likeness and then wrote: "Thus this Piece of Vanity will be finished. May it be the last" (quoted in Prown 1966, vol. 2, p. 300).

69. *Diary and Autobiography of Adams*, vol. 1, p. 293.

70. Ibid., pp. 326–27.

71. Barbara Novak, "Self, Time, and Object in American Art: Copley, Lane, and Homer," in *American Icons: Transatlantic Perspectives on Eighteenth- and Nineteenth-Century American Art*, ed. Thomas W. Gaehtgens and Heinz Ickstadt (Santa Monica, 1992), p. 64.

72. Richard E. Amacher, *Benjamin Franklin* (New Haven, 1962), pp. 43–44.

73. Breen, "Meaning of 'Likeness,'" p. 40.

74. *Letters and Diary of Rowe*, pp. 95, 216, 229, 246, 211, 238, 289.

75. Bushman, *Refinement of America*, p. 99.

76. Prown 1966, vol. 1, p. 129.

77. See ibid., vol. 2, pp. 314ff.

78. Quoted in Richard Wendorf, "Hogarth's Dilemma," *Art Journal* 46 (Fall 1987), p. 201.

79. Reynolds, *Discourses on Art*, Discourse 4, p. 61; Sir Joshua Reynolds, *Portraits*, ed. Frederick W. Hilles (London, 1952), p. 66.

80. Richardson, *Painting in America*, p. 73; Prown 1966, vol. 1, p. 34. See also Novak (*American Painting of the Nineteenth Century*, p. 24), who finds "little psychological penetration" in Copley's American portraits.

81. *Diary and Autobiography of Adams*, vol. 1, p. 282.

82. Ernst H. Gombrich, "The Mask and the Face: The Perception of Physiognomic Likeness in Life and Art," in E. H. Gombrich, Julian Hochberg, and Max Black, *Art, Perception, and Reality* (Baltimore, 1970), p. 42.

83. Stafford, "'Peculiar Marks,'" p. 185.

84. *Diary and Autobiography of Adams*, vol. 1, p. 271.

85. Ibid., p. 151.

86. Ibid., p. 294.

87. Ibid., p. 295.

88. Dunlap 1834, vol. 1, p. 124.

89. Fred Licht, "The End of the Portrait," typescript, 1994.

90. Dunlap 1834, vol. 1, p. 126.

91. Licht, "End of the Portrait."

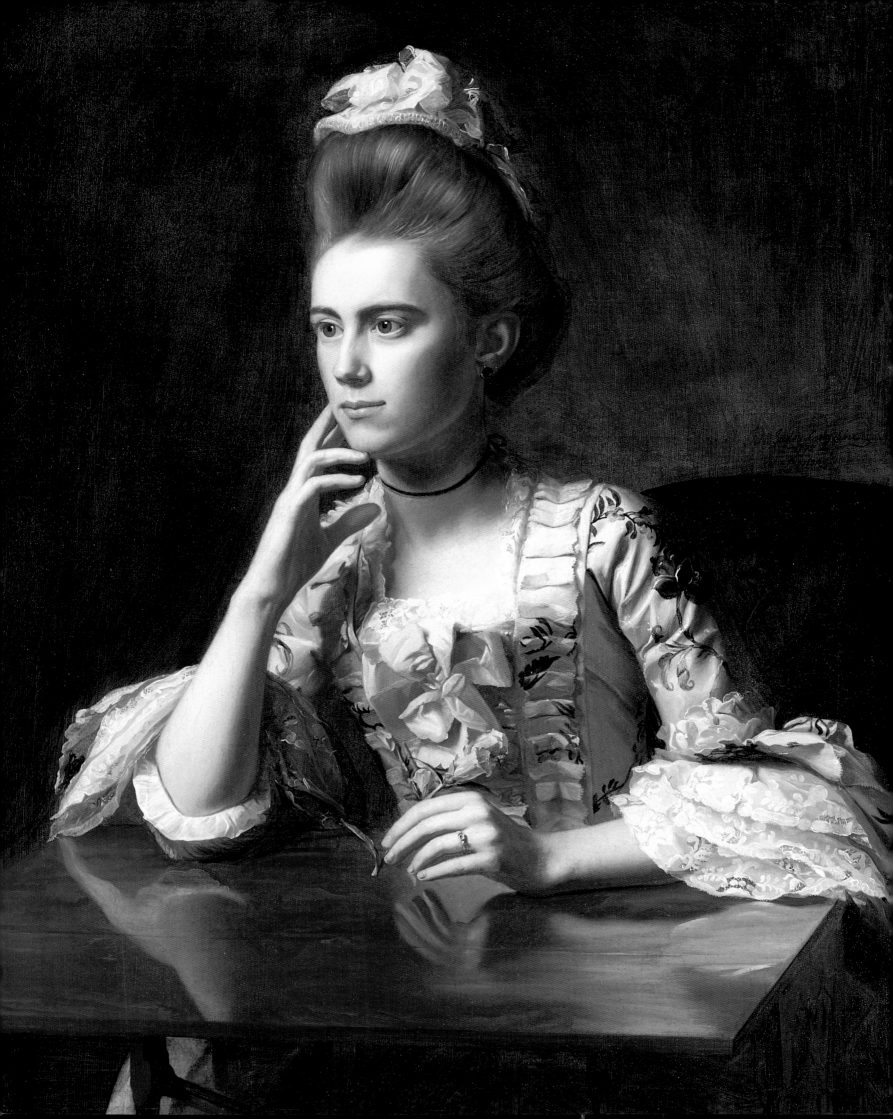

"The Whole Art of Dress": Costume in the Work of John Singleton Copley

AILEEN RIBEIRO

In 1761 John Adams urged his young nieces to read William Hogarth's discussion of the "line of beauty" as applied to dress in his *Analysis of Beauty* of 1753 if they wished to attract "a worthy Companion in Life." Maintaining that a study of "Hogarths mathematicks" would help to reveal "the whole Art of Dress," he averred that "the finest face, and shape, that ever Nature formed, would be insufficient to attract and fix the Eye of a Gentleman without some Assistance and Decoration of Dress. And I believe an handsome shoe, well judged Variety of Colours, in Linnen, Laces &c., and even the Rustling of silks has determined as many Matches as any natural features, or Proportions or Motions."[1] Adams's admonition conveys some sense of the importance of a fashionable image in eighteenth-century America.

By 1744, when Alexander Hamilton, a Scottish doctor, traveled from Maryland to Maine, there was a seemingly insatiable thirst in the colonies for the latest European fashions and accessories. Hamilton noted that Boston "abounds with pritty women who appear rather more abroad than they do att York and dress elegantly," with a determination to be "a la mode" as dictated by English styles.[2] Some twenty years later fashionable imported clothing was as popular as ever, although the political ties between the American colonies and Great Britain were under considerable strain. William Eddis, Surveyor of Customs at Annapolis, wrote in 1771: "The quick importation of fashions from the mother country is really astonishing. I am almost inclined to believe that a new fashion is adopted earlier by the polished and affluent American, than by many opulent persons in the great metropolis; nor are opportunities wanting to display superior elegance."[3] Eddis exaggerated here to make a point, but he was in a position to know the extent of American reliance on goods imported from Great Britain. "At present," he commented in 1773, "it is evident that almost every article

of use or ornament is to be obtained on much more reasonable terms from the mother country, than from artizans settled on this side of the Atlantic."[4]

It was impossible for the American colonies to be self-sufficient in the making of textiles, of the humbler as well as of the refined sort, for production was haphazard, often hampered by climate and poor communications, and manufacturers had limited access to new technology (only recently introduced even in England) and lacked established business skills. Some cotton and linen goods were produced; stockings made in Germantown, Pennsylvania, for example, were esteemed,[5] as were shoes made in Lynn (near Boston), and beaver hats from Philadelphia were reputedly "superior in goodness to any in Europe."[6] There were some ineffectual attempts to introduce silk culture to America, but the main thrust of textile production was in the area of woolen cloths, the basic fabric for men's clothing and for much informal dress for women. The Reverend Andrew Burnaby observed on visiting Boston in 1760: "like the rest of the colonies [Boston residents] also endeavour to make woollens, but have not yet been able to bring them to any degree of perfection; indeed, it is an article in which I think they will not easily succeed; for the American wool is not only coarse, but, in comparison of the English, exceedingly short."[7]

Despite the poor quality of the American product, some Americans, inspired by a surge in patriotic feeling before the Revolution, adopted homespun wool to make a political point.[8] Women and children were persuaded by the clergy to "set their Spinning Wheels a whirling in Defiance of Great Britain,"[9] and some Sons and Daughters of Liberty occasionally wore the fabrics they made. However, they were making token gestures, and there is no evidence that clothing made of homespun was the basic form of dress for the majority of Americans.[10] Human nature prevented the imposition of a self-denying ordinance that disallowed the importation of stylish textiles.

Detail, *Mrs. Richard Skinner (Dorothy Wendell)* (cat. no. 76)

Fig. 88 Advertisement for Jolley Allen, *Boston Gazette*, September 7, 1767

To a large extent, then, colonial taste in fabrics and dress seems to have followed that of Great Britain, with an emphasis on woolen cloths (constituting perhaps as much as 60 percent of all materials), followed by printed linens and cottons, half-silks (silks mixed with other fabrics, such as linen), and finally plain and patterned silks,[11] the plain being more popular, as Copley's portraits bear witness. Most of the silks imported into America were English (like the fine Spitalfields silk Copley painted in *Mrs. Richard Skinner* [cat. no. 76; frontispiece, this essay]), but there were also small quantities of French silks, which were more expensive. Silks from China (damasks and painted silks were favorites), sometimes listed in inventories and advertisements as "India goods," were exported by the British East India Company, which also dealt in cottons from India. After the middle of the eighteenth century the quality of printed cottons and linens improved greatly, and the industry that produced them flourished in England and Ireland; according to the

Boston newspapers (see fig. 88), a wide range of cottons and linens was available in both specialist and general shops of the city.[12] Ships came from English ports to Boston each year, laden with an enormous assortment of goods that included textiles, millinery, and haberdashery selected by the American merchants' London agents,[13] and even some made-up or partly made-up items of clothing.[14] Tailors and dressmakers (the contemporary word was "mantua-maker") advertised their skills in the Boston newspapers, an English connection adding an essential cachet to their business.

It is against this background of a consumerist colonial society in which a fashionable image based on English textiles and modes was important for both men and women that Copley's treatment of costume in his portraits must be examined. Copley himself dressed stylishly; in his autobiography the artist John Trumbull (1756–1843) recalled seeing him early in 1772 "in a fine maroon cloth, with gilt buttons"[15] (an outfit perhaps similar to that depicted in Copley's *Isaac Smith* [cat. no. 50]). The painter and author William Dunlap later maintained that "the elegance displayed by Copley in his style of living, added to his high repute as an artist."[16] Copley seems to have realized the importance of refinement in self-presentation, both as an important social aid in the world of his wealthy and upper-class clients and as a way of increasing the stature of painting itself. Certainly, he was conscious of his mission to improve the lowly status of art in America, a somewhat difficult task in a society whose members needed to be taught that art had a value beyond mere likeness. He understood his audience well and occasionally expressed his dismay at the prosaic view taken of painting by his sitters, who, he complained, regarded it as "no more than any other usefull trade, as they somtimes term it, like that of a Carpenter tailor or shew maker, not as one of the most noble Arts in the World. Which is not a little Mortifiing to me."[17]

In reality, most of Copley's predecessors were no more than journeymen; largely undistinguished painters, they were not particularly good at creating likenesses or at reproducing the details of dress. Copley, however, succeeded in conveying the individuality of his sitters with the support of a masterly technical ability apropos the depiction of fabrics and fashions.[18]

The representation of women's costume presented some difficulties for Copley, for he was aware that more than the mere depiction of reality in feminine dress was sometimes required. Writing to Benjamin West (1738–1820) in London early in 1768, Copley confessed his perplexity as to "what will please the Coniseur" in terms of drapery and dress. He himself preferred "simplissity in the dress," hoping that it would not be contrary to prevailing taste and displease his audience. He continued: "Nor indeed can I be suplyed with that variety of Dresses here as in Europe, unless I should put myself to a great expence to have them made."[19]

This comment is rather baffling, for although it is not known how much Copley had in the way of studio draperies, or even dresses, he appears to have used such props, varying color and accessories, for a number of different portraits; moreover, as his correspondence reveals, he relied on an artist's layman for help in rendering draperies.[20] For example, at about the time Copley painted Mrs. Thomas Gage (cat. no. 67) in a salmon-pink silk dress with echoes of fashionable *turquerie* (perhaps an oblique reference to the sitter's Greek grandmother who lived in Turkey), he portrayed Mrs. Joseph Hooper (fig. 209) in a similar pink gown and Mrs. Roger Morris (cat. no. 70) wearing a cream silk version of the dress, draped over the shoulders and with a spotted scarf. Of the three costumes, only the dress of Mrs. Gage seems real, as if it were painted from a studio property modeled by the sitter; the other two look like copies of that property, never worn by the subjects. The Gage dress seems to be real, thanks to Copley's skillful rendering and what appears to have been a sympathetic relationship with the model. But it would not have been worn in real life and instead represents an artistic convention remotely related to a supposedly Turkish prototype[21] and more closely to fashionable loose "undress" gowns worn en déshabillé.

Another example of what may be a studio dress, possibly painted when it was pinned and/or draped on the lay figure, is the heavy, slithery white satin shown in *Rebecca Boylston* (cat. no. 33); the triple-bobbin lace ruffles are so accurately rendered that they are certainly painted from life. Again, as in the Gage portrait, this is not an outfit that was worn outside the studio, yet it looks alive and convincing because of the painter's virtuoso skill and perhaps his particular rapport with the sitter. Indeed, the dress seems considerably more real than the similar white satin costume with short-sleeved overgown pictured in *Mrs. Woodbury Langdon* (cat. no. 36), a portrait completed the same year *Rebecca Boylston* was painted.

Copley's complaint notwithstanding, the American artist could "be suplyed with [a] variety of Dresses"—as well as poses—by means of engraved English portraits; these were advertised in the newspapers and served to keep the colonists in touch with political affairs and intellectual and artistic trends in the mother country.[22] Such engravings were an essential source for artists; as Henry Pelham's remarks in

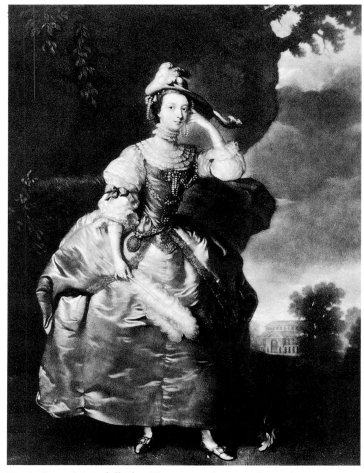

Fig. 89 James McArdell after Thomas Hudson. *Duchess of Ancaster*, 1757. Mezzotint, 11⅞ x 8⅞ in. (30.2 x 22.5 cm). The Metropolitan Museum of Art, New York, Harris Brisbane Dick Fund, 1917

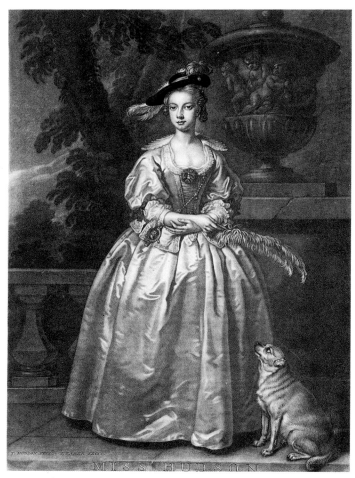

Fig. 90 John Faber after Thomas Hudson. *Miss Hudson*, ca. 1740s. Mezzotint, 13¾ x 9¾ in. (35.1 x 24.8 cm). Trustees of the British Museum, London

a letter of 1776 to Copley suggest: "I have amused myself for some hours past with viewing 4 fine prints I bought yesterday at Vendue. 3 of them please me very much. they are the portraits of Lady Middleton, half length, after Sir. P. Lely; the Dutchess of Ancaster after Hudson; and Lady Campbell, the duke of Argyle's Daughter, whole leng[th] after Ramsay."[23]

Both the Hudson and the Ramsay pictures referred to show the sitters in Vandyke costume, a popular artistic convention in England related to the vogue for fancy dress and the masquerade. Thomas Hudson's portrait of 1757 (fig. 89) depicts the duchess of Ancaster in the costume worn in Rubens's portrait of his wife, Helena Fourment (fig. 170), attributed during the first half of the eighteenth century to Van Dyck. This type of dress inspired the costume in Copley's *Mrs. Samuel Quincy* (cat. no. 12), in which the sitter is shown in a bodice and skirt of salmon pink trimmed with gold, a blue ribbon indicating the rather high waistline of the

early 1630s; instead of the open collar of the Rubens portrait, Mrs. Quincy wears the wide, flat double collar seen in Van Dyck's images of Queen Henrietta Maria. The black hat, decorated with a white ostrich feather and pinned up at the side with a jeweled clasp, recalls the Rubens prototype. As a source for Mrs. Quincy's portrait, Copley could have used James McArdell's mezzotint of Helena Fourment or— possibly more likely, because of the arrangement of the hands—John Faber's *Miss Hudson* (fig. 90), both from the 1740s.

This kind of artistic cross-reference was meaningless in an American context, insofar as there was no colonial equivalent to the English vogue for dressing à la Vandyke at fancy-dress parties; yet it testifies to the educated taste of both artist and sitter and to their feeling that the dress of the past was more acceptable for representation in painting than constantly changing contemporary fashions were. By the early eighteenth century there were a number of English

artists whose penchant for timeless draperies derived from the work of Peter Lely (1618–1680) and Godfrey Kneller (1646–1723) inspired them to eschew the detail of high fashion and produce portraits with very generalized costume.[24] Copley certainly knew and was influenced by the work of the Scottish artist John Smibert (1688–1751), who became, in Jules Prown's words, "the first major practitioner of the Lely-Kneller Baroque tradition in American painting."[25] One of Copley's early essays in this genre is his portrait of Ann Tyng (cat. no. 7) as a shepherdess in a white silk dress trimmed with bows, an imaginary garment loosely related to the generalized Lely-Kneller costume—even the hairstyle has long Knelleresque ringlets. Possibly Copley used James Lovelace's engraving of Hudson's *Mary Carew* (fig. 160) as a source; a more remote inspiration might have been Van Dyck's portrait *Mary Villiers, Duchess of Lennox and Richmond, as Saint Agnes*, 1637 (Royal Collection, Windsor Castle, Windsor), with Villiers in a white dress, her hand caressing her emblematic lamb.

A rather more accomplished adaptation of the Lely-Kneller mode combined with some elements of fashionable contemporary dress appears in Copley's *Mrs. George Watson* (cat. no. 20). The costume, although imaginary, incorporates specifics of contemporary styles, namely the loose back drapery of the popular *sacque*—or sack, as it was usually called in England—dress, a fashion that originated in France and was taken up by Englishwomen in the 1730s, and the long pointed bodice reinforced by the tight corseting of the 1760s. Copley is here either showing off his own acquaintance with the work of Van Dyck in the gesture of hand on hip, fingers curved inward holding drapery in place, or, more likely, borrowing from McArdell's mezzotint of Mrs. Bonfoy by Sir Joshua Reynolds (fig. 91).

Reynolds (1723–1792) was the last great interpreter of the generalized Baroque style in dress, and during the 1750s and 1760s he painted a number of portraits in which the costume, usually a loose bedgown with crossover front and a mantle or wide-sleeved robe, harks back to the later seventeenth century. The simple lines of these outfits are sometimes used together with elements of stylish *turquerie* and reflect not only the mode of the previous century but also the trend, particularly strong during the 1760s, toward greater simplicity in women's informal costume. Reynolds's portrait *Lady Caroline Russell* of about 1760, which was engraved by McArdell (fig. 92), shows a typical example of this sort of dress. This engraving was the prototype for Copley's portrait of Mrs. Jerathmael Bowers of about 1763 (fig. 93), and it or something similar by Reynolds or his great rival

Francis Cotes (1726–1770) may have inspired the nearly contemporaneous image of Mrs. Woodbury Langdon in her white dress with crossover front and blue short-sleeved gown.

Mrs. Bowers's costume is as unconvincing as Mrs. Langdon's; equally unreal as an ensemble, although beautifully painted, is the plum-colored overgown lined with green over a blue dress draped diagonally over the breast in *Mrs. Isaac Smith* (cat. no. 51). The décolletage would have been somewhat improper in an actual garment, and the sitter's expression seems to suggest the absurdity of the entire conceit. Nevertheless, there exists some sense of interaction between artist and sitter, a feeling quite absent in Copley's pretentious portrait of Mrs. Jeremiah Lee (cat. no. 53), which is marked by an over-genteel pose and gestures and an extravagant costume. With its ermine-trimmed gown, Mrs. Lee's finery echoes both the attributes of aristocracy—at royal coronations English peeresses wore mantles with ermine capes in which the number of rows of ermine tails was determined by the rank of their husbands—and the robes worn by grand Turkish ladies.[26] Copley's sources here

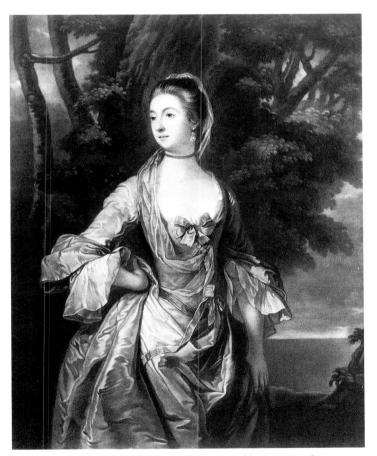

Fig. 91 James McArdell after Sir Joshua Reynolds. *Mrs. Bonfoy*, 1755. Mezzotint, 13¾ x 10⅞ in. (34.9 x 27.6 cm). Trustees of the British Museum, London

might include John Dixon's mezzotint after Reynolds's portrait of the duchess of Ancaster in a loose crossover dress and peeress's mantle (fig. 94) and—for the *turquerie*—an engraving made in 1762 by Edward Fisher of Reynolds's *Ladies Amabel and Mary Jemima Yorke* (Cleveland Museum of Art), in which Lady Amabel's costume is similar in style to that paraded by Mrs. Lee.[27]

To our post-Romantic eyes, Mrs. Lee's homely face seems incongruous in juxtaposition with her luxurious, unreal dress; such contrasts between a sitter's features and costume do not exist or are less marked in eighteenth-century English portraiture, both because the concept of fancy dress was more meaningful in England and because painters usually idealized female faces. In the trading, mercantilist society of America, however, it was occasionally important for artists to record with accuracy and honesty the features and characteristic poses of relatives who lived far away from the mother country. A rather rare glimpse of a client's instructions in this respect was provided by the patron who commissioned *Mrs. Humphrey Devereux* (cat. no. 59). This client, the sitter's son in London, wrote that he was "desirous of seeing the good Lady's Face, as she now appears, with old age creeping upon her." He asked for a seated half-length in "as natural a posture as possible" and, as for the costume, noted, "I shall only observe that gravity is my choice of Dress."[28] The resulting portrait is one of Copley's most successful and moving works. Mrs. Devereux is portrayed in her fittingly somber brown satin dress, knitted black mitts (fingerless gloves that kept the skin white and the hands warm) and, a single small concession to vanity, a front roll of false hair, which can be seen quite clearly under the linen cap with its goffered frill (a crimped edging made with a goffering iron).

Plain dark-colored satins like that of Mrs. Devereux's costume were appropriate wear for middle-aged and elderly women—the fabric was expensive and suitably old-fashioned by the 1760s. By that time the most stylish formal type of dress was the *sacque*. In fashionable circles, a hooped petticoat was usually worn to create the full effect of the characteristic drapery that flows from the back of the shoulders of the *sacque*. It is not clear if the seated subjects of Copley's *Mrs. Thomas Boylston* and *Mrs. Ezekiel Goldthwait* (cat. nos. 30, 60), both of whom are shown in brown satin *sacques*, wear such hoops, but the spreading folds of the heavy, soft silk of the dresses create the requisite soberly fashionable amplitude. Mrs. Goldthwait demonstrates her wealth and status by a choice of luxurious accessories, the fine lace, possibly English Honiton, for her cap, kerchief, and

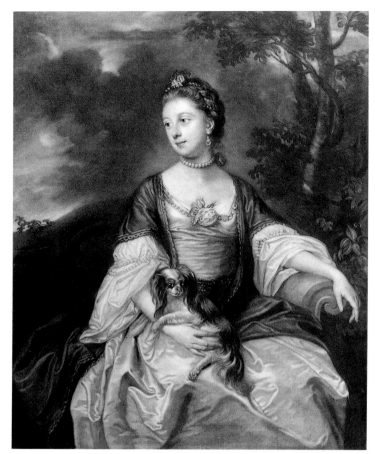

Fig. 92 James McArdell after Sir Joshua Reynolds. *Lady Caroline Russell*, ca. 1760. Mezzotint, 14¼ x 9⅞ in. (36.1 x 25 cm). Yale Center for British Art, New Haven, Paul Mellon Fund B1970.3.237

sleeve ruffles, and a fichu of black blonde silk lace crossed over her bosom.[29] Mrs. Boylston, as a widow, eschews lace for fine, starched plain linen, both for her coiflike cap, the style of which originated in the mid-seventeenth century, and for her sleeve ruffles. Her fichu is made of spotted and embroidered black net, and her mitts, which may be very like the "white glaz'd mitts, lin'd with sattin" advertised in the *Boston Gazette* of May 27, 1765, are depicted with the loving concentration Copley characteristically lavished on accessories.

It is one of the nice ironies in Copley's work that Mrs. James Warren, perhaps his most partisan female sitter and an advocate of the "homespun produce of the vales,"[30] should be shown in her portrait (cat. no. 15) in a most fashionable costume made of imported luxury materials, a blue satin *sacque* (here the back drapery is clearly visible) trimmed with ruched silk and silver braid.[31] The braid is applied in serpentine Rococo curves, and the fluted scallop-edged sleeve ruffles of the dress echo the graceful open fan shape of the bobbin lace ruffles; these details and indeed the

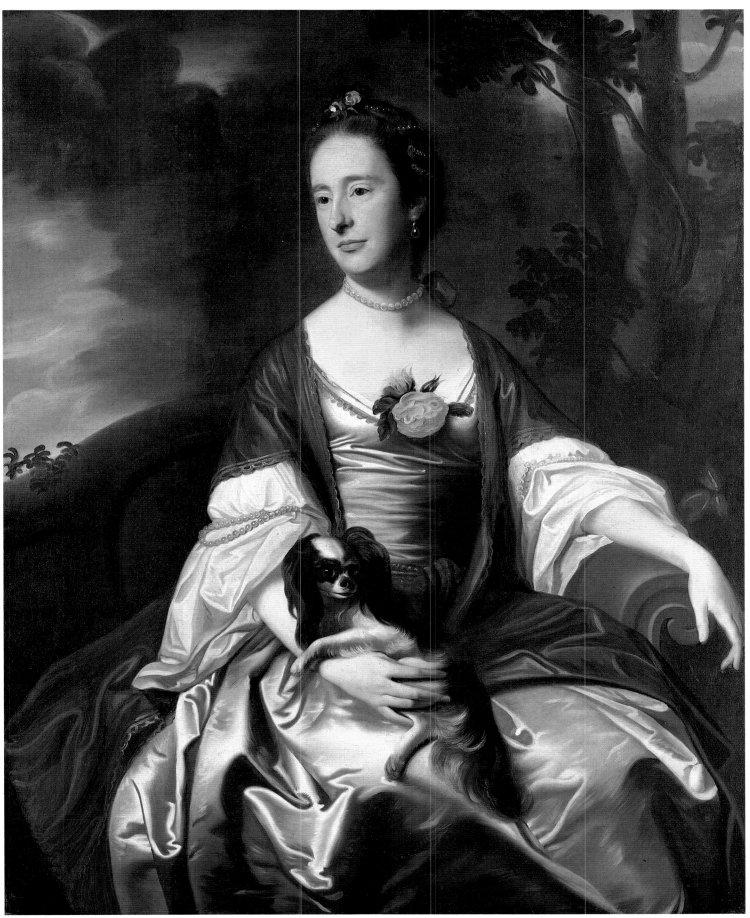

Fig. 93 *Mrs. Jerathmael Bowers*, ca. 1763. Oil on canvas, 49⅞ x 39¾ in. (126.7 x 101 cm). The Metropolitan Museum of Art, New York, Rogers Fund, 1915 15.128

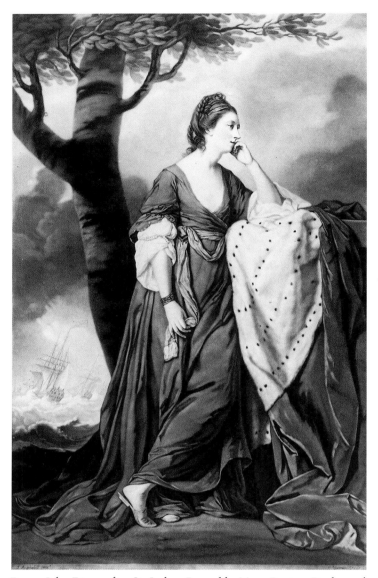

Fig. 94 John Dixon after Sir Joshua Reynolds. *Mary Panton, Duchess of Ancaster*, ca. 1764. Mezzotint, 24½ x 15 in. (62.2 x 38.1 cm). Trustees of the British Museum, London

whole ensemble call to mind Hogarth's remark that "the beauty of intricacy lies in contriving winding shapes."[32]

That Mrs. Richard Skinner had studied "the whole Art of Dress" is made quite clear by Copley's charming portrait of her (cat. no. 76). This is one of the few paintings in which the artist depicted a patterned silk, here a fine Spitalfields fabric with a delicate floral design on a pinkish cream ground in a dress with a bodice trimmed with a large pink silk rosette. Mrs. Skinner's hair is combed over a roll that enables it to reach the fashionable heights of the early 1770s.[33] A dress-cap of lace, gauze, and ribbon, a frivolous and very feminine confection that serves no practical purpose, alights atop this coiffure.[34] A similar concoction nestles on the crown of the hairstyle of the considerably less attractive Mrs. Isaac Winslow in the double portrait in which she appears with

her husband (cat. no. 81). Like Mrs. Skinner, she wears a fine brocaded silk with a floral motif, but here the sleeve ruffles are of broderie anglaise.

Such flowered silks were still stylish in the colonies but were becoming slightly old-fashioned in England by the 1770s, when Copley painted the Skinner and Winslow portraits. Perhaps for this reason Mrs. Winslow's patterned dress was replaced by a grayish-green one (fig. 230), a generalized version of the favored English costume of the 1770s, when she went to England, portrait in tow. The alteration may have taken place during Mrs. Winslow's stay in London in the 1780s; the moment of the overpainting is difficult to pinpoint, but it probably did not occur much later than this—for the hairstyle, usually the most sensitive of fashion barometers, was left untouched, although the cap was eliminated. The trend toward simpler women's styles in force by the 1770s could have encouraged Mrs. Winslow to decide that her outfit should be more consistent with her husband's sober riding costume of dark blue coat and leather breeches. Although the patterned silk that was revealed after recent conservation may well have struck a jarring note for the Winslows and their contemporaries in juxtaposition with the man's casual outdoor clothing, it certainly is more attractive than the plain one to the modern eye.

Some of Copley's most accomplished portraits of women are those with seated figures. Surprisingly few of them are depicted working at typically feminine domestic tasks such as embroidery, a prized pursuit of women. An exception is the rather bleak Mrs. Thomas Mifflin (cat. no. 80), who is portrayed in her suitably Quakerish gray dress, making silk fringe. The seated figures are tranquil, and their dress is usually of the most formal, luxurious type, which together with the rich accessories are tangible evidence of worldly property.

Mrs. Epes Sargent II was among the few women who chose to sit for Copley in informal attire. In her portrait (cat. no. 17) she stands in riding dress consisting of a jacket and skirt, possibly of camlet (a wool and silk mixture), with collar and cuffs of braided satin, and a black silk cravat. The shirt collar and cravat contribute to the restrained austerity and somewhat masculine feel of the costume. Riding dress, the ancestor of the modern suit, was worn for a number of outdoor activities in both England and the American colonies; although popular for portraits in the mother country, it is a style not often seen in American painting of the eighteenth century.

Mrs. Sargent's choice of costume allows her to display her fine riding whip, a popular fashion accessory that a contem-

porary German visitor to the colonies described as "elegantly made of fine wire, whalebone, and the like. The handle is usually of red velvet, of plush, of tortoise shell, of ivory or mother-of-pearl, and sometimes even of solid silver. . . . The women carry such whips with them even when they travel in the country or go riding into towns, or to church."[35]

The same visitor was impressed to see that the dress of American men was "all made of excellent english cloth or other similar material; and the shirts are also fine."[36] Given the predominance of English woolen cloths among textiles imported to the colonies, the popularity of English cloths that he noted is not surprising. Of course, for cultural as well as trade reasons there was a close linkage in terms of dress between English and American men of the commercial and professional classes. This is a linkage echoed in Copley's practice: he painted all of his male sitters in real dress, just as English artists portrayed their similar, mainly middle-class clientele in actual attire (male portraits in fancy dress were primarily the preserve of the aristocracy and gentry). Significantly, Copley recorded at least a third and possibly more of his female subjects in fancy dress, and a roughly comparable proportion of Englishwomen were so depicted in the mid-eighteenth century.

Copley painted men either in their everyday costume or in various kinds of official dress, such as clerical, legal, military, or academic. Most of Copley's male patrons presumably sat for him in these clothes, but he sometimes draped costumes, which may on occasion have been lent by the subject, on the studio lay figure that he asked Henry Pelham to send to him in New York in 1771. Copley's method of working with the actual costume is documented in his correspondence of 1768–69 with Myles Cooper regarding the latter's portrait in his academic gown (cat. no. 47). In August 1768 Cooper sent Copley from New York his "Gown, Hood and Band by which to finish the Drapery." However, the artist, who was renowned for being a slow worker, took a long time to complete the portrait, prompting the sitter to complain early in 1769: "the Gown I think you are unpardonable for keeping in your Hands so long."[37] Cooper had received his Doctor of Civil Law degree from Oxford in 1767 and clearly was anxious about his splendid red and pink gown, which must have been sent to him shortly before he sat for Copley.

Copley depicted nearly all of his male clients in the traditional three-piece suit that was formal or informal depending on its fabric and decoration. In America, as in England, this suit was a universally worn costume that offered no clues to its wearer's political allegiance but announced his

class and status. Colonial American gentlemen would have agreed with Lord Chesterfield's famous dictum that dress is "a very foolish thing . . . yet it is a very foolish thing for a man not to be well dressed according to his rank and way of life."[38] Essential to the image of the well-dressed man in the eighteenth century was the correct posture, which conveyed an easy gentility that avoided the extremes of stiffness and slovenliness. In fact, English etiquette books taught elegant poses, some of which were pictured in a series of drawings of the mid-1740s by Hubert Gravelot, the son of a tailor (see fig. 95).

Copley recorded the colonial gentleman's typical suit and bearing in *Theodore Atkinson Jr.* (cat. no. 8), showing his sitter dressed formally in a salmon-pink coat with matching knee breeches and a waistcoat of white silk embroidered in silver. Such a waistcoat would have been imported in ready-cut pieces, "waistcoat shapes" in contemporary parlance; the

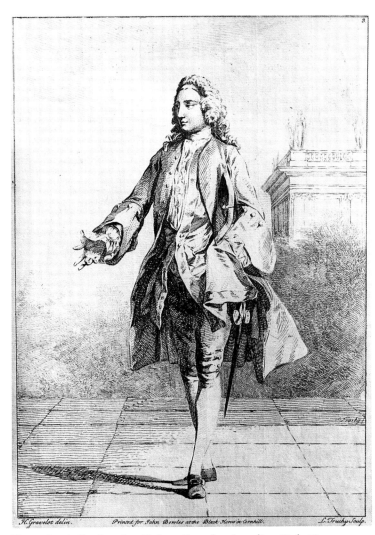

Fig. 95 Louis Truchy after Hubert Gravelot. *Standing Male Figure,* ca. 1745. Mezzotint, 9½ x 6¾ in. (24.1 x 17.1 cm). Trustees of the British Museum, London

quality of the embroidery of this particular example indicates fine professional English work. As the rules of elegant deportment dictated, Atkinson carries his hat under his arm (because the hat was held this way it was often termed a chapeau bras). Instead of grasping a sword hilt in the manner prescribed for English gentlemen by the manuals of etiquette, Atkinson places his right hand in his pocket, a gesture that displays the embroidery of the vest, traditionally the focal point of a man's attire.

Etiquette books instructed men to place a hand midchest through the partially unbuttoned waistcoat, a useful pose if the arm was not occupied with a chapeau bras and one that served to show off fine lace ruffles. This gesture is demonstrated in *Lemuel Cox* (cat. no. 55), in which the sitter's hand is placed in his gold-braided waistcoat. Cox's ruffles, however, like those of all of Copley's male clients, are plain linen, not lace: lace for sleeve ruffles and shirt frills was one European luxury that did not find favor with American men, for it was associated with very formal wear, particularly court attire, by the middle of the eighteenth century.

The range of fabrics and decoration employed for the three-piece suit was limited. The most costly fabric used was velvet,[39] which is shown in both *Nathaniel Sparhawk* and *Jeremiah Lee* (cat. nos. 19, 52), full-length portraits that are exercises in the grand manner. The costumes are suitably formal; indeed, the opulence of Lee's brown velvet suit trimmed with gold braid contrasts with his ungainly stance and awkward proportions. The clothes, as well as the powdered wigs, presented in the two portraits are somewhat old-fashioned, for a slimmer silhouette was in vogue for menswear by the 1760s, when Copley painted them. Older and more conservative gentlemen such as Sparhawk and Lee preferred the roomier styles of their youth, a fact acknowledged by at least one Boston tailor, who claimed: "with Gentlemen who do not chuse to have their Cloaths cut or finished according to the height of the Fashion, [the tailor] will endeavour to observe a medium, and will be particularly careful to follow any Direction given."[40]

It was the custom in America, as in England, for men and women of at least moderate income to have their clothes made to order. There was relatively little ready-made clothing, although partly made-up items, such as breeches pieces and the aforementioned waistcoat shapes, were imported. In the colonies and also in the mother country there was a flourishing market among less affluent consumers for secondhand clothes, and tailors were increasingly able to offer them a range of ready-made informal clothing (loose jackets and "trowsers," for example) for work and country

wear. By the 1760s a number of specialist shops were established in the major American cities that provided merchandise such as leather garb, including ready-made breeches of the sort Isaac Winslow wears in his portrait by Copley (cat. no. 81).[41]

Most of Copley's sitters wear bespoke suits, some velvet, the great majority wool. The woolen suits are usually sober in color, and for the most part have little trimming; examples are the reddish-brown garment in *Samuel Adams* (cat. no. 62) and the gray woolen cloth suit with no sleeve ruffles worn with black worsted stockings by the very austere sitter in *Eleazer Tyng* (cat. no. 74). The three elements of the typical suit may be of the same fabric (as in the Adams and Tyng portraits); the coat and breeches may match and contrast with the waistcoat (*Theodore Atkinson Jr.* [cat. no. 8]); or the coat and vest may be of the same color and/or material and contrast with the breeches, which are usually black (*Ezekiel Goldthwait* [cat. no. 61]).

More informal than the three-piece suit was the frock suit of the mid-eighteenth century. The frock suit featured a frock coat, which had a small turned-down collar and was usually made of woolen cloth and was lighter, closer fitting, and less structured than the coat of the traditional three-piece suit, whose lining was stiffer. Examples of the frock coat are depicted in Copley's portraits of Miles Sherbrook and Thomas Mifflin (cat. nos. 72, 80). Its relative informality made it an ideal garment for young men and boys such as Henry Pelham, who wears a dark blue frock coat with a pink satin collar over a buff waistcoat and a shirt with a casual open collar in one of his portraits (cat. no. 25). The most stylish version of the frock suit painted by Copley appears in *John Hancock* (cat. no. 22). John Hancock, who inherited his uncle Thomas's firm the year before this picture was executed, is portrayed here as a man of business, with pen poised and turning the page of a ledger, and also as a man of fashion. A man of fashion he was—he had written to his uncle from London in 1760 to justify his extravagance there: "I am not Remarkable for the Plainess of my Dress, upon proper Occasions I dress as Genteel as any one, and can't say I am without Lace. . . . to Appear in Character I am Obliged to be pretty Expensive."[42]

Copley created Hancock's genteel appearance not just with his elegant blue frock suit braided with gold and his silk stockings but also with his pigeon-wing powdered wig, tied at the back with a black silk bag. Older and less fashionable men tended to wear larger and heavier wigs, such as the physical wigs, a frizzed style favored by merchants and professionals, especially medical doctors, and recorded in

Copley's portraits of Robert Hooper, Jeremiah Lee, and Ezekiel Goldthwait (cat. nos. 40, 52, 61). The less formal bob wig was also popular with the professional and mercantile classes in both long and short versions; Moses Gill and Isaac Winslow are among the sitters who appear in bob wigs in Copley's portraits (cat. nos. 18, 81). In a number of paintings Copley clearly showed powder on coat shoulders—for powder-sprinkled clothes were an accepted consequence of the wearing of wigs, most of which were imported from London either ready-made or in the form of lengths of hair.[43]

A few men ignored the fashion for wigs and were content to reveal their own unpowdered hair. One of these was John Bours, pictured with his hair combed back over his ears in a fine portrait calculated to capture the sitter's sensitivity (cat. no. 56). From the 1760s an increasing number of men of various professions and all political stripes began to wear their own hair, lightly powdered or unpowdered, in the style of the short wig with side curls. Thus, cutting across the social and political divide, both Paul Revere and the Reverend Myles Cooper wear similar natural short bobs in two portraits of the late 1760s (cat. nos. 46, 47). The style suits the image of the craftsman Revere in shirtsleeves and waistcoat but provides an oddly informal touch in conjunction with Cooper's grand academic gown and bands.

Wigs were customarily used with formal academic dress such as Cooper's costume; it would have been inappropriate, however, to wear them with the loose T-shaped morning gowns adopted as fashionable "dishabille" by many men in the eighteenth century. These garments were sometimes called Indian gowns, more for their Oriental appearance than for their provenance, although a number were imported from India and the Far East by the East India Company. Nicholas Boylston, renowned for his elegant taste, wears one of these gowns, a superb sea-green example, over a beige waistcoat and breeches in his portrait (cat. no. 31). In 1755, in his *Dictionary*, Samuel Johnson described the morning gown as "a loose gown worn before one is formally dressed," and, fittingly, Boylston has on a velvet turban to protect his head from the cold before he dons his wig. Copley also depicted the Reverend Thomas Cary in a fine silk damask gown (cat. no. 65), and he portrayed himself in a blue silk damask gown over a laced waistcoat (fig. 25; cat. no. 49).[44]

Far different from these informal gowns were the uniforms Copley recorded in his paintings of military men. Among these is one of Copley's most perceptive portraits, that of the surveyor and engineer John Montresor (cat. no. 71), who had served in the Indian wars and at the fall of

Quebec. Montresor's black beaver hat, although military in style, has a fashionable nonregulation gold ribbon and button, and his red uniform with black velvet lapels is that of the Royal Engineers.[45] The same red-and-black color scheme characterizes the somewhat puzzling costume in Copley's portrait *Thomas Gage* (cat. no. 66). Gage was commander in chief of the British troops in North America, but his uniform is neither that of a staff officer nor that of any of his regiments.[46] It is highly improbable that Copley would have stretched artistic license to the point of inventing a uniform. However, Gage might have adapted and simplified a uniform to suit his own taste, for dress regulations had only relatively recently been established and some officers followed personal inclination in respect to sartorial matters. Whatever the answer to the conundrum presented by Gage's uniform, the finished portrait, which, according to British Captain John Small, was "universally acknowledg'd to be a very masterly performance, elegantly finish'd, and a most striking Likeness,"[47] clearly reveals how Copley used costume to indicate status and to reinforce character, in this case by providing an air of authority, without overwhelming the image with the minutiae of dress detail.

Like Hogarth in England, Copley in America far surpassed the indifferent artists who preceded him, joining the ability to portray a "striking Likeness" in both dress and physiognomy with a repertoire of international artistic conventions. Without Copley's accurate recording of dress, our knowledge of pre-Revolutionary costume would be infinitely poorer. In his portraits Copley fused depictions of dress with incisive interpretations of character to convey the increasingly self-confident image of colonists as they were transformed into Americans who, while retaining strong links with Great Britain, were creating a national culture.

1. *Diary and Autobiography of John Adams*, ed. Lyman H. Butterfield (Cambridge, Mass., 1961), vol. 1, p. 194. The remarks are from the draft of an unpublished essay of 1761 addressed to Adams's "Dear Nieces."

2. *Gentlemen's Progress: The Itinerarium of Dr. Alexander Hamilton, 1744*, ed. Carl Bridenbaugh (Chapel Hill, 1948), p. 145. Fashion plates and fashion dolls, known as "babies," were imported from England to keep American women abreast of the current styles in dress. They were available in the milliners' and dressmakers' shops.

3. William Eddis, *Letters from America* (London, 1792), p. 112.

4. Ibid., p. 144. In 1744 Dr. Hamilton had remarked that American goods "such as linnen, woolen and leather, bear a high price" (*Gentlemen's Progress*, p. 29).

5. Starting in the late seventeenth century, German immigrants to Pennsylvania produced linen and woolen goods, including stockings of fine thread, of linsey-woolsey (linen and wool), and of knitted wool. See

Martha C. Halpern, "Germantown Goods: A Survey of the Textile Industry, Germantown," *Germantown Crier* 43, no. 1 (1990), pp. 4–15. I am indebted to Dilys Blum, Curator of Costume and Textiles, Philadelphia Museum of Art, for bringing this article to my attention.

6. Andrew Burnaby, *Travels Through the Middle Settlements of North America in the Years 1759 and 1760* (London, 1775), p. 47. The finest beaver came from North America and, along with flax, raw cotton, tobacco, sugar, indigo, and whaling products, was among New England's most valuable exports. In the early 1750s, Gottlieb Mittelberger had noted that in Philadelphia, "very large and very fine beaver hats are worn, and no wonder, since Pennsylvania is the home of the beaver" (Gottlieb Mittelberger, *Journey to Pennsylvania*, trans. and ed. Oscar Handlin and John Clive [Cambridge, Mass., 1960], p. 89).

7. Burnaby, *Travels*, p. 79. Eddis concurred, stating: "coarse cloths for the wear of servants and negroes, the colonists may probably be enabled to manufacture, but insurmountable objections arise to the production of those of a superior quality" (Eddis, *Letters*, pp. 139–40).

8. There are some references to the use of homespun in the colonies, in the mid-1760s in particular, which may have been impelled by the boycott of certain British goods that followed the Stamp Act. See T. H. Breen, "'Baubles of Britain': The American and Consumer Revolutions of the Eighteenth Century," *Past and Present*, no. 119 (May 1988), pp. 73–104.

9. Peter Oliver, *Origin and Progress of the American Rebellion*, ed. Douglass Adair and John A. Schutz (San Marino, Calif., 1963), pp. 63–64. Oliver, the Loyalist Chief Justice of the Superior Court of Massachusetts, described this and other political gestures in his bitter account, written in 1781.

10. According to T. H. Breen: "Few colonial women . . . could possibly have clothed their families in homespun. The task would have taken more time than most young mothers had available. Moreover, it is doubtful that they would have possessed the tools necessary to spin yarn, and then to weave it into cloth" (T. H. Breen, "An Empire of Goods: The Anglicization of Colonial America, 1690–1776," *Journal of British Studies* 25 [Oct. 1986], p. 484).

11. Natalie Rothstein, "Silks for the American Market," part 2, *Connoisseur* 166 (Nov. 1967), p. 151. Some idea of the range of imported goods available in New England is revealed by an advertisement in the *Massachusetts Spy* (Boston), Oct. 3, 1771, announcing that Austin's in Boston was offering a variety of broadcloths (woolens), a "large and compleat Assortment of English, India and Scotch goods" (cottons and linens), and a broad "assortment of silks, as English and India damask, taffaties, striped and flowered lutestrings, changeable mantua silks."

12. In Boston there were specialist Irish linen shops and stores such as Austin's (see note 11 above) that carried a variety of printed muslins among its many textile goods. Printed cottons and linens made stylish and practical everyday costumes for women, particularly in warm climates. Some ready-made cotton gowns, exports from the thriving Manchester cotton industry, were available from the 1760s. In the period under consideration nearly all printed cottons came from England (chintzes from India were an exception). Only in 1773 did a British calico printer, John Hewson, establish a business in Philadelphia; soon thereafter other textile printers came to America from the mother country.

13. W[illiam] T. Baxter, *The House of Hancock: Business in Boston, 1724–1775* (Cambridge, Mass., 1945), p. 59.

14. As in England, most ready-made articles were those in which the fit was relatively unimportant, such as hats, caps, ruffles, kerchiefs, loose jackets, and mantles. The quality of the fit of more closely shaped garments was often not high. Ready-made clothing sometimes was purchased in Europe and brought over by colonists or their friends and relatives or bought in the form of secondhand garments at auctions that were advertised in the newspapers.

15. *The Autobiography of Colonel John Trumbull*, ed. Theodore Sizer (New Haven, 1953), p. 11.

16. Dunlap 1834, vol. 1, p. 107. Dunlap erroneously says that the suit was crimson velvet with gold buttons.

17. Copley, letter to [Benjamin West or Captain R. G. Bruce?], [1767?], in Jones 1914, pp. 65–66.

18. Even the virtuoso Copley, however, learned to expect commissions beneath his abilities. Indeed, George Livius of New Hampshire asked him to copy a family portrait by an exceptionally obscure artist ("De Kelberg") and to "improve" another by the same artist by replacing the sitter's powdered hair with light brown hair, narrowing her shoulders, and changing the "bed gown from the flaring colour it is of to a more becoming and grave one, to a garnet purple for instance" (George Livius, letters to Copley, Sept. 3 and 14, 1767, in Jones 1914, pp. 60–62).

19. Copley, letter to Benjamin West, Jan. 17, 1768, in Jones 1914, pp. 67–68.

20. Copley, letter to Henry Pelham, June 16, 1771, in Jones 1914, p. 117.

21. On the subject of *turquerie* and its impact on women's costume in the eighteenth century, see Aileen Ribeiro, "Turquerie: Turkish Dress and English Fashion in the Eighteenth Century," *Connoisseur* 201 (May 1979), pp. 17–23.

22. Frederick A. Sweet wonders if Copley "could have lent engravings to his lady patrons so that they could have their dressmakers fashion gowns for them after the models whose pose they are going to assume in their portraits" (Frederick A. Sweet, "Mezzotint Sources of American Colonial Portraits," *Art Quarterly* 14 [Summer 1951], p. 154). In light of the little we know of eighteenth-century artists' working methods, this seems an unlikely suggestion. Copley's virtuoso skills in the rendition of textiles, rather than the presence of actual gowns, probably accounts for what Sweet correctly describes as the "very solid three-dimensional manner in which many of the dresses are painted." It is certainly possible, however, that, as Sweet suggests, "the patrons themselves often purchased prints which they took to the artist to use as a model for a pose" (ibid.).

23. Henry Pelham, letter to Copley, Jan. 27, 1776, in Jones 1914, p. 369. All three plates were by James McArdell.

24. For a detailed discussion of this subject, see Aileen Ribeiro, "Some Evidence of the Influence of the Dress of the Seventeenth Century on Costume in Eighteenth-Century Female Portraiture," *Burlington Magazine* 119 (Dec. 1977), pp. 834–40.

25. Prown 1966, vol. 1, p. 11. Smibert had traveled in Italy, France, and Holland and brought a collection of old master prints with him to America. Wayne Craven claims that, because Americans preferred their own characteristically realistic portrayals, the generalized Kneller-type portrait did not find favor in the colonies; but it certainly did, and large numbers of early and mid-eighteenth-century American portraits are precisely what the author says they are not, "inept attempts at the baroque high style of Van Dyck or Lely" (Wayne Craven, *Colonial American Portraiture: The Economic, Religious, Social, Cultural, Philosophical, Scientific, and Aesthetic Foundations* [Cambridge, 1986], p. 48).

26. See note 21 above.

27. There is an even more direct link between Reynolds's *Ladies Amabel and Mary Jemima Yorke* and Copley's *Elizabeth Ross* (fig. 51). Here Copley closely copies both the costume, a plain, vaguely neoclassical gown and an ermine-trimmed robe, and the pose, in which a bird

perches on the lady's hand, of the original; he reverses the pose, however. Other examples of Copley's close use of an English portrait are *Mrs. John Murray,* 1763 (Worcester Art Museum), *Mrs. Daniel Hubbard,* 1764 (fig. 23), and *Mrs. John Amory,* ca. 1764 (Museum of Fine Arts, Boston), in which the generalized versions of fashionable dress and poses are all copied from Hudson's *Mary Finch, Viscountess Andover* (fig. 24), engraved by Faber in 1746.

28. John Greenwood, letter to Copley, Mar. 23, 1770, in Jones 1914, pp. 81–82.

29. I am grateful to Tina Levey for information on the lace worn by Copley's female sitters. Mrs. John Winthrop may also be wearing Honiton lace in her portrait (cat. no. 79).

30. From Mrs. Warren's poem "Woman's Trifling Needs," quoted in Elizabeth McClellan, *A History of American Costume, 1607–1870* (1904; reprint, New York, 1969), pp. 202–3.

31. Copley portrayed his subject in a similar blue satin *sacque* trimmed with silver in *Mrs. Benjamin Pickman* (fig. 73).

32. William Hogarth, *Analysis of Beauty,* ed. Joseph Burke (Oxford, 1955), p. 52.

33. Such rolls could be fashioned of various substances but were usually made of hair and advertised by hairdressers and wigmakers. One advertisement in the *Pennsylvania Gazette,* 1773, presented an offer to make rolls for women so that they could "raise their Heads to any Pitch they may desire" (quoted in McClellan, *American Costume,* p. 188).

34. Newspaper advertisements featured a wide range of laces for accessories such as caps and other headdresses, sleeve ruffles, kerchiefs, and dress ornaments. In the *Boston Gazette,* Feb. 3, 1772, for example, a Mrs. Hooper announced a "fresh supply of the newest kinds of Millenery Goods" from London, including "very best Brussels and Flanders lappets, with Laces of all sorts, newest fashion [as well as] Gauzes, Lawns, Muslins, Ribbons, Silver Blond Lace, italian Flowers" in addition to "a few ready-made Womens tasty English caps."

35. Mittelberger, *Journey to Pennsylvania,* p. 88.

36. Ibid., p. 89.

37. Myles Cooper, letters to Copley, Aug. 5, 1768, and Jan. 9, 1769, in Jones 1914, pp. 70–71, 74.

38. Lord Chesterfield [Philip Dormer Stanhope], *Letters to His Son,* ed. Eugenia Stanhope (London, 1774), vol. 1, p. 183.

39. The finest quality silk velvet came from Genoa, a popular stopping point for fashionable gentlemen on the Grand Tour. (Copley himself purchased some black velvet there in 1774.) Far humbler, and much less costly, were the cotton velvets manufactured by the Manchester weavers, which were among the fabrics exported to the colonies from England; one advertisement for them, in the *Boston Weekly News-Letter,* Jan. 3, 1771, refers to the "black and olive color'd low-pric'd Manchester velvets."

40. Advertisement for John Maud, *Boston Gazette,* Sept. 7, 1772.

41. The Scottish glover and breeches maker Alexander Ralston advertised in the *Massachusetts Gazette,* Dec. 10, 1772, that he could make "all kinds of Leather Breeches" in a range of colors and skins, including "Buck-skin, Doe-skin, Moose-skin."

42. John Hancock, letter to Thomas Hancock, 1760, quoted in Baxter, *House of Hancock,* p. 148. In English society, which was more formal than American, it would indeed have been appropriate for John Hancock to wear lace on his shirt and as sleeve ruffles.

43. Although there are a few references to wigs made of other materials— for example, the *Boston Gazette,* Dec. 1, 1766, advertised "mens worsted wiggs"—most were made of hair, usually human, occasionally animal. The list of items to be sold at auction in Boston in April 1769 included "a parcel of best Grizzel, Craped and not Craped London cured Hair, Goat ditto, Brown ditto, Bleach'd Tye 24 Inches long. Also several Grey Feather'd London made Wigs" (*Boston Weekly News-Letter,* Apr. 13, 1769).

44. See J. Herbert Callister, "Taste in Dress in Eighteenth-Century America," *Apollo* 88 (Dec. 1968), pp. 478–81. For a discussion of men's dressing gowns, see M. H. Swain, "Nightgown into Dressing Gown: A Study of Men's Nightgowns, Eighteenth Century," *Costume,* no. 6 (1972), pp. 10–12.

45. The corps of the Royal Engineers was granted army rank and uniform in 1757. See Cecil C. P. Lawson, *A History of the Uniforms of the British Army* (London, 1941), vol. 2, p. 192. From 1772 the buttons of its uniform bore the arms of the Board of Ordnance.

46. Sylvia Hopkins, Keeper of Uniforms, National Army Museum, London, letter to the author, Apr. 12, 1994. According to Hopkins, the full-dress uniform of a general officer was "scarlet with blue facings and gold lace, [the] lace of the loops was very wide and the cuffs a deep rounded turnback"; the undress "had no loops but the lapels were laced round, [and] again the cuff was rounded not slashed." The uniform of the Sixtieth Foot, of which Gage was colonel for a few months late in 1768, is closer than that of any other of Gage's regiments to the costume in Copley's portrait. However, the uniform of the Sixtieth Foot was red with blue facings and had silver lace, not the gold lace that appears in the portrait. Moreover, Hopkins notes that "the cuff is pre 1768 which does not accord with the date when Gage was Colonel of the 60th." Hopkins concludes that "the uniform appears to be that of an Infantry officer c. 1764–1767," and that "the evidence of the uniform leaves somewhat of a question mark over whether or not the portrait is of Gage."

47. Captain John Small, letter to Copley, Oct. 29, 1769, quoted in Prown 1966, vol. 1, p. 80.

Copley in Miniature

ERICA E. HIRSHLER

As a young man motivated by an assiduous desire to help support himself and his family through the only craft he knew, creating likenesses, John Singleton Copley investigated every possible method to increase his business opportunities. During the mid-1750s he explored painting in oil on canvas, engraving, working in pastel and in miniature, trying any format or medium that might attract customers. Although he later complained that portraits were the only artistic product the American market demanded, Copley nonetheless perfected two techniques that were suited principally for that genre—drawing in pastels and painting in miniature. He adopted them at the same time and abandoned both early in the 1770s, when he had firmly established himself as America's preeminent portraitist in oil on canvas. His ambition to be an artist in the grand tradition of Titian and Raphael led him to favor large-scale oil painting, but during his American career, Copley also proved himself to be a master of the miniature.

The literature on Copley's achievement in this genre is sparse. Among the early histories of American miniature painting, Anne Hollingsworth Wharton's *Heirlooms in Miniature* of 1898 discusses Copley's life and mentions specific works; however, several of the paintings the author cites are no longer attributed to Copley. Referring to a similarly varied selection of examples, Harry Wehle, Theodore Bolton, and Frederick Fairchild Sherman praised Copley's accomplishments as a miniaturist in the 1920s and 1930s. In 1957 Barbara Parker offered the most careful connoisseurship and complete discussion realized to that date of Copley's portraits on ivory in her distinguished catalogue *New England Miniatures, 1750–1850*. More recently such scholars as Dale T. Johnson, Susan Strickler, and Robin Bolton-Smith have produced collection catalogues that provide useful overviews of American miniature painting and invaluable material on specific portraits, a number of them by Copley. Among Copley scholars, early biographer Augustus Thorndike Perkins made note of the miniatures and included a few

examples in his checklist of 1873, but Martha Babcock Amory recorded nothing particular to the medium in her book, published in 1882. Barbara Parker and Anne Wheeler's monograph of 1938 lists Copley's miniatures without sitters' biographies, thereby according them lesser status than both oil portraits and pastels, which are accompanied by information on the subjects. Jules Prown, in his indispensable *John Singleton Copley* of 1966, offered a complete inventory of the miniatures but provided only brief discussion of them in his text. Prown simplified the categorization of Copley's small-scale work by dividing it primarily into two groups—oils on copper from the late 1750s and watercolors on ivory of the late 1760s. However, detailed bibliographic information on the sitters and recent technical examinations of the miniatures themselves reveal that Copley's transition from one medium to the other was gradual and that his interest in both was prolonged (see cat. nos. 14, 77, 78).

Copley was an American pioneer of portraiture in miniature—in a remarkably short time and without formal instruction, he first perfected a process of painting small likenesses in oil on copper and then moved on to the more stylish British manner of fashioning them in watercolor upon thin wafers of ivory. Although many of his oils on copper date from the late 1750s, he continued to experiment with that medium throughout the 1760s, well after he had begun to paint in watercolor on ivory. Copley developed technical innovations without ever leaving his native Boston, and his earliest ivory miniatures predate examples in the medium by his closest potential competitor in miniature painting, Charles Willson Peale, who learned the demanding technique when he was in London between 1767 and 1769.

Miniature portraits were known in America from the time of the first British settlers in the early seventeenth century, as a tiny image of the Puritan leader John Winthrop (Massachusetts Historical Society, Boston) attests. This miniature, crafted in watercolor on vellum, was probably painted in England just before Winthrop's departure for the colonies in 1630. In all likelihood, such small-scale portraits made their way to the New World much more frequently than

Portrait of the Artist (cat. no. 49)

117

full-size canvases did. Immigration to America separated families, often permanently, and, for those who could afford them, miniatures were easily transportable keepsakes, mementos of distant friends or relatives. That Winthrop was not the only colonist who commissioned miniatures is made clear by at least two large-scale seventeenth-century portraits that show sitters wearing miniatures, including *Elizabeth Eggington*, painted in Boston in 1664 (Wadsworth Atheneum, Hartford).[1] Such British miniatures could have provided prototypes for American artists, but the dearth of information about British miniatures in America makes it difficult to pinpoint specific models.[2]

It is possible that miniature portraits were produced by Americans in seventeenth-century Boston, although no examples are known. The word *limner* does appear in American documents of the period.[3] This term once had been used almost exclusively for producers of small-scale portraits in watercolor on vellum, and as Nicholas Hilliard, the most accomplished British miniaturist of the late sixteenth and early seventeenth centuries, explained, "Limning . . . is a thing apart from all other painting or drawing."[4] By the 1630s, however, the word *limner* was also used to refer to makers of other types of portraits, and thus its precise meaning in American documents is uncertain. Hilliard had described the specialized techniques of the limner in his book *The Arte of Limning*, first printed in 1573. Miniatures were also considered in such treatises as John Bate's *The Mysteries of Nature and Art* of 1634, which included a chapter on "Drawing, Limming, Colouring, Painting, and Graving." Bate's book was owned by Boston minister Increase Mather and then by his son Cotton;[5] Copley may well have had access to it through his stepfather, Peter Pelham, who had painted Cotton Mather in 1728.

All of these texts discussed miniature portraits in watercolor on vellum, which had first gained popularity in the royal court of Henry VIII. Despite its roots in France and Flanders, the craft became a British specialty. To create these precious likenesses, painters worked over the whole surface of small circles of vellum with a wash of whitish watercolor called a carnation, which served as the underlying flesh tone for faces. They defined figure and costume with subsequent layers of opaque watercolor and then mounted the picture on a card and set it in an intricate case.[6] This traditional technique was supplanted early in the eighteenth century when ivory came into use as a support. Ivory, although difficult to work, served as an ideal flesh tone and allowed artists to employ more transparent paint to create effects far fresher and more luminous than those possible with vellum. The

introduction of ivory supports, generally credited to the Venetian artist Rosalba Carriera (1675–1758), transformed miniature painting. Bernard Lens III (1682–1740) popularized their use in England; by the 1760s a variety of British artists had mastered them (over twenty advertised in London in 1763), and such small portraits on ivory became increasingly fashionable.[7]

Although painting in watercolor on vellum or ivory is the technique of the true portrait miniature, miniature portraits were created in a number of other media. During the first half of the eighteenth century, small enameled portraits were immensely popular in London. To create them, an image was fashioned in vitreous paints on a metal disk—most often copper—and then fired in a kiln; the firing turned the colors glassy and permanently bonded them to their support. Likenesses were also painted in oil directly on copper, a technique different from enameling. The latter method was the one Copley first mastered, possibly due in part to the influence of John Smibert (1688–1751). Smibert was most frequently employed to make large-scale portraits in oil on canvas, but he also painted smaller ones in oil on copper, a method generally designated as working "in Littell." His miniatures may have provided an important precedent for Copley's early efforts.

Smibert recorded his small paintings in his notebook, which lists six miniature portraits produced in London and two in Boston.[8] The only known surviving example is *Samuel Browne* (fig. 96), a tiny oval portrait in a locket made by the Boston goldsmith Jacob Hurd. Smibert had painted three-quarter-length oil-on-canvas images of the Salem landowner Samuel Browne and his wife, Katherine, in June 1734 (Rhode Island Historical Society, Providence), and the miniature, which was made in August, was likely copied from the larger picture. Its high price—twenty-five pounds, the same fee Smibert charged for half-length oils—indicates what a luxury miniatures were and explains in economic terms why Smibert seems to have painted so few of them in Boston: for the same amount of money, customers could get a much bigger and more impressive image in oil on canvas.[9]

Painting on copper supports was first adopted in northern Europe and in Italy in the mid-sixteenth century. Admired for the effects of glowing richness it produced, the technique became especially desirable for smaller pictures and flourished through the seventeenth century. Thereafter it declined in popularity save for "delicate and elaborate paintings," as Robert Dossie explained in his technical manual *The Handmaid to the Arts*, published in 1758.[10] The procedure would have been a logical choice for an oil painter such

as Copley; it was comparable to painting on canvas and therefore could be assimilated readily. Furthermore, if Copley learned it, he would have had no need to attempt the complicated craft of enameling, which demands specialized materials and equipment, including an appropriate furnace.

Copley probably was influenced to take up painting miniatures on copper not only by the legacy of Smibert and the British examples of the craft likely available to him but also by the activities of his stepfather, Pelham, as a portraitist in both oil and mezzotint. Pelham's procedure in transferring a likeness from a canvas to a copperplate engraving involved reducing the original to a smaller scale. For instance, Pelham painted the minister Mather Byles, ca. 1732 (American Antiquarian Society, Worcester, Massachusetts), in three-quarter length, in a format of 30 x 25 inches. He also made a mezzotint of the Byles portrait, for which he considerably contracted the composition: his original copperplate is only about 6 x 4 inches. This process of replicating images and of changing the scale of the copy was detailed in numerous technical manuals, but Copley may have learned the practice from Pelham, who clearly had mastered it.[11] Several Pelham mezzotints are modest in scale, almost as small as a few of Copley's early oil-on-copper portraits, which likewise were sometimes reduced from full-size canvases.

Furthermore, the use of copper as a painting support was often associated with etching or engraving studios.[12] Copperplates were employed in making both types of images, and Copley could have relied upon his stepfather's stock of metal plates for his own small oil portraits, just as he did for his mezzotint of the Reverend William Welsteed (cat. no. 1), for which he reworked a plate engraved by Pelham. Copley explored both media in the mid-1750s but did not pursue printmaking for very long. Some of Copley's earliest paintings in oil on copper, including *Miss Russell*, ca. 1755 (Museum of Fine Arts, Boston), and *Mrs. Todd* (fig. 97), were made on sheets of metal of a relatively heavy weight appropriate for printing plates.[13]

It is apparent that from the very start of his career, Copley offered his clients miniatures copied from larger likenesses as well as painted from life, for some of his first small-scale portraits, all in oil on copper, reproduce his own oils on canvas. Just as Smibert had made two versions of *Samuel Browne* in 1734, so Copley painted *Joshua Winslow* in both large and small sizes in 1755: the oil-on-copper miniature (private collection) reproduces the head and shoulders of Copley's three-quarter-length oil-on-canvas portrait of the officer (fig. 162). In adopting this procedure of copying, the young Copley was following a widespread practice that had

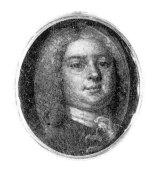 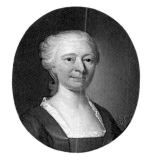

Fig. 96 John Smibert. *Samuel Browne*, 1734. Oil on copper, 1½ x 1⅜ in. (3.8 x 3.5 cm). Estate of Hereward Trott Watlington

Fig. 97 *Mrs. Todd*, 1755. Oil on copper, 2¾ x 2⅜ in. (7 x 6 cm). Museum of Fine Arts, Boston, Gift of Misses Aimee and Rosamond Lamb 1978.683

more than one application. A method of artistic training whereby a painter could familiarize himself with the pictorial strategies of an admired master, copying could also prove to be a lucrative trade. In England copyists were frequently employed to make reproductions in both full and reduced scale. As early as 1636 a document recorded the direction to London miniaturist John Hoskins (ca. 1590–1665) to "take my picture in little from my original that is at length."[14] In 1762 Horace Walpole also made note of the practice, quoting George Vertue's description of two small oil paintings by Cornelius Johnson (1593–1661): "these two are certainly coppyes from the larger ones and very probably it might have been a custom much used with him to do both great and small."[15] Copley certainly would have been familiar with the procedure and doubtless was aware of its economic implications—he could capitalize on his commissions for oil portraits by offering his clients an additional likeness, one that they could easily transport or present to a friend or relation. However, it is difficult to determine what Copley earned for these small paintings. In 1758 he charged one guinea for a miniature of Thankful Hubbard (location unknown), but his prices are otherwise unrecorded.[16]

Among the Copley miniatures from this period that do not relate to known larger portraits are *Mrs. Todd* and *Nathaniel Hurd* (private collection). Copley seems to have recorded Mrs. Todd only in oil on copper, but he painted the Boston silversmith Hurd in little about ten years before he produced a larger portrait that shows him in quite different garb (cat. no. 21). Although he was not always able to convince patrons who ordered large portraits to purchase miniatures, Copley did occasionally succeed in selling his buyers of oils on copper additional small-scale copies of his work. He was particularly successful with the Oliver family in this respect, painting three known versions of his small likeness

of Andrew Oliver (fig. 98; private collections), who was once lieutenant governor of Massachusetts, and two of his second wife, Mary Sanford Oliver (fig. 99), all in about 1758.

Copley's patrons for small oil-on-copper portraits included some of Boston's richest families. The most important were the Olivers, who commissioned almost two-thirds of Copley's work in this medium, along with several large-scale oils. Formerly patrons of Smibert and Joseph Blackburn, the Olivers were wealthy, highly educated, and particularly fond of portraits.[17] They hired Copley both to provide replicas of existing portraits by other artists and to paint original pictures for them. His three miniatures of Andrew Oliver and his single small painting of Andrew Oliver Jr., ca. 1758 (Museum of Fine Arts, Boston), may have been copied from earlier, large-scale portraits by Nathaniel Emmons and Blackburn, although he did not attempt to replicate his predecessors' artistic styles and slightly varied the details of the clothing. Copley's *Peter Oliver* (fig. 100), however, was an original likeness, not a replica of another portrait that the family owned, Smibert's canvas of about 1733 depicting the sitter in his youth. Here Copley rendered the mature Peter Oliver, now a judge in his forties, as careworn and appropriately bewigged. This miniature may have been painted in connection with Copley's own full-length portrait of Peter Oliver (date and location unknown). But the oil on canvas, documented as showing Oliver in the scarlet robes of his judicial office, was probably more ostentatious than the contemplative miniature. Although Copley conceivably could have used the miniature as a study for his full-length portrait and then sold it to Oliver (thus turning a profit from Sir Joshua Reynolds's warning that preliminary drawings on paper were not worthwhile),[18] it is more likely that the two

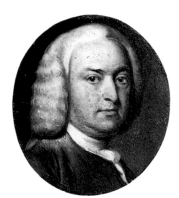

Fig. 98 *Andrew Oliver*, ca. 1758. Oil on copper, 2 x 1¾ in. (5.1 x 4.5 cm). Yale University Art Gallery, New Haven, Mabel Brady Garvan Fund 1955.5.5

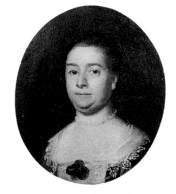

Fig. 99 *Mrs. Andrew Oliver (Mary Sanford)*, ca. 1758. Oil on copper, 1¾ x 1⅜ in. (4.5 x 3.5 cm). Yale University Art Gallery, New Haven, Mabel Brady Garvan Fund 1955.5.12

images, one large and one small, fulfilled two different functions, one public and one private.

The majority of Copley's portraits in oil on copper were made during the late 1750s and early 1760s. His stylistic progression in these miniatures parallels that in his large oils; the development is toward greater boldness, fluidity, and ease. In both, facial features are constructed in much the same way, with vermilion defining the creases of noses and eyelids, and single dots of white highlighting the eyes. Despite the limitations of the tiny format, which leaves no room for the full sweep of luxurious costumes and the elaborate backgrounds that embellish his canvases, Copley's handling of paint in the miniatures is swift and sure, accented by bold touches of color and sensuous, liquid brushstrokes. Typical of these accomplished small works is his image of Mary Sanford Oliver, whose lively expression and plump chins are defined with quick confidence. Copley gave special attention to the pearls encircling her neck and to the transparent lace wrapped about her shoulders; even on this minute scale they are carefully delineated with smooth, flowing strokes. Likewise, the diminutive size of the portrait of her daughter Griselda Oliver Waldo (fig. 101), who appears in a symphony of pinks, proves no impediment to Copley's brilliant display of satin ribbon, lace, and pearls.

The opulent detail displayed in these two images is echoed by Copley's technique. In both *Mrs. Oliver* and *Mrs. Waldo*, Copley layered his copper support with gold leaf before he began to paint, a procedure yet to be fully understood.[19] Earlier miniaturists had often relied upon powdered gold (shell gold) as a pigment, using it to add luxurious details to braid, embroidery, or jewels but not as a ground. Large paintings on copper do sometimes have metallic grounds, usually tin, silver, lead, or zinc. Although gold grounds are rare, Rembrandt employed them at least three times. The purpose of such a layer is uncertain; in some cases it enhances the appearance of the painting, but in others it is made virtually invisible by a subsequent layer of an additional ground, most often white lead. Metallic grounds may have been adopted in the belief that they would strengthen the bond between the support and the pigment or perhaps retard the corrosion of the copperplate. They proved ineffective in both respects, however.[20] Copley used gold-leaf grounds inconsistently and sometimes painted over them thickly and opaquely, eliminating the luster such burnished layers might have provided if they had been covered with a thin, translucent medium. Perhaps he turned to these precious grounds because he sought to impress his customers with the precious nature of the likenesses he created for them; definitive

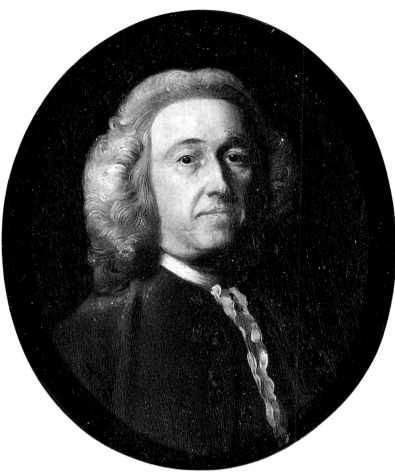

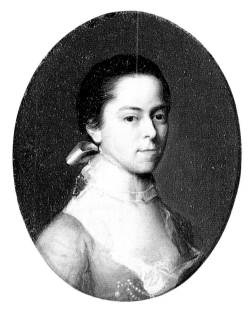

Fig. 101 *Mrs. Samuel Waldo (Griselda Oliver)*, ca. 1758. Oil on copper, 3¼ x 2½ in. (8.3 x 6.4 cm). Yale University Art Gallery, New Haven, Mabel Brady Garvan Fund 1955.5.6

Fig. 100 *Peter Oliver*, ca. 1758. Oil on copper, 5 x 4 in. (12.7 x 10.2 cm). Andrew Oliver Jr., Daniel Oliver, and Ruth Oliver Morley

explanations must await the gathering of more complete technical information.

Whether his ground was gold or white (probably white lead), at times Copley worked quite transparently, using the base layer as an integral part of his composition. In both *Samuel Fayerweather* (cat. no. 14), which has a gold ground, and *Andrew Oliver*, which has a white one, Copley outlined the figures with a reddish transparent paint. He then filled out the forms with thin colored glazes, covering most of his contour lines but leaving them barely visible about the face and eyes. The results he produced are much more radiant than those apparent in the earliest miniatures, and the grounds have a significant visual effect, lending a warm brilliance to *Samuel Fayerweather* and creating a cool translucence in *Andrew Oliver*. The sort of experimentation with thin paints evident in these works of the late 1750s and early 1760s seems to have coincided with Copley's growing interest in the luminous properties of watercolors on ivory.

Copley's last oil-on-copper miniatures date from the late 1760s, by which time he had largely abandoned the medium in favor of the more fashionable watercolor on ivory. Choice of medium may have been left to his clients: there is no documentation of transactions between Copley and his patrons in this regard, but a letter of 1772 reveals that Margaret Mascarene asked Copley's half brother, Henry Pelham, to replicate in miniature, specifically in oil on copper, a portrait of her late father.[21] Copley and his most sophisticated clients, who always followed high-style British taste, probably preferred ivory miniatures; for this reason Copley may have directed requests for oils on copper toward his half brother, as some scholars have suggested.[22] Whereas many oils on copper were relatively large and framed for public display, miniatures on thin wafers of ivory, sliced from tusk or whalebone, were always tiny.[23] Usually encased in gold, they were more private, personal possessions that often were used as jewelry. Copley first attempted to make ivory miniatures in the early to mid-1760s; he must have been challenged by their scale and the difficult technique they demanded, and intrigued by their status as fashionable and expensive objects.

The earliest known examples of ivory portrait miniatures crafted in America date from the 1740s. They were pro-

duced in Charleston by Mary Roberts (d. 1761), an artist born and trained in England, who advertised her accomplishments at "face painting" in the *South Carolina Gazette*.[24] Benjamin West (1738–1820), the first American-born artist to try the medium, limned at least one watercolor on ivory in 1758–59, a self-portrait apparently intended as a love token (Yale University Art Gallery, New Haven). He later described it as "not a bad picture for one who had never seen a miniature."[25] West probably was exaggerating his lack of exposure, for it seems unlikely that he could have so successfully managed the intricate technique of miniature painting, particularly on ivory, without ever seeing an example. He might well, however, have had access to books on the subject.

Technical manuals for making miniatures were available, although they described painting on vellum rather than on ivory. Dossie's *Handmaid to the Arts* was the most popular of these guides, and it was for sale at New York and Philadelphia booksellers by 1760, only two years after its publication in London. This encyclopedic book contained a section on miniatures, and more specialized volumes were also obtainable, including Claude Boutet's *Art of Painting in Miniature*. First published in French in 1676, Boutet's treatise was updated, translated, and printed in London in 1729; later English editions appeared in 1730, 1739, 1750, and 1752.[26] Intended primarily for painters of watercolor miniatures on vellum, it also described techniques of interest to artists who worked on ivory, including how to "dot," or stipple. Boutet asserted that such methods were impossible to analyze from visual examination alone, claiming that "when a Man sees this Effect, without having seen how it is produced he must, at least, be a Conjurer to discover the Order and Manner of it, supposing that he hath neither Book nor Master."[27] His *Art of Painting in Miniature*, subtitled *Teaching the Speedy and Perfect Acquisition of That Art Without a Master*, seems to have been tailor-made for a self-taught artist such as Copley.

Miniature painting on ivory was a demanding occupation. Artists were challenged not only by the constraints of scale but also by the slick character of ivory itself, which repelled liquid, including watercolors. Complicated preparation of the support was called for—it needed to be degreased, bleached, smoothed, and affixed to a backing before color could be applied—and the requirements for adding gum, water, and sugar candy to the pigment were precise. For these reasons it is unlikely that Copley perfected miniature painting without a guide, although his specific sources remain unknown. That many of his miniatures survive in

Fig. 102 *Mrs. John Melville (Deborah Scollay)*, ca. 1762. Watercolor on ivory, 1¼ x 1 in. (3.2 x 2.5 cm). Worcester Art Museum, Massachusetts, Museum purchase 1917.184

good condition makes clear his technical expertise, for if the ivory had been prepared inadequately, or if Copley had not mixed his medium properly, the paint could have flaked away. Such damage might happen quickly. For example, in 1796 Joseph Barrell (who, years earlier, had sat for Copley) complained to his London jeweler Stephen Twycross that the British miniatures on a pair of bracelets he had ordered from Twycross only ten years before were "cleaving from the Ivory."[28]

Copley's earliest extant watercolor miniature is a portrait of Deborah Scollay Melville (fig. 102), painted either at the time of her marriage in 1762 or in 1763–64, when he made pastels of her parents. This likely was not Copley's first effort at painting on ivory, for *Mrs. John Melville* is both an intense study of character and a refined, punctilious composition, created by a master rather than a student. Copley used tiny, long, thin brushstrokes for both figure and background and a subtle combination of rosy and salmon pinks for his sitter's dress and cap. To produce the effect of lace, he added white highlights with a precise and meticulous hand. The blue cast of her skin (now exaggerated by the disappearance of fugitive red pigments) was specified by some manuals, including Boutet's, which advocated employing bluish tints for the basic flesh tones of women and children and vermilion for men.[29]

Although Copley had made a radical transition from oils on copper to watercolors on ivory, he still perceived making miniatures as a way to enhance his business and continued to offer small-scale copies of his larger work. Of the ten subjects of watercolor miniatures listed in Prown's monograph, seven appear in other Copley portraits: two in full-size oils (cat. nos. 40, 52) and five in pastels. Among these seven sitters was the wealthy merchant Jeremiah Lee, one of Copley's most avid customers. Captivated with images and image making, Lee ordered ostentatious full-length portraits of himself and his wife, Martha (cat. nos. 52, 53), probably for

the stair hall of his Marblehead mansion in 1769. The huge paintings were anything but portable, and Lee asked Copley to duplicate his features in the miniature format—several times.[30] Although set in different types of cases, the two documented Lee miniatures (cat. no. 54; Marblehead Historical Society) are virtually identical, tiny, distilled likenesses that radiate a sense of Lee's proud demeanor.

Copley's replication of his own work is documented not only in such visual evidence as the Lee miniatures but also in a letter written by Captain John Small, who reported to the artist from his post in New York in 1769 that "the miniature you took from my *Crayon* Picture has been very much admir'd and approv'd of here, by the best Judges."[31] The most spectacular example of a Copley miniature copied from a larger work is his miniature self-portrait (cat. no. 49; frontispiece, this essay), which reprises in much-reduced scale a pastel of 1769 (fig. 25). The pastel is one of a pair of portraits Copley made of himself and his new wife, Susanna Clarke Copley (fig. 114), whom he married in November 1769; the miniature was most likely a gift for his new bride. In both Copley represented himself as wealthy and fashionable. However, the pastel portrait conveys an emphatic presence, showing the sitter's piercing eyes and ruddy complexion, while the man in the miniature seems more ethereal, thanks to the delicate stippled brushwork and the milky translucence of the ivory support that shines through it. Yet the miniature employs a palette as brilliant as that in the prototype and even enhances its complexity: the silk damask morning gown of the original has acquired a purple lining, and the red embroidered waistcoat now includes distinctive yellow stripes.

Copley's miniature self-portrait exemplifies the artist's achievements in presentation as well as in execution. It is set in a gold locket that probably was made by Paul Revere, Boston's most accomplished goldsmith. Revere often provided cases for Copley's miniatures, and extant account books document Copley's patronage of his work from 1763 to 1767. The entries are for gold bracelets, gold cases for pictures, silver and gold picture frames, and glass, all of which Copley paid for in cash. That the picture frames were intended for miniatures and not for large oils is evident from the low prices listed—which average about three pounds—for they could have covered only small quantities of gold or silver. The shorthand notations of names in the ledgers do not coincide with the sitters in Copley's known works and may refer to owners of miniatures that have been lost.[32] Revere was probably not the only supplier of Copley's miniature cases; the painter may have employed other goldsmiths as well, especially after his half brother's feud with Revere in 1770.

The settings Copley provided for Samuel and Sarah Cary indicate the personal nature of these tiny paintings. *Samuel Cary* (cat. no. 77), mounted in a bracelet, was clearly intended to be worn by a woman, while *Sarah Gray Cary* (cat. no. 78) is encased in a locket that could be worn on a ribbon or chain or kept in a gentleman's pocket.[33] The Cary pieces are the only documented pair of ivory miniatures by Copley to survive and are among the most intimate, refined, and precious objects the artist ever produced. In them his technique is subtle and extraordinarily detailed, its sophistication matched by the fashionable garb of his sitters—a damask morning gown for Samuel and a pearl-bedecked Turkish-style headdress for Sarah.

By 1770 Copley had reached the pinnacle of his artistic and technical accomplishment as a miniaturist. That year the New England painter William Johnston (1732–1772) wrote to him from Barbados asking for a watercolor portrait of his sister and enclosing a new brush for him to use. Johnston admitted that he wanted to have Copley's miniature to prove to his fellows that "several pictures in this Island lately arriv'd from England, that are so much thought of . . . [are] far inferior to some I have seen of my friends," adding, "to convince them it is not mere boast [I] should be glad to have [the miniature] as soon as you can conveniently do it."[34] However, as Copley reached the height of his achievement as a portraitist in both small and large formats, he all but stopped painting miniatures. The demanding and painstaking craft may have ceased to challenge him, or perhaps it was not proving financially advantageous. West had long before advised him to give it up; as Captain R. G. Bruce reported to Copley in 1766, "He condemns your working either in Crayons or Water Colours."[35] Although Copley initially protested to West that his pastel portraits were among his finest works, he did not question his disapproval of miniatures and eventually agreed with his pronouncement that "Oil Painting has the superiority over all Painting."[36]

Copley did not lose all interest in miniatures and continued to admire them, however. He evidently had taught Henry Pelham the craft and remained his advocate, encouraging him and offering technical advice. When Copley stayed in New York in 1771, he reported to Pelham that he had seen a miniature of Josiah Martin, governor of North Carolina, by "Meirs" (perhaps the renowned London artist Jeremiah Meyer) that he felt was well worth the thirty guineas and fifty sittings it had cost.[37] Pelham responded with a request for a "more perticular Discription of it."[38] In

1775 Copley wrote to his mother of Pelham's progress, noting that "his process in Miniature is I believe very right."[39] In 1776, after the Revolution precipitated the disintegration of Pelham's Boston business, he joined his half brother in London, where he continued to work as a miniaturist. In London Copley himself painted at least one miniature (of Mrs. Daniel Denison Rogers [private collection], who also sat for a full-size portrait [Fogg Art Museum, Cambridge, Massachusetts]), but the extent to which he pursued such work in England is as yet unknown.

In the end, the very function of miniatures as familial and loving souvenirs has frustrated our ability to evaluate their place in Copley's artistic career. Because they are small and easily transportable, many presumably have been lost as they accompanied family members through the dislocation of the Revolution and the passage of time. "I have not yet examined the Trunk you sent me from New York, nor the Hat Box," wrote Roger Morris from London to his wife, Mary Philipse Morris, in New York on July 4, 1775. "There is one particular, I own, I wish much to see, & that is your miniature Picture. You know my dear, it had been for some time past, in one of your Band Boxes."[40] Yet even if bandboxes remain unopened and the full extent of his work in miniature remains unknown, it is clear that Copley was the most important practitioner of the art in Boston up to 1773. It is also evident that he was the progenitor of a new group of local painters who specialized in miniatures, including Henry Pelham, Joseph Dunkerley, William Lovett, Edward Savage (who copied Copley's work), Edward Malbone, and William Doyle, who took small-scale portraiture to new heights of style and popularity. Despite the brief duration of his own involvement with the art and the small number of his surviving works, Copley stands as a master and a champion of American miniature painting.

This essay is written in honor of the late Dale T. Johnson, whose insight and encouragement transformed my enthusiasm for portraits in little. I would like to thank Rhona Macbeth, Assistant Conservator at the Museum of Fine Arts, Boston, for her patient help in explicating Copley's technical methods, and I am indebted to Theresa Fairbanks, Katherine G. Eirk, and especially Carol Aiken for generously offering suggestions and corrections to my text.

1. John Closterman's portrait of Daniel Parke, ca. 1705 (Virginia Historical Society, Richmond), also shows the sitter wearing a miniature; the painting was made in England after Parke left his Virginia home to become governor general of the Leeward Islands. The portrait eventually was sent to Virginia. See Ellen G. Miles, "John Closterman, *Daniel Parke*," in Richard H. Saunders and Ellen G. Miles, *American Colonial Portraits, 1700–1776* (exh. cat., Washington, D.C.: National Portrait Gallery, 1987), pp. 82–83.

2. John Smibert, for instance, is known to have seen at least one British oil-on-copper miniature in America, for he used it as a model for the figure of Daniel Oliver Jr. in his large triple portrait *The Oliver Brothers*, 1732 (Museum of Fine Arts, Boston). Daniel had died in London in July 1727 but earlier that year had sent his miniature likeness to his parents in Boston; they shared it with Smibert so that he might reunite on canvas the deceased Daniel with his brothers Peter and Andrew. The miniature is in the collection of Oliver family descendants and is illustrated in Andrew Oliver, *Faces of a Family: An Illustrated Catalogue of Portraits and Silhouettes of Daniel Oliver, 1664–1732, and Elizabeth Belcher, His Wife, Their Oliver Descendants and Their Wives, Made Between 1727 and 1850* (Portland, Maine, 1960), no. 4.

3. Jonathan L. Fairbanks, "Portrait Painting in Seventeenth-Century Boston: Its History, Methods, and Materials," in *New England Begins: The Seventeenth Century* (exh. cat., Boston: Museum of Fine Arts, 1982), vol. 3, pp. 413–14.

4. Quoted in Jim Murrell, *The Way Howe to Lymne: Tudor Miniatures Observed* (exh. cat., London: Victoria and Albert Museum, 1983), p. 3.

5. Fairbanks, "Portrait Painting," p. 423.

6. After the facial features were delineated, the carnation was rubbed away from the outlying areas and the costume and background were filled in. See V. J. Murrell, "The Restoration of Portrait Miniatures," in International Congress for Conservation, 5th, *Conservation of Paintings and the Graphic Arts: Preprints of Contributions to the Lisbon Congress, 1972* (London, 1972), p. 821.

7. Graham Reynolds, *English Portrait Miniatures*, rev. ed. (Cambridge, 1988), pp. 94–114. See also Patrick J. Noon, *English Portrait Drawings and Miniatures* (exh. cat., New Haven: Yale Center for British Art, 1979).

8. In London Smibert painted "a head of a Child in littele, a Coppie [March 1725]," "2 heads in Littele for Mr. Hucks [January 1726]," "2 heads in littel for — [possibly Robert Walpole, the preceding entry, February 1726]," and "a littel head for Mr. Hacks [May 1726]"; while in Boston he painted "mr. S Brown in Littell [August 1734]" and "Willm. Brown Esqr. in littell [August 1736]" (*The Notebook of John Smibert*, with essays by Sir David Evans, John Kerslake, and Andrew Oliver [Boston, 1969], pp. 80, 82, 92, 94). The medium of these works is not documented in Smibert's book; presumably, they were oil on copper.

9. See Richard H. Saunders, "John Smibert, *Samuel Browne*," in Saunders and Miles, *American Colonial Portraits*, pp. 122–23. Saunders misidentifies Smibert's miniature as an enamel.

10. The manual was reissued in 1764. Robert Dossie, *The Handmaid to the Arts*, 2d ed., 2 vols. (London, 1764), vol. 1, p. 219. For a history of painting on copper, see J. A. van der Graaf, "Development of Oil-Paint and the Use of Metal-Plates As a Support," in International Congress for Conservation, *Conservation of Paintings and the Graphic Arts*, pp. 139–51.

11. That Copley was adept at copying is most clearly demonstrated by his portrait of Nicholas Boylston, 1767, and the replicas he made of it (see fig. 135; cat. nos. 31, 32). Technical manuals of this period describe methods used to copy images on the same scale as the original and to reduce or enlarge them.

12. See the discussion in Isabel Horovitz, "Paintings on Copper Supports:

Techniques, Deterioration, and Conservation," *Conservator* 10 (1986), pp. 44–45.

13. It is rare, however, to find engraving lines on the copper support of an oil painting, although Adam Elsheimer's *Tobias and the Angel* (National Gallery, London), in which an engraved coat of arms appears under the paint surface, is one such example (ibid., p. 44). Rhona Macbeth and Roy Perkinson of the Museum of Fine Arts, Boston, offered helpful advice on the thesis that Copley might have used copperplates intended for printmaking for his miniatures.

14. Quoted in Carol Aiken, "Early Miniatures Painted in America," in *Dublin Seminar Proceedings, 1994* (forthcoming).

15. Quoted in ibid.

16. Copley charged four guineas for a portrait of 30 x 25 inches in 1764; prices for his earlier large-scale paintings are unknown. The bill for a miniature of Miss Thankful Hubbard, dated May 20, 1758, was made out to Thomas Fairweather. It is at the Massachusetts Historical Society, Boston, and is reproduced in Jones 1914, p. 27.

17. Prown 1966, vol. 1, p. 178. See also Oliver, *Faces of a Family*, pp. xi–xiv, 3–15.

18. Sir Joshua Reynolds, "Second Discourse," quoted in Noon, *English Portrait Drawings and Miniatures*, p. xii.

19. I am indebted to Theresa Fairbanks, Chief Conservator of the Yale Center for British Art, New Haven, for sharing her important discovery of Copley's gold-leaf grounds with me. Her research with Katherine G. Eirk into Copley's techniques and materials continues and will be published in the forthcoming catalogue *American Miniatures at Yale* and in their separate paper (in preparation) outlining Copley's techniques. Any errors or leaps of imagination in the present text are my own.

20. Horovitz, "Paintings on Copper Supports," pp. 44–45.

21. Margaret Mascarene, letter to Henry Pelham, Sept. 14, 1772, in Jones 1914, p. 189.

22. Dale T. Johnson, *American Portrait Miniatures in the Manney Collection* (exh. cat., New York: The Metropolitan Museum of Art, 1990), p. 177.

23. Many of Copley's oil-on-copper miniatures retain their original ebony black frames. That such pictures were used for display is documented in Louis Goupy's miniature portrait of Brook Taylor of 1720, which shows the eighteenth-century mathematician in his home surrounded by luxurious objects, including a tiny oval portrait of his wife hanging on the wall below a large landscape. See Malcolm Rogers, *Master Drawings from the National Portrait Gallery, London* (exh. cat., Alexandria, Va.: Art Services International, 1993), pp. 32–33. For the sizes and nature of ivory supports, see Murrell, "Restoration of Portrait Miniatures," pp. 821–22.

24. Ellen G. Miles, "Mary Roberts, *Woman of the Gibbes or Shoolbred Family*," in Saunders and Miles, *American Colonial Portraits*, p. 163.

25. Quoted in Helmut von Erffa and Allen Staley, *The Paintings of Benjamin West* (New Haven, 1986), p. 450. The Historical Society of Pennsylvania, Philadelphia, owns a West sketchbook that includes a pencil sketch for this self-portrait, as well as several other designs for miniatures. The portraitists Jeremiah Theus (ca. 1719–1774) and

26. Janice G. Schimmelman, "Books on Drawing and Painting Techniques Available in Eighteenth-Century American Libraries and Bookstores," *Winterthur Portfolio* 19 (Summer–Autumn 1984), pp. 195, 199. Boutet's manual was advertised for sale by a Boston bookseller in 1772, but copies may have been available to Copley earlier.

27. [Claude Boutet,] *The Art of Painting in Miniature: Teaching the Speedy and Perfect Acquisition of That Art Without a Master* (London, 1752), pp. 49–50. The opaque style recommended by Boutet fell out of favor as artists came to prefer the more translucent effects made possible by ivory supports. In 1800 Archibald Robertson discussed methods of miniature painting in an unpublished treatise that appears to record the techniques commonly practiced by his contemporaries (*Letters and Papers of Andrew Robertson, Miniature Painter . . . Also a Treatise on the Art by His Eldest Brother, Archibald Robertson . . .* ed. Emily Robertson [London, 1896], pp. 21–34 passim).

28. Joseph Barrell, letter to Stephen Twycross, Aug. 27, 1796, quoted in Martha Gandy Fales, "Federal Bostonians and Their London Jeweler, Stephen Twycross," *Antiques* 131 (Mar. 1987), p. 644.

29. [Boutet,] *Art of Painting in Miniature*, pp. 38–39.

30. See Thomas Amory Lee, "The Lee Family of Marblehead," *Essex Institute Historical Collections* 52 (1916), quoted in Louise Burroughs, "Colonel Jeremiah Lee, a Miniature by Copley," *Bulletin of The Metropolitan Museum of Art* 35 (Dec. 1940), p. 236. A copy of this likeness by another hand is in the collection of the Boston Athenaeum; another version (unexamined) was shown in *Portrait Miniatures in Early American History, 1750–1840: A Bicentennial Exhibition* at the R. W. Norton Art Gallery, Shreveport, Louisiana, in 1976.

31. Captain John Small, letter to Copley, Oct. 29, 1769, in Jones 1914, p. 77. Both of Small's portraits remain unlocated. For contemporary British copying practices, see Marcia Pointon, *Hanging the Head: Portraiture and Social Formation in Eighteenth-Century England* (New Haven, 1993), p. 41.

32. Prown 1966, vol. 1, no. 2, p. 30. Prown transcribes most of the relevant entries from the Revere account books, which are at the Massachusetts Historical Society, Boston.

33. Copley's miniature portrait *Jeremiah Lee* (cat. no. 54) is also set in a bracelet.

34. William Johnston, letter to Copley, May 4, 1770, in Jones 1914, pp. 91–92.

35. Captain R. G. Bruce, letter to Copley, Aug. 4, 1766, in Jones 1914, pp. 41–42.

36. Benjamin West, letter to Copley, Aug. 4, 1766, in Jones 1914, p. 45.

37. Copley, letter to Henry Pelham, July 14, 1771, in Jones 1914, p. 128.

38. Henry Pelham, letter to Copley, July 28, 1771, in Jones 1914, p. 134.

39. Copley, letter to his mother, June 25, 1775, in Jones 1914, p. 331.

40. Roger Morris, letter to Mary Philipse Morris, July 4, 1775, p. 6, Morris-Jumel Archives, New York. I am grateful to Emily Ballew Neff for bringing this letter to my attention. The location of the miniature is unknown.

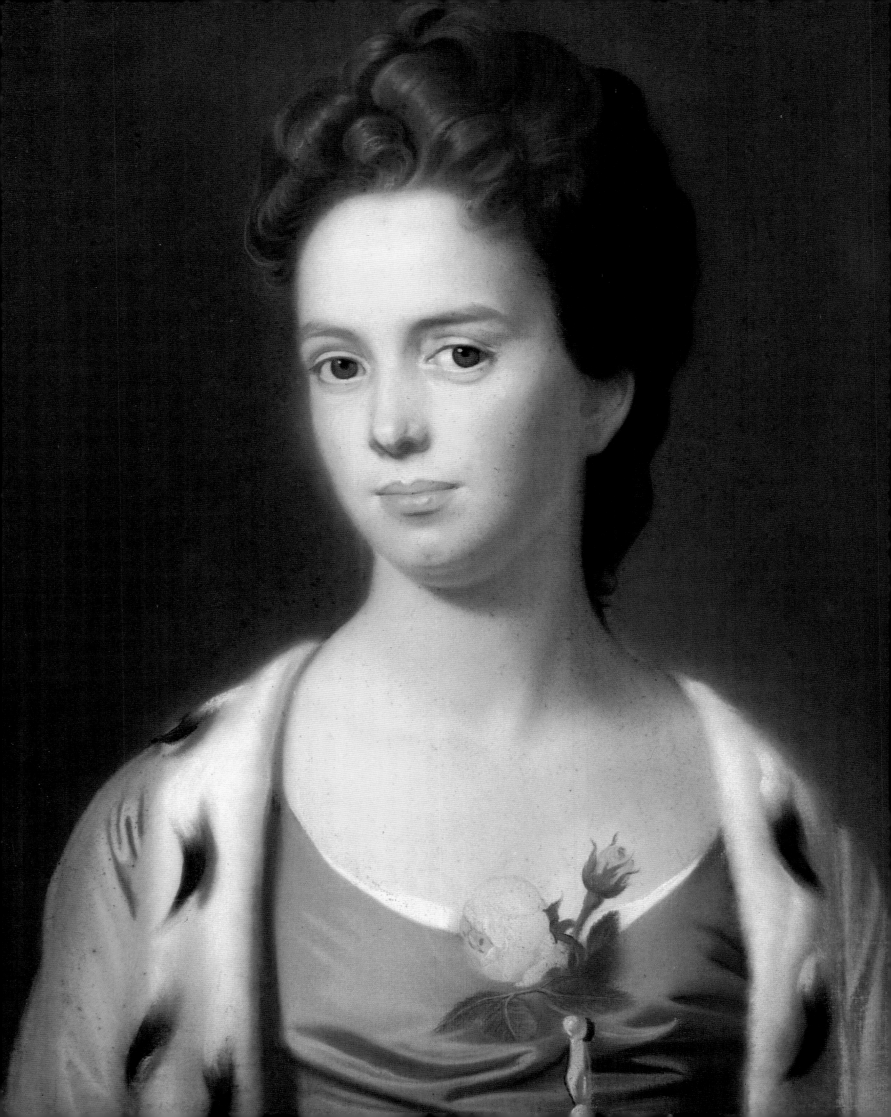

Painting in Crayon:
The Pastels of John Singleton Copley

MARJORIE SHELLEY

Pastel was in its heyday in Europe when young John Singleton Copley executed his first work in the medium. It had been catapulted into popularity early in the eighteenth century by the French artist Rosalba Carriera (1675–1757) and disseminated throughout the Continent by the many artists who flocked to Paris to learn from her and her followers. In England the technique had been thriving quietly since the seventeenth century but was given new impetus by the recently acquired taste for crayon pictures among travelers returning from the Grand Tour, by British fascination with the art of France, and by the peregrinations of the Swiss artist Jean-Étienne Liotard (1702–1789), who worked in London to great acclaim from 1753 to 1755. Indeed, the most enduring Rococo vogue was to have one's portrait painted in crayons. It was fast, required few sittings, and had none of the offensive odors of oil or turpentine, and the brilliant colors were held to be durable over time.

By the 1760s the burgeoning interest in pastel and the fashionable aura it projected reached the colonies. Not only Copley's affluent clientele would have been aware of this trend; the upwardly mobile, talented, yet notoriously slow young Boston artist himself would have been attuned to the social desirability and expedience of the medium. Copley produced approximately fifty-five crayon portraits before he left America for England in 1774. He may have executed more, but the fragility of the medium—its vulnerability to insect and moisture damage, smudging, breakage of the protective glass, and tearing—presumably took its toll on this work. Copley's earliest pastels are dated 1758. Writing to Liotard in 1762, in his first surviving letter to refer to this medium, Copley stated that he had heard of the Swiss artist's pastels from "several of My friend[s] who has seen em" and boldly requested a box of crayons, "a sett of the very best that can be got."[1] Copley referred to the medium

fairly frequently throughout his correspondence; the importance pastel held for him in these early years is revealed in a letter of 1766 to Benjamin West in which he claimed that his "best portraits [were] done in that way."[2]

At the time Copley took up pastels, however, crayon painting had not made significant inroads in the colonies. Henrietta Johnston (d. 1729) had been working in Charleston, South Carolina, from about 1708 to 1729, and Benjamin Blyth (1740–after 1781) is documented as having first used crayons in the 1760s in Salem.[3] Copley was aware of at least one pastel by Johnston; he copied her portrait *Thomas Amory I* (fig. 103) in about 1770 on commission from Amory's son. Yet he seems not to have learned very much from her provincial example, nor from that of Blyth, whom he is likely to have at least heard about during the late 1750s. Copley's earliest known pastels, *Hugh Hall* and *Gregory Townsend* (figs. 104, 105), both signed and dated 1758, far surpass the work of Johnston and Blyth in their realism, sharp definition of form, and modeling. There is little information on other pastelists working in the colonies, and there are no records from the Boston area documenting the existence of pastel portraits of colonists executed by European artists and brought back to America.[4]

During the 1760s, as Copley achieved artistic prominence, he often bemoaned the bleak milieu for the arts in America, including the prospects for pastelists. To Liotard in a letter of 1762 he professed that "however feeble our efforts may be, it is not for want of inclination that they are not better, but the want of oppertunity [in America] to improve ourselves."[5] Six years later, in a letter of January 17, 1768, to West, Copley rued the fact that he had never seen "more than three heads done in Crayons" and none "that could possably be esteem'd."[6]

With the scarcity of works in pastel to emulate and the absence of accomplished pastelists to instruct him in the rudiments of this art form, where, then, did the young Copley first encounter the medium, and how did he learn to use it?

Mrs. Joseph Barrell (Hannah Fitch) (cat. no. 58)

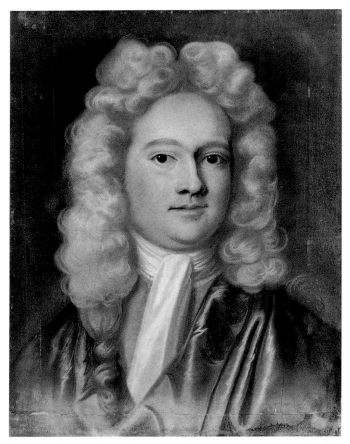

Fig. 103 *Thomas Amory I*, ca. 1770. Pastel on paper mounted on linen, 23 x 17¼ in. (58.4 x 43.8 cm). Museum of Fine Arts, Boston, M. and M. Karolik Collection of Eighteenth Century American Arts 37.41

Fig. 104 *Hugh Hall*, 1758. Pastel on paper, 15½ x 13 in. (39.4 x 33 cm). The Crane Collection, Boston

The curious connection between mezzotint engravers and pastelists suggests that Copley was probably introduced to the crayon technique in his stepfather's workshop. The role of Peter Pelham (1695–1751) as mentor to his stepson has been well established: he taught Copley to scrape mezzotint plates and encouraged him to copy prints as a means of learning to draw and as a source of poses and compositional ideas for his paintings. Pelham, who was trained as a mezzotint engraver in London and had lived in Covent Garden in a community of printmaker-pastelists that included George Knapton (1698–1778), Samuel Okey (active 1765–80), and Arthur Pond (ca. 1705–1758), would have used pastel in the process of making his prints. Following the invention of this engraving technique in the mid-seventeenth century, many English and Continental *peinture-graveurs* and reproductive printers also worked in pastel.[7] Various factors account for the simultaneous development of these media. Both were commonly employed to copy oil paintings. Technically, they were linked by the use of black and white chalks or pastel for transferring, or "calking," an image to the rocked copper-

plate or by drawing directly on it.[8] The broad handling of both chalk and pastel provided a model with tonal qualities for engraving the plate that would be translated to subtle gradations of light and dark in the print. The mezzotint was meant to evoke the effects of painting. Similarly, pastel, referred to as "painting in the dry manner," was applied in a stumped—that is, with strokes smoothed by rubbing—and modulated fashion and was intended to appear as if rendered with a brush.[9]

Whereas Copley's early encounters with pastel were likely to have been effected through Pelham, his interest in the medium may have been cultivated through his exposure to works in the collection of John Smibert (1688–1751). A contemporary and neighbor of Pelham's, Smibert assembled holdings of original portraits, copies after Renaissance masters, his own paintings executed in London and Boston, and "original drawings of the best masters and Prints," all of which exerted a considerable influence on local and visiting artists not only during Smibert's lifetime but also for many years after his death.[10] Although the full extent of his col-

Fig. 105 *Gregory Townsend*, 1758. Pastel on paper, 22½ x 17¾ (57.2 x 45.1 cm). Colonial Williamsburg Foundation 1992-221

lection is not known, it included works acquired during his Grand Tour of 1719 to 1721 and thus possibly the pastels purchased in Italy that he recorded in his notebook.[11]

In addition, Smibert owned a well-stocked color shop in Boston from which he sold art supplies and, as he advertised in the *Boston News-Letter* in 1734, "the best Mezotints, Italian, French, Dutch and English Prints."[12] Clearly this material added to the resources of his art collection. It is particularly noteworthy that Smibert's supplier was his friend Pond, reputedly London's leading virtuoso and connoisseur: collector, picture dealer, art supplier, publisher, restorer, etcher, mezzotint engraver, oil painter, pastelist, and copyist.[13] During the 1730s Pond became especially fashionable among "the country house builders" for his pastel imitations of Carriera's *Four Seasons* and, in the next decade, for his copies of Liotard's Turkish ladies.[14] Smibert's personal and business relationship with Pond, to which his correspondence and that of his nephew, John Moffatt, attest, raises the possibility that pastels by this artist may have been found in Smibert's collection or shop.

The widespread popularity of pastels in the eighteenth century and the common practice of producing these works in multiple copies make it feasible that some examples, perhaps including the "three heads in Crayons" noted in his letter of January 17, 1768, to West, could have been known to Copley. The extent of his familiarity with originals or copies of crayon paintings, of course, is not known. Copley's correspondence, however, does indicate that hearsay contributed to his development as a pastelist. He "formd a Judgment" of Liotard's work, for instance, based upon what he had heard of it from friends and hoped that one day Liotard's "Drawing with Justice [would] be set as patterns for our immitation."[15] Indeed, among the numerous contemporary European pastelists, Copley would have been particularly responsive to descriptions of this artist's distinctive handling of the medium. Liotard's tight plastic modeling, crisp naturalism, gradations of color, and precise attention to detail were remarkably akin to Copley's aesthetic sensibilities.

Copley's portrait *Mrs. Gawen Brown* (cat. no. 13), derived from a mezzotint of *Maria, Countess of Coventry* by Thomas Frye after an unknown artist (fig. 171), reveals that the pictorial sources Copley drew upon for his paintings also served for his pastels.[16] The great variety of prints readily available in Boston at mid-century might have further benefited the young artist as a source of information on the technical aspects of crayon work. Copley saw prints in private collections, and he also had access via Boston's booksellers and art dealers, including Smibert, to English and Continental engravings published by Pond, Robert Sayer, Carington Bowles, and others in that flourishing trade.[17] Like prints by or after oil painters, those either by or after pastelists tended to be widely disseminated, abroad and in the colonies.[18] Descriptions of pastels Copley might have heard would have been amplified by seeing prints after them, which communicated composition, velvety textures, strong tonal contrasts, and verisimilitude of detail. Prints in the crayon manner, which closely approached the powdery quality of pastel, would have provided information about technique as well. Among the earliest of these, dated 1736, were examples scraped by Pond; by the 1750s such prints were flooding the American and British markets.[19] From them Copley could have gotten a sense of the dry, friable grain of pastel and of stumping. Prints in the pastel manner, which simulated the high-keyed palette of the medium, were not refined until about 1769, when Copley's handling of crayons had become highly accomplished. However, other colored prints, such as the remarkable colored mezzotints of Jacques Christophe Le Blon (1667–1741), a contemporary of Pelham's and

Smibert's in London, and his pupil Jean François Gautier Dagoty (1710–1781), would have appealed to the young artist because of their deep, rich tonalities, painterly transitions, and solid, bold modeling, handling that bore a kinship with his works in pastel.[20]

Art treatises owned by Pelham and Smibert, or otherwise available in Boston, might have played a role in Copley's understanding of the pastel medium. Copley's letters to his half brother, Henry Pelham, reveal that he was familiar with various theoretical texts, clearly the source of some of his exalted ideas on art.[21] However, none of these books would have given him information on technique, and only two of them made even modest mention of artists practicing in pastel: Horace Walpole's *Anecdotes of Painting in England* of 1762 and the 1706 edition of Roger de Piles's *Art of Painting*, to which was appended Bainbrigg Buckeridge's "Essay Towards a British School."[22]

Although no evidence exists that Copley was familiar with artists' handbooks, such technical texts traditionally served as essential components of art training in the absence of academies and masters. Large numbers of these manuals, most appearing in numerous editions, were published in England in the seventeenth and eighteenth centuries, a time when systematic teaching was not the rule, and they were specifically directed toward the amateur working on his own. Surviving inventories of colonial booksellers reveal the presence of artists' handbooks in eighteenth-century America.[23] Because these practical guides lacked the stature of theoretical treatises among intellectuals or trained artists, there is little documentation of their ownership or use, yet surely they would have been known to the limner who had few sources of instruction.

Such manuals were based upon the practices of professional artists, which were usually recorded some time after they were effected, and thus tended to lag behind current styles and techniques. Those written before the 1750s provided only meager commentary on crayon painting, as this art form did not become popular among amateurs until the second quarter of the century. Among the most widely read handbooks with information on pastel that could have been known to colonial artists seen by Copley were Bernard Lens's *For the Curious . . . a New and Compleat Drawing-Book,* published in London in 1751; Claude Boutet's *The Art of Painting in Miniature,* sixth edition published in London in 1752; and Robert Dossie's *Handmaid to the Arts,* published in London in 1758. Dossie's work contained a substantial amount of information on pastel and ultimately became the most popular book of its type in colonial America.[24]

The technical information offered in many of these texts included instruction for fabricating pastel, which was accomplished by combining impalpably ground pigment for the color; a powdered white substance such as tailor's chalk, tobacco-pipe clay, or alabaster to form the tints; and the barest amount of a liquid agent, such as oatmeal whey or stale size, to bind the crayon stick so that it would deposit color when passed across a sheet of paper yet not crumble between the artist's fingers. Crayons, unlike oil paints or watercolors, do not lend themselves to mixing, a process that will flatten the pastel particles and result in a muddy tone and loss of freshness in the touch. The pastelist thus needed a vast array of colors in numerous tonal gradations.

The process of preparing the ingredients and determining suitable combinations and quantities thereof was so complex and laborious that crayons were manufactured by commercial makers in England and on the Continent by the early decades of the eighteenth century, a period when color shops were not common.[25] Although artists' supplies appear to have been sold in Boston, New York, and Philadelphia by the 1750s, listings specifically citing crayons are very rare. One of the earliest advertisements for ingredients that may have been intended for crayons was placed by John Merrett in the *New England Journal* on May 9, 1738, naming pigments, chalk, and sugar candy, the last of which was sometimes used as a binder for the powdery pastel stick.[26] More ambiguous yet appearing more frequently were notices like Smibert's 1734 advertisement for "all Sorts of Colours, dry or ground."[27] The first explicit reference to crayons by a colonial art-materials dealer may be the order Moffatt placed with Pond in 1752, requesting "crayons to the value of a Guinea."[28] In 1761, 1766, and 1768 John Gore, who is documented as having done business with Copley, advertised that he sold sets of crayons.[29]

The limited palette that Copley used in many of his early pastels, such as *Hugh Hall* and *Joseph Green* (cat. no. 26), may reflect both the lack of availability and the costliness of certain colors. Copley's 1762 letter to Liotard makes it clear that he was not satisfied with the pastels offered in Boston.[30] We do not know whether Copley received the Swiss pastels, yet the subtle gradations in the flesh tones and the expanded array of colors in his portraits of the later 1760s, such as his *Portrait of the Artist* (fig. 25) as well as his *Jonathan Jackson* and *John Temple* (cat. no. 45, fig. 106), indicate that by then he had a broader range of crayons at his disposal. Indeed, by the time Copley executed these pictures, the increased number of advertisements placed by crayon painters and of documents concerning the sale or fabrication of crayons

sian blue and orpiment, a mixture common at this time, when few pure green pigments were available. Whereas Copley's whites are primarily made up of calcium carbonate, in details requiring bright emphasis, such as the lace decoration in the portraits of Mrs. Joseph Henshaw (cat. no. 57) and Mrs. Edward Green, he used lead white along with flake white, recommended by Dossie when "an extraordinary degree of whiteness" was required.[33] Customarily employed by painters, lead white blackened when unprotected by an oil medium, as it has in these two works; for this reason pastelists were warned against its use. Lake and carmine, other pigments appearing frequently in these portraits, also tended to fly. Either could be used in modeling flesh tones, and both were components of scarlet crayons; Copley may have employed them for the now-faded turban (revealing traces of a pink color) of the leisured wit Joseph Green (fig. 108) and the sleeves of the *sacque,* which has also undergone some color alteration, in *Mrs. Joseph Barrell* (cat. no. 58; frontispiece, this essay). In 1765 Copley expressed the concern that his oil portrait of Henry Pelham (cat. no. 25), then en route to London, might become "unfit (through the

Fig. 106 *John Temple*, 1765. Pastel on paper mounted on canvas, 23½ x 18 in. (59.7 x 45.7 cm). Collection of Dr. Irving and Shirley Levitt

suggests that commerce in this commodity had expanded. Nonetheless, Copley continued to order his colors from abroad, as demonstrated by the 1765 invoice from J. Powell in London stating that he had taken "The pains To Go To The maker" for the requested crayons.[31]

With few exceptions the colors used for pastels were composed of the same pigments employed in oil paints of the period, and most have remained stable. Among the pastel colors that Copley frequently utilized were various shades and tints of Prussian blue, a synthetic introduced in about 1710. Considered to be an inexpensive and chromatically good substitute for ultramarine, by mid-century it was recognized as not especially durable.[32] Evidence of this pigment's fugitive nature is provided by the slight tonal alteration the color has undergone along the lower edge of the dress depicted in *Mrs. Ebenezer Storer II* (cat. no. 44). Prussian blue in a range of gradations appears in the gown and drapery backdrop in *Mrs. Edward Green* (cat. no. 27) as well as in the skies in *Mrs. William Turner* (cat. no. 37) and *Mrs. Andrew Tyler* (fig. 107). The lush green of the velvet turban in *Ebenezer Storer* (cat. no. 41) is composed of Prus-

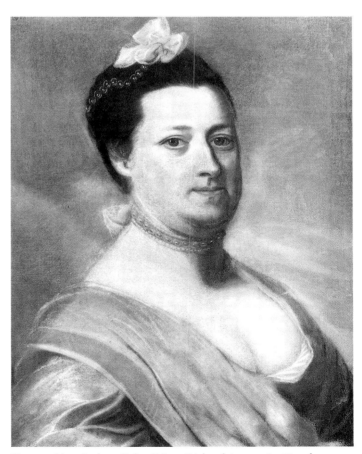

Fig. 107 *Mrs. Andrew Tyler (Mary Richards),* ca. 1765. Pastel on paper mounted on canvas, 22½ x 17¾ in. (57.2 x 45.1 cm). New England Historic Genealogical Society, Boston #61

Fig. 108 *Joseph Green*, 1767. Pastel on paper mounted on canvas, 24 x 17 in. (61 x 43.2 cm). Museum of Fine Arts, Boston, Julia Knight Fox Fund 25.50

changing of the colours)," suggesting his cognizance of the danger of this metamorphosis in oils.[34] For the pastels, however, either Copley defied conventional wisdom or his sources of information on the composition of his crayons and their vulnerability were simply limited.

The fillers in pastel crayons enhance opacity and provide body and tinting strength to the stick of color. The presence of clay mixed with lime white and red ocher in some of Copley's pink skin tones indicates that this substance was tobacco-pipe clay; in a few samples of Prussian blue, the filler consists of gypsum combined with bone white. That the filler was also found in one instance to contain high levels of arsenic serves to illuminate contemporary descriptions of the complexity of crayon composition.[35]

To execute his pastels Copley had to procure paper, cloth, and straining frames. No explicit references to the supports used for crayon painting remain in his letters or in newspaper advertisements. The invoice from Powell itemizes cloths, generally a reference to preprimed canvas, together with crayons; because the materials are listed together, the fabric may have been intended for pastel work.[36] A letter from Henry Pelham to Copley in New York mentions that paper, presumably for the crayons in the same shipping case, was packed "underneath Major Bayard's Picture," surely a practical means of keeping the sheets flat.[37] The many pastels by Copley that survive intact on their mounts reveal that he prepared the supports by pasting and laying down paper to fine- or medium-weight linen (approximately twenty to thirty threads per inch), which was tacked to the edges of a wooden strainer at irregular intervals with rose-head or flat iron nails. Some of the papers are smaller than the overall size of the straining frame; some others overlap the tacking edge on two sides. Of the strainers examined, each was beveled along the inner edge and was of tongue-in-groove, butt-end type construction held with wooden dowels at the corners and made of American white pine, indicating that they were provided by a local carpenter. This type of mounting, common for eighteenth-century European pastels, was used by professional practitioners; it does not seem to have been described in manuals until the 1760s.[38] Based on the format used by oil painters, it provided a resilient surface on which to work and gave the pastel composition the stature of an easel painting. Copley probably learned the technique by studying a crayon picture, perhaps one of the three that in his letter of 1768 he told West he had seen.[39]

Copley may have done the preliminary outlining and coloring of his portraits before pasting the paper to linen, a mounting procedure that—owing to the brief dampening of the sheet—held the pastel more firmly than did a dry one. Yet the pictures unquestionably were completed after the paper was fully mounted. This is evident in compositions in which the pastel ends abruptly at the fold in the paper along the tacking edge, as well as in the more curious instances in which the paper is smaller than the strainer but pastel is applied to all exposed surfaces. An example of the latter sort of work is *Mrs. Ebenezer Storer II*, in which Copley extended the sitter's bouffant coiffure from the paper onto the canvas.

Whereas many European pastelists prepared their papers by an elaborate process, removing all knots and traces of grain and softening the surface, Copley generally appears to have selected smooth sheets and used them as is. With the exceptions of the moderately rough surface of his *Portrait of the Artist* and the somewhat stout papers of *Jonathan Jackson* and *Joseph Green*, the examined supports show only subtle traces of laid and chain lines emerging through the pastel layer. The relatively uniform topography of these supports was aesthetically in keeping with Copley's realism

and specificity of form, an agreement of technical means and artistic goals that demanded that the texture of the paper and the stroke of the crayon be subjugated to image.

Of the twenty-five pastels closely scrutinized for this study, all were executed on light, "whited-brown" papers, most of which contained a small proportion of blue and red silk fibers. It is unlikely that they were made in America.[40] This type of paper (as well as blue paper, which was popular among English and Continental pastelists) was cited in many of the handbooks for its soft texture, the tooth being necessary to grab the pastel particles, and its neutral color, which provided a middle tone to facilitate the preliminary development of the bright and shadowed areas in the portrait.[41]

Excluding Copley's earliest pastels, which are among his smallest in this medium, the average size of his works in crayon is approximately 23 x 17 inches, proportions that would have been dictated by the necessarily limited dimensions of handmade paper and plate glass. Glass protected the delicate surface of the pastel, a requirement because Copley, like many eighteenth-century pastelists, did not use a fixative.[42] The size of these sheets was suitable for bust-length portraits, although the small dimensions meant that there was insufficient space for any attributes or signs of status aside from clothing or jewels. The incorporation of the occasional hand, rendered in a generalized manner, as well as the inclusion of rich damasks and furs, as displayed in *Jonathan Jackson* or *Mrs. Elijah Vose* (fig. 109), undoubtedly made these likenesses more costly.[43] Nonetheless, the small size, limited accessories, and less complicated artistic program enabled Copley to work more quickly in pastel than he could in oil and to sell the crayon portraits at a lower price.[44] These transactions appear to have included a frame, as did the sales of his oils.[45]

The dry, powdery nature of pastel must have challenged Copley in the application and blending of color and in the management of opacity. Lacking a master to teach him the fundamentals of this material, he developed a crayon technique based on his experience in oil.[46] Examination of nine crayon portraits by infrared reflectography reveals that Copley conceived of these works as he did his oil paintings, establishing a very simple preparatory base or groundwork.[47] Broad strokes observed beneath the turban in *Ebenezer Storer* suggest that Copley rubbed pastel into his neutral-toned paper to establish the light and dark values for the subsequent modeling of the forms. Only meager evidence of black chalk underdrawing was found in the faces of the sitters. The drawing detected was generally confined to stray lines in the vicinity of the nose, perhaps serving to mark the

placement of the head relative to the sheet, or, in the *Portrait of the Artist*, to a line describing the juncture between the forehead and the hair. Even at this preparatory stage, Copley demonstrated his insistence on truthfulness in the rather specific rendering of the mole beneath his nose.[48] Despite the spare traces of underdrawing, the possibility that carmine pastel or red chalk was used in this early phase should not be ruled out, for these colors readily blended with the flesh tones, and, lacking carbon, they are invisible to detection by infrared reflectography.[49]

The most significant evidence of underdrawing is seen in the drapery in *Mrs. Edward Green*. Here the black chalk lines defining the contour of the sitter's shoulders and the freely rendered corsage testify to the changes Copley made in the sheet (fig. 110). This draftsmanly handling, as well as the bold rendering of the bow visible at the nape of Mrs. Green's neck, stands in great contrast to his precisely controlled use of color and is especially informative in view of the absence of drawings from Copley's American period.[50]

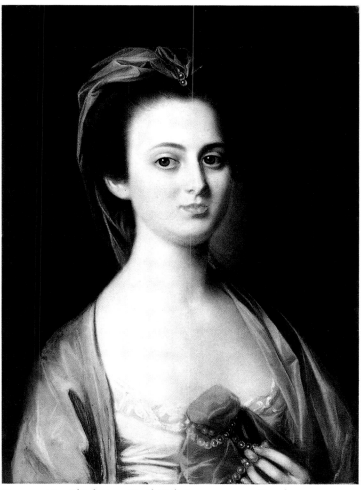

Fig. 109 *Mrs. Elijah Vose (Ruth Tufts)*, ca. 1770–72. Pastel on paper mounted on canvas, 23½ x 17¼ in. (59.7 x 43.8 cm). Hirschl and Adler Galleries, Inc., New York

Fig. 110 Computer generated infrared reflectogram assembly, *Mrs. Edward Green (Mary Storer)* (cat. no. 27)

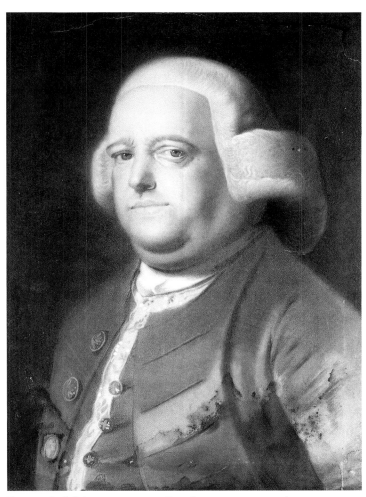

Fig. 111 *Ralph Inman,* ca. 1770. Pastel on paper mounted on canvas, 24 x 18 in. (61 x 45.7 cm). The Boston Athenaeum, gift of Miss Emily B. Warren, 1957

The few early pastels of about 1758, such as *Hugh Hall, Gregory Townsend,* and *Thomas Hancock* (private collection), reflect Copley's trials with this new material; the strong, vigorous strokes, rough modeling, subdued palette, and simple compositions of the pastels are characteristics seen in his oils. At this stage Copley did not consistently model with broad passages of color but rather gave form to the planes of the face with multiple strokes of a pale reddish-earth crayon, as if he were attempting to translate to colored pigment the graphic techniques of printmaking he used in his engraving *Reverend William Welsteed* (cat. no. 1). In *Hugh Hall* the simple dark background is thinly applied, allowing the strokes of color as well as the grain of the paper to be visible. This looser handling appears in Hall's wig, the light tones of which are the paper reserve, and in the summary treatment of his costume. In comparison with the later work, this portrait lacks solidity and polish, although the palette, the expert modeling of the eye area, and the assurance with which Copley emphasized the bright edges of

the cravat with bold strokes of white crayon are characteristic of his subsequent efforts.

Just as Copley moved away from his more forceful and more coarsely textured oils of the 1750s, he abandoned his early draftsmanly style in pastel. Perhaps he experimented with it in works that did not survive, for no pastels by him dating from between 1758 and 1763 are known. The enticement of the brilliant, dry colors and their potential to be blended and, as artists' books described, made seamless, "as if only a Brush had been used," no doubt accelerated his transition to a painterly style.[51] Copley's interpretation of this manner of handling finds its earliest expressions in *Mrs. Gawen Brown* of about 1763 and in the slightly later *Joseph Green,* among other works. The rather massive, sculptural quality of the figures during this transitional phase, the rigidity, the oversimplified features, and the summary treatment of details, including the scalelike curls of Joseph Green's wig or the broad planes of his clothing, correspond stylistically to some of the exaggerated effects seen in mezzotint engravings. In *Mrs. Gawen Brown,* which was derived

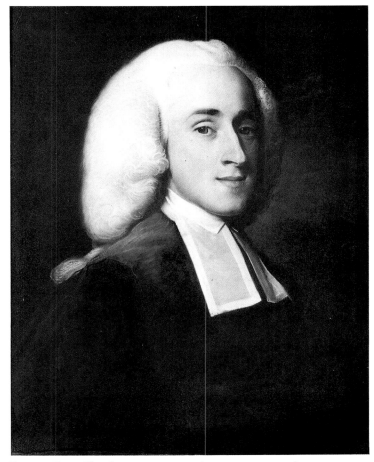

Fig. 112 *Peter Chardon,* ca. 1766. Pastel on paper mounted on canvas, 22¼ x 17¼ in. (56.5 x 43.8 cm). Yale University Art Gallery, New Haven, The Mabel Brady Garvan Collection 1949.1

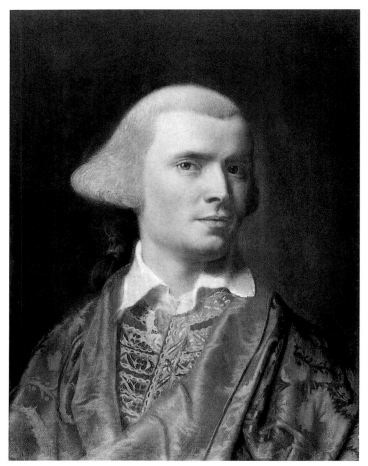

Fig. 113 *Portrait of the Artist* (fig. 25)

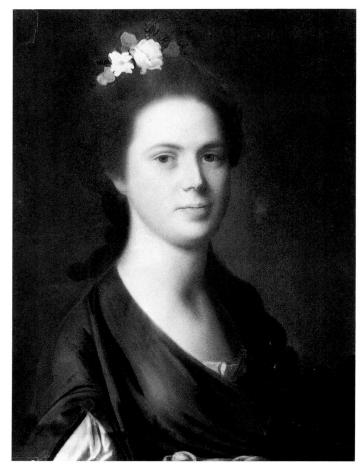

Fig. 114 *Mrs. John Singleton Copley (Susanna Clarke)*, ca. 1770. Pastel on paper mounted on canvas, 23 ⅛ x 17 ¼ in. (58.7 x 43.8 cm). Courtesy Winterthur Museum, Delaware G57.1128

from a mezzotint, this artificiality is most evident in the emphasis on outline and dark shadows to define the separate parts of the composition and in his use of color, which exhibits little variation within the clearly delineated areas of the sitter's face, hand, dress, or hair. In *Joseph Green* the palette is further simplified to grays and ruddy flesh tones.

During the period from about 1764 until the early 1770s, Copley produced approximately three-quarters of his pastels, and these works, like his oils, grew in their degree of verisimilitude and became increasingly refined in the modeling of the forms and the handling of color. As his palette expanded and he became more expert in the manipulation of pastel, the lininess, for which West had criticized his oils, decreased, and his forms assumed greater clarity and solidity. The blended and smoothed surface he attained with crayons was comparable to that of his oils: in both media he subjugated all sense of stroke to the portrayal of the physical object. In pastel he achieved this goal by applying a flat, uniform layer of color disposed in gradual tonal transitions. The

ready-made sticks of closely related tints and shades allowed him to model methodically from light to dark, matching his crayons to what he saw in reality, as he is said to have matched the paint on his palette knife to the complexions of his sitters in his oil paintings.

Such subtle modulations are seen in the pale skin tones of his female sitters, including those in *Mrs. Joseph Henshaw* and *Mrs. Joseph Barrell* (cat. nos. 57, 58; frontispiece, this essay), whose complexions are produced with a range of pinks, carmines, and whites arranged and smoothed to make the stroke of the crayon invisible. Similarly, in the deeper male complexions, such as that in *Ebenezer Storer II* (cat. no. 43), the tonal progression moves from the pale tints beneath the eye through the ecrus, pinks, greens, and gray of the five-o'clock shadow at the sitter's jawbone; in Copley's *Portrait of the Artist* the short tonal steps flow from tints of yellow and pink to gray, brown, burnt sienna, Indian red, and finally to dark grayish black. Even small details are treated in this exacting, precisionist manner. Close examination of

Mrs. Henshaw's lips, for example, reveals an array of six or seven distinct red and brown colors.

Throughout these compositions the interrelationship of colors enhances the plasticity and the realism of the objects represented. In *Ralph Inman* (fig. 111) the rusts and olives of the jacket and the sitter's ruddy complexion play off each other; in *Mrs. Joseph Henshaw* the dark blue folds of the subject's scarf are echoed in the shadows and highlights on her face. The flesh tones in Copley's self-portrait are reflected in the white satin lapel, while the colors of Copley's banyan and hair are mirrored in his face. Rather than applying these colors in interwoven, graphic strokes in the more atmospheric manner of such leading crayon painters as Jean-Baptiste-Siméon Chardin (1699–1779) in France and John Russell (1745–1806) in England, Copley naively blended them into the surrounding hues; in so doing he was virtually transcribing the instruction offered to young practitioners in artists' manuals, which specified that "colours [be] rubbed and worked together so that there is no single stroke."[52] Yet Copley's rich palette and skillful blending enabled him to endow his works with convincing solidity and texture, conveying a sense of the well-being of his sitters and giving them the realism that they demanded. This extraordinary ability earned him widespread recognition, even attracting West, who was curious to see his "Performance in Crayons."[53]

Applying color in one layer in graduated tones must have come fairly easily to Copley in his pastels, for the process was comparable to his oil technique, in which he built up forms and modified hues by using dark and light variants of the same color laid on side by side rather than by employing overlays of transparent glazes.[54] The inherent opacity of pastel, like all finely divided powders, would also have allowed him to transpose readily the clearly defined, solid forms of his opaque oil technique to this dry medium. In both the oils and the pastels Copley's practice in the early to mid-1760s was to develop color in distinct areas emphasized by dark, reddish-brown contours or shadows cast by features of the face; he achieved this effect in the two media by different means, however. In the oils this was accomplished by exposing the reddish-brown ground layer at the juncture between two colors, as in *Nicholas Boylston* (cat. no. 31); in the pastels the shadows were applied alongside the other colors, as in *Peter Chardon* (fig. 112), *Mrs. Edward Green* (cat. no. 27), and *Joseph Green* (cat. no. 26). Copley utilized this device most frequently in his earlier pastels; as he developed greater assurance in blending color, these linear elements diminished, becoming increasingly imperceptible in his latest

crayon portraits, done between 1770 and 1772, among them *Mrs. Joseph Henshaw* and *Mrs. Elijah Vose*.[55]

The powdery nature of pastel contributes to the melding of tones, but it also presents obstacles for the artist. Injudicious mixing or excessive layering flattens the particles that reflect light and give pastel its matte, velvety texture. Because the medium is opaque and does not form a continuous film, tactile surfaces and transparency can be produced only by illusion. Within the parameters pastel imposes, Copley communicated a diversity of effects, some of which were familiar to him from oil painting. Thus he implied the diaphanous lightness of Mrs. Joseph Henshaw's scarf by scumbling its bright blue outline over the dark brown background; the transparency of the fichu worn by the elderly Mrs. Ebenezer Storer (cat. no. 42) by the shadows cast by each dot; the luster of the pearls embellishing Mrs. Edward Green by an outline of muted white against her dark hair.

The portraits from the mid-1760s display Copley's tremendous range in manipulating the texture of his crayons. A difference in modulation, for example, is evident between the precision of line in his *Portrait of the Artist* (fig. 113) and the more heavily stumped *Mrs. John Singleton Copley* (fig. 114). Comparison of the eyes in *Ebenezer Storer II* and *Mrs. Ebenezer Storer* reveals a harder, more distinct quality of line in the male portrait, as seen in the blue, black, and sienna lines encircling the iris, and an aura of greater softness in the female portrait. The two versions of the elder *Mrs. Ebenezer Storer* (cat. no. 42; fig. 190) also offer technical variations: the Boston portrait, on close examination, is heavily stumped throughout with little direct crayon work, whereas the New York composition is far crisper.

Many of these differences are visible to the unaided eye. Microscopic examination, however, reveals the means by which Copley, like other eighteenth-century pastelists, produced the effects described above. In large passages he appears to have blended colors with his finger. As in his oils, the dark tones in most of the backgrounds, particularly in the shadowed areas immediately behind the heads, tend to be thinly laid on, hinting at the light-colored paper below. For areas with greater detail Copley seems to have blended his colors with a stump, a tight roll of brown paper or of chamois tied with string. In addition to blending color, stumping, referred to at the time as "sweetening," was a means of applying pigments too costly to prepare in a stick and of holding the pastel to the paper.[56] Sections of paper with disrupted and protruding fibers, generally in the drapery, suggest the use of this tool, which is rougher and more abrasive than the finger. Skin tones, as in his paintings, were

applied more thickly and tended to be smoothed with the broad surface of the crayon, evident from scratches in the pastel layer caused by the gritty inclusions in the stick. Small details such as lace or white highlights in an eye were jotted on with a broken piece of crayon, which left the pastel in higher relief. Significantly, in the ribboned waistcoat in his *Portrait of the Artist*, a composition on which he clearly lavished attention, Copley experimented, using the paper reserve as a coloristic element and modifying the texture of the pastel by wetting it with a liquid size.[57]

In 1775, several years after he abandoned the pastel medium, Copley, writing to Henry Pelham, compared the quality of the hues in Titian's palette to crayon colors and described Raphael's painting of the holy family as having "the Softness and general hew of Crayons, with a Perlly tint throughout."[58] Although the medium still held some importance for him, the practice of it did not. Copley had gone to Europe because he wanted to be a history painter, and pastel was a portrait medium. Years before, in 1766, the questionable status of crayon work had been explicitly stated by West, who told Copley to "make it a rule to Paint in [oil] . . . as much as Posible, for Oil Painting has the superiority over all other Painting."[59] When Captain R. G. Bruce wrote to Copley that Sir Joshua Reynolds "condemns your working either in Crayons or Water Colours . . . words, which are confirmed by the publick Voice," the artist was undoubtedly expressing sentiments stemming from the heated debates between history painters, who worked in oils, and portraitists, a large number of whom practiced in pastel, that had been waged in Paris at the Académie Royale throughout the previous two decades.[60] If Copley had retained any desire to work in crayons in London, it is likely that the prevailing artistic climate would have discouraged him from doing so. The bravura of the leading pastelist, Russell, and that of the European pastelists he undoubtedly encountered on his tour, would have demonstrated to him that his firmly modeled, precisionist style would not succeed. Such qualities, once acclaimed in the work of Liotard were now scorned.[61] The political atmosphere too was becoming inhospitable toward this medium. Once appreciated for its informality and intimacy, pastel was falling from favor, as the austere purpose and idealization of Neoclassicism, reflections of new political values, ascended. Keenly aware of current taste and sentiment, and determined to make his name and fortune, Copley appears never to have resumed his practice of pastel once he left America.

Of the pastels by Copley studied for this essay, fifteen were examined by stereo binocular microscopy, ultraviolet illumination, and infrared reflectography. Pigment samples, when available, were analyzed by scanning electron microscopy. The analytical research was made possible by several private collectors and by conservators and curators at a number of institutions: Wynne Phelan and Michael K. Brown, at the Museum of Fine Arts, Houston; John Krill, at the Winterthur Museum, Delaware; Teresa Fairbanks, at the Yale Center for British Art, New Haven; Theresa Russo and Mark Wypyski, at The Metropolitan Museum of Art, New York; and Roy Perkinson, at the Museum of Fine Arts, Boston.

1. Copley, letter to Jean-Étienne Liotard, Sept. 30, 1762, in Jones 1914, p. 26.
2. Copley, letter to Benjamin West, Nov. 12, 1766, in Jones 1914, p. 51. Among Copley's correspondence pertaining to his work in crayons are the following: Captain Peter Traille, letter to Copley, Mar. 7, 1765, in Jones 1914, p. 34 (Copley's crayon portraits lost at sea); J. Powell, letter to Copley, Oct. 18, 1765, in Jones 1914, p. 37 (Powell sends Copley a box of crayons and other supplies from London); Captain R. G. Bruce, letter to Copley, Aug. 4, 1766, in Jones 1914, p. 42 (Reynolds condemns Copley's working in crayons or watercolors); Captain R. G. Bruce, letter to Copley, June 11, 1767, in Jones 1914, pp. 52–55 (Benjamin West curious about crayon portrait Copley sent to Bruce); Copley, letter to Benjamin West, Jan. 17, 1768, in Jones 1914, pp. 66, 67 n. 3 (Copley sends a crayon portrait, has seen only three heads in crayon); Copley, letter to [Captain R. G. Bruce], [ca. Jan. 17, 1768], in Jones 1914, pp. 69–70 (Copley sends two pastels to the Society of Artists exhibition, London, 1768); Captain John Small, letter to Copley, Oct. 29, 1769, in Jones 1914, p. 77 (miniature painted from a crayon portrait, and Small's desire for a copy of his crayon picture); Copley, letter to Henry Pelham, June 16, 1771, in Jones 1914, p. 117 (asks that his crayons be sent to New York); Henry Pelham, letter to Copley, July 11, 1771, in Jones 1914, p. 126 (Pelham sends crayons and paper to Copley in New York); William Carson, letter to Copley, Aug. 16, 1772, in Jones 1914, p. 187 (comments on Copley's crayon portrait of Mrs. Gray); Copley, letter to Henry Pelham, Mar. 14, 1775, in Jones 1914, p. 304 (Copley compares Raphael's colors to crayon colors); Copley, letter to Henry Pelham, June 25, 1775, in Jones 1914, p. 341 (Copley compares Titian's palette to the strong, dry tints of crayons).
3. Nina Fletcher Little, "The Blyths of Salem," *Essex Institute Historical Collections*, Jan. 1972, p. 52.
4. The only documented pastel in America in the late 1750s was the portrait of James Rivington by Francis Cotes (1726–1770), done in London in 1756, shortly before Rivington came to New York (*Catalogue of American Portraits in the New-York Historical Society* [New Haven, 1974], vol. 2, pp. 665–66). One of the earliest printed notices relating to pastels that appeared in the *New-York Gazette* was that of Stephen Dwight, who on April 12, 1762, advertised that he would teach drawing in crayon (quoted in Rita S. Gottesman, comp., *The Arts and Crafts in New York, 1726–1776: Advertisements and News Items from New York City Newspapers* [New York, 1938], p. 127); in 1769 Benjamin Blyth of Salem announced in the *Salem Gazette* that he had "opened a Room for the Performance of Limning in Crayons" (quoted in Ellen G. Miles, "The Portrait in America, 1750–1776," in Richard H. Saunders and Ellen G. Miles, *American Colonial Portraits, 1700–1776* [exh. cat., Washington, D.C.: National Portrait Gallery, 1987], p. 43); and on January 7, 1768, George Mason proclaimed in the *Boston News-Letter* that he drew portraits in crayons (George Francis Dow, comp., *The Arts and Crafts in New England, 1704–1775*

[Topsfield, Mass., 1927], p. 2). By the mid-1770s such advertisements appeared slightly more frequently. Among those artists listed just prior to Copley's departure from America are William Birchall Tetley, who advertised on November 14, 1774, that he taught ladies and gentlemen drawing and painting in crayons and watercolors (*New-York Gazette and the Weekly Mercury*, quoted in Gottesman, *Arts and Crafts in New York*, p. 7); John Stevenson and Hamilton Stevenson, who on November 18, 1774, announced in the *South Carolina and American General Gazette* the opening of a drawing academy in Charleston, where they taught "Painting from the life in Crayons" (quoted in Alfred C. Prime, comp., *The Arts and Crafts in Philadelphia, Maryland, and South Carolina, 1721–1785: Gleanings from Newspapers* [Topsfield, Mass., 1929], p. 10); and John Grafton, who noted in the *South Carolina and American General Gazette* of November 4, 1774, that he drew "likeness with Crayons" (quoted in Prime, *Arts and Crafts in Philadelphia*, p. 4; and Miles, "Portrait in America," p. 37).

5. Copley, letter to Jean-Étienne Liotard, Sept. 30, 1762, in Jones 1914, p. 26.

6. Copley, letter to Benjamin West, Jan. 17, 1768, in Jones 1914, p. 67 n. 3 (erased in his first draft of the letter).

7. Among the mezzotint engravers who worked in pastel in England are Wallerant Vaillant (1623–1677), William Faithorne (1616?–1691), Edward Lutterell (active ca. 1680–1724), Francis Cotes (1726–1770), Samuel Okey (active 1765–1780), and Arthur Pond (ca. 1705–1758). Lutterell is suggested as having trained Henrietta Johnston (d. 1729) in Ireland (see Margaret S. Middleton, *Henrietta Johnston of Charles Town, South Carolina: America's First Pastellist* [Columbia, S.C., 1966], p. 2) as well as having developed a technique of applying pastel to copperplates prepared with the roulette for mezzotint engraving (an example is in the collection of the Yale Center for British Art, New Haven). Artists practicing both media on the Continent include Vaillant, Robert Nanteuil (1623–1678), Liotard, and Alex Loir (1712–1785).

8. Carol Wax, *The Mezzotint: History and Technique* (New York, 1990), p. 193. This phase of the mezzotint process was described, shortly after the technique was introduced, in early instruction manuals, such as Alexander Browne's *Ars Pictoria; or, An Academy Treating of Drawing, Painting, Limning, Etching* (1669; 2d ed., London, 1675), p. 110. Robert Dossie (*The Handmaid to the Arts*, 2d ed. [London, 1764], vol. 2, pp. 181–82) describes calking the sketch on the plate by rubbing the paper on the reverse with white chalk.

9. *The Compleat Drawing-Master* (London: Robert Sayer, 1766), p. 4; Bernard Lens, *For the Curious Young Gentlemen and Ladies, That Study and Practise the Noble and Commendable Art of Drawing . . . a New and Compleat Drawing-Book. . . .*, trans. from French of Gerrard de Lairesse, with extracts from Charles-Alphonse Dufresnoy (London, 1751), p. 7.

10. A poem crediting Smibert in "bringing fruits of civilization to a barbarous land," believed to have been written by Mather Byles (1707–1788), refers to the large size of this collection. The eighty-line poem was printed in the London *Daily Courant*, Apr. 14, 1730 (see Henry Wilder Foote, "Mr. Smibert Shows His Pictures, March 1730," *New England Quarterly* 8 [Mar. 1935], pp. 19–21). On Smibert's house as a mecca for artists, see Waller K. Watkins, "The New England Museum and the Home of Art in Boston," *Bostonian Society Publications*, ser. 2, 2 (1917), pp. 101–30.

11. *The Notebook of John Smibert*, with essays by David Evans, John Kerslake, and Andrew Oliver (Boston, 1969), p. 102 (p. 90 of original notebook).

12. *Boston News-Letter*, Oct. 10–17, 1734, quoted in Henry Wilder Foote, *John Smibert, Painter* (Cambridge, Mass., 1950), p. 76.

13. William T. Whitley, *Artists and Their Friends in England, 1700–1799* (London, 1928), vol. 1, p. 18. For the correspondence between Smibert and Pond, see Richard H. Saunders, "John Smibert (1688–1751): Anglo-American Portrait Painter" (Ph.D. diss., Yale University, New Haven, 1979), pp. 227–28, 230–32, 236–38, 240–43.

14. Louise Lippincott, *Selling Art in Georgian England: The Rise of Arthur Pond* (New Haven, 1983), p. 62.

15. Copley, letter to Jean-Étienne Liotard, Sept. 30, 1762, in Jones 1914, p. 26: "not that I have ever had the advantage of beholding any one of those rare peices from Your hand. but [have] formd a Judgment on the true tast of several of My friend[s] who has seen em." In a 1774 letter from Paris, Copley reminded Henry Pelham, "you possess an Accademy figure or two much stumpt" (Copley, letter to Henry Pelham, Sept. 2, 1774, in Jones 1914, pp. 245–46).

16. Prown 1966, vol. 1, p. 37.

17. Smibert's stock, for example, was advertised for sale in the *Boston News-Letter*, May 15–22, 1735: "A Collection of valuable Prints, engrav'd by the best Hands, after the finest Pictures in Italy, France, Holland, and England, done by Raphael, Michael Angelo, Poussin, Rubens, and other[s of] the greatest Masters, containing a great Variety of Subjects, as History, etc, most of the Prints very rare, and not to be met with except in private Collections: being what Mr. Smibert collected in the above-mentioned Countries, for his own private Use & Improvement" (quoted in Saunders, "John Smibert," p. 186).

18. Liotard owed a certain amount of his popularity in London in the 1750s to the engravings printed by Richard Houston, James McArdell, and William Delatour; Francis Cotes from 1752 on worked with most major printmakers in England. See Edward Mead Johnson, *Francis Cotes* (Oxford, 1976), p. 9.

19. John W. Ittman, "The Triumph of Color: Technical Innovations in Printmaking," in *Regency to Empire: French Printmaking, 1715–1814* (exh. cat., Baltimore: Baltimore Museum of Art, 1984), p. 22; François Courboin, *L'Estampe française* (Paris, 1914), p. 49. The earliest crayon-manner engraving is dated 1735. In 1739 Pond engraved a crayon-manner print after Watteau's portrait of Dr. Misaubin. I am grateful to McSherry Fowble for bringing this information to my attention.

20. See Otto M. Lilien, *Jacob Christoph Le Blon, 1667–1741: Inventor of Three- and Four-Colour Printing* (Stuttgart, 1985). Le Blon's technique, which "produce[d] pictures not essentially different from those that are painted," was praised and described in detail in Dossie, *Handmaid to the Arts*, vol. 2, pp. 47, 182–89. Le Blon received a patent for his multiple-plate technique for these colored "printed paintings." Although his 1723 treatise, *Coloritto*, was not well known, his process stirred great interest, and many thousands of these engravings were printed.

21. Jones 1914, pp. 51–57, 170–71, 303. Among others these texts included Charles-Alphonse Dufresnoy, *De Arte Graphica. . . .*, trans. Roger de Piles (London, 1695); James Gibbs, *A Book of Architecture, Containing Designs of Buildings and Ornaments* (London, 1728); George Turnbull, *A Treatise on Ancient Painting . . .* (London, 1740); Daniel Webb, *An Inquiry into the Beauties of Painting; and into the Merits of the Most Celebrated Painters, Ancient and Modern* (London, 1760); and Count Francesco Algarotti, *An Essay on Painting* (London, 1764). For a discussion of literary sources available to Copley, see Jules David Prown, "An 'Anatomy Book,' by John Singleton Copley," *Art Quarterly* 26 (Spring 1963), pp. 31–46.

22. Roger de Piles, *The Art of Painting and the Lives of the Painters . . .*

(London, 1706), included Bainbrigg Buckeridge's "An Essay Towards a British School," a brief sketch on two seventeenth-century pastelists, William Faithorne and Edmund Ashfield (d. ca. 1700), a "Dedication" praising pastels as equal to oil in force and beauty, and a summary comparison of Italian and English techniques.

23. Janice G. Schimmelman, "Books on Drawing and Painting Techniques Available in Eighteenth-Century American Libraries and Bookstores," *Winterthur Portfolio* 19 (Summer–Autumn 1984), pp. 193–205.

24. Bernard Lens III was a friend and colleague of Smibert's; Smibert painted his portrait on two occasions. There is no record that Lens's manual was available in colonial America; however, it is conceivable that Smibert or his nephew were aware of it. The earliest record of Dossie's manual in America is a 1760 catalogue from James Rivington's bookshops in New York and Philadelphia (ibid., p. 199). A copy of the book was purchased at Rivington's in about 1763 by Charles Willson Peale on a visit to Philadelphia (C. W. Peale, letter to Rembrandt Peale, Oct. 28, 1812 [quoted in Saunders and Miles, *American Colonial Portraits*, p. 229]).

25. For example, Robert Boyle (*The Art of Drawing and Painting in Water-Colours*, 3d ed. [London, 1732], p. 58) noted that "Crayons of every Sort of Colour . . . [are] sold by most of the most noted Colour-men in *London*."

26. Quoted in Dow, *Arts and Crafts in New England*, p. 238. Sugar candy was most commonly used as a binder for miniature painting.

27. *Boston News-Letter*, Oct. 10–17, 1734, quoted in Foote, *John Smibert, Painter*, p. 76.

28. Foote, *John Smibert, Painter*, p. 105. Moffatt, Smibert's nephew, had taken over Smibert's color business upon his death in 1751.

29. Dow, *Arts and Crafts in New England*, pp. 239, 241–42.

30. Copley, letter to Jean-Étienne Liotard, Sept. 30, 1762, in Jones 1914, p. 26.

31. J. Powell, letter to Copley, Oct. 18, 1765, in Jones 1914, p. 37.

32. Jo Kirby, "Fading and Colour Change of Prussian Blue: Occurrences and Early Reports," *National Gallery Technical Bulletin* (London) 14 (1993), pp. 64–65.

33. Dossie, *Handmaid to the Arts*, vol. 1, p. 205. Heightening the whites as described by Dossie appears to have been a traditional practice.

34. Copley, letter to Captain R. G. Bruce, Sept. 10, 1765, in Jones 1914, p. 35.

35. Pigment analysis by scanning electron microscopy was kindly performed by Mark Wypyski, Assistant Research Scientist, The Metropolitan Museum of Art.

36. J. Powell, letter to Copley, Oct. 18, 1765, in Jones 1914, p. 37.

37. Henry Pelham, letter to Copley, July 11, 1771, in Jones 1914, p. 126.

38. One of the earliest manuals to describe this procedure in any detail was Carington Bowles, *The Artist's Assistant. . .* , 2d ed. (London, 176-), p. 39. A more complete description of the mounting procedure was later given by John Russell, *Elements of Painting with Crayons* (London, 1772), p. 18.

39. Copley, letter to Benjamin West, Jan. 17, 1768, in Jones 1914, p. 67, n. 3.

40. Blue and red silk fibers were included in French paper pulps in the 1750s and in English pulps from about 1760. These papers were intended expressly for crayon work. See John Krill, "Silk Paper for Crayon Drawing in the Eighteenth Century," *IPH Yearbook*, 1994, pp. 4, 7, 13.

41. Among those addressing paper color and type was Boyle (*Art of Drawing and Painting in Water-Colours*, p. 58): "The colour of whited brown paper being a little dark, gives a better opportunity of shewing the light or white strokes of our crayons, and will give a good relief to the tender parts of our work . . . the little roughness of such paper will make the crayons of every colour express themselves much stronger, than if we were to draw them upon smooth paper." Lens, *For the Curious . . . a New and Compleat Drawing-Book*, p. 7, and *The Compleat Drawing-Book . . .*, 5th ed. (London: Robert Sayer, 1786), p. 8, recommended blue-or purple-colored paper to allow one to darken downward with black chalk and heighten the lighter parts with white French chalk.

42. Of the pastels examined for this study, one that appears to have been fixed is *Mrs. Andrew Tyler*, a process probably carried out many years after the work was completed by Copley. References to glass in Copley's correspondence specify a 10-x-14-inch size that would accommodate mezzotints but not his crayon pictures.

43. Copley, letter to Captain Stephen Kemble, [Apr. 1771], in Jones 1914, pp. 112–13, in which Copley gave his fees for oils, indicating a five-guinea increase if a hand was included.

44. The little information on Copley's charges for pastels indicate that they were lower than the prices for his oils. The fee for *Mrs. Gregory Townsend* (1765) was four guineas (Prown 1966, vol. 1, p. 57); for *Reverend Jonathan Mayhew* (1767), five guineas (ibid., p. 98); for *Thomas Amory I* (fig. 103), paid August 16, 1770, "£9-16" (Curatorial files, Museum of Fine Arts, Boston).

45. There is one reference in Copley's correspondence to a framed work in crayon: John Hurd's remark that the glass and frame were "not so good" on an otherwise satisfactory pastel (John Hurd, letter to Copley, May 4, 1770, in Jones 1914, p. 88). The elaborate carved and gilt frame of *Mrs. Edward Green* was specifically commissioned for this crayon likeness. See Morrison H. Heckscher, "Copley's Picture Frames," in this publication.

46. For a discussion of Copley's oil technique, see J. William Shank, "John Singleton Copley's Portraits: A Technical Study of Three Representative Examples," *Journal of the American Institute for Conservation* 23 (Spring 1984), pp. 130–52.

47. I am indebted to Theresa Russo, Assistant Museum Educator, The Metropolitan Museum of Art, for the infrared-reflectography examinations and for her assembly of the computer images.

48. I am grateful to John Krill, Paper Conservator, Winterthur Museum, Delaware, for enabling me to examine by infrared reflectography the Copley portraits in the Winterthur collection.

49. The practice of using carmine for preliminary drawing was first described in 1772 by Russell (*Elements of Painting with Crayons*, pp. 20–22). He compared the process to dead coloring in oil. Manuals prior to this time generally recommended black chalk or charcoal.

50. Unlike these examples of Copley's draftsmanship, the strong black chalk lines that define the lower areas of drapery in various portraits, including *Mrs. John Singleton Copley* (fig. 114) and *Ralph Inman* (fig. 111), appear to be the result of retouching water damage and abraded surfaces. Copley invariably modeled his shadows with color.

51. Lens, *For the Curious . . . a New and Compleat Drawing-Book*, p. 7.

52. Ibid. Other manuals expressed this concept: "Colours are wrought one into the other that the whole appears as if done with a brush" (*Compleat Drawing-Master*, p. 4); and "to blend the Shades and the Lights, so as to be lost the one in the other" ([Claude Boutet], *The Art of Painting in Miniature: Teaching the Speedy and Perfect Acquisition of That Art Without a Master*, 6th ed. [London, 1752], p. 129).

53. Captain R. G. Bruce, letter to Copley, June 11, 1767, in Jones 1914, p. 53.

54. Shank, "Copley's Portraits: Technical Study," p. 134; Prown 1966, vol. 1, p. 24.

55. The strong contrasts of light and dark produced by these contours and

shadows have been associated with the influence of mezzotint engravings on Copley's work; in some instances, however, the contrasts have been augmented by the damage wrought by time. In various oil paintings the contrasts have been unintentionally reinforced by repeated cleanings of the lighter passages and changes in the refractive index of the paint. In some pastels the fading of the flesh colors—particularly in portraits of female sitters, where lighter tints of the notoriously fugitive lake and carmine pigments were used, exemplified in the pale complexion of the subject in *Mrs. Elijah Vose*—has contributed to a reduction of the middle tones. I am grateful to Dorothy Mahon, Conservator of Paintings, The Metropolitan Museum of Art, for her insightful interpretation of Copley's oil technique.

56. *Compleat Drawing-Book*, p. 8.

57. Wetting pastel was not practiced until the late nineteenth century. A few oblique references to it are found in eighteenth-century manuals, such as Bowles, *Artist's Assistant*, p. 38: "crayons being dry will not alter their color, but will appear deeper if wetted."

58. Copley, letters to Henry Pelham, June 25 and Mar. 14, 1775, in Jones 1914, pp. 341, 304.

59. Benjamin West, letter to Copley, Aug. 4, 1766, in Jones 1914, p. 45.

60. Captain R. G. Bruce, letter to Copley, Aug. 4, 1766, in Jones 1914, p. 42.

61. Horace Walpole, *Anecdotes of Painting in England . . .* (London, after 1772), vol. 3, p. 27; Whitley, *Artists and Their Friends*, vol. 1, p. 268.

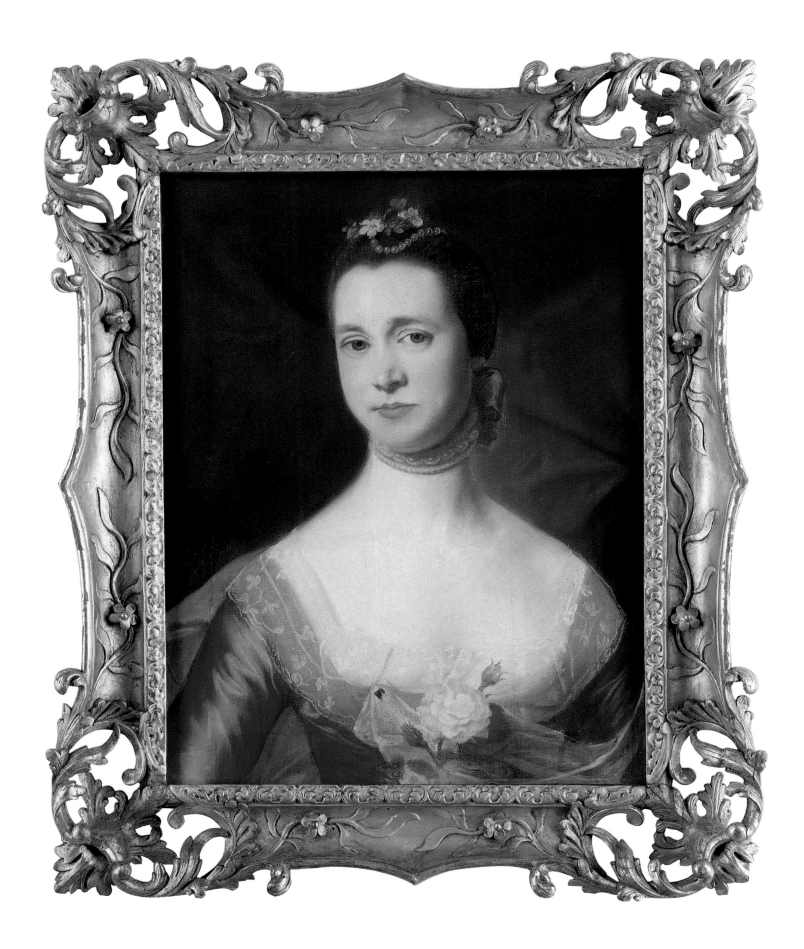

Copley's Picture Frames

MORRISON H. HECKSCHER

John Singleton Copley, in addition to being the preeminent painter in pre-Revolutionary America, was probably the first of the American artists who took an active role in the design, manufacture, and marketing of the frames for their pictures. His interest in supplying frames dates from about 1763–64, some ten years after he began painting. Ambitious and entrepreneurial, he doubtless sought financial gain from this involvement, but he also must have recognized the aesthetic dividend provided by an appropriate frame. It is hard to imagine Copley's great portraits of the late 1760s and early 1770s in other than their glorious carved and gilded Rococo frames.

Over the years there has been sporadic interest in Copley's frames. In 1870 extracts from Paul Revere's daybooks were published that documented the fact that between 1763 and 1767 the great patriot had made gold and silver frames to Copley's order for his portrait miniatures.[1] From this bit of information it took but a small leap of faith and patriotic fervor for Augustus Thorndike Perkins, Copley's first biographer, to write in 1873: "He [Revere] certainly designed almost all the solid wooden frames that surround Copley's pictures at the present time."[2] Subsequent studies have effectively dismissed that claim, though recent investigations of Copley's carved and gilded frames have shown a good number of them to be of Boston manufacture.[3]

This essay represents the beginning of an attempt to survey the frames on all of Copley's surviving American paintings and pastels.[4] The immediate aim, realized here, is to categorize the various styles of frames and to determine chronologies for them; the long-term goal, for a future study, is a complete catalogue of the frames. The complete catalogue will involve examinations of original frames on the works of other colonial American artists—such as John Smibert and Robert Feke, John Wollaston and John Greenwood—which are necessary for a full understanding of the significance of Copley's own frames.

Mrs. Edward Green (Mary Storer) (cat. no. 27)

Most of Copley's paintings were of standard sizes: 95 x 59 inches for the full-length; 50 x 40 inches for the half-length; 36 x 28 inches for the kit-cat; 30 x 25 inches for the quarter-length. Only the pastels vary somewhat in size, but most of them measure between 23 x 17 inches and 24 x 18 inches. This means that frames can be switched about and that, for this reason, it is often difficult to be sure that a given frame is original to a given painting. On the other hand, with the evidence of the type of wood used, it is often possible to identify a frame's place of origin. In New England the native eastern white pine (*Pinus strobis*) was consistently the preferred wood for any carving intended for gilding; in England it was red or Scotch pine (*Pinus resinosa* or *Pinus sylvestris*).[5] Recognizing the significance of wood in distinguishing American work from the English is nothing new in the case of Copley. In his *Lives of the Most Eminent British Painters and Sculptors* of 1831, Allan Cunningham described how Copley's portrait of a "Boy and a tame Squirrel" (cat. no. 25) was received at the Royal Academy in London in 1766 without identification and noted that the Academicians were "at a loss what to say about it in the catalogue, but, from the frame on which it was stretched being American pine, they called the work American."[6]

Various models of three basic frame styles are found on Copley portraits in sufficient numbers to allow us to safely conclude that they were the standard choices available and in fashion. They are the black-molded, or Dutch, style; the carved-and-gilded-molded; or what, for want of a better name, we shall call Baroque; and the Rococo. There is scant evidence that Copley employed more than a few Neoclassical frames before he departed Boston for London in 1774.

BLACK-MOLDED-WOOD FRAMES: THE DUTCH STYLE

The simplest, least expensive frames—such as those used for the portraits of Mr. and Mrs. Joseph Mann (fig. 115)—consist of one or more pieces of wood, shaped with molding planes (forming, in profile, a variety of combinations of

Fig. 115 Corner detail of frame, Boston, ca. 1754. White pine, painted black and gilded, 45 ⅝ x 33 ¾ in. (115 x 85.7 cm). For *Joseph Mann*, 1754. Oil on canvas. Museum of Fine Arts, Boston, Gift of Frederick H. and Holbrook E. Metcalf 43.1352

Fig. 116 Corner detail of frame, carving attributed to Thomas Johnston, Boston, ca. 1762. White pine, painted black and gilded, 56 ¼ x 46 in. (142.9 x 116.8 cm). For *Mrs. Samuel Phillips Savage (Sarah Tyler)*, ca. 1762. Oil on canvas, Worcester Art Museum, Massachusetts 1916.51

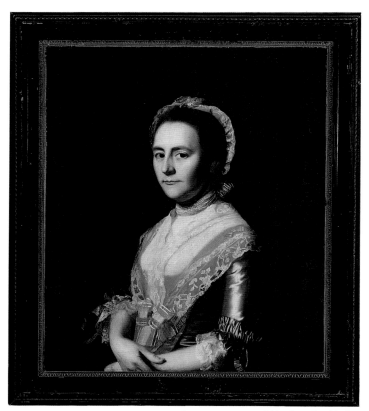

Fig. 117 Frame, Boston, ca. 1770. White pine, painted black and gilded, 35 ⅝ x 30 ⅞ in. (90.5 x 78.4 cm). For *Mrs. Alexander Cumming (Elizabeth Goldthwait)*, 1770. Oil on canvas. The Brooklyn Museum, New York, Gift of Walter H. Crittenden 22.84

Fig. 118 Corner detail of frame (fig. 117)

curves), sawed into lengths and joined at the corners with nailed miter joints. On these the wood was usually painted a shiny, burnished black, in imitation of the ebony employed for costly seventeenth-century Dutch frames: hence, the commonly used term *Dutch style*. To set off the picture, the inner edge was carved (sometimes with simple gouging that did not require a specialist carver) and gilded. On some frames of this sort one of the outer moldings was also carved and gilded. The profiles of the large elements of burnished wood take the form of a large ovolo (on the inside) and a cavetto (on the outside), which meet at a point. This type is found on Copley's earliest pictures, those of the mid- to late 1750s, and the first examples are probably the locally made frames on the portraits of the Manns, which were painted in 1753 and 1754.[7]

In the beginning Copley does not appear to have been much involved with the selection or purchase of these Dutch-style frames. Though their profiles were standard and could be fashioned readily by joiners, the carving and gilding usually required special skills and materials. In Boston such craftsmen as Thomas Johnston—a jack-of-all-trades whose skills included engraving, japanning, and house painting—did work of this sort. On April 23, 1762, he billed Samuel P. Savage £2-13-4 "To Making a handsome Half length Picture Frame inside edge Car[vd] & Gilt." (The implication is that the rest of the frame was black.) Two years later, on September 8, 1764, he charged a like amount "To 1 handsome frame y[r] Picture."[8] It is reasonable to assume that the frames Johnston referred to in his bills were for the portraits Copley painted of Samuel Savage in 1764 and of his wife, probably in 1762. The frame around Mr. Savage's image is in the fully carved and gilded Rococo style; the one on his wife's picture (fig. 116), however, is a black-and-gold-molded type (the profile is not unlike that of the frames made for the Manns) that generally conforms to what Johnston described and appears to be the original.[9]

Throughout Copley's American career, the black-molded frame remained a viable option for his clients who chose inexpensive frames. By the middle of the 1760s Copley himself regularly handled the acquisition of these simple Dutch-style frames. In 1769 he billed "Mrs. Elizabeth Cummings" (Mrs. Alexander Cumming, née Elizabeth Goldthwait) for portraits of herself and of Mr. and Mrs. MacWhorter (Reverend Alexander and Mary Cumming MacWhorter); in 1770 he billed Mrs. Cumming for "two Black Frames @ 24/ [£]2-8-0" (fig. 119); and in 1771 he charged Ezekiel Goldthwait (Elizabeth's father-in-law) "To a Black Frame for Mr. Cummings [£]1-8-0" (fig. 143). Neither of the

Fig. 119 Copley's bill of sale to Mrs. Alexander Cumming (see fig. 117). Historical Society of Pennsylvania, Gratz Collection

MacWhorters' pictures has its original frame, but Mrs. Cumming's does (figs. 117, 118), and it seems fair to claim that this is one of the examples that Copley supplied at a cost of £1-4-0 or £1-8-0. On later black-molded frames, such as these and the one that surrounds *Mrs. James Warren*, the profile has become a single large cavetto.[10]

CARVED-AND-GILDED-MOLDED-WOOD FRAMES: THE BAROQUE

The frames on *Mrs. John Powell* (figs. 120, 121), on another portrait of the sitter, and on *Epes Sargent* (fig. 123) are typical of a more elaborate and sumptuous molded-wood model, with allover carving and gilding, that appears on fourteen different pictures, eight of which were painted in 1763 and 1764. There is some variation in their carving, which may indicate the presence of more than one hand, but most of them look to be of white pine and lack the reinforcing corner splines of the English product and appear, therefore, to be of Boston origin.[11] In these frames a narrow carved ogee abuts the canvas and the characteristic profile constitutes a flat sanded frieze, an applied molding consisting of a shallow broad-shouldered ogee with a pattern of strapwork and leafage, and an outer edge decorated with an egg-and-dart motif.

Copley's own bill (fig. 124), his earliest known invoice that charges for a frame as well as a painting, reveals that Mrs. Powell's frame was supplied by the artist himself.[12] On April 17, 1764, Jeremiah Powell paid Copley in full for his invoice:

To painting your Mamma's portrait
at eight Guineas 11-4-
To a Gold frame for Do. at four pounds 4-
 £15-4-

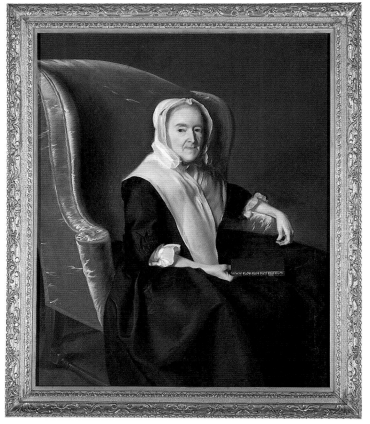

Fig. 120 Frame, Boston, ca. 1764. White pine, gilded, 57⅞ x 46½ in. (147 x 118.1 cm). For *Mrs. John Powell (Anna Dummer)*, 1764. Oil on canvas. The Cleveland Museum of Art, 1994, Gift of Ellery Sedgwick, Jr., in memory of Mabel Cabot Sedgwick 80.202

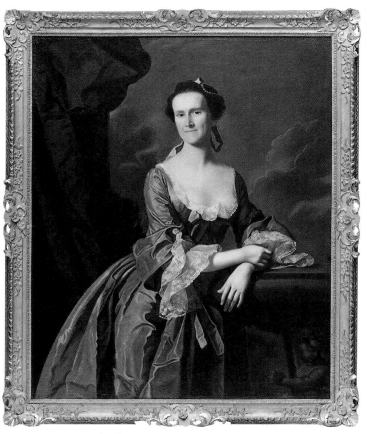

Fig. 122 Frame, England, probably London, ca. 1763. Red or Scotch pine, gilded, 56½ x 46¼ in. (143.5 x 117.5 cm). For *Mrs. John Amory (Katherine Greene)*, ca. 1763. Oil on canvas. Museum of Fine Arts, Boston, M. and M. Karolik Collection of Eighteenth Century American Arts 37.36

Fig. 121 Corner detail of frame (fig. 120)

Fig. 123 Corner detail of frame, Boston, ca. 1760. White pine, gilded, 57 x 46½ in. (144.8 x 118.1 cm). For *Epes Sargent* (cat. no. 11)

Fig. 124 Copley's bill of sale to Jeremiah Powell (see fig. 120). The Cleveland Museum of Art, Gift of Ellery Sedgwick Jr., in memory of Mabel Cabot Sedgwick 80.202A

The extensive, if flat, carving and allover gilding account for the relatively high cost of this frame, nearly twice what Johnston charged for his plain, black-painted examples.

A variant of this kind of frame has—punctuating the running moldings, carved scrollwork projections at each corner and in the center of each side—gentle intimations of the Rococo style. The frames of this category, except for the matching examples that enclosed portraits of married couples, differ from one another, and those that have been tested are made of red or Scotch pine, indicating that they were probably ordered at different times and from different suppliers and from England. Massive examples of the type, which appear to be English because of their exceptionally fine carving, enframe the portraits of Governor and Mrs. Jonathan Belcher, 1756, but no others are found on any picture painted prior to the mid-1760s. The red or Scotch pine frames on the portraits of Mr. and Mrs. John Amory (see fig. 122) have corners with shells and flanking C-scrolls from which extend vines of alternating leaves and flowers, all prefiguring the major motifs of the Rococo style.[13]

CARVED-AND-GILDED-WOOD FRAMES: THE ROCOCO

The Rococo style introduced a dramatically new approach to frame design. The purpose now was to break up and destroy, or at least camouflage, the simple, logical structure of the molded frame. To achieve this, the wood-carver with his chisels replaced the joiner with his molding planes. The large cavetto, or cove, of the molding-type frame was divided into a series of undulating C- and S-scrolls. What before had the

look of a strong architectural element, providing protection for the picture, was transformed into something fragile, tenuous, and playful. It is this style of frame with which Copley's name is now principally linked.

A new stylistic elegance in Copley's portraiture coincided with the flowering of the Rococo style in Boston in the mid-1760s. By about 1763 or 1764 he must have decided that the Rococo frame was ideally suited to enhance his current pictures: prior to that time few of his paintings had such frames—only two portraits from the 1750s now have Rococo frames that may be original to them; thereafter, however, large numbers of his works were encased in carved and gilt Rococo frames.

The scrapbook of London carver Gideon Saint, compiled between about 1763 and 1768, contains drawings for various popular Rococo frame designs (fig. 125), some of which were like models Copley used, and provides a rare glimpse of how an eighteenth-century craftsman worked.[14] One of Saint's full-scale patterns, or templates (fig. 126), illustrates

Fig. 125 Gideon Saint. *Designs for picture frames*, scrapbook, London, ca. 1763–68, p. 23. Ink wash on paper, 13½ x 8½ in. (34.3 x 21.6 cm). The Metropolitan Museum of Art, New York, Harris Brisbane Dick Fund, 1934 34.90.1

Fig. 126 Gideon Saint. *Template for carved picture frame motif*, insert in scrapbook, London, ca. 1763–68. Brown ink on paper, 3½ x 13½ in. (8.9 x 34.3 cm). The Metropolitan Museum of Art, New York, Harris Brisbane Dick Fund, 1934 34.90.1

Fig. 127 Frame, carved by Richard Fletcher, London, ca. 1770. Pine, gilded, 25 x 23 in. (63.5 x 58.4 cm). Judkyn/Pratt Collection, Bath, England

Fig. 128 Label, Richard Fletcher, London, ca. 1770. Engraving, 6¾ x 5 in. (17.1 x 12.7 cm). Affixed to frame (fig. 127). Judkyn/Pratt Collection, Bath, England

the procedure for laying out the design of a carved frame. First he drew, freehand and full size, on a folded sheet of paper, one half of a decorative motif. Then he pricked this drawing with a pin, duplicating it on the other half of the sheet. When he unfolded the paper he had a complete symmetrical image that could be transferred, by pen and ink or by pricking, to the wooden surface that was to be carved. The design at the bottom of Saint's page 23 (see fig. 125) is similar to that of a frame (fig. 127) bearing the label of Richard Fletcher (fig. 128), "Picture Frame Maker, Carver and Gilder" of London, one of a very few documented Rococo examples, and one that is closely related to a frame type used by Copley.

Rococo frames were constructed in two ways: with a flat backboard and a shallow applied cove or with a deep cove carved from the solid. Both methods were used in England, but the former is characteristic of Copley's imported frames and the latter distinguishes his Boston-made frames. For simplicity, in the present essay, let us dub them the "English manner" and the "Boston manner."

ROCOCO: THE ENGLISH MANNER

The English-manner frame is made up of a backboard about four inches wide, usually with a gadrooned inner (sight) edge and an egg-and-dart–decorated outer edge, with mitered corners reinforced in back with tapered dovetail splines. The scalloped scrollwork, pierced or cut out at centers and corners, is carved on a separate cove that is glued to the backboard. The wood is red or Scotch pine and is gilded.

The earliest example of such a frame used on a Copley is the one that surrounds his portrait of Ann Gardiner, ca. 1756. What was to become Copley's classic Rococo frame design first appeared in the frame, also made in the English manner, for *Theodore Atkinson Jr.*, ca. 1757–58 (figs. 129, 130). Here the space between the corner and the center is filled with symmetrically paired serpentine C-scrolls with a pierced trefoil at their juncture. Streamers of leaves and flowers are carved in the bed of the cove. The design matches that of the frame with Fletcher's label, except that it has a gadrooned rather than a beaded inner edge. The frame must be of English origin, as it is of red or Scotch pine.

In 1766 Copley painted Mrs. Thomas Boylston (fig. 131). By the end of 1767 he had completed six portraits of members of her immediate family—one of his most important commissions. The series includes paintings of her daughters Lucy (Mrs. Timothy Rogers), Mary (Mrs. Benjamin Hallowell), and Rebecca, and her sons Thomas II and

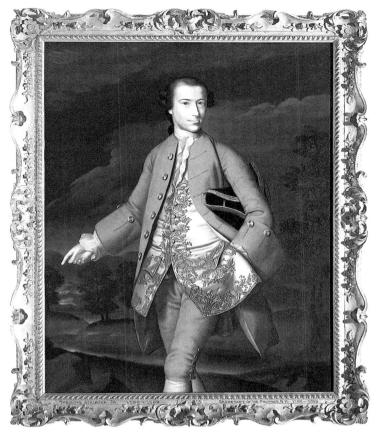

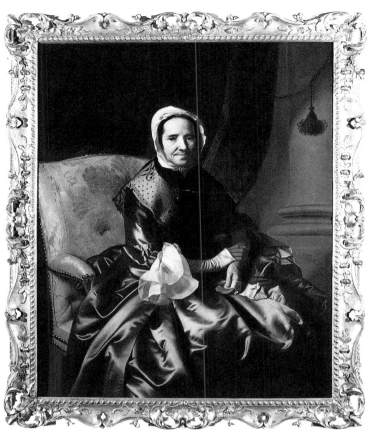

Fig. 129 Frame, England, probably London, ca. 1757–58. Red or Scotch pine, gilded, 58½ x 48½ in. (148.6 x 123.2 cm). For *Theodore Atkinson Jr.* (cat. no. 8)

Fig. 131 Frame, probably London, ca. 1766. Red or Scotch pine, gilded, 57½ x 47½ in. (146.1 x 120.7 cm). For *Mrs. Thomas Boylston (Sarah Morecock)* (cat. no. 30)

Fig. 130 Corner detail of frame (fig. 129)

Fig. 132 Corner detail of frame (fig. 131)

149

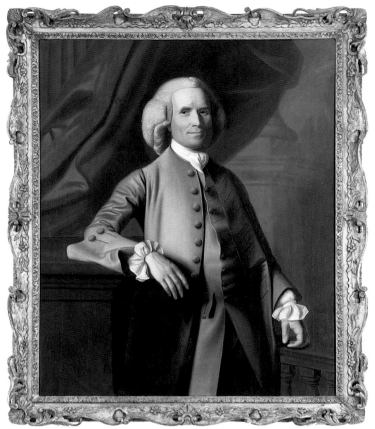

Fig. 133 Frame, Boston, ca. 1764. White pine, gilded, 58 x 48 in. (147.3 x 121.9 cm). For *Epes Sargent II* (cat. no. 16)

Fig. 134 Corner detail of frame (fig. 133)

Nicholas. All are housed in eighteenth-century carved and gilded Rococo frames (see fig. 131), which, except for the example enclosing Nicholas's likeness, are of the same design and appear to have been based upon the same template and carved by the same hand. This stylistic identity and the fact that they are made of red or Scotch pine indicate that they all must have been ordered at the same time and from England. The appearance of this group of frames determined the future look of Copley's production.

The portrait of Nicholas now has a Rococo frame of Boston manufacture[15] but probably originally was encased in a frame that was part of the Boylston set and is now on Copley's portrait of John Winthrop (an issue discussed below). A second version of Nicholas's portrait has been dated to about 1769. Its completion some two years after the other Boylston pictures were painted explains why its frame, which is unlike any other on a Copley, is different from those in the series of six: it must be from a different batch, ordered after the original group.[16]

There are three exceptions to the rule that Copley's Rococo frames with backboards are always English. The example on the pastel portrait of Joseph Green could easily be mistaken for one of the group of Boylston-family frames, except that the wood tests as white pine. (Did Copley, in this instance, ask John Welch, one of the Boston carvers upon whom he relied, to copy the newly arrived Boylston frames?) Then there are the frames installed on *Epes Sargent II* (figs. 133, 134) and *Mrs. Epes Sargent II*, whose surfaces retain much of the original gilding. Here the decorative scheme is the same as that of the English frame on Copley's *Ann Gardiner*—a not uncommon English model with scrollwork that flows, like cresting waves, out from the corners, but one almost never found on Copleys. But these are certainly American frames, for they are made of white pine and are without corner splines. They are among the artist's earliest Rococo frames and their carving is flat and stiff—suggesting that they may have been produced by a Boston carver without Welch's finesse whom Copley was trying out.

All the frames made in the English manner are structurally sound and have a playful Rococo surface effect. But because the cove is shallow and the pierced work opens onto a gilded backboard (rather than a wall of contrasting color), they appear flat and subdued in comparison to Copley's frames in the Boston manner.

The carved and gilded Rococo frames made in Boston constitute the largest, most distinctive, and best-documented group of original Copley frames. By present count they number some thirty-two examples, six of which are documented. The earliest dated painting by Copley with such a frame is the picture of John Spooner, 1763; the latest is the full-length replica of the portrait of Nicholas Boylston, 1773 (figs. 135, 136).

The frames of this group are distinguished principally by the use of thick slabs of eastern white pine (twenty-three of the thirty-two have been tested, and all are *Pinus strobis*) carved out in the so-called Venetian technique. In the frames fashioned according to this method there is no backboard to provide structural integrity—the sides are cut away at the back to free up the outlines of the scrollwork and to expose the pierced openings—and the scalloped cove necessarily has considerable thickness. A thin wooden strip is nailed to the top of the cove and over the openings. The result is thoroughly Rococo in style and often astonishingly insubstantial in construction. (Might it be that Copley decided to have these frames, the most elaborate and delicate he used, made in Boston because he considered them too fragile to import?)

The majority of Rococo frames in the Boston manner appear to be the work of two carvers: one, believed to be Welch, responsible for twenty-five identifiable frames; the other, as yet anonymous, responsible for seven. The frames of the Welch group are all of one basic design, a pattern that in most details duplicates the English frames on the Boylston portraits; but they are fabricated in the Venetian technique, and what a difference that makes!

John Welch (1711–1789) was one of Boston's leading carvers. He kept a shop on the town wharf from 1733 until 1758, when he sold most of his possessions in preparation for a stay in London. In February 1759 he wrote from London to his old friend Samuel Savage that he yearned for Boston. He returned home at a date that is unknown, but it would have been after firsthand exposure to London's carving shops (run by the likes of Saint and Fletcher). Welch must have been a principal catalyst in the introduction of the Rococo to the tradition-bound craftsmen of Boston.[17]

Direct links between Copley and Welch cannot be documented before the 1770s. In a letter of October 12, 1771, from New York, which constitutes the first known proof of a connection between the two men, Copley wrote his half brother and sometime agent, Henry Pelham, asking "what you paid Welch for carving and Whiting for Gilding."[18] Then, in 1773, for Harvard College, Copley painted a full-length replica of his portrait of Nicholas Boylston, for the frame of which Welch ultimately was paid eight guineas. An undated memorandum in the Harvard University Archives[19] lists:

Occasional Expenses, viz:

Boylston's Frame	[£]11-8-0
J. Copley Do. picture	56-18-0
J. Welch carving. Do.	8-8-0

This is the one frame for a Copley whose attribution to Welch is supported by documentation. Except for its great size and the diaper pattern within the corner and center C-scrolls, the Boylston frame is marked by the same features of design and execution that characterize the more than two dozen frames now attributed to Welch. Its carving is patently by the same hand responsible for a group of frames for the Gill family (see figs. 137, 138). Typically, the decorative scheme is well proportioned, and the carving is executed with Welch's usual assurance and grace.

Welch's frames can be subdivided into those with modest pierced work (see figs. 135, 137, 141) and examples with aggressive cutouts (see figs. 139, 145). The former category includes twelve frames made for canvases of 50 x 40 inches that are virtually indistinguishable from one another except for the motifs of their removable central cartouches. The earliest of the pictures for which these frames were made is the portrait of Moses Gill, dated 1764. However, the frames housing the pictures of Gill, his first wife, Sarah, and his second wife, Rebecca, are a set that matches even down to the too-small and ill-defined cartouches and could not, therefore, have been ordered until Rebecca was painted, in 1773. An equally odd and diminutive central ornament appears on the frame of *Mrs. John Greene*, 1769 (the cartouche on the frame of her husband's portrait is missing). More upright and assertive is the featherlike finial of Welch's frame for *Sylvester Gardiner*, ca. 1772.

The portraits of John and Samuel Winthrop, both of which are at Harvard, look to have been painted at the same time, about 1773, and presumably would have had identical frames. Since the frame now on Harvard's *Nicholas Boylston* matches, even to the pierced-shell cartouche, that on *Samuel Winthrop*, and since the frame now housing *John Winthrop* is identical to those on the Boylston-family pictures, it is reasonable to hypothesize, as noted above, that the frames on the pictures of Boylston and John Winthrop have been switched, particularly since both paintings have long

Fig. 135 Frame, carved by John Welch, Boston, ca. 1773. White pine, gilded, 106 x 70 in. (269.2 x 177.8 cm). For *Nicholas Boylston*, 1773. Oil on canvas. Harvard University Portrait Collection, Cambridge, Massachusetts, Painted at the request of the Corporation, 1773

Fig. 137 Frame, carving attributed to John Welch, ca. 1773. White pine, gilded, 57 x 47½ in. (144.8 x 120.7 cm). For *Mrs. Moses Gill (Rebecca Boylston)* (cat. no. 34)

Fig. 136 Corner detail of frame (fig. 135)

Fig. 138 Corner detail of frame (fig. 137)

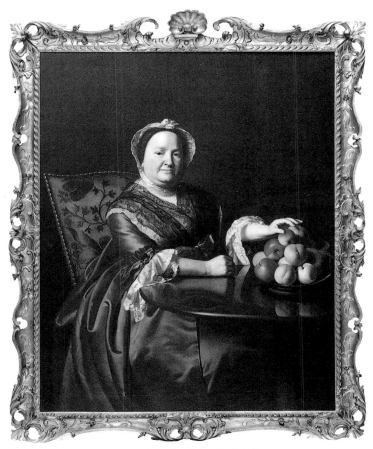

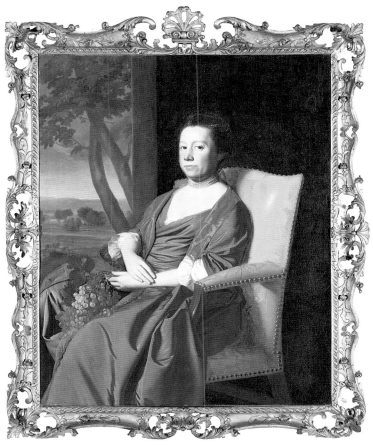

Fig. 139 Frame, carving attributed to John Welch, Boston, 1770–71. White pine, gilded, 58¾ x 46⅞ in. (149.2 x 119.1 cm). For *Mrs. Ezekiel Goldthwait (Elizabeth Lewis)* (cat. no. 60)

Fig. 141 Frame, carving attributed to John Welch, Boston, 1769. White pine, gilded, 58½ x 50 in. (148.6 x 127 cm). For *Mrs. Isaac Smith (Elizabeth Storer)* (cat. no. 51)

Fig. 140 Corner detail of frame (fig. 139)

Fig. 142 Corner detail of frame (fig. 141)

153

Fig. 143 Copley's bill of sale to Ezekiel Goldthwait (see fig. 139). Museum of Fine Arts, Boston

Fig. 144 Copley's bill of sale to Isaac Smith (see fig. 142). Massachusetts Historical Society, Boston

been in Harvard's collection.[20] Fragments of pierced-shell cartouches similar to those on the Winthrop frames survive on the frames Welch made in the modestly pierced style for two earlier Copley portraits, those of Nymphas Marsdon (Museum of Fine Arts, Springfield, Massachusetts) and Thomas Hubbard, both about 1767.

In 1771 Copley billed Ezekiel Goldthwait (fig. 143):

To his Lady's portrait half length	14Guis £19-12-0	
To his own Do		19-12-0
To two carved Gold Frames	at £9.0	18-0-0

These frames (see figs. 139, 140) are identical to the others of the modestly pierced group except that the one on Ezekiel's picture does not have the characteristic carved ruffle on the outer edge of its C-scrolls. In fact, the carved ruffle is the one ornamented detail that distinguishes the decorative scheme of the Welch frames from that of the English-made Boylston-family frames. Clearly, the former were directly inspired by the latter. The Goldthwait examples have their original shell cartouches and, alone of all Welch's frames, retain the original brass hanging rings screwed into their top edges, at the two lowest points of their top rails. Similar in all but a few decorative motifs to the modestly pierced group of frames by Welch are the massive frames on the full-length portraits of Mr. and Mrs. Jeremiah Lee.

The other frame model associated with Welch differs significantly from the foregoing examples attributed to him only in the amount of pierced, or open, work. The frames on the portraits of Mr. and Mrs. Isaac Smith (see figs. 141, 142)

are prime examples of this second type. In 1769 Copley billed Smith £39-4-0 for two half-length portraits and £18 for "two carved Gold frames for Do" (fig. 144). (Though generally identical in design, these frames differ in execu-

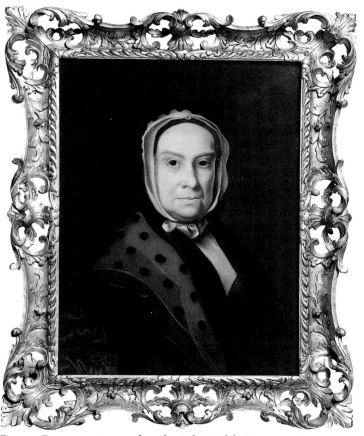

Fig. 145 Frame, carving attributed to John Welch, Boston, 1767–69. White pine, gilded, 30½ x 24½ in. (77.5 x 62.2 cm). For *Mrs. Ebenezer Storer (Mary Edwards)* (cat. no. 42)

Fig. 146 Corner detail of frame (fig. 145)

Fig. 147 Corner detail of frame (frontispiece)

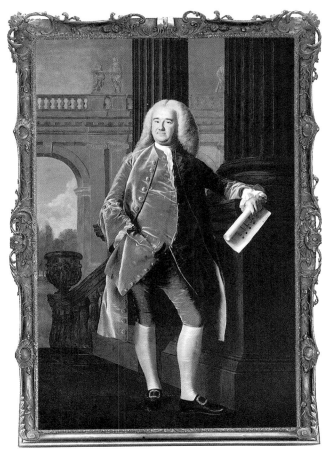

Fig. 148 Frame, Boston, ca. 1764. White pine, painted black, 99½ x 69¾ in. (252.7 x 177.2 cm). For *Nathaniel Sparhawk* (cat. no. 19)

Fig. 149 Corner detail of frame (fig. 148)

tion. Is one the work of an apprentice?) The entire background surrounding the central leaf motif and within the flanking C-scrolls at the corners and centers of these frames has been cut away. All that remains of structure are the thin fillet under the gadroon and the rim applied over the open areas and nailed to the top of the cove.[21] The price of nine pounds per frame is the same that Goldthwait was to pay two years later for his own less flamboyant frames. The pierced-shell cartouches on the Smith frames are identical to those on the frames of the Winthrop portraits painted four years later, a fact that reinforces the belief that Welch was responsible for both groups.

The only other half-length portrait with a frame comparable to those of the Smiths, albeit one surmounted with a family crest, is the painting of Richard Dana, ca. 1770.[22] The structural risks of the fully exploited Rococo manner must have been apparent to Copley and his clientele, because it is otherwise employed only in frames for images of smaller format: the kit-cat paintings of Samuel Quincy and of his wife, both ca. 1761, and the pastels of Joseph Green, ca. 1765, and two members of the Storer family, 1767–69.[23] These frames (see figs. 145, 146) share certain distinctive features: at the pierced centers of the sides, reeded panels within the three middle leaves—a motif Welch borrowed from the frames imported in 1767 for the Boylston-family portraits; at the corners, complex piercing patterns and a wavelike motif at the edge of the gadroon.

The Rococo frames on Copley's pastels seem massive. At about 24 x 18 inches on average, the dimensions of the pastels are just under half those of the canvases of 50 x 40 inches, and their area is a bit less than one-quarter that of the paintings. Yet the scale of the decorative motifs on the pastel frames is fully four-fifths that of the larger frames. Copley may have sensed a disjunction between the scale of these frames and his pastels, which would explain why he experimented with Neoclassical frames for some of these pictures even before he moved to England.

A group of seven frames on Copley portraits dating between 1764 and 1767 is so distinctive, in the quality of the carving as well as in the individual design motifs, that it must have been made by another craftsman, the anonymous artisan mentioned above. The frame on the pastel *Mrs. Edward Green (Mary Storer)* (fig. 147; frontispiece, this essay), drawn some two years before the other Storer pastels, represents a small-format example of this group; that on *Nathaniel Sparhawk* (figs. 148, 149), a large-format one. In the entire series the inner (sight) edge is embellished with a form of egg-and-dart patterning rather than gadrooning,

and the sides curve out to a gentle middle point—features not seen in Welch's frames.[24] The design works best on the full-length frames, where structural imperatives prevented the carver from overindulging in openwork corners. Examples of the full-length frames appear on the portraits of Harvard College benefactors Thomas Hancock and Thomas Hollis, painted between 1764 and 1766. On July 9, 1766, Edward Holyoke, president of the college, wrote to Hollis's nephew, then in England: "The Carver who hath made a frame for [your] excellent Unckle's Picture . . . hath constructed it so, as to have an Eschucheon for his Arms on the Top of it wherefore if you will please to send us the Blazonry They shall be added."[25] The frame for *Nathaniel Sparhawk* is unusual in that it originally was painted black rather than gilded.[26] The escutcheon is missing and the bottom board largely replaced, but otherwise it is well preserved, with paint intact, and impressive.

The frames on the pictures of Mrs. Sylvanus Bourne, 1766, and Mrs. Jerathmael Bowers, ca. 1763, are the only two known Copley frames carved in the Venetian technique that are not of Boston manufacture. Both are of spruce (*Picea*), a wood not thought to have been used by American carvers; and both are executed in Rococo patterns commonly found in English products.[27]

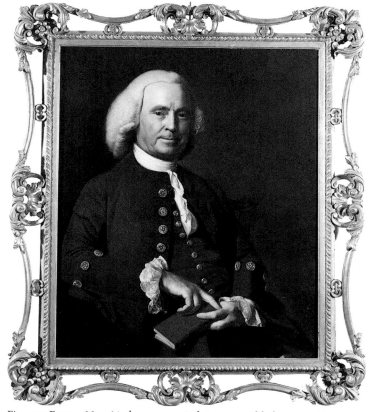

Fig. 150 Frame, New York, ca. 1771. White pine, gilded, 44 x 37¼ in. (111.8 x 94.6 cm). For *Josiah Quincy*, ca. 1767. Oil on canvas. Dietrich American Foundation

Copley spent the latter half of 1771 in New York City, busily painting the local worthies. His correspondence with Henry Pelham shows that frames for these pictures were shipped from Boston. On September 10 Pelham wrote of sending a box of frames that "are (I think) as good as any that have been done, and are such, as I hope will please the Taste of the Gentry at New York."[28] In the same letter of October 12 in which Copley asked Pelham what had been paid to Welch for carving frames and to Whiting for gilding them, he wrote that he had sold two small frames but would not order others before they were commissioned.[29] No example of a Boston frame shipped to New York has yet been identified; indeed, none of Copley's New York portraits still seem to be in their original frames. But the frame for the picture of Mary Mallett Livingston (fig. 150), though now on another Copley, can be traced. This frame is altogether different from others used by Copley in that it has a gadrooned inner edge surrounded by a boldly pierced leaf-and-scroll-carved mantle. In these design features it conforms closely to the frames carved by James Strachan, a London-trained carver, in New York in 1767 for John Durand's portraits of James Beekman's six children.[30] Strachan died in 1767, so he cannot be credited with the Livingston frame, but it is likely that another New York carver, who was influenced by him, executed this piece.

Perhaps the most puzzling of all Copley frames is the one on the portrait of Bostonian Joshua Henshaw, ca. 1770.[31] The top, bottom, and sides of this complex Rococo confection are all carved in different designs, and the leafage has a distinctive allover pattern of fine parallel lines. It is unlike any other American frame, yet the eastern white pine with which it is made and the carved and painted escutcheon of the Henshaw arms that surmounts it are ample proof of its American provenance and originality to the picture.

NEOCLASSICAL MOLDED FRAMES

The Neoclassical style rejected the excesses of the Rococo and reflected an attempt to return to the simple logic of the molded frame. In comparison with the molded frame of the 1750s, however, the Neoclassical molded frame was lighter and more delicate in scale and favored tiny, cast decorative motifs and burnished surfaces rather than simple carving and black and gold paint. It is a fact that in Philadelphia as early as 1770 Charles Willson Peale was using either black with gold or entirely gilded molded Neoclassical frames on his portraits. But we do not know whether Copley ever specifically requested frames of Neoclassical design before he

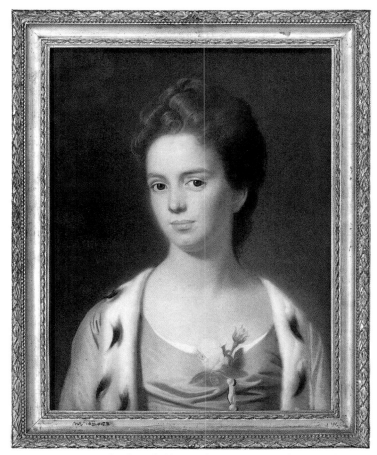

Fig. 151 Frame, England, probably London, ca. 1771. Red or Scotch pine, 27½ x 21½ in. (69.9 x 54.6 cm). For *Mrs. Joseph Barrell (Hannah Fitch)* (cat. no. 58)

went to London in 1774. There are not enough Copley portraits of the 1770s with Neoclassical frames to present a detectable pattern of production (unless, based on the delicacy of the moldings, we choose to judge all the black-molded frames, such as that on Mrs. Cumming's picture [figs. 117, 118], as Neoclassical).

Of the handful of his pastels with Neoclassical frames, those most likely to be original to the works are the matching pair on the pictures of Joseph Barrell, 1767–69, and his second wife, Hannah Fitch Barrell, ca. 1771 (fig. 151). Made of red or Scotch pine and with corner splines, they must have been imported. Here a narrow carved band on the inner edge is bordered by a large burnished gold cove, followed by a string of beading and finally a broad carved outer ovolo.

Neoclassical frames are equally scarce on Copley's oil portraits. Those most likely to be original to the pictures are the frames that house *Mrs. Humphrey Devereux*, 1770, and *Joseph Gerrish*, 1770–72, both of which have alternating plain and carved moldings. On the frames for two other contemporary portraits, *Samuel Cooper*, 1769–71, and *John Montresor*, 1771, carving has been eliminated almost entirely

in favor of broad burnished surfaces. The frame in which *Reverend Thomas Cary*, ca. 1770–73, came to the Museum of Fine Arts in Boston and which recently was installed on *Samuel Adams*, ca. 1770–72, is also Neoclassical in design: at first a black-molded piece, it was later embellished with an outer molded strip with a Neoclassical bead-and-reel design and allover gilding.

CONCLUSION

What, then, can we conclude about Copley's picture frames? First, that they were not only of the carved and gilded Rococo type that has been synonymous with the artist's name for generations. Just as the style of his paintings evolved, so did the style of his frames develop: from simple black-and-gold-molded types to progressively more elaborate and gilded forms, culminating in full Rococo pieces, accompanied by an occasional tentative exploration of the Neoclassical manner. Second, that price must have had a lot to do with the frame style chosen. The simple black frame always remained an option for clients who wished to save money. It cost about two pounds, whereas the charge for the full Rococo treatment was on the order of nine pounds— half the price of a portrait by America's greatest painter! Third, as the evidence of the woods employed reveals, the frames were, in very many cases, made right in Boston; and the carved Rococo examples of local manufacture may be judged both more handsome and more stylish than the imported ones. These original frames, which set off Copley's portraits to such good advantage, are themselves extraordinary examples of New England artistry.

It would not have been possible to write this essay without Carrie Rebora's enthusiastic interest and the generosity with which she opened her extensive files for my perusal. Across the country, museum colleagues graciously provided photographs and information about the frames on the Copleys in their care; among them I must single out for special thanks Carol Troyen and Andrew Haine, at the Museum of Fine Arts, Boston, for their help in examining every one of that institution's multitudinous Copley frames.

I have assigned frames for dated works to circa the year of that work. Thus the frame of a painting of 1764 is dated ca. 1764.

In this essay the present owners of paintings or pastels are given only if the works are not illustrated here or cited in Prown 1966.

1. "Extracts from Col. Paul Revere's Day-Book," *Massachusetts Historical Society: Proceedings of the Society*, Oct. 1870, pp. 390–91.
2. Perkins 1873, p. 8.
3. The first serious investigation of Copley's frames was Barbara M. Ward and Gerald W. R. Ward, "The Makers of Copley's Picture Frames: A Clue," *Old-Time New England* 67 (July–Dec. 1976), pp. 16–20. For a detailed technical examination of the carving of the frames and the first attribution of them to John Welch, see Luke Beckerdite, "Carving Practices in Eighteenth-Century Boston," *Old-Time New England* 72 (1987), pp. 123–62; see also Morrison H. Heckscher and Leslie Greene Bowman, *American Rococo, 1750–1775: Elegance in Ornament* (exh. cat., New York: The Metropolitan Museum of Art, 1992), pp. 137–42.
4. The list of illustrations in Prown 1966, vol. 1, pp. xv–xxiv, was taken as the basic checklist for this study. Unless otherwise noted, Prown's dating is used. From Prown's list 23 comparatives and 29 Copley miniatures have been deleted, leaving 236 known Copley oils and 45 Copley pastels; to this total 5 subsequent discoveries, 2 of which are oils and 3 pastels, have been added, so that we have a body of 286 works. Of these, 141 have been examined in person, 100 have been studied in photographs, and 45 are yet to be investigated and have been left out of the study. Of the 241 paintings included, approximately 100 have what look to be their original frames.
5. In this paper I refer to red or Scotch (Scots) pine where analysis has not distinguished between the two species.
6. For a later edition, see Allan Cunningham, *The Lives of the Most Eminent British Painters and Sculptors* (New York, 1868), vol. 4, p. 140.
7. Black-molded frames of this type also appear on portraits of Reverend and Mrs. Arthur Browne, 1757; Mrs. Metcalf Bowler, ca. 1758; and Mr. and Mrs. Thaddeus Burr, 1758–60. The same combination of moldings is used in three somewhat narrower frames that are fully gilded (though the gilding may have been added sometime after their completion), all at Harvard and certainly made en suite, encasing Copley's images of Edward Holyoke, 1759–61; his brother-in-law Nathaniel Appleton, 1759–61; and Mrs. Nathaniel Appleton, 1763. The frame for Copley's picture of Mary and Elizabeth Royall, ca. 1758 (cat. no. 10), is an unusual variant of the black-molded type.
8. The bill is transcribed in Sinclair Hitchings, "Thomas Johnston," in *Boston Prints and Printmakers, 1670–1775* (Boston, 1973), pp. 116–17.
9. Hitchings first suggested that Johnston's frames were for the Copley portraits (ibid.). A modern gilt liner has been inserted between the picture of Mrs. Savage and the frame, probably necessitated by a reduction in the size of the canvas brought about when it was trimmed and glue-lined. The frame's construction is unusual: backboards are half-lapped and double-pegged at the corners, and there are two applied moldings, the inner ovolo and the outer cavetto, the latter secured with rosehead nails to the backboards.
10. The frame on Mrs. Cumming's portrait is constructed of backboards mortised and through-tenoned together and double-pegged. The molding is nailed to the backboards (through the outer gilt edge), and the nails are clinched. There is evidence of an original central hanging device. This type of frame is found on Copley's paintings of Dorothy Murray, 1759–61, James Warren, ca. 1763, and Mrs. Joseph Calif, ca. 1764, as well as on the pictures of Mrs. Cumming and Mrs. Warren.
11. The other Copley paintings that appear to have original frames of this type are portraits of Joshua Winslow, 1755; John Bours, ca. 1770; Jacob Fowle, ca. 1761; Mrs. Metcalf Bowler, ca. 1763; Mrs. Roland Cotton, ca. 1763; Mr. and Mrs. Nathaniel Allen, 1763; Mrs. Daniel Sargent, 1763; Mr. and Mrs. Daniel Hubbard, 1764; and Mrs. Nathaniel Ellery, 1766. Variants of this kind of frame, some of which may be original to their paintings and which deserve further study, are installed on portraits of Mr. and Mrs. James Otis, ca. 1758; Mr. and Mrs. Rufus Greene, 1758–61; and Mrs. Isaac Royall, 1769–70. The frames on the Hubbard pictures tested as white pine. Microanalysis on the

other examples in the group has not yet been undertaken. The frame on the portrait of Mrs. Metcalf Bowler is the only one in the series that has corner splines.

12. The frame now has a narrow gilt liner on its inner (sight) edge, presumably necessitated by the trimming of the canvas during conservation. A contemporary replica of the portrait of Mrs. John Powell has a frame of the same model, also probably the original. Joseph Blackburn's portrait of Mrs. Nathaniel Barrell, 1761, is in a frame of this type, which proves that Copley did not have exclusive rights to the design. See William Adair, *The Frame in America, 1700–1900: A Survey of Fabrication Techniques and Styles* (Washington, D.C., 1983), p. 16, fig. 16.

13. Edwin J. Hipkiss, who was meticulous about such matters, claimed that the frames on the pictures of the Amorys were original to them (Edwin J. Hipkiss, *Eighteenth-Century American Arts: The M. and M. Karolik Collection . . .* [Cambridge, Mass., 1941], pp. 8, 10). Rebacking and regilding carried out since Hipkiss wrote have obscured the evidence he used to support his conclusion. Other original proto-Rococo frames appear on portraits of Elizabeth Wentworth, 1763, and John Gray, 1766. Worthy of further examination to determine whether they are original are the proto-Rococo frames on *Young Lady with Bird and Dog*, 1767; *Lemuel Cox*, 1770; *Mrs. Sylvester Gardiner* (*Abigail Pickman Eppes*), ca. 1772; and *Mr. and Mrs. Isaac Winslow*, 1773.

14. See Morrison H. Heckscher, "Gideon Saint: An Eighteenth-Century Carver and His Scrapbook," *Bulletin of The Metropolitan Museum of Art* 27 (Feb. 1969), pp. 299–311.

15. Illustrated in Heckscher and Bowman, *American Rococo*, no. 90.

16. Additional Rococo frames of atypical design, and probably of English origin, include examples on Copley's portraits of Mr. and Mrs. James Murray, 1768, and Samuel Savage, 1764. Others deserving further examination are installed on the portraits of George Watson, 1768, and Isaac Royall, 1769.

17. For Welch, see Mabel M. Swan, "Boston Carvers and Joiners, Part I, Pre-Revolutionary," *Antiques* 53 (Mar. 1948), pp. 198–201.

18. Copley, letter to Henry Pelham, Oct. 12, 1771, in Jones 1914, p. 166. Stephen Whiting, born 1720, advertised in 1757 that at his shop "Looking Glasses are Quick-silvered, and Pictures and Maps framed and varnished"; in 1767 he called himself a "Glassman" and "Japanner" (George Francis Dow, *The Arts and Crafts in New England, 1704–1775* [Topsfield, Mass., 1927], pp. 23, 129). Luke Beckerdite explains that carving and gilding were separate crafts in Boston in "Contrasting Traditions: The Carving and Gilding Trades in Pre-revolutionary Boston and Philadelphia," in *Gilded Wood: Conservation and History* (Madison, Conn., 1991), pp. 127–37.

19. The memorandum appears in a list of omissions in "The Late Treasurer Hancock's Acct.," ca. 1780, in the Harvard University Archives, Cambridge, Massachusetts. I am indebted to Louise Todd Ambler for bringing this reference to my attention.

20. Prown records a 1¼-inch difference in the heights of the two portraits, a discrepancy that requires further examination (Prown 1966, vol. 1, pp. 210, 235).

21. The portraits of Mr. and Mrs. Smith are shown hanging from their original brass rings in an 1855 photograph at the Yale University Art Gallery, New Haven, of the parlor of a Smith descendant's house.

22. Painting illustrated in frame in Heckscher and Bowman, *American Rococo*, no. 91.

23. These family members were Ebenezer and Mary Edwards Storer. Matching Rococo frames remain on the pastel of Ebenezer I and on both versions of the portrait of his wife. (The pastels of Ebenezer II and his wife, Elizabeth Green Storer, though now in eighteenth-century black-molded print frames with applied gilt borders, may originally have been framed en suite with the three pictures of Ebenezer I and Mary.)

24. Large versions of this anonymous Boston carver's frames are also found on portraits of Mary Oxnard Watts, 1765, and Elizabeth Ross, ca. 1767.

25. From President Holyoke's book of draft letters, Harvard University Archives, Cambridge, Massachusetts. I am indebted to Louise Todd Ambler for bringing this reference to my attention. The portrait of Hollis is illustrated in its frame in Heckscher and Bowman, *American Rococo*, p. 139, fig. 33.

26. The only other black-painted Rococo Copley frames are those on the portraits of John Spooner, 1763, and Mrs. Henry Hill, 1765–70, the latter now gilded. It has been suggested that black frames were used on portraits of sitters who were in mourning, but this theory has not been substantiated.

27. The Bowers portrait is illustrated in its frame in John Caldwell and Oswaldo Rodriguez Roque, *American Paintings in the Metropolitan Museum of Art*, vol. 1, *A Catalogue of Works by Artists Born by 1815* (New York, 1994), p. 87.

28. Henry Pelham, letter to Copley, Sept. 10, 1771, in Jones 1914, p. 155.

29. Copley, letter to Henry Pelham, Oct. 12, 1771, in Jones 1914, p. 166.

30. Painting illustrated in its frame in Heckscher and Bowman, *American Rococo*, no. 105.

31. Painting illustrated in its frame in F. Lanier Graham, *Three Centuries of American Painting . . .* (exh. cat., San Francisco: M. H. de Young Memorial Museum and California Palace of the Legion of Honor, 1971), front cover.

Catalogue

Reverend William Welsteed

1753

Mezzotint, 13⅝ x 9¾ in. (34.6 x 24.8 cm)

Museum of Fine Arts, Boston, Gift of Mrs. Frederick Lewis Gay,

1919 M 27849

This mezzotint is possibly Copley's earliest work and his only extant print. It helps to document the artistic relationship between the young Copley and his stepfather, Peter Pelham, from whom he probably learned engraving techniques. For the Welsteed print he rescraped his stepfather's engraved plate for the portrait *Reverend William Cooper* (fig. 152). Copley burnished out the head and collar in the Pelham plate and substituted the features of Welsteed; he also removed parts of the original inscriptions and replaced them.[1]

Born into a merchant family, William Welsteed was baptized in Boston in June 1696. He graduated from Harvard in 1716 but remained there to study for the ministry. Over the next decade he worked as a librarian, tutor, and teaching fellow at Harvard; among

his pupils were future governors Thomas Hutchinson of Massachusetts and Jonathan Trumbull of Connecticut. According to another of his students, Samuel Mather, Welsteed "took care not only to bring us forward in useful human Literature, but to give us Suitable Admonitions and Counsels with regard to our Spiritual State."[2] In 1728 Welsteed married Thomas Hutchinson's sister Sarah, and that same year he was ordained as minister of New Brick Church in the North End of Boston. Welsteed, who was considered progressive in his views,[3] served at New Brick for twenty-five years, until his death in 1753.

Copley's mezzotint portrait, dated the year of the minister's death, was probably issued as a memorial image. Although Copley inscribed the plate "pinx^t et fecit.," indicating that he was both the painter and engraver of the image, no oil of the subject attributable to him survives.[4]

<div align="right">K E Q</div>

1. Prown 1966, vol. 1, pp. 15–16. Copley changed the sitter's last name (Cooper to Welsteed) and age (50 to 58) and the year (1743 to 1753). He burnished out the painter's inscription ("J. Smibert Pinx."), as well as the engraver's ("P. Pelham fecit."), and added his own, "J. Copley pinx^t et fecit.," at left below the title.
2. Samuel Mather, *The Walk of the Upright* (Boston, 1753), p. 26.
3. Clifford K. Shipton, *Sibley's Harvard Graduates*, vol. 6 (Boston, 1942), p. 156.
4. A portrait of Welsteed in the collection of the Massachusetts Historical Society, Boston, was once attributed to Copley (Bayley 1915, p. 261), but Parker and Wheeler (1938, p. 238) noted that the hand was not Copley's. Prown (1966, vol. 1, p. 16) reattributed the portrait to Joseph Badger. Andrew Oliver, Ann Millspaugh Huff, and Edward W. Hanson (*Portraits in the Massachusetts Historical Society* [Boston, 1988], p. 116) simply list the artist as unknown.

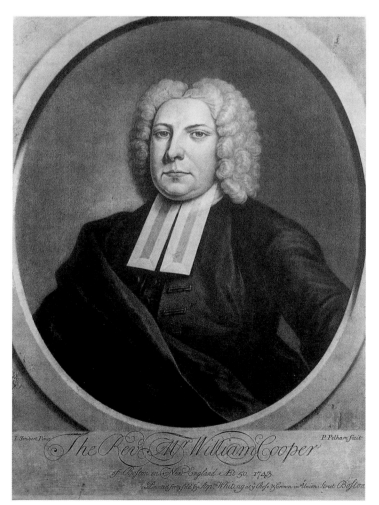

Fig. 152 Peter Pelham after John Smibert. *Reverend William Cooper*, 1743. Engraving, 13⅝ x 9¾ in. (34.6 x 24.8 cm). Yale University Art Gallery, New Haven, The Mabel Grady Garvan Collection 1946.9.199

Charles Pelham

ca. 1753–54

Oil on canvas, 36 x 28 in. (91.4 x 71.1 cm)

Private collection

Charles Pelham (1722–1793) was the second son born to Peter Pelham and his first wife, Martha, in London.[1] As a young boy Charles came to the colonies with his parents, who were settled in Boston by 1727. On May 22, 1748, his father, by then a widower, married the widow Mary Copley, mother of John Singleton Copley. Charles was thus Copley's stepbrother and the half brother of Henry Pelham, who would be born to Peter and Mary Copley Pelham.

This portrait of Charles Pelham is one of Copley's earliest surviving paintings, executed when he was just fifteen or sixteen years old. Although the technique is still undeveloped here, signs of Copley's later brilliance are already evident. Hints of the artist's

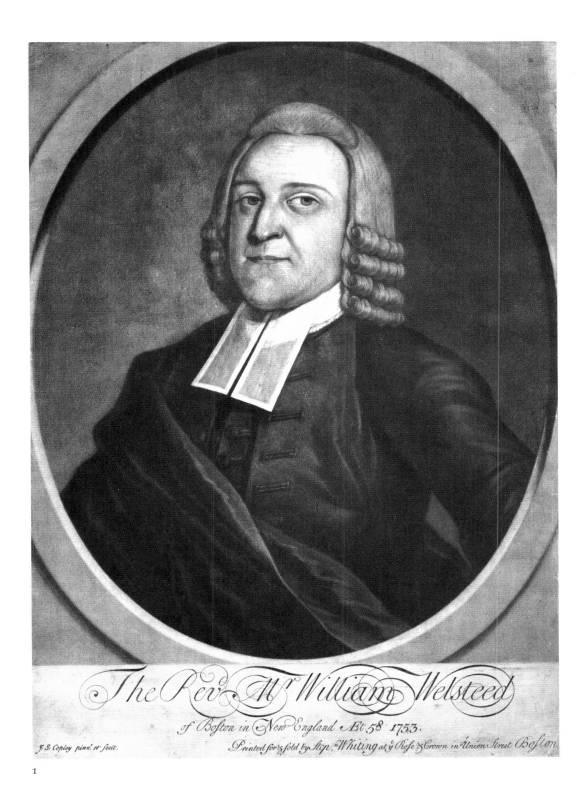

1

mature skill at replicating fabrics are present in the careful rendering of the vest and the ruffles of the linen shirt, and his fully formed abilities as a colorist are foreshadowed in his use of salmony reds and grayish browns. Moreover, Copley quite successfully rendered the sitter's right hand and the letter held in it, a difficult passage that must have been a challenge to the young painter. The still life of quill pen, inkwell, and penknife is an early example of the attributes that Copley often included in his por-

traits to indicate his sitters' professions or interests, for Charles Pelham was known not only for his penmanship but also for his writing skills. His grandfather wrote to his father in 1739, "I was mightily Pleas:d with Charles:s Prety Letter."[2]

Unlike the majority of Copley's portraits, which were commissioned by his sitters, the pictures of his family were probably painted at the artist's request, to provide him with the opportunity to improve his skills and also with samples to show to prospective

clients. (In 1765 Copley would use Henry Pelham as a model for a painting he wished to exhibit in London [cat. no. 25].)

Charles Pelham relates closely to two other portraits by Copley, one traditionally identified as a likeness of Peter Pelham (fig. 153),[3] the other *Joseph Mann*, 1754 (Museum of Fine Arts, Boston). All three pictures, in turn, reveal affinities with several portraits executed by Copley's friend John Greenwood before he left Boston for Suriname in 1752. Like Copley's canvases, the Greenwood paintings, which include *Judge Robert Brown*, 1748 (private collection), *John Langdon*, ca. 1748 (Museum of Fine Arts, Boston), and *Patrick Tracy* (fig. 154), show men sitting at cloth-covered tables.[4] Copley followed Greenwood's models very closely for *Peter Pelham(?)*. However, he enlivened *Charles Pelham* by departing from the rigid poses of his prototypes and turning his subject's body to the left while showing his head facing right; thus the picture became the first of numerous Copley portraits to feature a graceful s-curve extending from head to hands.

Copley portrayed his stepbrother, who was a merchant, school-master, and practitioner of many trades,[5] at his writing table and wearing a powdered wig and the formal dress of a gentleman; he would thereafter dignify a long line of merchants with similar dress and pose. Charles Pelham shared more than costume and pose with his stepbrother's other subjects: like so many of Copley's sitters, including Paul Revere, the Reverend Thomas Cary, Samuel Quincy, John Hancock, and Joseph Warren, he was a Mason. Established in the colonies in 1732, Freemasonry appealed to a diverse group of politically engaged and often commercially active men who liked the society's combination of secrecy, philanthropy, and conviviality as a social club. In September 1744 Charles Pelham was elected secretary of the Mason's First Lodge in Boston, replacing his father, who had resigned from that duty, and he served until at least 1754. In 1745 Charles was elected secretary of the Masters Lodge, and by 1750 he was also grand secretary of the Provincial Grand Lodge. One historian of Freemasonry remarked, "From this date [1739] to the end of the volume the entire record is in the beautiful penmanship of Peter and Charles Pelham."[6]

Pelham apparently was successful at his various occupations. In April 1765 he purchased from Reverend John Cotton his Newton, Massachusetts, homestead, which included a house, barn, and cider mill, and 103 acres of adjoining land, for £735.[7] He settled there with his wife, Mary Tyler, niece of Sir William Pepperrell, commander of the Louisburg expedition of 1745 and subject of a mezzotint by Peter Pelham. Shortly after the Pelhams moved to Newton, Charles opened a private academy in his house, where he prepared students from Boston and other towns for Harvard.[8] Mary died in 1776, and Charles married Mehetabel Gerrish in 1778.[9]

Beginning in October 1765 Charles Pelham participated in the town meetings that helped draw up patriotic resolutions in reaction to the Stamp Act and the Navigation Acts. He was in fact chairman of the committee that drafted the resolves issued in response to the tax on tea and was said to be their author. Despite these activities, Charles was suspected of Loyalist sympathies be-

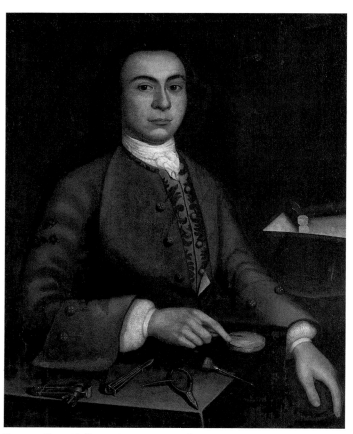

Fig. 153 *Peter Pelham (?)*, ca. 1754. Oil on canvas, 34½ x 27¾ in. (87.6 x 68.6 cm). Private collection

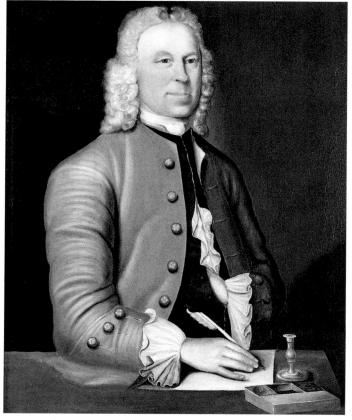

Fig. 154 John Greenwood. *Patrick Tracy*, 1754. Oil on canvas, 35⅝ x 28⅜ in. (90.4 x 72.1 cm). Massachusetts Historical Society, Boston, Gift of Dr. and Mrs. Lamar Soutter of Concord, 1986

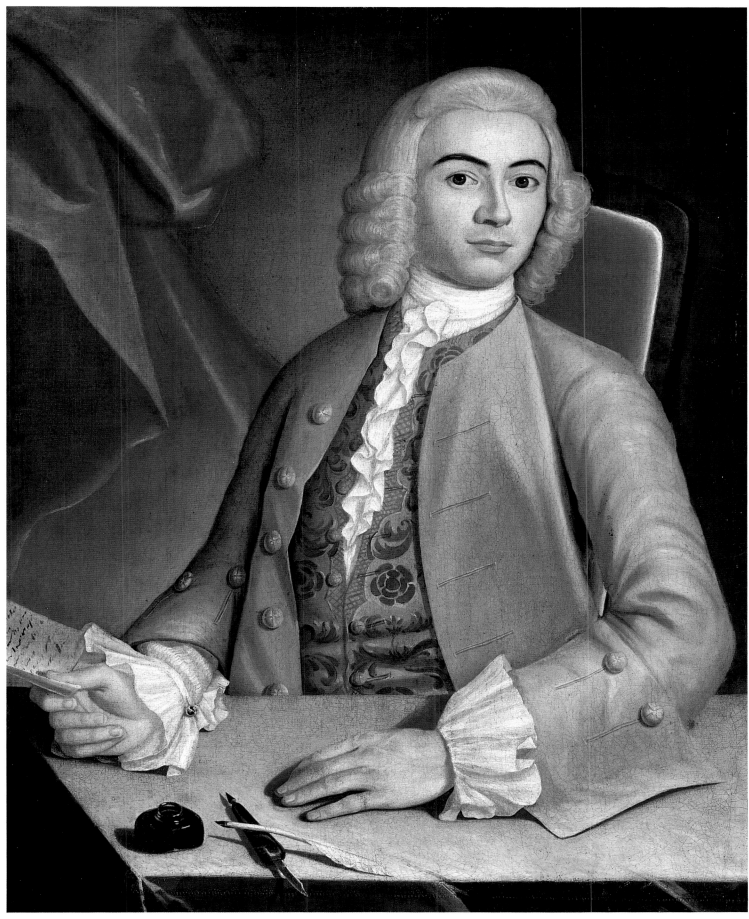

cause he was an Anglican.[10] However, he seems to have lived out his life with the respect of his neighbors, continuing to run his school and hiring laborers to work his farm. His stepmother died in 1789, and her will named as executor her "good friend Charles Pelham, of Newton." Since neither of her own sons, Copley and Henry Pelham, lived in Massachusetts at the time of her death, Charles took care of the arrangements.[11]

<div align="right">JLC</div>

1. Charles Pelham was baptized in St. Paul's, Covent Garden, on December 9, 1722 (Frederick W. Coburn, "More Notes on Peter Pelham," *Art in America* 20 [June–Aug. 1932], p. 144).

2. Peter Pelham Sr., letter to Peter Pelham Jr., Sept. 12, 1739, in Jones 1914, p. 4. I am grateful to Irene Konefal of the Conservation Department of the Museum of Fine Arts, Boston, for sharing with me her observations on Copley's early work and to Roy Perkinson, Conservator, Museum of Fine Arts, Boston, for his help in identifying the writing implements in the painting.

3. The identity of the sitter is uncertain, although it probably is a member of the Pelham family, since the painting has the same provenance as *Charles Pelham*. If it is Peter Pelham, the picture would have to have been painted posthumously and based on a previous portrait because Pelham died in 1751 and the portrait was painted in 1753; moreover, the subject appears to be quite young. It is unlikely that Charles's older brother, also named Peter (b. 1721), is the sitter, since he had moved to Virginia by September 1750. Nothing is yet known about Charles's younger brother William (1729–1761) that would connect him with the engraving tools displayed in the portrait; therefore, he cannot be identified as the sitter now, although he would have been about the age of the man depicted.

4. Alan Burroughs, *John Greenwood in America, 1745–1752* (exh. cat., Andover, Mass.: Addison Gallery of American Art, 1943), passim.

5. Some idea of the nature of Charles Pelham's varied professions can be gleaned from correspondence and advertisements. His aunt, who remained in England, wrote to her brother, "In your last you were so good as to tell my father how your sons was disposed of. . . . As Charles is brought up a merchant I flatter myself that some time or an other he will come to England" (Helena Pelham, letter to Peter Pelham Jr., Oct. 3, 1748, in Jones 1914, p. 17). Charles advertised his intention "again to open a Dancing School" (*Boston News-Letter*, Apr. 23, 1762, quoted in Melvin M. Johnson, *The Beginnings of Freemasonry in America* [New York, 1924], p. 291). And Isaac Royall, a Loyalist who had fled Medford, Massachusetts, for England, referred in a letter to "Charles Pelham, Esq., who used to do business for me" (quoted in William H. Whitmore, "The Early Painters and Engravers of New England," *Proceedings of the Massachusetts Historical Society*, ser. 1, 9 [1866–67], p. 208).

6. Johnson, *Freemasonry in America*, pp. 292, 300, 372, 233.

7. On the deed he was listed as a schoolmaster from Medford, Massachusetts (Francis Jackson, *History of the Early Settlements of Newton from 1639 to 1800* [Boston, 1854], p. 386).

8. Ibid., p. 68.

9. *Vital Records of Newton, Massachusetts, to the Year 1850* (Boston, 1905), pp. 354, 489.

10. S. F. Smith, *History of Newton, Massachusetts* (Boston, 1880), pp. 318–29; Henry Pelham, letter to Copley, May 1775, in Jones 1914, p. 316.

11. Johnson, *Freemasonry in America*, p. 291; Jackson, *Early Settlements of Newton*, p. 388.

3

The Forge of Vulcan

1754
Oil on canvas, 30 x 25 in. (76.2 x 63.5 cm)
Signed and dated lower left: John S. Copley Pinx 1754
Stanley P. Sax

The amorous exploits of Mars, Venus, and Vulcan, or Ares, Aphrodite, and Hephaistos, as described by Homer, Virgil, Ovid, Shakespeare, and other great poets, were popular subjects for artists centuries before Copley contemplated his painting career.[1] Nicholas Tardieu drew inspiration from the Greek poet Anacreon's ode 45 in his engraving of Charles-Antoine Coypel's painting of the myth (fig. 155), the source for the present work, Copley's first history painting.[2] Coypel's interpretation of the poem is almost comical: Venus acts more flirtatious than seductive as she dips arrows forged by her husband, Vulcan, into her love potion before presenting them to her paramour, Mars; Mars readily drops his spear into the hand of a mischievous putto as he approaches Venus. Unlike the episode of passion and deception that is portrayed by Van Dyck (Musée du Louvre, Paris) or the carnal em-

Fig. 155 Nicholas Tardieu after Charles-Antoine Coypel. *The Forge of Vulcan*. Engraving. Bibliothèque Nationale, Paris

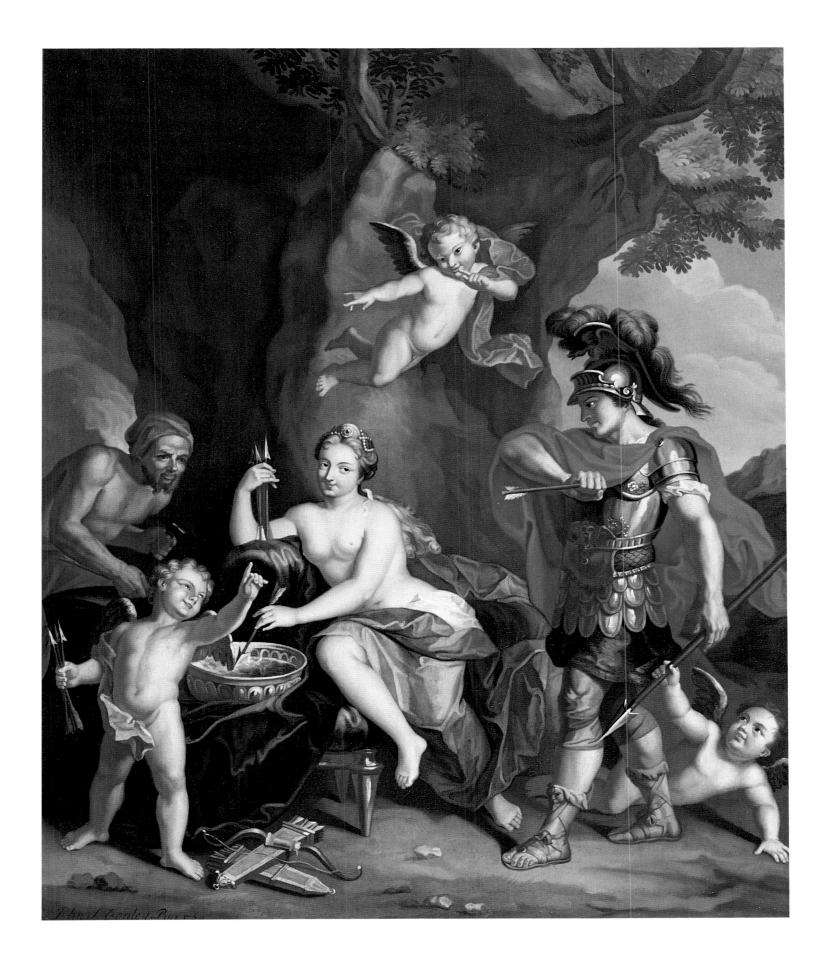

brace shown in Boucher's depiction of the myth (Wallace Collection, London), Coypel's composition is free of both intensity and ardor and offers only the slightest clues—Venus's sidelong glance, the topmost putto's giggle—that there is treachery afoot.

If he read the myth, Copley, an inquisitive and intelligent young man, may have been captivated by its themes of adultery, secrecy, and betrayal. But the youthful artist's liking for this subject matter would not entirely account for his attraction to Coypel's irreverent rendition of the story or for his selection of vivid, clear colors to enhance his dispassionate reprise of the tale. Very possibly he cared not a whit for the myth's moral lesson and sexual tension that appealed to other artists. It is, however, likely that Copley was drawn to Tardieu's print, as well as to two other engravings he copied in about 1754 (see cat. no. 4), above all by its correspondence to his idea of what he later called "a Clasick subject."[3] As Copley leafed through the mezzotints at his local printseller's shop in Boston, or perhaps those in his late stepfather's collection, in search of subjects that would test his talents and satisfy his ambition to learn the compositional manner of European history painters, Tardieu's engraving would have seemed a highly suitable choice. It gave him the opportunity to paint male and female anatomy, shiny drapery, gleaming armor, flesh, trees, rocks, sky, and furniture in the context of classical narrative. (Indeed, in 1773 Copley would commend just such an exercise, based on Coypel's work, undertaken by John Trumbull.)[4] Copley's choice of rich, vibrant colors for *The Forge of Vulcan* was perhaps also inspired by works of "Clasick subject": he may have been guided by the palettes of copies of old-master paintings left in John Smibert's studio, such as the brightly colored *Continence of Scipio* after Poussin (Bowdoin College Museum of Art, Brunswick, Maine).[5]

It is often said that Copley abandoned history painting in favor of portraiture until he went to Europe in 1774. The lessons he learned from copying Tardieu's *Forge of Vulcan* and other works on mythological themes, however, inform the portraits he painted throughout his successful and lucrative American career. By the early 1760s Copley was expert at quoting passages from mezzotints in his portraits that provided his sitters with attributes and settings that flattered them and implied their exalted social status. Soon after he completed *The Forge of Vulcan*, Copley translated Coypel's image of Venus swathed in lavish drapery, adorned with a pearl-bedecked coiffure and a ribbon cascading over her shoulder, and posed in front of a rock formation and a rugged landscape into his portrayals of Ann Tyng (cat. no. 7), Hannah Loring (fig. 47), Sarah Prince Gill (fig. 178), and other modest Bostonian goddesses.

C R

1. I am grateful to Anne W. Lowenthal for giving me a draft of her discussion of artistic depictions of the myth.
2. Jules David Prown and Peter Walch ("A Note on Copley's *Forge of Vulcan*," *Art Quarterly* 33 [1970], pp. 176–78) identify the source of Copley's painting, recommend changing the title from *Mars, Venus, and Vulcan* to *The Forge of Vulcan*, and transcribe the verses engraved on the margin of Tardieu's print.
3. Copley, letter to Henry Pelham, Mar. 14, 1775, in Jones 1914, p. 300.
4. "Among the engravings in the [Harvard] library, was one from a painting by Noel [*sic*] Coypel. . . . This I admired and copied in oil, the same size as the engraving; the forms, expressions, characters, and light and shadow were before me; the colors I managed as well as I could from my own imagination. This received so much approbation from the officers and students in college, that I ventured to show it to Mr. Copley, and had the pleasure to hear it commended by him also" (*The Autobiography of Colonel John Trumbull*, ed. Theodore Sizer [New Haven, 1953], pp. 15–16).
5. See Susan E. Wegner, "Copies and Education," in *The Legacy of James Bowdoin III* (exh. cat., Brunswick, Maine: Bowdoin College Museum of Art, 1994), p. 141; and Richard H. Saunders, "John Smibert's Italian Sojourn—Once Again," *Art Bulletin* 66 (June 1984), pp. 312–18.

4

The Return of Neptune

ca. 1754

Oil on canvas, 27½ x 44½ in. (69.9 x 113 cm)

The Metropolitan Museum of Art, New York, Gift of Mrs. Orme Wilson, in memory of her parents, Mr. and Mrs. J. Nelson Borland, 1959

59.198

In March 1775, a few months after he arrived in Rome, Copley wrote to his half brother, Henry Pelham, to tell him "in what manner an Historical composition is made . . . in that way I have found best myself to proceed." He had recently begun a painting of the Ascension (Museum of Fine Arts, Boston), and, although it was not yet complete, he felt confident that Pelham would be "glad" to have a step-by-step description of the method he adopted for historical compositions, from considering the placement of the figures, to sketching the "general Idea," to determining "the Action of each figure and the manner of wraping the Drapery," which he ac-

Fig. 156 Simon François Ravenet after Andrea Casali. *The Return of Neptune*, 1749. Mezzotint, 12½ x 20 in. (31.8 x 50.8 cm). The Metropolitan Museum of Art, New York, The Elisha Whittelsey Collection, The Elisha Whittelsey Fund, 1951 51.501.4555

complished with wet cloth and a layman. He explained that he had a model sit for the heads of Christ and the apostles, transferred sketches from tracing paper to paper and canvas, and "studied the works of Raphaiel, etc., and by that kept the fire of the Imagination alive." He guessed that Pelham would wonder, after having read "a minute detail" of his procedure, "is it good for anything?"[1] The last history paintings Pelham had seen from his half brother's brush had been painted twenty years before, in the mid-1750s, and his method of making a historical composition then had been quite different. Copley's minute detail of the proper manner of making a painting such as *The Return of Neptune* might have read: find a mezzotint of an appealing and challenging subject by an acclaimed artist and copy it precisely onto canvas in colors chosen according to your best judgment.[2]

The Return of Neptune is one of three historical works Copley painted, probably within a relatively brief period, in about 1754; they were the last compositions of this kind he executed before devoting his talents exclusively to portraiture. Like *The Forge of Vulcan* (cat. no. 3) and *Galatea* (fig. 157), the two other compositions in the group, *Neptune* is closely derived from a mezzotint. So close is the derivation that only very limited originality is involved in any of the three paintings. In fact, the degree of originality,

which presumably increased as Copley proceeded, may be the key to establishing the order in which he executed them. *Vulcan*, plausibly the first in the sequence, is a perfect reproduction of its source. *Neptune*, probably the second, is based on Simon François Ravenet's engraving after a design for a theatrical transparency by Andrea Casali (fig. 156) and differs from the print only in the absence of heavy shadows behind the figures, the clouds that have been added to the sky, and the accentuated horizon line.[3] *Galatea*, which would be the third, is thought to be a pendant to *Neptune* and certainly is related to it in subject matter; somewhat further removed from its source than the other paintings, it imitates an engraving by Augustinus after Gregorio Lazzarini's *Galatea triomphe sur l'onde* (fig. 158) but adds drapery on Galatea, removes two swimming goddesses at the far right, and changes the positions of the flying putti at the top of the composition.

From one painting to the next, only the compositions show artistic progress. No improvement in Copley's knowledge of anatomy or his understanding of light and shadow or perspective is visible; his figures, shapes, and spatial relationships match their models in his graphic sources. Thus, the recent speculation that Neptune's anatomy is more accurately portrayed than that of the mermaids because Copley had access to male but not to female

Fig. 157 *Galatea*, ca. 1754. Oil on canvas, 37 x 52 in. (94 x 132.1 cm). Museum of Fine Arts, Boston, Picture Fund 12.45

Fig. 158 Augustinus after Gregorio Lazzarini. *Galatea triomphe sur l'onde*. Mezzotint. The New York Public Library, Astor, Lenox and Tilden Foundations, General Research Division

models is fundamentally flawed, although it may contain a grain of truth.[4] Copley drew precisely what Ravenet had drawn in his own *Return of Neptune*.

Copley certainly was interested in human anatomy—two years after he painted *Vulcan*, *Neptune*, and *Galatea*, he compiled a sketchbook of anatomical parts and figures for his own reference (cat. no. 6). In these pictures, however, his main concern seems to have been the manner in which a historical composition is made. *Neptune* is a finished work of art that Copley sold from his studio,[5] yet it is primarily a technical exercise in which the young painter tested his ability to copy and learn from others much more skilled in composing complicated historical scenes. With its cast of men, women, putti, satyrs, and horses in a variety of active poses, Ravenet's *Neptune* must have challenged the youthful Copley's skills. C R

1. Copley, letter to Henry Pelham, Mar. 14, 1775, in Jones 1914, pp. 295–99.
2. Infrared reflectography examination, June 30, 1994, revealed no indication of underdrawing. Further examination suggests that Copley painted the composition without the aid of extensive, if any, graphite or chalk sketches.
3. Albert Ten Eyck Gardner identifies the source of Ravenet's engraving ("A Copley Primitive," *Bulletin of The Metropolitan Museum of Art* 20 [Apr. 1962], pp. 257–63).
4. Oswaldo Rodriguez Roque and John Caldwell, *American Paintings in the Metropolitan Museum of Art*, vol. 1, *A Catalogue of Works by Artists Born by 1815* (New York, 1994), p. 86.
5. *The Return of Neptune* was purchased in 1774 by Johnathan Simpson, about whom little is known but who must be counted among the more enlightened American art patrons of his day.

5

The Gore Children

ca. 1755

Oil on canvas, 41 x 56½ in. (104.1 x 143.5 cm)
Courtesy Winterthur Museum, Delaware 59.3408

These are four of the thirteen children born to John and Frances Pinkney Gore of Boston; exactly which ones are depicted has been a subject of some uncertainty. According to Barbara Neville Parker and Anne Bolling Wheeler, they are, from left to right, Frances, a girl who might be Elizabeth, John, and a boy who might be Samuel.[1] Jules Prown identifies the elder boy as John.[2] Charles Hammond and Stephen Wilbur believe the children to be Frances, Sarah or Elizabeth, John, and Samuel.[3] Recent genealogical evidence confirms their identities, however. The girl on the far left is indeed Frances Pinkney (1744–1788). The second girl is Elizabeth (b. 1749) and not Sarah, who was born in 1752 and would thus have been too young to be the child depicted. The boy in the center is John (1745–1771), the eldest son and the father's namesake. The fourth child is Samuel (1750–1831).[4]

The picture itself is the most ambitious of Copley's early career. The circumstances of its commission are unknown. But it seems clear that Mr. Gore, who made his living in the city primarily as a coach painter, would not have been in a position to acquire such a large portrait unless Copley had offered to paint it for a low price. Certainly the teenaged Copley took this commission as an opportunity to stretch himself artistically. It is a large, multifigured picture and includes a porch where the sitters are located, beyond the balusters of which is a landscape containing a lake, a sailboat, and a bridge. As Prown notes, the picture is "almost a résumé of American colonial painting."[5] Frances and Elizabeth are based on the seated women in both John Smibert's *Dean Berkeley and His Entourage* and Robert Feke's *Isaac Royall and Family* (figs. 159,

164). John is adapted from Feke's numerous standing-male portraits, such as his *Isaac Winslow* (fig. 228). Samuel resembles the children painted by Joseph Badger.

As in most colonial group portraits of children, dress is used here as the primary means of differentiating the figures by age and gender. The two girls on the left are costumed and posed much as an older woman would be. They wear women's bodices and are shown with a gathering basket containing roses and jasmine, trappings similar to those in Copley's portrait of the forty-year-old Rebecca Boylston (cat. no. 33). Though placing children in such a situation might make them seem mature to modern eyes, in the visual culture of the eighteenth century, it had the reverse effect: it indicated to what degree adult women were treated as immature and subordinate.[6]

The boys in Copley's picture are distinguished from the girls and from each other. Samuel, who is about five, wears a buttoned robe and petticoat to signify his inferior position. He occupies himself by petting his spaniel. His brother John, who is about ten and the eldest son, has outgrown childish dress and behavior to assume

Fig. 159 John Smibert. *Dean Berkeley and His Entourage (The Bermuda Group)*, ca. 1729–31. Oil on canvas, 69½ x 93 in. (176.5 x 236 cm). Yale University Art Gallery, New Haven, Gift of Isaac Lothrop 1808.1

171

his position as a masculine power. He gestures authoritatively to the property behind the assembled group and wears adult breeches, waistcoat, and jacket, all emblems of his passage into manhood.[7]

This picture was exhibited in 1893 at the World's Columbian Exposition in Chicago.

P S

1. Parker and Wheeler 1938, p. 86.
2. Prown 1966, vol. 1, p. 21.
3. Charles A. Hammond and Stephen A. Wilbur, *"Gay and Graceful Style": A Catalogue of Objects Associated with Christopher and Rebecca Gore* (Waltham, Mass., 1981), p. 9.
4. The family genealogy and biography is at Gore Place in Waltham, Massachusetts; it was compiled by Theodore Woodman Gore for the New England Historic Genealogical Society. Copley painted another portrait of two of the Gore daughters (private collection; Prown 1966, vol. 1, no. 30).
5. Prown 1966, vol. 1, p. 21.
6. See Karin Calvert, "Children in American Family Portraiture, 1670–1810," *William and Mary Quarterly* 39 (Jan. 1982), pp. 87–113.
7. See Ross W. Beales Jr., "In Search of the Historical Child: Miniature Adulthood and Youth in Colonial New England," *American Quarterly* 27 (Oct. 1975), pp. 378–98.

6

Book of Anatomical Drawings

1756

Graphite, chalk, and ink on paper, 17½ x 12 in. (44.5 x 30.5 cm)
Signed and dated lower left on plates II and VI: J: Singleton Copley Del: 1756; signed lower left on plates VII, VIII, IX, and X: J: Singleton Copley Dellin
Trustees of the British Museum, London

Copley's letters to Henry Pelham contain numerous references to the books and treatises that informed his efforts at self-education. Perhaps the clearest document of Copley's reliance upon books and prints, and of his considerable resourcefulness in managing his own instruction, is the series of anatomical drawings he executed and bound together in 1756 at the age of eighteen. With these drawings he made himself a textbook of sorts, a manual of human anatomy and musculature that he is thought to have kept with him throughout his career.[1]

Copley's book includes eight sheets of drawings of human anatomy, seven of which are graphite and chalk écorchés, studies of figures and body parts flayed to reveal muscles, veins, and joints. The drawings are delineated in hard and soft lines with meticulous hatching in areas of contour. In each écorché particular muscles are labeled with letters keyed to explanatory texts. Three of the sheets—studies of arms (cat. no. 6b), legs (cat. no. 6c), and torsos

(cat. no. 6d)—face text pages. On the remaining four pages—studies of a full figure from the front (cat. nos. 6a, f), side (cat. no. 6e), and rear (cat. no. 6g)—Copley incorporated the text into the drawings. The final sheet (cat. no. 6h) is an ink drawing of the Venus de Medici from the right side that is copiously annotated with measurements; it includes two inset drawings, also marked with measurements, of the statue's foot from different angles.

Jules Prown has discussed in detail and illustrated Copley's sources for each sheet and has described the alterations the fledgling artist made as he translated the work of others into a book he could profitably use.[2] The first three sheets derive from Bernardino Genga and Giovanni Maria Lancisi's *Anatomy Improv'd and Illustrated with Regard to the Uses Thereof in Designing: Not Only Laid Down from an Examen of the Bones and Muscles of the Human Body, But Also Demonstrated and Exemplified from the Most Celebrated Antique Statues in Rome* (London, 1723; first published Rome, 1691). Comparison of Copley's work to this book reveals that he used his source quite selectively even though he probably traced Genga and Lancisi's illustrations. He chose not to transcribe the plates of antique statues or those of skeletons, and he made minor improvements in the plates he did copy. For example, he reorganized figures to show six arms in a single composition rather than on six separate sheets and telescoped the accompanying texts into an easily readable chart. He translated Latin phrases into English and introduced new terms, suggesting that he used Genga and Lancisi thoughtfully and with the assistance of a friend or adviser who had expertise in medicine and anatomy.

The four sheets of full figures also testify to Copley's process of judicious selection and alteration. In these he copied the figures from Jacob Van Der Gracht's *Anatomie der wtterlicke deelen van het Menschelick Lichaem* (The Hague, 1634) but transcribed them in reverse. He placed the text for each figure in the margins of the drawing rather than following Van Der Gracht's method of segregating it on a facing page.

The prototype for Copley's drawing of the Venus di Medici, which does not appear in Genga and Lancisi, has not been identified. It must have been reproduced in another book or manual that illustrated the rather commonly held theory that antique statues portrayed ideal human proportions, for a letter of 1775 alludes to another such publication to which he had access.[3] In this letter he reminded Henry Pelham to consult "the Book of the Antique Statues publish'd with their measures." He wrote, "When you know the Mussels . . . You may sketch any figure from Idea well anough for an historical composition."[4]

Virtually any of the books on artistic theory and technique that Copley knew could have inspired the determined young artist to master human anatomy by drawing and copying. It recently has been suggested that he used Van Der Gracht because that source was recommended by William Salmon in *Polygraphice; or, The Art of Drawing, Engraving, Etching, Limning, Painting, Washing, Varnishing, Colouring, and Dying* (London, 1672).[5] Here Salmon

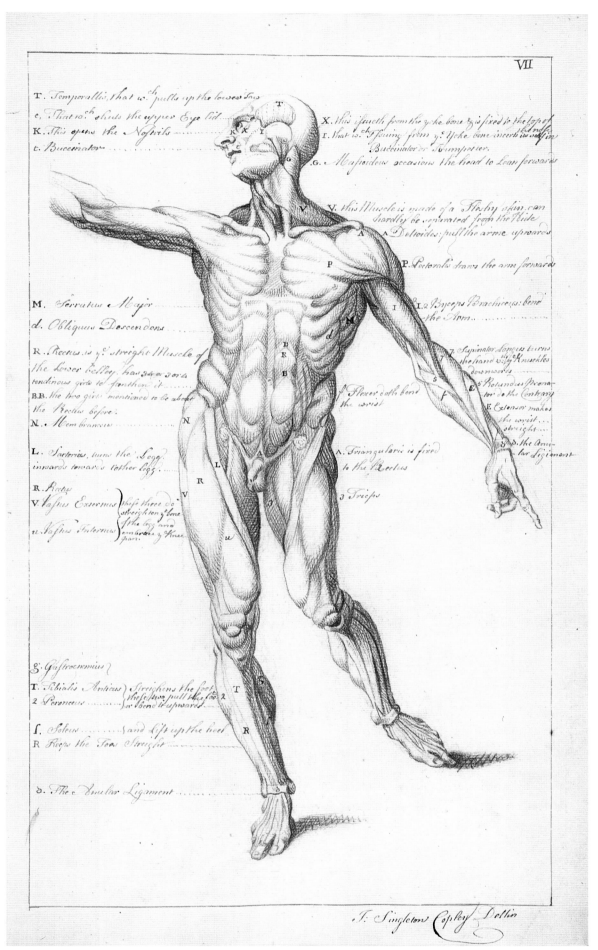

VII

T. *Temporallis, that w.ch pulls up the lower Jaw*

c. *That w.ch shuts the upper Eye lid.*

K. *This opens the Nostrils*

c. *Buccinator*

X. *This issueth from the yoke bone & is fixed to the top of*

I. *That is.ch issuing from y.e Yoke bone inserts its self in Buccinator or Trumpeter.*

G. *Mastoideus occasions the head to Lean forwards*

V. *this Muscle is made of a Fleshy skin can hardly be separated from the Hide*

A. *Deltoides pull the arme upwards*

P. *Pectoralis draws the arm forwards*

I. 2 *Byceps Brachiceus bend the Arm*

M. *Serratus Major*

d. *Obliquus Descendens*

R. *Rectus is y.e streight Muscle of the Lower belley, has 3 4 or 3 or 4 tendineous girts to fasthen it*

B.B. *the two girts mentioned to be about the Rectus before.*

N. *Membraneus*

L. *Sartorius turns the Legg inwards towards tother legg.*

R. *Rectus*

V. *Vastus Externus*

u. *Vastus Internus*

}*those three do streighten y.e bone of the legg and embrace y.e Knee pan.*

7. *Supinator Longus turns the hand with the knuckles downwards*

6. *Rotundus Pronator do the Contrary*

E. *Extensor makes the wrist streight*

f. *Flexer doth bend the wrist*

Λ. *Triangularis is fixed to the Rectus*

3 *Triceps*

δ. *the Annular Ligament*

g. *Gastrocnemius*

T. *Tibialis Anticus*

2 *Peroneus*

}*streighens the foot these two pull the toe or bend it upwards*

f. *Soleus* }*and Lift up the heel*

R. *Keeps the Toes Streight*

δ. *The Annular Ligament*

J: Singleton Copley Delin

6b

6c

6d

wrote that "in drawing the muscles of a human body" without live models, it was essential to have "very good Patterns made either of Plaster, or drawn in Pictures, enough of which are to be found in Anatomical Books, but chiefly the Book of Jacob Vander Gracht."[6] Copley's frequent references to such artistic manuals in his correspondence indicate that he considered patterns of this sort critical to his advancement as an artist. Just how Copley might have used his personal textbook of human anatomy remains a question, however.

By 1756 Copley had completed three history paintings (fig. 157; cat. nos. 3, 4), each of which included nude figures closely copied from mezzotints. If he recognized that the graphic sources he used for these paintings contained distorted anatomical forms and had gone on to devise original historical compositions, his book of drawings would have served him very well by providing him with models of properly proportioned figures. But Copley did not execute another history painting for twenty years, turning instead to the exclusive practice of portraiture. Indeed, the very year he made his sketchbook, he produced as many as seven portraits, most of them three-quarter-length likenesses, efforts that already reflect his talent and burgeoning ambition in this realm. He may have referred to the anatomical drawings as he worked on his portraits; when he was in New York in 1771, he asked Henry Pelham to send his "Drawings" to him, as he would "not be able to do long without them."[7] Yet few if any of his early portraits nor the ones that followed them take advantage of his knowledge of anatomy. Copley made himself an anatomy textbook, it seems, not as a tool he could use as a portraitist but as a resource that would serve him in a future, more exalted career as a history painter; he kept it with him as a reminder of his ultimate goal.

C R

1. Prown 1966, vol. 1, p. 19. The book was probably lot 676 in the Lyndhurst library sale of 1864 at Christie's, London. The British Museum acquired it that year, at which time the original binding was replaced with the present red leather binding.

2. Jules David Prown, "An 'Anatomy Book' by John Singleton Copley," *Art Quarterly* 26 (Spring 1963), pp. 31–46.

3. See Jonathan L. Fairbanks, "America's Measure of Mankind: Proportions and Harmonics," *Smithsonian Studies in American Art* 2 (Winter 1988), pp. 73–87; and Jonathan L. Fairbanks, "Portrait Painting in Seventeenth-Century Boston: Its History, Methods, and Materials," in *New England Begins: The Seventeenth Century* (exh. cat., Boston: Museum of Fine Arts, 1982), vol. 3, pp. 422–26.

4. Copley, letter to Henry Pelham, June 25, 1775, in Jones 1914, p. 338.

5. Elliot Davis, "Training the Eye and the Hand: Drawing Books in Nineteenth-Century America" (Ph.D. diss., Columbia University, New York, 1992), p. 24.

6. William Salmon, *Polygraphice; or, The Art of Drawing, Engraving, Etching, Limning, Painting, Washing, Varnishing, Colouring, and Dying* (London, 1672), p. 14.

7. Copley, letter to Henry Pelham, June 16, 1771, in Jones 1914, p. 117.

6e

6f

6g

6h

Ann Tyng

1756
Oil on canvas, 50 x 40¼ in. (127 x 102.2 cm)
Museum of Fine Arts, Boston, Juliana Cheney Edwards Collection
39.646

Copley painted the twenty-three-year-old Ann Tyng as a shepherdess immediately before or after her marriage in 1756 to Thomas Smelt, an army officer who fought at the Battle of Louisburg in 1745. The picture is one of the artist's first efforts at constructing an imaginary persona.

The idea of giving a sitter the attributes of a poetic shepherdess dated back to seventeenth-century England and Holland, in particular to the portraits of Peter Lely and Jan Mytens.[1] The trope passed into eighteenth-century English painting, exemplified in the work of Godfrey Kneller, Thomas Hudson, Willem Wissing, and Sir Joshua Reynolds. Some of these pictures, such as Hudson's portrait of Mary Carew (The British Museum, London), were engraved and thus may have been exported to America in the form of prints (see fig. 160).[2] The English artist Joseph Blackburn painted Mary Sylvester as a shepherdess when he was working in Boston in 1754 (fig. 161). It is possible that Copley's Ann Tyng was influenced directly by the Blackburn portrait, with regard not only to

the iconography but also to the Rococo palette that includes a peach-tinted sky and salmon-orange drapery.[3]

In Copley's version of the shepherdess trope, strange rocks and an idealized landscape remove Tyng from the temporal world, while her cascading hair and plunging décolletage declare her sexuality. At the same time she retains her claim to polite gentility, as Copley has carefully avoided endowing her with some of the most overt characteristics of the courtesan that often accompanied the role of shepherdess.[4] The delicately held crook crosses the picture plane like a bar, behind which are the visible but protected forms of a lady: creamy satins and lace cuffs speak of her class; a rustic setting and an affectionate domestic animal tell of her maternal instincts; disciplined shoulders and erect posture announce her polite training.

In eighteenth-century England patrician women played shepherdesses at masquerades, at which the inversion of classes reinscribed social hierarchies.[5] But masquerades were proscribed in

Fig. 160 James Lovelace after Thomas Hudson. *Mary Carew*, 1744. Mezzotint, 13⅞ x 11 in. (35.2 x 27.9 cm). Trustees of the British Museum, London

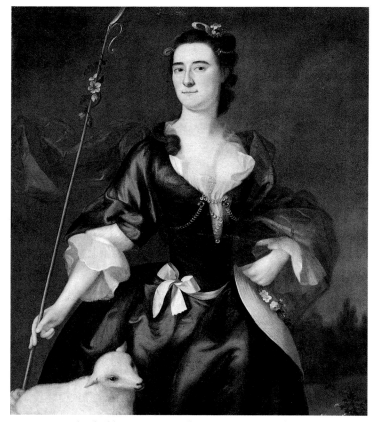

Fig. 161 Joseph Blackburn. *Mary Sylvester*, ca. 1754. Oil on canvas, 49⅞ x 40 in. (126.7 x 102.1 cm). The Metropolitan Museum of Art, New York, Gift of Sylvester Dering, 1916 16.68.2

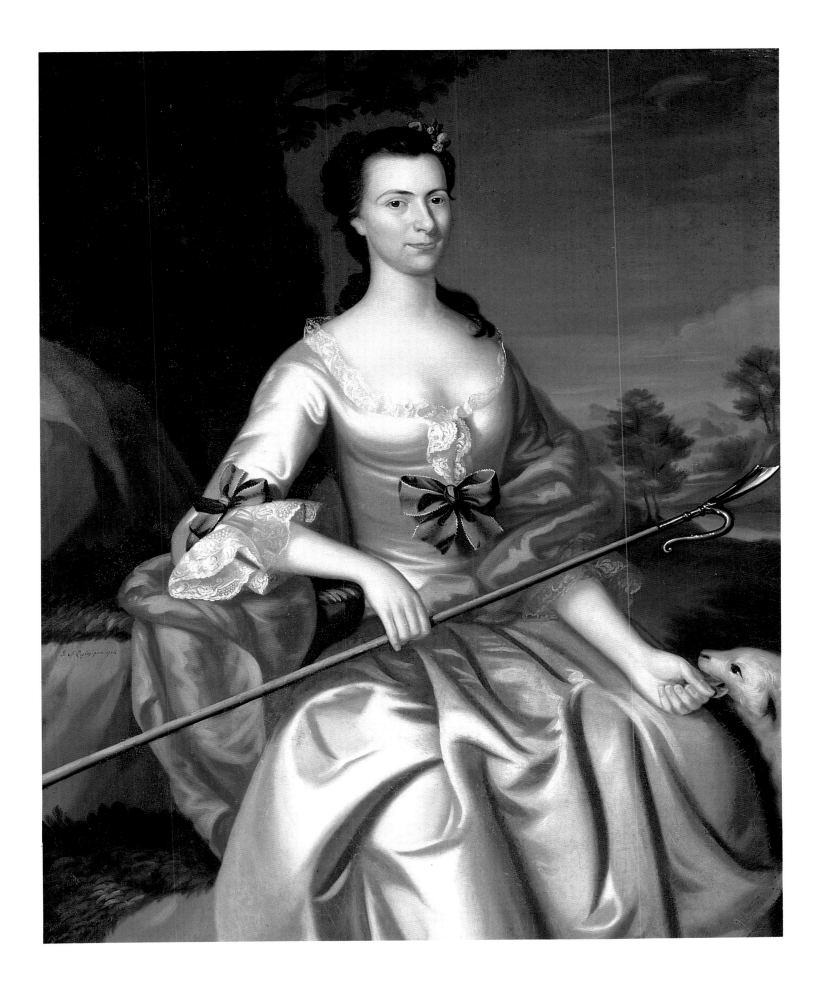

Boston as licentious activities. The only way a woman in Boston could participate in a performatory entertainment that liberated the self was emblematically, through portraits such as this one.

Ann Tyng was the daughter of Edward and Ann Waldo Tyng. Her uncle Eleazer was painted by Copley in 1772 (cat. no. 74). She died a month after her wedding.

PS

1. See Alison McNeil Kettering, *The Dutch Arcadia: Pastoral Art and Its Audience in the Golden Age* (Totowa, N.J., 1983); Aileen Ribeiro, *The Dress Worn at Masquerades in England, 1730–1790, and Its Relation to Fancy Dress in Portraiture* (New York, 1984), pp. 249–64.
2. Kneller's portrait of Lady Middleton as a shepherdess was engraved by John Faber.
3. A similar iconography, though not specific portraits, could be found in ten-stitch embroidery in eighteenth-century America; see Elizabeth Moody's embroidered pastoral of 1735 (The Metropolitan Museum of Art, New York) and the Bourne Heirloom, ca. 1750–60 (Museum of Fine Arts, Boston).
4. For example, Abraham Bloemart's shepherdesses were brazenly sexual.
5. For the sexualized shepherdess in eighteenth-century culture, see Terry Castle, *Masquerade and Civilization: The Carnivalesque in Eighteenth-Century English Culture and Fiction* (Stanford, Calif., 1986), pp. 1–51.

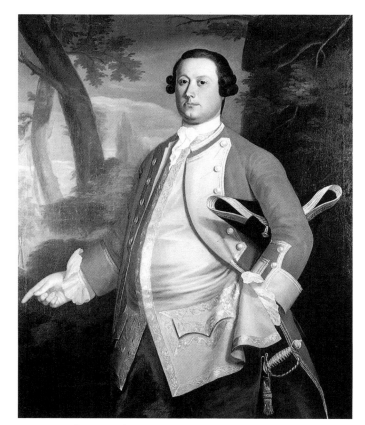

Fig. 162 *Joshua Winslow*, 1755. Oil on canvas, 50 x 40 in. (127 x 101.6 cm). Santa Barbara Museum of Art, Gift of Mrs. Sterling Morton for the Preston Morton Collection

8

Theodore Atkinson Jr.

ca. 1757–58

Oil on canvas, 49½ x 39¾ in. (125.7 x 101 cm)

Museum of Art, Rhode Island School of Design, Providence, Jesse Metcalf Fund 18.264

Theodore Atkinson Jr. was born in 1737 in Portsmouth, New Hampshire, the son of the enormously powerful and wealthy president of the Council of New Hampshire, secretary and chief justice of the colony, major general in the militia, collector of Portsmouth, sheriff, and delegate to the Albany Congress in 1754. Theodore's mother was Hannah Wentworth Atkinson, sister of Benning Wentworth, governor of the province of New Hampshire from 1741 until 1767. Because of his parents' prominence, Theodore Atkinson Jr. was ranked first in his class at Harvard College, where position was determined by social status. When his father returned to Massachusetts from the Albany Congress, Atkinson led his class to Cambridge Common to greet him.[1] The younger Atkinson graduated from Harvard in 1757 and remained in Boston for a few years thereafter, "apparently working in the warehouse of his merchant uncle, Samuel Wentworth."[2] It was probably in about 1757–58, shortly after his graduation from college, while he was living in Boston, that he sat for his contemporary Copley.

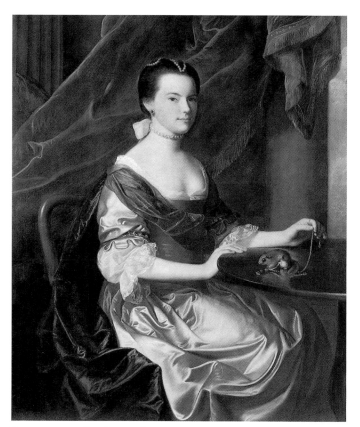

Fig. 163 *Mrs. Theodore Atkinson Jr. (Frances Deering Wentworth)*, 1765. Oil on canvas, 51 x 40 in. (129.5 x 101.6 cm). The New York Public Library, Astor, Lenox and Tilden Foundations

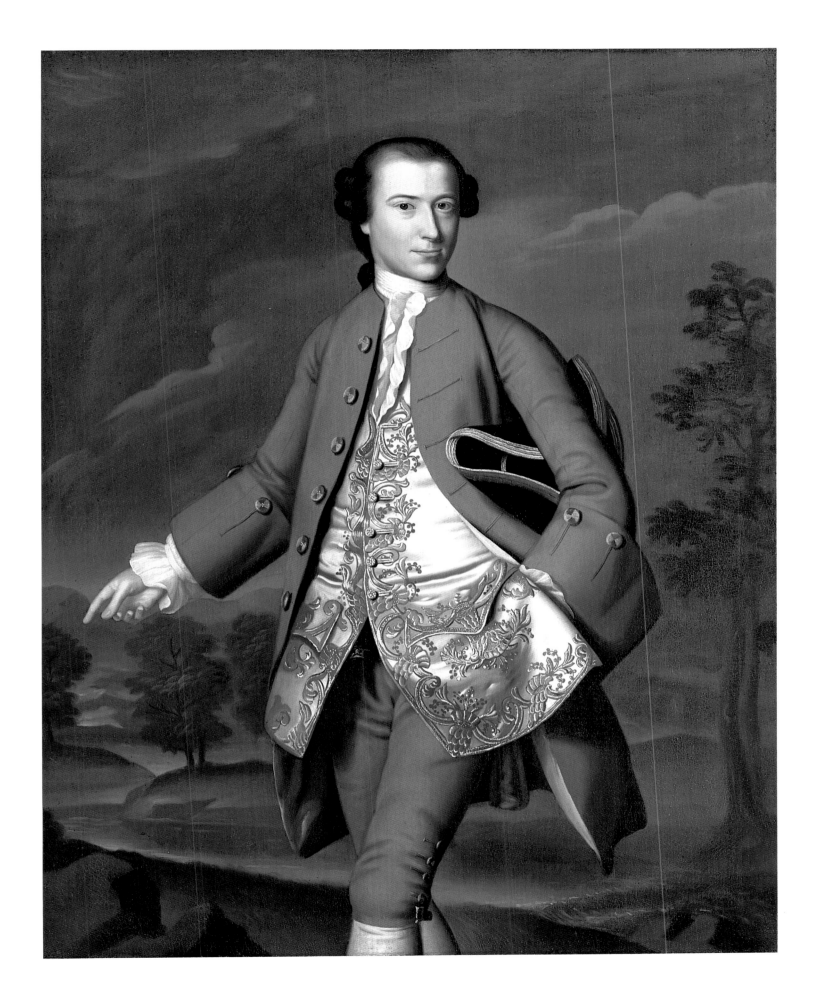

What led Atkinson, or his parents, to commission the nineteen- or twenty-year-old Copley to execute this portrait is unknown. Perhaps Copley was recommended by the Reverend Arthur Browne, rector of Queen's Chapel in Portsmouth; Copley had painted Browne's daughter Jane in 1756 (National Gallery of Art, Washington, D.C.) and both Browne and his wife in 1757 (Heritage Foundation, Deerfield, Massachusetts), and Atkinson Jr. may have encountered the portraits on a visit to Portsmouth. Or the young Atkinson might have seen Copley's handsome picture of Joshua Winslow (fig. 162) or his likeness of William Brattle (fig. 41) when the sitter was living on King Street in Boston. Whatever the circumstances of the Atkinson commission, it was an important one for Copley, for it might have led to orders for other portraits from members of the very wealthy young subject's large circle of prosperous and prominent people in both Portsmouth and Boston.[3]

Copley's portrait of Atkinson reflects the influence of Joseph Blackburn, who was active in North America from 1753 to 1763 and to whom this canvas was once attributed.[4] Blackburn arrived in Boston in 1755, when Copley was just sixteen or seventeen, bringing with him the British Rococo style. The graceful poses, light palette, and masterly renditions of silk, lace, and jewelry in Blackburn's portraits for a time beguiled the elite of Boston, Portsmouth, and Newport. Apparently, they appealed to Copley as well, for he began to enhance his compositions with elegant poses, refined gestures, and beautifully painted stuffs inspired by Blackburn's prototypes. As *Theodore Atkinson Jr.* testifies, Copley not only learned Blackburn's lessons well but also soon surpassed him as a portraitist—perhaps motivating Blackburn to move to Portsmouth by 1760. There Blackburn painted members of prominent families, including Theodore Atkinson's parents. Along with the Wentworths, the Olivers, and the Winslows, the Atkinsons patronized both Blackburn and Copley.

Copley painted Atkinson from just below the knees, striding ahead with his left leg forward. The pose is similar to the one the painter employed in *Joshua Winslow*. Like Winslow, Atkinson is turned toward his right, with his left hand hidden in his pocket, his silver-trimmed three-corner hat tucked under his arm, and his right hand pointing to the right. However, Atkinson's face is turned left, and his eyes and his lively expression engage the viewer, whereas Winslow appears detached, looking impassively toward his right. Atkinson seems more alert and active than Blackburn's sitters and the subjects of his own earlier portraits. For this reason and also because it demonstrates Copley's superior ability to replicate sumptuous materials and utilize genteel poses and opulent settings, *Theodore Atkinson Jr.* represents an important step for the artist beyond Blackburn and toward the realization of his own unmistakable mature style.

Atkinson's fashionable rose-brown coat lined with white satin that flares over tight breeches and especially his lavish ivory-colored satin waistcoat embroidered with metallic thread provided Copley with an opportunity to display his new technical facility. But these elegant trappings also serve to indicate the exalted status

of this son of an elite colonial family. To underscore the message, Copley made Atkinson a commanding figure by showing him from below, against an extensive landscape that includes a meandering stream, a waterfall, rolling hills, and the afterglow of a sunset in a cloud-filled sky—a backdrop that reminds the viewer of the sitter's vast properties in the province of New Hampshire.

During his stay in Boston after he graduated from Harvard, Atkinson grew close to his beautiful cousin Frances Deering Wentworth (1745–1813), daughter of Samuel Wentworth, who was the brother of Theodore's mother and Governor Benning Wentworth. Frances was said to be fond of both Theodore and another cousin, John Wentworth, at this time. But when John went to England for an extended period, she decided to marry Atkinson. The wedding took place on May 13, 1762, in Boston's King's Chapel, and within the next few years Frances sat for Copley (fig. 163). Though Mrs. Atkinson is seated at a shiny tea table in an interior, her likeness is probably a pendant to her husband's image—for the two pictures are the same size, and it was not uncommon for Copley to paint portrait pairs with one figure standing and the other sitting or one indoors and the other in an outdoor setting.[5] Indeed, the two paintings work well as pendants, with husband and wife turned in each other's direction, and his right hand pointing toward her and her left hand extended toward him.

After their marriage, the couple went to live in Portsmouth, where Atkinson had been appointed secretary of the province of New Hampshire. He also became a member of His Majesty's Council, collector of customs at Portsmouth, and a grantee of some fifty New Hampshire towns on both sides of the Connecticut River thanks to the power and influence of his father.[6] Theodore Atkinson Jr. was known as a generous man, for when the Reverend Ebenezer Cleaveland sought help in establishing Dartmouth College in 1762, Atkinson offered several hundred acres for the cause.[7]

Tragically, Theodore Atkinson Jr. died of consumption on October 28, 1769, at the age of thirty-three. He was buried in the family tomb in Queen's Chapel (renamed St. John's Church in 1791) in Portsmouth on November 1, while guns were fired from Castle William and Mary and from HMS *Beaver* by order of John Wentworth, who was now governor of New Hampshire. On November 11, 1769, Atkinson's widow married Governor Wentworth in Queen's Chapel. The Reverend Arthur Browne, who had conducted Theodore's funeral just ten days earlier, officiated at the wedding.[8]

Copley may have been in Portsmouth during the period between Atkinson's death and his widow's marriage to Governor Wentworth. Wentworth wrote to his kinsman Paul Wentworth on October 27, 1769, "I expect Copley here next week to take my picture which I kindly thank you for accepting."[9] According to John Wentworth's letter book, the portrait in question, a pastel (Hood Museum of Art, Dartmouth College, Hanover, New Hampshire), was sent to Paul Wentworth on January 6, 1770, and Copley made a copy of it (private collection) for the governor, which he sent to him in the spring of 1770.[10]

JLC

1. Clifford K. Shipton, *Sibley's Harvard Graduates*, vol. 14 (Boston, 1968), p. 130.

2. Ibid.

3. Among these were commissions for portraits of Atkinson's wife, his cousin Governor John Wentworth, and the Woodbury Langdons (cat. nos. 35, 36).

4. Until 1943 *Theodore Atkinson Jr.* was thought to be one of Blackburn's best works; in fact, it was used as the frontispiece for Lawrence Park's monograph *Joseph Blackburn: A Colonial Portrait Painter* (Worcester, Mass., 1923). However, at a seminar convened in conjunction with the exhibition *New England Painting, 1700–1775* held at the Worcester Art Museum in 1943, William Sawitzky argued that the "sculptural form, solidity, linear precision and marmoreal flesh tones are closer to Copley than to Blackburn's weaker formal sense and greater reliance on chromatic and tonal quality, even allowing for the influence that the precocious Copley exercised on his older English-trained colleague." Anne Allison, Charles K. Bolton, Louisa Dresser, Henry Wilder Foote, John Hill Morgan, Mrs. Haven Parker, and other experts in attendance agreed, and the portrait was assigned to Copley. See "News and Comments," *Magazine of Art* 36 (Mar. 1943), p. 115.

5. See, for example, *Mrs. John Murray*, 1763 (Worcester Art Museum, Massachusetts), and *John Murray*, ca. 1763 (New Brunswick Museum, Saint John, New Brunswick), and *Benjamin Pickman*, 1758–61 (Yale University Art Gallery, New Haven), and *Mrs. Benjamin Pickman* (fig. 73).

6. Shipton, *Sibley's Harvard Graduates*, p. 130.

7. Jere R. Daniell II, "Eleazar Wheelock and the Dartmouth College Charter," *Historical New Hampshire* 24 (Winter 1969), p. 15.

8. John Wentworth had returned to the colonies as the royal governor of New Hampshire in 1767. He lived in Portsmouth within view of the Atkinson house. According to Charles Brewster, "gossips used to say that signals from one to the other were passed" (*Rambles About Portsmouth* [Portsmouth, 1859], p. 108). The hasty nature of the Atkinson-Wentworth nuptials is perhaps explained by an entry in the parish register for Queen's Chapel that records the baptism of "John son of John and Frances Wentworth P. B." on June 9, 1770 (*Parish Register of Queen's Chapel, Portsmouth, N. H., During the Rectorship of Rev. Arthur Browne*, typescript, Portsmouth Public Library). John died during infancy (John Wentworth, *The Wentworth Genealogy* [Boston, 1878], p. 550).

9. Quoted in Lawrence Shaw Mayo, *John Wentworth, Governor of New Hampshire, 1767–1775* (Cambridge, Mass., 1921), p. 68.

10. Ibid.

9

John St. Clair

1758
Oil on copper, 1¾ x 1⅜ in. (4.5 x 3.5 cm)
Signed and dated lower right: ISC 175[?]
Historical Society of Pennsylvania, Philadelphia 1881.2

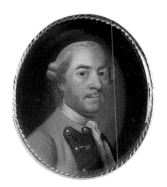

Born at an unknown date in Scotland to an aristocratic family, Sir John St. Clair joined the army as a young man and served both on the Continent and in Minorca. He was appointed deputy quartermaster general of British forces in America in 1754; the next year, with the rank of lieutenant colonel, he arrived in Virginia to prepare for General Edward Braddock's ill-fated march against the French at Fort Duquesne, later Pittsburgh. After he recovered from wounds sustained there, St. Clair was transferred to New York under the command of General William Shirley. In 1756 he was assigned to the Royal Americans, a regiment composed largely of German-speaking Pennsylvanians. St. Clair was subsequently promoted to the rank of colonel and appointed to the Forbes expedition of 1757–58.

That campaign, in which General John Forbes opened a road through Pennsylvania to Fort Duquesne, was completed in November 1758. The following month St. Clair was sent to Boston to consult with General Jeffrey Amherst, one of the heroes of Louisburg; it was St. Clair's only known trip to the city and undoubtedly the occasion of this portrait by Copley. Here the young painter carefully rendered the details of St. Clair's red and blue uniform with its metal buttons, and the ruddy cast he gave to his sitter's face reflects his active, outdoor life as well as his well-documented quick temper. Thomas Willing of Philadelphia, to whom St. Clair gave this image, reported that it was "the strongest likeness" he had ever seen.[1] At the time Copley made this miniature, he depicted several other British officers, including General William Brattle, Commissary General Joshua Winslow, and Captain George Scott, all in his more typical medium of oil on canvas and his usual three-quarter-length format. For Winslow, he also painted an oil-on-copper miniature.

After his visit to Boston, St. Clair returned to Philadelphia and in 1762 married a local lawyer's daughter. He died at his country home in New Jersey in 1767.

EEH

1. Quoted in Charles R. Hildeburn, "Sir John St. Clair, Baronet," *Pennsylvania Magazine of History and Biography* 9 (1885), p. 11. Hildeburn provides a detailed account of St. Clair's life.

Mary and Elizabeth Royall

ca. 1758

Oil on canvas, 57½ x 48 in. (146 x 121.9 cm)

Museum of Fine Arts, Boston, Julia Knight Fox Fund, 1925 25.49

Mary MacIntosh (1745–1786) and Elizabeth (1747–1775) were the daughters of Isaac Royall of Medford, Massachusetts, one of the wealthiest merchants in New England. At age twenty-two, in 1741, he had his young family painted by Robert Feke (fig. 164). The young child in the center of the picture, flanked by her aunt Mary Palmer and mother, Elizabeth MacIntosh Royall, was also named Elizabeth. But she is not the Elizabeth whom Copley painted. Family records show that Feke's subject died in 1742. The Royalls' third daughter, Copley's subject, was born in 1747.

Royall inherited a fortune from his father, who had traded with and for a while lived in the West Indies. The younger Royall also was heir to his father's grand Georgian-style home in Medford (fig. 165) and beginning in 1747 redesigned its west facade. The home, where Copley's picture of the Royall sisters, the Feke portrait, and two other paintings by Copley probably hung until 1776, was the site of Royall's lavish parties. "He loved to give," wrote one historian, "and loved to speak of it, and loved the reputation of it. Hospitality, too, was almost a passion with him. No

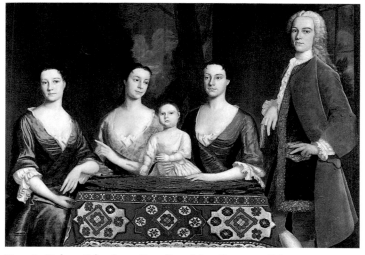

Fig. 164 Robert Feke. *Isaac Royall and Family*, 1741. Oil on canvas, 56¼ x 77¾ in. (142.9 x 197.5 cm). Harvard Law Art Collection, Cambridge, Massachusetts, Gift of Dr. George Stevens Jones, March 31, 1879

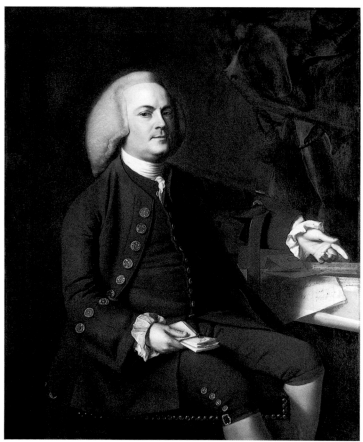

Fig. 166 *Isaac Royall*, 1769. Oil on canvas, 50¼ x 40 in. (127.6 x 101.6 cm). Museum of Fine Arts, Boston, M. and M. Karolik Collection of Eighteenth Century American Arts 39.247

Fig. 165 Royall House, Medford, Massachusetts

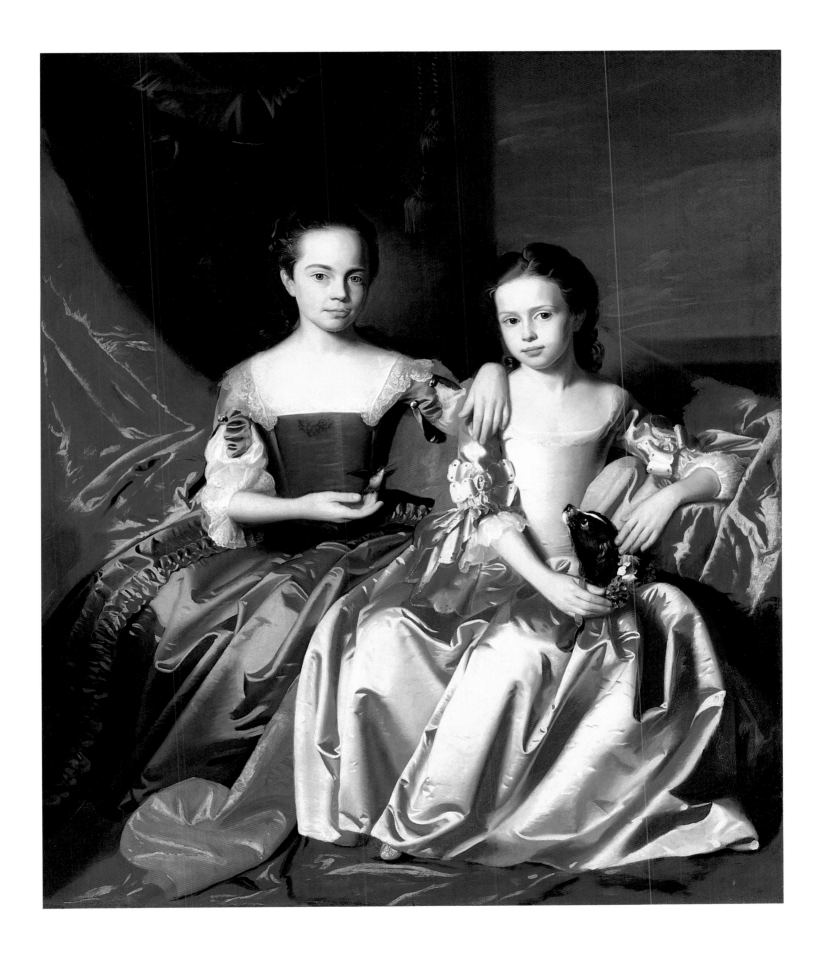

house in the Colony was more open to friends; no gentleman gave better dinners, or drank costlier wines."[1]

Royall's materialism is evident in Copley's portrait of his daughters. The two girls are so enveloped in yards of expensive silk fabric imported from England that the furniture on which they sit is barely suggested. The setting, too, is indistinct, for a deep red, agitated curtain blocks off most of the background, except for a patch of sky behind Elizabeth's head. The lavishly dressed girls wear satin and lace, and their sleeves are in the revived Vandyke style fashionable in England. The hummingbird, which may have been imported from the West Indies on one of their father's boats, is fluttering its wings as it stands on the fingertips of Mary's right hand. It is not meant to be read as a wild creature but, like the dog at Elizabeth's side, is domesticated, an apparent reference to Mary's skills as a polite, disciplined young lady.

This picture, the largest of Copley's early works, is the first evidence of his mature style. It bears some resemblance to Feke's *Royall Family*, especially in the vocabulary of gesture, the additive, lateral positioning of figures, and the nonhierarchical focus. But it has a brilliance of color and fluency of forms that no previous colonial artist had achieved. Moreover, Copley, who rarely painted children, explored the nature of the relationship between the two sisters. Though nothing is known of the girls' personalities, from the evidence of Copley's portrayal it would seem that Mary played the part of the protective older sister: her left hand proprietarily rests on Elizabeth's shoulder, and her right hand, while holding the bird, gestures toward the smaller and prettier child. Elizabeth is the center of all attention, both psychological and compositional. She is pressed forward, in front of Mary. The dog admires her from the side, and a network of arm and hand gestures converges at her head.

Isaac Royall hired Copley again, in about 1769, to paint portraits of himself (fig. 166) and his wife (Virginia Museum of Fine Arts, Richmond).

Mary, who was also known as Polly, married George Erving in 1775. They fled to Halifax during the Revolution and then immigrated, along with Isaac Royall, to England. Elizabeth married William Pepperrell, the son of Nathaniel Sparhawk, in 1767, and they lived first in Boston and then in Roxbury. She died of dysentery in 1775. William, an avid Loyalist, claimed that Boston's boycott of British goods forced the family to eat salt provisions at a time when Elizabeth was nursing their fourth child, causing his wife's death.[2] He and the children sailed for England in 1776. There in 1778 Copley painted the Pepperrells, including Elizabeth in the picture posthumously.

<div align="right">P S</div>

1. Lorenzo Sabine, *Biographical Sketches of Loyalists of the American Revolution* (Boston, 1864), vol. 2, p. 241.
2. Clifford K. Shipton, *Sibley's Harvard Graduates*, vol. 16 (Boston, 1972), p. 401.

11

Epes Sargent

ca. 1760
Oil on canvas, 49⅞ x 40 in. (126.6 x 101.7 cm)
National Gallery of Art, Washington, D. C., Gift of the Avalon Foundation 1959.4.1

In Kenneth Roberts's novel *Northwest Passage* of 1937, which re-creates events of the 1760s, the sight of a portrait "of an elderly gentleman with small, laughing blue eyes and white wig from which a drift of white powder had fallen on the shoulder of his drab broadcloth coat" on an easel in Copley's studio leaves Langdon Towne awestruck. Towne has just returned to Boston after an absence of four years, during which Copley had become well known, moved to Beacon Hill, and started to display "an even livelier taste" in clothing and a "more elegantly dressed" hairstyle than he had previously affected. For Towne, however, the most compelling proof of the artist's success is the portrait, which is *Epes Sargent*; even "in the cold north light of his studio" it seems to bring the old man to life: "He was leaning carelessly on a piece of stone-work, and his hand rested flat against the front of his coat. It was a gnarled and puffy hand—the hand of a man who had spent his days on the seacoast of New England—in Salem, perhaps, or Gloucester or Newburyport. . . . 'You never learned this of Blackburn [a rival portraitist]. What's Blackburn have to say?' Copley looked solemn. 'He said he didn't like 'em! They seemed to make him angry. He's left Boston—gone I don't know where.' 'I don't wonder,' [Towne] said. 'He knew he'd seen a miracle.'"[1]

Fig. 167 Marcantonio Raimondi after Raphael. *Force*, ca. 1525. Mezzotint. 8⅝ x 4¼ in. (21.9 x 10.8 cm). The Metropolitan Museum of Art, New York, Harris Brisbane Dick Fund, 1926 26.50.1(71)

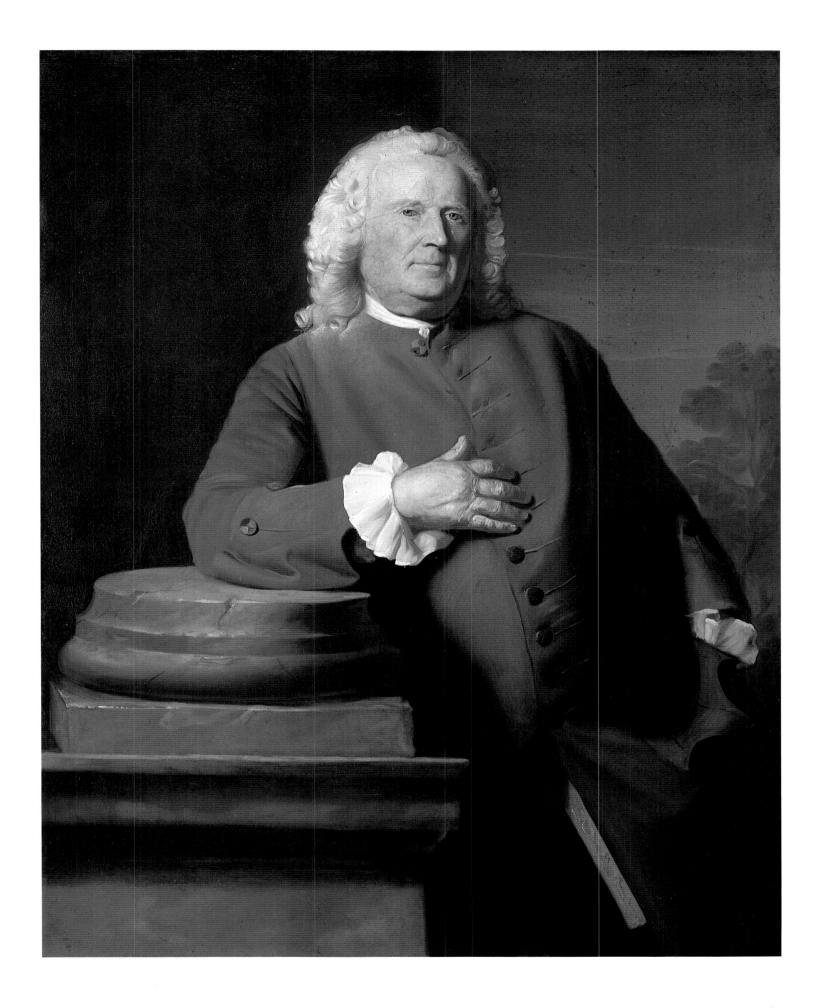

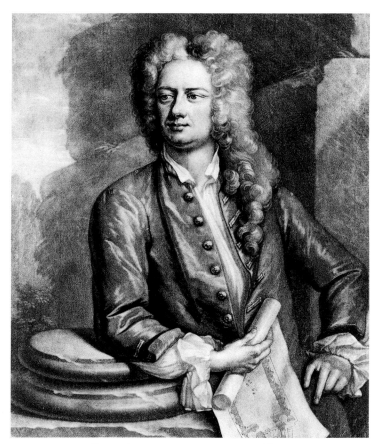

Fig. 168 Peter Pelham after Hans Hysing. *James Gibbs*, ca. 1726. Mezzotint, 13⅞ x 9⅞ in. (35.2 x 25.1 cm). The Metropolitan Museum of Art, New York, Gift of Estate of Ogden Codman, 1951 51.644.480

Although Roberts altered historical facts and manufactured dialogue for the sake of creating a good story, his protagonist's assessment of *Epes Sargent* as "a miracle" must be a fairly accurate reflection of the opinions of colonial Bostonians, who applauded Copley's swift and astounding coming of age as a portraitist. In less than five years from the time he began his professional career in the mid-1750s, Copley emerged as an extremely competitive painter of powerful originality and high accomplishment. Thus, *Joshua Winslow*, 1755 (fig. 162) and *Jonathan Belcher*, 1756 (Beaverbrook Art Gallery, Fredericton, New Brunswick), are the products of a derivative artist who is still experimenting with a variety of sources, but *Epes Sargent* already bears the mark of a mature and unique hand.

In 1760, at approximately the time this portrait was painted, Epes Sargent was seventy years of age, a resident of Salem and owner of nearly half the town of Gloucester, where he had been raised. The son of William and Mary Duncan Sargent, he became a successful merchant and shipowner like his father. In 1720, when he was appointed justice of the peace, he married Esther MacCarty (or MacCarthy), who bore ten children before she died in 1743. That year Sargent received a colonel's commission from George II just before King George's War broke out. The next year he married his third cousin Catherine Winthrop, the well-to-do widow of

Samuel Browne of Salem, and moved into Browne's house, the finest and largest mansion in the town. This second union would produce five more children. A highly respected, industrious, and well-liked man, Sargent was a devoted father who exerted a positive influence on his fifteen children, many of whom would excel in law, medicine, commerce, and the arts.

Sargent's portrait is unlike any other that Copley had yet painted. Here Copley dispensed with his usual iconography, the luxurious attributes of his sitters' rich public and lavish personal lives, in favor of a subdued palette and plain props that speak of his subject as elderly, distinguished, and modest. The painter showed Sargent leaning against a truncated column in an outdoor setting. His right elbow casually rests on the torus of the shaftless column, which in turn stands on a square pedestal. The variegated gray stone of the architectural element harmonizes with Sargent's gray-green coat and the neutral green and brown landscape background, constituting a setting of warm tones that gently frame his head and hand. Copley made Sargent's left hand an invisible participant in the composition, its presence marked by a turned-up ruffled cuff and the disturbance that pushes the coat's left pocket flap up and forward toward the picture plane. Sargent's right hand, near the center of the composition, is the most prominent element of the composition and rests lightly on his massive chest. Fleshy, swollen, and chapped, it is the hand of a merchant who takes an active interest in his ships and cargo. Copley described the rough texture and mottled color of its skin with a close range of pink, gray, and blue hues and paint applied in measured impasto strokes; the colors and texture stand out in contrast to the smooth white paint of the ruffled cuff that is thrown back against the coat sleeve to fully expose the back and fingers of the hand. This is the hand that inspired Gilbert Stuart's oft-quoted remark, "Prick that hand, and blood will spurt out."[2] Four of Sargent's fingers arch downward, and the thumb curves up in the direction of the face, which is soft and large, smooth, and pink, with a double chin and a sharp nose and clear blue eyes. His wig is of the rather modest natural style, featuring ringlets swept off the face, and powdered white; some excess talc is sprinkled on his shoulder. The fashionable yet practical broadcloth coat, whether chosen by Sargent himself or by the painter as appropriate to his interpretation of the subject, has silk-thread-covered buttons rather than the gold ones that shine in most Copley portraits. Only the gold embroidered edge of the waistcoat that is revealed as if by accident at the lower opening of the coat betrays Sargent's appreciation for a bit of embellishment. (That Sargent's taste was in reality for high-style costume is confirmed by his probate inventory, which lists a scarlet coat, a "red gold laced" waistcoat, and a black velvet waistcoat, and many other pieces of rather fancy clothing as well as accessories such as eleven wigs, a silver watch, and a "Gold Laced Hatt"—along with "1 Drab Great Coat.")[3] In any event, the understated clothing depicted here helps convey an image of well-being rather than grandeur, elegance without ostentation, and gentility without aristocratic pretension.

The choice of pose may have been derived from illustrations of Samson or the personification of *Force* (fig. 167), two figures usually shown with a partial column. Another possible prototype is the portrait of the architect James Gibbs by Hans Hysing that was engraved by Copley's stepfather, Peter Pelham, in about 1726 (fig. 168).[4] The stance as adopted for Sargent conveys worldliness, confidence, and self-assurance. The relaxed pose, the nonchalance of which is enhanced by the hand in the pocket, is disciplined yet easy, just the type of attitude Lord Chesterfield advised his son to assume: "The man of fashion is easy in every position . . . he leans with elegance . . . [and] need not . . . fear to put his hands in his pockets, take snuff, sit, stand, or occasionally walk about the room."[5]

In 1761 Sargent represented Gloucester in the Great and General Court and Assembly, a position of honor; this appointment might have occasioned the portrait and argues for dating it to that year. However, the painting commemorates nothing specific about his life. For this reason it seems more likely that Sargent commissioned the image as a record of his manner, circumstances, and character for posterity, perhaps at the urging of his children, three of whom—his daughter Sarah (fig. 46), his namesake, and that son's wife (cat. nos. 16, 17)—also sat for Copley. This portrait may be the "1 Picture" cited on the first line of Sargent's probate inventory taken within a year of his death in 1762; its worth was assessed at £13.6.8, precisely the same value given to the second-to-last item on the list, "1 Shomakers Shop."[6] CR

1. Kenneth Roberts, *Northwest Passage* (New York, 1937), pp. 447–49.
2. Stuart, quoted in S. G. W. Benjamin, *Art in America* (New York, 1879), p. 20.
3. Epes Sargent, Probate inventory, Nov. 10, 1763, Essex County, Docket no. 24610, Archives, Supreme Judicial Court, Boston.
4. See Roland E. Fleischer, "Emblems and Colonial American Painting," *American Art Journal* 20, no. 3 (1988), pp. 31–32.
5. Lord Chesterfield [Philip Dormer Stanhope], *Principles of Politeness and of Knowing the World* (Portsmouth, 1786), p. 23.
6. Epes Sargent I, Probate inventory, Nov. 10, 1763, Essex County, Docket no. 24610, Archives, Supreme Judicial Court, Boston.

12

Mrs. Samuel Quincy (Hannah Hill)

ca. 1761
Oil on canvas, 35½ x 28¼ in. (90.2 x 71.7 cm)
Museum of Fine Arts, Boston, Bequest of Miss Grace W. Treadwell
1970.357

Hannah Hill Quincy (1734–1782) was the daughter of Hannah Cushing Hill and of Thomas Hill, a successful Boston distiller and landowner whose business provided his family with considerable financial security and social prominence. Little is known of her upbringing; it is clear, however, that she grew up in an intellectually ambitious household—her father was a subscriber to Prince's *Chronological History of New England,* and her brother Henry was sent to Harvard, where, in recognition of the family's social status, he was ranked tenth in his class. Youthful exposure to contemporary literature may account for her styling herself "Sophia" or "Sophy" as an adult.[1] Her portrait by Copley was probably painted on the occasion of her marriage, in 1761, to Samuel Quincy (1735–1789), third in his Harvard class and one of the cleverest lawyers in Boston.

Although Samuel Quincy was considered by his contemporaries to be preoccupied more by social matters than by professional ambitions,[2] he built a reasonably prosperous law practice, served as solicitor general, and was admired for his keen legal mind. The couple lived on fashionable South Street until 1771, when they sold their fine house to Thomas Hutchinson and built an even grander residence on Hanover Street. During this period they had several children (at least two sons and one daughter are known to have survived infancy). Quincy's political sympathies were initially Whig, like those of the rest of his and his wife's families; he dined with the Sons of Liberty and represented the town of Boston against the accused British soldiers in the celebrated Boston Massacre case of 1770. But as political tensions mounted, Samuel Quincy increasingly began to travel in the company of Loyalists. In opposition to her husband's allegiances, Hannah Quincy remained staunchly Whig. In May of 1775, when Samuel left Massachusetts for England, Hannah elected to remain in America and with her children sought refuge in her brother's home in Cambridge. Quincy's poignant letters to her, written from England during the Revolution, indicate the deep affection and equally deep disagreement between them. His letter of New Year's Day, 1777, reads, "The continuance of our unhappy separation has something in it so unexpected, so unprecedented, so complicated with evil, and misfortune, it has become almost too burdensome for my spirits."[3]

The Quincys' private life was apparently as complicated as were their political positions. She was known for having a fondness for social engagements, and in fact the Quincy family would later claim (without much substantiation) that Hannah's aspirations, more than her husband's, led to his downfall: "The social privileges which surrounded the British officials were held to have had an attraction for Mrs. Quincy that she was able to communicate to her husband."[4] Yet Samuel was, if anything, more socially ambitious than his wife. During his Harvard days he had been known as an "easy, social and benevolent Companion, not without Genius, Elegance and Taste."[5] This reputation persisted even after his marriage—he is mentioned frequently in the diary of that inveterate diner-out John Rowe as a participant in the gayest of festivities.[6] This is the side of Quincy's character that Copley captured in his portrait of about 1767 (fig. 169), which shows him in his lawyer's robe and wig but makes clear by his casual pose and debonair expression that he was a man of urbanity, style, and charm.

Fig. 169 *Samuel Quincy*, ca. 1767. Oil on canvas, 35 ½ x 28 ¼ in. (90.2 x 71.7 cm). Museum of Fine Arts, Boston, Gift of Miss Grace W. Treadwell 1970.356

Fig. 170 Peter Paul Rubens. *Helena Fourment*, ca. 1620. Oil on canvas, 73 ¼ x 33 ½ in. (186 x 85 cm). Museu Calouste Gulbenkian, Lisbon

John Adams wondered whether Quincy's "love of pomp and gaiety and other social extravagancies," more than any hoped-for professional advantage, might not have led Quincy to "sacrifice his principles."[7] Yet Quincy's pleasure-seeking nature was tempered by a puritan streak. A few years before his marriage, he wrote an essay on women, denouncing their want of modesty, their "Indecencies of Dress . . . Manners, and Behaviour" and their "immodest, masculine Air; that creates rather Aversion than Esteem."[8] These conflicting attitudes may well be reflected in Copley's portrait of Hannah Hill Quincy; it is not unreasonable to suppose that Quincy commissioned the portrait at the time of their marriage and had a voice in its design. His wife's views and whether they left their mark on the picture are unknown. As has often been noted, she is shown in the guise of Rubens's famous portrait *Helena Fourment* (fig. 170). Pose, hat, and features of Mrs. Quincy's dress were all borrowed from that image, which entered a prominent British collection in 1730 and touched off a frenzy for such costume portraits. Copley presumably knew of these British emulations of the Rubens painting from prints, such as *Miss Hudson*, ca. 1740s, by John Faber after Thomas Hudson (fig. 90); he may also have been exposed to the fashion for such romantic portraiture through Joseph Blackburn, who produced a modest version of this conceit in his painting of Hannah Babcock (Worcester Art Museum, Massachusetts) in 1759.[9]

It is likely that Mrs. Quincy enjoyed both the historic allusions of her painted costume and the affiliation with up-to-the-

moment British taste that it granted her. Such costumes were especially popular at masquerades and other public entertainments in London, and being portrayed in historic fancy dress had great romantic appeal in England, though the fashion was little known in Boston.[10] Mrs. Quincy's costume is rich and sensuous. With its low, square bodice and satin stomacher, its wide sleeves pulled back with gold chains, and its blue sash giving the effect of a high waist, it appears all the more exotic and alluring for the obvious derivation from the Rubens portrait. Mrs. Quincy is thus flatteringly presented as a woman situated at the vanguard of taste. With her reputed love of social engagements, she must have shared her man-about-town husband's pleasure in being associated with the entertainments at which such romantic, and sometimes revealing, costumes were often worn. On the other hand, Samuel Quincy's professed taste for the virginal (as well as traditional New England propriety) would have approved the custom of augmenting portraits done in historic dress with elements of contemporary attire, frequently the sitter's own lace and jewelry. Hence Hannah's lace cape is secured with an elegant brooch to cover up her deep décolletage, and the racy plume held by Helena Fourment is replaced by a sprig of larkspur, a flower that signified "ardent attachment."[11]

C T

1. The name's allusion to wisdom made Sophia a popular alias among intellectual women in the mid- and late eighteenth century. The name was also chosen by Henry Fielding for the virtuous heroine in his popular novel of 1749, *Tom Jones*.

2. In his diaries for the summer of 1759, John Adams left a draft of a letter to Quincy concerning legal studies and expressing admiration for Quincy's talents. Following the letter are some jottings that suggest Adams's private assessment of Quincy's character: "Cards, Fiddles, and Girls, are the objects of Sam. Cards, Fiddles and Girls. Kissing, fidling and gaming. A flute, a Girl, and a Pack of Cards" (*Diary and Autobiography of John Adams*, ed. Lyman H. Butterfield [Cambridge, Mass., 1961], vol. 1, p. 109).

3. Quoted in James H. Stark, *The Loyalists of Massachusetts* (Boston, 1910), pp. 369–70. Although most accounts of the Quincys' lives claim that Hannah died without seeing her husband again, a letter of 1782 from Samuel to her brother, describing her death in his arms, testifies to their brief reunion. See Samuel Quincy, letter to "My dear Brother" [presumably Henry Hill], Nov. 20, 1782, Samuel Quincy Papers, Massachusetts Historical Society, Boston.

4. "Remarks by Mr. Josiah Quincy," *Proceedings of the Massachusetts Historical Society* 19 (Jan. 1882), p. 213.

5. *Diary and Autobiography of Adams*, vol. 3, p. 261.

6. Rowe mentions Quincy as a companion on a sleighing party, at Harvard's commencement celebrations, at numerous dinners, and at meetings of various fraternal organizations. See *Letters and Diary of John Rowe, Boston Merchant*, ed. Anne Rowe Cunningham (Boston, 1903), pp. 37, 43, 72, 122, 125, 230.

7. Quoted in E. Alfred Jones, *The Loyalists of Massachusetts* (London, 1930), p. 242.

8. Samuel Quincy, letter to Robert Treat Paine, Feb. 2, 1756, R. T. Paine Papers, Massachusetts Historical Society, Boston, quoted in Clifford K. Shipton, *Sibley's Harvard Graduates*, vol. 13 (Boston, 1965), p. 479.

9. For a discussion of Copley's use of the costume and pose of "Rubens's wife," see Louisa Dresser, "Copley's Receipt for Payment for the Por-

traits of Mr. and Mrs. Samuel Phillips Savage with a Note on Blackburn's Portrait of Hannah Babcock," *Worcester Art Museum Annual* 9 (1961), pp. 36–38; and "Mrs. Samuel Quincy," in Carol Troyen, *The Boston Tradition: American Paintings from the Museum of Fine Arts, Boston* (exh. cat., Boston: Museum of Fine Arts; New York: American Federation of Arts, 1980), pp. 60–62.

10. See Aileen Ribeiro, "Some Evidence of the Influence of the Dress of the Seventeenth Century on Costume in Eighteenth-Century Female Portraiture," *Burlington Magazine* 119 (Dec. 1977), pp. 834–40.

11. See Ernst Lehner and Johanna Lehner, *Folklore and Symbolism of Flowers, Plants, and Trees* (New York, 1960), p. 119.

13

Mrs. Gawen Brown (Elizabeth Byles)

1763
Pastel on paper mounted on canvas, 17½ x 14½ in. (44.5 x 36.8 cm)
Signed and dated right center: ISC [monogram] del. 1763
Museum of Fine Arts, Houston; The Bayou Bend Collection, gift of Miss Ima Hogg B.54.21

In 1763 Copley derived a number of portraits from mezzotints. Most are remarkably close to their print sources, showing little or nothing original in their compositions, costumes, or poses— *Mrs. Nathaniel Allen* (fig. 46) and *Mrs. John Murray* (Worcester Art Museum, Massachusetts) are typical examples. *Maria, Countess of Coventy* by Thomas Frye (fig. 171) inspired two portrayals of Mrs. Gawen Brown that Copley executed about 1763, this pastel and an oil (fig. 172); one is much less derivative than the other, however, not only suggesting the order in which they were executed but also revealing the evolution of Copley's conception and working method over a short period of time. It is assumed that Copley first rendered Mrs. Brown's likeness in the pastel.[1] One of his earliest experiments in this medium, it is expertly executed in deft strokes of crayon that achieve an effect of refinement and grace. The picture is not a slavish copy of its source; Copley simplified Frye's pearl headdress and drop earrings and replaced the lacy train of the veil in the mezzotint with a thick, shiny braid of hair; moreover, Mrs. Brown's eyes engage her spectator, but the countess gazes off to the side. Copley moved Mrs. Brown's image in the oil portrait even further away from its source, replacing her ermine-trimmed robe with a lace-edged cape that ties at the neck in a ribbon bow. The pearls have disappeared from her hair, and her hands are no longer included in the composition. In the translation from pastel to paint, Copley took Mrs. Brown from countess to commoner, from a fancily bejeweled apparition to a smartly beribboned woman.

Elizabeth Byles Brown, born in 1737 to the poet and popular minister Reverend Mather Byles and his wife, Anna Gale, died in June 1763; it is possible that Copley executed one, if not both, of

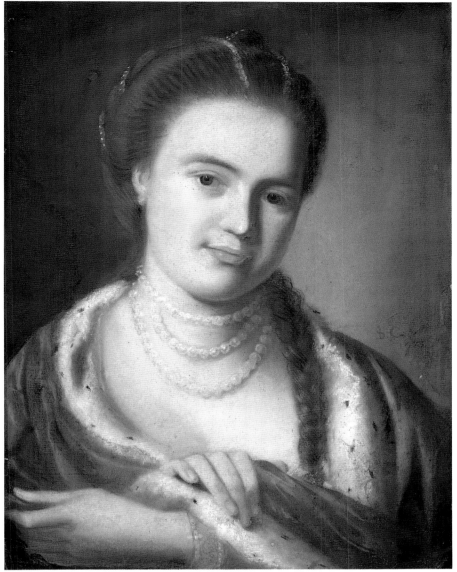

13

Fig. 171 Thomas Frye after unknown artist. *Maria, Countess of Coventry*. 1761. Mezzotint, 19⅞ x 13⅞ in. (50.5 x 35.2 cm). The Metropolitan Museum of Art, New York, Purchase, Harry G. Friedman Bequest, 1966 66.695.3

Fig. 172 *Mrs. Gawen Brown (Elizabeth Byles)*, ca. 1763. Oil on canvas, 19 x 17¾ in. (48.3 x 45.1 cm). A Southern Anonymous Collection

the portraits after her death. The wife of the clockmaker Gawen Brown (1719–1801), she was the mother of Mather Brown (1761–1831), upon whose birth she wrote a long poem that included the following lines:

> When with a Parents partial Eye
> My Babe within my Arms I spy
> I form a Thousand airy Schemes
> And paint his future Life in Dreams.[2]

She might have been gratified to know that her infant son grew up to be a portrait painter.

C R

1. David B. Warren, *Bayou Bend: American Furniture, Paintings, and Silver from the Bayou Bend Collection* (Houston, 1975), p. 134.
2. "By Mrs. Elizabeth Brown on Her Infant Son," Byles Family Papers, Massachusetts Historical Society, Boston.

14

Reverend Samuel Fayerweather

ca. 1763
Oil on copper, 3 x 2½ in. (7.6 x 6.4 cm)
Yale University Art Gallery, New Haven, Mabel Brady Garvan Collection 1948.69

Best known as the minister of St. Paul's Episcopal Church in North Kingston, Rhode Island, Samuel Fayerweather (1725–1781) was a Bostonian by birth and a Harvard graduate. His first appointment was as chaplain of a British man-of-war in the fleet that sailed against the French stronghold at Louisburg in 1745. In 1755, after service as an itinerant Congregationalist preacher that took him as far south as Georgia and north to Wells, Maine, Fayerweather embarked for England. He was ordained in the Episcopal Church in London in 1756 and was awarded a master of arts at Oxford University. In 1757 he apparently traveled directly from London to his parish assignment in South Carolina, where he lived until 1760, when he was called to North Kingston. He remained there as pastor for the rest of his career, marrying Abigail Hazard Bours (formerly the sister-in-law of John Bours) in February 1763. Fayerweather earned a reputation and was gently chided for his florid oratorical style, his frequent travels away from his parish, and his fondness for pageantry, which Copley documented by painting him in his Oxford regalia.

The date of this miniature is most often given as about 1758, but it was more likely made after 1760, when Fayerweather returned to New England from South Carolina. It may have been commissioned at the time of his marriage in 1763. The original silver frame is thought to be the work of Paul Revere; if it is by his hand, its appearance on the portrait would support the later date, as Copley first used Revere's services in 1763. Furthermore, Fayerweather corresponded with "Mr. John Copley, Limner" in January of that year, one month before his wedding, although his letter does not mention this painting.[1]

Copley's technique in *Samuel Fayerweather* is unusual and worthy of remark. He gilded this copperplate before painting it, apparently outlined the figure in a transparent red glaze, and allowed the gold-leaf ground to show through the glaze in discrete areas. Copley rendered Fayerweather's academic hood with small, fluid strokes of reddish-pink paint; dressing his sitter in academic garb permitted the artist to avoid the dull palette of the typical portrait of a minister in black and white clerical robes.[2]

E E H

1. Samuel Fayerweather, letter to Copley, Jan. 7, 1763, in Jones 1914, pp. 27–28. For Fayerweather's biography, see Clifford K. Shipton, *Sibley's Harvard Graduates,* vol. 11 (Boston, 1960), pp. 221–29; and John B. Carney, "In Search of Fayerweather: The Fayerweather Family of Boston," *New England Historical and Genealogical Register* 144 (July 1990), pp. 227–32.
2. I am grateful to Theresa Fairbanks, Chief Conservator at the Yale Center for British Art, New Haven, for sharing her discovery of Copley's gold ground with me. Rhona Macbeth offered me valuable insights about Copley's technique.

Mrs. James Warren (Mercy Otis)

ca. 1763
Oil on canvas, 51¼ x 41 in. (130.1 x 104.1 cm)
Museum of Fine Arts, Boston, Bequest of Winslow Warren 31.212

Mercy Otis Warren (1728–1814) would become one of the first chroniclers of the American Revolution and a dedicated campaigner for the patriot cause; however, when Copley painted her, at the age of about thirty-six or thirty-seven, she was a Plymouth, Massachusetts, housewife and mother of three sons (two more were to be born between 1764 and 1766). Her upbringing was unusual for a woman in the colonies, for she was well educated—her parents, James and Mary Alleyne Otis (whom Copley had painted about 1758), had allowed her to attend her older brother's lessons with a tutor as he prepared for Harvard.[1] She had an unconventional marriage too: her husband, James Warren (1726–1808) (fig. 173), himself a graduate of Harvard, a prosperous merchant and farmer, and an ardent patriot, also encouraged her intellectual pursuits.

Mercy Otis Warren began writing poetry in about 1759, five years after her marriage, but it was not until 1772 and the pseudonymous publication of her satiric drama *The Adulateur* in the *Massachusetts Spy* that her work reached the public. Over the next several decades she would pen a series of plays and parodies mocking Lieutenant Governor Thomas Hutchinson and other Loyalists, essays on political issues, and a volume of poems and dramas written in defense of human liberty and dedicated to George Washington. In 1805 she published her three-volume *History of the Rise, Progress, and Termination of the American Revolution*, which she had begun in the late 1770s and which, unlike most of her earlier efforts, appeared under her own name.

Although generally admired, these literary achievements were not realized without cost to Mrs. Warren. She was deeply troubled by the conflict between her intellectual ambitions and the behavior expected of women in her era. In 1775 she wrote to John Adams to inquire whether she would be perceived as "deficient" in womanly qualities if she were to exercise her gift for political satire and parody. Elsewhere she wrote, "Whatever delight we may have in the use of the pen, however eager we may be in the pursuit of knowledge . . . yet heaven has so ordained the lot of female life that every literary attention, must give place to family avocations."[2] Her husband, too, felt that she was torn, describing her as having "Masculine Genius" while at the same time possessing that "Weakness which is the Consequence of the Exquisite delicacy and softness of her Sex."[3]

In Copley's image Mercy Warren does not allude to her budding literary ambitions but rather enacts prescribed feminine roles. Her portrait offers a graceful complement to that of her husband. Their heads are turned toward each other, and she is slightly lower

in the picture plane than he. His figure is frontal, but her body is in profile. Their settings are not identical or contiguous, yet they do contain parallels.[4] James Warren is very much the country squire, walking stick in hand, ruddy complexion suggesting time spent out of doors overseeing his estate. The carefully demarcated architecture behind him suggests lands measured, cultivated, and controlled. He wears a bob wig and a gray coat over a long black waistcoat—a sober costume but by no means a poor man's garb. Mercy Otis Warren, by contrast, has a delicate, sallow complexion (possibly yellower now than originally, for Copley's pink flesh tones tend to fade) and is dressed in a most fashionable blue satin *sacque* dress trimmed with ruched silk and silver braid, with a lace stole and lace ruffles at her sleeve. She is on a hill; the landscape falls away behind her. She stands before a summarily painted rocky backdrop that parallels the crimson swag of drapery behind her husband. Her setting recalls the tradition of Van Dyck's theatrical portraits, on the one hand, and speaks of a Rousseauean communion with nature, on the other.[5] Both Warrens are portrayed as cultivators: he, the gentleman farmer, stands foursquare on his property; she fingers her nasturtium vines, plants that were valued both as food and for their bright, colorful blossoms.

Copley first portrayed Mercy Otis Warren with roses—their ghosts can still be seen beneath the green nasturtium leaves— flowers that were more appropriate for cutting and arranging than nasturtiums, which until the 1840s were known only as vine flowers. X rays of the portrait suggest the possibility that Mrs. Warren originally stood before a masonry wall, perhaps like that at the left in Copley's portrait of Mrs. Daniel Sargent (fig. 74). The revisions in the setting allied Warren more directly with the world of nature; the flowers she tends, but does not cut, are a trope for her role within the family as nurturer of children. Like the cultivation of flowers, the training of children was the responsibility of women.[6] Flowers were emblems of fertility—appropriate to Mercy Warren, who gave birth to sons both the year before and the year after she sat for Copley. But they were also tokens of the fragility of life and may have been meant to recall Warren's beloved sister Mary (fig. 174), who died the year this portrait was painted.

Mercy Otis Warren seems to have captured Copley's imagination more than her husband did. Both portraits have been described as indebted to Joseph Blackburn in composition and palette,[7] and *James Warren* is part of a group of conventionally posed male portraits Copley produced in the late 1750s and early 1760s. *Mercy Otis Warren*, however, relates to a series of portraits of women from about 1763 in which Copley experimented with

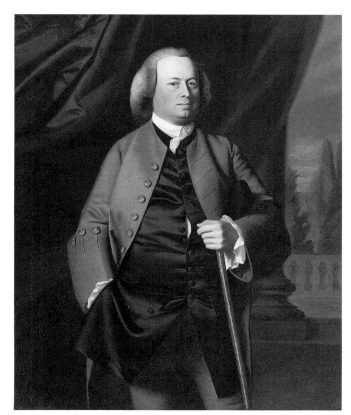

Fig. 173 *James Warren*, ca. 1763. Oil on canvas, 51¼ x 41 in. (130.1 x 104.1 cm). Museum of Fine Arts, Boston, Bequest of Winslow Warren 31.211

Fig. 174 *Mrs. John Gray (Mary Otis)*, ca. 1763. Oil on canvas, 50 x 39¼ in. (127 x 99.7 cm). Massachusetts Historical Society, Boston, Bequest of Winslow Warren, 1923

gestures—some invented, some culled from prints—designed to emphasize the sitter's femininity. These gestures vary widely: nasturtium vines trail through Mercy Warrens's sensuous fingers, while her sister toys with the pearls at her wrist; Mrs. Nathaniel Allen (fig. 46) gently pulls on an elbow-length glove; Mrs. Benjamin Pickman (fig. 73) twirls a parasol; and Mrs. Daniel Sargent lifts a scalloped shell to catch water flowing from a fountain, thereby alluding symbolically to feminine virtue and beauty.[8]

As has often been noted, Mrs. Pickman and Mrs. Sargent wear dresses virtually identical to Mercy Otis Warren's. Mrs. Pickman and Mrs. Sargent were only nineteen or twenty—much younger than Mrs. Warren—and were painted at the time of their marriages. The gowns of both young sitters are cut low, and the pale skin of their chests is exposed in advertisement of their beauty; Mercy Warren's dress, however, has been augmented with a lace stole, a modest touch appropriate to her age and status as matron. Other details also divide the ingenues from the more mature woman. Mrs. Pickman gazes out of the picture with a charming, dimpled smile. Mrs. Sargent's expression is demure, her eyes cast down. But Mercy Otis Warren looks directly at the viewer; the levelness of her gaze and the determined set of her mouth suggest (at least to the modern observer with the luxury of hindsight) the

side of her character that will within a decade venture forth from the realm of such acceptable feminine pursuits as needlework, gardening, and child rearing into the masculine sphere of dramaturgy, political satire, and historical analysis.

C T

1. For Warren's education and other biographical data, see Maud Macdonald Hutchison, "Mercy Warren, 1728–1814," *William and Mary Quarterly*, ser. 3, 10 (July 1953), pp. 378–402; and Robert A. Feer, "Warren, Mercy Otis," in *Notable American Women, 1607–1950: A Biographical Dictionary*, ed. Edward T. James (Cambridge, Mass., 1971), vol. 3, pp. 545–46.

2. *Warren-Adams Letters: Being Chiefly a Correspondence Among John Adams, Samuel Adams, and James Warren* (Boston, 1917–23), vol. 1, pp. 37, 42–44, quoted in Mary Beth Norton, *Liberty's Daughters: The Revolutionary Experience of American Women, 1750–1800* (Boston, 1980), p. 121; Linda K. Kerber, *Women of the Republic: Intellect and Ideology in Revolutionary America* (Chapel Hill, 1980), p. 256. Although Adams was for a long time supportive of Warren and her literary efforts, he was less sanguine when he became the target of her critical pen. His imperious response to her *History . . . of the American Revolution* has often been quoted: "History is not the Province of the Ladies" (*Warren-Adams Letters*, vol. 2, p. 380, quoted in Norton, *Liberty's Daughters*, p. 123).

3. Quoted in Norton, *Liberty's Daughters*, p. 121.

15

4. The Warren pictures are typical of Copley's portrait pairs, which rarely contain specific elements—such as unified settings or complementary gestures—that knit the two pictures together. Here, the lack of obvious correspondences may reflect not only Copley's characteristic approach but also the fact that the artist may have portrayed James Warren several years earlier than his wife. Copley chose a coarse canvas for Warren's likeness—the sort he used in his earlier work—and the handling is generally broader and not as skilled as in her portrait. If Mr. Warren did pose some years before Mrs. Warren did, it would explain why she seems to acknowledge him in her portrait far more than he does her in his, in contradiction of what appears to have been their actual relationship.

5. Such invented natural settings frequently were used by Van Dyck in portraits meant to evoke masques; this fashion was carried on through the next generation of English painters and was transmitted to Copley through prints, such as the mezzotint after Sir Godfrey Kneller's *Countess of Essex* by John Smith, 1695.

6. "Not only the training of children, but of plants, such as needed peculiar care or skill to rear them, was the female province" (Mrs. Anne Grant, *Memoirs of an American Lady: With Sketches of Manners and Scenery in America As They Existed Previous to the Revolution* [London, 1808; reprint, New York, 1970], p. 39).

7. Prown 1966, vol. 1, p. 38.

8. The shell is an attribute of Venus, goddess of love and beauty. See Marc Simpson, Sally Mills, and Jennifer Saville, *The American Canvas: Paintings from the Collection of the Fine Arts Museums of San Francisco* (New York, 1989), pp. 30–31.

16

Epes Sargent II

ca. 1764
Oil on canvas, 49 x 39 in. (124.5 x 99.1 cm)
Collection of Erving and Joyce Wolf

17

Mrs. Epes Sargent II (Catherine Osborne)

1764
Oil on canvas, 49 x 39 in. (124.5 x 99.1 cm)
Signed and dated lower right: J. S. Copley pinx. 1764
Mason Bowditch Cabot and Courtenay Bromfield Cabot

The eldest of fifteen children and namesake of Epes Sargent was born in Gloucester in February 1721.[1] He was twenty-two and a merchant in business with his father when his mother, Esther MacCarty (or MacCarthy), died in 1743. In 1745, the year after his father remarried and moved to Salem, Epes Sargent II began his own family after marrying Catherine Osborne (1722–1788), one year his junior and the daughter of John and Sarah Woodbury Osborne of Boston. The couple made its home in the elder Epes

Sargent's Gloucester house. Epes Sargent II seems to have inherited his father's superb mercantile skills—together they owned most of the land on Gloucester's east side, and, on his own after his father's death in 1762, he acquired ten ships for fishing and foreign trade. A man of elevated tastes, the younger Sargent kept company with other very wealthy merchants, including Nathaniel Sparhawk and Jeremiah Lee, and was one of Paul Revere's best customers. His record of orders and payments for silver goods reveals his appreciation of luxury items as well as his unselfish nature: he bought not only objects for himself (such as porringers, coffeepots, and spoons engraved with the family coat of arms) but also gifts for his children (shoe buckles and clasps) and his church, the First Parish Church of Gloucester (a christening basin, two cups, and two beakers).[2]

Like his father, Epes Sargent II cherished his family above all else. Driven from Gloucester to Boston in 1775 for remaining loyal to England, he was about to flee to Halifax when he decided to return to Gloucester rather than live apart from his relatives. He was particularly reluctant to be separated from his wife, who was, according to a descendant, "a lady of rare virtue, of winning conversation and manners, benevolent and charitable to the highest degree."[3] The daughter of a merchant who at one time commanded a packet that sailed from London, Catherine took an active interest in her husband's business affairs and stood with him in difficult times, most notably during the Revolution in matters of political loyalty and religious practices. Between the mid- and late 1770s Epes II and Catherine Sargent, together with Epes's brother Winthrop, his wife, and other family members, were charged with bigotry. They were expelled from and sued by the First Parish Church of Gloucester and subsequently formed an independent congregation to accommodate the Universalist teachings of Reverend John Murray.[4] Catherine cosigned numerous petitions and letters regarding religious freedom with her husband, and, after he died in 1779 as a result of a smallpox inoculation, she remained a staunch defender of their beliefs despite continued persecution.

The Sargents sat for Copley in 1764, the same year Epes ordered a copperplate engraving of his family's coat of arms and 150 prints of it for use as bookplates (fig. 175) from Revere.[5] That Epes and Catherine commissioned grand portraits and Rococo labels bearing the family's own crest within a single year suggests that husband and wife recognized the importance of commemorating themselves and marking their possessions with distinctive signs of status, now that they were both in their forties. Moreover, Sargent may have had his portrait painted by Copley two years after his father's death in 1762 as a way of asserting his role as head of his family. Copley had presented the first Epes Sargent unadorned, as a dignified man of strong character and simple virtue and taste. However, the grand architectural setting of his son's picture, the crimson drapery, the color and cut of his suit, which is on the lavender side of gray and features stylishly large boot-cuffs on the coat, and the fashionable pigeon-wing wig (undoubtedly plaited in the back) are lavish attributes of a gentleman concerned

Fig. 175 Paul Revere. *Bookplate of Epes Sargent II*, 1764. Engraving, 3¼ x 2½ in. (8.3 x 6.4 cm). American Antiquarian Society, Boston

white satin cuffs, de rigueur teal camlet fitted coat, full skirt with petticoat, high stock, and generous black cravat, the outfit is perfectly fashionable.[7] But of all the stylish costumes she or Copley might have selected for her portrait, the riding habit—a dress actually derived from men's clothing—was by far the most masculine and effective in removing her from the realm of typical feminine sensuality and motherliness. Even her hair, pulled back sleekly so it disappears under the plumed hat, is in keeping with the mannish image. Copley did not have to invent the costume; it was no doubt real, for Catherine Sargent probably rode horses. Epes Sargent I owned a "Womans Pellion," or pillion, indicating that horseback riding was an activity in which the Sargent women participated.[8] Copley did, however, work diligently to render the precise details of her outfit; his struggle to get it right is revealed in various pentimenti. With her riding crop poised diagonally in front of her, Catherine Sargent seems Copley's updated version of Ann Tyng with her crook (cat. no. 7), the gentle, fecund shepherdess turned determined, capable equestrian.

In typical eighteenth-century pendant portraiture the sitters face each other, the color schemes are related, and the compositions come together to present the idea of marriage or oneness. However, the Sargent portraits do not share these traits. Copley did not depict Epes and Catherine as a couple in an obvious, direct manner. He chose to show them not as mirror images of each other but as images that reflect a balance of being. The paintings work as well alone as together, implying the same about the Sargents.

C R

with his social role and elegant appearance. Yet, despite the elite trappings, he remains his father's son. Like the elder Epes, he is portrayed leaning on a pedestal, with gently smiling eyes. Copley may have been instructed that the portrait of Epes II should complement not only the picture of his wife but also that of his father. Family history has it that Epes I commissioned all three portraits, even though he was painted in about 1760 and Epes II and his wife did not sit for Copley until 1764. Moreover, they were treated as a group by the family, for Epes II's probate inventory reveals that the three portraits hung together "in the great Chamber" of his Gloucester home. Archival photographs show that the paintings remained together, with the portrait of Epes II installed between those of his father and his wife, until the late 1950s.[6]

The similarities between husband and wife as Copley showed them are as interesting as the contrast he drew between father and son. As portrayed by Copley, Epes II and Catherine share the same pose—erect stance with right arm bent at a relaxed forty-five-degree angle, left arm straight, and left thumb touching forefinger. They also share the same classical setting, column for column. Her fountain parallels his pedestal, her tree stands in for his drapery. And Catherine's riding habit, although it suggests an activity for which Epes, in his fine suit, is not dressed, strikes a note of masculinity as well as elegance and, hence, confers upon her a certain equality with her husband. With its gold embroidery on

1. Emma Worcester Sargent and Charles Sprague Sargent, *Epes Sargent of Gloucester and His Descendants* (Boston, 1923), pp. 10–11.
2. Paul Revere, Ledgers, various entries, Oct. 1762–Aug. 1780, Massachusetts Historical Society, Boston. On Sargent's friends and acquaintances, see *Letters and Diary of John Rowe, Boston Merchant*, ed. Anne Rowe Cunningham (Boston, 1903), pp. 103, 229.
3. Sargent and Sargent, *Sargent of Gloucester*, p. 11.
4. See Levi M. Powers, *Sketch of the Independent Christian Church and the Sargent Murray Gilman House* (Boston, 1915); and Richard Eddy, *Universalism in Gloucester, Mass.* (Gloucester, 1892).
5. Paul Revere, Ledger, Sept. 27, 1764, Massachusetts Historical Society, Boston.
6. Epes Sargent II, Probate inventory, Mar. 17, 1779 (Essex County, Docket no. 24611, Archives, Supreme Judicial Court, Boston), lists "3 Portraits (Half Length) . . . 45." Conversation with Caroline Dixwell Cabot. The three paintings hung together until 1959, when the portrait of Epes Sargent I (cat. no. 11) was acquired by the National Gallery of Art, Washington, D.C. The two others remained together until 1975, when the portrait of Epes Sargent II was sold.
7. Edward Warwick, Henry C. Pitz, and Alexander Wyckoff, *Early American Dress: The Colonial and Revolutionary Periods* (New York, 1965), pp. 180–82, 222–23.
8. Epes Sargent I, Probate inventory, Nov. 10, 1763, Essex County, Docket no. 24610, Archives, Supreme Judicial Court, Boston.

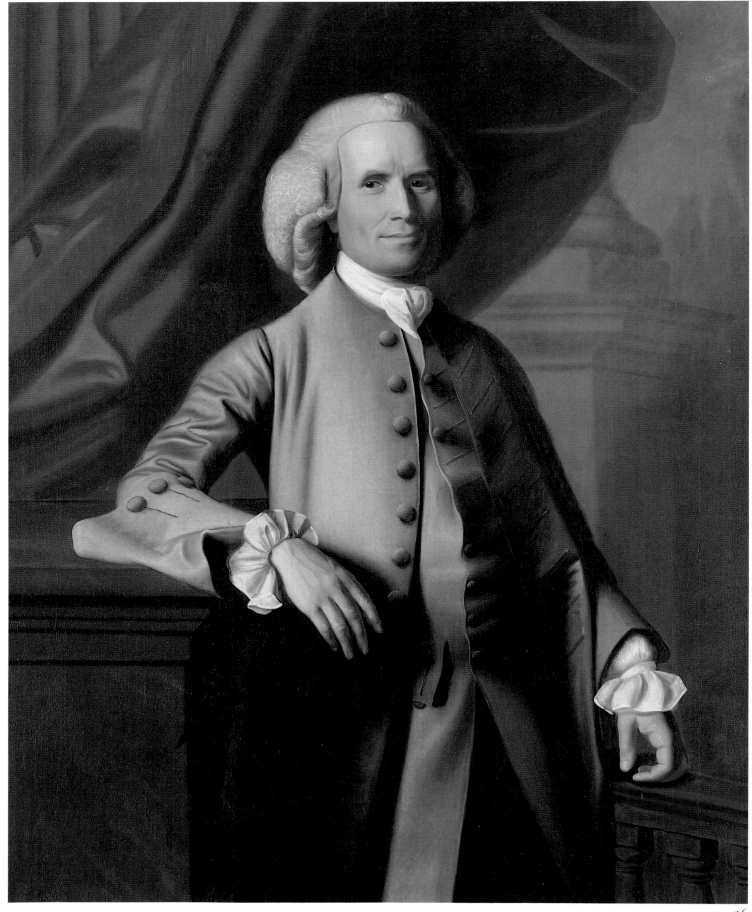

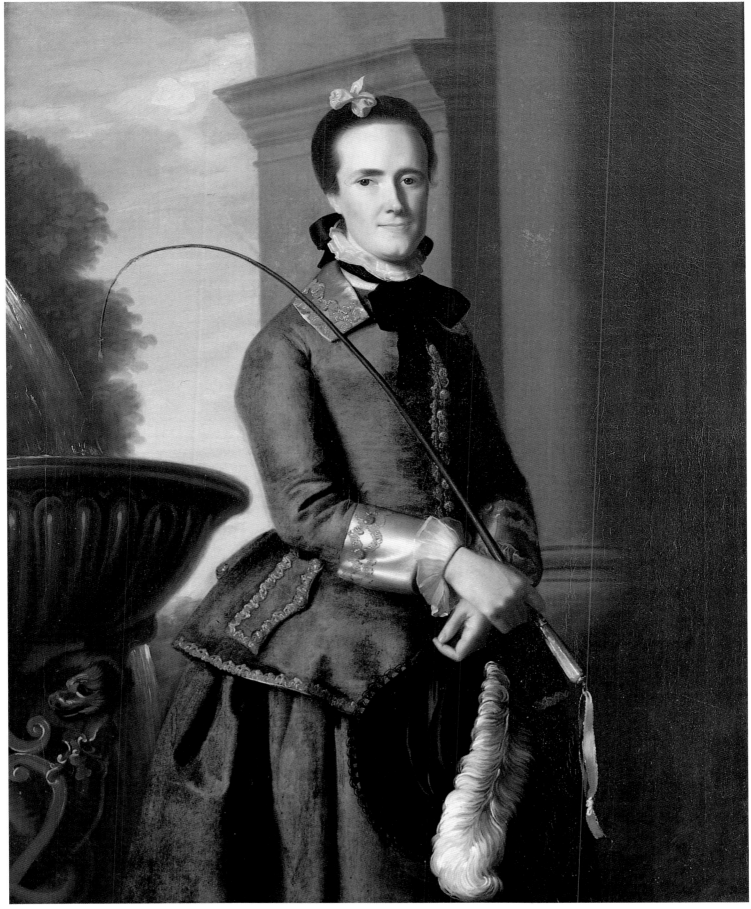

Moses Gill

1764
Oil on canvas, 49¾ x 39½ in. (126.4 x 100.3 cm)
Signed and dated lower left: J S Copley Pinx¹ 1764.
Museum of Art, Rhode Island School of Design, Jesse Metcalf Fund
07.117

In *Moses Gill* Copley employed a pose he would use frequently in the mid- and late 1760s to convey that appearance of engaging nonchalance and easy dignity so desired by mid-eighteenth-century gentlemen.[1] The pose, featuring one hand on the sitter's jutting hip and the other, casually holding a letter or other document, resting on a plinth or chair, had initially been popularized in England in the 1740s and 1750s by Allan Ramsay and especially by Thomas Hudson. Copley's source was most likely an engraving by James McArdell after a well-known portrait of 1757 by Hudson of George Townshend (fig. 176). Although the pose has been associated with various pieces of eighteenth-century sculpture, it actually has more celebrated classical antecedents, namely a statue of Mercury in the Uffizi and the *Faun of Praxiteles* (fig. 177).[2] Both works had recently come to public attention in Europe: in 1753

Pope Benedict XIV purchased the Faun from a renowned private collection and presented it to the Museo Capitolino in Rome, and in 1756 Sir Horace Mann, writing to Horace Walpole from Florence, deemed a reproduction of the Mercury "suitable for the decoration of a country house." Shortly thereafter copies of Mercury graced the libraries of many British estates.[3] In using the elegant, languid stance of these figures so soon after it gained currency for portraiture in England, Copley showed his instinctive awareness of British taste and, whether innocently or knowingly, endowed Gill with a link to the increasingly fashionable Neoclassical style. He would make this connection more overt in the full-length portrait of Nathaniel Sparhawk, also painted in 1764 (cat. no. 19), for there the subject stands in front of an imaginary classical arcade and a balustrade with a large urn. A few years later, on the Continent,

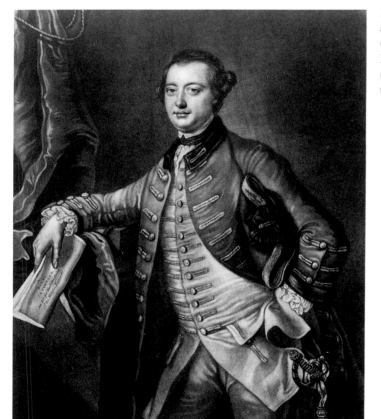

Fig. 176 James McArdell after Thomas Hudson. *George Townshend*, ca. 1758. Mezzotint, 13⅝ x 10¾ in. (34.6 x 27.3 cm). Trustees of the British Museum, London

Fig. 177 *Faun of Praxiteles*. Marble, h. 67⅛ in. (170.5 cm). Museo Capitolino, Rome

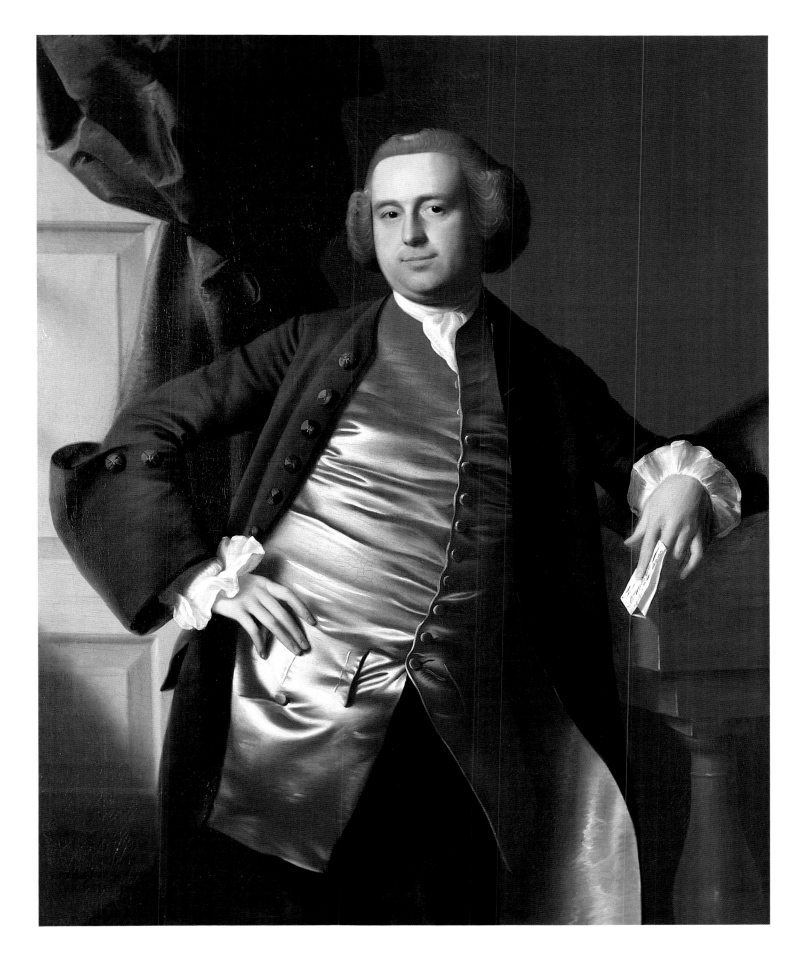

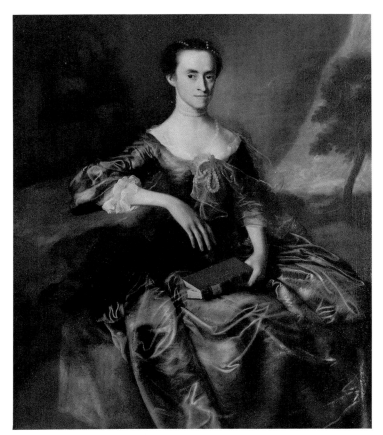

Fig. 178 *Mrs. Moses Gill (Sarah Prince)*, ca. 1764. Oil on canvas, 49¾ x 39½ in. (126.4 x 100.3 cm). Museum of Art, Rhode Island School of Design, Providence, Jesse Metcalf Fund 07.118

Pompeo Batoni would canonize the use of this classically inspired pose for portraiture by showing a sitter with his right hand on his hip and his left arm draped over a Greek krater.[4]

Moses Gill, the vehicle for this richly allusive posture, was a thirty-year-old hardware merchant and minor town official who, by means of an advantageous marriage to Sarah Prince (daughter of the rector of Boston's Old South Church), would become one of the principal landowners of Worcester County. By 1775 he was a judge of the Court of Common Pleas. He later became a member of the Executive Council and at the end of his career served as lieutenant governor (1797–99) and acting governor (1799–1800) of Massachusetts. Jules Prown describes Gill's income as only moderate;[5] however, his vast landholdings surely indicate a greater prosperity. Certainly, he lived lavishly: he was known to be "a fine looking, and very aristocratic man, and given to display." His estate in Princeton, Massachusetts, was famous for its size and the grandeur of its setting:

> [Gill's] elegant and noble seat . . . contains upward of 3000 acres. . . . The mansion house is large, being 50 x 50 feet. . . . elegant fences were erected around the mansion house, the outhouses, and the garden. The prospect from this seat is extensive and grand, taking in horizon to the east, of seventy miles at least. The blue hills of Milton are discernable with the naked eye . . . as well as the waters of the harbour of Boston. . . . When

we view this seat, these buildings, and this farm of so many hundred acres, now under a high degree of cultivation, and are told that in the year 1766 [the year the Gills inherited the land] it was a perfect wilderness, we are struck with wonder, admiration, and astonishment.[6]

Both Gill's taste for elegance and the esteem in which he was held are clearly indicated in this portrait. His handsome, pearl-gray silk waistcoat is unbuttoned at the neck to show off his frothy cravat and then buttoned again across his fashionable girth. He sports a frock coat in an opulent blue velvet with a gray silk lining that matches his vest and with deep, closed boot cuffs ornamented with embroidered buttons in the English style.[7] Like his costume, the imaginary setting in which he is posed—a paneled wall behind a satin drape, a mahogany baluster on which his arm rests—connotes a luxurious lifestyle. Gill's amiable expression lends credence to the glowing account of his character that appears in the history of the town of Princeton; he was admired as "an upright and liberal merchant" and as an ardent patriot.[8]

Moses Gill married twice and commissioned Copley to paint a portrait of each of his wives. He also arranged that each be presented in an elaborate Rococo frame to match the frame on his own picture. The first portrait, *Mrs. Moses Gill (Sarah Prince)* (fig. 178), was presumably painted as a pendant to this likeness. As is often the case with Copley's portrait pairs, the two figures are united by parallel, rather than matching, settings and gestures: he, the man of affairs, stands indoors, while she, the partner who brought the vast Princeton landholdings to the marriage, sits in a wooded setting. For the highly polished plinth over which Gill's arm is draped, a rough, rocky outcropping has been substituted in her portrait. He holds a letter, she a book, and so on. Gill probably commissioned the portrait of his second wife, Rebecca Boylston Gill (cat. no. 34), shortly after their marriage in 1773. Like her predecessor, she is shown out of doors. With the huge spray of lilies in her hand, Rebecca Boylston Gill advertises the elegant gardens for which their estate in Princeton was famous.

<div align="right">CT</div>

1. "Ease of bearing was as important to the gentleman as ease of the company was to a brilliant entertainment. The bent elbow, the hand on the hip, the feet at an angle . . . signified the sitter's ease. In the last half of the eighteenth century, the desire for ease grew stronger. . . . The genteel thought it the height of elegance to relax their formal standards and move into these easy poses" (Richard L. Bushman, *The Refinement of America: Persons, Houses, Cities* [New York, 1992], pp. 65–66).
2. While noting its derivation from the antique, Ellen G. Miles suggests that the pose was inspired by the Shakespeare statue erected in the Poets' Corner of Westminster Abbey in 1741 or the monument to James Cragg at Westminster. See Ellen G. Miles, *Thomas Hudson, 1701–1779: Portrait Painter and Collector* (exh. cat., London: Iveagh Bequest, Kenwood, 1979), no. 27.
3. See Francis Haskell and Nicholas Penny, *Taste and the Antique: The Lure of Classical Sculpture, 1500–1900* (New Haven, 1981), pp. 209–10, 266–67; Mann is quoted on p. 267. The Faun would become even more famous toward the end of the century as such scholars as Johann Winckelmann debated its merit. Its greatest celebrity would come

in the next century, when Anna Brownell Jameson sang its praises and it was heralded in Nathaniel Hawthorne's *The Marble Faun* of 1860. See ibid. Haskell and Penny also note that "in England and Ireland . . . there were probably more copies of the *Mercury* than elsewhere" (ibid., p. 267).

4. See his portrait of Prince Karl Wilhelm Ferdinand, later duke of Braunschweig and Lüneberg, 1767, as discussed in Anthony M. Clark, *Pompeo Batoni: A Complete Catalogue of His Works*, ed. Edgar Peters Bowron (New York, 1985), pp. 308–9, pl. 284.

5. That is, between one hundred and five hundred pounds per year (Prown 1966, vol. 1, p. 106).

6. Reverend Peter Whitney, *The History of the County of Worcester, in the Commonwealth of Massachusetts* (Worcester, Mass., 1793), p. 107, quoted in Francis Everett Blake, *History of the Town of Princeton, in the County of Worcester and Commonwealth of Massachusetts, 1759–1915* (Princeton, Mass., 1915), vol. 1, pp. 270–71.

7. Edward Warwick, Henry C. Pitz, and Alexander Wyckoff, *Early American Dress: The Colonial and Revolutionary Periods* (New York, 1965), p. 155. One aspect of Gill's attire—the frock coat lined with gray silk to match his waistcoat—is very unusual and may well have been invented by Copley for compositional effect. However, Gill's inventory lists stylish clothing, including a "suit pearl colour cloath" ("Mr. Gill's Cloaths," Gill Papers, American Antiquarian Society, Worcester). If Copley did concoct the frock coat, it would appear that the article was not far from a real model and was very much in keeping with Gill's character.

8. "When the controversy between Great Britain and America became serious and it was seen that a resort to arms would be the probable consequence, Mr. Gill, came forward with his property and cast it liberally into the lap of his country's fortune. His person and property were laid at the foot of the altar of liberty, ready for the sacrifice, if his country needed them" (Blake, *History of the Town of Princeton*, vol. 1, p. 272).

19

Nathaniel Sparhawk

1764

Oil on canvas, 90 x 57½ in. (228.6 x 146 cm)

Signed and dated center right: John S. Copley / pinx 1764.

Museum of Fine Arts, Boston, Charles H. Bayley Picture and Painting Fund 1983.595

This picture is Copley's first attempt at a lifesize, full-length portrait.[1] The idea for the format came from two principal sources. The full-length likenesses of the English monarchs that were on display at the Town-House, the seat of colonial government in Boston, constituted one prototype. These were imported from England and included pictures of Charles II, James II, and George III, the last of which was a replica of Allan Ramsay's official portrait (fig. 179). They were all swagger portraits; that is, their rhetoric was theatrical, often encompassing distinctive gestures, yards of gathered drapery, and inflated, if not actually imaginary, settings.[2]

The other source was the American portraits of the heroes of Louisburg, which was a key battle, fought in 1745, in King George's War of 1740 to 1748, the American phase of the War of the Austrian Succession. John Smibert painted three full-length Louisburg pictures, and Robert Feke one. The most accomplished is Smibert's of Sir William Pepperrell (fig. 180), who was Sparhawk's father-in-law and in the 1760s the owner of three of the Louisburg paintings.[3] In 1747 Peter Pelham, Copley's stepfather, engraved a mezzotint after Smibert's portrait of Pepperrell.

Sparhawk (1715–1776), however, was neither hero nor monarch. He was instead a merchant from Kittery, Maine, posing as a man of state in Copley's image. Though he had achieved some wealth trading in wood and molasses, it was his marriage in 1742 to Elizabeth Pepperrell that made him socially prominent. When Sir William died in 1759, Sparhawk inherited part of his large estate and in addition acquired his seat on the Court of Common Pleas for York County.

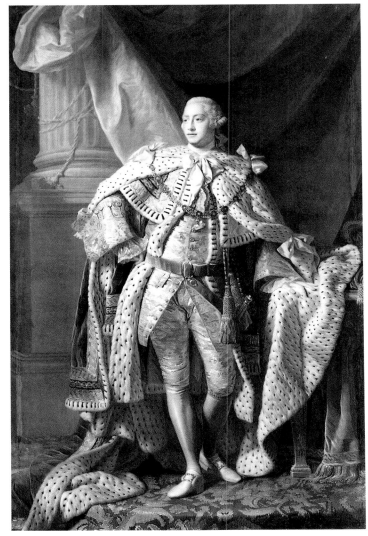

Fig. 179 Allan Ramsay. *George III*, 1761. Oil on canvas, 98¼ x 64⅛ in. (249.7 x 163 cm). Her Majesty the Queen, London

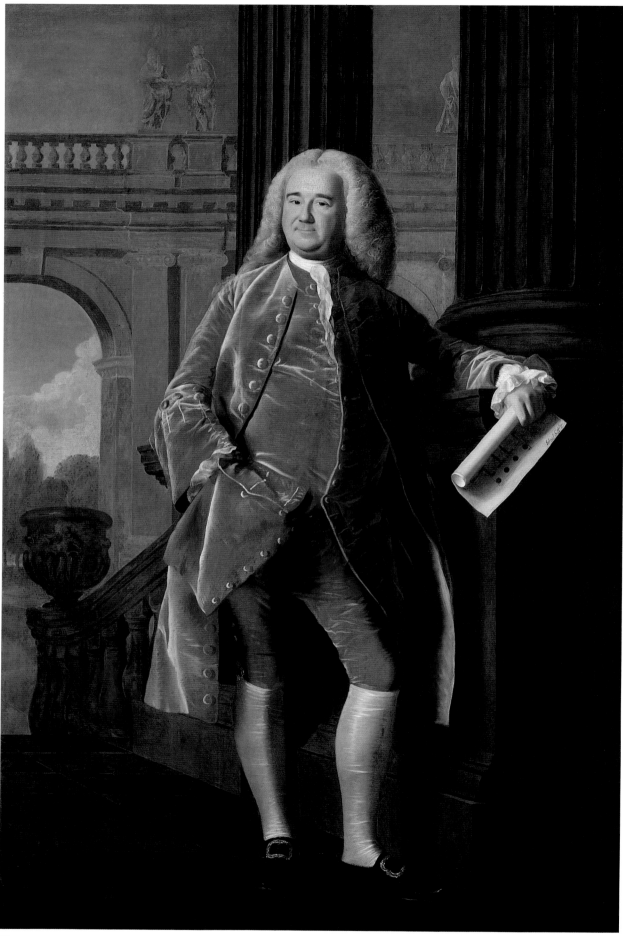

19

Fig. 180 John Smibert. *Sir William Pepperrell*, 1746. Oil on canvas, 96 x 56 in. (243.8 x 142.2 cm). Peabody Essex Museum, Salem, Massachusetts, Gift of George Atkinson Ward

Sparhawk's grand pose also suggests an inheritance from Sir William, as he was represented by Smibert. But Sparhawk's grace and informality contrast with the stiffness of the Louisburg sitters. Sparhawk's animated pose was consistent with emerging codes of bodily conduct that postulated the ideal gentleman as relaxed and conversational. Copley had used the new body etiquette as early as 1758 in his portrait of Thaddeus Burr (fig. 43). The motif of the plinth on which Sparhawk rests his arm also comes from the portrait of Burr and from the still earlier print of the English architect James Gibbs by Peter Pelham (fig. 168). Like Gibbs, Sparhawk not only leans on a plinth but also holds in his hand an architectural drawing. But the four-columned porch diagrammed in Sparhawk's drawing was never used in the two building projects associated with him, his own house of 1742 and his mother-in-law's of the 1760s.[4]

Copley placed Sparhawk in an imaginary setting. Two colossal columns flank him on the right, and at the rear a classical arcade surmounted by sculpted figures suggests an Italian villa. The arcade bears resemblance to the patterns used in James Gibbs's *Rules for Drawing the Several Parts of Architecture.*[5] However, this feature may more directly derive from the pillar-and-arch wallpaper in Sparhawk's home. Block printed in England, the wallpaper hung in the stairhall of Sparhawk Hall (fig. 181) and was probably installed by Sparhawk shortly after Sir William's death.[6]

PS

1. For a thorough discussion of this picture, see Carol Troyen, "John Singleton Copley and the Grand Manner: *Colonel Nathaniel Sparhawk,*" *Journal of the Museum of Fine Arts, Boston* 1 (1989), pp. 96–103. See also Wayne Craven, *Colonial American Portraiture: The Economic, Religious, Social, Cultural, Philosophical, Scientific, and Aesthetic Foundations* (Cambridge, 1986), pp. 337–38.
2. See Andrew Wilton, *The Swagger Portrait: Grand Manner Portraiture in Britain from Van Dyck to Augustus John, 1630–1930* (exh. cat., London: Tate Gallery, 1992).
3. Smibert painted Sir William Pepperrell, 1746 (Essex Institute Museum, Salem, Massachusetts); Sir Peter Warren, 1746 (Portsmouth Athenaeum, New Hampshire); and William Shirley, 1747 (location unknown). Feke painted Brigadier General Samuel Waldo, ca. 1748 (Bowdoin College Museum of Art, Brunswick, Maine). See Ellen G. Miles, "Portraits of the Heroes of Louisburg, 1745–1751," *American Art Journal* 15 (Winter 1983), pp. 48–66.
4. See John Mead Howells, *The Architectural Heritage of the Piscataqua: Houses and Gardens of the Portsmouth District of Maine and New Hampshire* (New York, 1937), pp. 6–13, 38–41.
5. James Gibbs, *Rules for Drawing the Several Parts of Architecture . . .* (London, 1732), pls. 32, 39.
6. Richard C. Nylander, Elizabeth Redmond, and Penny J. Sander, *Wallpaper in New England: Selections from the Society for the Preservation of New England Antiquities* (Boston, 1986), pp. 48–51.

Fig. 181 Stairhall, Sparhawk Hall, Kittery Point, Maine

Mrs. George Watson (Elizabeth Oliver)

1765
Oil on canvas, 49⅞ x 40 in. (126.7 x 106.7 cm)
Signed and dated lower right: J. S. Copley. pinx / 1765
National Museum of American Art, Smithsonian Institution,
Washington, D. C., Partial gift of Henderson Inches, Jr., in honor of his
parents, Mr. and Mrs. Inches, and museum purchase made possible in
part by Mr. and Mrs. R. Crosby Kemper through the Crosby Kemper
Foundations; the American Art Forum; and the Luisita L. and Franz H.
Denghausen Endowment

Elizabeth Oliver Watson stands with her right elbow bent, the
knuckles of her right hand on hip, with her body turned in a
three-quarter pose against a dark green curtain and generalized
architectural setting that work as a foil for her dazzling magenta
dress. In her left hand she holds a white vase decorated with a blue
floral motif and filled with a small bouquet of two spotted purple
and white blossoms and one bright yellow flower with jagged red
edges that fans like a flame in the direction of the open air. Her left
forearm is swathed in a length of lustrous satin that cascades
across the composition to serve as a drape for the column and an
embellishment for her skirt. Her corseted gown, worn over a lace-
trimmed shift and designed to exploit to fullest effect the sheen of
the unfigured fabric, has no visible seams, a full skirt, a tight-fitting
bodice, and a *sacque* that falls from the back of her shoulders.
Pearls trim the sleeves, and wide lavender ribbons adorn the neck-
line as well as her coiffure. Her face and décolletage, creamy
smooth and pale, reflect the light.

This is a stunning portrait that shares the masterly orchestra-
tion of rich colors and vivid textures characteristic of Copley's best
work from the mid-1760s. In particular, it reveals an extraordinary
painterly technique and artistic ingenuity of the sort found in the
portrait of Henry Pelham from the same year (cat. no. 25): both
pictures are contrived to showcase Copley's talent in rendering
surface effects, Henry Pelham's for public exhibition and Mrs.
Watson's for private viewing; taken together they reveal the strik-
ing ways in which the painter modified props and settings to reflect
his sitters' characters and circumstances. When he composed his
portrait of Mrs. Watson, Copley may have had in mind the similar
picture that his teacher Joseph Blackburn painted some five years
earlier (fig. 182), purportedly for a member of the Watson family
(although perhaps not the same Watson family to which Elizabeth
belonged).[1] Whether or not there was a deliberate reference, a
comparison of the two portraits pointedly reveals the ways in
which Copley surpassed his teacher and the reason Blackburn de-
cided to leave Boston.

Copley's portrait of Elizabeth Watson conveys a powerful sense
of the multifaceted life and character of this wealthy New England
woman. Her pose, especially the detail of the hand on hip, speaks
of strength and poise, and her facial expression, particularly her di-

Fig. 182 Joseph Blackburn. *Portrait of a Woman*, ca. 1760. Oil on canvas,
44¼ x 36⅛ in. (112.2 x 91.8 cm). The Brooklyn Museum, New York,
Dick S. Ramsay Fund 50.57

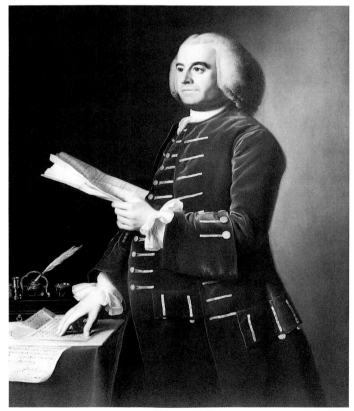

Fig. 183 *George Watson*, 1768. Oil on canvas, 50 x 40 in. (127 x
101.6 cm). New Orleans Museum of Art, Museum Purchase, 1975
Acquisition Fund Drive

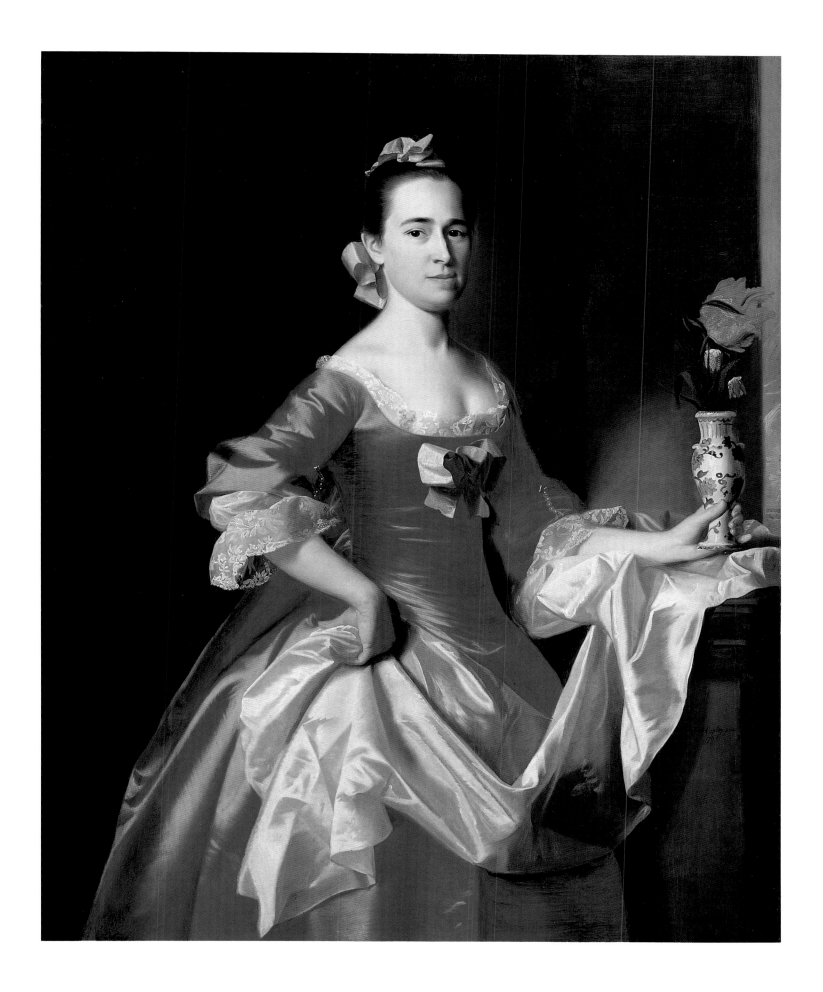

rect gaze at the viewer, betrays intelligence. The vase of flowers, a prop that Copley had not used before and would use only once again, in a different form and less effectively in his portrait of Mrs. Benjamin Blackstone, ca. 1766 (Mead Art Museum, Amherst College, Massachusetts), stands at once as a typical example of the Watsons' expensive possessions and as an emblem of feminine grace. Its porcelain body is a pastiche of Delft and Chinese forms, its floral contents—two checkered fritillaria or guinea hen flowers and one parrot tulip, both species that are hearty but rare in New England—a mix of simple and showy forms that might symbolize prudence and passion in this woman's life.[2]

The daughter of Peter Oliver, a respected and wealthy judge who was as well known for his flamboyance as for his wisdom, Elizabeth Oliver was nineteen in 1756 when she married George Watson (1718–1800), a prominent Plymouth merchant and Loyalist who served as a mandamus counselor during the Revolution. Shortly after her wedding, she made a confession of faith, in which she vowed that she would think of God as "my Friend, my everlasting Potion" and expressed the hope that she would "be enable'd to come up to every Duty that is set before me in the way that is most agreeable to thy holy will."[3] She was twenty-eight and the mother of four when she sat for Copley. She died only three years later, one of fourteen Plymouth adults who succumbed during the harsh winter of 1767.[4] Parts of the eulogy that the Reverend Chandler Robbins delivered in her memory provide a verbal counterpart to Copley's incisive portrait. Robbins described dualities of personality and existence that might be read in Copley's painting: consort and mother, servant to the Lord and her husband, chaste and sociable, wealthy and charitable, "an honor and ornament to her sex." Yet Robbins's description also includes passages that contradict Copley's portrayal: "She never affected gaiety or ostentation in dress, either for herself or her children. But always observed a *modest decorum*, though in affluent circumstances."[5] Either Robbins had not seen Mrs. Watson in fancy dress, or Copley concocted the costume in which he depicted her, an elegant garment that gives the sitter an unusually sleek profile, contrary to the effect created by conventional stays and corsetry.[6] She was, Robbins explained, entirely "free from all affectation and haughtiness in her deportment," a characterization that does not accord with the contrived pose and composition Copley deemed suitable for her. It may be that Copley used as much artistic license as Robbins did rhetorical language, each portraying Mrs. Watson in the most flattering terms possible, and that the clue to her true nature lies somewhere between the portrait and the lines of the eulogy.

George Watson sat for Copley the year after his wife's death. Although beautifully composed and filled with objects that allude to an opulent and active life, the widower's portrait (fig. 183) is comparatively somber and lacking in lush textures: a sobriety of mood and manner that may reflect the sitter's state of mind as well as Copley's changing style. It has been suggested that the Watson portraits should be considered pendants despite their stylistic dissimilarities.[7] Whether Watson commissioned both portraits at the same time or had his own picture painted after his wife's death as a belated commemoration of his marriage is, however, unknown. Here Copley may not only have provided a work of art and a likeness but also performed a service that consoled his grieving patron.[8]

<div align="right">C R</div>

1. The Blackburn portrait was once attributed to Copley. See Parke-Bernet Galleries, Inc., *Paintings and Art Property from the Estate of the Late Walter Jennings* (sale cat., New York, Oct. 25–26, 1949), lot 349, listed as *Mrs. Davenport of Portsmouth, N.H.*, by Copley. I am grateful to Theresa A. Carbone of The Brooklyn Museum, New York, for giving me a draft of her collection catalogue entry on the Blackburn painting.

2. The Watsons may have owned Delft vases, which were commonly found in upper-class homes in Boston after about 1730, or Chinese export porcelain, which was harder to come by. See Garry Wheeler Stone, "Ceramics in Suffolk County, Massachusetts: Inventories, 1680–1775," *Conferences on Historic Site Archaeology Papers* 3 (1968), pp. 73–90.

3. Elizabeth Watson, "Confession of Faith," Feb. 22, 1756, Pilgrim Hall Museum, Plymouth, Massachusetts.

4. Chandler Robbins, *A Sermon Occasioned by the Death of Mrs. Elizabeth Watson of Plimouth, Late Consort of George Watson, Esq; and Daughter of the Hon. Peter Oliver, Esq;* ... (Boston, 1767), p. 34.

5. Ibid.

6. Claudia Kidwell, National Museum of American History, Smithsonian Institution, Washington, D.C., for information regarding corsetry.

7. Virgil Barker, *American Painting: History and Interpretation* (New York, 1950), p. 140.

8. A miniature portrait of Elizabeth Oliver Watson probably taken from Copley's oil in the nineteenth century is in the Yale University Art Gallery, New Haven. That it is not Copley's work is certain.

21

Nathaniel Hurd

ca. 1765

Oil on canvas, 30⅜ x 25⅜ in. (77.1 x 64.5 cm)

The Cleveland Museum of Art, 1994, Gift of the John Huntington Art and Polytechnic Trust 15.534

Predating his portrait of Paul Revere (cat. no. 46) by about three years, Copley's *Nathaniel Hurd* was his first depiction of an artisan, a colleague from his own social class rather than a patron from one of Boston's elite families. Nathaniel Hurd, born in 1730, descended from a long line of skilled laborers whose handiwork had been well known in Boston since the early seventeenth century. His great-grandfather was a tailor, his grandfather was a joiner, and his father was the esteemed and prolific silversmith Jacob Hurd (1702/3–1758).[1] Nathaniel apprenticed to his father and became competent at the craft he learned from him, but he excelled as an engraver on silver, gold, and copper. He cut his first bookplate, which was on copper, in 1749 at age nineteen and within

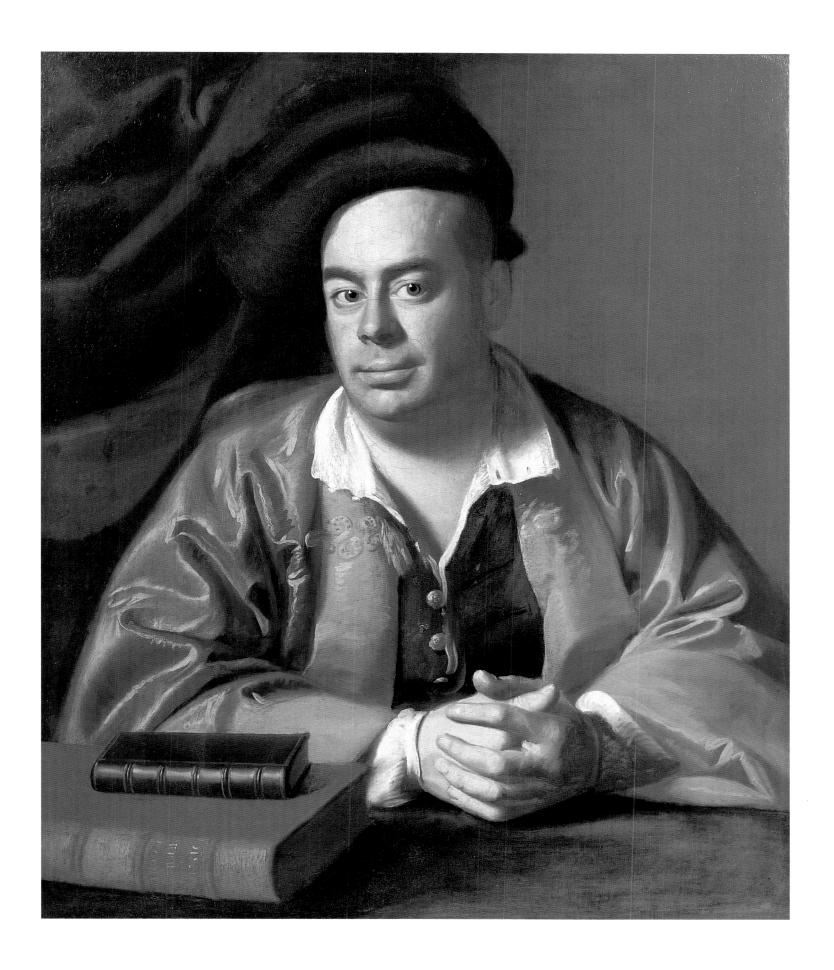

Fig. 184 *Nathaniel Hurd*, ca. 1765. Oil on canvas, 29⅜ x 24⅝ in. (74.6 x 62.5 cm). Memorial Art Gallery of the University of Rochester, New York, Marion Stratton Gould Fund 44.2

two years was commissioned to cut a view of the "South Prospect of the Court House in Boston" for dedication to Thomas Hubbard, speaker of the Massachusetts House of Representatives.[2] He is thought to have been the first American to have engraved on copper. After establishing his own shop during the mid-1750s, Hurd specialized in bookplates and also engraved summonses, trade cards, loan certificates, bills and receipts, invitations, portraits, cartoons, and the like, made "in the neatest Manner, and at reasonable Rates."[3] In 1765, about the time he sat for Copley, he designed the seal of Harvard College.

Hurd and Copley probably first met in about 1755, when the engraver had his portrait done in oil on copper by the painter (private collection). Hurd tried his hand at miniature painting and may have commissioned an example of Copley's work in the genre so that he could study it. The two artists are said to have collaborated on at least one occasion: in 1764 Hurd apparently engraved Copley's portrait of the Reverend Joseph Sewall (location unknown), the minister of Boston's Old South Church, after Copley failed to find an English mezzotinter for the job.[4] It is possible that Copley painted Hurd's portrait in exchange for his services as an engraver.

Even if Copley did barter the picture, his sympathetic and in many ways remarkable portrait of Hurd suggests an understanding between the two men that extended beyond mere practical collaboration and business dealings. Just eight years apart in age,

Copley and Hurd grew up amid similar circumstances under the guidance of craftsmen fathers—both skilled engravers—who not only encouraged their sons' artistic talents but also taught them the art of self-promotion and entrepreneurship. Both Copley and Hurd entered their chosen professions in the mid-1750s, set up shops in the same area of Boston, and worked for the same set of clients. And although one painted and the other engraved, they achieved similar status through their respective crafts. In eighteenth-century Boston, Hurd's crest-emblazoned bookplates, many of which he designed or fashioned for patrons who did not have a family coat of arms or seal, were as much in demand as Copley's pictures. Indeed, there were elements of portraiture in both products: bookplates as well as likenesses recorded desired personal attributes, pride in self, and aristocratic pretensions. And both had similar market value. In 1763 Hurd charged seven pounds for a large engraved seal, only slightly less than what Copley was paid for a half-length portrait measuring 50 x 40 inches in 1764.[5]

Copley's portrait of Hurd is at once a likeness that conveys a sense of the personality of the engraver and an homage to the creative essence of his craft. This Copley did, in part, by creating formal analogies between the portrait and Hurd's work: the painting's asymmetrically disposed details and flourishes of paint echo the Rococo irregularities of Hurd's cartouches and designs. Copley might also have paid tribute to his fellow professional by depicting him in the act of engraving or with his tools or an engraving set in front of him on the table at which he sits. An unfinished portrait of Hurd (fig. 184) that is generally considered to be a study or an aborted first start for the present portrait reveals that Copley initially intended to show Hurd at work in his rolled-up shirtsleeves. But Copley, perhaps aware that English painters commonly portrayed themselves and their colleagues at leisure, abandoned that idea and presented his subject in a sumptuous taupe silk banyan with embroidered salmon pink lining and a dark green turban. Seated on a polished side chair at a fabric-covered table with his clean hands gently folded and two leather-bound books before him, Hurd is depicted as a leisured gentleman; the image Copley cast him in is very close to the one he constructed two years later for the wealthy and fashionable businessman Nicholas Boylston (cat. no. 31). Copley offered subtle clues to Hurd's middle-class rank and his occupation, however: his open collar and narrow unruffled cuffs suggest his true station, and the books on his table, John Guillim's *Display of Heraldry* and Samuel Sympson's *New Book of Cyphers*, published in London in 1724 and 1726, respectively, betray his vocation. Copley was not recording a charade—an engraver posing as an aristocrat—but rather was conflating signs of the artisan with signs of the aristocrat to constitute an ideal image of the artist as a gentleman. Apparently Copley deemed his painting of Hurd successful in this respect, for he depicted himself the same way in his self-portraits of 1769 (fig. 25; cat. no. 49).

Copley carefully and consciously chose the way he portrayed Hurd, but the portrait is by no means contrived. The books cer-

tainly belonged to the sitter, who perhaps inherited them from his father—of the approximately fifty extant bookplates bearing Hurd's inscription, twenty-eight derived from designs drawn or described by Guillim.[6] And there is no reason to suspect that Hurd, who was quite successful by the mid-1760s, did not own the lavish banyan, waistcoat, and turban he wears in the painting, for his will lists clothing, furniture, prints, silver, books, and ample liquid assets.[7] A bachelor once called "a Hogarthian talent of character and humor," Hurd died in 1777, leaving most of his considerable possessions to his brothers and sisters.[8] CR

1. Hollis French, *Jacob Hurd and His Sons Nathaniel and Benjamin: Silversmiths, 1702–1781* (Boston, 1939), gives much information about the Hurd family.
2. See Abbott Lowell Cummings, "A Recently Discovered Engraving of the Old State House in Boston," in *Boston Prints and Printmakers, 1670–1775* (Boston, 1973), pp. 174–84.
3. Advertisement in *Boston Gazette*, Apr. 28, 1760.
4. See Copley, letter to [an English Mezzotinter], Jan. 25, 1764, Copley-Pelham Papers, CO5/38:51, Public Record Office, London. This letter and the proposal for printing Reverend Sewall's portrait that was enclosed in it are misdated 1765 in Jones 1914, pp. 31–32. There are no extant copies of Hurd's engraving of Copley's portrait. See "Early American Artists and Mechanics: Nathaniel Hurd," *New-England Magazine* 3 (July 1832), p. 5.
5. See Hurd's receipt for payment for "one Large Seal for Governor Wilmott, with his Coat of Arms, September 17, 1763," Hancock Collection, Massachusetts Historical Society, Boston; and Prown 1966, vol. 1, pp. 97–98.
6. Charles F. Montgomery and Patricia E. Kane, eds., *American Art, 1750–1800: Towards Independence* (exh. cat., New Haven: Yale University Art Gallery, 1976), p. 133. Kathryn C. Buhler, *American Silver, 1655–1825, in the Museum of Fine Arts, Boston* (Greenwich, Conn., 1972), p. 201, suggests that the books originally belonged to Jacob Hurd.
7. Nathaniel Hurd, Probate will, signed Dec. 8, 1777, and executed Jan. 23, 1778, Suffolk County, Docket no. 16448, Archives, Supreme Judicial Court, Boston.
8. "Early American Artists and Mechanics," p. 5.

22

John Hancock

1765
Oil on canvas, 49½ x 40½ in. (125.7 x 102.9 cm)
Dated on ledger: 1765
Museum of Fine Arts, Boston, Deposited by the City of Boston 30.76d

23

John Hancock

ca. 1770–72
Oil on canvas, 30 x 25 in. (76.3 x 63.7 cm)
Massachusetts Historical Society, Boston, Bequest of Henry Lee Shattuck, 1971

John Hancock (1737–1793) was at the threshold of his social, economic, and political destiny when Copley painted him in 1765. His origins, however, had been poor and thus disenabling in the rigidly class-stratified society of mid-eighteenth-century Massachusetts.[1] His father, the Reverend John Hancock, an inconsequential clergyman in North Braintree, died in 1744, leaving a widow, seven-year-old John, and two other children. But John Hancock—alone of his family—was rescued by his uncle Thomas, then the richest merchant in Boston, who adopted him, educated him at Boston Latin and Harvard College, and attempted to train him in the social and business habits of the House of Hancock, the largest transatlantic shipping firm in Boston. He became a full partner in his uncle's business in 1763 and sole owner after Thomas died in 1764.

Sometime between 1764 and 1766 Hancock had Copley paint a posthumous portrait of Thomas (fig. 1) for Harvard College. Expanded from Copley's bust-length pastel of about 1758, the eight-foot picture represents the elder Hancock full length in a three-quarter pose. The picture is a spectacle of the trappings of elite class. Thomas rests his ungloved right hand on an imported Queen Anne armchair with fancy volutes. To the right is an ornate English Rococo, marble-slab-top pier table of about 1740, upon which are placed an unadorned tricornered hat and a gilt-handled walking stick. Behind and to the left of the sitter is a salomónica Baroque column partially shrouded in drapery, and behind it, arcing from the left background to the right foreground, is a colonnade of paired composite columns of a type not found in American architecture.

Soon after this commission was completed, Hancock called on Copley to have his own portrait painted for his house, a magnificent mansion on Beacon Hill that he inherited from his uncle. But whereas the *Thomas Hancock* is regal, the *John Hancock* is austere. The younger man wears a dark blue frock coat trimmed in gold braid to accentuate the line of buttons and the edges of the plain wool material. On his head is a modest bob wig. He sits on an outdated Queen Anne chair of about 1740. And his environment is almost extinguished, bare except for a piece of hanging drapery and a covered table on which rest an open account ledger and a small inkstand.

The costume and setting are unexpected for a man who enjoyed the luxurious prerogatives of extreme wealth. King Hancock, as he would later come to be known, was conspicuous in the 1760s for wearing silk-velvet suits, driving around Boston in a bright yellow carriage, and stocking his mansion with the finest fabrics, furniture, glass, and Madeira wines that he could import from England. Equally surprising is the depicted action: Hancock working in a business ledger, seemingly ready to make or having just finished making entries in it. If anything, he neglected the House of Hancock as well as financial matters in general.

His uncharacteristic engagement with the account book has been interpreted by Wayne Craven as expressive of Calvinistic virtues, especially the idea that material rewards in life are the tan-

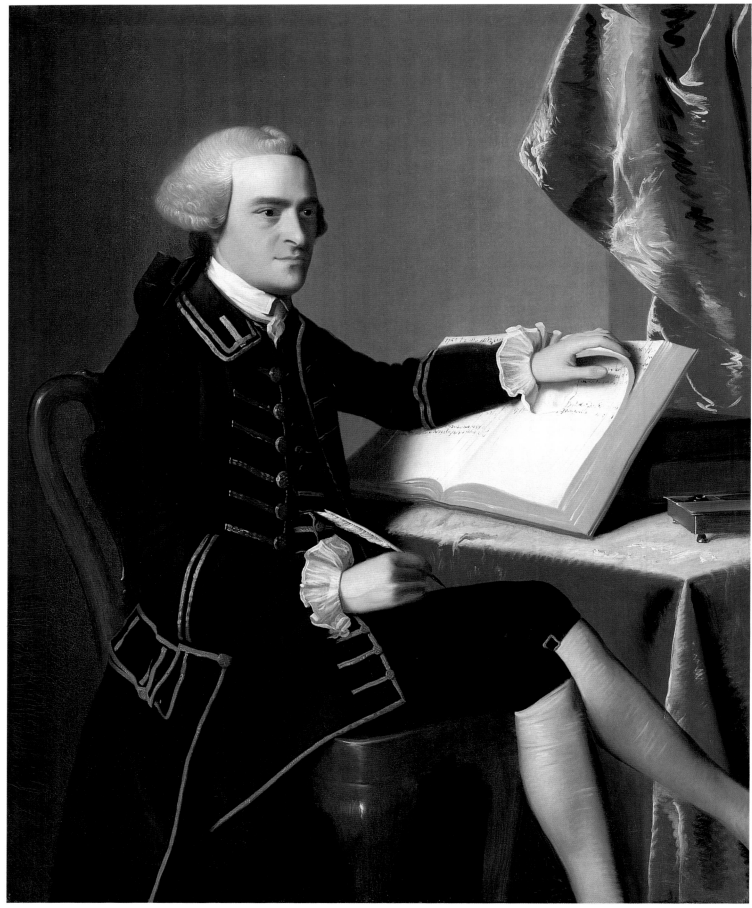

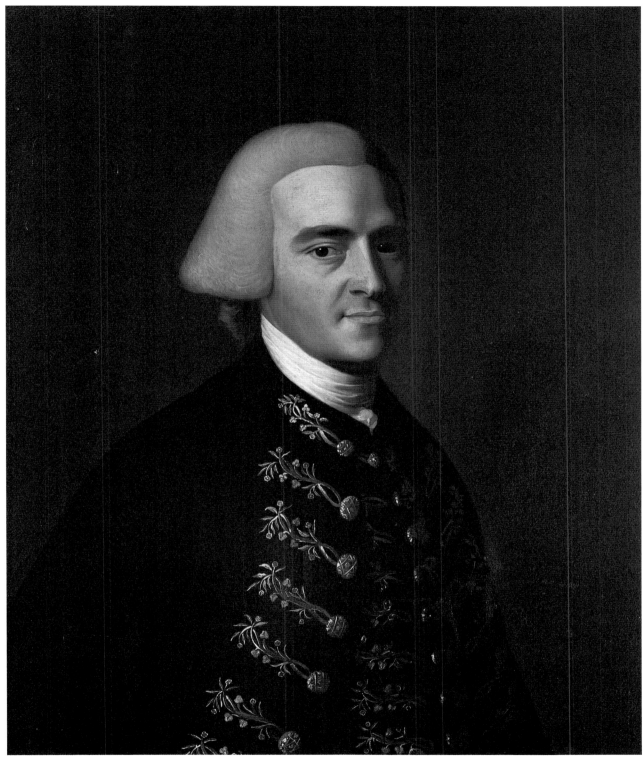

23

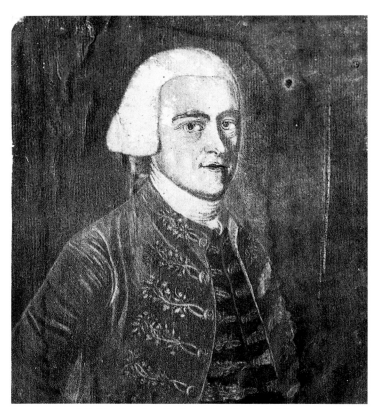

Fig. 185 Joseph Hiller Sr. after Copley. *John Hancock*. Mezzotint with watercolor, 9⅞ x 7⅞ in. (25.1 x 20 cm). Peabody Essex Museum, Salem, Massachusetts

Representatives.[4] While Hancock served as president of the Continental Congress between 1775 and 1777, one of the later Copley portraits was rendered in mezzotint by Joseph Hiller (fig. 185).[5]

A number of authors claim that one of the portraits of 1770–72 or the likeness of 1765 hung with Copley's painting of Samuel Adams (cat. no. 62) in the drawing room of the Hancock mansion.[6] Alternatively, the 1765 picture has been located in the parlor over the fireplace.[7] However, the probate inventory taken at Hancock's death, though it shows there were 128 pictures in the house, does not specifically mention any Copley portrait.[8]

P S

1. For John Hancock's biography, see W[illiam] T. Baxter, *The House of Hancock: Business in Boston, 1724–1775* (New York, 1945).
2. Wayne Craven, *Colonial American Portraiture: The Economic, Religious, Social, Cultural, Philosophical, Scientific, and Aesthetic Foundations* (Cambridge, 1986), pp. 324–26.
3. Gordon S. Wood, *The Radicalism of the American Revolution* (New York, 1991), pp. 88–89.
4. Prown 1966, vol. 1, p. 83.
5. The only known version of the mezzotint is illustrated here.
6. For example, John C. Miller, *Sam Adams: Pioneer in Propaganda* (Stanford, Calif., 1967), p. 254.
7. Craven, *Colonial American Portraiture*, p. 342; Margaret Henderson Floyd, "Measured Drawings of the Hancock House," in *Architecture in Colonial Massachusetts* (Boston, 1979), p. 93.
8. John Hancock, Probate inventory, 1795, Suffolk County, Docket no. 20215, Archives, Supreme Judicial Court, Boston.

gible proofs of God's divine blessing.[2] The ascetic image of Hancock may also be considered in political terms. Hancock's economic empire allowed him to form what Gordon Wood called "one of the most elaborate networks of political dependency in eighteenth-century America."[3] He had been using that political and economic capital since 1762, by running for public office in Boston—testing his power in a period marked by increasing attacks by such men as Samuel Adams on the entitlements and extravagances of the highest classes. The assaults on the privileged reached a crescendo when the houses of some of the elite were ransacked during the Stamp Act crisis of 1765, the year Copley first painted John Hancock. The violence against flamboyant elites may have inspired the young merchant to negotiate with Copley for a disciplined image of a workingman in a stark setting—an image Hancock could use as part of an effort to claim political authority in an era in which Americans were rejecting deference and embracing the new republican ideal of the man of the people.

Copley painted two more portraits of Hancock—the present cat. no. 23 and a picture in a private collection—between 1770 and 1772, when the businessman was increasingly identified as a radical Whig. These are identical, waist-length likenesses and, like the earlier canvas, are simple and unadorned images, representing Hancock in bare settings. Jules Prown speculates that one of the portraits may have been painted after the election of May 27, 1772, in which Hancock and Samuel Adams were reelected to the House of

24

Henry Pelham

ca. 1760
Oil on canvas, 16¾ x 13¾ in. (42.5 x 34.9 cm)
Private collection

25

Boy with a Squirrel (Henry Pelham)

1765
Oil on canvas, 30¼ x 25 in. (76.8 x 63.5 cm)
Museum of Fine Arts, Boston, Gift of the artist's great granddaughter
1978.297

These two pictures of Copley's half brother, Henry Pelham, are the only profile portraits the artist produced during his years in America. The picture of Pelham reading by lamplight appears to have been painted for Copley's own pleasure in about 1760 and is unique among his American works in terms of both style and sub-

ject matter—for it is smaller, more loosely brushed, and less detailed than his usual canvases of the period. It may be the candlelight painting that Charles Willson Peale recalled borrowing on a visit to Copley's studio in 1765: "I introduced myself to him [Copley] as a person just beginning to paint portraits. He received me very politely. I found in his room a considerable number of portraits, many of them highly finished. He lent me a head done by and representing candle light which I copied."[1] A candlelight painting is also referred to in correspondence between the Reverend Myles Cooper and Copley, further evidence of the artist's interest in the genre. In 1768 Cooper wrote to the artist: "if a Couple of Guineas will purchase the little Piece which I so much admired, the Nun with the Candle before her, You may send that also, which I will deposit in our College Library, as a Beginning to a public Collection." Copley responded, "as to the Candle light In consideration of the use you propose to make of it I will part with it for two Guineas, as it is my desire to see some publick collection begun in America."[2] The picture he sold to Cooper is unidentified and may be a work that Copley bought or a copy he made from a print.

Paintings of night scenes with artificial illumination originated in Renaissance Italy and were popular in Europe in the late sixteenth and early seventeenth centuries. In the mid-eighteenth century they enjoyed a revival, which may have been sparked by widely circulated prints that featured especially dramatic treatments of the theme.[3] Because it was an era of increasing literacy, pictures of children reading by candlelight, such as Sir Joshua Reynolds's *Boy Reading*, 1747 (private collection), were particularly favored. Reynolds's canvas and others of the sort have a Rembrandtesque quality, and Copley may have had the Dutch old master in mind when he conceived *Henry Pelham*.[4]

Joseph Wright of Derby, the British artist who made a specialty of candlelight and fireside scenes, produced *A Girl Reading a Letter by Candlelight*, ca. 1760–62 (Collection of Lt. Col. R. S. Nelthorpe), at about the same time Copley painted *Henry Pelham*. Wright is of special interest to Copley scholars because the early styles of the two artists share certain similarities—such as sophisticated rendering of textures and attributes and notably successful expression of the characters of their up-and-coming sitters. In fact, when Reynolds first saw *Boy with a Squirrel* at the Society of Artists exhibition in London in 1766, he mistook it for the work of Wright, who had shown with the society for the first time the preceding year.[5] Wright's portraits of the young brothers Samuel Rastall and William Rastall, both ca. 1762–64 (private collection), also bear resemblances to *Boy with a Squirrel*. The intriguing affinities between the work of Copley and Wright appear to be coincidental, the result of independent development on the part of each artist in his own provincial homeland; however, the reliance of both painters on mezzotints for inspiration may account for some of the stylistic parallels their pictures exhibit.[6]

Copley's second portrayal of his half brother, *Boy with a Squirrel (Henry Pelham)*, unlike the vast majority of his American works, was executed not as a portrait in the strict sense of the term but rather as an exhibition piece and was conceived not for his familiar patrons in Boston but instead for a distant, unknown audience in London. By 1765 Copley's style was mature, and he had achieved enormous commercial success in Boston; but now he was eager to know whether his work met English standards. In order to find out, he painted *Boy with a Squirrel*, using Henry Pelham as a model, and sent the canvas, which he had finished by early fall 1765, to London for inclusion in the spring 1766 exhibition of the Society of Artists. Admitting "some apprehension of its not being so much esteem'd as I could wish," he awaited the response.[7]

In May 1766 the art critic for the *London Chronicle* remarked that "a Boy with a Flying Squirrel" by Copley was "very clever" and that "with proper application, there is no doubt of his making a good painter."[8] A few months later Copley received two letters bearing the news that the British reaction to his work was generally favorable. In one, his friend Captain R. G. Bruce, who had transported the painting to London for him, quoted the opinion rendered by Reynolds, the leading English portraitist of the day. Reynolds said "that in any Collection of Painting it will pass for an excellent Picture, but considering the Dissadvantages . . . you had laboured under, that *it was a very wonderfull Performance*," despite "a little Hardness in the Drawing, Coldness in the Shades, An over minuteness." He maintained further that the young American could become "one of the first Painters in the World" provided that he come to study in Europe "before [his] Manner and Taste were corrupted or fixed by working in [his] little way at Boston."[9] The other letter was from the American-born Benjamin West, who had already achieved artistic prominence in London, where he had settled just three years earlier. West, like Reynolds, criticized aspects of Copley's style, declaring that he and other artists found his painting "to liney." However, he spoke also of "the great Honour the Picture has gaind you," encouraged Copley to paint a second picture for exhibition in London and to consider an extensive European trip, and offered him ongoing assistance.[10] In September of 1766 the Society of Artists elected Copley a fellow in recognition of his talent.[11]

The significance of *Boy with a Squirrel* has been recognized by almost every critic of American art who has written since 1834, when William Dunlap quoted Allan Cunningham's judgment that "of all that he ever painted, nothing surpasses his 'Boy and Squirrel' for fine depth and beauty of colour." Notable among nineteenth-century commentators was Henry T. Tuckerman, who asserted that the picture shaped Copley's "whole future career." More recently John Wilmerding described the painting as Copley's "early masterpiece and a significant milestone in colonial American art," noting that it was the "first major work painted by an American artist for himself, rather than on commission, and it also became the first American picture to be exhibited abroad."[12]

Since the nineteenth century commentators also have observed that *Boy with a Squirrel* is not simply a portrait. For example, in

24

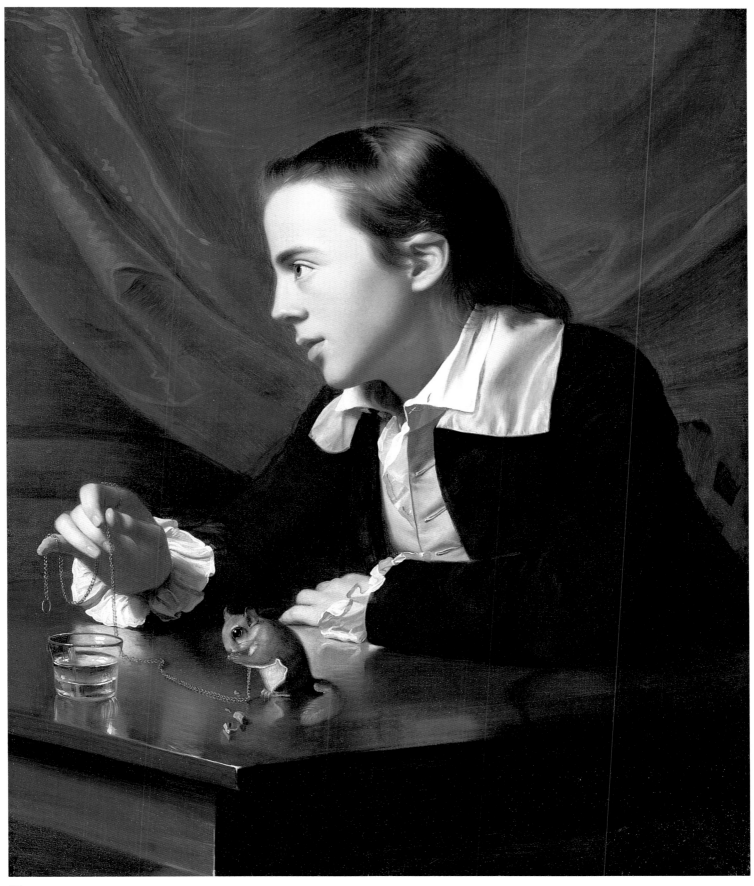

25

1880 S. G. W. Benjamin judged it to be one of Copley's most important history paintings, along with his *Death of Major Peirson* (fig. 10) and *Death of Chatham* (Tate Gallery, London); and in 1983 Trevor Fairbrother drew parallels between the work and "European devotional pictures" as well as Chardin's genre scenes of boys shown in profile playing cards.[13] Apparently, Copley realized that his style was too detailed and specific to meet the demands of English taste, and so he gave his adolescent sitter a dreamy, idealized look that removed his picture from the realm of portraiture as he usually practiced it. Although he generalized and softened Henry's face, he painted the squirrel's fur, the glass of water, the pink satin collar of the frock coat, and the reflections in the shiny tabletop as well as other details with his accustomed sharpness and attention to material reality. Because the work was an exhibition piece meant for a new and important audience, Copley was especially careful about the proportions of his figure. Recent conservation has revealed that he reworked the table and Pelham's arms to make them larger and bring them into a more appropriate relationship with the head.[14]

Pelham's beautifully rendered right hand holds the gold chain around the neck of a flying squirrel, a member of a tree-dwelling species native to the eastern United States. Copley accurately and meticulously portrayed this nocturnal creature, showing its large, appealing eyes and the white-edged gliding membrane that allowed it to "fly." When taken from the nest at an early age, such an animal can be tamed and makes an affectionate and delightful pet. Tuckerman reported that Copley was "said to have been intimately acquainted with the natural history of this animal, and made pets of several of the species,"[15] certainly a plausible contention in view of the careful detail of its depiction here. Copley included another flying squirrel in *Mrs. Theodore Atkinson Jr.* (fig. 163) and other kinds of squirrels in *John Bee Holmes* (fig. 55), and *Daniel Crommelin Verplanck* (cat. no. 68).[16] He must have chosen to use the little animals in these portraits because they were common pets in colonial America and also because a squirrel taking meat from a nut was an emblem of patience, diligence, and perseverance. They were featured in several emblem books available to Copley, including *Emblems for the Improvement and Entertainment of Youth* of 1755, as symbols of desirable character traits and were thus suitable for inclusion in portraits of children and women.[17]

After *Boy with a Squirrel* was exhibited at the Society of Artists in 1766 (as *A Boy with a Flying Squirrel*) and again in 1768 (as *A Boy Playing with a Squirrel*), Copley wrote to Captain Bruce that he was "quite willing to part with [it] at such a price as you may think proper."[18] However, the painting remained in the Copley family until Copley's great-granddaughter gave it to the Museum of Fine Arts, Boston, in 1978.

Henry Pelham (1749–1806) was Copley's half brother, the son of his widowed mother, who had married Peter Pelham in 1748. Henry's father died when he was just two years old, and so his early education was provided by his half brothers, including Charles Pelham, who was a schoolmaster, and Copley. He later attended the Boston Latin School, where he was in the class of 1758 with the future General Henry Knox. Under Copley's tutelage, Pelham became a painter of both miniature and large-scale portraits, an engraver, and a cartographer; in addition, he was unofficial business manager and assistant to Copley. The copious correspondence between the two men, published in 1914 in *Letters and Papers of John Singleton Copley and Henry Pelham, 1739– 1776*, attests to their close relationship and mutual affection, evident especially when Copley was in New York in 1771 and Pelham was overseeing his Boston affairs.

Among Pelham's early works is a drawing of 1770 of the Boston Massacre, which Paul Revere appropriated without attribution for his famous engraving of that event—prompting Pelham to write an indignant letter to Revere.[19] Although fewer than a dozen of Pelham's miniatures have been located, those extant, such as *Stephen Hooper*, 1773 (The Metropolitan Museum of Art, New York), affirm his skill in this format. Pelham executed a copy in miniature (private collection) of Copley's portrait of the Reverend Edward Holyoke (fig. 45), in 1772, since Copley himself was no longer painting miniatures at this time.[20] He amply demonstrated his facility as a cartographer in 1775–76, when he drew his map of Boston and vicinity, which was etched by Francis Jukes and published in London in 1777 (fig. 33). More strongly Loyalist than his half brothers, Pelham was given access to English military maps and a pass authorizing him to visit the front lines in Charlestown shortly after the Battle of Bunker Hill in order to finish his map.[21]

Unable to earn a living in Boston because of the Revolution, Pelham left the colonies in August 1776 with other Loyalists and settled in London, where Copley was already established. In London he continued to paint miniatures and large-scale portraits and taught drawing, geography, and astronomy. He exhibited his painting *The Finding of Moses* (location unknown), later engraved by W. Ward, at the Royal Academy in London in 1777 and showed several miniatures there in 1778. Pelham settled in Ireland with his Irish wife, Catherine Butler, but returned to London when she died after bearing twin sons. In 1789 Pelham was appointed agent for Lord Lansdowne's Irish estates, a position in which he served ably, utilizing his expertise as a cartographer and civil engineer. He drowned in 1806 while overseeing the construction of a martello tower on an island in the River Kenmare in Ireland.

JLC

1. Charles Willson Peale, letter to Rembrandt Peale, Oct. 28, 1812, in John Sartain, *The Reminiscences of a Very Old Man 1808–1897* (1899; reprint, New York, 1969), p. 147.
2. Myles Cooper, letter to Copley, Aug. 5, 1768, in Jones 1914, p. 71.
3. Benedict Nicolson, *Caravaggism in Europe*, 2d ed., rev. Luisa Vertova (Turin, 1989), vol. 1, pp. 25–28; David Alexander and Richard T. Godfrey, *Painters and Engraving: The Reproductive Print from Hogarth to Wilkie* (New Haven, 1980), pp. 3, 30.
4. See Christopher White, David Alexander, and Ellen D'Oench, *Rem-*

brandt in Eighteenth Century England (exh. cat., New Haven: Yale Center for British Art, 1983). Several scholars have noted that Reynolds's *Boy Reading* bears a strong resemblance to Rembrandt's *Titus*, 1655 (Museum Boymans-van Beuningen, Rotterdam). In addition to prints of Rembrandt's work, Copley had available to him a "likeness of Richard Saltonstall said to have been painted in Holland in 1644 by Rembrandt" (Samuel Isham, *The History of American Painting* [New York, 1905], p. 23).

5. Benjamin West, letter to Copley, Aug. 4, 1766, in Jones 1914, p. 44.
6. Judy Egerton, *Wright of Derby* (exh. cat., London: Tate Gallery; New York: The Metropolitan Museum of Art, 1990), pp. 49–50, 56–57; Benedict Nicolson, *Joseph Wright of Derby: Painter of Light* (London, 1968), pp. 3–4, 12–13, 29, 34. Nicolson discusses Copley's use of a mezzotint by Thomas Frye for the pose used in *Mrs. Gawen Brown*, 1763 (Yale University Art Gallery, New Haven), and the "vital part Frye's mezzotints played in the construction of heads and gestures in [Wright's] famous subject pieces and genre scenes from 1765 onwards" (ibid., p. 31).
7. Copley, letter to [Captain R. G. Bruce], Sept. 10, 1765, in Jones 1914, p. 35.
8. *London Chronicle*, May 17–20, 1766, clipping in W. T. Whitley Papers, vol. 3, p. 344, British Museum, London. I am grateful to Carrie Rebora for bringing this reference to my attention.
9. Captain R. G. Bruce, letter to Copley, Aug. 4, 1766, in Jones 1914, pp. 41–42.
10. Benjamin West, letter to Copley, Aug. 4, 1766, in Jones 1914, pp. 43–44.
11. Francis M. Newton, letter to Copley, Sept. 3, 1766, in Jones 1914, pp. 45–46.
12. Allan Cunningham, quoted in Dunlap 1834, vol. 1, p. 125; Tuckerman 1867, p. 77; John Wilmerding, *American Art* (Harmondsworth, 1976), p. 37.
13. S. G. W. Benjamin, *Art in America* (New York, 1880), p. 21; Trevor J. Fairbrother, catalogue entry for *Boy with a Squirrel*, in Theodore Stebbins Jr., Carol Troyen, and Trevor J. Fairbrother, *A New World: Masterpieces of American Painting, 1760–1910* (exh. cat., Boston: Museum of Fine Arts, 1983), pp. 194–95.
14. I am grateful to Jim Wright, Jean Woodward, and Rita Albertson of the Conservation Department, Museum of Fine Arts, Boston, for sharing this information with me.
15. Tuckerman 1867, p. 77.
16. Joseph Badger was one of the first American artists who used squirrels in portraits. He featured them in particular in his pictures of children. Among his paintings with squirrels are: *Benjamin Badger*, 1758–60 (Winterthur Museum, Delaware); *Rebecca Orne*, 1757 (Worcester Art Museum, Massachusetts); and *Portrait of Two Children*, ca. 1760 (Abby Aldrich Rockefeller Folk Art Center, Williamsburg, Virginia). Numerous American artists followed the lead of Badger and Copley in depicting squirrels in portraits of women and children. Examples of their works are: William Williams, *Deborah Hall*, 1766 (The Brooklyn Museum, New York); John Durand, *James Beekman Jr.*, 1766 (The New-York Historical Society); and Ralph Earl, *Portrait of Mrs. Gershom Burr*, 1798 (location unknown; illustrated in *Quality: An Experience in Collecting* [exh. cat., New York: Hirschl and Adler Galleries, 1974], no. 15). Squirrels rarely appear in eighteenth-century European paintings. See Fairbrother, entry for *Boy with a Squirrel*, in Stebbins, Troyen, and Fairbrother, *New World*, pp. 194–95.
17. See Roland E. Fleischer, "Emblems and Colonial American Painting," *American Art Journal* 20, no. 3 (1988), pp. 3–35.
18. Quoted in Allan Cunningham, *The Lives of the Most Eminent British Painters and Sculptors* (New York, 1868), vol. 4, p. 142. p. 228.

19. Henry Pelham, letter to Paul Revere, Mar. 29, 1770, in Jones 1914, p. 83.
20. See Richard H. Saunders and Ellen G. Miles, *American Colonial Portraits, 1700–1776* (exh. cat., Washington, D.C.: National Portrait Gallery, 1987), pp. 307–8; and Dale T. Johnson, *American Portrait Miniatures in the Manney Collection* (exh. cat., New York: The Metropolitan Museum of Art, 1990), pp. 177–78.
21. James [?] Johnson, letter to Henry Pelham [1775?], in Jones 1914, p. 350. For a discussion of Pelham's map of Boston, see John W. Reps, "Boston by Bostonians: The Printed Plans and Views of the Colonial City by Its Artists, Cartographers, Engravers, and Publishers," in *Boston Prints and Printmakers, 1670–1775* (Boston, 1973), pp. 52–56. For the best account of Pelham's life, see D. R. Slade, "Henry Pelham, the Half-Brother of John Singleton Copley," *Publications of the Colonial Society of Massachusetts* 5 (1902), pp. 193–211.

26

Joseph Green

ca. 1764–65
Pastel on paper mounted on canvas, 22 x 17 in. (55.9 x 43.2 cm)
Museum of Fine Arts, Boston, Gift of Dr. Samuel Abbott Green 10.34

Already identified in the nineteenth century as "among the good specimens of [Copley's] skill and style,"[1] this portrait of Boston merchant Joseph Green (1703–1765) is a strong example of the artist's early work in pastels. It is in monochrome except for the sitter's face; his body is close to the picture plane and is nearly frontal, filling almost the entire space. Green's large head is made to seem all the more dominant by the ruddiness of his complexion, which contrasts strikingly with the soft grays of his jacket and wig and the dark background. The planes of his face are smooth and his features generalized; the details of his costume and even the curls of his wig are rendered schematically so as to concentrate attention on Green's massive, powerful presence.

The forcefulness that Copley attributes to this sixty-two-year-old man (Jules Prown aptly characterizes him as "gruff")[2] is only partly borne out by surviving biographical information. Born in Salem Village (now Danvers), Massachusetts, Green was the fourth child of the Reverend Joseph and Elizabeth Gerrish Green. After the death of his father in 1715, his family moved to Cambridge, where his mother married the Reverend William Brattle. In 1727 Green married Anna Pierce of Portsmouth, New Hampshire. They had twelve children, of whom two—George Green (see cat. no. 48) and Elizabeth Green Storer (see cat. no. 44)—sat for Copley several years after this portrait was drawn.

As a merchant, Green was successful enough to maintain a business on Brattle Street and a separate residence on Hanover

26

27

Street, a neighborhood of churches and clerics. He was sufficiently involved in civic affairs to hold a commission as magistrate under governors William Shirley and Francis Bernard. His political leanings were signaled by his signing of the Tax Petition of 1755 (which requested an abatement of Boston's taxes); however, eulogies that appeared shortly after his death suggest that his activism was temperate and define his personality as conciliatory rather than aggressive. One such notice hailed him as:

Without ambition and without desire,
But such as glow'd with true celestial fire. . . .
And always ready when the wretched call
To dry their tears, to check the rising sigh,
Hear their complaints, and soon relief apply.
By practice good, and by experience wise,
Spoke as he thought, and as he liv'd he dies.[3]

CT

1. Tuckerman 1867, p. 72.
2. Prown 1966, vol. 1, p. 41.
3. Unidentified newspaper clipping, transcribed in the curatorial files, Department of Paintings, Museum of Fine Arts, Boston.

27

Mrs. Edward Green (Mary Storer)

1765
Pastel on paper mounted on canvas, 23 x 17½ in. (58.4 x 44.5 cm)
Signed and dated left center: John S. Copley / fec.t 1765
The Metropolitan Museum of Art, New York, Charles B. Curtis Fund,
1908 08.1

Commissions from the closely related Green and Storer families of Boston accounted in large measure for Copley's extremely prolific production of pastel portraits during the mid-1760s. Mary Storer, who was born to Ebenezer and Mary Edwards Storer in 1736 and married Edward Green in 1757, was among the first in her family to sit for Copley. Her vivid portrait probably was executed within months of her father-in-law's (cat. no. 26) and predates those Copley drew of her parents and her brother and sister-in-law (cat. nos. 41, 42, 43, 44). Despite a slightly awkward elongation of her neck, the portrait is among Copley's most successful works in pastel crayons. His virtuoso rendering of satin, lace, pearls, flowers, and background drapery captures subtle effects that only the relatively few masters of this difficult medium have been able to achieve.

Mary was the second of three Storer children to marry into the Green family. Her brother, Ebenezer II, married Elizabeth Green in 1751, and Hannah Storer married Joshua Green in 1762. Mary's husband Edward, one of nine surviving children of Joseph and Anna Pierce Green, was probably a merchant like his father. An inventory of his rather meager possessions taken at the time of his death suggests that the Greens suffered financial loss during the Revolution.[1] Mary Storer Green married Benjamin Hall in 1791. She did not have children. CR

1. "Percival and Ellen Green," *New England Historical and Genealogical Register,* Apr. 1861, pp. 107–9; Edward Green, Probate inventory, Aug. 16, 1790, Suffolk County, Docket no. 19557, Archives, Supreme Judicial Court, Boston.

28

Thomas Hancock

ca. 1758, enlarged 1766
Oil on copper, sight, 3⅞ x 2⅞ in. (9.8 x 7.3 cm)
National Portrait Gallery, Smithsonian Institution, Washington, D. C.
NPG.81.17

29

Mrs. Thomas Hancock (Lydia Henchman)

1766
Oil on copper, sight, 3⅞ x 2⅞ in. (9.8 x 7.3 cm)
Signed and dated lower right: JS. Copley [monogram] / pinx 1766
National Portrait Gallery, Smithsonian Institution, Washington, D. C.,
Gift of Charles H. Wood, 1981 S/NPG.81.4

Thomas Hancock (1702–1764) rose from rather modest beginnings as an impecunious minister's son to pursue a successful career as a merchant, eventually becoming one of Boston's richest citizens and the benefactor of his nephew John Hancock. Thomas first worked as a bookbinder's apprentice; by age twenty, however, he owned his own bookshop, and he soon expanded his interests to include paper manufacturing and provisioning the Newfoundland fishing fleets. In 1730 he married Lydia Henchman (1714–1777), the daughter of a prominent bookseller, and thereafter enlarged his business even further, becoming the principal supplier of the British forces in Nova Scotia by 1746. When his partner, Charles Apthorp, died in 1758, Hancock took over exclusive control of his enterprises and his wealth increased yet again; he also inherited considerable assets from the Henchman family in 1761. In 1764, just before his death, he complained that the new British taxes were oppressive for businessmen, maintaining to a colleague in England that "we are worth Saving in this part of the world."[1]

Hancock belonged to an older generation than many of Copley's patrons of oils, and he commissioned only a modest pastel (private collection) and this related miniature from him. Yet in his younger days, as befitted his status as a wealthy and socially prominent merchant, Hancock had been quite a collector: he ordered portraits of himself and his fiancée from John Smibert in 1730 (Museum of Fine Arts, Boston; Colby College, Waterville, Maine), and his will documents "pictures of all kinds and . . . Paintings [in and] not in Frames."[2] Within two years of Hancock's death in 1764, Copley replicated his pastel likeness of him (location unknown), reworked this miniature of him, made the present miniature of Lydia Henchman Hancock and a pendant to the pastel replica of Thomas (location unknown), and painted a full-length posthumous oil portrait of Thomas (fig. 1).

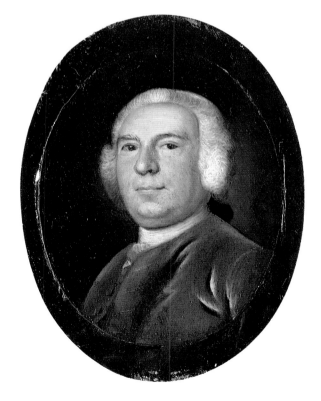

John Hancock instigated at least part of this spurt of artistic activity. Flush with the fortune he inherited from his childless uncle, he commissioned Copley to paint the full-length portrait, which he presented to Harvard in 1766 in honor of Thomas for endowing a professorship in languages. John Hancock may also have paid for some of Copley's other late likenesses of Thomas in tribute to his generosity; several portraits of the elder Hancocks, including these miniatures, descended from John, but it is not known when he acquired them.[3]

These miniatures are an unusual pair, as one was made about eight years after the other. Thomas was painted when he was in his mid-fifties. Shown in a plain brown suit and a simple wig tied with a black ribbon rather than with the luxurious trappings he was able to afford, he appears prosperous—even his modest wig indicates elite status—and unpretentious. With its long, fluid brushstrokes, *Mrs. Thomas Hancock* reveals Copley's more mature painterly style. The sitter is presented as a loyal middle-aged widow, her white cap and fichu draped with black net. When he painted Lydia on a slightly larger piece of copper than he had used for Thomas, Copley enlarged the earlier likeness by setting it into a wooden surround and painting over the edges. These small portraits were framed for display as pendants. E E H

1. Quoted in John W. Tyler, *Smugglers and Patriots: Boston Merchants and the Advent of the American Revolution* (Boston, 1986), p. 84.
2. Hancock left them all to his nephew John Hancock but specified that his widow might "hold [them] during her life only" (Thomas Hancock, Will, 1764, Suffolk County, Docket no. 13484 [Suffolk County Probate Records, vol. 63, pp. 277–78], Archives, Supreme Judicial Court, Boston).
3. Lydia Henchman Hancock's will of 1777 (Suffolk County, Docket no. 16409 [Suffolk County Probate Records, vol. 76, pp. 257–59], Archives, Supreme Judicial Court, Boston) does not mention the miniatures, but they appear in John Hancock's 1793 inventory, along with numerous other works of art.

30

Mrs. Thomas Boylston (Sarah Morecock)

1766
Oil on canvas, 51 x 40⅛ in. (129.5 x 102 cm)
Signed and dated center right: Jno. S: Copley / pinx 1766
Harvard University Portrait Collection, Cambridge, Massachusetts,
Bequest of Ward Nicholas Boylston, 1828

Matriarch of a great dynasty, Sarah Morecock Boylston (1696–1774) was one of the first of six members of the Boylston family painted by Copley in 1766 and 1767. Her husband, Thomas Boylston, described himself as a shopkeeper, but in fact he was extremely prosperous, running a thriving importing business and owning considerable property in Boston, Roxbury,

Brimfield, and Bedford. When he died in 1739, he left to Sarah "the whole income of my Estate, both Real and Personal, by her to be employed . . . toward her comfortable support, and the maintenance and education of my children." The estate was valued at nearly six thousand pounds, and it formed the nucleus of the extraordinary fortune the Boylstons would accumulate over the next thirty years.[1] No family pictures were enumerated in this legacy—the Boylstons apparently did not consider themselves the equals of such leading families as the Bowdoins and the Winslows, who had hired John Smibert, Robert Feke, Joseph Blackburn, and other masters to create a visual record of each generation. However, the purchase of a grand house on School Street in the early 1760s must have made the acquisition of such portraits quite desirable, because in 1766 Copley was hired to paint Mrs. Boylston, her sons Nicholas (cat. no. 31) and Thomas II (fig. 187), and her daughters Rebecca (cat. no. 33), Lucy, and Mary (figs. 186, 52).[2] (Mary's husband, Benjamin Hallowell, had been painted by Copley a year or two before; this portrait jointly owned by Colby College Museum of Art, Waterville, Maine, and Bowdoin College Museum of Art, Brunswick, Maine.)

These portraits are all in Copley's customary half-length, or 50- x 40-inch, format; astonishingly, most retain their original matching Rococo frames.[3] Except for Rebecca, all are shown seated in chairs of the newly fashionable Chippendale, or Rococo, style,

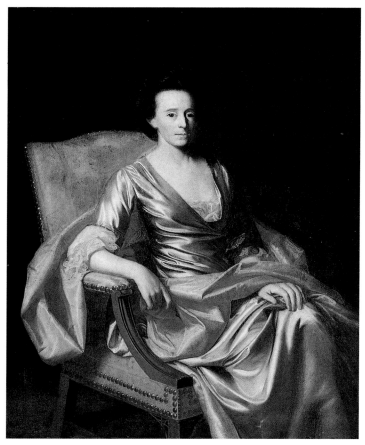

Fig. 186 *Mrs. Timothy Rogers (Lucy Boylston)*, ca. 1766–67. Oil on canvas, 50 x 40 in. (127 x 101.6 cm). Museum of Fine Arts, Boston, Bequest of Barbara Boylston Bean 1976.668

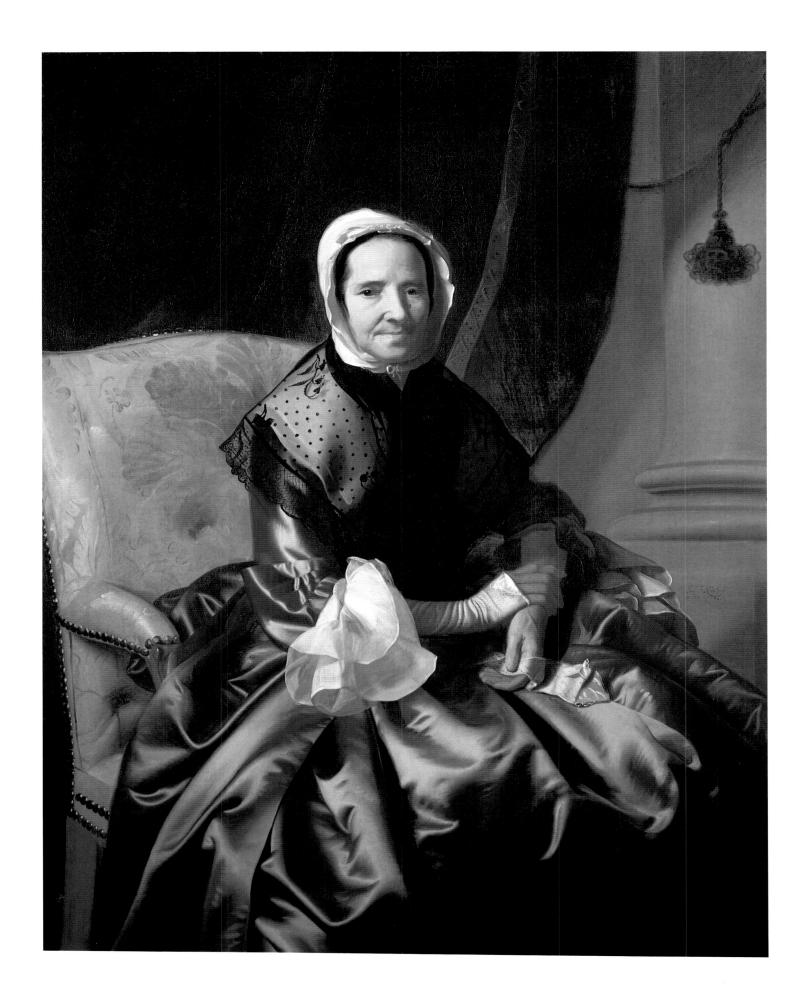

and, in fact, Mrs. Boylston and Lucy are seated in the identical upholstered armchair, probably of Massachusetts origin.[4] The portraits share an aura of luxury and elegant taste, and all reveal Copley's unique ability to allude to his sitters' exalted social station by inventing settings of spectacular grandeur (here a massive column and an enormous swag of smoky drapery form the background) while rendering details with compelling verisimilitude. For example, in *Mrs. Thomas Boylston*, where the chair is covered in a rich silk damask, a fabric that presumably came in relatively narrow widths, Copley carefully delineated the seam in the upholstery and revealed the pattern of the brocade to have been imperfectly aligned.[5]

The decorative scheme of this portrait is one of Copley's most skillful. He painted Mrs. Boylston in the subdued tones he often reserved for elderly women, with color harmonies of great subtlety: here, for example, the bronze-gold of the dress resonates with the creamy yellow-gold of the chair. Clear, diffused light accentuates the remarkable sheen of the sitter's satin gown, but it also draws attention to her face, which has variously been described as genial, intelligent, and typically Yankee.[6] Also highlighted are the starched linen sleeve ruffles at Mrs. Boylston's right elbow and the graceful gesture of her hands, the right hand resting on the left wrist, while the left holds the mitt that she has just removed. At the same time, the deep shadow partially disguises the awkward placement of the left arm; it is possible that the left forearm and the top fingers of the right hand are unfinished. The seventy-year-old Mrs. Boylston sits erect in her chair, an alert and disciplined posture softened by her thoughtful expression. Her black net fichu and her gown are spread out in a great pyramid, creating a form of such serenity and balance that it becomes a monument to the stability of matriarchy.

Mrs. Thomas Boylston has been one of Copley's most frequently exhibited and reproduced paintings. It was displayed at the Boston Athenaeum in the early nineteenth century and was included in every major Copley exhibition, as well as in many survey shows of American art, in the twentieth. Even in the late nineteenth century, when Copley's reputation declined somewhat in the face of a vogue for French-influenced styles, admiration for *Mrs. Thomas Boylston* remained constant. It was one of five Copley oils displayed in the *Chronological Exhibition of American Art*, held in 1872 at the Brooklyn Art Association, and in 1888 the perceptive critic William Howe Downes used it to refute the charge that "Copley could paint nothing so well as his sitter's clothes," maintaining that "Copley's fame may rest secure upon the portrait of Mrs. Thomas Boylston, which recalls to mind the work of the great masters by its simplicity, repose, penetrating truth, and refinement."[7]

CT

1. Thomas Boylston, Last will and testament, Boylston Papers, Massachusetts Historical Society, Boston; William Bentinck-Smith, "Nicholas Boylston and His Harvard Chair," *Proceedings of the Massachusetts Historical Society* 93, 1981 (1982), pp. 18–19.

2. *Lucy Boylston (Mrs. Timothy Rogers)* is a posthumous portrait, for Mrs. Rogers died in 1759.

3. The fact that the portraits are all in the same format and in very similar frames suggests that they may have been intended to be displayed en suite in the hall of the Boylston Mansion House on School Street. See Morrison H. Heckscher, "Copley's Picture Frames," in this publication.

4. Mary Boylston's chair has slightly different arms and only a single row of brass tacks along the seat. These Chippendale chairs, also known as elbow chairs or French chairs, were very stylish in America and reflected a predilection on the part of colonists for English fashion. I thank Gerald W. R. Ward for information about them.

5. A very similar chair, also with seamed upholstery, appears in a number of Copley portraits (see, for example, *Mrs. Isaac Smith* [cat. no. 51]), suggesting that it quite likely was a studio prop. Prown (1966, vol. 1, p. 54) notes the frequency with which the chair, Mrs. Boylston's pose, and aspects of her costume appear in Copley's work of the period, particularly in his portraits of older women.

6. "First Great American Painter Liked Women's Dress and Hands," *New York Sun*, Jan. 5, 1937, Copley Papers, reel 53, frame 86, Archives of American Art, Smithsonian Institution, Washington, D.C.; Prown 1966, vol. 1, p. 54; [William Howe Downes], "Boston Painters and Paintings," *Atlantic Monthly* 62 (July 1888), p. 93.

7. [Downes], "Boston Painters and Paintings," p. 93.

31

Nicholas Boylston

1767
Oil on canvas, 49 x 40 in. (124.5 x 101.6 cm)
Signed and dated lower left: JSC [monogram] p. 1767.
Harvard University Portrait Collection, Cambridge, Massachusetts, Bequest of Ward Nicholas Boylston, 1828

32

Nicholas Boylston

ca. 1769
Oil on canvas, 50¼ x 40¼ in. (127.6 x 102.2 cm)
Museum of Fine Arts, Boston, Bequest of David P. Kimball 23.504

Even in the increasingly materialist climate of mid-eighteenth-century Boston, Nicholas Boylston (1716–1771) stands out as an unusually wealthy and stylish man. His firm, Green and Boylston, became extremely successful in the 1760s, importing from abroad the textiles, paper, tea, and glass eagerly sought by avidly consumerist Bostonians. He bought his house on School Street in about 1761 from Jacob Wendell. Known as the Mansion House, it was in one of the city's most elegant quarters; his business partner and good friend Joseph Green, Richard Clarke (Copley's father-in-law and also a prosperous importer), and James Otis were among

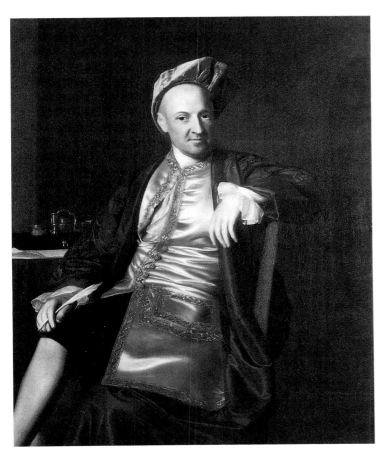

Fig. 187 *Thomas Boylston II*, ca. 1767. Oil on canvas, 50 x 40¼ in. (127 x 102.2 cm). Harvard University Portrait Collection, Cambridge, Massachusetts

Known to be somewhat irascible,[3] Thomas manifests an expression that seems rather more suspicious than Nicholas's, but the attitudes and attire of the two men are otherwise parallel. Hanging in the School Street house, these portraits, along with those of the Boylstons' mother, Sarah (cat. no. 30), and sisters Rebecca (cat. no. 33), Lucy, and possibly Mary (figs. 186, 52), all commissioned at the same time, bespoke an extraordinary family solidarity that even the Revolution could not entirely disrupt.

Sometime after he completed the first group of Boylston portraits in 1767, Copley was hired to paint Nicholas Boylston again and in 1773 was asked to produce a third likeness (fig. 135), based on the first but in full length. The sheer number of portraits commissioned of a single family was rare in Copley's practice and the demand for two large-scale replicas unprecedented. The request for a second portrait of Nicholas Boylston gave Copley, an unusually ambitious and self-motivated painter, the occasion to try to improve upon his art. The result was a portrait superficially quite similar to the first but markedly different in expressive effect, an achievement that could not fail to please Copley's discerning patron.

The two half-lengths are identical in virtually every detail, and the figure in the third exactly replicates that in the first two. Copley may have been able to achieve this astonishing correspondence by tracing the figure: in a letter he wrote to his half brother, Henry Pelham, from Italy the year after he painted the last portrait, he referred to his use of this technique. He explained "when I was uncertain of the effect of any figure Or groop of figure[s] I drew them of the sise on a peace of Paper by themselves shaded them and traced them on the Paper on which my Drawing was to appear to the Publick, *just in the way you have seen me proceed with Draperys, etc., in my portraits* [author's italics]."[4]

The few discrepancies between the first two portraits definitively establish Harvard's version as the initial composition and the one owned by the Museum of Fine Arts, Boston, as the second version. These changes also effected subtle improvements in the design.[5] Most significant among them is an adjustment, revealed by pentimenti, in the outline of the turban. This headgear is flat across the top in Harvard's painting; it was originally conceived the same way in the Boston portrait but subsequently was given a more peaked profile. The revised turban is more flattering than the first one to the oval shape of the sitter's head and more gracefully echoes the diagonal of the drapery behind him.

Although the first two portraits have in the past been assigned the same date, 1767, stylistic differences suggest that there may have been a longer interval between the painting of the first and second versions than is generally supposed. Between about 1766 and the end of the decade Copley's style evolved from a somewhat decorative manner, in which he lavished as much attention on details of costume and accessories as on the head of his subject, to a style in which the sitter, particularly his or her face and hands, was given greater prominence.[6] In the second Boylston portrait the color scheme of the costume—rich gold and purple—is deeper than that of the first, contrasting with and setting off the head and

Boylston's neighbors. His entertainments were lavish, and his gardens were celebrated for their beauty.[1] His love of elegant clothing, evinced in these portraits, is further documented in his will, in which one of the first items mentioned is all his "Wareing Appearelle," left to his brother, Thomas II.[2]

The likeness of Nicholas Boylston at Harvard is among Copley's most successful renderings of a wealthy gentleman at ease. Rather than appearing in formal attire, Boylston wears a blue-green morning gown of heavy silk damask over a beige silk waistcoat, partially unbuttoned to reveal a ruffled white linen shirt that also has ruffles at the cuffs. A red velvet turban covers his shaved head (the absence of a wig is a further indication of informality). Boylston sits in a graceful Massachusetts Chippendale side chair, in front of a grand swag of drapery. In the distance, a three-masted ship (an allusion, presumably, to the vessels owned by Green and Boylston) sails past a lighthouse into the harbor. Boylston's right hand is at his waist; his left arm rests casually on a pile of ledgers. His body is shifted toward the viewer, and his face wears an expression that is at once placid and inquiring. In Copley's portrait of Nicholas's brother Thomas Boylston II (fig. 187) the sitter is attired with similar informality, in morning gown and turban; he is shown at his writing desk and is likewise turned to address the viewer.

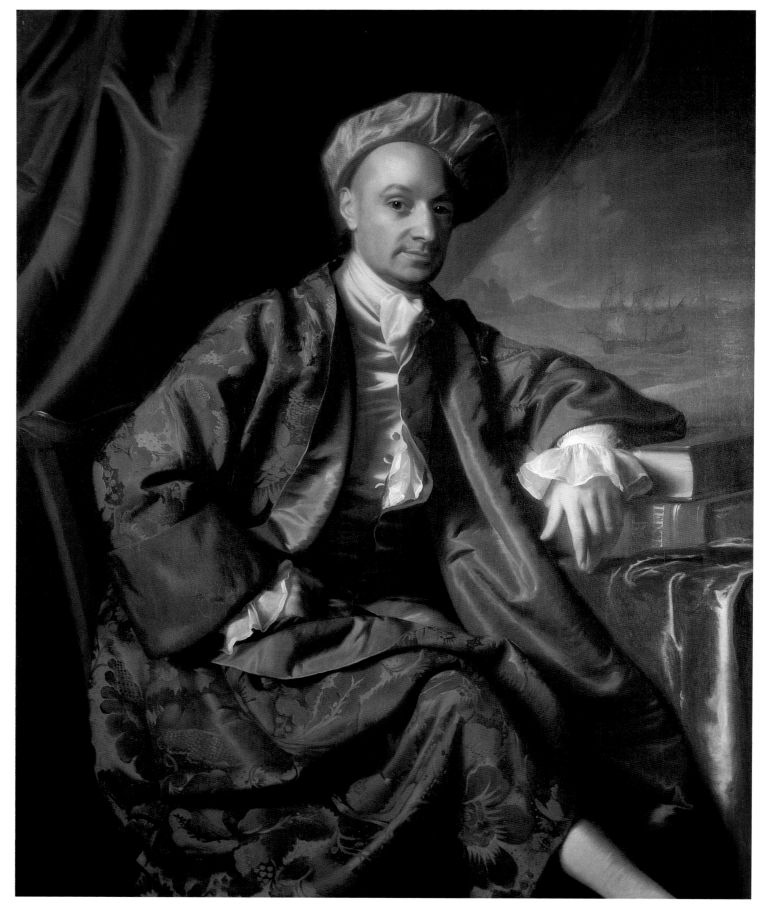

31

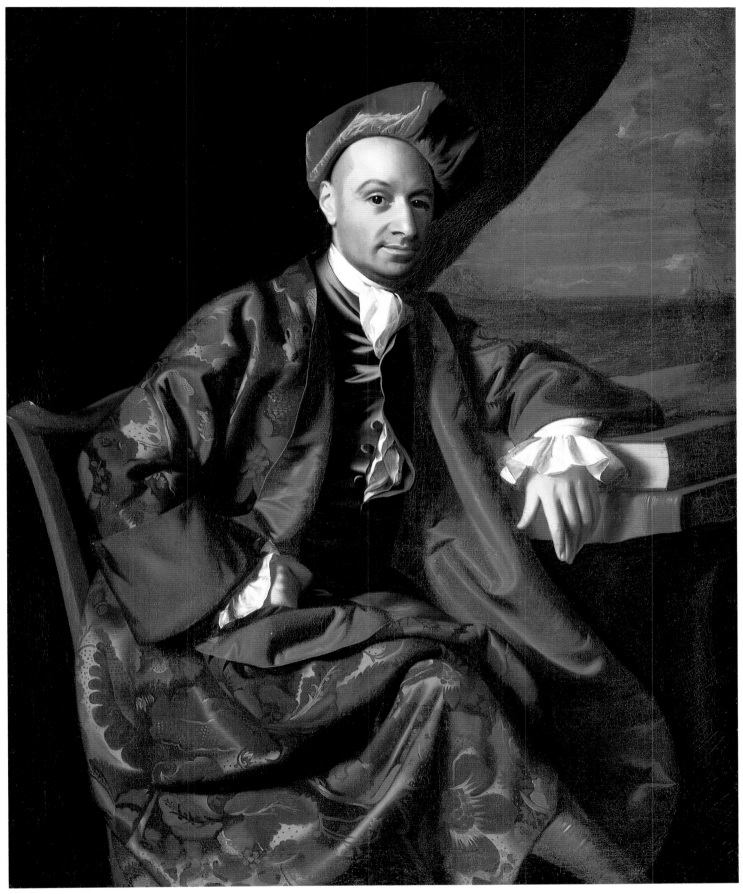

hands. For the evenness of value seen in the first version Copley substituted a more compelling variety of intensities: light and atmosphere were subtly adjusted to place greater emphasis on the sitter's face. The modeling is bolder, and at the same time aspects of the picture Copley previously found so tantalizing—the pattern of a brocade, the textures of silk and velvet—are subordinated to the careful rendering of the face.[7] If the first *Nicholas Boylston* impresses with the sumptuousness of its decorative detail, the second provides a more probing characterization and portrays the Boston merchant as a man of powerful presence and distinction as well as a man of lavish tastes.

The third and last portrait of Nicholas Boylston is the grandest of the three but the least successful. This version was commissioned by a grateful Harvard College in 1773, two years after Nicholas made a bequest of £1,500 to establish the Boylston Professorship of Rhetoric and Oratory. It was intended to join the full-length portraits of Thomas Hancock and Thomas Hollis (other donors of professorships) in the college's Philosophy Room. Copley was required to expand his original conception so that it would conform to the format of those two likenesses. As a result, a self-confident merchant, elegantly attired and commanding a stately, if abstract, space became a sitter whose stylish garb is completed by a pair of awkwardly oversized slippers, and who seems somewhat overwhelmed by surroundings that have been aggrandized with pilasters, columns, and a busily patterned Turkey carpet on the floor.

The full-length portrait of Nicholas Boylston commemorated in a prominent setting the leading member of a family that had been only moderately visible in pre-Revolutionary Boston. John Adams described Nicholas and Thomas Boylston and their brother-in-law Benjamin Hallowell as "hotspurs all," but in fact, for all his economic influence, Nicholas Boylston was not a very vocal participant in the ever more vehement political debates of his day. He was more inclined to pleasant socializing: he held no office higher than town auditor but was known to be an enthusiastic fisherman; was active in the Charitable Society, serving as an overseer of the poor; and was a genial member of the Fire Club.[8] He considered himself a moderate in politics, although he seems to have dined more often with Lieutenant Governor Thomas Hutchinson than with his radical neighbor Otis,[9] and during the 1760s his business interests increasingly encouraged loyalty to Governor Francis Bernard. He was deeply distressed by the destruction of Hutchinson's property and by the damage done to the Hallowells' newly built house (his brother-in-law was then comptroller of the port) during the Stamp Act riots of 1765.

Indeed, it was just at the time Nicholas was sitting for Copley that his political perspective can clearly be seen to have shifted: with a number of other businessmen (including Clarke), he declined to support the nonimportation agreement that was instituted among Boston merchants in 1769. Because he was perceived as one of the "First Merchants of the Town," Boylston's reluctance to support this boycott of British goods marked a significant break

in the unity of colonial resistance; Samuel Adams denounced him and other similarly inclined businessmen as "enemies of their country." In October 1769 the brigantine *Wolfe*, which Boylston owned in partnership with Green, was seized, and its cargo impounded, when it attempted to enter Boston Harbor laden with British goods.[10]

This acceleration of events might have pushed Nicholas Boylston's political views and actions even further toward the Loyalist side had he not died, after a brief illness, in August 1771. He was eulogized as a "Man of good understanding & sound Judgment,"[11] and, in fact, Boylston did show measured judgment in distributing his estate, devising a sharing out of property meant to perpetuate the interconnectedness of the family, particularly the unmarried members. His bachelor brother, Thomas, was left his paternal estate, the School Street house and half its furnishings; the other half (as well as "my Picture Rings and all my Plate") went to his other unmarried sibling, Rebecca. Rebecca also received an enormous sum in trust, to be managed by Thomas and Green, Boylston's executors, the income from which was to be hers for life. Generous bequests were made to his sister Mary Hallowell and his nephew and adoptive namesake, Ward Nicholas Boylston.

However, the Revolution temporarily divided the family and its property. The Hallowells, Ward Nicholas Boylston, and Thomas Boylston fled to England, while Rebecca, who in 1773 had married the patriot Moses Gill, moved to Roxbury and then Princeton, Massachusetts, apparently leaving the School Street property under Green's stewardship. The house was leased and so it deteriorated; some of the furnishings were dispersed (including, possibly, the portrait of Rebecca and the second portrait of Nicholas, which were temporarily held by Green). After the Revolution the estate gradually returned to family proprietorship: Gill assumed possession of the house in exchange for a payment of one thousand pounds from the exiled Thomas, and he reclaimed the portraits from the Committee on Sequestration, which had seized them and other property from Green—just as it had confiscated goods from many other Loyalists.[12] The Boylston portraits and the rest of the family estate, if not the family itself, were reunited, now under a patriot banner.

C T

1. John Adams dined at Boylston's house and was amazed at its sumptuousness; he marveled at the astonishingly expensive and lavish furnishings in a diary entry that has often been quoted; *Diary and Autobiography of John Adams*, ed. Lyman H. Butterfield (Cambridge, Mass., 1961), vol. 1, p. 294. See the third epigraph in Paul Staiti, "Character and Class," in this publication. Adams's appraisal is echoed in a contemporary newspaper account, which found the grounds as impressive as the house: "having . . . an elegant Court-Yard, and Kitchen Yard, a large Garden, with a very great Variety of the best English Fruit Trees, and other Accomodations, too many to be enumerated" (*Boston-Gazette and Country Journal*, Apr. 22, Sept. 16, 1771, quoted in William Bentinck-Smith, "Nicholas Boylston and His Harvard Chair," *Proceedings of the Massachusetts Historical Society* 93, 1981 [1982], p. 24).

2. Nicholas Boylston, Will, August 1, 1771, Suffolk County, Docket no.

14979 (Suffolk County Probate Records, vol. 70, pp. 223–25), Archives, Supreme Judicial Court, Boston.

3. John W. Tyler, *Smugglers and Patriots: Boston Merchants and the Advent of the American Revolution* (Boston, 1986), p. 30.

4. Copley, letter to Henry Pelham, Mar. 14, 1775, in Jones 1914, p. 298.

5. The most obvious change in the second version is in the background, where the ship has been eliminated. The deletion of the ship may have been motivated by political circumstances—at a time when Boylston was under fire for continuing to bring British goods into Boston despite a nonimportation agreement among local merchants, such an obvious allusion to his career as an importer might have been an embarrassment—but in any case it removes a somewhat awkwardly drawn and distracting detail from the composition.

6. This development in Copley's style may have been prompted, in part, by criticisms from abroad. In 1767, the same year he painted Nicholas Boylston for the first time, Copley sent *Young Lady with a Bird and Dog* (cat. no. 38) to the exhibition of the Society of Artists in London and was deeply disappointed by the negative reactions of such masters as Benjamin West and Sir Joshua Reynolds. The picture was faulted for color that was considered too brilliant throughout and for a kind of allover quality that resulted in peripheral details being "to Conspichious for Excesry things." (Prown 1966, vol. 1, p. 50; Benjamin West, letter to Copley, June 20, 1767, in Jones 1914, p. 57.)

7. Furthermore, the second *Nicholas Boylston* demonstrates an increased sophistication in paint handling—the purple vest, for example, was created by laying down a transparent layer of blue over a layer of red pigment, a complicated system of glazing that results in an iridescence not apparent in the earlier portrait.

8. Bentinck-Smith, "Boylston and His Harvard Chair," pp. 22, 25.

9. *Letters and Diary of John Rowe, Boston Merchant*, ed. Anne Rowe Cunningham (Boston, 1903), pp. 28–30, 196.

10. Governor Francis Bernard and Samuel Adams, quoted in Tyler, *Smugglers and Patriots*, pp. 117, 129.

11. *Boston-Gazette and Country Journal*, Aug. 26, 1771, quoted in Bentinck-Smith, "Boylston and His Harvard Chair," p. 29. A cousin (who had been disdainful of Boylston's ostentatious lifestyle) now described him as a "worthy relation whose inoffensive and useful life may console us for his loss and afford us a pattern for imitation" (John Boylston, letter to Thomas Boylston, Sept. 19, 1771, Boylston Papers, Massachusetts Historical Society, Boston).

12. Gill's agreement of 1778 with Thomas—according to which Gill not only assumed responsibility for the Mansion House but also undertook all necessary repairs to the house, barn, and gardens at his own expense—was for a time a source of friction between the two men. From London in the 1780s Thomas Boylston unsuccessfully attempted to reclaim the house: as was usually the case, the local authorities tended to support Whig claims on family property over those of their Loyalist relatives. The patriot Gill was awarded Green's Boylston family portraits on the same principle. Both the debate over the house and Gill's negotiations with the Committee on Sequestration are detailed in the Boylston Papers, Massachusetts Historical Society, Boston.

33

Rebecca Boylston

1767

Oil on canvas, 50 x 40 in. (127 x 101.6 cm)

Signed and dated lower left: JSC [monogram] p 1767

Museum of Fine Arts, Boston, Bequest of Barbara Boylston Bean 1976.667

34

Mrs. Moses Gill (Rebecca Boylston)

1773

Oil on canvas, 49¾ x 39½ in. (126.4 x 100.3 cm)

Museum of Art, Rhode Island School of Design, Gift of Isaac C. Bates, William Gammell, H. D. Sharpe, Ellen Sharpe, Elizabeth A. Shepard, D. B. Updike, George Wetmore, and Mrs. Gustav Radeke 07.120

Rebecca Boylston was forty years old and unmarried the first time Copley painted her. About six years later, on the occasion of her marriage to the wealthy landowner Moses Gill, she sat for him a second time. She is therefore doubly unusual: among Copley's more than three hundred American portraits, there are no other spinsters represented, nor were any of Copley's other female sitters painted a second time in commemoration of a change in status.

In the first picture, Rebecca Boylston is depicted in a manner that sets her apart from most of the matrons of her own age in Copley's work, those "plump, formally attired matriarchs who sit passively upon upholstered chairs in dim rooms."[1] Rather, she is slim and handsome, wears a showy, low-cut gown, and stands before a dark grotto whose mystery adds to her allure. Her clothes and the openwork basket brimming with flowers that she carries are features that Copley usually reserved for much younger women. They are comparable to the costumes and flowers depicted in the portraits of Mrs. Woodbury Langdon (cat. no. 36) and of Mrs. John Stevens, 1770–72 (private collection): the nineteen-year-old Mrs. Langdon wears nearly identical garb, as does Mrs. Stevens, who was about twenty and, like Mrs. Langdon, recently married at the time Copley painted her. These young brides, shown against sylvan backdrops and bearing just-picked lilies, roses, peonies, and other fragrant blossoms, advertise their husbands' exalted status. In both of their portraits the flowers also function as a token of hope for a flourishing marriage. But when Copley painted Rebecca Boylston in 1767, she had no husband, and it is instead as mistress of the vast estate of her wealthy, unmarried brother Nicholas that she is presented here.[2]

This was a role seldom assumed by older unmarried women in colonial society, who on the whole had an unenviable lot: most were dependent on the hospitality of relatives, for whom they performed housekeeping or nursing tasks in exchange for room and

board. Such women frequently supported themselves as seam-stresses or domestics and generally were considered inferior to their married sisters in a social hierarchy that already was based on the assumption of the dependent, subordinate status of all women.[3] Rebecca's wealth (she had been allocated a share of her father's ample estate and would also inherit from Nicholas), her intelligence, and her "singular degree of obliging civility," which "procured her the confidence and esteem of all who were so happy as to be introduced to her acquaintance,"[4] guaranteed for her a more prominent position. Copley was one of the many who were charmed by her; in a letter written shortly after her marriage and his arrival in Rome in 1774, he instructed his wife, Susanna, to "remember me to all my friends . . . particularly to Docr. Byles, to Mrs. Gill, and all others that think me worth inquiring after."[5]

Following the death of her brother Nicholas in 1771 and shortly before her mother died, Rebecca married Moses Gill. Probably at the behest of her husband, Copley painted her again, in 1773. Although aspects of her new pose, in particular the emphasis on her hands, take into account the genial, expansive likeness of Moses Gill that Copley had painted nearly ten years before, the second portrait seems equally a commentary on the first *Rebecca Boylston*. It acknowledges Rebecca's new status as matron but repeats many of the devices used in the earlier picture: a wooded background, luxurious attire, and, paralleling the original basket of roses and peonies, an enormous sheaf of lilies. However, in the first portrait Rebecca appears *en négligée*, uncorseted and garbed in a succession of flowing, brilliantly colored draperies of the sort that she would never have worn in public. The rich reds, iridescent purples, and silvery tones of these satin, velvet, and lace garments, as well as the variety of their textures, are a testimony to the sitter's great wealth (and a declaration of the painter's great dexterity), and were designed to harmonize with the equally opulent and informal garb worn by her brother Nicholas in his portrait. In the second portrait of Rebecca Boylston the costume is no less luxurious but is less flamboyant, as befits a married woman of middle age. Yet it is, if possible, even more contrived. Rather than the pearls that earlier adorned her hair, Mrs. Gill wears an elaborate turban. Her gown is ornamented at the neck with delicate embroidery as well as with lace and is belted with a wide embroidered sash similar to that worn by Mrs. Thomas Gage (cat. no. 67) and by Mrs. Joseph Hooper (fig. 209) in their portraits. While not so clearly meant to evoke the highly fashionable Turkish style as the costumes of those two women, Mrs. Gill's dress lends a hint of exoticism to a sitter whose delicate features have, with the passage of time, taken on an almost classical austerity and, perhaps, a tinge of sadness.

The two portraits of Rebecca Boylston demonstrate Copley's development from the Rococo to a more sober style over the few years that separate them, a progression from an aesthetic of aristocratic opulence and ease to one marked by greater formality and restraint. In the first painting, the pose is lively, expansive, and relaxed: one arm rests on the fountain, and one knee pushes forward,

suggesting a demure female version of the famous cross-legged stance assumed by so many of Copley's male sitters. Rebecca Boylston is seen frontally, in full light against a dark ground; the portrait is a sparkle of decorative details woven across the picture surface. Her fluid posture is echoed by the sinuous contours of the garden ornament behind her; the spray of water from the fountain picks up the brilliant highlights of her satin gown. By contrast, in the later picture Rebecca Gill stands erect; her pose is noble, stately, and restrained. Much of her body is in shadow, to a degree absorbed by the dark background. Highlights are reserved for her face, hands, flowers, décolletage, and the red shawl billowing over her extended arm; she is thus given a sculptural presence. The playful fountain of the first likeness is now an urn, regular and solid; the loose blossoms cascading forward from the openwork basket have become a towering, formal mass of lilies that echoes Mrs. Gill's imposing headdress.

Although flowers appear in many of Copley's images of women, they are particularly prominent in these two portraits. The Boylston house on School Street (which by 1778 had become the Gills's winter residence) had long been noted for its "large, beautifull and agreable" gardens.[6] Moreover, the Gills had a deep interest in horticulture; Moses was a member of the Massachusetts Society for Promoting Agriculture, and his estate of over three thousand acres in Princeton, Massachusetts, included not only a mansion house but also an orchard and "an extensive garden."[7] The flowers were undoubtedly Rebecca's domain: in the eighteenth century, flowers were considered an attribute of refinement and gardening an appropriate employment for gentlewomen.[8] Copley's portrait offers a compliment to the new Mrs. Gill, suggesting that the "perfect wilderness" that was Gill's estate when he acquired it in 1766[9] would be civilized by the virtuous nurturing of a feminine hand.

C T

1. Trevor J. Fairbrother, "Rebecca Boylston," in Theodore E. Stebbins Jr., Carol Troyen, and Trevor J. Fairbrother, *A New World: Masterpieces of American Painting, 1760–1910* (exh. cat., Boston: Museum of Fine Arts, 1983), p. 197.
2. It is unlikely that this portrait was intended as a belated advertisement of Rebecca Boylston's charms and hence her marriageability. Rather, the image was probably meant to take its place among the row of portraits of the other Boylston family members—Mrs. Thomas Boylston, her sons Nicholas and Thomas, and perhaps the deceased Lucy—in the hall of the Mansion House on School Street.
3. Mary Beth Norton, *Liberty's Daughters: The Revolutionary Experience of American Women, 1750–1800* (Boston, 1980), pp. 40–41.
4. These remarks are from the eulogies for Rebecca Boylston Gill by the Reverend Peter Thacher of Boston's Brattle Square Church and by the Reverend Joseph Russell of Princeton, Massachusetts, quoted in Parker and Wheeler 1938, p. 45.
5. Copley, letter to Susanna Copley, Nov. 5, 1774, Copley Family Papers, Acc. 10, 122.1, reel no. 171, Library of Congress, Washington, D.C.
6. *Diary and Autobiography of John Adams*, ed. Lyman H. Butterfield (Cambridge, Mass., 1961), vol. 2, p. 85.
7. See Reverend Peter Whitney, *The History of the County of Worcester; in the Commonwealth of Massachusetts* (Worcester, 1793), p. 107; and Alice G. B. Lockwood, *Gardens of Colony and State: Gardens and Gar-*

deners of the American Colonies and the Republic Before 1840 (New York, 1931), pp. 106–7.

8. "A woman in very easy circumstances, and abundantly gentle in form and manners, would sow, and plant, and rake, incessantly. These fair gardeners too were great florists: their emulation and solicitude in this pleasing employment did indeed produce 'flowers worthy of Paradise'" (Mrs. Anne Grant, *Memoirs of an American Lady: With Sketches of Manners and Scenery in America As They Existed Previous to the Revolution* [London, 1808; reprint, New York, 1970], pp. 39–41).

9. Francis Everett Blake, *History of the Town of Princeton, in the County of Worcester and Commonwealth of Massachusetts, 1759–1915* (Princeton, Mass., 1915), vol. 1, p. 271. For a full description of the property, see cat. no. 18.

35

Woodbury Langdon

1767
Oil on canvas, 49¾ x 40 in. (126.4 x 101.6 cm)
Signed and dated center left: JSC [monogram] 1767
John H. Claiborne III

36

Mrs. Woodbury Langdon (Sarah Sherburne)

1767
Oil on canvas, 49¾ x 39¾ in. (126.4 x 101 cm)
John H. Claiborne III

Despite the effects of the Seven Years War, the 1760s were a golden age for the merchants, shippers, builders, and craftsmen of Portsmouth, New Hampshire. By the middle of the decade Portsmouth had fewer than five thousand residents, but among them were some of the wealthiest people in New England—and Woodbury Langdon (1738/39–1805) was one of the youngest and richest merchants in town.[1] On April 28, 1766, Langdon, who was then dissolving his partnership with Henry Sherburne so that he could go into business for himself, wrote to his brother John, then captain of a merchant vessel en route to London, about various business and family matters. He cautioned John against any rash or large expenditures "as the times are so extream difficult."[2] Yet the times were not so difficult that Woodbury felt he must forfeit the opportunity to order some things from London. Accordingly, he enclosed in his letter a four-page list specifying between £850 and £900 worth of goods that he deemed "suitable for this market": Turkey carpets, "Handsome" looking glasses, mahogany sideboards in the "newest Fashion," "Silver Canns neatly Polish'd," japanned waiters, ivory-handled knives and forks, silk mitts, damask, linen, alamode, buckram, and much more. Many of these

items, however, would never arrive on the market, as they were certainly meant for Langdon himself. A newly wedded husband outfitting a newly built house, he gave his brother precise measurements for three "compleat" sets of beds and bedding, with matching window-seat cushions and curtains for winter (in "Crimson Worsted Damask in Grain") and for summer (in "Orange Colour & white Linen & Worsted Check"). He drew on a separate piece of paper a coat of arms that he wished engraved on "a seal, pretty large" and on some of the silver, which he directed should also be marked "SS," the initials of his wife, Sarah Sherburne (1748–1827), his former partner's daughter.[3]

And on April 29, 1766, the very next day after Woodbury compiled his order, Sarah Langdon wrote up her own list of requests for John, whom she had known before her marriage. In fact, she once had worn John's portrait in a bracelet and had carried on a gossipy correspondence with him; he in turn had brought her many precious and stylish things from London.[4] Now she asked him to buy her "one handsome suit & Milonary, Viz. 2 Caps, 1 Stomager, 1 pr sleeve Knotts, 1 pr Bussles, 1 Hankerchief, 1 Apron, 1 Macklinbourgh Tippett & 1 Turban, 1 head flower, 1 Breast flower, 1 Cloak and Hat without any Silver about any of them Except in the Tippett, Turban & Flowers."[5] By summer the Langdons must have received most of the goods they had ordered, but Woodbury remained concerned about his seal, for he wrote to his brother again about his coat of arms. The arms he had drawn, he explained, were derived from those given to Walter Langdon of County Cornwall "in Cromwell's time" and he felt fairly secure in claiming them as his own, but to make sure he wanted John to see if he could trace them back to their great-grandfather. He reminded John that the times remained "very difficult" yet closed with an order for "two hampers" each of Port wine and "good" Dorchester ale and one forty-pound Cheshire cheese.[6]

The recently discovered inscription on Woodbury's picture proves that Copley's pendant portraits of Mr. and Mrs. Langdon, long assumed to have been painted in 1765, the year of their marriage, were executed in 1767.[7] By this time living in a house filled with fine imported furniture, the Langdons called upon Copley not merely to celebrate their union in matrimony but also, and primarily, to put the finishing touch on their decor and to cap their reputations as collectors of exquisite status symbols. The "remarkably goodlooking" Woodbury, a man described as shrewd, haughty, and often sarcastic, and his wife, "one of the fairest creatures who ever stepped out of a Portsmouth doorway" and as coquettish and enchanting as she was pretty, no doubt wanted portraits as flattering as those Copley had painted for Portsmouth residents Theodore Atkinson Jr. (cat. no. 8) and his wife, the popular and prominent Frances Wentworth Atkinson (fig. 163), who was Sarah Langdon's cousin and good friend.[8] And so the Langdons went to Boston to have their portraits painted by an artist who would record their youthful good looks in a manner commensurate with their taste in furniture and clothing in "the newest Fashion."[9]

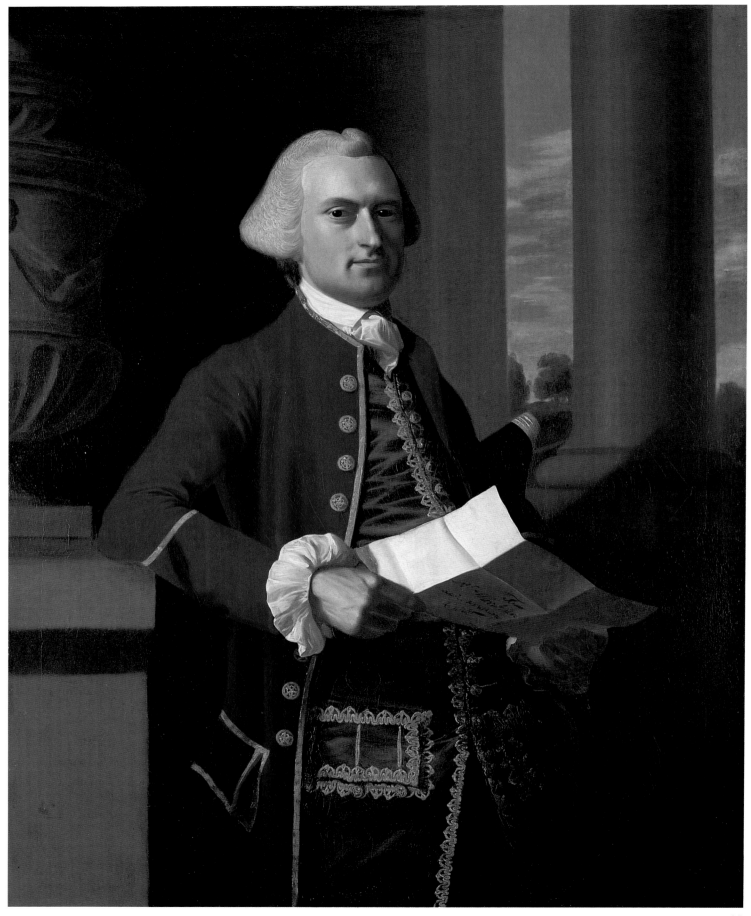

35

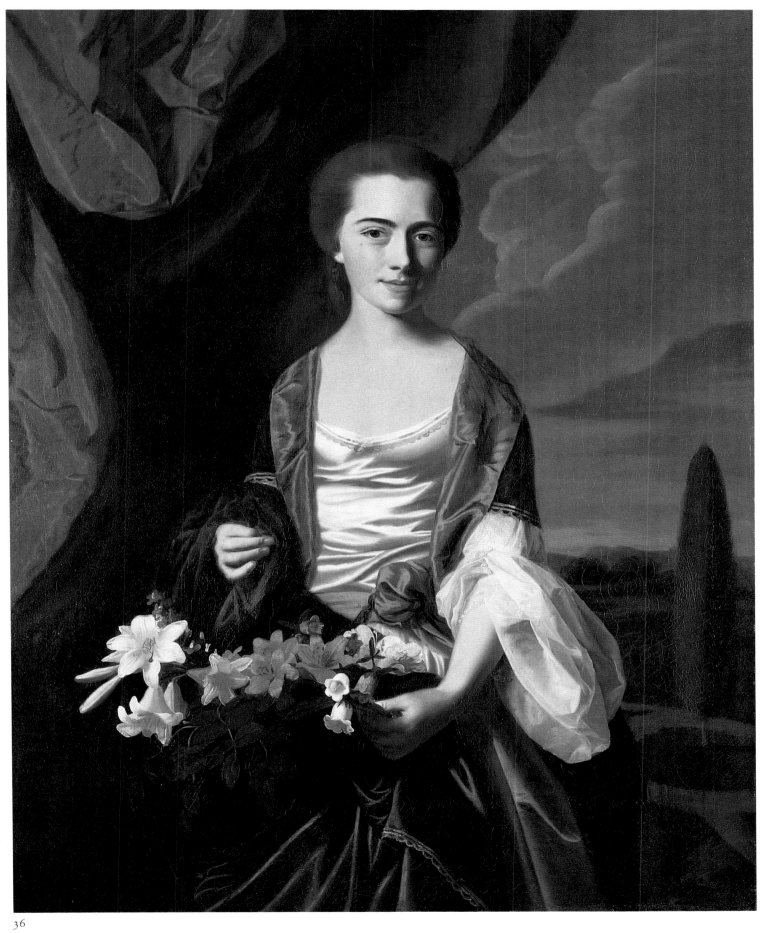

Given the opportunity to work for such young, socially ambitious, and self-possessed sitters, who, he hoped, would recommend him to their Portsmouth friends and relatives, Copley put to use his most painstaking technique and the full scope of his knowledge of conventional and fashionable English portraiture. Nevertheless, both paintings are remarkably direct and immediate, without a trace of slavish derivation from their foreign sources. The pendants are unusually well balanced and harmonious in terms of their color schemes, poses, and compositions; at the same time one is distinguished from the other by careful attention to details that suggest the differences between the lives and personalities of each Langdon. Woodbury Langdon, dressed in a wine-colored coat and dark green satin waistcoat, both adorned with elaborate gold braid trim, is turned slightly to the side and holds a letter while leaning on a pedestal that supports a large, ornate urn. He is thus shown to be a man of estimable wealth, polished yet easy manners, and serious affairs. Sarah Langdon, who wears an uncorseted white satin gown, billowing engageants (lace undersleeves), and a dark green robe with iridescent lavender lining, stands perfectly erect and facing front before a wine-colored curtain and a romantic landscape, smiling shyly and holding a magnificent bouquet of white and orange lilies, white and blue campanula, and pink clematis in the folds of her dress. She is presented as a woman of considerable gentle charm and elegance who is involved with exquisite, cultivated things. Both seem entirely absorbed with the viewer, whose eye they engage with their own riveting glances, rather than with any task or with each other.

These portraits, and very little else, survived the fire that ravaged the Langdons' home in March 1781. By 1785 the family had settled into a magnificent new three-story, five-bay Adamesque structure, the first brick house in Portsmouth.[10] Woodbury, who at first remained loyal to England and opposed the Revolution but later seems to have changed his allegiance, hurried to England in 1775 to salvage his land and accounts in London and remained abroad for two years. Upon his return to America in 1777, he was imprisoned in New York because of his Tory sympathies. After the war Langdon served as a delegate to the Continental Congress and was later appointed Supreme Court judge for the state of New Hampshire, a position he held until 1790, when he resigned after an impeachment trial that miscarried. His death in 1805 was lamented in the local paper, which proclaimed, "a great man is fallen in our Israel."[11] Sarah Langdon, the mother of five sons and five daughters, survived her husband for twenty-two years and remained in their Portsmouth mansion until she died. The Copley portraits are listed in her probate inventory from 1828, valued at twenty dollars each.[12]

C R

1. See James L. Garvin, "That Little World, Portsmouth," in *Portsmouth Furniture: Masterworks from the New Hampshire Seacoast*, ed. Brock Jobe (Boston, 1993), pp. 22–23.
2. Woodbury Langdon, letter to John Langdon, Apr. 28, 1766, Langdon Manuscripts, New Hampshire Historical Society, Concord.

3. [Woodbury Langdon], Memorandum of Sundry Furniture, Apr. 1766, Langdon Papers, Strawbery Banke Museum, Portsmouth, New Hampshire. At some point, this memorandum became separated from the letter it accompanied. Although they have not been connected before, there is no doubt that they belong together.
4. In a letter of January 26, 1765, to John Langdon, Sarah Sherburne requested "a par of brasslites with your Picter apon the locke," and threatened to "not exsept of him" if he did not send his portrait, and in an undated letter of about the same time, she thanked him for "the fan you promest me." (Both transcribed in Lawrence Shaw Mayo, *John Langdon of New Hampshire* [Concord, N.H., 1937], pp. 17–20.)
5. Sarah Langdon, letter to John Langdon, Apr. 19, 1766, Langdon Papers, Strawbery Banke Museum, Portsmouth, New Hampshire.
6. Woodbury Langdon, letter to John Langdon, June 12, 1766, Langdon Papers, Strawbery Banke Museum, Portsmouth, New Hampshire.
7. Jules Prown dates the portraits 1765–66 (Prown 1966, vol. 1, pp. 53, 221).
8. Langdons described in Mayo, *John Langdon of New Hampshire*, pp. 1, 17. For Woodbury, see also Albert Stillman Batchellor, ed., *Early State Papers of New Hampshire*, vol. 21 (Concord, N. H., 1892), pp. 812–15; and *National Cyclopaedia of American Biography*, vol. 10 (New York, 1900), pp. 90–91. Sarah Langdon's grandmother, Dorothy Wentworth, and Frances Atkinson's grandfather, John Wentworth, were brother and sister. A letter from Frances to Sarah of October 4, 1770, suggests that they were on quite familiar terms with each other (Wentworth Papers, New Hampshire Historical Society, Concord).
9. It is conceivable that Copley might have come to the Langdons, rather than vice versa. He visited Portsmouth in October 1769, when he drew Governor John Wentworth's likeness in pastel. Prown quotes John Wentworth, letter to Paul Wentworth, Oct. 27, 1769, in which he says that he expects Copley the next week (Prown 1966, vol. 1, p. 67).
10. James L. Garvin, "Academic Architecture and the Building Trades in the Piscataqua Region of New Hampshire and Maine" (Ph.D. diss., Boston University, 1983), pp. 292–304.
11. Obituary, *New Hampshire Gazette* (Portsmouth), Jan. 29, 1805.
12. Sarah Sherburne Langdon, Probate inventory, Jan. 15, 1828, Rockingham County Probate Court, Docket no. 11548, Exeter, New Hampshire.

37

Mrs. William Turner (Ann Dumaresq)

1767
Pastel on paper mounted on canvas, 23 1/4 x 17 1/2 in. (59.1 x 44.5 cm)
Signed and dated lower left: JSC [monogram] 1767
The Boston Athenaeum, Gift of Mrs. Howland S. Warren, Mrs. Nelson W. Aldrich, Howard M. Turner, Jr., and Mrs. Richard M. Jackson

Ann Dumaresque (1746–1824) married William Turner (1745–1792) in Christ Church, Boston, on October 26, 1767; they had seven children. Turner was a dancing master, an occupation he shared with Copley's stepfather, Peter Pelham, and a profession that, like Copley's own, was designed to imbue Boston's citizens with the aura of gentility.[1] Little is known about Mrs.

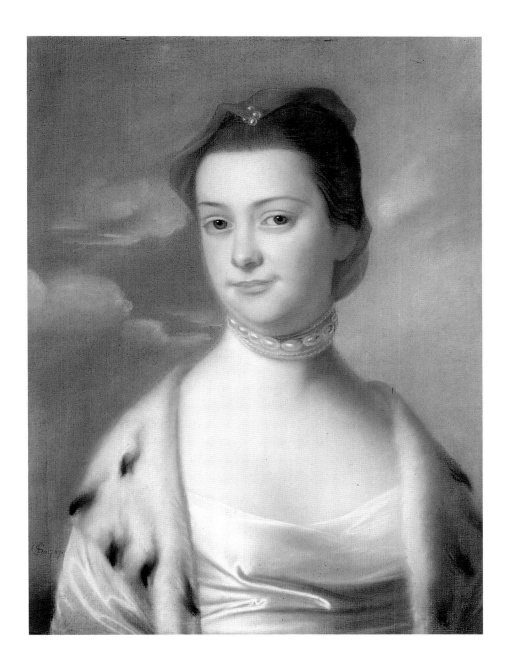

Turner; it is apparent, however, that Mr. Turner was admired for his charming personality (the Reverend William Bentley called him "chatty, familiar"),[2] and she no doubt shared in the benefits of her husband's popularity: they are mentioned as dining at Colonel Benjamin Pickman's and were friends of John Hancock's (himself a musician).

Ann Dumaresque Turner was twenty-one and her husband twenty-two when Copley drew them, probably on the occasion of their marriage, and they are presented as a stylish and self-possessed young couple. She is attired in a particularly elegant fashion, in a *sacque* dress and ermine-trimmed stole, with pearls in her hair and a handsome moonstone choker at her neck. Although some elements of *Mrs. Turner* appear formulaic—the dress and ermine stole are worn by a number of sitters in Copley's pastels of the late 1760s and early 1770s (see cat. no. 58)—the portrait is animated by the slight turn of the sitter's body from the picture plane and by the cloud-filled sky behind her. Like a number of

Fig. 188 *William Turner*, ca. 1767. Pastel on paper mounted on canvas, 22 ¾ x 17 ¼ in. (57.8 x 43.8 cm). Private collection

Copley's pairs of sitters, husband and wife do not relate to each other explicitly, in terms of pose or surroundings. Mr. Turner (fig. 188) is shown in three-quarter view, against a gathered drape that suggests an interior space.[3] As in many of Copley's oils, the disparate settings here signal the man's sphere as the world of affairs and the woman's as the world of nature.

<div align="right">C T</div>

1. Turner taught dancing and arranged concerts in a hall on Hanover Street that he purchased from John Hancock in 1769; after the Revolution he became a wine merchant in a shop on Cornhill (apparently there was less demand for professional musicians in Boston after the departure of the British). See *Music in Colonial Massachusetts, 1630–1820* (Boston, 1985), vol. 2, pp. 1057–76. Turner's contemporaries believed that his first profession made a significant contribution to the social order, a judgment that provides insight into the Turners' social status, if not their income. In his diary the Reverend William Bentley described dancing as "a valued accomplishment" and opined that "it were to be wished that it [be] made a part in every education for more reasons than one . . . " (*The Diary of William Bentley, D.D., Pastor of the East Church, Salem, Massachusetts* [1905–14; reprint, Gloucester, Mass., 1962], vol. 1, p. 176).
2. *Diary of Bentley*, vol. 1, p. 176.
3. It was unusual for Copley to include settings in his pastels; most have neutral backdrops. He did, however, use a similar background in at least two other pastels of women: *Mrs. Andrew Tyler* (New England Historic Genealogical Society, Boston) and *Mrs. George Turner* (private collection), drawn at about the same time as this pastel.

38

Young Lady with a Bird and Dog

1767

Oil on canvas, 48 x 39¾ in. (122 x 101 cm)

Signed and dated lower left: Jno: Singleton Copley pinx 1767

The Toledo Museum of Art, Purchased with funds from the Florence Scott Libbey Bequest in Memory of her Father, Maurice A. Scott

Young Lady with a Bird and Dog is the title originally given this picture when it was shown as no. 28 in the exhibition of the Society of Artists in London in 1767. The artist was erroneously cited in the catalogue as William Copeley. For years after the painting came on the art market in 1910, the work was retitled on the basis of speculation that the sitter, a girl between the ages of seven and ten, was Mary Warner of Portsmouth, New Hampshire. But the Mary Warner whom Joseph Blackburn painted in 1761 (Warner House, Portsmouth) bears no resemblance to this child. Moreover, Mary Warner was eighteen years old in 1767, too old to be this little girl. No other name has been attributed to the sitter, and thus it seems best to revert to the painting's original title.

The circumstances surrounding the creation of the picture are nearly unique in Copley's career. Like *Boy with a Squirrel* (*Henry Pelham*) (cat. no. 25), it was not painted on commission.[1] Instead, Copley solicited this girl to sit for him as a model for a portrait he would send to London for exhibition and criticism—to the same audience to which he already had submitted *Boy with a Squirrel*, in another effort at self-pedagogy. At the time, Copley was at the peak of his American career, boasting that his studio was "full of Pictures unfinished, which would ingage me these twelve months."[2] His *Boy with a Squirrel* had been shown at the Society of Artists in 1766, during the American boycott of English goods prompted by the Stamp Act. Arriving as it did, when American manufactures were identified as separate from British, that picture was perceived as American goods, different from works of art that conformed to accepted English academic taste. After pointing out faults in *Boy with a Squirrel*, Benjamin West recommended that Copley submit another picture for exhibition, perhaps "a Picture of a half figure or two in one Piec, of a Boy and Girle, or any other subject you may fancy. And be shure [to] take your Subjects from Nature as you did in your last Piec, and dont trust any resemblanc of any thing to fancey, except the dispositions of they figures and they ajustments of Draperies, So as to make an agreable whole. . . . lett it be Painted in oil."[3]

The picture of the young girl arrived in London, along with an unidentified pastel drawing, in the spring of 1767. Sir Joshua Reynolds critiqued it when it was exhibited. As reported by Captain R. G. Bruce, "he exclaimed against the Subject, but approved of the Painting, and perseveres in his Opinion that you only want Example to be one of the first Painters in the World. He dislikes your Shades; he says they want Life and Transparency. He says 'your Drawing is wonderfully correct, but that a something is wanting in your Colouring.'" Bruce continued, assuring Copley that the artists "already put you on a footing with all the Portrait Painters except Mr. Reynolds."[4] West in turn conveyed Reynolds's opinion that "Each Part of the Picture [is] Equell in Strenght of Coulering and finishing, Each Making to much a Picture of its silf, without the Due Subordanation to the Principle Parts, viz they head and hands." The color, thought West and Reynolds, was "missapplyed, as for instance, the Gown too bright for the flesh, which over Came it in brilency." The dog and carpet were "to Conspichious."[5] Captain Bruce wrote that many artists thought the subject itself was an "unlucky choice."[6]

Reynolds's criticism of the picture was a rehearsal for the ideas he would eventually express in his *Discourses on Art*. He addressed the problems of minuteness of detail in the fourth discourse (delivered in 1771), of aggressive color and insubordinate parts in the eighth (1778), and of all subjects in the eleventh (1782).[7]

Copley explained his apparent failure by claiming, with seeming facetiousness, that "subjects are not so easily procured in this place." More seriously, he blamed his lack of firsthand knowledge of European art and disparaged American culture, complaining, "A taste of painting is too much Wanting to affoard any kind of helps," and "the people generally regard it no more than any other usefull trade."[8]

238

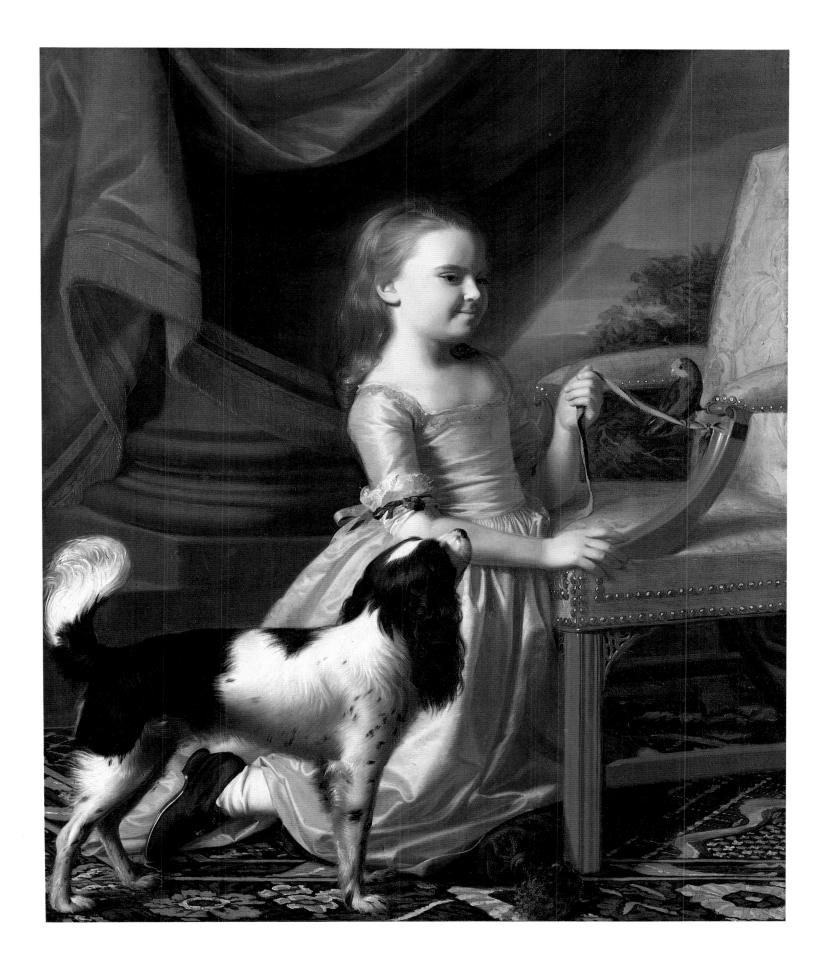

Reynolds and West were accurate in their observations on Copley's style, even if their judgments of his aesthetic failure are not necessarily justified. The picture is indeed busy with objects that vie for the viewer's attention. The girl, in a sherbet-pink dress with gold neckline and wearing teal shoes, is set before a lemon-yellow damask armchair of English design. In her left hand she holds a blue ribbon tied to the chair; on the ribbon perches a parrot from either South Carolina or Latin America. The bird stares at a King Charles spaniel that stands in front of the sitter on a cut-pile Axminster carpet. A column draped in vermilion-red fabric is behind her to the left. In the right distance is a landscape.

In *Young Lady with a Bird and Dog* Copley ostentatiously paraded his show of talent for the benefit of Reynolds and West. But in presenting so graphically his ability to paint so many different things, he lost sight of his primary subject, the girl. Copley himself may have been somewhat aware of this when he painted the picture, for the only possible reason he would have exposed the child's right shoe was to indicate a fact that is easily overlooked amid the clutter of objects: she is not standing, but kneeling on a cushion.

PS

1. Further indicating that the pictures were not commissioned, William Dunlap quotes from a now-lost letter to Captain R. G. Bruce in which Copley says that both *Boy with a Squirrel* and *Young Lady with a Bird and Dog* were for sale (Dunlap 1834, vol. 1, p. 112).
2. Copley, letter to Thomas Ainslie, Feb. 25, 1765, in Jones 1914, p. 33.
3. Benjamin West, letter to Copley, Aug. 4, 1766, in Jones 1914, pp. 44–45.
4. Captain R. G. Bruce, letter to Copley, June 11, 1767, in Jones 1914, pp. 53–55.
5. Benjamin West, letter to Copley, June 20, 1767, in Jones 1914, p. 57.
6. Captain R. G. Bruce, letter to Copley, June 25, 1767, in Jones 1914, p. 59.
7. Sir Joshua Reynolds, *Discourses on Art* (London, 1959), pp. 56, 138–43, 177.
8. Copley, letter to [West or Bruce] [1767?] in Jones 1914, p. 65.

39

Robert Hooper

ca. 1764
Watercolor on ivory, 1¼ x 1 in. (3.18 x 2.54 cm)
Diplomatic Reception Rooms, Department of State, Washington, D. C.

40

Robert Hooper

1767
Oil on canvas, 50 x 39¾ in. (127 x 101 cm)
Signed and dated lower right: JSC [monogram] p.1767.Bosn.
The Pennsylvania Academy of the Fine Arts, Philadelphia, The Henry S. McNeil Collection. Given in loving memory of her husband by Lois F. McNeil and in honor of their parents by Barbara and Henry A. Jordan, Marjorie M. Findlay, and Robert D. McNeil

39

In Copley's day two men ruled Marblehead's fishing industry, but only one was called "King." Robert King Hooper assumed control of his father-in-law Joseph Swett's prosperous business in the 1740s, made his fortune trading in foreign ports, and earned his sobriquet decades before his brother-in-law Jeremiah Lee entered the fish trade.[1] By the time Copley painted Hooper's portrait in 1767, his business had been surpassed by Lee's in the sheer volume of its trade. Yet he remained Marblehead's merchant prince, a man of eminence, affable character, philanthropic leanings, integrity, and inexhaustible wealth who gave lavish parties, supported his community financially, and rode in a fine carriage through the streets of town.

The son of Greenfield and Alice Tucker Hooper, Robert was born June 26, 1709, in Marblehead, where he lived his entire life.[2] He was married four times, first to Ruth Burrill (1711/12–1732); next to Ruth Swett (1718/19–1763), who gave him five children and a connection to her father, the son and namesake of the man to whom Marblehead owed its commercial prosperity during the eighteenth century; third to Hannah White Cowell (d. 1776); and finally to Elizabeth Pousland. Hooper lived in his father's three-story house, which he furnished handsomely with mahogany tables and chairs, gilt-framed mirrors, Wilton carpets, and damask upholstery and draperies, and greatly enhanced with interior additions, including a ballroom with a vaulted ceiling, and exterior embellishments, most notably a Georgian facade of clapboards painted and grooved to simulate stone.[3] Hooper owned other land in Marblehead, as well as tracts in Lyndeborough, New Hampshire, and Salem and Danvers, Massachusetts, the site of his country seat, The Lindens, where he hosted his most extravagant gatherings of friends and business associates. The Lindens was built in 1754 after a design by Peter Harrison, and, like Harrison's Redwood Library in Newport, was a wooden structure painted and sanded to achieve the look of ashlar masonry.[4]

His vast wealth and opulent lifestyle could have earned Hooper his royal nickname, but family tradition holds that he became King of Marblehead for reasons that had more to do with his dignified

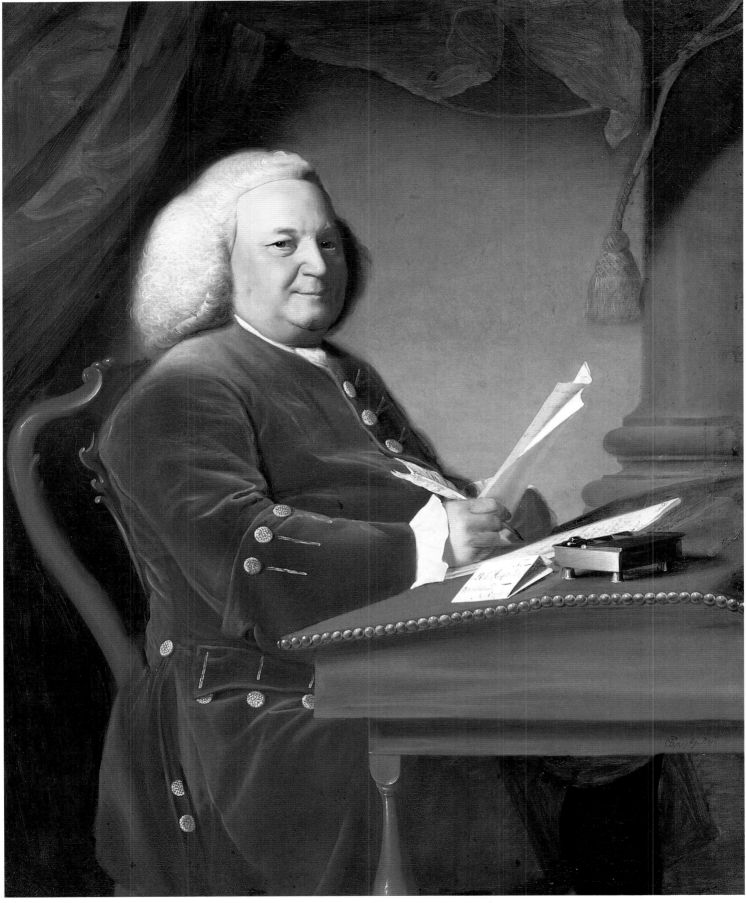

40

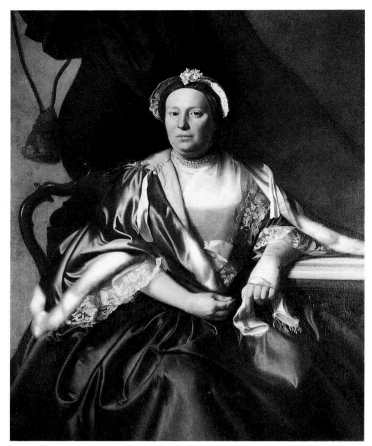

Fig. 189 *Mrs. Robert Hooper (Hannah White)*, ca. 1767. Oil on canvas, 50 x 39½ in. (127 x 100.3 cm). The New York Public Library, Astor, Lenox and Tilden Foundations

manner and benevolent attitudes. He earned the respect and gratitude of his sailors by paying fair wages and mandating decent working conditions and good food aboard his ships. In 1747, the same year he improved his father's house, Hooper established a school for children of poor Marblehead families. In 1751 he bought the town a fire engine and served on the board of fire wards. He was passionately religious, once telling his granddaughter that "the way of Holyness is the kings high Road to Happiness, for without Holiness no man Can see the Lord—a Holy life will end in a happy death, & a Glorious Resurrection to life Eternal."[5]

Hooper was responsible for Copley's first Marblehead commission, a portrait of his daughter Alice (Department of State, Washington, D.C.) ordered on the occasion of her marriage to Jacob Fowle in 1763. It may have been at about this same time that he commissioned Copley to paint a miniature portrait of himself, a delicate and impressive watercolor that fills the ivory oval with his plump likeness. About three years later Hooper commissioned oil portraits of himself, his wife Hannah (fig. 189), and, presumably, his daughter Ruth and her husband, Tristram Dalton (both location unknown). John Rowe, who dined with Hannah Hooper and the

Daltons at the home of Ezekiel Goldthwait on April 23, 1767, wrote in his diary that day that "Mrs. Hooper went to Copley to have her Picture drawn as did Capt Dalton & wife."[6] Rowe's account and the inscription "Bos[n]." on Robert Hooper's portrait indicate that the Hoopers and the Daltons—like most of Copley's clients—sat for the artist in Boston. Copley must have known that his portraits of the Hoopers would provide him with his entrée into Marblehead, a town described by a contemporary observer as populated with individuals "so much cultivated as to be remarkable for their civilities" and a place blessed with "a pattern of industry, [that was] flourish[ing] in trade and abound[ing] in wealth."[7] In fact, his success with the Hoopers can be measured in the subsequent commissions he received from Marbleheaders: he would paint Hooper's children, Robert (Museum of Fine Arts, Boston) and Joseph and his wife, Mary (figs. 221, 209), and the Jeremiah Lees (cat. nos. 52, 53, 54) as well as other townspeople.

Copley portrayed King Hooper at work. Seated with pen poised to write and paper in hand at a slant-top, baize-covered desk—perhaps similar to the "old pine writing Desk" listed in his probate inventory—the merchant seems to pause in the midst of responding to a letter—the note to the left of the standish clearly reads "To / Rob[t] Hooper Esq / in / Marblehead / New England." He wears a heavily powdered square peruke with pigeon-wing puffs, a wide wig that suits the wide man. Copley accentuated Hooper's distinctive corpulence, posing him in near profile to make clearly visible the contour of his enormous paunch, which seems to be held up by the edge of his desk and is marked with ornate gold buttons and generous folds of lush silk velvet that draw the eye. Hooper is working, but there is no question that he is affluent. Even if the desk was actually old and made of pine, in the picture it bears the deep color and exquisite grain of fine mahogany. His chair, with its thick turned and carved frame and delicate splat, is so richly wrought that it is inconceivable as a real object—yet anything simpler would not have enthroned Hooper as well. The outline of this incredible chair is more legible in Copley's pendant portrait of Hannah Hooper, where it is only one of many props in an abundant assemblage of lush, fine-textured materials—satin, fur, lace, marble, mahogany, cording, flowers, and pearls, out of which, as Jules Prown put it, "her head seems to pop."[8] As Copley painted them, the Hoopers are king and queen, not so much merchant elite as merchant royalty.

Hooper exiled himself to Danvers during the war and invited Thomas Gage and his troops to use his house there on a number of occasions. He was not persecuted for his Loyalist politics, perhaps because he declined an appointment by the British as mandamus counselor and also because of his advanced age. After the war he lost virtually all of his property but none of his standing in Marblehead. According to a contemporary diarist, the procession that took place in Marblehead harbor on May 23, 1790, of vessels draped in mourning to mark his death three days earlier "exceeded anything before known" in the town.[9]

C R

1. William H. Bowden, "The Commerce of Marblehead, 1665–1775," *Essex Institute Historical Collections* 68 (Apr. 1932), pp. 122–36.
2. See Charles Henry Pope and Thomas Hooper, *Hooper Genealogy* (Boston, 1908), pp. 107–9; and James H. Stark, *The Loyalists of Massachusetts* (Boston, 1910), pp. 221–23.
3. Robert Hooper, Probate inventory, July 2, 4, 1791, Essex County, Docket no. 13871, Archives, Supreme Judicial Court, Boston.
4. Hooper's Marblehead house is preserved as the headquarters of the Marblehead Arts Association. His Danvers mansion was moved to Washington, D.C., in 1935. See Nancy A. Iliff, "Living with Antiques: The Lindens, Washington, D.C.," *Antiques* 115 (Apr. 1979), pp. 744–55. The drawing room of The Lindens is installed at the Nelson-Atkins Museum of Art, Kansas City.
5. Robert Hooper, letter to Ruth Hooper Deblois, Mar. 17, 1790, in Pope and Hooper, *Hooper Genealogy*, p. 109.
6. *Letters and Diary of John Rowe, Boston Merchant*, ed. Anne Rowe Cunningham (Boston, 1903), p. 129.
7. John Eliot quoted in Bowden, "Commerce of Marblehead," p. 136.
8. Prown 1966, vol. 1, p. 57.
9. Entry for May 23, 1790, in *The Diary of William Bentley, D.D., Pastor of the East Church, Salem, Massachusetts* (Salem, Mass., 1905–14), vol. 1, p. 170.

41

Ebenezer Storer

ca. 1767–69
Pastel on paper mounted on canvas, 24 x 18 in. (61 x 45.7 cm)
The Metropolitan Museum of Art, New York, Gift of Thomas J. Watson, 1940 40.161.1

42

Mrs. Ebenezer Storer (Mary Edwards)

ca. 1767–69
Pastel on paper mounted on canvas, 24 x 18 in. (61 x 45.7 cm)
The Metropolitan Museum of Art, New York, Gift of Thomas J. Watson, 1940 40.161.2

Ebenezer Storer was born in 1699 in Saco, in what is now the state of Maine, moved to Boston as a young man, and before long established himself as a merchant, justice of the peace, overseer of the poor, and deacon of the Brattle Square Church. He was reportedly famous for "his kindness, charity, and devotion to good works."[1] His widow, Mary Edwards, was one year his junior and survived him by ten years. The Storers owned a three-story mansion with extensive gardens on the corner of Sudbury and Portland Streets which Ebenezer deeded to his son and namesake in 1759. The elder Mr. Storer died in 1761.

When Copley's pastel portraits of Ebenezer I and his wife entered the Metropolitan Museum's collection in 1940, there was a good deal of discussion about whether the presumed picture of Ebenezer I might actually represent his son.[2] Copley's technique in the supposed portrait of Ebenezer I, especially in the area of the face and head, does not match the treatment in the picture of Mrs. Storer, and Ebenezer appears to be much younger than his wife; indeed, he looks younger than his son. Jules Prown's observation that the Storer pastels resemble the Boylston oil portraits of 1766–69 (cat. nos. 30–33) and should be dated to the same period resolved the problem: Copley must have drawn Ebenezer Storer I posthumously, using an earlier portrait of him as his model for the face.[3] Ebenezer II's sitting would have provided Copley with a source for the elder Ebenezer's turban and banyan; the costumes of father and son differ only in color, the damask pattern, and the degree of modeling. Copley drew Mary Edwards Storer's portrait twice. Both the present pastel and its analogue (fig. 190) descended in the Storer family, suggesting that one is a replica painted by Copley at the request of Mrs. Storer or one of her children. The two portraits are so close in style, handling of the medium, and degree of finish that it is difficult to determine which is the replica.

C R

1. Clifford K. Shipton, *Sibley's Harvard Graduates*, vol. 12 (Boston, 1962), p. 208.
2. Hermann Warner Williams Jr., "Two Early Pastels by Copley," *Bulletin of The Metropolitan Museum of Art* 36 (June 1941), pp. 136–40.
3. Prown 1966, vol. 1, pp. 66–67.

43

Ebenezer Storer II

ca. 1767–69
Pastel on paper mounted on canvas, 23⅛ x 17⅛ in. (58.7 x 43.2 cm)
Private collection

44

Mrs. Ebenezer Storer II (Elizabeth Green)

ca. 1767–69
Pastel on paper mounted on canvas, 23⅞ x 17⅝ in. (60.6 x 44.8 cm)
Private collection

Ebenezer Storer II (1729–1807) was the owner of his late father's house and warehouse, where he had apprenticed before becoming a partner in Ebenezer Storer and Son Merchants in 1754, and he oversaw the affairs of his elderly mother during the last decade of her life. He may have been responsible for commissioning Copley to produce four pastel portraits of Storer family

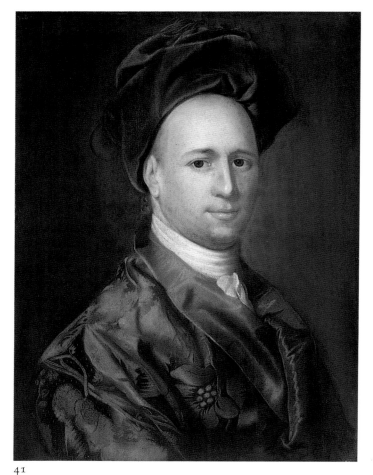

41

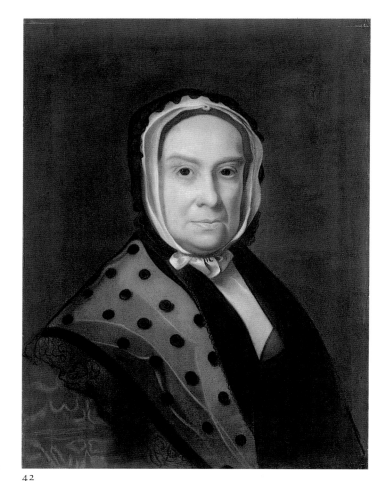

42

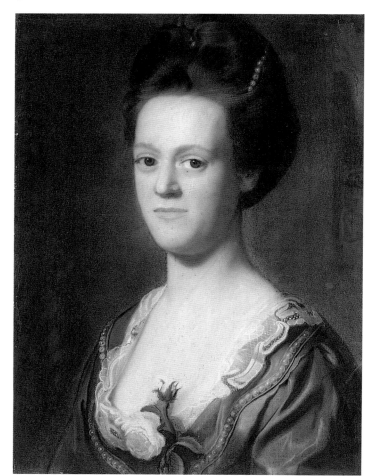

43

44

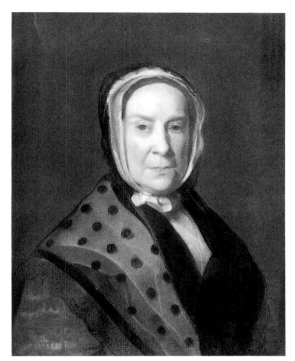

Fig. 190 *Mrs. Ebenezer Storer (Mary Edwards)*,
ca. 1767–69. Pastel on paper mounted on linen,
23 x 17¼ in. (58.4 x 43.8 cm). Museum of Fine Arts,
Boston, Gift of Mrs. Francis Storer Eaton 55.505

1. E. S. M. Quincy, *Memoir of the Life of Eliza Susan Morton Quincy* (Boston, 1861), p. 90.
2. Clifford K. Shipton, *Sibley's Harvard Graduates*, vol. 12 (Boston, 1962), p. 209.
3. Obituary, *Boston News-Letter*, Dec. 16, 1774, p. 3.

45

Jonathan Jackson

ca. 1767–69
Pastel on paper mounted on canvas, 23 x 17 in. (58.4 x 43.2 cm)
Museum of Fine Arts, Boston, Gift of Mr. and Mrs. Francis W. Peabody
in memory of George C. and Virginia C. Shattuck, and Henry H. and
Zoë Oliver Sherman Fund 1987.295

In his pastel portrait of merchant Jonathan Jackson (1743–1810), Copley imbued the sitter with a suavity and sophistication he reserved primarily for himself. He drew Jackson, a man just five years his junior, at about the same time he produced his own portrait in pastels (fig. 25). Both men are dressed in blue-green silk damask morning coats, and their coiffures are similarly arranged (although Copley clearly sports a powdered wig, while Jackson is shown with his own hair or possibly an unpowdered wig). More important, they exhibit a similar worldliness and self-possession, a reflection of the positions they had obtained by the late 1760s:

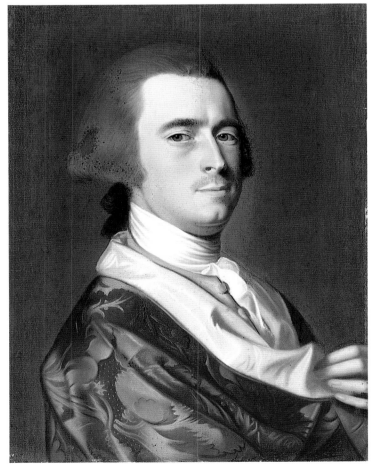

members during the late 1760s. These pictures of Ebenezer II, his wife, his father, and his mother (cat. nos. 41, 42) hung together in matching carved and gilt Rococo-style frames in the Storer house.[1] Ebenezer II's likeness is arguably the finest of the four, a work that is superior in expression and finish to the somewhat labored depiction of his late father, as well as to the portraits of Storer's wife and his mother, which are themselves splendid.

A religious man, the younger Storer kept a diary of meditations and was familiarly known as "Deacon" in recognition of the position he held at Boston's Brattle Square Church until 1773. He ran his father's business for many years; at the same time he contributed his efforts and wealth to many benevolent organizations. He was especially interested in any cause formed to halt "the progress of Vice and Immoralities" and "to promote a Reformation of Manners."[2] Storer served on the committee that introduced street lights to Boston; although he fled the city in 1775, he returned within a year and accepted the post of overseer of the poor and selectman. His wife, Elizabeth Green (1734–1774), the daughter of Joseph and Anna Pierce Green, "excelled in all the Characters of Wife, Parent, Friend, Mistress, and Benefactor." "If she had a Fault," reported her obituary, "it was a too tender Heart, and too great a fondness for her Friends."[3] Three years after her death, Ebenezer married Hannah Quincy Lincoln (d. 1826).

CR

45

Jackson, married in 1767 to Sarah Barnard of Salem, had significant financial interests in Newburyport and Boston and was a partner in the flourishing importing firm of Jackson and Bromfield; Copley, recently married to the daughter of a wealthy and prominent importer, was essentially without competitors for Boston's portrait business.

There seems to have been a special rapport between the two men as well, or else Jackson was a great admirer of Copley's work, for the merchant ordered at least three portraits of himself from Copley in the late 1760s. Both the second version of this pastel (Massachusetts Historical Society, Boston) and a miniature (private collection), 1767–69 and ca. 1770, respectively, show Jackson in profile, head turned back to address the viewer. The pastels share the device of long, tapered fingers holding the satin lapel of the morning coat, a gesture of Van Dyckian elegance and grace. Three other likenesses of Jackson by Copley are listed in Augustus Perkins's 1873 catalogue of Copley's works; these are all oils in various formats and cannot be identified today.[1]

Copley's pastel reinforces the claim of Jackson's biographer that the merchant was careful of his personal appearance and was "a slave to his black barber";[2] the elegant informality of his attire testifies both to the sitter's comfort with his social position and to the fashionable intimacy of the medium. Copley portrayed his subject not only as stylish and urbane but also as a thoughtful man, and in the years following the creation of this portrait, Jackson proved to be a person of great nobility and high principle, sacrificing much of his personal wealth to the revolutionary cause and serving his country in a number of civic offices. As the Revolution approached, he freed his slave Pomp, "in Consideration of the Impropriety I feel & have long felt, in holding any Person in Constant Bondage more especially at a time when my Country is so warmly contending for the liberty every man ought to enjoy."[3] Jackson himself was a member of the Committee of Safety, a delegate to the Continental Congress, United States marshal for Massachusetts, treasurer of the state, and treasurer of Harvard College. For the last seven years of his life he was president of Boston Bank (now the Bank of Boston). CT

1. Perkins 1873, pp. 78–79. As Jules Prown notes, a number of Copley's clients ordered more than one portrait of themselves, and often, one, if not both, of these works was a pastel (Prown 1966, vol. 1, p. 137). For example, Joseph Barrell commissioned a pastel (in which his attire, pose, and gesture are almost identical to Jackson's) (Worcester Art Museum, Massachusetts) and a miniature from Copley; and the artist made two pastels of Mrs. Ebenezer Storer (cat. no. 42; fig. 190) and of Governor John Wentworth (Hood Museum of Art, Dartmouth College, Hanover, New Hampshire). However, Jackson was unusual for ordering at least three images of himself; only the extraordinarily wealthy Hancocks and Jeremiah Lee were depicted more often by Copley.
2. Clifford K. Shipton, *Sibley's Harvard Graduates*, vol. 15 (Boston, 1965), p. 59.
3. Suffolk County Probate Records, vol. 75, p. 36, quoted in John J. Currier, *History of Newburyport, Massachusetts, 1764–1905* (Newburyport, 1906), p. 71.

46

Paul Revere

1768

Oil on canvas, 35 x 28½ in. (88.9 x 72.3 cm)

Museum of Fine Arts, Boston, Gift of Joseph W. Revere,

William B. Revere, and Edward H. R. Revere 30.781

Paul Revere is Copley's only finished portrait of an artisan at work, dressed in shirtsleeves. Revere is shown half-length, seated behind a highly polished table, and casually attired. He cradles his chin in his right hand and regards the viewer as if he has just looked up from the teapot in his left hand; the pot is finished but remains undecorated, and the engraving tools at Revere's elbow attest to the work yet to come.

When Copley painted Revere's portrait, his sitter was an accomplished, well-established silversmith. Revere (1735–1818) apprenticed to his goldsmith father and probably took over the family business upon the death of the senior Revere in 1754.[1] No records survive of his first years on his own, but by 1761 Paul Revere began to keep track of his business transactions, and his ac-

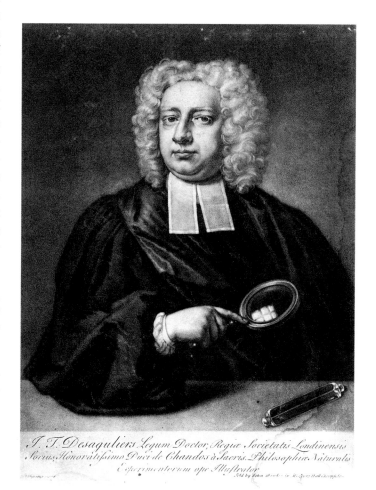

Fig. 191 Peter Pelham after Hans Hysing. *John Theophilus Desaguliers*, n.d. Mezzotint, 13¾ x 9⅞ in. (34.9 x 25.1 cm). Museum of Fine Arts, Boston, Gift of Charles P. Pelham M20149

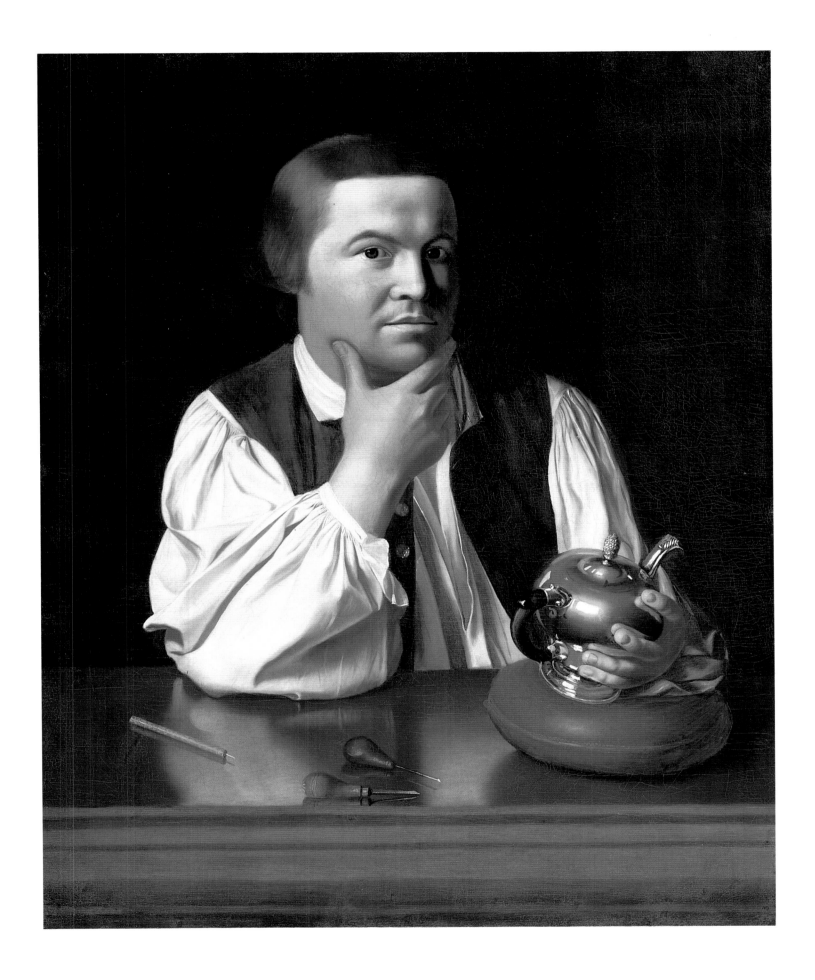

count book shows a varied and busy trade.[2] He made assorted silver salts, porringers, coffeepots, teapots, cream pots, tankards, and salvers; however, flatware and personal objects, such as buttons and shoe and knee buckles, constituted 75 percent of his work in silver.[3] Revere also produced a few gold items, among them buttons, finger rings, and thimbles, and repaired many kinds of metal objects. About 1762 he began to make engravings, including bookplates (see fig. 175), trade cards, and illustrations for magazines and broadsides; his first political print appeared in 1765 in response to the Stamp Act.[4] By the end of the decade he was practicing dentistry, advertising in a Boston newspaper that he could replace lost teeth.[5]

In addition, Paul Revere was actively involved in his native North End and the larger Boston communities. A lifelong member of the Congregational New Brick Church, he served on its Standing Committee.[6] He became a Mason of St. Andrew's Lodge in 1760 and held his first office in the fraternity in 1762.[7] He joined the Sons of Liberty in 1765, and his participation in revolutionary politics intensified during the remainder of the decade and in the early 1770s.[8]

Copley's image of Revere is unprecedented not only in his own oeuvre but also in American colonial painting. Though Copley had produced a few portraits of craftsmen, his usual patrons were clergymen and merchants and their wives. He first depicted an artisan with the attributes of his trade in one of his earliest portraits, *Peter Pelham(?)* (fig. 153), dated about 1754.[9] Like Revere, the subject is seated at a table strewn with tools, but this craftsman wears a jacket, stock, and patterned waistcoat. The more formal attire makes the sitter appear posed rather than caught in the middle of his work. *Peter Pelham(?)* bears striking similarities to the mezzotint *John Theophilus Desaguliers* by Copley's stepfather, Peter Pelham (fig. 191).[10] Copley may have referred to Pelham's mezzotint and also to his own *Peter Pelham(?)* for the composition, pose, and other details of *Paul Revere*. Both mezzotint and early portrait, like *Paul Revere*, offer half-length views of figures seated behind tables with tools; each of these subjects, like Revere, is turned slightly to the side, right arm leaning on a table, left hand holding an object, a magnifying glass in the case of Desaguliers, an engraving tool and burin in the case of the sitter presumed to be Pelham, and each man looks straight out at the viewer. The print is closer to *Paul Revere* in some respects, however. The table in the mezzotint, like Revere's table, is aligned parallel to the picture plane, not at a slightly awkward angle as in *Peter Pelham(?)*; the complicated gathers of Revere's sleeve seem to be derived directly from those of Desaguliers's sleeve; and the magnifying glass and the teapot complement the sitters' faces and reflect light. In conceiving his portrait of Revere, Copley may also have been inspired by the European tradition of depicting artists and craftsmen with their tools and the objects they create as attributes or by Northern Renaissance portrayals of jewelers, goldsmiths, and bankers, images he would have known through prints.[11]

In about 1765, before he painted Revere, Copley had executed two portraits of another artisan, silversmith Nathaniel Hurd.[12] In the first version (fig. 184), which is unfinished, Copley may have intended to show Hurd with his sleeves rolled up, possibly at work. In the completed version (cat. no. 21), however, Hurd is presented as a gentleman of leisure, wearing a banyan; the only allusion to his craft is the title of one of the volumes at his elbow, *Display of Heraldry*. In his pastel self-portrait of 1769 (fig. 25), Copley also avoided any reference to his artistic profession, instead choosing for himself the image of a gentleman, unsullied by any reference to work, in his at-home finery.

The wigless Revere wears a plain white linen shirt with no cravat and only a hint of a frill on the right sleeve. The shirt is open, revealing an undershirt or possibly an untied stock beneath.[13] His blue-green waistcoat, made of wool or matte silk, is likewise unfastened; two gold buttons are visible below Revere's right hand. The open shirt and waistcoat worn without a jacket are associated with work clothes.[14] However, other aspects of his costume, such as its cleanliness and the gold buttons (possibly used here, along with the teapot, to advertise Revere's products), do not accurately reflect the garments Revere actually wore to ply his trade. Moreover, the polished table is not the craftsman's workbench but perhaps the counter in his shop at which he conducted sales.[15] Thus, in his portrait of Revere, Copley presented an idealized image of the artisan at work.

Though *Paul Revere* is now one of the most celebrated of American portraits, the circumstances of its execution are uncertain. It is known that Copley had met Revere by 1763, when the painter ordered a gold bracelet from the smith, and that he purchased frames and cases for his miniatures between 1763 and 1767.[16] However, the occasion for the commission of the portrait and who paid for it remain a mystery.[17] Recent examination of the painting has revealed that the canvas bears the date 1768. This date enhances the iconographic significance of the teapot, both as an aesthetic and a political symbol. Teapots were among the most complex objects Revere made; they signified his craft in its highest form. According to Revere's account book, he made a total of nine teapots from 1762 to 1773.[18] Of those nine, six were made between 1762 and 1765, one in 1768, and the other two in 1773.[19] By 1768 Revere's production of teapots had declined in response to the Townshend Acts, which imposed duties on a variety of imported goods, including tea. The teapot, then, was a provocative attribute for Revere, especially given his radical Whig politics during the early 1770s.

Unlike the portraits *Samuel Adams* and *John Hancock* (cat. nos. 62, 22), which were translated into prints and displayed in Faneuil Hall, Boston, *Paul Revere* did not become a public image during the Revolution or in its aftermath. The Copley portrait remained in the Revere family after the sitter's death in 1818 and until late in the nineteenth century lay "neglected for many years in an attic."[20] According to family tradition, Revere's daughter Harriet so disliked the informality of the portrait that she had her nephew, Joseph Warren Revere, an amateur artist, use only the face

from the original when he copied the painting; he replaced the shirtsleeves with a red uniform.[21] The portrait was resurrected within the Revere family only after Henry Wadsworth Longfellow's poem "Paul Revere's Ride" was published in 1861.[22] The image of Revere, which is so familiar today, became widely known only in the twentieth century; Copley's portrait apparently was not publicly displayed until it was lent to the Museum of Fine Arts, Boston, in 1928.[23] Since then it has become one of the major icons in American colonial painting. KEQ

1. For an excellent, succinct summary of Revere's life and work, see Patrick M. Leehey, "Reconstructing Paul Revere: An Overview of His Ancestry, Life, and Work," in *Paul Revere—Artisan, Businessman, and Patriot* (exh. cat., Lexington, Mass.: Museum of Our National Heritage, 1988), p. 26. Other biographies of Revere include Elbridge Henry Goss, *The Life of Colonel Paul Revere* (Boston, 1891); Esther Forbes, *Paul Revere and the World He Lived In* (Boston, 1942); and most recently David Hackett Fischer, *Paul Revere's Ride* (New York, 1994).

2. This ledger, the Revere Waste and Memoranda Book, was kept from 1761 to 1797 and is in the collection of the Massachusetts Historical Society, Boston. For an analysis of Revere's business, see Janine E. Skerry, "The Revolutionary Revere: A Critical Assessment of the Silver of Paul Revere," in *Paul Revere—Artisan, Businessman, and Patriot*, p. 46.

3. Deborah A. Federhen, "From Artisan to Entrepreneur: Paul Revere's Silver Shop Operation," in *Paul Revere—Artisan, Businessman, and Patriot*, p. 69.

4. For Paul Revere's engravings, see Clarence S. Brigham, *Paul Revere's Engravings* (1954; rev. ed., New York, 1969).

5. Federhen, "From Artisan to Entrepreneur," p. 72. Some of the advertisements are reproduced in Goss, *Life of Paul Revere*, pp. 440ff.)

6. Goss, *Life of Paul Revere*, p. 30.

7. Edith J. Steblecki, "Fraternity, Philanthropy, and Revolution: Paul Revere and Freemasonry," in *Paul Revere—Artisan, Businessman, and Patriot*, pp. 117, 126.

8. Fischer, *Paul Revere's Ride*, p. 22. In the 1770s Revere was a member of the North End Caucus and of the Long Room Club, took part in the Tea Party, and made numerous trips as a courier before and after the famous midnight ride (ibid., pp. 27–28, 299–307).

9. The identity of the sitter has been questioned. See cat. no. 2, n. 3, in this publication.

10. See Trevor J. Fairbrother, "John Singleton Copley's Use of British Mezzotints for His American Portraits: A Reappraisal Prompted by New Discoveries," *Arts Magazine* 55 (Mar. 1981), pp. 122–30.

11. Fairbrother compares the painting to a 1767 portrait of Diderot by Michel Van Loo (catalogue entry on *Paul Revere*, in Theodore E. Stebbins Jr., Carol Troyen, and Trevor J. Fairbrother, *A New World: Masterpieces of American Painting, 1760–1910* [exh. cat., Boston: Museum of Fine Arts, 1983], p. 198). Possible Northern Renaissance sources include Petrus Christus's *Saint Eligius* (Robert Lehman Collection, The Metropolitan Museum of Art, New York) and Quentin Massys's *Money Changer and His Wife* (Musée du Louvre, Paris).

12. Copley also painted a miniature of Hurd in about 1755–58 (private collection).

13. Fairbrother (in Stebbins, Troyen, and Fairbrother, *New World*, p. 198) suggests it is an undershirt. I am indebted to Nicola Shilliam, Assistant Curator of Textiles, Museum of Fine Arts, Boston, for her help in identifying Revere's clothing.

14. See, for example, Aileen Ribeiro, *A Visual History of Costume: The Eighteenth Century* (London, 1983), pp. 110–11.

15. See Federhen, "From Artisan to Entrepreneur," p. 81, fig. 30.

16. Revere Waste and Memoranda Book, 1761–1783, pp. 14–16, 19, 26, 28, 33, Revere Family Papers, Massachusetts Historical Society, Boston. The bracelet was probably for a Copley miniature; see Erica E. Hirshler, "Copley in Miniature," in this publication.

17. Forbes (*Revere and the World He Lived In*, p. 107) may have been the first to suggest that Copley exchanged the portrait for goods from Revere, but no mention of the trade is made in the Revere account books. According to Patrick Leehey, Coordinator of Research, Paul Revere Memorial Association, Boston, the Waste and Memoranda Book does not include every commission Revere executed. Robert Dubuque ("The Painter and the Patriot: John Singleton Copley's Portrait of Paul Revere," *Revere House Gazette* 17 [Autumn 1989], pp. 1–5) suggests that Revere did not commission the portrait, but rather that Copley initiated it.

18. Revere Waste and Memoranda Book, 1761–1783, Revere Family Papers, Massachusetts Historical Society, Boston. See also Federhen, "From Artisan to Entrepreneur," pp. 67–68.

19. Revere Waste and Memoranda Book, 1761–1783, Revere Family Papers. See also Federhen, "From Artisan to Entrepreneur," p. 67; and Michael K. Brown, "A Tempest of Economics and Politics in the Eighteenth Century Teapot," in *1984 Theta Charity Antiques Show* (n.p., 1984), p. 51.

20. Goss, *Life of Paul Revere*, p. 598.

21. Brigham, *Paul Revere's Engravings*, pp. 6–7.

22. "Paul Revere's Ride" was published in January 1861 in the *Atlantic*. According to Goss (*Life of Paul Revere*, p. 598), by 1875 the Copley portrait had "been finally restored."

23. *Paul Revere* was given to the Museum of Fine Arts, Boston, in 1930.

47

Reverend Myles Cooper

1768–69
Oil on canvas, 30 x 25 in. (76.3 x 63.5 cm)
Columbia University in the City of New York, Gift of the New-York Historical Society, 1820

The second president of King's College in New York (later Columbia University), doctor of civil law, professor of moral philosophy, classical scholar, published poet, and Anglican priest nicknamed "Rambling Cooper" for his love of travel, Myles Cooper was a conspicuous and vocal high-church Tory. He was born in 1737 in Cumberland County, England, received bachelor's and master's degrees from Oxford University, was ordained a priest by the Bishop of Oxford in 1761, and was appointed assistant to Samuel Johnson, the first president of King's College, in 1762. Within a year Johnson retired and Cooper assumed his office, embarking upon what some have referred to as the Oxfordization of the college.[1] He became known as a shrewd ad-

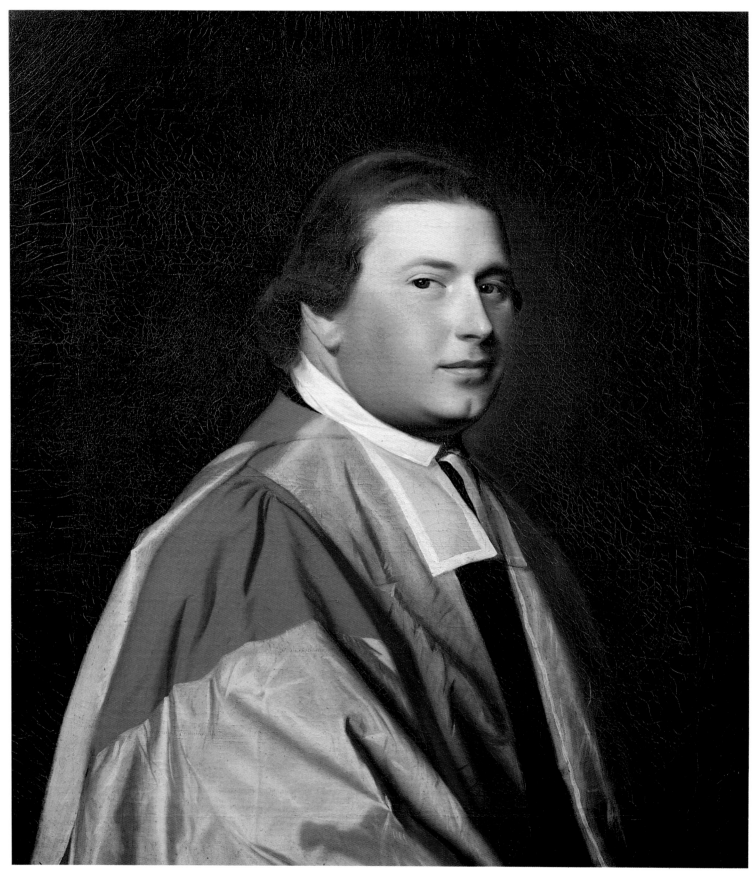

47

47

ministrator and an astute academician whose efforts enhanced the school's prestige and a strict disciplinarian who recorded students' misdeeds in a black book. He revised the curriculum, raised money to increase the endowment, established a medical school, and began an art collection for display in the college library. Some thought his great appetite for food and drink shocking in a man of the cloth, and he was "cordially hated" by his students, although perhaps primarily by the mischief makers.[2] Cooper freely offered and published his opinions with "great strength and elegance of style" but often with so much vehemence and sarcasm that he offended those he wished to persuade.[3] He wrote that "the people of Boston are a crooked and a perversion generation" but nonetheless commissioned his portrait from Boston's preeminent painter, Copley.[4]

Cooper sat for Copley when he visited Boston in 1768, probably in the early summer; at this time he apparently inaugurated the college art collection, purchasing from Copley's studio a painting of a nun seen by candlelight, presumably by another artist. Both the portrait and the picture of the nun were "much admired," Cooper told Copley when he received them a little over a year later, in August 1769.[5] As for the portrait, it is an arresting quarter-length image that shows Cooper as a clergyman-scholar. Cooper's direct gaze and the slight turn of his head over his shoulder account for much of the painting's impact, but the unusually eye-catching red and pink academic robe he wears also contributes markedly to the effect. However, it seems that Cooper did not pose in the robe, which was the costume of a doctor of civil law, a degree he received in 1767; only after he returned to New York did he send Copley "the Gown, Hood, and Band, by which to finish the Drapery."[6] Parting with the robe represented quite a sacrifice, for it was extremely important to Cooper, a fact confirmed by the correspondence that passed between him and Copley during the year that the painter worked on the portrait. In January 1769, when Cooper berated Copley for not having finished his portrait—which he had heard was "exceeding *like* me"—he was more concerned about the robe than the painting and complained: "The want of [the portrait] cannot be attended with any great Inconvenience; but the Gown I think you are unpardonable for keeping in your Hands so long. . . . I beg, Sir, you would send at least, my Gown by the first Opportunity."[7]

The letters exchanged by Cooper and Copley perhaps attest to the artist's painstaking and protracted manner of working. On the other hand, he may have been slow to finish Cooper's portrait simply because he was busy with other paintings; he did mention other obligations in one of his letters. Copley also wrote that he hoped that Cooper would return to Boston for another sitting.[8] Cooper did not see the need to pose again and promised to tell "those who have either Discernment enough to taste its Excellencies, or Penetration sufficient to observe its Defects" that the portrait's finish was not exactly to Copley's satisfaction.[9] When Cooper finally received his portrait, his robe, and the painting of the nun, he invited Copley to come to New York, where he said he "would find an unparalleled Degree of Encouragement," suggest-

ing that neither he nor anyone else noticed flaws in the likeness or the execution.[10] Copley did find encouragement when he went to New York in 1771, although Cooper, who was in England at the time, could not smooth the way for him; his portrait, however, may have attracted new patrons to the artist's door.

The Revolution foiled Cooper's attempts to build an art collection as well as his other plans for King's College. As early as April 1768 Cooper betrayed his preoccupation with politics to the exclusion of all else when he petitioned the Bishop of London to provide him with a residence in Maryland, to which he might flee at any time "in case of an accident."[11] And toward the end of that same year, when Copley urged Cooper to return to Boston for a second sitting, Cooper declined, declaring that "if I *do* see the Place again, it will hardly be before both You and I have seen Europe"—an assertion that not only speaks of his worries but also suggests that Copley must have cultivated his Loyalist patron's friendship with sympathetic conversation.[12] During the early 1770s Cooper remained an energetic and effective leader at King's College but spent more and more of his time writing incendiary pamphlets and newspaper articles. These caused him to become "the most hated Loyalist in all of New York," and in May 1775 he was forced to flee the country in his nightclothes.[13] His flight from New York was facilitated by his good friend Nicholas William Stuyvesant, who eventually came into possession of the Copley portrait, which his nephew and namesake presented to the New-York Historical Society in 1817. Shortly before the Historical Society gave the painting to Columbia College in 1820, the author and politician Gulian C. Verplanck described it as "a good portrait . . . which has often been remarked for its striking resemblance to the common engravings of the poet Dryden."[14] C R

1. Clarence Hayden Vance, "Myles Cooper," *Columbia University Quarterly*, Sept. 1930, p. 263.
2. A. Leroy Jones, "Myles Cooper, LL.D.," *Columbia University Quarterly*, Sept. 1899, p. 353.
3. Gulian C. Verplanck, "Sketch of the Life and Literary Character of the Late President Cooper," *Analectic Magazine* 14 (July 1819), p. 76.
4. Myles Cooper, *A Friendly Address to All Reasonable Americans on the Subject of Our Late Political Confusion* (New York, 1774), quoted in Jones, "Myles Cooper, LL.D.," p. 354.
5. Myles Cooper, letter to Copley, Aug. 21, 1769, in Jones 1914, p. 71. The correspondence between Cooper and Copley is published in Guernsey Jones, "A Copley Portrait of President Cooper," *Columbia University Quarterly*, Sept. 1909, pp. 460–64, as well as in Jones 1914.
6. Myles Cooper, letter to Copley, Aug. 5, 1768, in Jones 1914, p. 71.
7. Myles Cooper, letters to Copley, Oct. 24, 1768, Jan. 9, 1769, in Jones 1914, pp. 73–74.
8. Copley, letter to Myles Cooper, Oct. 24, 1768, in Jones 1914, pp. 73–74.
9. Myles Cooper, letter to Copley, Oct. 24, 1768, in Jones 1914, p. 74.
10. Myles Cooper, letter to Copley, Aug. 21, 1769, in Jones 1914, p. 76.
11. Myles Cooper, letter to Bishop of London, Apr. 4, 1768, Fulham Palace Archives, quoted in Vance, "Myles Cooper," p. 269.
12. Myles Cooper, letter to Copley, Oct. 24, 1768, in Jones 1914, p. 73.
13. Vance, "Myles Cooper," p. 278.

14. Verplanck, "Life and Literary Character of Cooper," p. 76. The gift was made on condition that the college pay for a copy of the portrait that would remain at The New-York Historical Society. The copy was painted by S. B. Hutchings. See E. R. S., "The Copley Portrait of President Cooper," *Columbia University Quarterly*, June 1910, pp. 299–301; *Catalogue of American Portraits in The New-York Historical Society* (New Haven, 1974), p. 156; and *Minutes of The New-York Historical Society* 1 (Jan. 14, 1817; Apr. 11, May 9, 1820), pp. 75, 92–93. William Dunlap erroneously noted that the copy was at Columbia on July 18, 1833 (*Diary of William Dunlap, 1766–1839* [New York, 1931], vol. 3, p. 722).

48

George Green

ca. 1768–69
Oil on copper, 3¼ x 2½ in. (8.3 x 6.4 cm)
Museum of Fine Arts, Boston, Emily L. Ainsley Fund 49.81

Little is known of George Green's life. One of twelve children of the Boston merchant Joseph Green[1] and active as a merchant with a shop at Williams's Court, George Green (1742–1814?) married Katharine Aspinwall in Brookline, Massachusetts, in November 1769. Green left Boston in 1773 and traveled to London, hoping to procure a political appointment in the colonies. His wife remained in Brookline. He likely gave this miniature to her as a memento, for it descended in the Aspinwall family. Katharine Green died in 1776; her husband never returned to America.[2]

In *George Green*, Copley eschewed the painterly surface effects he created in many of his other works on copper. Here the paint is laid on thickly and opaquely, with strokes consciously diminished so as to leave little evidence of the artist's hand, save in the areas of the sitter's collar and hair, which are enlivened by looser brushwork. This portrait is closely related stylistically to Copley's contemporary work in pastels, which demonstrates a similar compact smoothness. Pastels and miniatures seem always to have been linked to each other in Copley's mind; he frequently rendered sitters in both media, although there is no indication that *George Green* replicates a pastel. However, Copley portrayed several other members of the Green family in pastels between 1764 and 1770, among them George's father, Joseph, his sister Elizabeth Green Storer and her husband, Ebenezer Storer II, and his sister-in-law, Mary Storer Green (cat. nos. 26, 44, 43, 27). EEH

1. This Joseph Green (1703–1765) was not the same man as Nicholas Boylston's partner Joseph Green (1705–1780). The histories of those two merchants are somewhat intertwined, although it is clear that the former was a patriot and the latter a Loyalist.
2. Samuel Abbott Green, *An Account of Percival and Ellen Green and Some of Their Descendants* (Groton, Mass., 1876), pp. 21, 51, 53.

49

Portrait of the Artist

1769
Watercolor on ivory, 2 x 1⅛ in. (3.3 x 2.7 cm)
Signed and dated lower right: ISC [monogram] 1769
Collection of Gloria Manney

By the mid-1760s Copley had mastered the demanding technique of painting true miniatures, meaning watercolors painted on ivory. This small portrait, like many others he did for his clients, was probably made as a token of affection—in this case, Copley's own. Copley married Susanna (Sukey) Farnham Clarke

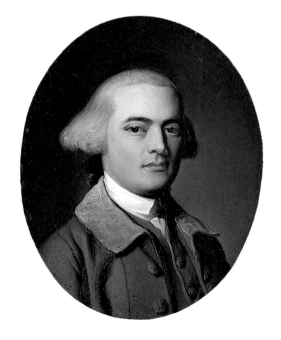

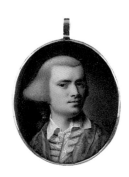

in November of 1769, and he likely gave this picture and its tiny gold case to her as a keepsake. The image was apparently based upon a pastel self-portrait he had completed that same year, a pendant to one he made of his bride at about the same time (figs. 25, 114).

Here, as in the pastel, Copley presented himself as both fashionable and well-to-do. He wears a blue silk damask morning gown with lavender facings over a red and yellow striped and embroidered waistcoat, apparel that connotes wealth and leisure. His stylishness is indicated not only by his clothes but also by the portrait itself, for such tiny likenesses, used as expensive personal adornments, represented the height of elegance in England. This miniature completely expresses Copley's outlook and ambition: he showed himself not as the "Carpenter, tailor or shew maker" that he complained his countrymen considered painters to be but as a gentleman worthy to receive the laurels that he thought should "adoarn the brows of those Elustrious Artists."[1]

The cool blue tone that saturates this miniature is the hue that such writers as Claude Boutet recommended to create flesh color, with the addition of vermilion for men's faces.[2] The blue now likely is somewhat exaggerated, for the mitigating effects of reds and pinks may have disappeared, as those rosy tints fade easily. The gold locket, original to the piece, is thought to be the work of Paul Revere.[3] E E H

1. Copley, letter to [Benjamin West or Captain R. G. Bruce?], [1767?]; Copley, letter to John Greenwood, Jan. 25, 1771, in Jones 1914, pp. 65–66, 106.
2. [Claude Boutet], *The Art of Painting in Miniature: Teaching the Speedy and Perfect Acquisition of That Art Without a Master* (London, 1752), pp. 38–39.
3. See Dale T. Johnson, *American Portrait Miniatures in the Manney Collection* (New York, 1990), pp. 98–100.

50

Isaac Smith

1769
Oil on canvas, 50⅛ x 40⅛ in. (127.3 x 101.9 cm)
Yale University Art Gallery, New Haven, Gift of Maitland Fuller Griggs, B.A. 1869, L.H.D. 1938 1941.73

51

Mrs. Isaac Smith (Elizabeth Storer)

1769
Oil on canvas, 50⅛ x 40⅛ in. (127.3 x 101.9 cm)
Yale University Art Gallery, New Haven, Gift of Maitland Fuller Griggs, B.A. 1869, L.H.D. 1938 1941.74

Isaac Smith (1719–1787), son of William and Abigail Fowle Smith, married Elizabeth Storer (1726–1786), daughter of Ebenezer and Mary Edwards Storer (cat. nos. 41, 42), at Boston's Brattle Square Church on October 9, 1746. After twenty-three years of marriage, in the summer of 1769, Isaac Smith ordered from Copley "his & his Ladys portrait in Half Length" and paid him the handsome fee of fourteen guineas (about twenty pounds) for each painting.[1] Smith also bought through Copley "two carved Gold frames," for which he was charged the lordly price of eighteen pounds for the pair. In making these purchases, Smith was following the Storer family's recently inaugurated tradition of ordering ornately framed pictures from Copley. Smith's commission was for oils, however, whereas the Storers' portraits were pastels, sold with Rococo frames, executed between 1765 and 1769, of Elizabeth Smith's parents, her sister, and her brother and sister-in-law (cat. nos. 41, 42, 27, 43, 44).

His own family's tradition involved portraits of a more modest sort. On the occasion of his marriage, Smith had commissioned a rather simple portrait of his bride from Joseph Badger (fig. 192), and within the next decade or so his now-remarried mother, Abigail Smith Edwards, also ordered a likeness from Badger (fig. 193). Without knowing precisely when Mrs. Edwards sat for Badger, it is impossible to determine whether she deliberately chose his rather somber and restrained style over Joseph Blackburn's relatively deft and elegant manner, or even over the already masterly inventions of a third Boston painter, the young Copley: Blackburn would have been available to her only between 1755 and about 1763, when he worked in Boston, and she could have gone to Copley only beginning in the mid-1750s. In any case, Mrs. Edwards, a wealthy woman whose will included a "flowerd damask gown" and "a green & yellow silk robe,"[2] among other expensive and colorful articles of clothing, was commemorated as dour and puritanical by Badger. Evidently, by 1769 this sort of interpretation no longer suited her son, a self-made merchant who built a mansion for his wife and three children in 1758 at the top of King Street in Boston. And so, at the peak of his mercantile career, Isaac Smith chose to commission from Copley opulent companion portraits of himself and his wife and to have them embellished with the highest style frames available in New England.

The Smith paintings are among Copley's best-orchestrated and iconographically richest pendants, rivaling the superb full-length portraits of the Lees (cat. nos. 52, 53), which were painted the same year. The Smiths, like the Lees, were fabulously wealthy patrons for whom Copley would have been eager to display the virtuoso skills at his command and to draw upon the full range of his formal vocabulary and knowledge of companion portraits. He linked this portrait pair by selecting for them similar colors, compositions, and poses that are parallel down to hand gestures and position of knees; yet he individualized his sitters by endowing each with distinctive attributes and settings appropriate to their respective characters.

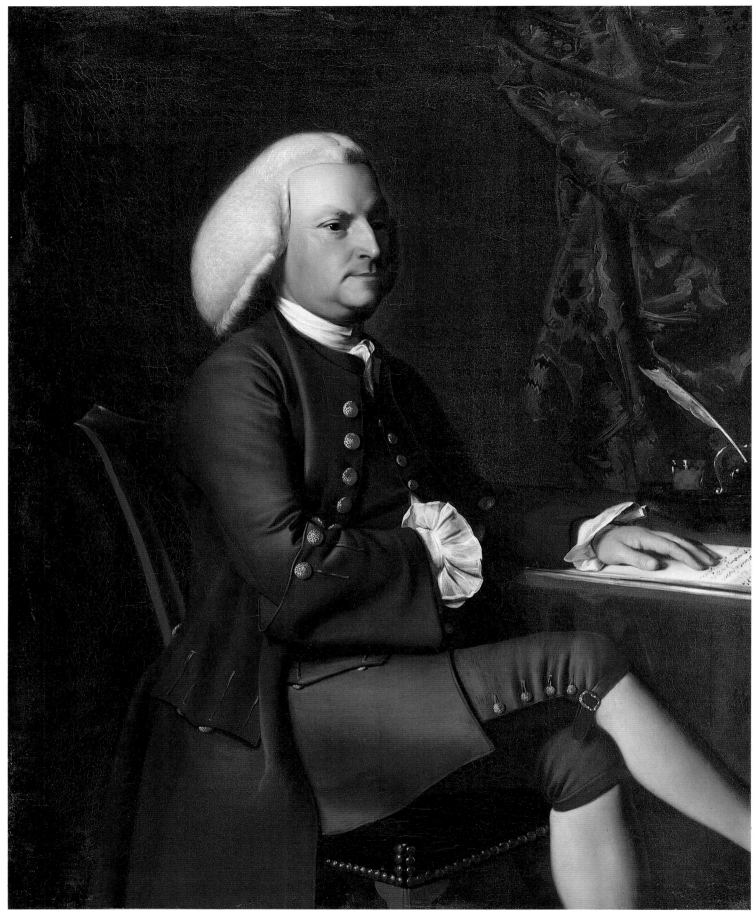

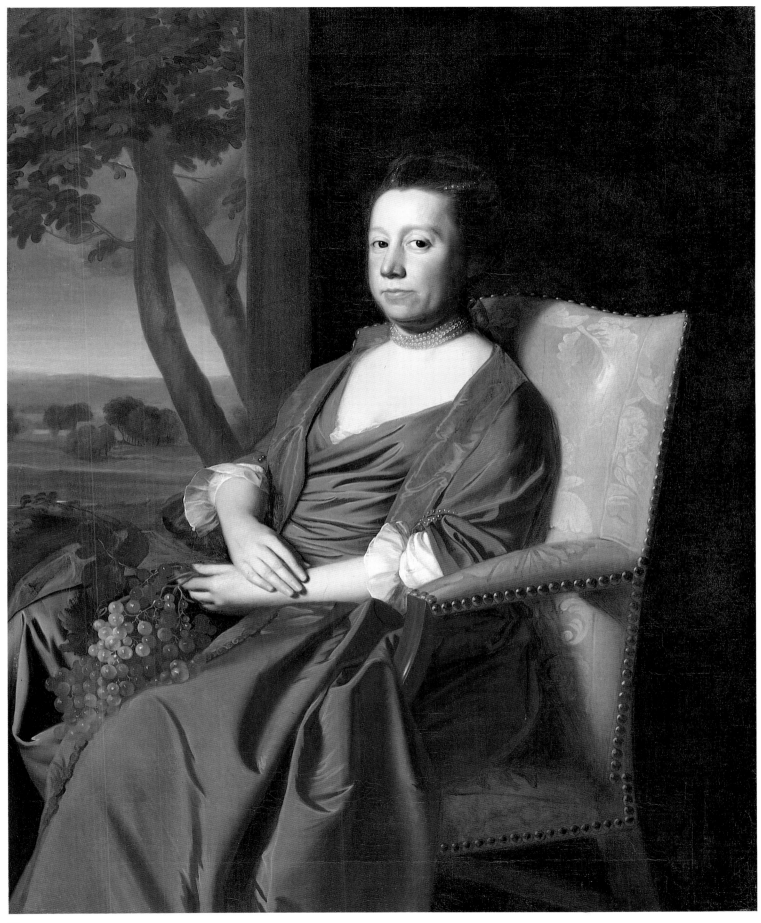

51

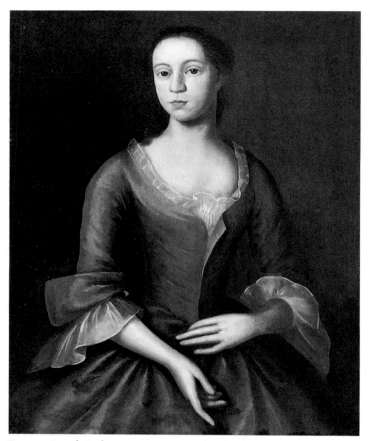

Fig. 192 Joseph Badger. *Mrs. Isaac Smith (Elizabeth Storer)*, ca. 1746. Oil on canvas, 36 x 29 in. (91.4 x 73.6 cm). Museum of Fine Arts, Boston, Bequest of Frances Cordis Cruft 43.376

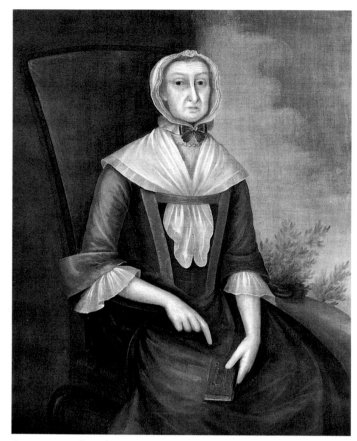

Fig. 193 Joseph Badger. *Mrs. John Edwards (Abigail Fowle)*, ca. 1750–60. Oil on canvas, 46⅜ x 35½ in. (117.7 x 90.2 cm). Museum of Fine Arts, Boston, Gift of Dr. Charles Wendell Townsend 24.421

Isaac Smith is seated, right leg crossed over left, at a desk, in an elegant Chippendale side chair, his left hand resting on a slim pile of papers, his fingers marking the end of a line that he has apparently just finished writing. He has paused in his work, but his far-away gaze suggests that he remains preoccupied with his task. His quill pen rises from an inkwell to his left; the feather stands out against a deep purple figured damask curtain and, together with the paper and the sitter's stockinged right shin, is one of three white elements that point in the direction of the facing image of Mrs. Smith. His attributes—pen, inkwell and standish, paper, script and correspondence, desk, and side chair—are items commonly associated with business, masculinity, and gentility.[3] In complement to her husband's image, Elizabeth Smith is also seated, but she is shown at leisure. Her gold-damask-covered armchair is related to his side chair—they are upholstered according to similar methods, and the profile of her arm support matches that of his top rail—but the visual effect of each is entirely different. The brass tacks of Isaac's chair look sharp and resonate with the hard and shiny gold buttons on his suit, while the tacks of Elizabeth's seat participate with pearls and grapes in a symphony of softly glowing round elements. Her robe is basically the same color as his suit but is luminous, whereas his garment is relatively lusterless and faced with a changeable green silk lining that contrasts with

her bright turquoise-blue wrapping gown. Mr. Smith is sheltered in an entirely closed interior setting; Mrs. Smith's interior setting opens onto a verdant landscape. Her attributes are signs of natural life—trees, a river, fruit—and her outward-directed gaze confirms her engagement with the world around her in contrast to his symbols of power and intellectual preoccupation.

In these portraits Copley may have accurately transcribed the physiognomies of the sitters as well as the furniture and other props, for the faces are unidealized and the objects accord with records of the Smiths' possessions.[4] By the same token, the bunch of grapes on Elizabeth Smith's lap, identified by their wine-colored leaves and green skin as a European species of wild grape rare but not unknown in Massachusetts during the eighteenth century, also could have been drawn from life.[5] They may allude to the couple's expensive taste in food or to the source of some of Isaac Smith's income as an importer and vendor of brandy, Madeira, and other wines.[6] Given Copley's familiarity with traditional symbols as presented in books and prints, however, it seems likely that the grapes are emblematic of more than mere food or business. In sixteenth- and seventeenth-century European portraits of married women and mothers (see fig. 194), sitters are frequently shown holding fruit without coming into contact with it, like Mrs. Smith, who barely touches the stem of her grapes. This peculiar icono-

256

graphical detail has been interpreted in the context of Dutch painting as a reference to the "unsullied marital sex life"[7] of a woman who offers fruit without staining her virtue. A recent study on the subject argues that the image relates more generally to fertility: the sitter holds the stem, or the vine, which symbolizes motherhood, and the stem bears fruit, or children.[8] Both analyses maintain that grapes symbolize a large and healthy family, a trope that may well be applicable to Elizabeth Smith. Perhaps also relevant here is the idea that fertility and motherhood involve nurture as much as nature,[9] that a mother such as Mrs. Smith rears her children with care, just as her exquisite, highly cultivated fruit has been raised.

Smith's motives for commissioning his pendant portraits and what he and his wife wanted Copley to express about their lives and characters are unknown. Although there is no precedent in American art history for a commission occasioned by a pregnancy, it is tempting to suppose that Isaac ordered the portraits to celebrate an impending birth—for Elizabeth was expecting a child when she sat for Copley. An even more likely possibility is that he wished to commemorate his marriage and his wife's image in case she died in childbirth. In the eighteenth century deaths in childbirth occurred with some frequency, with the danger increasing as the age of the mother advanced, and Elizabeth was forty-four when Copley painted her.[10] The pregnancy must have been very special for the Smiths—the last of their children, Mary, had been

born in 1757, when Elizabeth was thirty-one—which Copley may have known and which supports the conjecture that the commission honored her condition. On January 30, 1770, Isaac Smith wrote to his firstborn son, by then a twenty-year-old man traveling in London: "This morning your mother was safely delivered of a daughter by which you have a sister of the Name of yr Mother."[11] The Smiths had already given the name Elizabeth to two girls, born in 1750 and 1753, but both died in infancy. They subsequently repressed their desire for a namesake for Mrs. Smith, calling the next girl Mary after her grandmother. That the couple named their new, unexpected, and belated baby Elizabeth must indicate that she represented a revival of hopes.

Despite the stern facial expression Copley captured, Elizabeth Smith was known as warm and caring, a mother who encouraged her children's myriad aspirations and taught them piety, poetry, and penmanship. She was remembered by her niece, Abigail Smith Adams, as a woman with "the Law of Kindness & Hospitality written upon her Heart."[12] Isaac Smith, who was a moderate Whig, moved his family to Salem during the Revolution and served as a director of the bank he helped establish there. He and Elizabeth continued to live in Boston until they died within a year of each other.

C R

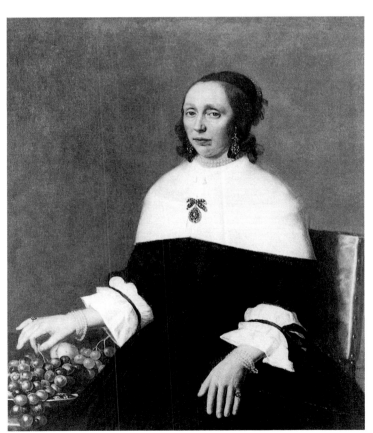

Fig. 194 Jan de Bray. *Portrait of a Woman*, ca. 1660–80. Oil on canvas, 39 x 32 in. (99.1 x 81.3 cm). Private collection

1. Receipt, dated 1769, Smith-Carter Papers, Massachusetts Historical Society, Boston. Isaac Smith's nephew, John Adams, wrote that he "went to take View of Mr. Copelys Pictures" on August 11, 1769 (*Diary and Autobiography of John Adams*, ed. Lyman H. Butterfield [Cambridge, Mass., 1961], vol. 1, p. 340).

2. Abigail Edwards, Last will and testament, Jan. 18, 1760, Massachusetts Historical Society, Boston.

3. For a discussion of penmanship and correspondence as signs of gentility and politeness in the eighteenth century, see Richard L. Bushman, *The Refinement of America: Persons, Houses, and Cities* (New York, 1992), pp. 92–96.

4. A 1775 inventory of Smith's household property at the Massachusetts Historical Society, Boston, is not detailed enough to prove that he owned the specific chairs that Copley painted but records that they owned a considerable number of armchairs, side chairs, and easy chairs. Furniture scholars at Yale University display a Massachusetts upholstered armchair (Yale 1930.2106) next to Elizabeth Smith's portrait; the resemblance of this chair to the furniture in the painting confirms the accuracy of Copley's depiction. For more related chairs, see Patricia E. Kane, *300 Years of American Seating Furniture* (New York, 1976), pp. 223–24.

5. Conversation with John Mickel and Rupert Barneby, New York Botanical Gardens. See also Ann Leighton, *American Gardens in the Eighteenth Century: "For Use or For Delight"* (Boston, 1976), p. 232.

6. Smith's 1775 inventory at the Massachusetts Historical Society, Boston, lists crates of brandy, Madeira, port, Malaga, and other wines. An advertisement that reads "To be Sold at Isaac Smith's Store in State Street Choice Madeira, Sherry, Lisbon and Malaga wines[,] Jesuits Bark, Cordage of all Sizes[,] currants. Also Sea Coal for grates," appeared in the *Boston Independent Chronicle*, Oct. 6, 1785.

7. E. de Jongh, "Grape Symbolism in Paintings of the 16th and 17th Centuries," *Semiolus* 7 (1974), p. 177.

8. "Fruit and Fertility," in Jan Baptist Bedaux, *The Reality of Symbols:*

Studies in the Iconology of Netherlandish Art, 1400–1800 (The Hague, 1990), pp. 71–104.

9. Ibid., p. 103.

10. Mary Beth Norton, *Liberty's Daughters: The Revolutionary Experience of American Women, 1750–1800* (Boston, 1980), pp. 75–77; Claire Elizabeth Fox, "Pregnancy, Childbirth, and Early Infancy in Anglo-American Culture, 1675–1830" (Ph.D. diss., University of Pennsylvania, Philadelphia, 1966).

11. Isaac Smith, letter to Isaac Smith Jr., Jan. 23, 1770, postscript dated Jan. 30, Massachusetts Historical Society, Boston. The birth of Elizabeth, as well as the births of the Smiths' other children, is recorded in the inside front cover of the family Bible (*The New Testament of Our Lord and Saviour Jesus Christ* [Oxford, 1768]), Massachusetts Historical Society, Boston. The births are also recorded in William S. Appleton, ed., *Boston Births, 1700–1800* (Baltimore, 1978), p. 321, and *Records of the Church in Brattle Square, Boston, With Lists of Communicants, Baptisms, Marriages, and Funerals, 1699–1872* (Boston, 1902), pp. 173, 174, 175, 176, 186.

12. Abigail Smith Adams, letter to Isaac Smith, July 31, 1786, Massachusetts Historical Society, Boston. Elizabeth Smith's many long letters to her son Isaac reveal much about her relationship with her children. See, for example, letters dated Nov. 18, 1763, and Jan. 23 and May 18, 1771, Massachusetts Historical Society, Boston.

52

Jeremiah Lee

1769

Oil on canvas, 95 x 59 in. (241.3 x 149.9 cm)

Signed and dated center left: JSC [monogram] p.1769

Wadsworth Atheneum, Hartford, The Ella Gallup Sumner and Mary Catlin Sumner Collection Fund

53

Mrs. Jeremiah Lee (Martha Swett)

1769

Oil on canvas, 95 x 59 in. (241.3 x 149.9 cm)

Signed and dated on base of pillar: JSC [monogram] 1769

Wadsworth Atheneum, Hartford, The Ella Gallup Sumner and Mary Catlin Sumner Collection Fund

54

Jeremiah Lee

ca. 1769

Watercolor on ivory, 1½ x 1¼ in. (3.8 x 3.2 cm)

The Metropolitan Museum of Art, New York, Harris Brisbane Dick Fund, 1939 39.174

The portraits of the merchant grandee Jeremiah Lee and of his wife, Martha, are perhaps the most opulent pictures Copley painted during his American career. They were his fourth and fifth full-length, lifesize portraits. Copley also painted a miniature, in watercolor and gouache on ivory, of Mr. Lee's head.

The Lees were among the wealthiest families in New England. Her father, Joseph Swett, had helped Marblehead achieve its position as the second largest port in New England in the early eighteenth century. Lee's father came to Marblehead in 1745 and established an import-export trade that rivaled that of the Hancocks in Boston. Jeremiah Lee (1721–1775) worked in his father's firm and also was active in civic affairs and politics. By the time Copley painted him in 1769, he had a fleet of thirty ships and had been a justice of the peace and a colonel in the Marblehead regiment. He had also identified himself, like John Hancock, as a radical Whig. He organized citizens in Marblehead who opposed the Stamp Act of 1765. And later, in 1774, Lee was elected to represent the town at the Continental Congress. He declined this office in favor of serving in the provincial Congress that protested against the Tea Act to Governor Thomas Gage and resolved to boycott

Fig. 195 Lee Mansion, Marblehead, Massachusetts

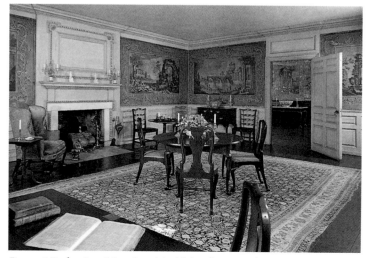

Fig. 196 Parlor, Lee Mansion, Marblehead, Massachusetts

Fig. 197 John Faber after John Vanderbank. *Sir William Lee*, 1738. Mezzotint, 18⅝ x 13¾ in. (47.3 x 34.9 cm). Trustees of the British Museum, London

Fig. 198 Joseph Blackburn. *Governor Benning Wentworth*, ca. 1760. Oil on canvas, 92 x 56¼ in. (233.7 x 142.9 cm). New Hampshire Historical Society, Concord F390

any citizens who cooperated with the Crown. The day before the Battle of Lexington, in 1775, British troops searched for Lee in Concord. He managed to escape at night, but, according to historical lore, exposure during his flight caused a severe fever that led to his death a month later.[1]

The full-length pictures hung in the Lees' majestic home in Marblehead, which was built in 1768–69, at the same time the portraits were painted, and served as a symbol of the family's success and cultural aspirations (fig. 195). The house is designed along the lines of eighteenth-century English town houses, imitating foreign originals in both its architecture and furnishings. The main walls, for example, are cut to mimic stonemasonry. The extravagant wood carvings in the interior (fig. 196) are based on English patterns.

Copley's portraits are equally aggressive efforts to represent the Lees at the pinnacle of economic and social status. He is shown standing monumentally, dressed in a silk-velvet coat and lavish waistcoat trimmed in galloon, a gold braid. Holding recently unfolded letters that show him to be a man of affairs, he buttresses his portly body against a marble-slab-top pier table carved with nude female figures and gilded. Tables like this were not in the

Lees' house and in fact were unknown in America. Copley, who had used a similar table in his portrait of Thomas Hancock (fig. 1), may have learned about them from prints, such as John Faber's engraving after John Vanderbank's portrait of Sir William Lee of 1738 (fig. 197), or from pattern books, such as Batty Langley's *City and Country Builder's and Workman's Treasury of Designs* of 1740.[2] The carpet is an Axminster woven in an Ushak design. Inventories of the Lee estate state that the furnishings of the house included carpets, but they are not described in enough detail to indicate whether or not the one pictured was among them.[3] Behind the sitter is a deep landscape and a column partially covered by a red damask curtain. Both the setting and Lee's pose recall Joseph Blackburn's portrait of Governor Benning Wentworth (fig. 198).

Copley portrayed Mrs. Lee (1726–1791) in an uncorseted pumpkin-colored caftan held together by a purple sash knotted into a rosette. A red underdress is visible at her ankles, and a pelisse trimmed with ermine tips falls from her shoulders. In her hair and around her neck are multiple strands of pearls. This is not the kind of outfit that an American woman would have worn in public; rather, it is like a masquerade costume, intended as part of a Turkish fantasy Mrs. Lee plays for the viewer. She is shown climbing

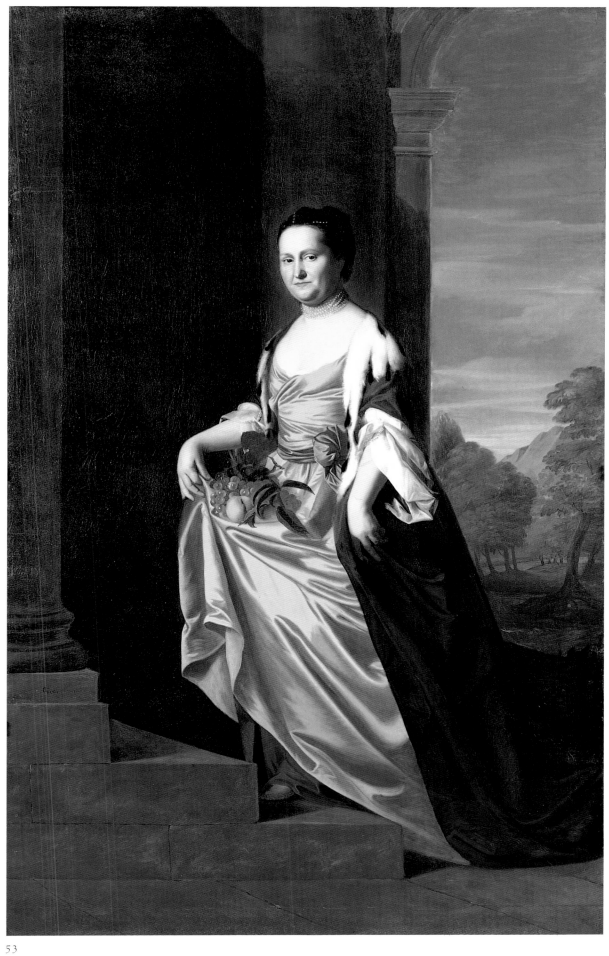

53

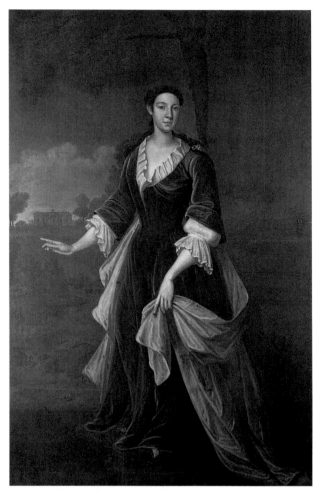

Fig. 199 John Smibert. *Mrs. William Browne*, n.d. Oil on canvas, 92½ x 57 in. (235 x 144.8 cm). Halsted Collection of The Johns Hopkins University, Baltimore, on extended loan to The Baltimore Museum of Art L.23.13.10A

stairs and tenuously cradling a harvest of peaches and grapes in the folds of her caftan, a pose that resembles the one John Smibert used in his portrait of Mrs. William Browne (fig. 199). Copley may have had other precedents for Mrs. Lee's pose: subjects are occasionally shown in the act of ascending stairs in English paintings such as Van Dyck's portrait of Beatrice de Cusance, princess of Cantecroix and duchess of Lorraine, ca. 1638 (Collection of Her Majesty the Queen, London).

The Lee portraits may have been commissioned specifically for the couple's new house, with a particular location in mind. Stuart Feld suggests that these large pictures could only have hung on the landing between the first and second floors, the one place with walls high enough to accommodate them when they were in their original frames, which were surmounted by cartouches. Moreover, this would have been a particularly strategic spot, for visitors to the Lee house in the eighteenth century would have had ample opportunity to see the portraits, since the second-floor parlor was frequently used for entertaining. To a viewer climbing the stairs, Mrs. Lee would have seemed to be a few steps away, turning her head to look back. [4] P S

54

1. For his life, see Thomas Amory Lee, *The Lee Family of Marblehead* (1916; reprint, Salem, Mass., 1917), pp. 49–59.
2. Batty Langley, *The City and Country Builder's and Workman's Treasury of Designs* (1756; reprint, New York, 1967), pls. 143, 144, 147.
3. For the carpet, see Sarah B. Sherrill, "Oriental Carpets in Seventeenth- and Eighteenth-Century America," *Antiques* 109 (Jan. 1976), pp. 142–66.
4. I thank Mr. Feld for a copy of an unpublished paper on this subject.

55

Lemuel Cox

1770
Oil on canvas, 49¾ x 39¾ in. (126.4 x 101 cm)
Signed and dated lower left: J.S.C. p. 1770
The Baltimore Museum of Art, Bequest of Elize Agnus Daingerfield
BMA 1944.98

In 1770 the wheelwright and bridge builder Lemuel Cox (1736–1806) of Boston[1] designed a machine for cutting card wires, a device that streamlined the otherwise tedious process of preparing yarn for spinning.[2] This invention, which would reduce considerably the cost of domestic textile production, had the potential not only to revolutionize the industry but also to decrease the American dependence on English dry goods, as well as on the implements for their manufacture.[3] As such, the device had political in addition to economic significance, for at the time it was introduced many Bostonians were advocating the boycott of British imports in retaliation for the hated Townshend Acts. Although the invention was subsequently stolen from Cox, it initially must have seemed his avenue to wealth and celebrity. His anticipated prosperity may have prompted him to commission Copley to paint his portrait. Certainly, he looks at the viewer with the self-confidence born of success.

For his image of this up-and-coming young inventor, Copley formulated a variant on a familiar pose. He showed Cox leaning to his right, with one arm draped over a plinth, a nonchalant posture based on the hand-on-hip stance long used to express a kind of aristocratic ease and self-assurance. But for the hand on the hip,

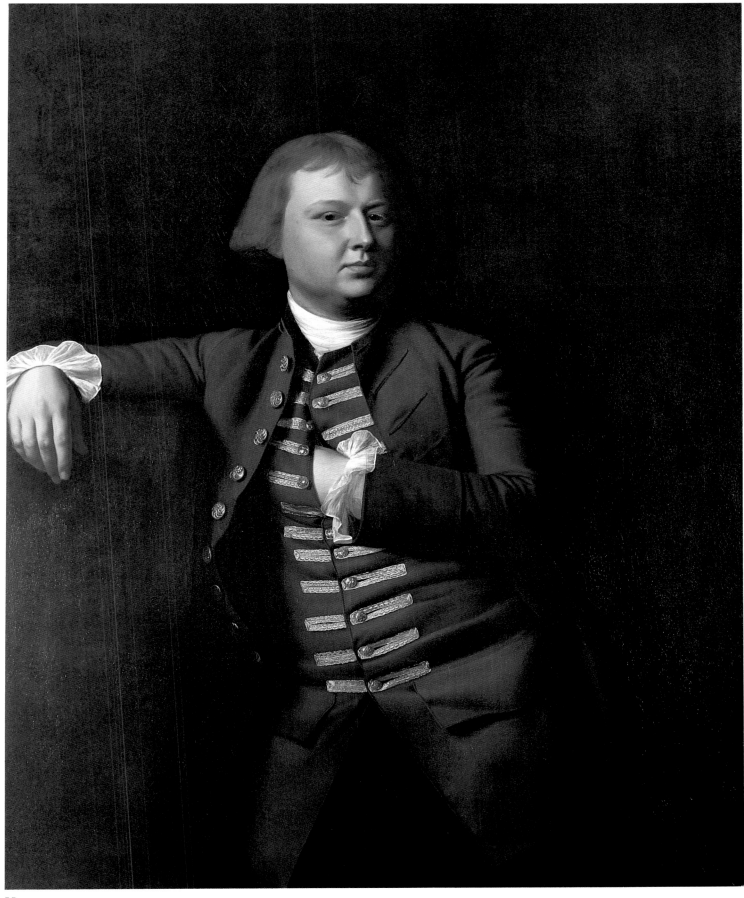

Copley substituted the hand tucked into the waistcoat. This gesture, which etiquette books recommended as expressive of "Decency and genteel Behaviour,"[4] attributed to Cox, an artisan, the bearing of a gentleman. However, the casual aggressiveness of his expression, coupled with the intense contrasts between dark suit and background and strongly lit hands and face, emphasizes Cox's physical presence and creates an aura of forcefulness that Copley would surpass only rarely, in the drama of such paintings as *Samuel Adams* (cat. no. 62).[5]

When he sat for Copley, Cox was a patriot. He is recorded as one of the party of rebels who met regularly for discussion and dinner at the Liberty Tree in Dorchester.[6] Like a number of the younger men Copley painted in the years just preceding the Revolution, Cox is presented in a manner that reflects the advent of a simpler, perhaps even more democratic, style of dress in America. Neither bewigged nor beturbaned, Cox looks forward to an era when such symbols of a man's wealth would pass from currency. The suit was likely Cox's best, of fine blue wool cloth with gold braiding on the vest and brass buttons on the coat, and, like his pose, it indicates his social aspirations. Such suits were worn by men of varying levels of income and status as well as political perspectives, but few farmers or artisans were likely to have owned one. Yet compared to the rich imported velvets and brocades worn by Copley's extremely wealthy patrons of middle age, Cox's apparel was relatively modest.[7]

It is not clear whether Cox's attire reflects his political views or simply his improving financial position, but neither was to last. By the time the war began, Cox seems to have redirected his loyalties, for in 1775 he was imprisoned at Ipswich on suspicion of spying for the British.[8] Thereafter, he left the country, to return in 1782—a homecoming no doubt sanctioned because of his engineering genius. In 1785–86 he supervised the construction of the first bridge across the Charles River, connecting Boston and Charlestown. He was the architect and builder of several other large bridges, both in Massachusetts and in Ireland, erected one of New England's first powder mills, and devised a program whereby the prisoners of Castle Island in Boston Harbor could be employed to manufacture nails. In recognition of these designs, and in restitution for his invention of the card-wire cutting machine (for which he had never been compensated), the Massachusetts Legislature granted him one thousand acres of land in Maine in 1796. Nonetheless, he died insolvent in 1806.[9]

C T

1. The identification of this subject with Lemuel Cox has not been definitively established, although the painting has been owned by Cox's descendants for generations, and no evidence that it is not he has emerged. Jules David Prown, letter to Sona K. Johnston, May 18, 1978, as noted in Sona K. Johnston, *American Paintings, 1750–1900, from the Collection of the Baltimore Museum of Art* (Baltimore, 1983), p. 41.
2. Carding, a process whereby fibers of wool are untangled prior to spinning, was accomplished by manipulation of two comblike devices, or cards. Before the card-wire cutting machine was invented, the cards, pieces of leather with hundreds of protruding wires set into them, were produced by hand in the home. See *Handbook of the Merrimack Valley Textile Museum* (North Andover, Mass., 1965), unpaged.
3. According to T. H. Breen, "The customs records reveal that approximately half of all colonial imports consisted of textiles" (T. H. Breen, "The Meaning of 'Likeness': American Portrait Painting in an Eighteenth-Century Consumer Society," *Word and Image* 6 [Oct.–Dec. 1990], p. 335).
4. See, for example, F. Nivelon, *The Rudiments of Genteel Behavior* (London, 1737), unpaged. Although the device of the hand in the waistcoat does not appear in earlier Copley portraits, it had been popular at mid-century with such American painters as Robert Feke and with a host of British portraitists, and Copley would use it frequently in the 1770s.
5. The comparison with the Adams portrait was first made by Prown (1966, vol. 1, p. 77).
6. Cox is listed among the diners on August 14, 1769 (Walter K. Watkins, "A Medford Tax Payer: Lemuel Cox, the Bridge Builder and Inventor," part 1, *Medford Historical Register* 10 [Apr. 1907], p. 34).
7. See, by way of comparison, the portraits of Nathaniel Sparhawk and Nicholas Boylston (cat. nos. 19, 31). Cox was not included in Jules Prown's statistical analysis of 240 of Copley's sitters, but his attire is similar to that in the picture of John Greene, ca. 1769 (Currier Gallery of Art, Manchester, New Hampshire), whose income level Prown lists as "medium," or between one hundred and five hundred pounds a year (Prown 1966, vol. 1, p. 127).
8. E. Alfred Jones, *The Loyalists of Massachusetts* (London, 1930), p. 315.
9. See Walter K. Watkins, "A Medford Tax Payer: Lemuel Cox, the Bridge Builder and Inventor," part 2, *Medford Historical Register* 10 (July 1907), pp. 57–64.

56

John Bours

ca. 1770
Oil on canvas, 50¼ x 40⅛ in. (127.6 x 101.9 cm)
Worcester Art Museum, Massachusetts 1908.7

The dating of this picture has always been uncertain. Barbara Neville Parker and Anne Bolling Wheeler placed it about 1763 on the basis of the picture's "style" and "the age of the sitter."[1] They did not, however, elaborate on the specific elements of style that argue for that date. Jules Prown suggested an earlier date, 1758–61, relating it "in concept" to a small portrait of about the same time of Copley's half brother, Henry Pelham (cat. no. 24), and in terms of its pose to the picture of the Reverend Edward Holyoke (fig. 45).[2]

Such an early date might also be recommended by Bours's unfashionability. His velvet jacket has the deep cuffs and long skirt consistent with early eighteenth-century menswear. And the corner chair in which he sits is carved in the Queen Anne style popular in the 1740s. The chair is further significant for its unusual legs. Ordinarily a corner chair has crisscrossed stretchers, but the stretchers here are at right angles to the legs. And typically there is only one cabriole leg, but this chair has two. The two other legs

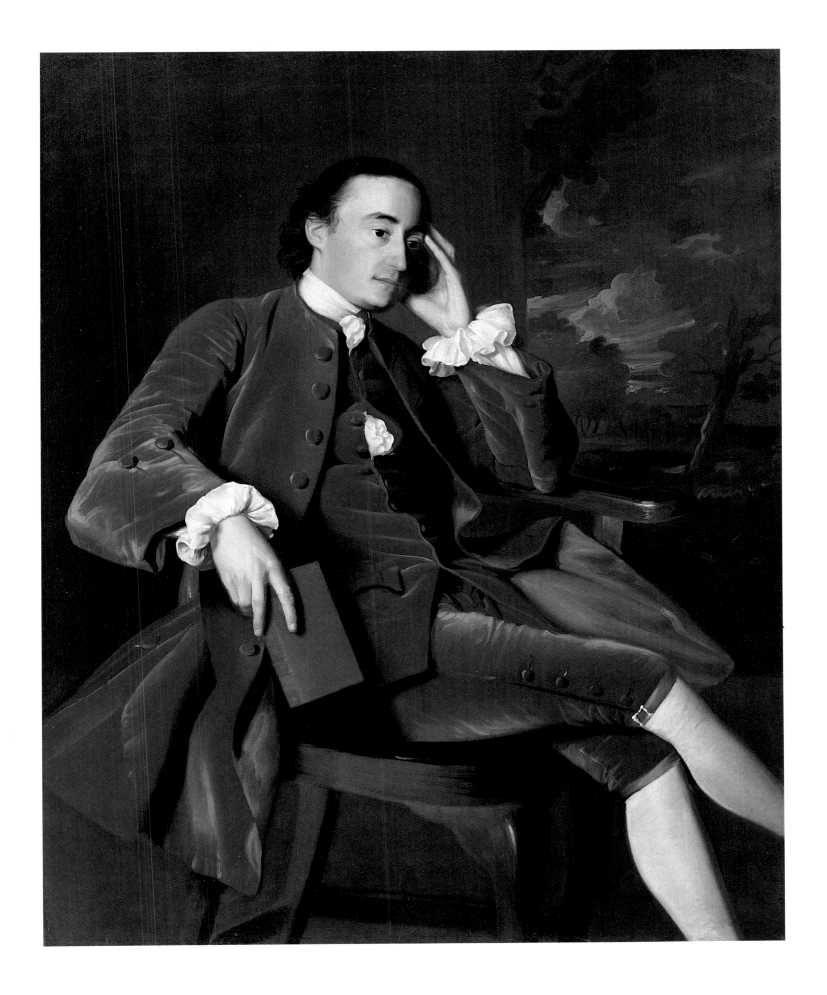

Fig. 200 John Faber after J. B. Van Loo. *Alexander Pope*, 1742. Mezzotint, 12⅛ x 10 in. (30.8 x 25.4 cm). Trustees of the British Museum, London

are flared, suggesting that Copley's studio prop was a side chair and/or that the artist began to depict it as such.

Fashionability may not be relevant in dating this portrait, however, whereas technique and psychological aura more probably are. The exceptionally fluid pigments and brushy technique give it an English look, suggesting Copley's attempt, after he received advice from Benjamin West in 1767, to alter his crisp edges and opaque pigments. He painted broadly here, using both wide and narrow brushes in an obvious, self-confident manner inconsistent with the technique of his early work. He also applied pigment directly, avoiding the colored glazes that he employed in about 1760 to modify color after it was applied to the canvas. But it is the image of faraway contemplation that Bours shares with Margaret Kemble Gage, Mary Charnock Devereux (cat. nos. 67, 59), Dorothy Quincy (fig. 224), and Dorothy Wendell Skinner (cat. no. 76), all subjects of works of about 1770, that most closely links the picture to that period.

Bours (1734–1815) looks removed from the temporal world, though as a professional man he was actively engaged in commerce. He was a merchant who owned a shop at the sign of the Golden Eagle in Newport, Rhode Island, in which English consumer goods were sold. He was also identified in town as vestryman of Trinity Church from 1765 to 1811. But his public life as a

merchant and church layman is nowhere referenced in the portrait. Instead, Copley stressed Bours's private, contemplative nature. Bours is depicted without a wig, showing his own fine hair pulled over his ears, suggesting that he is at home and in private. He apparently has been reading a passage from the book of unspecified title that he holds limply in his right hand. In a gesture that parallels that of his right arm and hand and unifies book and mind, his left arm angles upward toward his head and his long, pale fingers gently touch his temple. Seemingly moved by the literature, Bours has a distant, melancholic look. He is so engrossed in his thoughts that he has allowed his body to slide into a supine pose that would have been considered impolite were he in company with others. He stares downward and to the right, his head bracketed, both literally and metaphorically, by a romantic landscape of twisted trees and dark, turbulent clouds. The shadow on the left side of his face adds to the sense of mystery surrounding what he has read and is now thinking.

Bours dedicated part of his life to books, serving as treasurer and president of the Redwood Library, the most distinguished classical institution in Newport. But this is not an image of the philanthropist or the man of civic virtue. Rather, Copley has represented Bours as the sickly poet, in the manner of English portraits of Alexander Pope (see fig. 200), in which the sitter is provoked by the reading of literature to enter a reverie.[3] In this, one of his most intimate images, Copley cultivated for Bours a "sensibility." Possessed with a sensibility, as that term was used in the eighteenth century, the sitter could express himself primarily through a state of mind rather than through a public posture. Sensitive and abstracted from the temporal world, Copley's Bours is the rare man of thought.

P S

1. Parker and Wheeler 1938, p. 39.
2. Prown 1966, vol. 1, pp. 33–34.
3. See William K. Wimsatt, *The Portraits of Alexander Pope* (New Haven, 1965).

57

Mrs. Joseph Henshaw (Sarah Henshaw)

ca. 1770

Pastel on paper mounted on canvas, 24 x 17¾ in. (61 x 45.1 cm)

The Museum of Fine Arts, Houston; The Bayou Bend Collection, Gift of Miss Ima Hogg B.54.25

In 1770 or soon thereafter Joseph Henshaw (1727–1794) and his wife Sarah (1736–1822) sat for Copley, as did several other members of the Henshaw family. Joseph's bust-length pastel portrait (Fine Arts Museums of San Franciso) is among Copley's most restrained efforts. The palette is somber, the background is

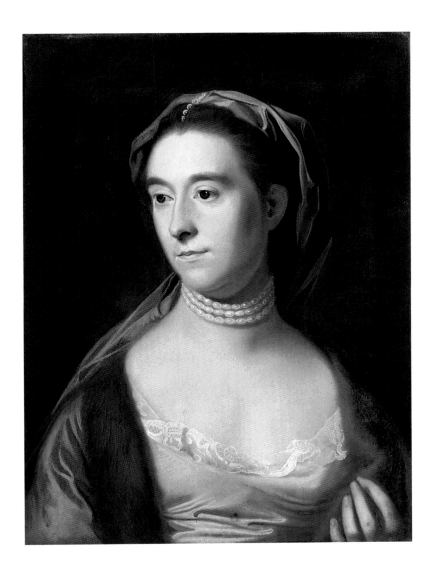

dark, the hands are not included, and there is very little articulation of the clothing. By contrast, the likeness of Sarah Henshaw is brightly colored and precisely detailed and shows the delicate touch of her fingers on drapery; indeed, it is among Copley's most fully realized pastels (and probably one of the last he drew). Although it is derived from an engraving after Catherine Read's *Catherine Macauley, In the Character of a Roman Matron* (fig. 201), which Copley may have seen in the *London Magazine* for July 1770, the image is nonetheless fresh, for with the borrowed elements it incorporates details the artist invented to suit his patron. The rendering of soft fur, delicate lace, shimmering moonstones, and satiny skin reflects Copley's skills at their peak. That Copley created a virtuosic display of different textures so at odds with the reined-in effects in the portrait of Joseph suggests that he conceived of Mrs. Henshaw's likeness as a project entirely separate from the other commissions. In the absence of documentation that explains Copley's motivation, the assumption must be that in drawing such a sober Joseph and such a radiant Sarah he was giving his patrons precisely what they wanted.

Sarah and Joseph Henshaw were first cousins. She was the daughter of the prosperous merchant and perennial selectman

Fig. 201 Williams after Catherine Read. *Catherine Macauley, In the Character of a Roman Matron*, from *London Magazine*, July 1770. Engraving, 6½ x 4⅝ in. (16.5 x 11.7 cm). The New York Public Library, Astor, Lenox and Tilden Foundations, General Research Division

267

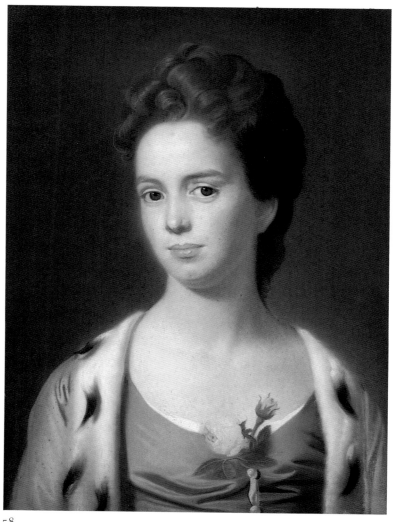

58

Joshua Henshaw, he the son of Joshua's brother David. Joseph Henshaw graduated from Harvard, spent the following two years selling American goods in Italian ports, and returned to Harvard in 1752 to receive his master's degree.[1] He prospered as a merchant, trading in London with a packet named *Sarah,* and became a prominent member of the Sons of Liberty, who often met in his home. The Henshaws, who had no children, moved to Leicester, Massachusetts, in 1774 and, after the Revolution, to Shrewsbury.

C R

1. Clifford K. Shipton, *Sibley's Harvard Graduates,* vol. 12 (Boston, 1962), p. 268.

58

Mrs. Joseph Barrell (Hannah Fitch)

ca. 1771

Pastel on paper mounted on linen, 23 x 17¼ in. (58.4 x 43.8 cm)

Museum of Fine Arts, Boston, Gift of Benjamin Joy 52.1472

Joseph Barrell (1740–1804) of Charlestown, Massachusetts, a wealthy merchant, was married three times and had twenty children. He ordered from Copley a pastel and a miniature of himself (Worcester Art Museum, Massachusetts; private collection); two very different images of his first wife, both in pastel (private collections); and this delicate likeness of his second wife, the mother of five of his children, Hannah Fitch (1753–1777), whom he married in 1771, when she was only seventeen.

The date given to this pastel, suggested by the sitter's apparent age and the date of her marriage, is supported by a letter to Copley from Henry Pelham, in which he reported having received money (presumably in payment for portraits) from "Messers. Sargent, Fenno, Barrell. . . . "[1] One of the last of Copley's known pastels, the work exhibits the delicacy and refinement of his late style. In it Copley used a broad range of colored chalks, carefully blended and smoothed so that individual strokes are no longer visible, a painterly style that dexterously combines softness and uniformity of texture with clarity and detail. Copley also took advantage of the medium's characteristic informality and intimacy. Mrs. Barrell is placed slightly lower on the sheet than was usual in such portraits, and the background is unarticulated; the tilt of her head makes her attitude seem almost conversational. As he did in

many of his late works in oil, here Copley renounced many of his stock accessories and complex poses to concentrate on the sitter's character. Hannah Barrell's hair is unadorned; she wears no lace; the roses at her bodice and her ermine stole are her only ornaments. The sitter's natural pose and direct, yet demure, gaze complement her fresh and youthful beauty. ᴄᴛ

1. Henry Pelham, letter to Copley, Sept. 24, 1771, in Jones 1914, p. 162.

59

Mrs. Humphrey Devereux (Mary Charnock)

1771
Oil on canvas, 40½ x 32 in. (103 x 81.3 cm)
Signed and dated lower left: JS Copley [fragmentary] 1771
Museum of New Zealand Te Papa Tongarewa, Wellington, Gift of the Greenwood family, 1965 1965-13-1

Copley's sympathetic portrait of Mrs. Humphrey Devereux (1710–1794) was designed to perform two functions, both of which were specified by his patron, John Greenwood, the sitter's son. Greenwood's letter to Copley is frequently cited to demonstrate that eighteenth-century portraits were often intended as mementos: "as I have of late enter'd into connections, that may probably keep me longer in London than I coud wish, I am very desirous of seeing the good Lady's Face as she now appears, with old age creeping upon her. I shoud chuse her painted on a small half length or a size a little broader than Kitt Katt, sitting in as natural a posture as possible. I leave the pictoresque disposition intirely to your self and I shall only observe that gravity is my choice of Dress." The portrait was commissioned on the occasion of Mrs. Devereux's sixtieth birthday, and Copley shared in her son's solicitude for her (and also excused himself for taking some ten months to complete the commission) when he wrote that sittings had to be postponed, "the weither being so very hot as to make it inconvenient for the Old Lady to come to Town."[1] Yet the Boston-born Greenwood, who was an active picture dealer, auctioneer, and a founding member of the Society of Artists in London, began his letter to Copley by seeking the painter's participation in the coming season's exhibition and proposing the picture of his mother as a "very proper [subject] for your next years Applause, and our amusement."[2] Thus, from the beginning, this tender portrait was also meant to be an exhibition piece, a public image whose merit would be judged apart from its success as a personal token.

Copley obliged his friend with a work that was both a sensitive likeness of an elderly woman and a painting designed to win approbation at the Society of Artists' annual show. Mrs. Devereux sits in a dark blue wing chair against a neutral background; her costume, although grave in tone, as Greenwood requested, is

nonetheless elegant: the golden-brown satin of Mrs. Devereux's sleeve has a dazzling sheen; the sheer, black dotted net mantle over her simple chemise demonstrates Copley's deftness at painting transparent fabrics and his cleverness at orchestrating dark-light contrasts. Her white bonnet, a simple mobcap worn by a number of Copley's older sitters—see, for example, *Mrs. William Coffin* (fig. 202)—frames her face and reflects the light, focusing attention on her homely features and contemplative expression.

The hand at Mrs. Devereux's face also suggests thoughtfulness. Although Copley had occasionally used the gesture before, he would turn to it frequently in future years, albeit primarily for likenesses of younger women, notably Dorothy Quincy (fig. 224) and Dorothy Skinner (cat. no. 76). However, in those portraits the sitters are more fragile and introspective and appear more detached; they evince little of the quiet emotionalism of Mrs. Devereux. Although her turned head and averted gaze prevent engagement with the viewer, she seems psychologically as well as physically present. Unlike the relatively weightless Mrs. Skinner,[3] Mrs. Devereux leans forward in her chair, her rounded shoulders connoting real bulk, her left forearm and right elbow convincingly bearing the weight of her upper body. Her chin resting in her right hand, the set of her mouth, and her heavy-lidded eyes all suggest a woman in a mood of reverie and contentment. That her son, so many miles distant, would have inspired such affectionate meditation would have been pleasing to both sitter and patron.

Mrs. Devereux is seated at a gateleg table—a somewhat old-fashioned piece of furniture that Copley employed in the portrait of Mrs. Skinner and several other canvases of this period. The highly polished tabletop upon which Mrs. Devereux leans is also a feature that appeared frequently in his work. In fact, there is much about this painting that recalls a specific predecessor among Copley's portraits: its size, the seated pose and averted gaze of the sitter, the emphasis on surface texture and brilliant light effects, and the use of the tabletop as a means of echoing a demonstration of painterly brio all repeat the formula the artist had devised for *Boy with a Squirrel (Henry Pelham)* (cat. no. 25) to achieve his initial success at the Society of Artists exhibition. Like that painting, *Mrs. Humphrey Devereux*, which was exhibited as "No. 22. A lady; half length," was well received. Benjamin West wrote to Copley on June 16, 1771, "Your Picture of Mrs. Greenwood was exhibited and did great honour."[4] Horace Walpole noted in his copy of the catalogue, "Hard, but very natural."[5] And a collateral descendant of the Greenwood family bragged that the enthusiastic reception given this picture was the deciding factor in persuading Copley to immigrate to England.[6]

When Copley did settle in London, Greenwood attempted to draw him into his circle. In 1775 he approached Copley on behalf of the Society of Artists, "requesting the continuance of his attachment to this society." But Copley had greater ambitions and joined the more exclusive Royal Academy instead.[7] Nonetheless, Greenwood remained proud of his association with his more accomplished countryman and kept the portrait of his mother in his

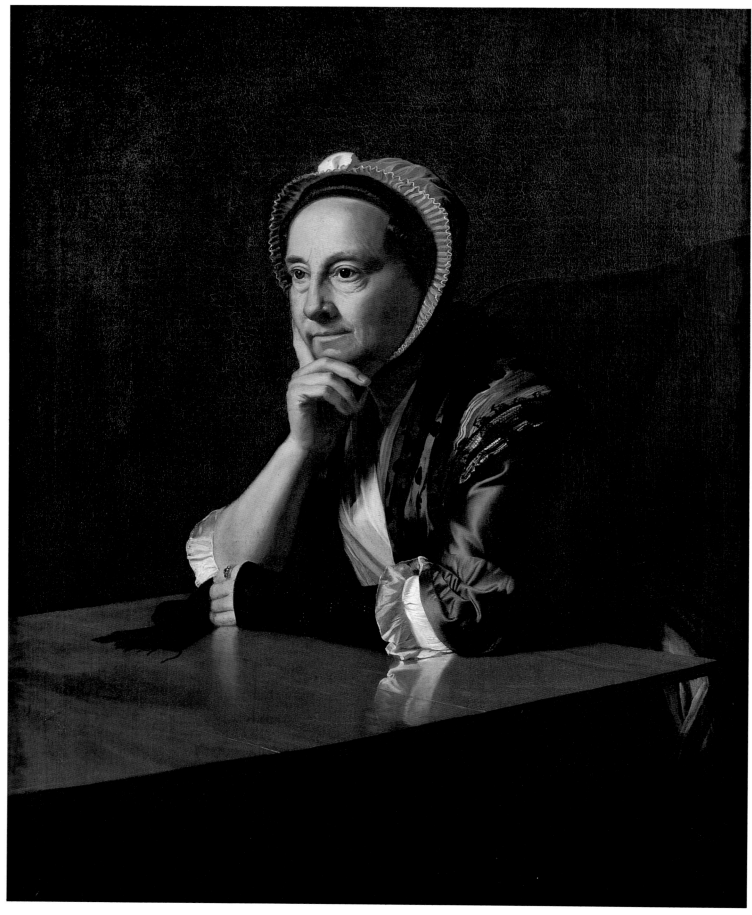

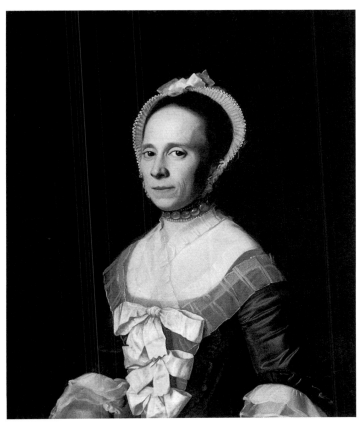

Fig. 202 *Mrs. William Coffin (Ann Holmes)*, ca. 1770. Oil on canvas, 30¼ x 20¾ in. (76.8 x 52.7 cm). Museum of Fine Arts, Boston, Gift of Walter D. and William D. Sohier 1991.1059

Leicester Fields house,[8] inviting many to see it. Some years later, according to Greenwood family legend, Sir Joshua Reynolds admired *Mrs. Humphrey Devereux* and sniffed, "Copley can't paint like that now."[9] However, Copley enjoyed great success during his first decades in England, and it seems likely that a bit of professional rivalry was behind Reynolds's remark. C T

1. John Greenwood, letter to Copley, Mar. 23, 1770, in Jones 1914, pp. 81–82; Copley, letter to John Greenwood, Jan. 25, 1771, in Jones 1914, p. 105. See also Ellen G. Miles, "The Portrait in America, 1750–1776," in Richard H. Saunders and Ellen G. Miles, *American Colonial Portraits, 1700–1776* (exh. cat., Washington, D.C.: National Portrait Gallery, 1987), p. 49.
2. John Greenwood, letter to Copley, Mar. 23, 1770, in Jones 1914, p. 81. Greenwood himself had painted his mother in about 1747, as a part of the large group portrait known as the *Greenwood-Lee Family* (Museum of Fine Arts, Boston). Mary Devereux, then Mary Greenwood, is seated at left, and was approximately thirty-seven at the time. The portrait remained in the Lee family and did not go to England with Greenwood. By the time of her sittings with Copley some twenty-four years later, Mary Devereux had been married three times: first, in 1726, to Samuel Greenwood, a Boston merchant who died in 1742; subsequently, in 1757, to Joseph Prince, a Boston sea captain who had been her first husband's business partner; and finally, in 1762, to the farmer Humphrey Devereux of Marblehead, who died in 1777. Mary Devereux died in Marblehead at the age of eighty-four. I thank Margy P. Sharpe for the information about Mrs. Devereux.
3. Dorothy Skinner's erect carriage, which contributes to the decorative

quality of her portrait, was required by the cut of her gown and furthermore was considered a token of genteel behavior. Older people may not have been held to the same standard—see, for example, the postures in Copley's images of Eleazer Tyng and Epes Sargent (cat. nos. 74, 11)—and Mrs. Devereux's more natural pose was appropriate to the expression Copley sought in her portrait. I thank Claudia Kidwell for her observations about Mrs. Skinner's posture.
4. Benjamin West, letter to Copley, June 16, 1771, in Jones 1914, p. 116. Upon seeing it at West's, another admirer of the portrait noted, "it was of a Woman and a very ordinary one, and yet so finely painted that it appeard alive. West was lavish in its praises . . . [and] said Mr. Copley wou'd make no small figure in the World of Painters" (Unnamed correspondent, letter to [Montresor?], [Jan. 1772], in Jones 1914, p. 182).
5. Quoted in John Hill Morgan, "Some Notes on John Singleton Copley," *Antiques* 31 (Mar. 1937), p. 118, n. 6.
6. "This picture was sent to England, and gained Copley so much credit as induced him to visit that country, where he has remained ever since" (Isaac J. Greenwood, "Copley the Artist," *Magazine of American History* 2 [1878], p. 117).
7. As cited in Alan Burroughs, *John Greenwood in America, 1745–1752* (exh. cat., Andover, Mass.: Addison Gallery of American Art, Phillips Academy, 1943), p. 53.
8. The portrait was owned by Greenwood until his death in 1792 and remained in his family thereafter. One of Greenwoods descendants, Dr. John Danforth Greenwood, immigrated to New Zealand in 1843 and, according to family tradition, took the portrait with him. The painter Charles Hopkinson rediscovered the portrait in 1952 in the Eastbourne, New Zealand, home of Elizabeth Greenwood; in 1965 the Greenwood family gave the portrait to the Museum of New Zealand, Te Papa Tangarewa, Wellington.
9. Greenwood, "Copley the Artist," p. 117.

60

Mrs. Ezekiel Goldthwait (Elizabeth Lewis)

1771
Oil on canvas, 50 x 40 in. (127 x 101.6 cm)
Museum of Fine Arts, Boston, Bequest of John T. Bowen in memory of Eliza M. Bowen 41.84

61

Ezekiel Goldthwait

1771
Oil on canvas, 50 x 40 in. (127 x 101.6 cm)
Signed lower right: JSC [monogram]
Museum of Fine Arts, Boston, Bequest of John T. Bowen in memory of Eliza M. Bowen 41.85

M*rs. Ezekiel Goldthwait* has often been singled out in recent criticism as one of the great triumphs of Copley's last years in Boston. In his *American Tradition in Painting* of 1963, John McCoubrey, the first modern art historian to write about the

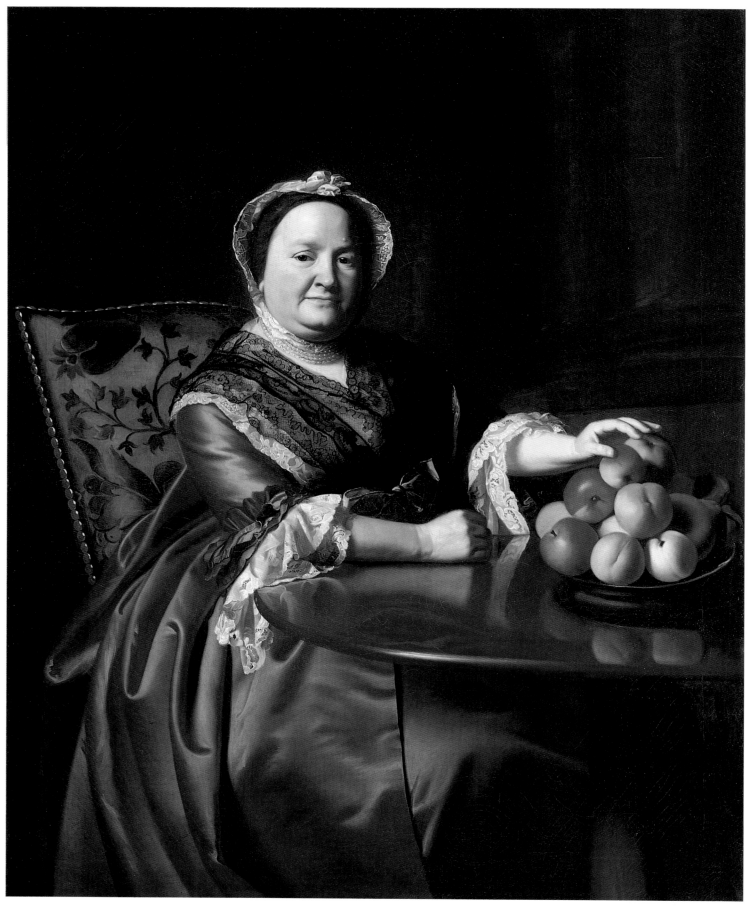

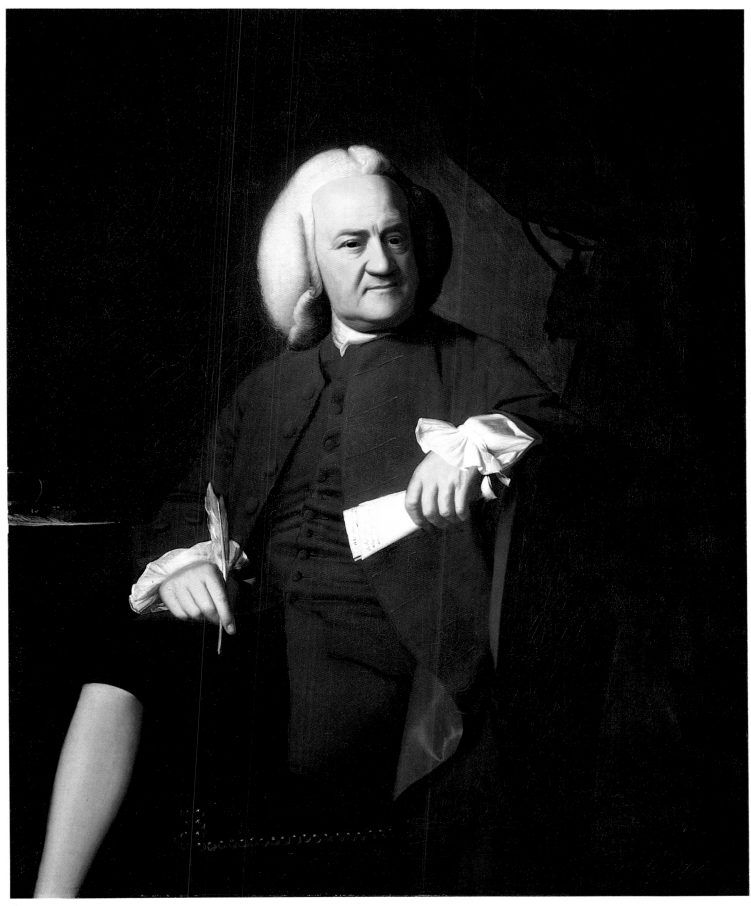

61

work, extolled the "startling success" of its "illusion of three-dimensional volume."[1] A few years later Jules Prown called it "a particularly successful portrait," noting that "the picture bulges with rounded forms," and since the late 1960s the painting has been included in many surveys of American art.[2] The companion portrait of Mrs. Goldthwait's husband, *Ezekiel Goldthwait,* is equally splendid but has appeared far less frequently in the literature.[3] Furthermore, the two paintings are rarely discussed together, although they rank among Copley's most successfully unified pendant portraits.

Ezekiel and Elizabeth Goldthwait are both depicted at three-quarter length, seated in darkened interiors, he at a desk and she at a table. Their bodies are turned toward each other, but both look out at the viewer. Both portraits are painted in the same subdued rich browns, a muted palette Copley substituted for the dazzling Rococo colors he had employed during the previous decade. A powerful light issuing from a single source, at the left, plays against the quiet tones and dramatically illuminates the face and hands of each sitter. Furthermore, Copley charged each portrait with a sense of uncontrived immediacy, which he achieved by showing his sitters interrupted in the course of their actions to regard the viewer—holding quill and papers, Ezekiel turns from writing at his desk, and Elizabeth pauses as she reaches for a piece of fruit.

In both portraits Copley also included a profusion of textures and objects—polished tabletop, lace, silks, pearls, chairs, quill, and fruit—that serve to indicate not only his virtuosic skill at illusionistic representation but also the material wealth of his subjects. For Ezekiel Goldthwait (1710–1782), who was born in the North End of Boston to parents originally from Salem, was prosperous indeed. The Goldthwait family "held high rank among the most aristocratic and fashionable circles of the town"[4] and lived on Hanover Street in the North End in what was described as a "Mansion House."[5] In 1770 John Adams reported that Goldthwait had invited him to "dine . . . at flax Pond near Salem. Rowe, Davis, Brattle and half a dozen, as clever fellows as ever were born, are to dine there under the shady Trees, by the Pond, upon fish, and Bacon and Pees &c. and as to the Madeira, nothing can come up to it."[6] The ten-page inventory compiled at the death of Goldthwait attests to his wealth. In addition to the Hanover Street home, he owned houses on State Street and Ann Street, a chaise, considerable china, silver, glassware, and furniture, over thirty pictures (none of which was described specifically), some two hundred books, and a gold watch.[7]

Goldthwait spent most of his life in public office. From 1740 to 1776 he served as Suffolk County registrar of deeds, and, for two decades beginning in 1741, he was simultaneously the town clerk for Boston. In addition, at various times he held the posts of selectman, town auditor, and Town Meeting moderator. Copley alluded to his subject's profession of record keeper by depicting him seated at a desk with writing implements[8] and with quill and inscribed papers in hand.

In 1732, before he began his political career, Goldthwait was married by the Reverend William Welsteed at Boston's New Brick Church to Elizabeth Lewis (1713–1794), sister of his older brother Joseph's wife, Martha. Elizabeth, known as Betsey, and Martha were remembered as "young ladies of note,"[9] but little is known of their family. During the first twenty-five years of her marriage, Elizabeth bore thirteen children, five of whom, all girls, survived to adulthood. Scholars have proposed that Copley represented the matriarch with a bowl of apples, peaches, and a pear to indicate her fecundity or to allude to the renowned Goldthwait gardens or the sitter's prowess as a gardener;[10] however, it is also possible that he used the fruit here, as he may have used flowers in other portraits, as a generalized feminine symbol.

Ezekiel Goldthwait initially supported the Whig cause. In 1760 his signature appeared on a petition to the General Court charging Crown officials with appropriating provincial funds. In April 1771, at about the time that Copley painted the Goldthwait portraits, Ezekiel Goldthwait defeated Samuel Adams in an election for registrar of deeds of Suffolk County. His victory elicited a vehement response from Samuel Adams's opinionated cousin, John Adams. The same John Adams who had responded so enthusiastically to Goldthwait's invitation only a year earlier wrote in his diary on May 2, 1771: "The Tryumphs, and Exultations of Ezekl. Goldthwait and his pert Pupil Price, at the Election of a Register of Deeds, are excessive. They Crow like dunghill Cocks. They are rude and disgusting."[11] By 1774 Goldthwait had aligned himself on the Tory side; he was one of the 124 merchants, traders, and other citizens, among them John Singleton Copley, who signed an address in support of departing Governor Thomas Hutchinson. Although Goldthwait was known to be a Loyalist, he was not forced to leave Boston; he merely removed his family to nearby Weston to wait out the Revolution at the home of his brother. After the hostilities ended, the Goldthwaits returned to their North End residence, where they remained until the end of their lives.

Toward the conclusion of his public career Ezekiel Goldthwait commissioned Copley to paint these two portraits. They apparently were executed in 1771, for this date was recently discovered at the bottom right of Ezekiel's picture, after the artist's monogram. In June 1771 Copley billed Goldthwait £57.4 for the paintings and for their carved and gilded frames.[12] The pictures are the last of a group of five portraits Copley executed for the extended Goldthwait family. In 1770 he painted *Mrs. Alexander Cumming* (fig. 117), a likeness of the Goldthwaits' eldest daughter, Elizabeth. The previous year Elizabeth Goldthwait Cumming's sister-in-law and her husband sat for their portraits, *Mrs. Alexander MacWhorter (Mary Cumming)* and *Reverend Alexander MacWhorter* (both Yale University Art Gallery, New Haven). Copley billed Elizabeth Cumming for all three portraits (fig. 119) as well as for the black frames for the MacWhorter pair. The charge for the black frame on Elizabeth's picture appeared on the bill Copley submitted for her parents' portraits and gilded frames in 1771 (fig. 143).

The portraits of Mr. and Mrs. Goldthwait remained in the family until they were given to the Museum of Fine Arts, Boston, in 1941. *Ezekiel Goldthwait* had been lent to the museum briefly in 1909–10 and again in 1930. *Mrs. Ezekiel Goldthwait* was also lent to the museum in 1930, at roughly the same time that its pendant was on display there.

KEQ

1. John McCoubrey, *American Tradition in Painting* (New York, 1963), p. 18.
2. Prown 1966, vol. 1, p. 76. Mrs. Goldthwait's portrait is also discussed by Barbara Novak in "Copley: Eye and Idea," *Art News* 64 (Sept. 1965), p. 24; and Barbara Novak, *American Painting of the Nineteenth Century* (New York, 1969), p. 20. Among the surveys the painting has appeared in are: John Wilmerding, ed., *The Genius of American Painting* (New York, 1973), p. 18; and *Petit Larousse de la peinture* (Paris, 1979), vol. 1, unpaged. The still life in the painting is discussed in William H. Gerdts and Russell Burke, *American Still-life Painting* (New York, 1971), p. 21.
3. The most notable survey in which *Ezekiel Goldthwait* appears is E. P. Richardson, *Painting in America* (New York, 1956), p. 73.
4. *Boston Evening Transcript* [ca. 1890], quoted in Charlotte Goldthwaite, *Descendants of Thomas Goldthwaite* (Hartford, 1899), p. 86.
5. Ezekiel Goldthwait, Inventory, Jan. 19, 1784, Docket no. 17872 (Suffolk County Probate Records, vol. 83, p. 122), Archives, Supreme Judicial Court, Boston.
6. *Diary and Autobiography of John Adams*, ed. Lyman H. Butterfield (Cambridge, Mass., 1961), vol. 1, p. 352.
7. Ezekiel Goldthwait, Inventory, Jan. 19, 1784, Docket no. 17872 (Suffolk County Probate Records, vol. 83, pp. 113–22), Archives, Supreme Judicial Court, Boston.
8. A similar arrangement of tray and small glass cup with sponge appears in Copley's *Isaac Smith* (cat. no. 50) and *Jeremiah Lee* (cat. no. 52). In *Ezekiel Goldthwait*, however, the cup, which is clearly visible in the two other pictures, has almost disappeared, save for its highlight.
9. Hannah Goldthwaite Gowen, letter to Ellinor (Ellen) Dorr Hayward, in Goldthwaite, *Descendants of Thomas Goldthwaite*, p. 354.
10. See, for example, Prown 1966, vol. 1, p. 76; Wayne Craven, *Colonial American Portraiture: The Economic, Religious, Social, Cultural, Philosophical, Scientific, and Aesthetic Foundations* (Cambridge, 1986), p. 331; and Carol Troyen, *The Boston Tradition: American Paintings from the Museum of Fine Arts, Boston* (exh. cat., Boston: Museum of Fine Arts; New York: American Federation of Arts, 1980), p. 63. It is clear that the Goldthwaits had great gardens, which were described as "extending more than one hundred and fifty feet from Hanover Street, [and] which [were] always kept in a high state of cultivation" (*Boston Transcript*, quoted in Goldthwaite, *Descendants of Thomas Goldthwaite*, p. 86); however, there is no evidence regarding whether the kinds of fruit Copley depicted in Mrs. Goldthwait's portrait were grown in them. Parker and Wheeler (1938, p. 85) make note of the gardens but do not relate them specifically to the fruit in Copley's painting. Elsewhere, Barbara Parker ("Portraits of the Goldthwait Family of Boston," *Bulletin of the Museum of Fine Arts* 39 [June 1941], p. 43) does connect the fruit to the Goldthwait gardens. Mrs. Goldthwait is called "an accomplished gardener" in *American Paintings in the Museum of Fine Arts, Boston* (Boston, 1969), p. 75. There do not seem to be any earlier references that document her gardening skills.
11. *Diary and Autobiography of Adams*, vol. 2, p. 10.
12. Archives, Museum of Fine Arts, Boston. Goldthwait was charged £19.12.0 for each portrait and £9 for each frame. Goldthwait paid Copley's half brother, Henry Pelham, for the portraits on July 1, 1771, as Copley himself was in New York at the time.

62

Samuel Adams

ca. 1770–72
Oil on canvas, 50 x 40¼ in. (127 x 102.2 cm)
Museum of Fine Arts, Boston, Deposited by the City of Boston 30.76c

Canonized on a contemporary print as "His Country's Saviour, Father, Shield & Guide" and reviled by Royal Governor Thomas Hutchinson of Massachusetts as "[the greatest] incendiary in the King's dominion" and "a man of great . . . malignity of heart," Samuel Adams (1722–1803) was always a highly controversial figure. His cousin John Adams described him as an unselfish and disinterested man, "a plain, simple, decent citizen, of middling stature, dress, and manners."[1] In his celebrated portrait of Samuel Adams, Copley provided evidence of this modesty: he pictured him in a simple suit of dark wool, with no ornamental braid or embroidery, and with a single ruffle of linen at the wrist. The lapels of his waistcoat are bunched and sloppily folded over, and two buttons of it are undone, suggesting Adams's utter lack of vanity and of concern for appearances (although his detractors would have seen this as evidence of his wildness and unreliability).

Adams is shown at what he himself would always consider his greatest moment: his confrontation with Hutchinson the day after the Boston Massacre of March 5, 1770, during which Adams demanded the expulsion of British troops from the town. He points to the charter and seal granted Massachusetts by King William and Queen Mary; in his right hand is the petition *Instructions of . . . Town Boston*, prepared by his aggrieved fellow citizens. Although some historians have suggested that Adams stage-managed the massacre in order to force this showdown with Hutchinson, John Adams described their meeting in terms entirely flattering to his cousin: "With a self-recollection, a self-possession, a self-command, a presence of mind that was admired by every person present, Samuel Adams arose with an air of dignity and majesty, of which he was sometimes capable, stretched forth his arm, though even quivering with palsy, and with an harmonious voice and decisive tone, said '. . . nothing short of the total evacuation of the town by all regular troops will satisfy the public mind or preserve the peace of the province.'"[2] Yet Samuel Adams's own often-quoted account of the meeting reveals his fanatical, vengeful side and gives evidence of the "malignity of heart" of which Hutchinson accused him: describing the governor's appearance, Adams

275

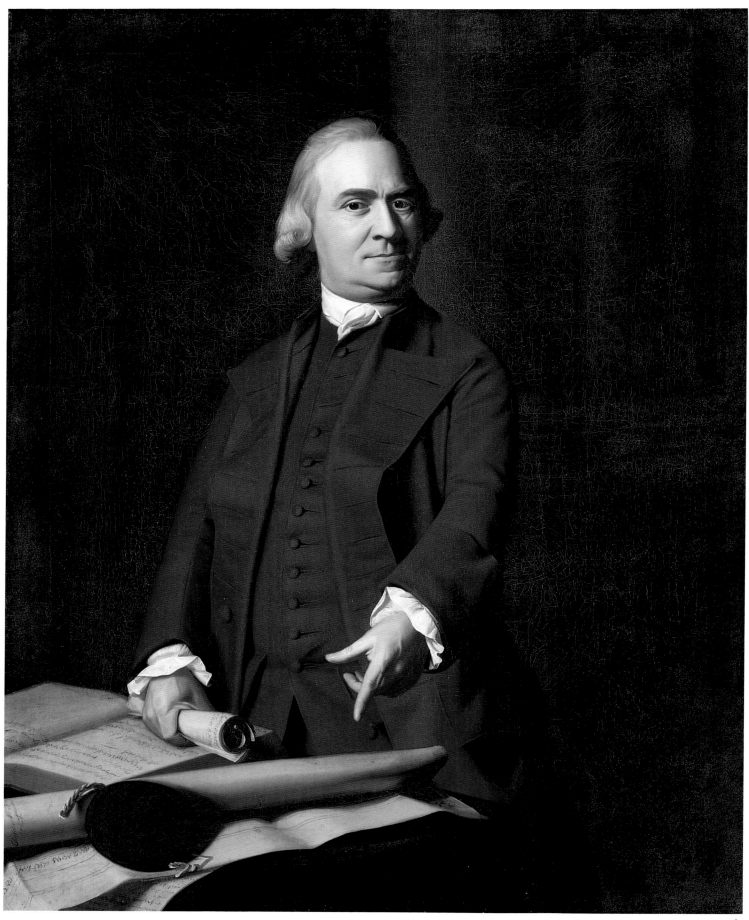

wrote, "If Fancy deceived me not, I observ'd his Knees to tremble. I thought I saw his face grow pale (and I enjoyed the Sight)."[3]

Copley's portrait brilliantly conveys the electricity of the moment. By about 1770 he had come to work in a relatively austere manner, markedly decreasing his reliance on prints as models for poses and accessories and reducing the decorative elements in his pictures. Instead of embellishing his portraits with a wealth of detail, Copley concentrated on personality, which he emphasized through a simplified palette and, above all, through an increased attention to the expressive potential of light-dark contrasts. In *Samuel Adams* dramatic style and dynamic sitter are admirably matched. Adams is placed slightly off center, his body shifted to the left, his head turned back. He crowds the table, pushing forward and threatening the viewer's space. Using a deliberately muted palette, Copley called special attention to Adams's head and hands. They seem spotlit, while Adams's dull reddish-brown suit barely emerges from the dark background. Adams's proportions, like those of many of Copley's male sitters, seem peculiar: his head is overlarge and his torso appears small and ungainly; he is barrel chested and has sloping, shrunken shoulders. But characteristics that are often attributed to deficiencies in Copley's drawing have a vital expressive effect here: Adams's leonine head becomes all the more impressive and commanding, his piercing stare all the more intense, in contrast to his paltry frame.

According to tradition, this portrait was commissioned by John Hancock, Adams's sometime partner in revolutionary activities. Certainly in the early 1770s Adams was in no position to pay for it himself. Although sixth in his class at Harvard, where ranking was determined by social position,[4] and the inheritor of a thriving malt-producing company as well as an attractive house and garden on Purchase Street, he had no aptitude for trade and ruined the family business not long after his father's death. For most of his life he lived primarily on his wife's earnings. From the 1760s he devoted himself almost entirely to politics, with a passion alternately described as wholly unselfish or as cunning and unscrupulous.[5] John Rowe noted in his diary that, beginning in 1766, the Boston Town Meeting elected Adams to the House of Representatives every year. Adams's fellow citizens seemed to prefer his advocacy to his friendship, however, for he is seldom mentioned as a guest at the many congenial dinner parties detailed in Rowe's diary.[6]

In addition to dominating Town Meeting and manipulating the machinery of local politics, in this period Adams was also cultivating a group of younger men to help him promote the revolutionary effort. These included Joseph Warren, John Adams, and especially Hancock, who, with Samuel Adams's backing, sought to overcome his image as a young dandy in order to become a significant figure in Boston politics. Although the relationship between Adams and Hancock would cool somewhat by the late 1760s, when Hancock came to believe that Adams's radicalism was hurting the patriot cause, the Boston Massacre and subsequent events renewed Hancock's appreciation for Adams's powers. The usefulness of an in-

cendiary image of Adams, and the advantages of a certain measure of identification with him after he successfully defied Hutchinson, would have been clear to Hancock, whose commissioning of the portrait would more likely have been a shrewd political move than a gesture of affection. Hanging in Hancock's house, the site of important political meetings in the 1770s, the portrait of Adams could not fail to inspire. The image became widely known, for it was copied in oil and several prints were made after it, including one by Paul Revere that was paired with an engraving of Hancock, also by Revere. Revere's prints were published in 1774 as the frontispiece to the *Royal American Magazine*, where the heads of the patriot leaders were flanked by allegorical figures of liberty.[7] Thus, both on the walls of Hancock's house and in reproduction, Copley's image of Adams became an instrument of propaganda, an implement of the Revolution.

Although Copley was careful not to advertise his political views (which, however, certainly were not those of this sitter), the commission to paint Adams gave him the opportunity to experiment with a kind of portraiture that was as radical as his subject. In most of his earlier paintings, he adhered to the convention of including attributes that alluded in only a general way to the career of his sitter—a merchant might be shown with a ledger, a landowner against a grand architectural backdrop, and so on. A portrait might have been occasioned by a significant event in a sitter's life—such as marriage or coming into an inheritance—but these events would be referred to obliquely, if at all. In an era when portraits were meant to present an ideal conception of the subject, more direct allusions would have been considered too particularizing. But in *Samuel Adams* there are no distancing, moderating decorative accessories. The sitter is commandingly real, almost terrifyingly present. Copley linked the portrait to a specific historic moment that was urgently familiar to all who saw it. Yet at the same time he created an image with a larger-than-life message. Adams's defiant gesture and gaze arrest the viewer, who is cast in the role of Governor Hutchinson himself. The charge to Hutchinson, who unlike other royal representatives was not imposed upon Massachusetts from abroad but was himself a Bostonian, was also a challenge to the viewer's loyalty, a challenge at once stirring and discomforting. Adams's declamatory gesture, worthy of a Roman senator, connotes power and authority; his figure is unusually sculptural. Although his zeal is undeniable, there is little of the fanatic, the incendiary, here. The documents he points to insist upon the rule of law, not emotion, and the classical columns behind him underscore an association with republican virtue and rationality. Adams is presented as a man of reason, and the image is all the more potent for it.

For Copley, whose ambitions had already led him to weary of "preserving the resembla[n]ce of perticular persons,"[8] *Samuel Adams* was a stirring history painting in the guise of a portrait. In its electrifying characterization, its enactment of a contemporary event, and its moralistic admonition, it was the forerunner of such groundbreaking canvases as *Watson and the Shark* (fig. 12) and

especially *The Death of Major Peirson* (fig. 10), history paintings that would prove to be the masterpieces of Copley's British career.

CT

1. A large, widely circulated mezzotint of Samuel Adams, derived from Copley's design for this portrait, bore the inspirational legend, "Lo! Adams rose in Warfare nobly try'd,/His Country's Saviour, Father, Shield & Guide,/Urg'd by her Wrongs, he wag'd ye glorious Strife./Nor paus'd to waste a coward Thought on Life" (Charles Reak and Samuel Okey after J. Mitchell, *Mr. Samuel Adams*, April 1775). Thomas Hutchinson, quoted in James K. Hosmer, *Life of Thomas Hutchinson* (Boston, 1896), p. 215, quoted in Carl Lotus Becker, "Adams, Samuel," in *Dictionary of American Biography*, ed. Allen Johnson, vol. 1 (New York, 1928), p. 98. John Adams, *The Works of John Adams* (Boston, 1850–56), vol. 10, p. 251, quoted in Clifford K. Shipton, *Sibley's Harvard Graduates*, vol. 10 (Boston, 1958), p. 440.

2. John Adams, quoted in Cass Canfield, *Samuel Adams's Revolution, 1765–1776* (New York, 1976), p. 46.

3. Massachusetts Historical Society, *Collections*, vol. 72, p. 9, quoted in Shipton, *Sibley's Harvard Graduates*, p. 436.

4. Adams graduated with the class of 1740, intending to enter the ministry. He became involved with the North Caucus Club and other political organizations, however, and in 1743 returned to Harvard for his master's degree, prophetically arguing the thesis, "Whether it be lawful to resist the Supreme Magistrate, if the Commonwealth cannot be otherwise preserved." See Shipton, *Sibley's Harvard Graduates*, pp. 421–22; and Becker, "Adams, Samuel," p. 95.

5. The account in Shipton, *Sibley's Harvard Graduates*, while offering a clear outline of Adams's career and providing many contemporary comments about his character, presents him from a Loyalist perspective as an unscrupulous intriguer (pp. 420–64). In more recent publications, such as Pauline Maier's *The Old Revolutionaries: Political Life in the Age of Samuel Adams* (New York, 1980), Adams is portrayed as a man absolutely, and virtuously, dedicated to the colonial cause. This judgment is echoed by Gordon Wood, who viewed Adams with admiration: "Adams was a Harvard-educated gentleman who literally devoted himself to the public. He was without interests or even private passions. . . . He had neither personal ambition nor desire for wealth. . . . No one took republican values as seriously as Adams did" (Gordon S. Wood, *The Radicalism of the American Revolution* [New York, 1991], p. 205).

6. Rowe records the election of "Mr. Saml Adams who had a great zeal for Liberty" as Clerk of the House on May 28, 1766 (*Letters and Diary of John Rowe, Boston Merchant*, ed. Anne Rowe Cunningham [Boston, 1903], p. 97; subsequent elections are noted on pp. 162, 201–2, 215, 227).

7. See *The Classical Spirit in American Portraiture* (exh. cat., Providence: Bell Gallery, Brown University, 1976), pp. 32–33; and Clarence S. Brigham, *Paul Revere's Engravings* (Worcester, Mass., 1954), pp. 82, 84, pls. 34, 34A. The print by Okey (see note 1 above) replicates the whole of Copley's dramatic image, including the charter and seal, with inscriptions clearly visible. In October 1774 Okey and his partner, Reak, wrote to Henry Pelham, asking him to arrange for them to work from Copley's portrait, then in John Hancock's house. Apparently he was unable to obtain access for them, and their print was made after a copy of Copley's original by the otherwise unknown J. Mitchell. See Charles Reak and Samuel Okey letters to Henry Pelham, Oct. 5, 1774, and Mar. 16, 1775, in Jones 1914, pp. 264–65, 308–9.

8. Copley, letter to [Benjamin West or Captain R. G. Bruce?], [1767?], in Jones 1914, p. 65.

63

Thomas Amory II

ca. 1770–72
Oil on canvas, 50 x 40⅛ in. (127 x 101.9 cm)
The Corcoran Gallery of Art, Washington, D. C., Museum Purchase
1989.22

Sources refer to Thomas Amory II as a distiller, a merchant, and a gentleman with manners "typical of his social group."[1] But the same authors indicate that Amory was also known about Boston as one of "The Three Cocked Hats," together with his two younger brothers. By all accounts, Amory was not particularly foppish or flamboyant, even if his family was noted for hosting lavish social gatherings and he himself counted the wealthy and extravagant Nicholas Boylston among his closest friends. The epithet was conferred simply because he habitually met his brothers Jonathan, four years his junior, and John, two years younger still, for leisurely walks along Washington Street. And, indeed, in Copley's portrait Amory seems to have paused during just such a stroll.

Amory holds his walking stick, nearly obscuring its pierced gold cap with his cupped hands, the right gloved, the left bare, shifting his left hip back and gently bracing his weight against the diagonally poised, honey-colored wooden cane. The line of the stick is carried through to the modest ruffle of his shirt and finally to his face, the brightest spot in the almost entirely brown, uniformly textured composition. Only Amory's face and hands, shirt collar, cuffs, and powdered wig relieve Copley's otherwise monochromatic palette: his leather-edged gloves are taupe, and his coat, waistcoat, and trousers, as well as their buttons and piping, are deep chocolate brown, just a few shades darker than the column to his right and the undefined space behind him. Understated and unembellished, the portrait presents an image of a responsible, steadfast, middle-aged man who, true to historical description, knew how to balance work and leisure.

Amory was born in Boston, on April 23, 1722, the eldest son and namesake of a prodigiously active businessman. Thomas Amory I, a resourceful merchant who distilled rum and turpentine for trade, died tragically as the result of a fall into his stillhouse cistern when Thomas II was just six years old. The senior Amory's wife, Rebecca Holmes Amory, the daughter of a successful tavern owner, ran the distillery herself for over a decade until young Thomas succeeded her. Thomas II, who had taken divinity courses at Harvard, forfeited his calling on his mother's behalf and took over the family enterprise, while his brothers became his partners in various related mercantile ventures. His marriage in 1764 to his cousin Elizabeth Coffin, whose father William was a rival distiller, merged the Amory and Coffin family fortunes. "Old Mr. Coffin," it was recorded, celebrated his daughter's wedding with "a great company . . . & a great dance."[2]

The Amory family's patronage of Copley began in 1763, when John Amory's bride, Katherine Greene, sat for a portrait by him

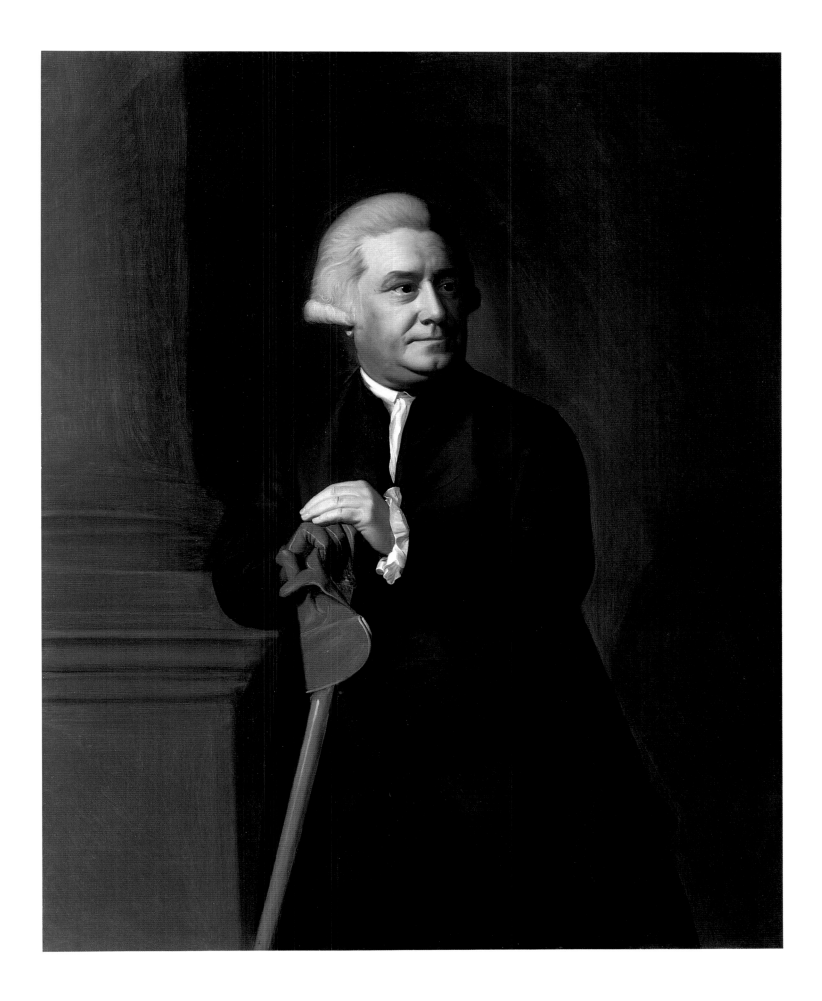

(Museum of Fine Arts, Boston). Five years later John Amory commissioned his own portrait from Copley (Museum of Fine Arts, Boston), and in about 1770 he asked him to execute a posthumous pastel likeness of his father (fig. 103).[3] John asked his older brother to pay part of the fee for their father's picture, and it may have been through this involvement that Thomas Amory II was introduced to Copley. Within a year or so Thomas ordered from Copley his own half-length portrait and a bust-length portrait of his wife (private collection). The portrayals of Thomas and Elizabeth Coffin Amory are stylistically and expressively far removed from the relatively opulent pictures of John and Katherine. Elizabeth's portrait is especially unpretentious; it is curious that this picture was not conceived as a pendant to her husband's sober but comparatively grand likeness. Perhaps the two canvases were meant to hang in specific and separate places in their home; or Mrs. Amory may have been particularly modest and so disinclined to own a large-scale portrait of herself; or possibly Mr. Amory wanted his own picture to be larger than his wife's so that it would symbolize his dominance. Disparate as they may be, both portraits capture a sense of the reserved elegance and tasteful affluence that must have characterized the couple's style of life and circumstances in the early 1770s. In 1770 Thomas Amory purchased the Governor Belcher House, with its generous expanse of surrounding gardens, at Washington and Harvard Streets. Amory's portrait hung in the entry hall of this grand house, where it remained for some time after his death on August 18, 1784.[4] C R

1. Clifford K. Shipton, *Sibley's Harvard Graduates*, vol. 11 (Boston, 1960), p. 4; Gertrude Euphemia Meredith, *The Descendants of Hugh Amory, 1605–1805* (London, 1901), p. 109.
2. Entry for Nov. 8, 1764, in *Letters and Diary of John Rowe, Boston Merchant*, ed. Anne Rowe Cunningham (Boston, 1903), p. 68.
3. Copley apparently copied his likeness from a portrait by Henrietta Johnston. A dated bill for the portrait of John Amory is preserved at the Massachusetts Historical Society, Boston, and another for the pastel of Thomas Amory I is at the Museum of Fine Arts, Boston.
4. Thomas Amory II, Probate inventory, Feb. 20, 1785, Suffolk County, Docket no. 18252, Archives, Supreme Judicial Court, Boston, lists "painted Canvas in the Entry."

64

William Vassall and His Son Leonard

ca. 1770–72
Oil on canvas, 49⅞ x 40⅞ in. (126.7 x 103.8 cm)
Fine Arts Museums of San Francisco, Gift of Mr. and Mrs. John D. Rockefeller 3rd 1979.7.30

Before he left America in 1774 Copley painted over 350 portraits, only a few of which included more than one sitter. Among his earliest portraits were group compositions that showed the Gore and the Royall children (cat. nos. 5, 10), and in the 1770s he produced pictures with two sitters. But during the 1760s Copley concentrated exclusively on single-figure paintings—despite Benjamin West's advice that he paint "two in one Piec."[1] He must have declined commissions for group or double portraits in this period, for it seems improbable that he would not have been asked to execute any works of this sort for a decade. His portrait of the Thomas Mifflins (cat. no. 80) long was thought to have been his first mature foray into the realm of double portraiture, with his more ambitious and successful picture of the Isaac Winslows of the same year (cat. no. 81) confirming that the earlier essay was neither a unique experiment nor an artistic lark.

Copley's little-known portrait of William Vassall and his son Leonard, which remained in the sitters' family until the early 1970s, predates the Mifflin pictures by as much as three years and represents a significant addition to the list of compositions. It also proves to be a likely prototype for portraits of fathers and sons by other American artists who were influenced by Copley's work. Matthew Pratt's portrayals of Cadwallader Colden and his grandson (fig. 203) and James Balfour and his son, 1773 (Virginia Historical Society, Richmond), and John Trumbull's painting of Jeremiah and Daniel Wadsworth, 1784 (Wadsworth Atheneum, Hartford), each may owe a debt to Copley's portrait of the Vassalls.

How it came about that Copley executed a double portrait of the

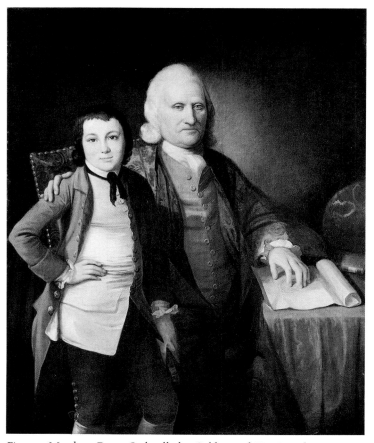

Fig. 203 Matthew Pratt. *Cadwallader Colden and His Grandson Warren DeLancey*, ca. 1772. Oil on canvas, 50 x 40 in. (127 x 101.6 cm). The Metropolitan Museum of Art, New York, Morris K. Jesup Fund, 1969 69.76

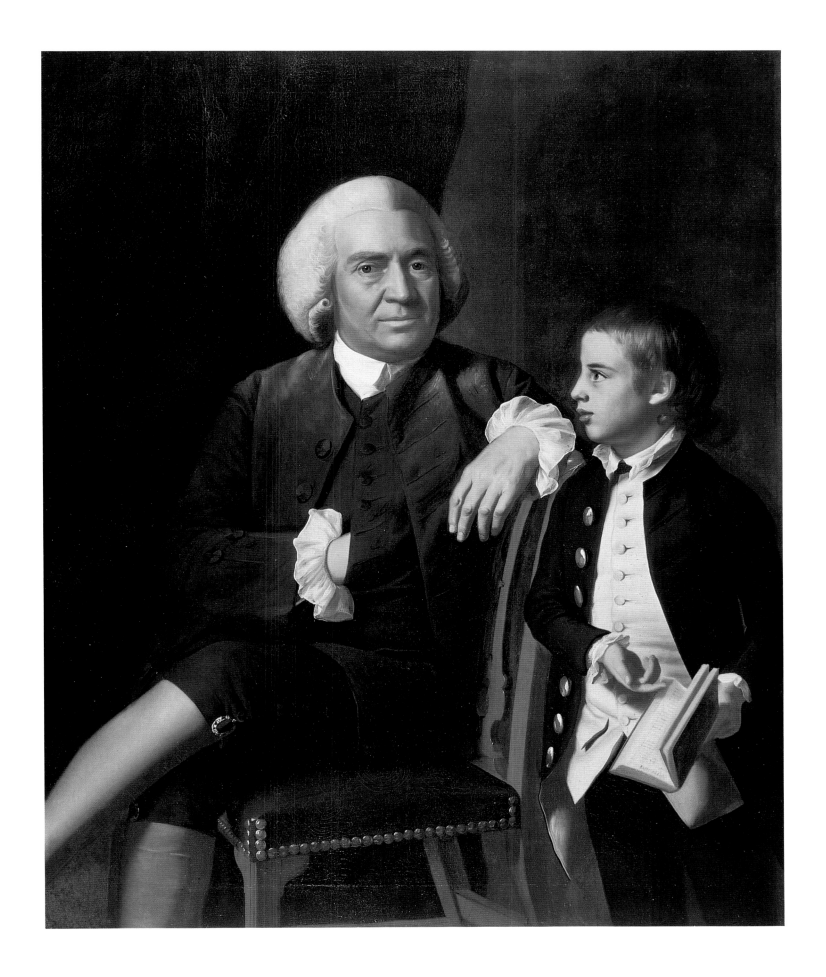

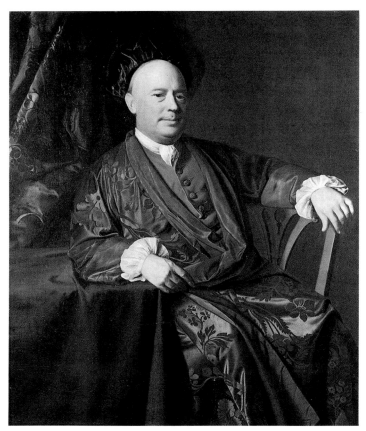

Fig. 204 *Joseph Sherburne*, ca. 1767. Oil on canvas, 50 x 40 in. (127 x 101.6 cm). The Metropolitan Museum of Art, New York, Amelia B. Lazarus Fund, 1923 23.143

Vassalls deserves consideration. Although Copley was not known for compositions with two sitters, it is not impossible that Vassall would have asked for a painting of this kind, but it is fairly unlikely. Even if Vassall did make such a request, Copley, who had produced only single-figure portraits for over a decade, well might have turned him down. Perhaps the patron did not attempt to persuade the painter after all: it may be that Vassall originally commissioned a portrait of himself alone, and Copley proposed to add the figure of Leonard, as an afterthought, in response to some pictorial or conceptual problem, in the course of the artistic process.

Whatever the circumstances of its genesis, the picture as it stands is somewhat disjunctive; without Leonard, the composition would seem complete. Presenting Vassall just off-center on the canvas with his left forearm resting on the back of a reddish brown side chair, the painting appropriates the pose, composition, and prop of Copley's *Joseph Sherburne* (fig. 204), a notably spare portrait whose success derives largely from its lack of extraneous accoutrements. However, Copley described Sherburne as an affluent, leisured merchant but portrayed Vassall as a modest man in plain surroundings, unfettered by fancy clothing—exchanging the former sitter's background drapery and turban and lavishly figured silk damask banyan for the latter's nondescript curtain and fine brown broadcloth suit. Thus attired, with powder from his square wig carelessly dusting both shoulders, Vassall looks almost as genial and honorable as Epes Sargent does in his portrait by

Copley (cat. no. 11). But Copley conveyed a sense of Sargent's paternal qualities without including any of his children in his portrait—something the painter, or the sitter, evidently felt he could not do in Vassall's case.

The likeness of Leonard, who was the fifteenth of Vassall's sixteen children, functions as his father's most telling attribute. Copley portrayed the boy sensitively, so that his small figure and inquisitive gaze add an endearing note to the portrait; indeed, his tender expression resembles that of Daniel Crommelin Verplanck (cat. no. 68). But the artist did not leave enough room for Leonard's figure and inserted it awkwardly, at the edge of the canvas. Painted flatly and in strict profile, the boy does not communicate, either psychologically or formally, with his frontal, fully dimensional father. No doubt Copley's problem here arose from his lack of experience in dealing with more than one figure and, as has recently been explained, because father and son probably sat separately.[2] If there were separate sittings, they most likely took place not as a consequence of a flawed working method but because the painting originally was conceived as a portrait of only one of the subjects.

There is no reason to suspect that William Vassall was not devoted to his children. He apparently had a compassionate side and once specified that the slaves on his Jamaica plantations be treated "in the kindest and most humane manner and that they have everything that is necessary for their comfort and well-being both in health and in sickness."[3] Yet Vassall was not particularly well known for his kindness. He was extravagant and litigious, a high-stakes gambler whose father, Leonard, specified in his will that William "solemnly make an Oath that for the future he will not play any game whatsoever" before claiming his inheritance and who was described by his friend John Adams as garrulous despite his "letters and virtues."[4] He was often punished for playing cards and dice at Harvard, where he was known as Billy and was a Fellow Commoner, a rank granted to students whose fathers made gifts to the university and paid double tuition. A rather insolent young man, Billy probably acquired his passion for lawsuits from his often vengeful father, who even sued a Harvard tutor for boxing his son's ears. The court found for the tutor, who had the right to strike a student who failed to doff his cap to a faculty member, but the case seems to have impressed William, who would himself initiate suits against businessmen, his church, and the state of Massachusetts, spending over a thousand pounds annually in legal fees for most of his adult life.

The son of an extremely wealthy plantation owner, Vassall was born in Jamaica on November 23, 1715, and raised in Boston. He received degrees from Harvard in 1733 and 1743 but never practiced any profession. He was married twice, first to Ann Davis, who died in 1760, and shortly thereafter to Margaret Hubbard (1722–1794), and he supported his household on the considerable proceeds of the family's West Indian sugar plantations. In addition to his holdings in the West Indies, Vassall owned approximately one thousand acres along the Kennebeck River in Maine, near present-day Vassallboro; a summer home in Poppasquash Neck, Rhode

Island, near Bristol; and a large estate on Pemberton Hill in Boston. The Pemberton Hill property had terraced gardens and a "roomy and elegant" mansion overlooking Scollay Square and the harbor that was decorated with expensive furniture and paintings, including a group of portraits by John Smibert.[5] William Vassall was one of very few Bostonians who rode about town in a carriage; his was emblazoned with the family's coat of arms. He was parodied in Mercy Otis Warren's farce *The Group* as "Beau Trumps," a dandy who finds nothing so charming "as rank and show, and pomp, and glitt'ring dress" and proclaims:

> *Perhaps by my abilities and fame,*
> *I might attain a splendid glitt'ring car,*
> *And mount aloft, and sail in liquid air,*
> *Like Phaeton, I'd then out-strip the wind,*
> *And leave my low competitors behind.*[6]

A shrewd rationalizer, Vassall explained in his plea for the restitution of his property after the Revolution that the extraordinary sums he spent on lawyers, property, clothing, and other trappings demonstrated his "friendly disposition to [the United] States."[7] According to an authority on the Vassall family, William "wrought out for himself an honorable and unblemished reputation" despite his rather extravagant lifestyle.[8] It is possible that Vassall went to Copley for help in wringing out his reputation, hoping to obtain from the painter a portrait that would present a proper image to the world. He did not, after all, commission a likeness of his wife or of any other members of his family, and the picture Copley produced, despite Leonard's presence in it, is primarily a portrait of William. The inquisitive boy does, however, turn what might have been a portrayal of an irascible and contentious man into a portrait of a wise and benign father. It is a ploy worthy of the sitter.

William Vassall, who was a conspicuous and prominent Loyalist, fled to London with his family in 1775 and lived in a villa in Battersea Rise, Surrey, until his death in 1800. He lost most of his American property but contrived to recover some compensation for it with the help of his good friend Dr. James Lloyd, who kept this portrait and the portraits by Smibert in Boston until Leonard Vassall claimed them after his father died.[9] Leonard attended Oxford and was called to the bar at Lincoln's Inn in 1793. In 1801 he married Sarah Fitch, an American whose parents settled in Battersea Rise at the same time the Vassalls moved there.

C R

1. Benjamin West, letter to Copley, Aug. 4, 1766, in Jones 1914, p. 44. See also Prown, 1966, vol. 1, p. 90.
2. Sally Mills, *The American Canvas: Paintings from the Collection of the Fine Arts Museums of San Francisco* (New York, 1989), p. 34.
3. J. G. Taylor, *Some New Light on the Later Life and Last Resting Place of Benedict Arnold and of His Wife, Margaret Shippen* (London, 1931), p. 42.
4. Leonard Vassall, Probate will, undated, Suffolk County, Docket no. 17367, Archives, Supreme Judicial Court, Boston; Adams, letter to Thomas Jefferson, May 3, 1816, in John Adams, *The Works of John Adams*, vol. 10 (Boston, 1856), p. 214.
5. Estes Howe, "The Abode of John Hull and Samuel Sewall," *Massachusetts Historical Society Proceedings*, ser. 2, 1 (Nov. 1884), p. 324. These portraits, which are of William, his wife, his daughter, and his son William, are listed in Smibert's notebook for 1743 and in Vassall's will. They are at present unlocated. See *The Notebook of John Smibert*, with essays by Sir David Evans, John Kerslake, and Andrew Oliver (Boston, 1969), pp. 98–99, nos. 224, 226–28, 234.
6. Mercy Otis Warren, *The Group* (Boston, 1775), pp. 8, 11. For the identification of Vassall and others parodied in this play, see Worthington Chauncy Ford, "Mrs. Warren's 'The Group,'" *Massachusetts Historical Society Proceedings* 62 (1928–29), pp. 15–22.
7. William Vassall, letter to Simeon Potter, Apr. 10, 1784, in *Massachusetts Historical Society Proceedings*, ser. 3, 1 (Nov. 1907), pp. 211–12.
8. Edward Doubleday Harris, *The Vassals of New England and Their Immediate Descendants* (Albany, 1862), p. 12.
9. See Taylor, *New Light on Arnold and Shippen*, pp. 41–42, 74–75; E. Alfred Jones, "Lost Objects of Art in America," *Art in America* 8 (June 1920), p. 191; and E. Alfred Jones, *The Loyalists of Massachusetts: Their Memorials, Petitions, and Claims* (London, 1930), p. 285. Susanna Copley (letter to Henry Pelham, Sept. 18, 1775, in Jones 1914, p. 359), mentions that "Mr. Vassall and Family . . . arive'd here last week."

65

Reverend Thomas Cary

ca. 1770–73
Oil on canvas, 50 x 40¼ in. (127 x 102.2 cm)
Museum of Fine Arts, Boston, Gift of Mrs. Richard Cary Curtis 57.67

Thomas was fond of study, went through college, and was settled as a minister at Newburyport before he was twenty-one. . . . The parson, as he was called in those days, was always a favorite with his father. His studious, quiet habits and early settlement in life were very agreeable to the old gentleman." Thus was the Reverend Thomas Cary remembered by his niece Margaret G. Cary.[1] Born in Charlestown, Massachusetts, in 1745, Cary was the son of Captain Samuel Cary, a seaman and merchant who graduated from Harvard, and Margaret Greaves Cary, whose family owned substantial land in Chelsea, Massachusetts. Cary was a favorite with his father and seems to have closely resembled his mother, who "was small in person, plain . . . but very intelligent."[2] He entered Harvard at the tender age of eleven and three-quarters, when, according to college president Edward Holyoke's diary entry, he weighed only eighty pounds.[3] Upon graduation in 1761, Cary became a schoolteacher in Weston and then in Haverhill, Massachusetts; in Haverhill he lived with his uncle, the Reverend Edward Barnard, who was himself painted by Copley sometime between 1770 and 1774 (Peabody Essex Museum of Salem, Massachusetts). In 1768 Cary was ordained minister of the First Church in Newburyport, Massachusetts, a position he retained for forty years, until his death in 1808. After his father died in 1769, he received part of his parents' considerable estate in Charlestown and became a wealthy man.

Newburyport, a seaport forty miles north of Boston on the Merrimack River, owed its prosperity in the late eighteenth century to shipbuilding and the West Indian trade. Plentiful stands of oak trees along the Merrimack provided timber for both activities, and a harbor that rarely froze in winter assured a brisk mercantile economy. Among the town leaders were many Harvard graduates, including Cary's classmates Jonathan Jackson; Stephen Hooper, son of Robert Hooper of Marblehead; Captain Edward Wigglesworth; and the Reverend Christopher Bridge Marsh, minister of North Church. Newburyport counted hardly any Tories among its citizens and supported the revolutionary cause from its beginnings. Only one resident signed any of the addresses bidding farewell to Governor Thomas Hutchinson when he departed Massachusetts in 1774, and he later apologized in an open letter to the "Inhabitants of Newburyport."[4] Cary seems to have sided with the majority, always referring to Americans in his diary as "our men"; an entry for June 1775, for example, reads, "Charlestown the Place of my Nativity Set on Fire by the Regulars. They at the same time took possession of Bunker's Hill. Our Men retreated. A Considerable Loss on both sides."[5] Although he did not take a leadership role in revolutionary matters, Cary led prayers at Town Meetings and at the General Court. He was a trustee of the Merrimack Humane Society (which was established "for the purpose of rewarding acts of valor and heroism and aiding mariners cast ashore on Plum island"),[6] served on the first board of trustees of Dummer Academy in nearby Byfield, and was a member of the King Cyrus Chapter of the Royal Arch Masons. Cary's parish was described by diarist William Bentley in 1787 as "the best in the port, including the best families."[7] During his ministry its membership reached two thousand.[8]

In 1775 Cary married the daughter of one of Newburyport's wealthy merchants. Of the event he wrote in his diary: "I was married by the Rev. Mr. Parsons to Esther Carter. Eldest Daughter of N Carter, Esqr. Wedding private on Account of our public Troubles."[9] Esther died in 1779, leaving a two-year-old son. In 1783 Cary married Deborah Prince of Exeter, New Hampshire, who bore ten children. Of his eleven children only two survived infancy, both sons who were to graduate from Harvard, and Cary himself suffered a "paralytic affliction" in 1788 that restricted his activities.

The most striking and unusual aspect of Copley's depiction of Cary is its relative informality. Copley showed almost all of the other thirteen or so ministers he painted in America in their clerical robes and wearing wigs, usually in bust-length views or, if at three-quarter length, seated at a table with books.[10] Cary, however, is portrayed sitting relaxed in a Windsor chair, his hands folded with fingers interlaced on an open Bible in his lap, with his books and a red drapery behind him. The private, casual nature of the moment at which he is captured is underscored by his attire: he is wigless and wears, instead of ecclesiastical garb, a dressing gown, or banyan, like Nicholas Boylston (cat. no. 31) and other prosperous merchants who sat for Copley. Cary's skillfully rendered opulent blue silk damask robe with rose-colored lining and what appear to

be two rings support the connection with his elite counterparts in the commercial world and help to cast him in the image of a wealthy gentleman-scholar. Copley used a dramatic light issuing from a source at the left to focus attention on Cary's face and hands, illuminating an expression that scholars have described as "slightly devilish" and "unministerial puckish."[11] Such characterizations are at odds with a contemporary account by Bentley of Salem of the Reverend Cary as a cleric who gave "a pious and rational discourse . . . a man of wealth and of kind manners."[12] Whether devilish or pious, in Copley's depiction this patrician clergyman looks up from his reading and seems ready to engage in conversation with a visitor entering his library.

That Cary decided to commission Copley to paint his portrait is not surprising, for a number of his relatives also sat for the artist: Copley painted miniatures of his older brother, Samuel, and his wife, Sarah Gray Cary, ca. 1773 (cat. nos. 77, 78), drew a pastel of his cousin Mrs. Samuel Henley, ca. 1765 (Museum of Fine Arts, Boston), and painted an oil of his aunt Mrs. James Russell (fig. 219). The portrait of Thomas Cary remained in the hands of the sitter's family until it was given to the Museum of Fine Arts, Boston, in 1957.

Copley's portrait of Cary has been dated 1773 based upon an

Fig. 205 Benjamin Blyth. *Reverend Thomas Cary*, ca. 1773. Pastel on paper, 22 x 14¼ in. (55.9 x 43.8 cm). Lent by the First Religious Society, Newburyport, Massachusetts, courtesy of the Museum of Fine Arts, Boston

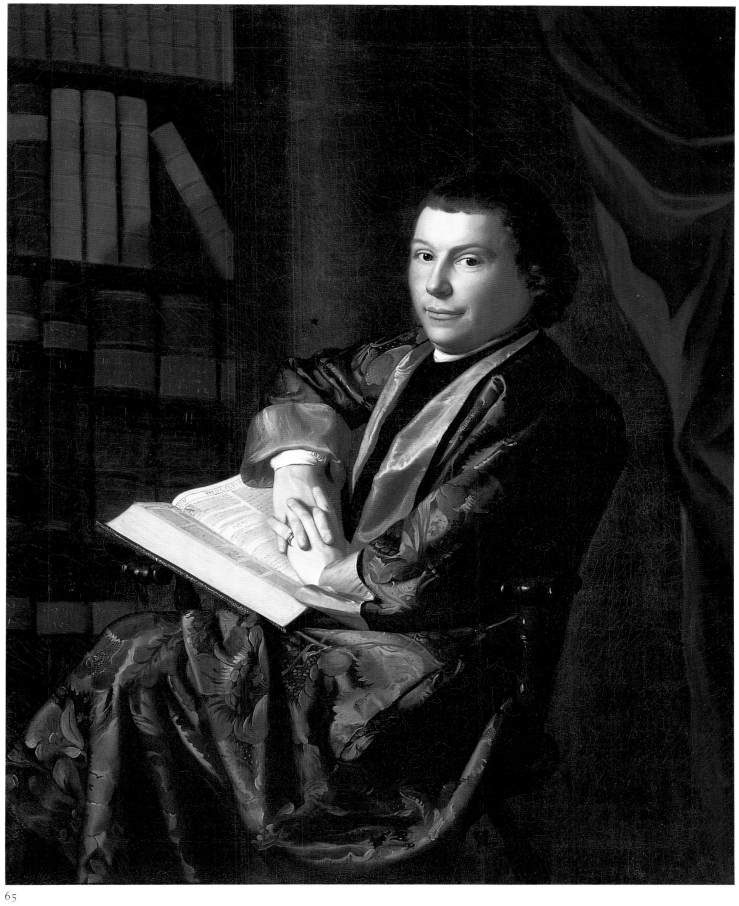

65

entry in Cary's diary from January 20 of that year: "Din'd at Mr. Copely's."[13] However, given the sitter's luxurious costume, it is possible that the picture was executed as early as the summer of 1770, when Cary received his share of his father's estate.[14] He might well have commissioned his likeness to commemorate the event, just as Nathaniel Sparhawk, John Hancock, and others used the inheritance of generous legacies as occasions for ordering their own portraits (see cat. nos. 19, 22).

Cary also sat for Benjamin Blyth, a Salem artist, probably in 1773 (fig. 205). The bust-length pastel that Blyth executed, although much simpler and less finished than Copley's painting, confirms that Cary had the arched eyebrows and bowlike mouth that Copley showed. Cary is dressed in the same manner in both portraits, suggesting that the choice of costume was his. The likeness by Blyth was probably drawn to hang in Newburyport's meeting house, as it does to this day, together with portraits of his predecessor, the Reverend John Lowell, and several later ministers.[15] J L C

1. *The Cary Letters*, ed. Caroline Gardiner Curtis (Cambridge, Mass., 1891), pp. 4–5.
2. Ibid., p. 3.
3. Clifford K. Shipton, *Sibley's Harvard Graduates*, vol. 15 (Boston, 1970), p. 29.
4. Benjamin W. Labaree, *Patriots and Partisans: The Merchants of Newburyport, 1764–1815* (Cambridge, Mass., 1962), p. 38.
5. "Interleaved Almanac of Thomas Cary," New England Historic Genealogical Society, Boston.
6. John J. Currier, *History of Newburyport, Mass., 1764–1909* (Newburyport, 1909), vol. 2, p. 128.
7. *The Diary of William Bentley, D.D., Pastor of the East Church, Salem, Massachusetts* (1905–14; reprint Gloucester, Mass., 1962), vol. 1, p. 116.
8. Minnie Atkinson, *A History of the First Religious Society in Newburyport, Massachusetts* (Newburyport, 1933), p. 31.
9. "Almanac of Thomas Cary."
10. Clergymen painted by Copley in bust-length portraits include Arthur Browne, Joseph Sewall, Myles Cooper (cat. no. 47), Alexander MacWhorter, Samuel Cooper (depicted twice), William Hooper, Edward Barnard, and Mather Byles (depicted twice). Nathaniel Appleton and John Ogilvie are portrayed seated at tables with books. Edward Holyoke is painted enthroned in a chair (fig. 45), as befitted the president of Harvard College. Samuel Fayerweather is recorded in a miniature (cat. no. 14).
11. Alfred M. Frankenstein, *The World of Copley, 1738–1815* (New York, 1970), p. 9; Prown 1966, vol. 1, p. 88.
12. *Diary of William Bentley*, vol. 1, p. 61.
13. "Almanac of Thomas Cary."
14. Cary's entries in his Almanac detail his settling of his father's estate: "July 5 1770 Began to apprize the Estate"; "July 24 Divided the plate at his House"; "July 26 Divided the Furniture at Chelsea"; "September 21 Divided Pictures" ("Almanac of Thomas Cary").
15. An inscription on the stretcher of the Blyth portrait reads, "October [?] / 1773 / A Gift / of the / Revd / Thomas / Cary of / Newburypt / D Balch." That Peter Pelham, Copley's stepfather, chose the Reverend Cotton Mather as the subject of the first mezzotint he executed in America indicates there was a market in the colonies for portraits of ministers. Cary himself had on his wall a portrait by Joseph Badger of

the Reverend Ellis Gray, father of Sarah Gray Cary. William Bentley mentions "a painting of Revd. Mr. Otis [*sic*] Gray, one of the ministers of New Brick Church, Boston. Revd. Mr. Cary of Newburyport has another painting of the same person both by Badger" (*Diary of William Bentley*, vol. 3, p. 368).

66

Thomas Gage

ca. 1768–69

Oil on canvas mounted on Masonite, 50 x 39¾ in. (127 x 101 cm)
Yale Center for British Art, New Haven, Paul Mellon Collection
B1977.14.45

67

Mrs. Thomas Gage (Margaret Kemble)

1771

Oil on canvas, 50 x 40 in. (127 x 101.6 cm)
The Putnam Foundation, Timken Museum of Art, San Diego

During the 1760s and early 1770s Thomas Gage was among the most powerful and influential men in North America. The second son of Thomas, first Viscount Gage, and Benedicta Hall, he was born in Firle, Sussex, in 1721 and became a lieutenant with the Forty-eighth Foot at the age of twenty.[1] He came to America as a lieutenant colonel under General Edward Braddock in 1754 and remained in this country for over twenty years. He served as military governor of Montreal before his appointment in 1763 as commander in chief of British forces in North America; he retained this post, which headquartered him in New York, until 1774, when he became governor of Massachusetts. Popular among most colonists for his tact, dignity, common sense, and kind manner, he gave Americans, according to one of his biographers, "a feeling that he . . . would never push matters to civil war."[2]

Copley and Gage met when the commander came to Boston in 1768 on orders from the king to still the unrest caused by British soldiers in the town. Gage was not entirely successful in his efforts and, indeed, met the opposition of patriots such as Samuel Adams. But his presence was appreciated by many colonists, especially members of the Massachusetts elite. Copley's portrait betrays no hint of the strife that surrounded his sitter but presents an authoritative picture of a distinguished and affable officer pointing out troops performing orderly drills and equestrian maneuvers. It is an archetypal image of a military man, the composition of which Copley may have derived from any number of similar portraits of British officers that he would have known through mezzotints; it is especially close, for example, to John Smibert's portrait of William Shirley (fig. 206), which was engraved by Copley's stepfather, Peter Pelham. It is also among his more formulaic and

restrained efforts, the product of an artist who perhaps felt inhibited by the task of producing an enduring image of a very important man. The pressure involved may account as well for the ill-conceived positioning of Gage's baton, upon which he appears to lean as if it were a walking stick.

Gage sat for Copley shortly after Myles Cooper, who had also come from New York to Boston on business, posed for him, and the painter seems to have paid as much attention to Gage's brilliant red and black uniform as he did to Cooper's stunning academic robe (see cat. no. 47). Whereas Cooper obliged the painter by leaving his robe in Boston for over a year, Gage no doubt did not allow Copley to study his uniform for any longer than was required to paint the likeness; this may account for the fact that Gage's outfit seems a rather free adaptation of the commander in chief's uniform and errs in certain details, such as the facings, button loops, and cuffs.[3]

Copley was extremely fortunate to count Gage among his patrons. The commander's portrait, hanging in his stately home on Broad Street in New York, advertised Copley's talents to those who had never seen his work, or anything like it by an American artist. And, as Captain John Small of Gage's staff wrote to Copley in 1769, the painting was "universally acknowledg'd to be a very masterly performance, elegantly finish'd, and a most striking Likeness; in short it has every property that Genius, Judgement and attention can bestow on it."[4] Gage took his portrait to London, where he also helped to establish Copley's reputation, as early as 1770, when the picture "was receiv'd *at home* with universal applause and Looked on by real good Judges as a Masterly performance," even when hung alongside Gage family portraits by Sir Joshua Reynolds.[5] Two of those real good judges apparently were the English portraitists David Martin and Hugh Barron, who both copied Copley's portrait of Gage (fig. 207; The Firle Collection, East Sussex, England). Gage's picture motivated other New York residents to commission likenesses from the artist. Captain Small, for example, ordered his own portrait in pastel (location unknown), which was "greatly admir'd by Crowds . . . who come to Look at

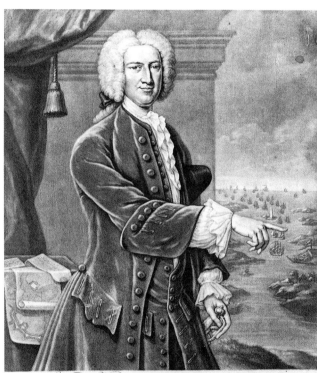

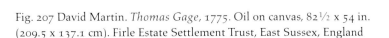

Fig. 206 Peter Pelham after John Smibert. *William Shirley*, 1747. Mezzotint, 11⅞ x 9⅞ in. (30.2 x 25.1 cm). National Portrait Gallery, Smithsonian Institution, Washington, D. C. NPG.75.80

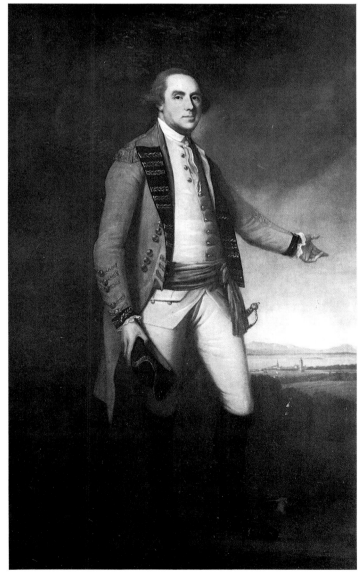

Fig. 207 David Martin. *Thomas Gage*, 1775. Oil on canvas, 82½ x 54 in. (209.5 x 137.1 cm). Firle Estate Settlement Trust, East Sussex, England

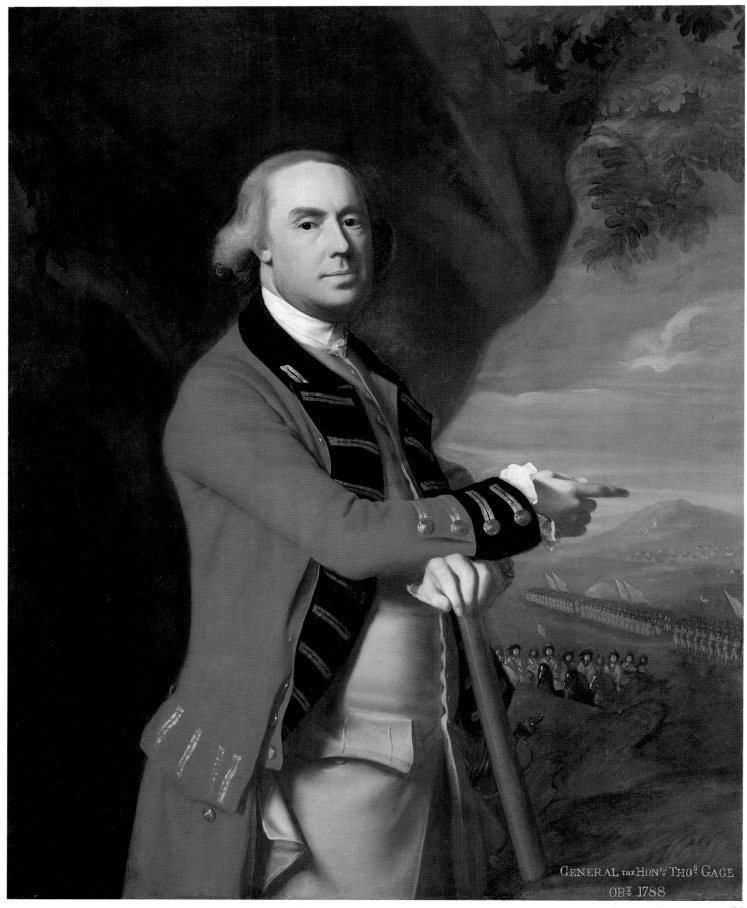

GENERAL the HONble THOs GAGE
OBt 1788

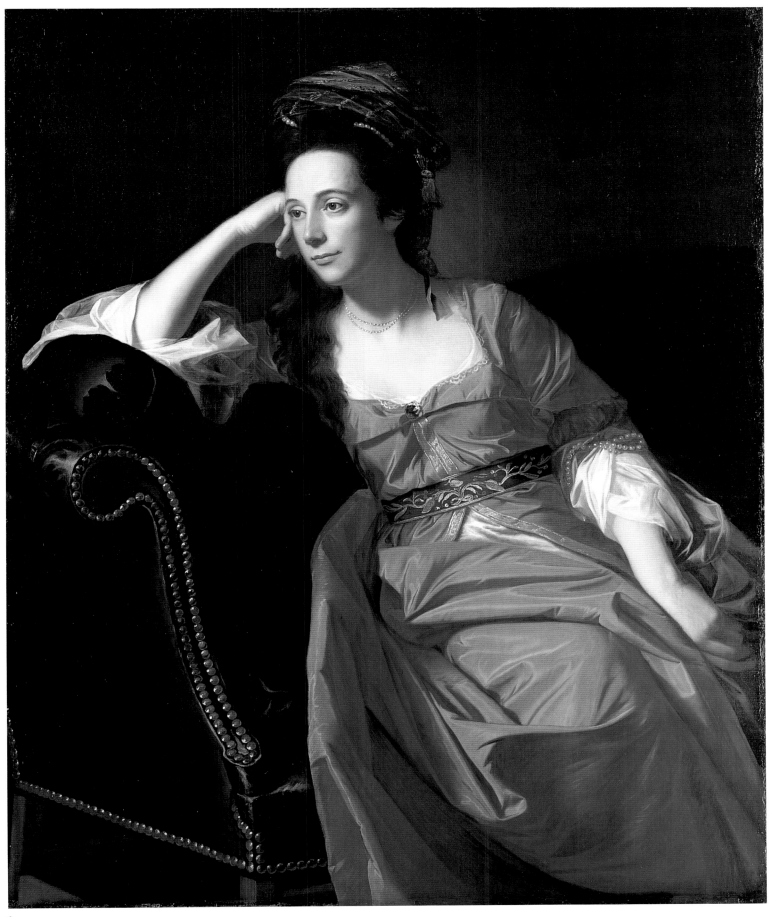

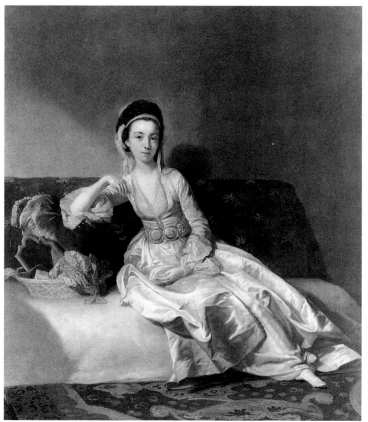

Fig. 208 George Willison. *Nancy Parsons*, ca. 1771. Oil on copper, 22½ x 18⅝ in. (57 x 47.5 cm). Yale Center for British Art, New Haven, Paul Mellon Collection B1981.25.681

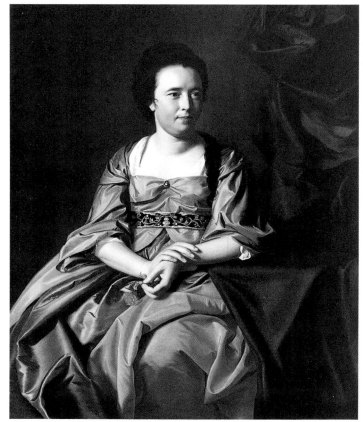

Fig. 209 *Mrs. Joseph Hooper*, ca. 1770–71. Oil on canvas, 50 x 40 in. (127.3 x 101.9 cm). The Baltimore Museum of Art, Gift of Dr. Morton K. Blaustein, Barbara B. Hirschorn, and Elizabeth B. Roswell, in Memory of Jacob and Hilda K. Blaustein BMA 1981.74

it."[6] In fact, the Gage portrait attracted so much interest in Copley in New York that he came to the city in the summer of 1771. Although Captain Stephen Kemble made Copley's arrangements for the trip, it was Gage's wife who inspired the visit by putting her name at the top of the list of subscribers for portraits.[7]

The eldest daughter of Peter Kemble of New Brunswick, New Jersey, a gentleman of outstanding wealth and political influence, Margaret Kemble Gage (1734–1824) was Stephen Kemble's younger sister and arguably the most socially prominent woman in New York.[8] Through her mother, Gertrude Bayard, she was a first cousin to the Van Cortlandts, the de Lanceys, and the Van Rensselaers, New York's leading families. Through her marriage to Gage on December 8, 1758, she extended her elite familial circle and gained many important social and political acquaintances as well; Gage's fellow officers and staff reportedly called her "Duchess" and she was "known as a belle in social circles throughout the middle colonies."[9] It is not known whether Margaret Gage accompanied her husband to Boston in 1768, but Copley began her portrait within three days of his arrival in New York on June 13, 1771. So eager was he to begin her portrait that, by his own account, he gave himself barely enough time to find a place to live and arrange his studio before she came to sit for him on Monday, June 17.[10] Copley's hasty preparations seem ample indication that he felt his success in New York depended on this com-

mission; the portrait itself, which is unlike anything he had painted in Boston, is further proof of the same. When it was finished, he said himself that "it is I think beyand Compare the best Lady's portrait I ever Drew."[11]

Mrs. Gage's languid, informal posture and withdrawn expression are in striking contrast to the comparatively erect postures and emotional neutrality of Copley's female Bostonian sitters, and her costume is more exotic than anything he had shown before. If Copley's initial idea for his subject's pose, dress, and attitude of melancholy or blissful preoccupation was based on an engraving of Sir Godfrey Kneller's portrait of Lady Mary Wortley Montagu, which served as the inspiration for a number of eighteenth-century English portraits (see fig. 208), the details of Mrs. Gage's likeness are original to the commission at hand. As a sublime aesthetic statement it is unique as well. The dress, for example, is much more elaborately detailed than the one Kneller portrayed: a square-necked open robe trimmed with gold braid and held closed with a large ruby brooch and a wide embroidered belt, over a long white shift with lace trimmings at the neckline, and sleeves held up with strands of pearls. Worn with a swath of green embroidered silk loosely wrapped as a turban, the costume is in keeping with the Turkish style then popular for masquerade in London or occasionally affected in public by Lady Montagu and other Englishwomen who embraced the fashion after they traveled

to the Levant.[12] Masquerades were not the custom in New York, and Mrs. Gage is not known to have visited Turkey, but her father, who had a Greek mother, was born in Smyrna and lived there until he was sixteen. Thus the costume was an appropriate attribute of her foreign ancestry. It is flattering to her dark curly hair, deep brown eyes, and ruddy complexion; on this ground and because Mrs. Gage would have wanted to follow the English fashion it represented, there is little reason to suggest that she did not own the costume. When Copley painted Mrs. Roger Morris (cat. no. 70) and Mrs. Joseph Hooper (fig. 209) in similar garb, he may have been recalling Mrs. Gage's dress.

The painter Matthew Pratt, who saw Mrs. Gage's portrait in Copley's New York studio, said that it would "be flesh and Blood these 200 years to come, that every Part and line in it is Butifull."[13] Henry Pelham had heard so much about the portrait that he wrote to Copley specifically to tell him of his desire to see it, "particularly

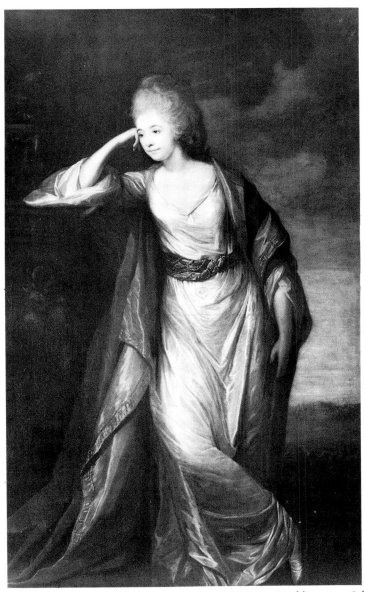

Fig. 210 David Martin. *Mrs. Thomas Gage (Margaret Kemble)*, 1775. Oil on canvas, 82½ x 48½ in. (209.5 x 123.1 cm). Firle Estate Settlement Trust, East Sussex, England

after Mr. Pratt's hansome Speach upon it."[14] Copley was so proud of the painting that he sent it to the Society of Artists exhibition of 1772 in London, where it was praised by many, including Benjamin West and Reynolds, and mildly criticized by others, primarily Mrs. Gage's friends, who "did not think the likeness so favourable as they could wish."[15] Her friends might have preferred the portrait Martin painted a few years later (fig. 210), which shows her as a refined English aristocrat with powdered hair, a pale complexion, a less elaborate costume, and a traditional landscape background even though it is derived from Copley's composition.

Reports of Mrs. Gage's appearance, personality, and activities suggest that both portraits were accurate in their own way. Both hung at Firle, the Gage family estate, during her lifetime and remained there almost to the present day.[16] Martin's comparatively bright and conventional work might be said to illustrate her role as lady of the manor: she was, after all, the devoted mother of eleven who looked after her children, entertained visiting dignitaries, and each Sunday evening read a service and delivered a sermon for houseguests and servants.[17] Copley's dark and romantic portrait, in contrast, offers some indication of the despair and loneliness that seems to have defined her married life. Thomas Hutchinson, who stayed at Firle in 1774, proposed that her divided loyalties and yearning to live full-time in New York had become a source of tension between the Gages; he maintained as well that he had seen a letter that the commander had written to her "in which he says he is ready to wish he had never known her."[18] Another acquaintance declared that "she hoped her husband would never be the instrument of sacrificing the lives of her countrymen" and that she felt akin to Blanche in Shakespeare's *King John*, who agonizes:

> *Which is the side that I must go withal?*
> *I am with both: each army hath a hand;*
> *And in their rage, I having hold of both,*
> *They whirl asunder and dismember me.*[19]

It has been suggested that Mrs. Gage revealed British military secrets to Joseph Warren, leader of the colonial militia, and in so doing contributed to the destruction of her husband's reputation and their mutual estrangement.[20] Despite his distinguished career before the Revolution, Gage is best remembered for precipitating the Battles of Lexington and Concord. Combatants on both sides of the struggle criticized him severely; Bostonians burned him in effigy, and the king recalled him to London after the catastrophic Battle of Bunker Hill. He was commissioned a general in 1782, five years before his death.[21] Mrs. Gage survived her husband by thirty-six years and did not remarry. C R

1. On Gage, see John R. Alden, *General Gage in America* (Baton Rouge, 1948); John Shy, "The Empire Militant: Thomas Gage and the Coming of War," in *A People Numerous and Armed* (Ann Arbor, 1990); David Hackett Fischer, *Paul Revere's Ride* (New York, 1994); and James Truslow Adams, "Gage, Thomas," in *Dictionary of American Biography*, ed. Allen Johnson and Dumas Malone, vol. 7 (New York, 1931), pp. 87–88.
2. Shy, "Empire Militant," p. 115.

3. Sylvia K. Hopkins, Keeper of Uniforms, National Army Museum, London, letter to the author, Feb. 1, 1985, curatorial file, Yale Center for British Art, New Haven.

4. Captain John Small, letter to Copley, Oct. 29, 1769, in Jones 1914, p. 77.

5. Captain John Small, letter to Copley, May 15, 1770, in Jones 1914, p. 94.

6. Ibid.

7. Stephen Kemble, letter to Copley, Apr. 17, 1771, in Jones 1914, p. 114.

8. On Peter Kemble, see Stephen Kemble, *The Kemble Papers* (New York, 1884–85), vol. 1, pp. xiii–xv.

9. Alden, *Gage in America*, p. 44.

10. Copley, letter to Henry Pelham, June 16, 1771, in Jones 1914, pp. 116–17.

11. Copley, letter to Henry Pelham, Nov. 6, 1771, in Jones 1914, p. 174.

12. Aileen Ribeiro, "The Influence of Oriental Dress on Masquerade Dress," in *The Dress Worn at Masquerades in England, 1730 to 1790, and Its Relation to Fancy Dress in Portraiture* (New York, 1984), pp. 217–48; "Going Turkish in Eighteenth-Century London: Lady Mary Wortley Montagu and Her Portraits," in Marcia Pointon, *Hanging the Head: Portraiture and Social Formation in Eighteenth-Century England* (New Haven, 1993), pp. 141–58.

13. Copley, letter to Henry Pelham, Nov. 6, 1771, in Jones 1914, p. 174.

14. Henry Pelham, letter to Copley, Nov. 17, 1771, CO5/39, Public Record Office, London.

15. Jonathan Clarke, letter to Copley, Dec. 20, 1772, and Benjamin West, letter to Copley, Jan. 6, 1773, in Jones 1914, pp. 190, 197.

16. When Copley's portrait was sold in the 1980s, the Gage family had a copy painted to replace the painting at Firle.

17. Entry for Aug. 20, 1774, in *The Diary and Letters of His Excellency Thomas Hutchinson*, ed. Peter O. Hutchinson (London, 1883), p. 223.

18. Ibid.

19. Alden, *Gage in America*, p. 248; Fischer, *Paul Revere's Ride*, p. 96.

20. See Fischer, *Paul Revere's Ride*, pp. 94–96; and Alden, *Gage in America*, pp. 247–50.

21. The inscription in the lower right corner of Copley's portrait, which reads "GENERAL the HON^BLE THO^S GAGE / OB^T 1788," is incorrect and is not in Copley's hand.

68

Daniel Crommelin Verplanck

1771

Oil on canvas, 49½ x 40 in. (125.7 x 101.6 cm)

The Metropolitan Museum of Art, New York, Gift of Bayard Verplanck, 1949 49.12

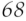Daniel Verplanck lived a privileged, cultured childhood. The sole heir of the prosperous banker and merchant Samuel Verplanck, he was born in Amsterdam in 1762 and grew up in New York in a large Georgian-style brick house on Wall Street that was separated from Federal Hall by an abundant garden.[1] The house had originally belonged to his grandfather, but Daniel's parents

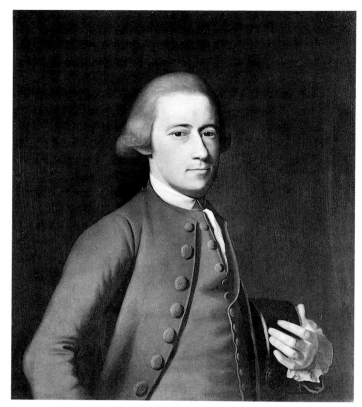

Fig. 211 *Samuel Verplanck*, 1771. Oil on canvas, 30 x 25 in. (76.2 x 63.5 cm). The Metropolitan Museum of Art, New York, Gift of James DeLancey Verplanck, 1939 39.173

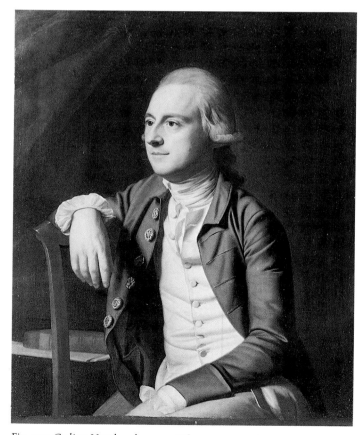

Fig. 212 *Gulian Verplanck*, 1771. Oil on canvas, 36 x 28 in. (91.4 x 71.1 cm). The Metropolitan Museum of Art, New York, Gift of Mrs. Bayard Verplanck, 1949 49.13

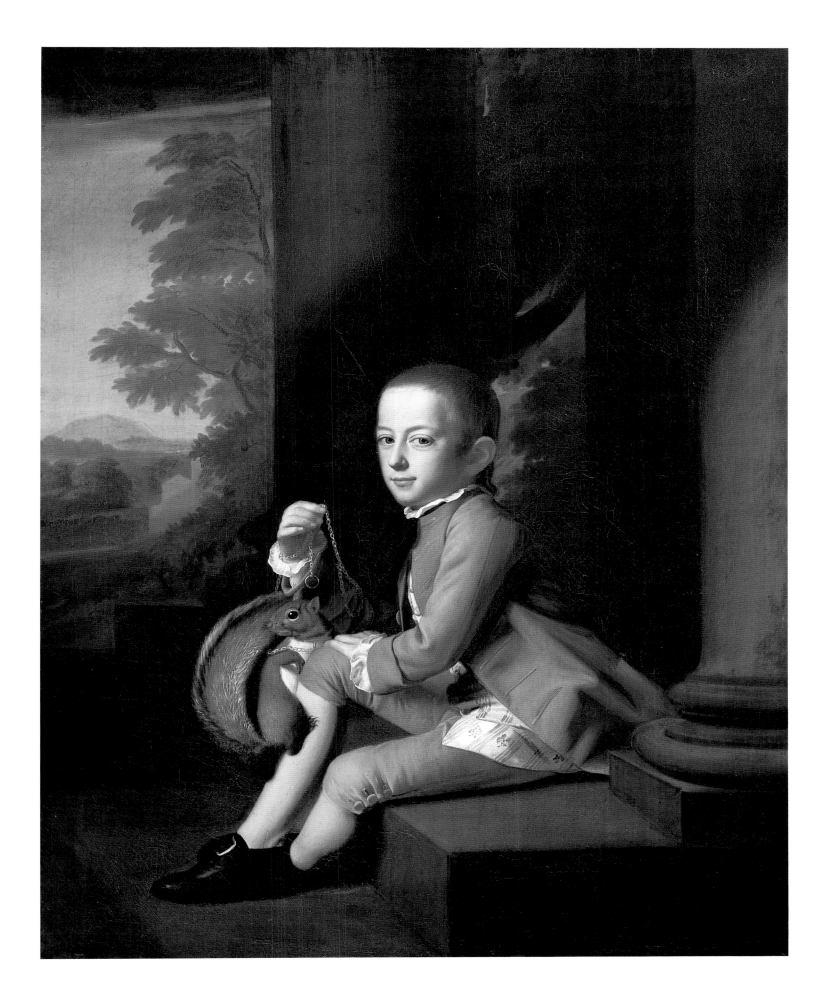

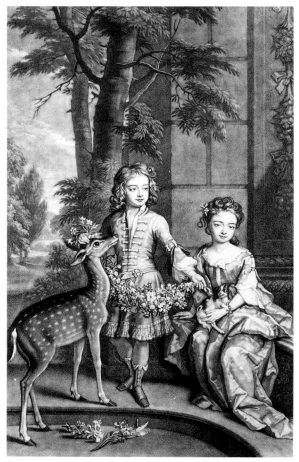

Fig. 213 John Smith after Sir Godfrey Kneller. *Lord Buckhurst and Lady Mary Sackville*, ca. 1715–25. Mezzotint, 16¾ x 10⅛ in. (42.5 x 25.7 cm). Courtesy Winterthur Museum, Delaware

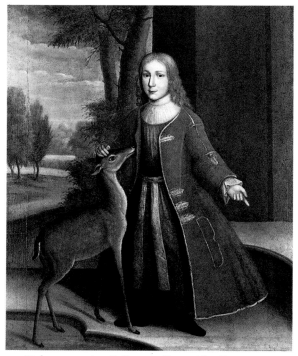

Fig. 214 Unknown artist. *DePeyster Boy with a Deer*, ca. 1730. Oil on canvas, 50¼ x 41 in. (127.6 x 104.1). Collection of the New-York Historical Society, Bequest of Catherine Augusta De Peyster

filled it with high-quality American furniture, fine silver and upholstery fabrics, and Chinese export porcelain and other imported luxuries shortly after they married in 1761. The family may have summered at Mount Gulian, the Verplanck country estate located on a bluff overlooking the Hudson River in Fishkill, New York. Daniel's father had a collection of paintings and drawings—most acquired on trips abroad—and his mother, the former Judith Crommelin, owned an array of diamond, pearl, and gold jewelry.[2] Daniel attended the city's best schools and, judging from his adult penchant for art, music, and excellent wine, his parents inculcated in him their taste for the finest of everything.

When Copley wrote to his half brother that he was taking extra time to finish his paintings in New York because "the Gentry of this place distinguish very well, so I must slight nothing," he could very well have been describing the Verplancks.[3] They were among his most avid as well as worldliest patrons in the city. Although only one Verplanck, Daniel's aunt Mary McEvers, is included on Stephen Kemble's list of New York subscribers for portraits by Copley, the artist painted at least four family members. Samuel Verplanck ordered a bust-length portrait (fig. 211), as did his sister Mrs. McEvers (private collection); their brother Gulian Verplanck commissioned a kit-kat canvas (fig. 212), and family tradition has it that Gulian's wife, the former Mary Crommelin, and daughter, Anne, also sat for Copley.[4]

Of the extant Verplanck portraits by Copley, Daniel's is by far the most ambitious. It is the only three-quarter-length canvas among them and, because his nine-year-old figure could be accommodated in the format, also the only full-length portrait. Daniel's likeness shares with Copley's portraits of Samuel, Gulian, and Mary Verplanck a muted palette and a striking attention to face and hands. But the portraits of the dark-garbed elder Verplancks are simple and stark, while Daniel's is grand and intricate. The boy's stylish suit is light colored, his vest is beautifully brocaded, he sits on a porch amid imposing classical columns, and the landscape background situates him in a lush setting distant from the city of New York and, in fact, far removed from anywhere the Verplancks lived. The porch does not belong to Mount Gulian, which was a one-story Dutch-style wooden house with a balustraded porch, rectilinear columns, and a shingled roof. As for the mountain in the distance that reads as a marker of the location, it too is a fantasy, for there was no Mount Gulian at Mount Gulian. The squirrel is a direct quotation from Copley's portrait of his half brother, Henry Pelham (cat. no. 25), which met with great success when it was exhibited at London's Society of Artists, where the painter was eager to make a good impression. Perhaps the desire to please another new audience, his potential New York customers, encouraged him to reprise a prop in the picture that was so well received in London. In any case, in the portraits of both Henry and Daniel, the squirrel gave Copley the opportunity to enliven the formal and narrative content of his work. Copley's painting of his brother is, however, essentially an original conception, whereas his interpretation of young Verplanck is based closely on a picture by

Sir Godfrey Kneller that shows children outdoors with tame wild animals (fig. 213), a model that was very popular with painters who worked for prominent families in the Hudson River Valley during the early eighteenth century (see fig. 214). Copley is not known to have used this composition in New England.

It has been noted recently that Anglicans were more disposed than Congregationalists were toward having their children's portraits painted and that this explains why the Anglican Verplancks commissioned Copley's elaborate picture of Daniel.[5] But an inclination to have a child's likeness recorded does not satisfactorily account for Samuel Verplanck's decision to have his son aggrandized to an extent unmatched in the other portraits Copley painted of his family or for his willingness to expend the time, thought, and money demanded by a commission of this magnitude. Perhaps the decision to have Daniel portrayed in grand style was not Verplanck's but Copley's own: the boy's likeness may have been one of the first that Copley began in New York, a portrait, like that of Mrs. Thomas Gage (cat. no. 67), with which he hoped to build his local reputation. By the artist's own record, he started Mrs. Gage's portrait on June 17 and by June 20 had begun two more; he said that he intended "as soon as time permits to fill my room" with portraits so that he would have a considerable range of work to show to prospective patrons who visited his studio.[6]

Daniel Verplanck's likeness certainly represented a tour de force on the part of Copley. And for Samuel Verplanck, who likely wished to see his son portrayed as the precocious scion of one of New York's most prominent families, a boy who would inherit great wealth and power, the portrait might have represented a perfect rendering of Daniel's potential. A future graduate of King's College in New York, Daniel chose law as his career, served in the United States Congress, and managed his vast inheritance with wisdom and skill. He married twice, was the father of nine children, one of whom was the noted statesman and author Gulian Crommelin Verplanck, and after 1804 lived mostly at Mount Gulian, thus becoming the first Verplanck to make the house his primary residence. He died at the age of seventy-two in 1834.

C R

1. Biographical sources disagree on the place of Daniel's birth, but Verplanck family histories consistently maintain that his parents, who married in Amsterdam in 1761, did not return to New York until 1763.
2. Judith Crommelin, Marriage contract, Mar. 25, 1761, typescript, Archives, The Metropolitan Museum of Art.
3. Copley, letter to Henry Pelham, Nov. 6, 1771, in Jones 1914, p. 174.
4. William E. Ver Planck, *The History of Abraham Isaacse Ver Planck and His Male Descendants in America* (Fishkill, N.Y., 1892), p. 108. The portrait of Mary and Anne Verplanck is listed as a single work under the heading "Attributed Works" in Prown 1966, vol. 1, p. 242.
5. Jules David Prown, "John Singleton Copley in New York," *Walpole Society Notebook*, 1986, p. 35.
6. Copley, letters to Henry Pelham, June 16 and June 20, 1771, in Jones 1914, pp. 117, 120.

69

Portrait of a Lady

1771
Oil on canvas, 48½ x 39½ in. (123.2 x 100.3 cm)
Dated on letter: 1771
Los Angeles County Museum of Art, Museum Acquisition Fund 85.2

Like a wild dance of lost souls at Halloween . . . the best of Copley's early hard English portraits have been arriving beneath the ghostly banner of Nathaniel Dance," wrote an art historian in 1961.[1] Shortly thereafter Jules Prown discovered that among the "hard English portraits" that had been given to Dance was a Copley painting of a rather somber, dark-haired woman half-reclining on a plum-colored damask sofa and holding a letter dated 1771.[2] This particular misattribution to Dance was in part the result of the misidentification of the sitter as Hester Lynch Salusbury Thrale, a patron of the arts, perhaps best known as the intimate friend of author and lexicographer Samuel Johnson. During the nineteenth century the portrait descended in the Lansdowne-Keith family, to which Mrs. Thrale was related. Members of the family must have seen a resemblance between the sitter and their distinguished ancestor that was strong enough to convince them to inscribe Mrs. Thrale's name and life dates at the lower left edge of the canvas. (Such information was often added to Dance's portraits.)[3] Prown's opinion that the picture had been painted by Copley during his visit to New York in 1771, which was supported by other experts, threw out not only the Dance attribution but the Thrale identification as well, since Mrs. Thrale never traveled to America. Although her biographers continue to insist that it is she who is depicted in the portrait, there can be no question that the canvas was painted by Copley and that it was executed in America.[4]

Given the indisputable attribution, the date inscribed on the letter held by the woman in the portrait constitutes the most explicit evidence that the picture was painted in New York, where Copley lived and worked from mid-June through December 1771. The most compelling reason to locate the picture in this brief period of Copley's career, however, is its remarkable similarity to two documented portraits that he executed in New York. It looks strikingly like *Mrs. Roger Morris* (cat. no. 70), especially in terms of facial features and expression; indeed, the resemblance is so close that the woman reclining on the sofa might be identified as Mrs. Morris's slightly older sister, Susannah Philipse Robinson (1727–1822). Mrs. Robinson's name does not appear on Copley's roster of New York subscribers for portraits, but the list is torn just below Mrs. Morris's name and in any case does not register every picture he painted in New York.[5] The picture of our unknown lady is also comparable in style, choice of props, palette, and general mood to *Mrs. Thomas Gage* (cat. no. 67), the first portrait Copley painted in New York. The upholstery in the former is almost precisely the color of the dress in the latter, and the meticulously detailed

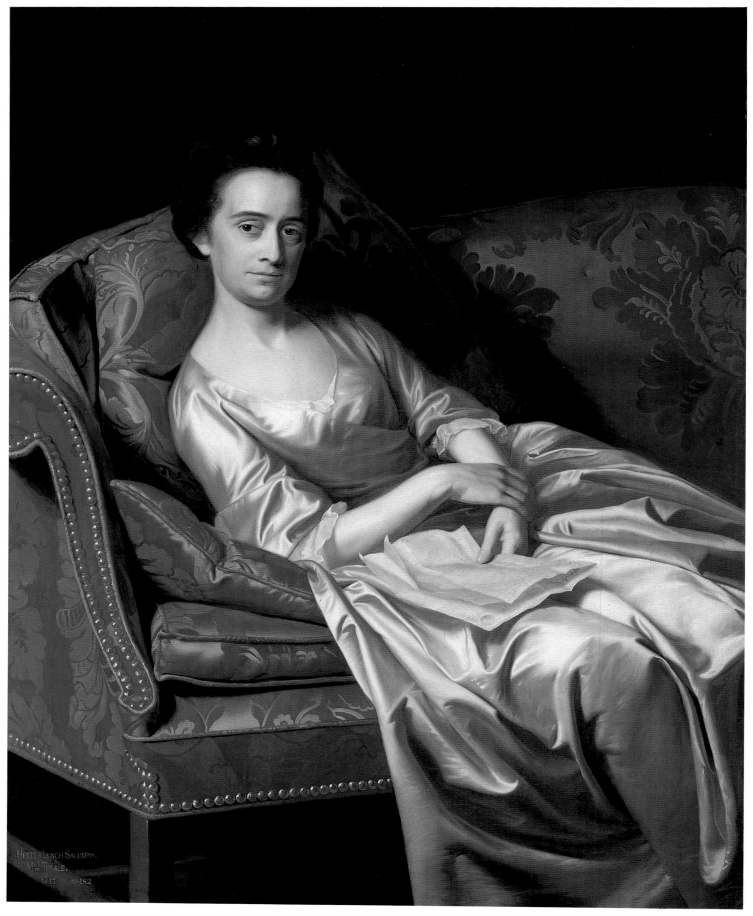

69

and correctly rendered camelback sofas that appear in both paint-ings, based on a piece of furniture that may have been moved into Copley's studio from the adjoining furnished rooms he and his wife took on Broadway during their stay in the city, are identical in all respects but color.[6] Perhaps the most significant parallels are those of posture and costume: both sitters lean to the left in lan-guid repose against soft damask-covered pillows and cushions and wear shimmering silk damask gowns that flow over their laps in thick, luxurious folds. The echoing of details in these two New York pictures is certainly not unprecedented, for in Boston Copley often used the same pose and setting for more than one sitter. Moreover, Copley was extremely pleased with his portrait of Mrs. Gage and, therefore, surely would have been disposed to recycle its basic elements for another subject.

It might be assumed that Mrs. Gage and the unknown woman did not know each other, for if they did, or if the portraits were likely to be shown together, Copley presumably would not have adopted such similar approaches for them. Yet the contrary is also possible: perhaps the sitters were friends or relations and asked the artist to portray them in the same way. Copley's list of New York subscribers lends credence to the latter speculation. Mrs. Gage signed up for two half-length portraits measuring 50 x 40 inches, only one of which, her own, is known. The second could be the pic-ture of our anonymous lady, ordered by Mrs. Gage, for a relation. If it is, the subject might be Mrs. Gage's maternal cousin, Ann Ed-wards (1728–1808), who was raised in the Kembles' New Jersey home as her sister: she is the only woman in the Kemble or Gage families who would have been the apparent age of the unknown sitter in 1771.

The identity of Copley's anonymous subject in this portrait may yet be discovered by setting aside circumstantial evidence of the sort that points to Mrs. Gage's cousin and finding among the Lansdowne-Keith ancestors someone who was in New York in 1771. Such research could confirm the widely held supposition that the sitter is the Miss Johnston on Copley's list of subscribers and of whom no documented portrait has been found. Michael Quick has recently suggested she is indeed Miss Johnston and Miss John-ston was Ann Johnston, the daughter of the affluent and respected Perth Amboy physician Lewis Johnston (1704–1773) and wife of John Burnet, an officer in the British army.[7] Her birth date is not known, but she is thought to have been her parents' second child, situated between her brother John, who was born in the early to mid-1740s, and her sister Margaret (1750–1786); she lived until at least 1831, when her Loyalist pension ceased being issued to her.[8]

Copley's list of subscribers and the many pictures he painted in New York offer still other clues that may lead to the identification of this sitter. In addition to the two unlocated half-length portraits of women subscribed for by Mrs. Gage and Miss Johnston there is an order for a portrait of unspecified size assigned to a Mrs. Mortier (d. 1787), presumably the wife of Abraham Mortier, deputy paymaster general of British Forces in North America, whose picture has not been found. It is conceivable as well that Miles Sherbrook, who subscribed for and received a half-length portrait of himself (cat. no. 72), might have commissioned a pen-dant portrait of his wife, Elizabeth Van Taerling (b. 1730), the niece of Mrs. Paul Richard, who also sat for a half-length portrait (cat. no. 73). And Copley painted many more pictures during his six and a half months in New York than are recorded on the existing torn subscription list.[9] The anonymous lady in question could, there-fore, be Ann Edwards, Miss Johnston, Mrs. Mortier, Mrs. Sher-brook, or any of the women cited on the missing fragment of the order sheet.

Without a conclusive identification of the sitter in *Portrait of a Lady* it is, of course, still possible to appreciate the picture, which stands among Copley's most beautifully painted and insightful images. Whoever the subject is, she inspired the artist to produce a captivating image, in which he surrounded her with fabrics arranged and colored to brighten her strong countenance and complement her distinctive attitude, which sets her apart from the similarly posed Mrs. Gage. Unlike Mrs. Gage, who props herself up against the camelback sofa, this woman sinks into the cushions as if seeking their comfort. Yet, unlike Mrs. Gage, she is not so much melancholic as reserved, not dreamy but pensive. Neither her ex-pression nor her posture reveals whether the letter she holds, which is illegible except for the date, contains mundane informa-tion or disappointing news.

For the sake of taxonomy it would, however, be valuable to know who this lady was: an identification would provide one more portrait to match against the subscription list or perhaps lead to the discovery of still other New York portraits that have not been ac-counted for. Beyond this, her name, biography, and social situation would provide more information about Copley's extraordinary patronage and productivity in New York. As Richard Brilliant explains, every portrait contains "a deliberate allusion to the [human] original that is not a product of the viewer's interpreta-tion but of the portraitist's intention."[10] For now, viewers can only guess at Copley's intention. C R

1. Charles Merrill Mount, "A Hidden Treasure in Britain, Part II: John Singleton Copley," *Art Quarterly* 24 (Spring 1961), p. 33.
2. Prown 1966, vol. 1, p. 80.
3. See David Goodreau, *Nathaniel Dance, 1735–1811* (London, 1977).
4. The painting is illustrated as a portrait of Mrs. Thrale in James Clif-ford, *Hester Lynch Piozzi* (New York, 1987), and William McCarthy, *Hester Thrale Piozzi: Portrait of a Literary Woman* (Chapel Hill, 1985). The attribution to Copley is discussed in Prown 1966, vol. 1, p. 80; Jules David Prown, "John Singleton Copley in New York," *Walpole Society Notebook*, 1986, pp. 36–37; and Michael Quick, *American Art: A Catalogue of the Los Angeles County Mu-seum of Art Collection* (Los Angeles, 1991), pp. 94–96.
5. The list of subscribers was enclosed in Stephen Kemble, letter to Cop-ley, Apr. 17, 1771, in Jones 1914, pp. 113–14.
6. Michael Quick describes the distinctive arrangement of this sofa's box-edge and knife-edge cushions (Quick, *American Art: Los Angeles Collection*, p. 96).
7. Ibid., pp. 94–95.

8. Reverend W. Northey Jones, *The History of St. Peter's Church in Perth Amboy, New Jersey* (Perth Amboy, N.J., 1924), pp. 314–15.

9. Copley's actual production in New York is tallied in Prown 1966, vol. 1, p. 79.

10. Richard Brilliant, *Portraiture* (London, 1991), p. 7.

70

Mrs. Roger Morris (Mary Philipse)

1771

Oil on canvas, 30 x 24½ in. (76.2 x 62.2 cm)

Signed lower left: COPLEY

Courtesy Winterthur Museum, Delaware

In December 1756 a military man who signed himself "Timothy Scandal Adjutant" recorded the "Return of the State of Capt. Polly Phillips's Dependant Company," a mock roll of writ describing the status of some thirty-nine men who were romantically interested in Mary Philipse, Copley's future sitter. He noted, for example, that the Earl of Loudoun "muster'd Occasionally," General Webb was "wounded but tis hop'd may serve," Lieutenant Colonel Mercer was "Mortally wounded," Captain McAdam was "Desperate," Captain Delancey was "Not accepted," Mr. Gordon, Engineer, "made approaches but at too great a distance," and Mr. Parker was "Discharg'd but willing and able to serve." In a coda to the writ, Scandal explained that the list, although long, was certainly not complete, and he entreated "Any Gentlemen who have any Demands on the Captain . . . to apply immediately, as we have great reason to imagine the Company will soon be broke."[1] Omitted from Scandal's roster was George Washington, who entered Captain Polly's company in February 1756 and received news of her from a faithful correspondent during 1757. But Colonel Washington ignored his correspondent's advice that he make "a kind of flying march" to her because another officer "was laying close siege."[2] As Scandal had predicted might happen, Captain Polly disbanded her company; however, she commissioned a company of one by marrying Captain Roger Morris, whom Scandal had listed as having been "Shot Thro the Heart."

The daughter of Frederic Philipse, the second lord of Philipsburgh Manor in what is now Westchester County, New York, Mary Philipse was born in 1730 and enjoyed every advantage a young woman might want: a good education, charming manners, equestrian skills, physical beauty, and a large inheritance. She was "adored by half the officers in New York," many of whom were crushed by the news of her marriage.[3] Her wedding banquet in January 1758 is portrayed in family histories as one of the social highlights of the century. The bride was given away by her brother, who wore the "jeweled badge of the ancestral office of keeper of the deer forests," and she met the groom under "a crim-

son canopy emblazoned with the golden crest of the family."[4] Roger Morris (1727–1794), a British soldier and "Ladys Man," arrived in America in 1755 as the aide-de-camp to General Edward Braddock, was made a captain under General Thomas Webb, and was promoted to major.[5] He remained in the service until 1764, when he retired to help his wife oversee the Philipse Highlands, a domain of approximately fifty-one thousand acres in Dutchess County with mills, gardens, pastures, and forests that was occupied by tenants who paid total rents of over one thousand pounds annually. The Morrises kept a house on Stone Street in New York City, a wooden structure that Roger razed and rebuilt in brick in 1765; a grand, porticoed mansion in Harlem Heights overlooking the Harlem River and boasting views in all directions; and a cabin in the Highlands where Mrs. Morris stayed during her twice-yearly visits to her tenants.[6] Among the Morrises four children were two sons, Henry Gage and Amherst, named for British officers.

Portraits of Mary Philipse Morris do not indicate her great beauty, which may have been as much a matter of personal animation and charm as physical attractiveness and thus difficult to convey on canvas. John Wollaston's interpretation of her at about age twenty (fig. 215), painted before her marriage, is typical of the likenesses he produced when he lived in New York from 1749 to 1752; its rather formulaic approach and iconic pose allow only a hint of Miss Philipse's character and personality to emerge. Yet she was pleased enough with the picture to have it copied (Morris-

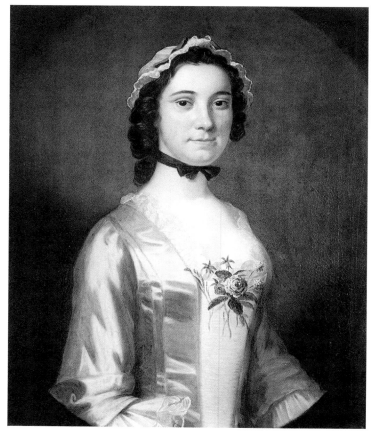

Fig. 215 John Wollaston. *Mary Philipse*, ca. 1749–52. Oil on canvas, 30 x 25 in. (76.2 x 63.5 cm). Historic Hudson Valley, Tarrytown, New York

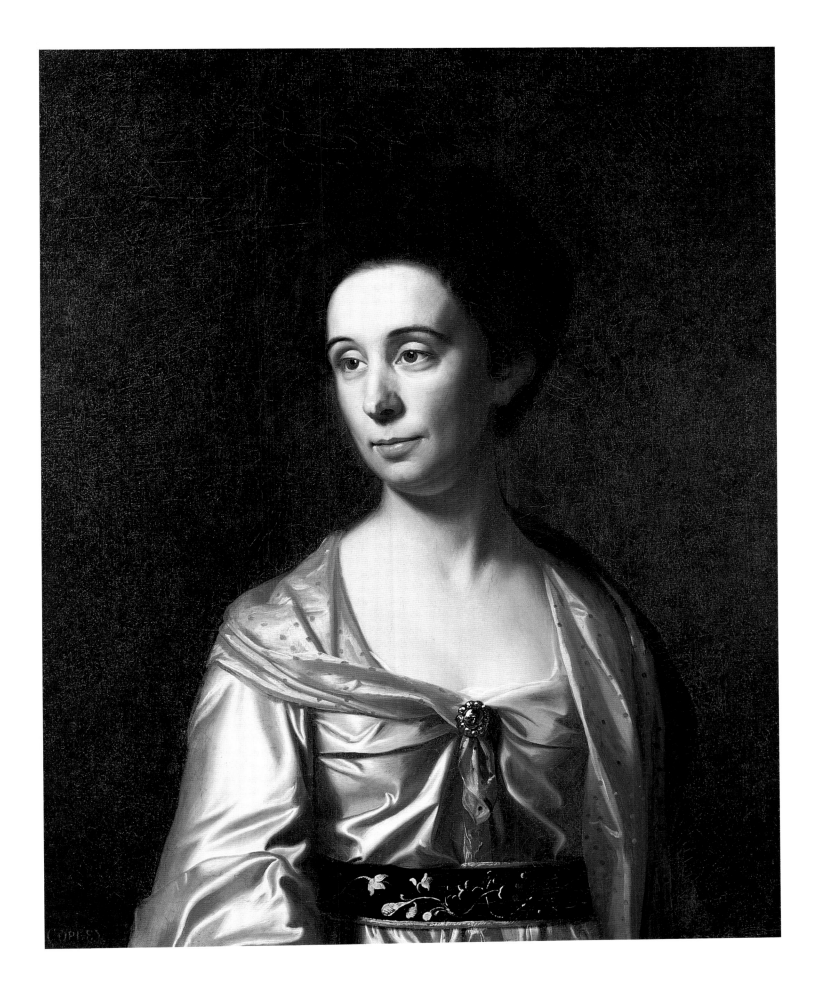

Jumel Mansion, New York)—or even to copy it herself, as some say she did. Mrs. Morris commissioned a portrait from Copley when he came to New York and may have shown him Wollaston's effort to give him an idea of what she wanted. The two paintings do, in fact, share certain similarities: both are bust-length, cut off at the bend of the elbows and the waist of the gown, and display the sitter against a dark background. But the differences are striking, for Wollaston's figure is frontal and static whereas Copley's is asymmetrical and dynamic and incorporates ideas tested in his own best work.

Indeed, Copley's portrait of Mrs. Morris shows strong affinities with his picture of Mrs. Thomas Gage (cat. no. 67), which he painted immediately upon his arrival in New York. The women's open robe dresses, with their square necklines, jeweled brooches, gold trim, and embroidered dark blue belts, are identical in design, although the Turkish references of the costume, so powerful in Mrs. Gage's picture, are diminished in Mrs. Morris's by the addition of a carelessly unfastened neckline scarf and the subtraction of a headdress. Mrs. Morris's portrait is simpler than Mrs. Gage's, but both convey an aura of melancholy, fatigue, and dreaminess. And both women share dark features, heavy eyelids, and a faraway gaze. Both sitters were beautiful American heiresses who married British officers in 1758 and faced similar problems as their conflicting loyalties to their husbands and their native countries were continually challenged. Mary Morris and Margaret Gage were also close friends. Copley may have given them parallel images in recognition of their parallel lives and their friendship.

Mary Morris's tribulations became a popular legacy. In his novel *The Spy* of 1821 James Fenimore Cooper wrote the character of Frances Wharton, a woman torn between her devotion to her American father and her British lover during the Revolution, with her in mind. Like Frances, Mary Morris stood by her husband during the war, although Roger Morris himself was politically ambivalent. In the early stages of the conflict he had been determined to stay in America; if they were desperate, Roger told his wife in 1776, they could move to "our log house, [which] will then be a Palace for us, and I hope to live as comfortably . . . as ever we did."[7] But in 1783, after their estates were confiscated by the state legislature, the Morrises left for England, settled in Yorkshire, and never returned to Mary's native soil. The Copley portrait had been packed since 1775, and when they moved out of their Stone Street house they took it with them. The major had instructed his wife that "Copley's Performance I beg may be particularly taken care of."[8]

C R

1. Timothy Scandal Adjutant, "A Return of the State of Capt. Polly Phillips's Dependant Company, with the Kill'd, Wounded, Deserted, and Discharg'd &c, during the Campaigns 1756 & 1756 [sic]," Dec. 25, 1756, LO 6475, Huntington Library, San Marino, California.
2. Joseph Chew, letters to George Washington, Feb. 14 and July 13, 1757, in Edward Hagaman Hall, *Philipse Manor Hall at Yonkers, N.Y.: The Site, the Building, and Its Occupants* (New York, 1912), p. 126.
3. Stanley M. Pargellis, "Morris, Roger," in *Dictionary of American Biography*, ed. Dumas Malone, vol. 7 (New York, 1934), p. 226.
4. Hall, *Philipse Manor Hall*, p. 130.
5. Pargellis, "Morris, Roger," p. 226. On Roger Morris, see also Lorenzo Sabine, *Biographical Sketches of Loyalists of the American Revolution* (Boston, 1864), vol. 2, pp. 104–6.
6. Constance Greiff, untitled manuscript essay on the Morris's mansion, courtesy of the Morris-Jumel Mansion, New York. See also Helen Comstock, "History in Houses: The Morris-Jumel Mansion in New York," *Antiques* 59 (Mar. 1951), pp. 214–19.
7. Roger Morris, letter to Mary Philipse Morris, June 11, 1776, Morris-Jumel Archives, New York.
8. Roger Morris, letter to Mary Philipse Morris, Sept. 2, 1775, Morris-Jumel Archives, New York. Morris reminded his wife about the portrait in letters of Oct. 4 and Dec. 23, 1775, Morris-Jumel Archives, New York.

71

John Montresor

1771
Oil on canvas, 30 x 25 in. (76.2 x 63.5 cm)
Detroit Institute of Arts, Founders Society Purchase, Gibbs-Williams Fund 41.37

In Copley's portrait John Montresor, dressed in a bright red jacket with black velvet lapels, polished gold buttons, and beaver hat and resting his arms on a tree stump, is lost in thought. The references to his occupation are unmistakable: the book titled "FIELD ENGIN^r" (possibly the first edition of the English translation of John Muller's *The Field Engineer*), the remains of the felled tree, and the uniform identify him as a member of the Royal Corps of Engineers.[1] Yet this is not a typical military portrait, a genre with which Copley had little experience during his American career but one that he had mined with some success when he painted Thomas Gage in about 1768–69 (cat. no. 66). In that picture he had presented a conventional image of Gage as an active, authoritative figure, but he portrayed Montresor as contemplative, romantic, and slightly melancholic, with a brushwork unlike any seen in his other portraits of the period. In his attitude Montresor recalls other sitters Copley painted in New York, particularly the preoccupied Mrs. Gage and the dreamy Mrs. Roger Morris (cat. nos. 67, 70).

In many respects his portrait also resembles Copley's earlier likenesses of Nathaniel Hurd and Paul Revere (cat. nos. 21, 46). To be sure, Montresor's smart and proper uniform contrasts sharply with Hurd's relaxed banyan and Revere's flowing shirtsleeves and open vest, but there are striking formal and conceptual similarities: all three men are at ease, leaning on their elbows, shown with emblems of their craft and talent, and preoccupied, conceivably with thoughts of their creative tasks ahead. Hurd presumably is considering the choice of a heraldic crest for one of his bookplates or

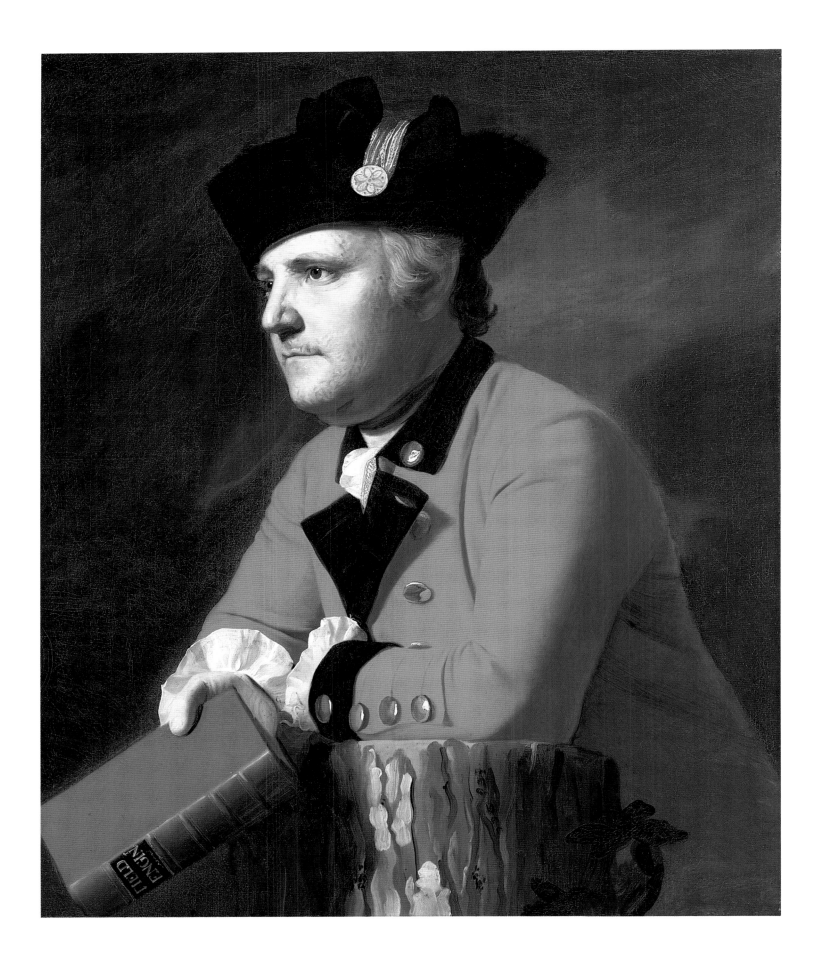

Fig. 216 Peter Andrews after John Montresor. *A Plan of the City of New York and Its Environs to Greenwich*, 1767. Engraving, 25½ x 20¾ in. (64.8 x 52.7 cm). The Metropolitan Museum of Art, New York, Bequest of Charles Allen Munn, 1924 24.90.1345

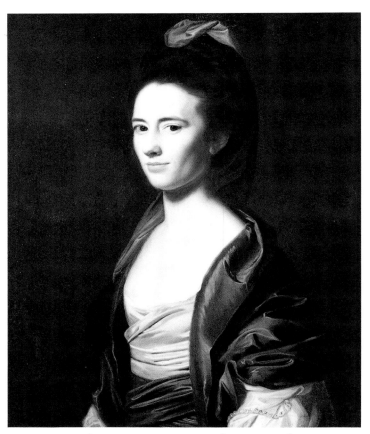

Fig. 217 *Mrs. John Montresor (Frances Tucker)*, 1771. Oil on canvas, 29⅝ x 24½ in. (75.2 x 62.2 cm). Private collection

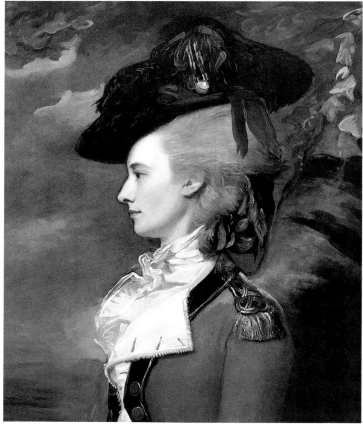

Fig. 218 *Mrs. John Montresor (Frances Tucker)*, ca. 1776–80. Oil on canvas, 30⅜ x 25⅛ in. (77.2 x 63.8 cm). Diplomatic Reception Rooms, Department of State, Washington, D. C.

pieces of silver; Revere, the chasing and engraving of the teapot he holds; and Montresor, the surveying of a clearing and devising of a fortification. Just as Copley portrayed his usual male sitters, the majority of whom were businessmen, lawyers, or clergymen, surrounded by and enjoying the fruits of their labors, so he represented the artisans or designers Hurd, Revere, and Montresor with the tools or products of their own professions, contemplating the creative process.

Montresor (1736–1799) was a prolific and skilled engineer, with numerous maps, forts, redoubts, and barracks in Detroit, New York, Philadelphia, Boston, Niagara Falls, and the Bahamas to show for his two-and-one-half decades of service in America. He came to America from Gibraltar, his birthplace, with his father, the esteemed engineer James Gabriel Montresor, in 1754 and was that year appointed an ensign under General Edward Braddock.[2] He rose through the army ranks, serving in numerous military encounters under celebrated generals, until he reached the position of captain in 1771, the year he designed the fort at Mud Island in the Delaware River below Philadelphia and had his portrait painted by Copley.

The Royal Engineers had been granted an army affiliation and its own uniform only in 1757, and its members seem to have remained somewhat isolated from the core of the military. Montresor's rank reflected his standing as an extraordinary engineer,

although his talents were varied, and his technical expertise made him an indispensable aide to his commanding officers, whom he served with apparent enthusiasm and gratitude. He painted a little-known portrait of General James Wolfe in 1759 at Montmorenci, near Quebec, a sprightly image in profile of a wide-eyed, grinning officer.[3] His map of New York (see fig. 216) bears a dedication in an ornate cartouche to Thomas Gage, and he bestowed Gage's name upon his fifth son. And he drew a panoramic view of Montreal for Major General Jeffrey Amherst.[4] Nevertheless, Montresor felt that his engineering skills were not sufficiently appreciated: "It is rather extraordinary," he wrote, "that in a country [England] where the Arts and Sciences are so much encouraged that a scientific body, and of so important a nature that the very Defence of the Realm depends upon, should be so totally neglected."[5] What Montresor told Copley about himself, his goals, and his profession is impossible to know; it is clear, however, that the artist was impressed by him, for he wrote to Henry Pelham that "Capt. Montresor is a Gentleman we have received great Civility from" and encouraged him to consult with Montresor on how to construct a proper "peaza" for his new house.[6] It is apparent also that Copley understood that his patron's occupation involved creative art as much as exact science. By portraying him in a manner he had previously reserved for artisans and clothed in his distinctive military garb, he expressed both facets of Montresor's talent.

By comparison with Montresor's vivid and powerful image, its companion, Copley's likeness of the captain's wife, Frances Montresor (fig. 217), is modest and less imaginative, if lovely. This portrait of Bermuda heiress Frances Tucker Montresor (1744–1826), the stepdaughter of Reverend Samuel Auchmuty of Trinity Church in New York, exemplifies many of the conventions Copley often employed to represent his female sitters in New York in 1771; indeed it is nearly identical to his depiction of Mary Verplanck McEvers (private collection)—although enlivened by a distinctive bright pink dress, teal robe, and delicately rendered facial features. Mrs. Montresor sat for Copley again, in England, five to ten years after he painted the first portrait, at which time he produced a much different image (fig. 218), far closer in character to her husband's picture. In fact, the profile pose, military-style costume, and dashing brushwork of the second canvas convinced many commentators that it is the real companion to Montresor's portrait. These authors have long speculated that Copley either fulfilled Montresor's order for his wife's portrait some years after it was placed in 1771 or painted both the captain and his wife in England. The Montresor family itself relegated the first picture of Mrs. Montresor to a back room, and descendants displayed the portraits of the red-coated captain and his red-coated wife together for almost a century. C R

1. Francis W. Robinson, manuscript notes, Curatorial files, Department of American Art, Detroit Institute of Arts.
2. See *The Montresor Journals*, ed. G. D. Scull (New York, 1881); *The Evelyns of America* (Oxford, 1881); John Clarence Webster, "Life of John Montresor," *Transactions of the Royal Society of Canada* 22

(May 1928), pp. 1–13; and Stanley M. Pargellis, "Montresor, John," in *Dictionary of American Biography*, ed. Dumas Malone, vol. 7 (New York, 1934), pp. 101–2. An alternative version of Montresor's life is suggested in Susanna Haswell Rowson's *Charlotte Temple* (New Haven, 1801). In this popular novel "founded on fact" the title character falls in love with a Lieutenant Montraville, who entices her to come to America with him, only to steal her virginity, father her bastard child, and abandon her. Contemporary wisdom named Montresor, the cousin of Susanna Rowson's father, as the real-life Montraville, and no one in his family disputed the claim.
3. See A. E. Wolfe-Aylward, *The Pictorial Life of Wolfe* (Plymouth, 1924), p. 125.
4. The drawing was used as the basis for a bas-relief that was placed over the door of Amherst's house. See Jessie Poesch, "A British Officer and His 'New York' Cottage: An American Vernacular Brought to England," *American Art Journal* 20 (1988), p. 79.
5. Quoted in Webster, "Life of John Montresor," p. 8.
6. Copley, letters to Henry Pelham, Oct. 12 and Nov. 6, 1771, in Jones 1914, pp. 166, 175.

72

Miles Sherbrook

1771
Oil on canvas, 49½ x 39 in. (125.7 x 99 cm)
Dated on letter: 1771
The Chrysler Museum, Norfolk, Virginia, Gift of Walter P. Chrysler, Jr., in Memory of his Grandparents, Anna-Maria Breymann and Henry Chrysler 80.219

As portrayed by Copley, Miles Sherbrook (or Sherbrooke) seems a forthright character. In 1771, when this likeness was painted, he was the American agent for Perry, Hayes, and Sherbrook, a mercantile concern with headquarters in London. He was British-born, having come to New York in 1758 at the age of twenty-four, presumably to establish his business interests in America. In 1762 Sherbrook married Elizabeth Van Taerling, who had been raised by her uncle, Paul Richard. He subsequently became a founding member of the New York Chamber of Commerce and acquired an estate in New Jersey, not far from the Spotswood ironworks, which he owned with his partners. His firm generated an annual income estimated at approximately four thousand pounds.[1]

When Copley arrived in New York, Sherbrook had in his house the painter's portrait of "Capt. Richards," which reportedly was "so much admired that vast numbers went to see it."[2] What Richards's portrait looked like—indeed, who Richards was—remains a mystery, but it seems to have acquainted Sherbrook and other New Yorkers with Copley's work and stimulated their interest in it. For his part, Sherbrook commissioned a half-length portrait of himself from Copley.[3] The picture Copley produced for him is simple and restrained. The composition, which shows the subject seated at a table holding emblems of business, is conventional and is executed

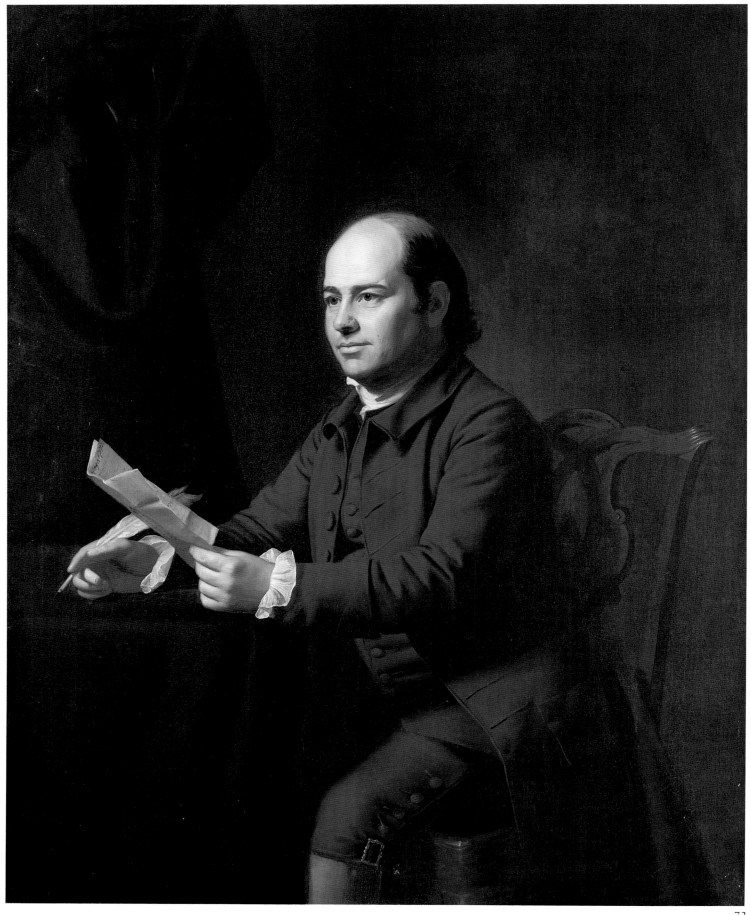

72

in warm brown tones, without flamboyant or ostentatious flourishes or props; apparently, in 1771 Sherbrook did not yet own the gold watch, stock buckle, gold sleeve buttons, and silver shoe buckles that he itemized as prized possessions in his will, or he, or Copley, made a deliberate decision to leave them out of the painting.[4] This seems a conspicuously candid likeness, successful as a painting and as a portrait not only because of the scrupulous details Copley incorporated but also because he excluded lavish embellishments, probably with his client's compliance and possibly at his urging.

Sherbrook is wigless and wears a stylish brown wool suit distinguished by the fine tailoring of the frock coat: narrow cuffs, sleek coattails that Copley made progressively slimmer in the course of painting—as pentimenti evidence—self-fabric-covered buttons, and self facings. He sits at a damask-covered table on a clearly identifiable Boston side chair, carefully rendered to show its various woods, lacy, pierced splat, bow crest rail, and the blunt-ended ears that continue the serpentine curve of the crest rail.[5] The businessman holds a quill pen in one hand and a letter in the other. The address on the letter is illegible, making it impossible to ascertain whether Sherbrook wrote or received it, but the inscription "1771" on the upper right corner of the sheet is clearly readable and dates the painting as well as the moment in Sherbrook's life. At this moment he was partially bald, strands of gray ran through the hair on the side of his head, and his brow, nose, and cheek were pockmarked, all attributes of age and prior illness that might have been eradicated or at least diminished by Copley's cosmetic brush if the artist had been so inclined or if the patron had been vain enough to demand such erasures. Sherbrook smiles ever so subtly, and the smile breaks through the monochrome tableau like a beam of light.

Within five years of the completion of this portrait, Sherbrook's fortunes changed. In 1776 he was imprisoned in Connecticut as a British sympathizer. He was released after five months and paroled to New York, where he seems to have salvaged at least some of his fortune and fulfilled a degree of civic responsibility—he publicly advertised his charitable support of the city's poor in 1777—although American troops had taken over his ironworks.[6] In 1779, as a consequence of previous allegedly treasonous activities, his estate was seized under the New York Confiscation Act of 1779.[7] After the war Sherbrook tried to no avail to recover his property and gain compensation for the bar iron taken from his ironworks. He died a widower in Westchester County in 1805.

CR

1. Gregory Palmer, *Biographical Sketches of Loyalists of the American Revolution* (London, 1984), p. 781.
2. Copley, letter to Henry Pelham, July 14, 1771, in Jones 1914, p. 128. Jules D. Prown (1966, vol. 1, p. 226) speculates that the portrait depicted either Charles Lloyd Richards (location unknown) or John Richards (private collection).
3. Stephen Kemble, letter to Copley, Apr. 17, 1771, in Jones 1914, p. 114.
4. Miles Sherbrook, Will, drafted Apr. 15, 1803, proved Aug. 6, 1803, Surrogate Court of Westchester County, New York.

5. I am grateful to Peter Kenny, Associate Curator of American Decorative Arts, The Metropolitan Museum of Art, for assistance in identifying the chair. See also John T. Kirk, *American Chairs: Queen Anne and Chippendale* (New York, 1971), p. 37.
6. Palmer, *Biographical Sketches of Loyalists*, p. 781; Henry B. Dawson, *New York City During the American Revolution* (New York, 1861), pp. 154–55.
7. Thomas Jones, *History of New York During the Revolutionary War* (New York, 1879), vol. 2, pp. 269, 271, 276, 291, 305.

73

Mrs. Paul Richard (Elizabeth Garland)

1771
Oil on canvas, 50 x 39½ in. (127 x 100.3 cm)
The Museum of Fine Arts, Houston; The Bayou Bend Collection, Gift of Miss Ima Hogg B.54.18

Relatively little has been discovered about this distinguished elderly woman, apparently the oldest of Copley's known New York patrons. Elizabeth Garland was born in London in 1700 to Thomas and Rachel Garland (or Gorland). She was in New York by 1726, the year of her marriage to Paul Richard, a successful merchant and politician three years her senior. As first lady of New York from 1735 to 1739, during Richard's eventful mayoralty, she was presumably in the public eye while her husband presided over a city with a population of approximately ten thousand. Mayor Richard established the first municipal police force, attempted to abolish billiard and gambling houses, built a quarantine station at Bedloe's Island, erected the city's first hospital, organized a militia, and, perhaps most notably, signed the documents handed down at the first American trial concerning newspaper libel, which acquitted Peter Zenger, editor of the *New York Weekly Journal*. After he finished his term, Richard accepted a seat in the General Assembly but spent most of his time developing his highly profitable importing business. At his death in 1756, he was one of the wealthiest merchants in the city and maintained branch offices of his firm in New Haven, Norfolk, and Bermuda.[1]

The Richards lived on the corner of Pearl Street and Broadway and had no children. According to Mr. Richard's will, his wife was to receive all of his "plate, household goods, and pictures and ⅓ of [his] movable estate, also all the rents and profits of all [his] houses, lands, and tenements during her life," provided she did not remarry, which she did not.[2] The first wish Mrs. Richard recorded in her own will was to be interred "as near as may be" to her husband.[3] When she died in 1774, Elizabeth Richard left a considerable estate, including numerous pieces of silver, fine clothing, and land in upstate New York.

Mrs. Richard's portrait is not on the list of subscribed commissions that Stephen Kemble drew up prior to Copley's visit to New

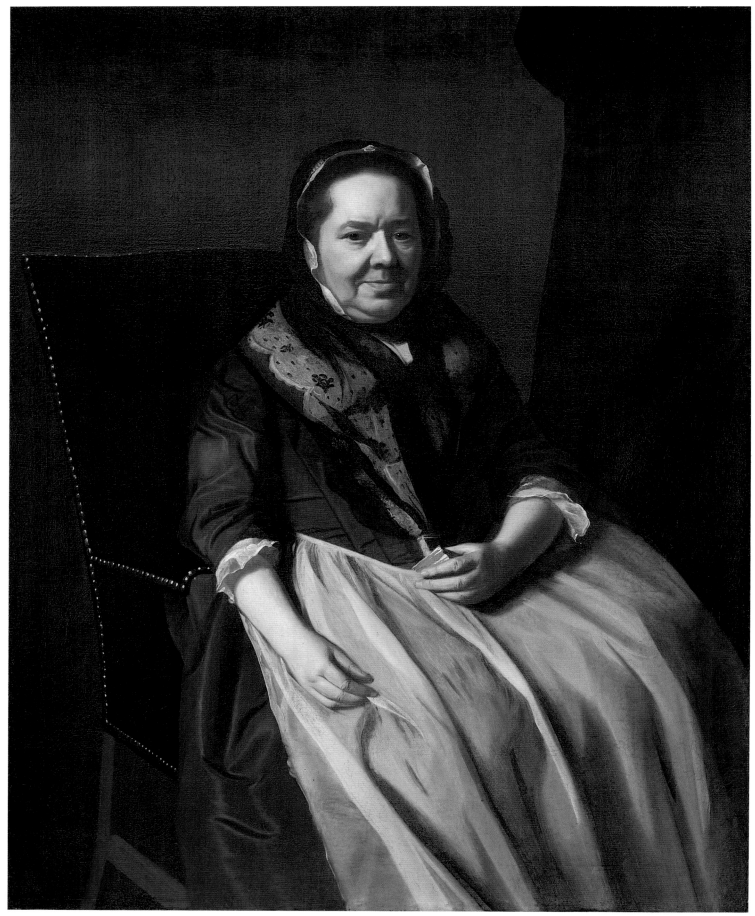

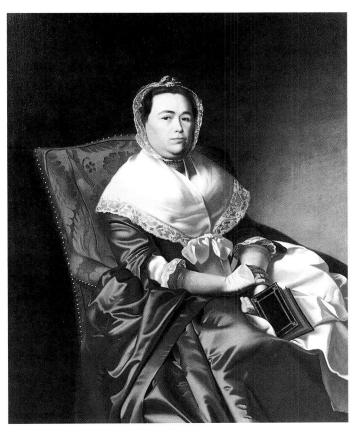

Fig. 219 *Mrs. James Russell (Katherine Graves)*, ca. 1770. Oil on canvas, 50¼ x 40¼ in. (127.6 x 102.2 cm). North Carolina Museum of Art, Raleigh, Purchased with funds from the North Carolina Art Society (Robert F. Phifer Bequest) and the State of North Carolina, by exchange

York in 1771, but it was undoubtedly painted during the artist's stay in the city. Her nephew Miles Sherbrook, whose name does appear on Kemble's list, may have encouraged her to sit for Copley or may at least have introduced her to the artist. He would have had ample time to bring them together: Sherbrook apparently was one of the first New Yorkers to entertain Copley in his home, so their acquaintance was established early in the visit.[4] The portraits of Sherbrook and Mrs. Richard share a similar brown palette that sets them apart from Copley's other New York paintings. The round, half-smiling faces of both sitters glow with a pleasant composure rarely encountered in the artist's work. Both compositions are rather conventional; hers is a modification of a scheme Copley often reserved for older women. Facing right, seated on a damask-covered armchair, her hands on her lap, Mrs. Richard is disposed in a tableau of the sort previously employed for Mrs. Thomas Boylston (cat. no. 30), Mrs. Sylvanus Bourne (The Metropolitan Museum of Art, New York), and Mrs. James Russell (fig. 219). Despite Mrs. Richard's wealth, however, Copley eliminated from her portrait the flattering, opulent trappings that enhance the pictures of the other sitters. Mrs. Richard wears a dress of rich satin not unlike those of her New England contemporaries, but the unfigured fabric that billows out to fill the lower foregrounds of the Boston portraits is reduced in hers to reveal the back legs and side rail of her armchair, and the diminished skirt is

hidden by a sheer white apron. Copley painted women in aprons only twice, here and in his later portrait of Dorothy Quincy (fig. 224); if Miss Quincy's flower-embroidered apron is a rather dainty, clean embellishment for a delicate young woman, Mrs. Richard's plain cotton apron is, by contrast, a rather homely, unsophisticated garment that adorns a slightly rotund, venerable woman. To complete the picture of a less than stylish woman, Mrs. Richard wears her black lace fichu not neatly placed around her shoulders but as a veil that wraps her chest in a rather careless fashion. She holds an indefinable object that might be a small box.

Mrs. Richard lived with her portrait by Copley for just three years before she died and prized it highly enough to leave it to her "dearly beloved kinsman" and executor, her nephew Theophylact Bache, who inherited the bulk of her estate.[5] C R

1. Paul Richard Brown, "Address Delivered Before The New-York Historical Society," ca. 1896, New-York Historical Society.
2. Paul Richard, Will, Mar. 9, 1749, in Abstract of Wills on File in the Surrogates Office, City of New York, liber 20, p. 143.
3. Elizabeth Richard, Will, Mar. 3, 1773, in Abstract of Wills, liber 29, p. 201.
4. Copley mentioned his visit to Sherbrook's house "when we came here" in his letter to Henry Pelham, July 14, 1771, in Jones 1914, p. 128.
5. Elizabeth Richard, Will, in Abstract of Wills on File in the Surrogates Office, City of New York, Mar. 3, 1773, p. 202.

74

Eleazer Tyng

1772
Oil on canvas, 49¾ x 40⅛ in. (126.5 x 100.2 cm)
Signed and dated lower left: John Singleton Copley / pinx 1772.
Boston
National Gallery of Art, Washington, D. C., Gift of the Avalon Foundation 1965.6.1

Copley's portrait is a study in venerability. The eighty-two-year-old sitter, the artist's oldest, shows all the physical hallmarks of great age: a deeply furrowed forehead, paper-thin skin, diminutive legs, watery eyes, reddened eyelids, bushy eyebrows that are like canopies, and a rheumatic left hand that must be buttressed by an arm of the chair. Yet Copley's portrayal is complex and probes other aspects of Tyng's persona. His shrinking body still has a coiled energy. The expression on his luminous face seems both amused and smug. And his head, disproportionately large in comparison with his body, is both imperial and monstrous. An anonymous reviewer of the Copley exhibition of 1965 referred to some of the sides of Tyng's pictured character when he described him as a "cynical, vigorous, wise-eyed, half-smiling octogenarian."[1]

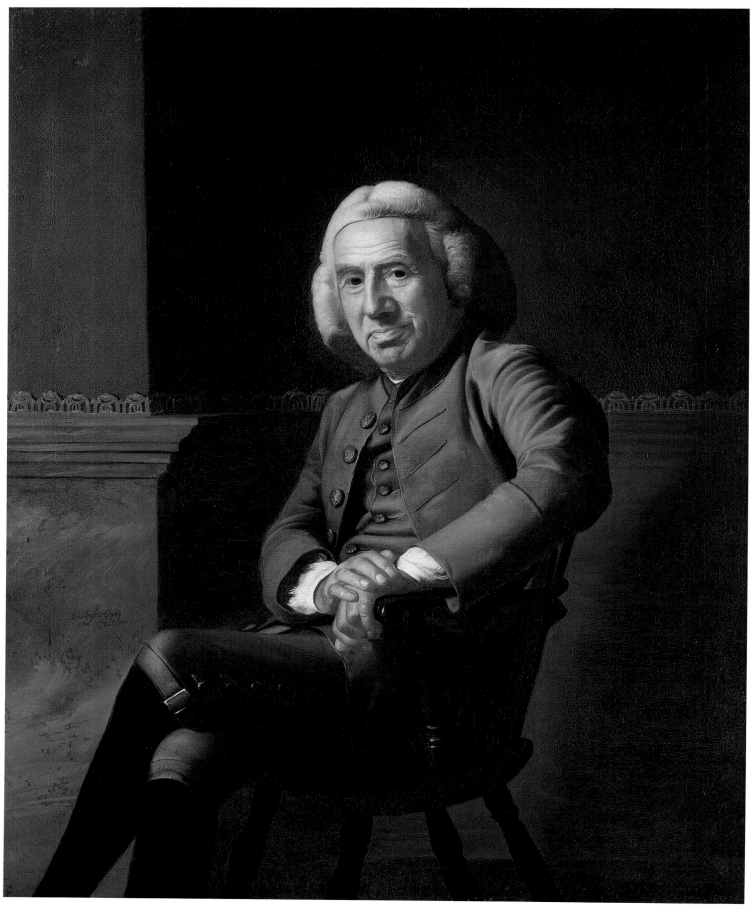

Fig. 220 Jacques-Louis David. *Cooper Penrose*, 1802. Oil on canvas, 51⅜ x 38⅜ in. (130.5 x 97.4 cm). The Putnam Foundation, Timken Museum of Art, San Diego

Like many sitters in Copley's late American portraits, Tyng is presented in a space that is simple, almost ascetic relative to that of the work of the mid-1760s. The crisp silhouetting of the brilliantly lighted head against the dark neutral background and the placement of the figure in the immediate foreground give Copley's painting a Neoclassical appearance, not dissimilar to that of the portraits of Jacques-Louis David (see fig. 220).

Tyng, who died in 1782, was a wealthy landowner when Copley painted him. But unlike most of the rest of Copley's rich sitters, he was a member of the landed gentry, not a merchant. He inherited part of his father's estate in the town of Dunstable in Middlesex County, Massachusetts, and increased the size of his property to six thousand acres in the 1720s. The town was eventually renamed Tyngsborough in his honor.[2] Copley indexed Tyng's high status with the expensive wig, the dado painted to look like mahogany, and the gilded papier-mâché border on the green wallpaper. At the same time he represented him as an ordinary man of the country. He sits in a plain painted green Windsor armchair, which was informal furniture in the eighteenth century. His coat is made out of simple broadcloth. He wears unfashionable black stockings. His shirt has narrow cuffs, like those worn by artisans, such as Paul Revere (see cat. no. 46). And, most startling, he has dirt under his fingernails, as if he recently had been raking his hands through the soil.

P S

1. *New York Herald Tribune*, Nov. 21, 1965.
2. Little has been written about Tyng. For basic information, see Clifford K. Shipton, *Sibley's Harvard Graduates*, vol. 5 (Boston, 1937), pp. 651–53; and Elias Nason, *A History of the Town of Dunstable, Massachusetts, from Its Earliest Settlement to the Year of Our Lord 1873* (Boston, 1877), pp. 74–76, 99–106, 214–16.

75

Sylvester Gardiner

ca. 1772
Oil on canvas, 50 x 40 in. (127 x 101.6 cm)
Private collection

According to his obituary, Sylvester Gardiner (1708–1786) "possessed a most uncommon Vigour and Activity of Mind."[1] This notice also described him as diligent, attentive, pious, and honest, a characterization corroborated by other accounts of his life. The sickly child of a cordwainer from South Kingston, Rhode Island, Gardiner was tutored by his brother-in-law Reverend James McSparran, a Scottish Presbyterian missionary and rector. McSparran encouraged his pupil's interest in medicine, first by setting him up as an apprentice to Dr. John Gibbons in Boston and then by underwriting his course of study in England and France. Gardiner studied abroad for eight years, starting in 1727, primarily under William Cheselden at St. Thomas' Hospital in London but also with a brief training period in Paris with the surgeons Jean Louis Petit and Henri François LeDran. He returned to Boston in 1734 with an education unrivaled in the colonies, where academic training in medicine was not yet a prerequisite for practice.[2] Gardiner specialized in kidney and bladder stone operations—he earned some renown for removing a stone from a six-year-old boy in 1741. In the eighteenth century, however, surgery was not a full-time career, and his eminence in Boston's medical community rested more on his range of activities than on his particular expertise. Gardiner lectured at the Boston Medical Society, maintained a general practice, headed a committee that was responsible for creating a smallpox hospital in Boston, and, most significantly, revolutionized the way medicine was dispensed in Massachusetts and Connecticut by founding a number of apothecary shops. He accumulated a fortune by importing and selling drugs at the sign of the Unicorn and Mortar in Boston and by developing real estate in Maine. As the head of the Kennebec Company, which speculated in land along the Kennebec River, Gardiner owned as much as one hundred thousand acres and developed the mill towns of Pittston and Gardiner, Maine; apparently eager to assist the settlers in a town that bore his name, he lavished much attention and money on Gardiner.[3] A vestryman at King's Chapel, Boston, Sylvester Gardiner also founded Christ Church in Gardiner. He married three times, had six children, and hosted lav-

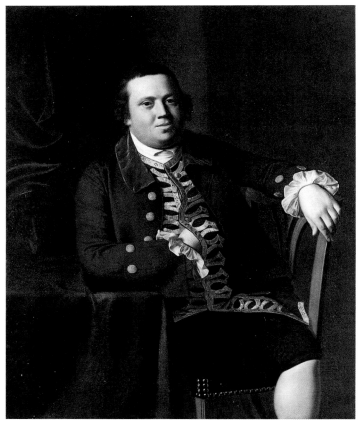

Fig. 221 *Joseph Hooper*, ca. 1770–71. Oil on canvas, 50⅛ x 40⅛ in. (127.3 x 101.9 cm). The Baltimore Museum of Art, Gift of Dr. Morton K. Blaustein, Barbara B. Hirschorn, and Elizabeth B. Roswell, in Memory of Jacob and Hilda K. Blaustein BMA 1981.75

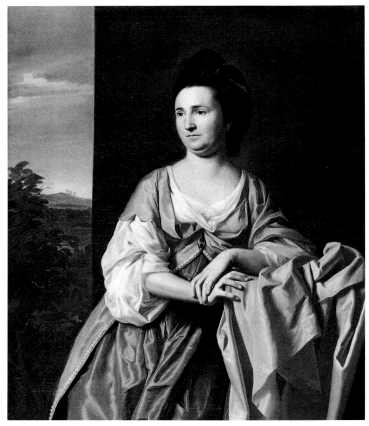

Fig. 222 *Mrs. Sylvester Gardiner (Abigail Pickman Eppes)*, ca. 1772. Oil on canvas, 50½ x 40 in. (128.3 x 101.6 cm). The Brooklyn Museum, New York, Dick S. Ramsay Fund 65.60

ish entertainments and important meetings at his principal residence in Boston; his absentee inventory of 1778 lists a total of six houses.[4]

Copley's austere portrait of Gardiner, which reveals nothing about the surgeon-businessman's interests, talents, or livelihood but conveys a keen sense of the inner man, seems an appropriate analogue to the sitter's remark that "there is nothing so dear to a man as his character."[5] A meticulously rendered likeness, it is among Copley's most dignified portraits, epitomizing the new clarity and simplicity that emerged in the work after 1770 and surpassing earlier portraits based upon the same compositional idea, such as *Joseph Sherburne* (fig. 204) and *Joseph Hooper* (fig. 221). Gardiner, like Sherburne and Hooper, sits casually on a side chair with a carved and pierced splat—perhaps a piece of furniture that Copley kept in his studio—with his legs spread apart so that one leg hangs over its side and the other hangs over the front. Each sitter leans to his right, elbow braced against a fabric-covered table, right hand inserted in his waistcoat, left arm draped over the top rail of the chair, so as to expose the ornamental splat. But in Gardiner's portrait there is no source of embellishment other than the bit of decoration on the chair: Copley eliminated from it not only the drapery that hangs in the background of the related pictures but also the figures in the fabrics shown in them; not even Gardiner's stockings or the legs of his chair are included. His suit

is warm reddish brown, virtually the same color as the chair, and his white shirt has a plain stock and narrow ruffled cuffs. Matching gold buttons, large on his coat, small on his waistcoat, add a touch of brilliance to the otherwise limited range of colors and textures, but the brightest spot in the composition is Gardiner's face; his serious yet amiable expression speaks of his steady temperament and wisdom and animates the picture.

By the time he sat for Copley in about 1772, Gardiner had known the artist for over a decade and two of his children, Ann and John, had already posed for him—in about 1756 and 1768, respectively (private collection; Westmoreland Museum of Art, Greensburg, Pennsylvania).[6] Why Gardiner had his portrait painted at this particular moment is undocumented, but the speculation is that the commission was linked to Copley's acquisition of real estate from the sitter: Gardiner owned the approximately five acres of land on Beacon Hill that Copley purchased in 1770 and 1773, and it has been suggested that the artist painted Gardiner, as well as Gardiner's second wife, Abigail Pickman Eppes (fig. 222), in partial payment for the lots and the two houses on them.[7] There is no record of what Copley owed Gardiner for the land, but Gardiner would have paid him as much as forty pounds for the two portraits—a sum that might be comparable to the cost of the lots. Copley is not known to have bartered any other commissions (although he may have exchanged Nathaniel Hurd's portrait

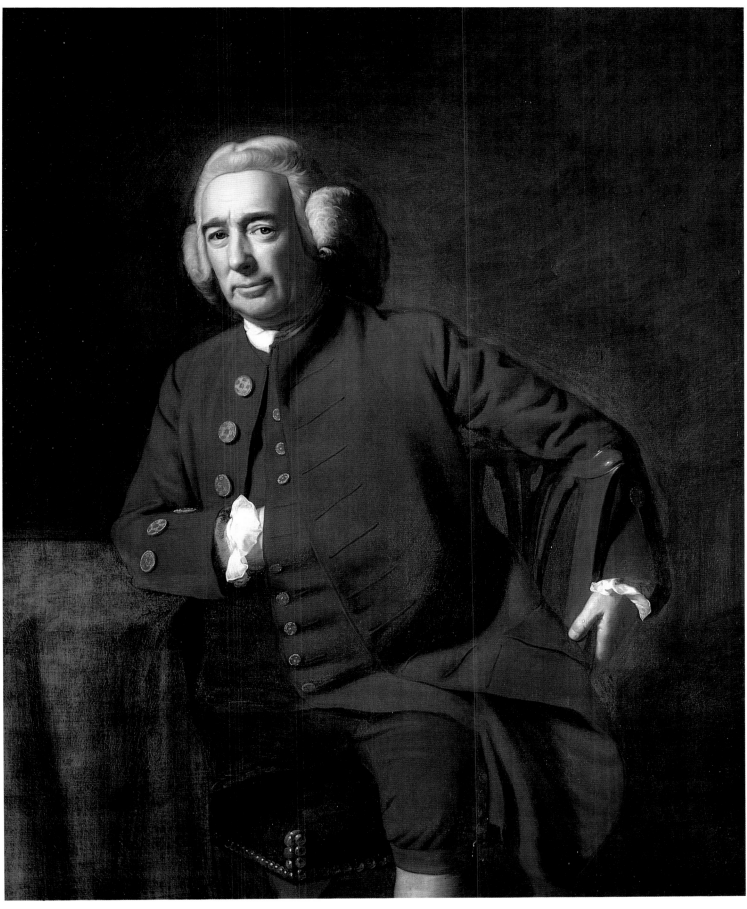

[cat. no. 21] for the sitter's services), and it is unlikely that financial circumstances would have forced him to make such a deal—for he had recently returned from a lucrative trip to New York. Yet the Beacon Hill property and the Gardiner portraits may well have been traded, given Gardiner's vocation as a dealer in land and Copley's entrepreneurial skill and ambition.

During the Revolution Gardiner fled to Halifax and then to London and lost his property, his scientific library, a fortune in timber, and his apothecary shops. This portrait and other "family pictures" were seized by the Committee of Sequistration and delivered to his daughter, Abigail Whipple, in February 1778.[8] CR

1. Obituary, *Mercury* (Newport), Aug. 14, 1786.
2. Eric H. Christianson, "The Colonial Surgeon's Rise to Prominence: Dr. Silvester Gardiner (1707–1786) and the Practice of Lithotomy in New England," *New England Historical and Genealogical Register* 136 (Apr. 1982), pp. 104–14.
3. Caroline Robinson, *The Gardiners of Narragansett* (Providence, 1919), pp. 32–34.
4. Sylvester Gardiner, Absentee inventory, Dec. 17, 1778, Suffolk County, Docket no. 16778 (Suffolk County Probate Records, vol. 77, p. 151), Archives, Supreme Judicial Court, Boston.
5. Sylvester Gardiner, letter to Samuel Hughes, Edward Payne, and Henderson Inches, Oct. 21, 1766, in *A Full Answer to the Pamphlet Intitled 'A Short Vindication of the Conduct of the Referees in the Case of Gardiner Versus Flagg &C'* (Boston, 1767), pamphlet at Brown University, Providence.
6. A portrait of Gardiner's first wife, Anne Gibbons, was assigned to Copley by Parker and Wheeler (1938, p. 79) but has since been reattributed to Joseph Blackburn.
7. See Prown 1966, vol. 1, pp. 63, 85. Theresa A. Carbone, The Brooklyn Museum, New York, has redated the portrait of Mrs. Sylvester Gardiner (Abigail Pickman Eppes) from ca. 1769 to ca. 1772, primarily on stylistic grounds.
8. Order dated Feb. 2, 1778, signed J. Warren, Massachusetts Historical Society, Boston.

76

Mrs. Richard Skinner (Dorothy Wendell)

1772
Oil on canvas, 39¾ x 30¾ in. (100.9 x 78.1 cm)
Signed and dated center right: John Singleton Copley. pinx./ 1772 /.
Boston.
Museum of Fine Arts, Boston, Bequest of Mrs. Martin Brimmer
06.2428

At the 1864 Lyndhurst sale, this elegant, half-length portrait of a woman was identified merely as "60. Portrait of a Lady." It was one of the few American portraits in the sale[1] and, along with the "Portrait of One of the Miss Copleys, in a hat,"[2] was purchased by George Henry Timmins of Boston, Copley's great-grandson. By

1873 it had come to be known as "Mrs. Spinner" and was so recorded in Augustus T. Perkins's compilation of works by Copley. By the time Timmins's sister, Mrs. Martin Brimmer, gave the painting to the Museum of Fine Arts, Boston, in 1906, the sitter's name had been amended to Mrs. Richard Skinner (née Dorothy Wendell, 1733–1822), and, on the basis of evidence both plausible and inconclusive, this identification has since been maintained.[3]

The association of this sitter with Dorothy Wendell Skinner has been based primarily upon her resemblance to the woman depicted in Nathaniel Smibert's portrait of 1755 of Dorothy Wendell (fig. 223). Furthermore, Dorothy Wendell was a first cousin of Dorothy Quincy, whose portrait Copley also painted about 1772, in a similar pose and setting (fig. 224). The gateleg table at which both the women in Copley's pictures are seated was undoubtedly a studio prop that the artist used frequently in the 1770s. In the Quincy portrait it is pushed away from the sitter to reveal her skirt, but in the Skinner picture it conceals the figure below the waist, and the reflective properties of the tabletop are given more attention. However, in both portraits such auxiliary details are subordinated to the treatment of the face and hands, a feature of Copley's work of the 1770s. The women in the two portraits are said to show a family likeness and, with their high cheekbones, slender fingers, and delicate coloring, could well be cousins. Finally, Dorothy Wendell Skinner was described as being "the proper age to be the sitter in this portrait."[4]

Yet Skinner would have been thirty-nine in 1772, when this painting was made. Born in 1733, she had been married to her stepbrother, Captain Richard Skinner of Marblehead, for sixteen

Fig. 223 Nathaniel Smibert. *Dorothy Wendell*, 1755. Oil on canvas, 29¾ x 24¾ in. (75.6 x 62.9 cm). Private collection

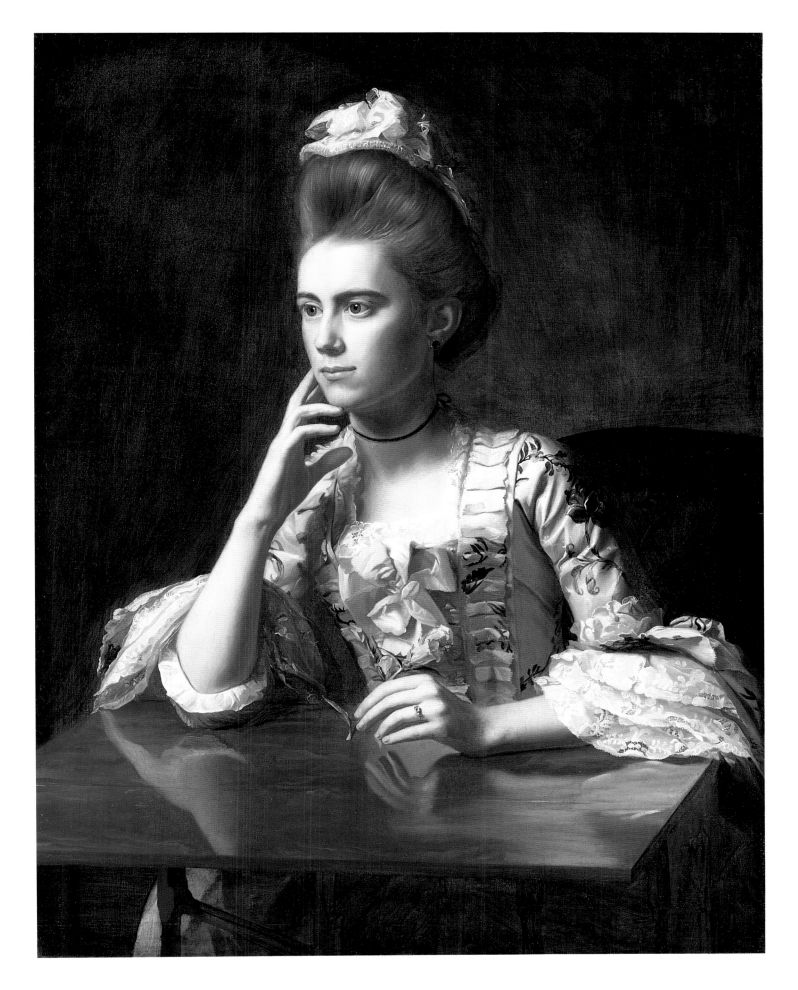

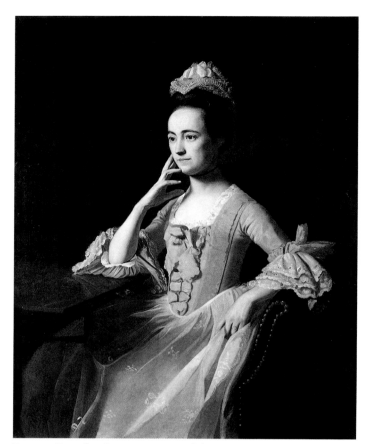

Fig. 224 *Dorothy Quincy*, ca. 1772. Oil on canvas, 50 x 39 in. (127 x 99 cm). Museum of Fine Arts, Boston, Charles H. Bailey Fund and Partial Gift of Anne B. Loring 1975.13

years and had had four children by the time she sat for her portrait. In contrast, her cousin Dorothy Quincy, fourteen years younger than she, was twenty-five when Copley depicted her. However, the two women appear to be about the same age in their likenesses. Moreover, the Smibert picture, painted when Dorothy Wendell was twenty-two and about to be married to Richard Skinner, shows the sitter with brown eyes, whereas the eyes in the Copley portrait are hazel. A sitter's age is a notoriously unreliable means of confirming the identity of the figure depicted; nonetheless, the youthful appearance of the supposedly middle-aged woman in this portrait, compared, for example, with the rather worn features of forty-one-year-old Mrs. Roger Morris (cat. no. 70), raises the question of whether she is really Mrs. Richard Skinner of Marblehead.

Although the identity of the sitter cannot be established with certainty, the quality of the portrait rarely has been questioned. Its appeal likely stems from the unusual beauty of the woman shown and from her intriguingly distant expression, which in our own era might be considered romantic, pensive, or even wistful. She is expensively dressed, in a close-fitting, formal open gown of imported Spitalfields silk.[5] Her upright posture, required by the conventions of genteel behavior as well as by the corset that would have been worn beneath such a gown, creates a sense of urgent attentiveness that is in subtle tension with her passive expression.

The portrait of Mrs. Skinner seems to have made its American debut in 1875—when it was still known as Mrs. Spinner—at Doll and Richards' Gallery in Boston. There it caught the eye of Henry James, whose admiration for the picture was tempered by what he suggested was the sitter's middle-class, prosaic nature—a view at odds with the modern perception of her aristocratic elegance. Yet he was sensitive to her seeming vulnerability and described the painting almost as though it were by Thomas Dewing or perhaps Thomas Eakins: "The lady leans her elbows on a small polished mahogany tea-stand; one hand holds a blue flower, the other, with fingers extended, supports one of her temples. . . . She is not beautiful, and one of the sources of interest of the picture is its intimation that the bloodless, nervous, attenuated type of American woman was not more exceptional among our great-grandmothers than among our wives and sisters. Copley's model in this case— her stately apparel apart—looks as if she might have stepped out of a Boston street-car."[6]

Skinner's detachment—what James saw as her bloodlessness— although rare in Copley's portraits of women, is not unique. Mrs. Adam Babcock (who may have been Copley's last sitter in America) has such a look in her likeness, 1774 (National Gallery of Art, Washington, D.C.), and in that portrait, as in Mrs. Skinner's, the delicate arrangement of the sitter's hands perhaps conveys more of a sense of her character than does her expression. Indeed, Mrs. Skinner's femininity is advertised both by her exceptional beauty and by her hands, one of which rests softly on her cheek while the other holds a sprig of Canterbury bells. Unlike earlier portraits, in which Copley used the polished surfaces of mahogany tables to mirror all manner of things in brilliant detail, here, all reflections are blurred except for the sensuous echo of the sitter's long, graceful fingers. CT

1. *Catalogue of the Very Valuable Collection of Pictures of the Rt. Hon. Lord Lyndhurst . . .* (sale cat., London: Christie, Manson, and Woods, Mar. 5, 1864), lot 60. It is not clear whether the family that commissioned the "Portrait of a Lady" was displeased with the picture and did not accept it (and there is little evidence that Copley's work was ever rejected during his American career), or whether the painting pleased Copley so much that he retained or reclaimed it, taking it across the ocean with him. In any case, it appeared at the Lyndhurst sale; the only other American picture at that sale (lot 85) that can be identified is of a Copley family member, namely *Boy with a Squirrel (Henry Pelham)* (cat. no. 25).

2. Ibid., lot 74; *Mrs. Charles Startin* (private collection), a portrait of Copley's sister-in-law. This picture was painted in London in 1783.

3. See Perkins 1873, p. 109. The donor of the painting had no doubt that it represented Mrs. Skinner. In a letter of July 10, 1891, to General Augustus Loring, Director of the Museum of Fine Arts, Mrs. Brimmer affirmed that "the portrait by Copley is of Mrs. Skinner" (Archives, Museum of Fine Arts, Boston).

4. Parker and Wheeler 1938, p. 182.

5. Aileen Ribeiro, *A Visual History of Costume: The Eighteenth Century* (London, 1983), p. 97. See also Ribeiro's comments on Mrs. Skinner's apparel in "'The Whole Art of Dress': Costume in the Work of John Singleton Copley," in this publication.

6. Henry James, [Portrait of Mrs. Skinner at Doll and Richards' Gallery] *Nation* 21 (Sept. 9, 1875), p. 166.

Samuel Cary

ca. 1773
Watercolor on ivory, 1½ x 1¼ in. (3.8 x 3.2 cm)
Private collection

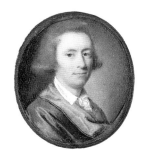

Mrs. Samuel Cary (Sarah Gray)

ca. 1773
Watercolor on ivory, 1⅜ x 1¼ in. (3.5 x 3.2 cm)
Signed lower right: ISC [monogram]
Private collection

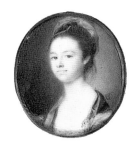

Samuel Cary (1742–1812), the oldest son of Samuel and Margaret Cary and the brother of Thomas Cary, grew up on his parents' Chelsea, Massachusetts, estate, the Retreat. His father was a ship's captain, a ship owner, and a distiller, with a thriving business in the West Indies. As a young man, at odds with his often absent but nevertheless domineering father, Samuel sought to develop his own interests. With one thousand pounds inherited from his mother in 1762, Samuel moved to Saint Kitts on the island of Grenada, where he became a prosperous merchant and sugar planter.[1]

Sarah (Sally) Gray (1735–1825), the daughter of the Reverend Ellis Gray of Boston, was seven years older than Samuel. They met at a ball in late 1770, in the course of Samuel's first visit to Boston in over five years, and soon thereafter were engaged. Samuel went back to Saint Kitts but often sent letters and such elaborate gifts as an English harpsichord to his betrothed. They were married on November 2, 1772, a month after Samuel had returned to Boston. The following August Samuel again sailed for Grenada, leaving Sally with her mother in Boston, awaiting the birth of their first child. Sally joined her husband in the West Indies in the winter of 1773–74. The couple lived there until 1791, when they settled in Chelsea permanently and considerably enlarged the family house and grounds. Cary's West Indian estates were destroyed in an uprising of 1795; he lost his fortune and turned to farming in Chelsea. Sally bore thirteen children and outlived her husband by thirteen years.[2]

For the Carys Copley painted miniature likenesses of great elegance and sophistication. By the time he made them, he had perfected his handling of watercolor and was able to apply to his ivory a subtle array of colors in thin, translucent layers, allowing the milky glow of the support to show through the veils of paint. Using a combination of stippling and longer, more fluid strokes, Copley captured a wealth of detail in these tiny portraits. Both sitters are stylishly garbed: Samuel wears a blue morning gown with a gray lining over a red vest and white shirt, and Sally is dressed in modified Turkish attire, her hair bound with pearls and a length of mauve silk that winds around her head, along her neck, and over her shoulder.

Copley's portraits of the Carys are among his finest paintings and the only surviving pair of his ivory miniatures. *Samuel Cary*, set in a woman's bracelet, and *Mrs. Samuel Cary*, mounted in a locket, were likely made in 1773, just after the Carys' marriage, and were conceived as tokens of affection and intimate keepsakes. They no doubt provided consolation to the newlyweds during the long separation they endured soon after their wedding.[3]

E E H

1. Clifford K. Shipton, *Sibley's Harvard Graduates*, (Boston, 1956), vol. 9, p. 32.
2. The mansion still stands near Parker Street in Chelsea. Gilbert Stuart painted Sally's portrait in Boston in 1819 (private collection). For further information on the Carys, see *The Cary Letters*, Caroline Gardiner Curtis, ed. (Cambridge, Mass., 1891); Mellen Chamberlain, *A Documentary History of Chelsea* (Boston, 1908), pp. 309–14, 370–71; and Mary Caroline Crawford, *Famous Families of Massachusetts* (Boston, 1930), p. 213.
3. Jules Prown dated these miniatures to 1769, before the Carys' marriage, based upon the stylistic similarity between these portraits and Copley's own miniature self-portrait of 1769 (cat. no. 49) (Prown, 1966, vol. 1, pp. 68, 211–12). However, Samuel Cary was not in Boston in 1769. He returned to the city from the West Indies in early July 1770 to help settle his father's estate; his brother Thomas noted in his diary that Samuel had arrived "after an Absence of five years and six months." Samuel left Boston again in December 1770 (soon after meeting Sarah Gray) and came back in October 1772. In January 1773 Thomas Cary dined several times with his brother and once with Copley; Thomas's own portrait was painted by Copley that year (Thomas Cary's Diaries, New England Historic Genealogical Society, Boston). I am grateful to Janet Comey for her help with the Cary family history.

Mrs. John Winthrop (Hannah Fayerweather)

1773
Oil on canvas, 35½ x 28¾ in. (90.2 x 73 cm)
The Metropolitan Museum of Art, New York, Morris K. Jesup Fund,
1931 31.109

Copley depicted Mrs. Winthrop seated at a round tilt-top table. She wears a blue satin dress trimmed generously in lace. Her house cap and dress are adorned with candy-striped ribbons. Six strands of pearls circle her neck tightly. The most important objects in the picture, however, seem to be the nectarine branch she holds in her left hand and a piece of the fruit in her right—a passage that recalls a similar motif in Copley's portrait of Mrs. Samuel Waldo (private collection).

The nectarine was a rare fruit in eighteenth-century America. It was difficult to grow on its own. Typically, nectarine stock was imported from England and had to be grafted onto peach or plum trees in order to survive. Recently improved varieties were available in Boston through George Spriggs, gardener to John Hancock. There is evidence suggesting that the Winthrops may have grown nectarines at their home, for it is known that they kept a fruit orchard.[1] And it is documented that Mrs. Winthrop's stepson, James Winthrop, cultivated them, keeping precise horticultural records of the blooming and fruiting of the trees in his orchards in Cambridge and Lexington.[2]

Whether Mrs. Winthrop did her own gardening is unknown. But her pride in the fruits with which she is shown is visible. In the picture they take center stage. Copley not only had her solicit the viewer's attention by holding up a single fruit in her right hand as if it were a gem; he also carefully framed the sprig in her left, its tip touching the table, within a parenthesis formed by her hands and their reflection.

The vivid focus upon the fruit suggests that it bears an analogical relationship to Mrs. Winthrop. In John Locke's educational theories, one's moral self was thought to be a tabula rasa awaiting inscription by life's education. One way women in particular were guided along a moral path was by gardening. Here, seemingly in accordance with Locke's theory, Mrs. Winthrop poises the sprig like a writing instrument on the surface of the empty table in an allusion to her own life as an act of self-creation.

Hannah Winthrop (1727–1790), daughter of Thomas and Hannah Waldo Fayerweather, was married twice, in 1745 to Farr Tolman and in 1756 to John Winthrop, Hollis Professor of Mathematics and Natural Philosophy at Harvard College. She and Winthrop lived in Cambridge. Copley painted Mr. Winthrop (fig. 225) and Mrs. Winthrop at about the same time, but the pictures must not have been pendants because they are different sizes.[3] On June 24, 1773, Copley recorded that he "Received of the Honble John Winthrop, Esq. the sum of ten Guineas in full for his Lady's portrait."[4] Mrs. Winthrop was then beginning to express

her Whig politics to her friend and correspondent Mercy Otis Warren. A few months before she sat for Copley, she told Mrs. Warren that the choices for America were stark: either "acquiesce in the bonds of slavery, or repurchase our freedom at the costly expence of the best blood of the land."[5] In subsequent letters she expressed her contempt for the merchants (among them Copley's in-laws) who were shipping taxable tea to Boston in late 1773, told of her harrowing flight from Boston during the invasion of 1775, and imagined her nation's deliverance from the "pestiferous barbarions" of George III.[6]

PS

1. Clifford K. Shipton, *Sibley's Harvard Graduates*, vol. 9 (Boston, 1956), p. 246.
2. Ann Leighton, *American Gardens in the Eighteenth Century: "For Use or For Delight"* (Boston, 1986), p. 235.
3. Recent examination reveals that Mrs. Winthrop's portrait was not cut down from a larger canvas; see John Caldwell and Oswaldo Rodriguez

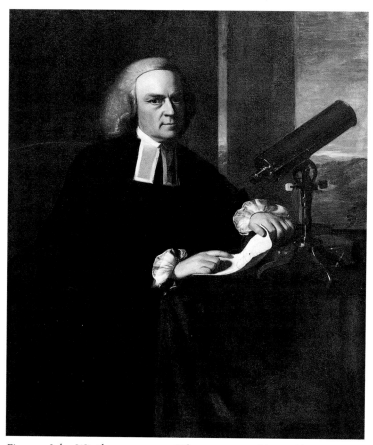

Fig. 225 *John Winthrop*, ca. 1773. Oil on canvas, 50¼ x 40¼ in. (127.6 x 102.2 cm). Harvard University Portrait Collection, Cambridge, Massachusetts, Gift of the Estate of John Winthrop, his grandson, 1894

Roque, *American Paintings in the Metropolitan Museum of Art*, vol. 1, *A Catalogue of Works by Artists Born by 1815* (New York, 1994), p. 97.

4. Parker and Wheeler 1938, p. 211. The note is in the collection of Ars Libri, Ltd., Boston.

5. Hannah Fayerweather Winthrop, letter to Mercy Otis Warren, Feb. 1773, Warren-Winthrop Papers, Massachusetts Historical Society, Boston.

6. Hannah Fayerweather Winthrop, letter to Mercy Otis Warren, Apr. 2, 1776, Warren-Winthrop Papers, Massachusetts Historical Society, Boston.

80

Mr. and Mrs. Thomas Mifflin (Sarah Morris)

1773
Oil on ticking, 60½ x 48 in. (153.7 x 121.9 cm)
Signed and dated upper right: J. Singleton Copley. Pinx. 1773. Boston.
Historical Society of Pennsylvania, Philadelphia 1900.2

When Copley painted this picture, Thomas Mifflin (1744–1800) was already well known in Philadelphia politics as a member of the colonial legislature and a colleague of Benjamin Franklin's. A radical Whig, he would become a delegate to the Continental Congress of 1774 and aide-de-camp to General George Washington after 1775. After the Revolution he would continue to hold prominent public positions, including delegate to the Constitutional Convention, president of Congress, and first governor of Pennsylvania.

His Quaker family was among the city's elite. His father was a wealthy merchant who was in the habit of having artists paint family portraits. Young Thomas, for example, was first portrayed as an adolescent by Benjamin West (fig. 226).[1] After Copley completed this picture, Mifflin had himself painted by Charles Willson Peale, 1795 (Independence National Historical Park, Philadelphia); by Gilbert Stuart, ca. 1800 (private collection); and twice by John Trumbull, ca. 1790 and 1790 (fig. 227; Yale University Art Gallery, New Haven).

Less is known about Sarah Morris Mifflin (1747?–1790). She was the daughter of Susanna and Morris Morris and married Thomas at Fairhill Meeting House in Philadelphia on March 4, 1767. John Adams once remarked that she was "a charming Quaker Girl."[2]

Copley painted the Mifflins during a visit they made to Boston in the summer of 1773. Their trip north was provoked by a death in the family and was marked by Thomas's meetings with Samuel Adams to discuss revolutionary insurgency.[3] The portrait's large size and intricate two-figured composition must have challenged Copley, for friends of the Mifflins' in Boston commented that "our friends Thomas and Sally have made a much longer stay with us, than they at first thought to do. Copley has been the happy means of their detention."[4] The lengthy painting process seems to have been an ordeal for the couple, according to the artist Rembrandt Peale. Recollecting in 1855 a conversation he had with

Fig. 226 Benjamin West, *Thomas Mifflin*, ca. 1758–59. Oil on canvas, 51½ x 38½ in. (130.8 x 97.8 cm). Historical Society of Pennsylvania, Philadelphia 1910.6

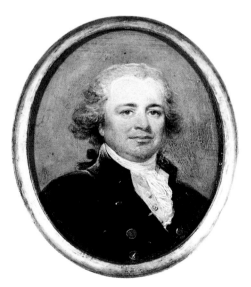

Fig. 227 John Trumbull. *Thomas Mifflin*, ca. 1790. Oil on mahogany, 4 x 3 in. (10.2 x 7.6 cm). The Metropolitan Museum of Art, New York, Gift of J. William Middendorf II, 1968 68.222.15

Mrs. Mifflin many years before, Peale wrote that Copley asked her to sit twenty times for the hands alone.[5]

The completed picture is unusually complex among Copley's American works. He depicted the Mifflins seated on adjacent sides of a gateleg table. She is working a handloom, weaving fringe, or trim, of the sort used for upholstery, hems, and cuffs. Five inches of the fringe hang below her left hand, which is pulling the yarn taut from the loom, as her right hand moves the beater that packs the weft threads. A teal-colored ribbon anchors the loom to an unseen object, allowing her to pull the fringe without dragging the machine across the table surface. Though she is actively weaving, Mrs. Mifflin is distracted, averting her head toward the picture plane and interrogating the viewer with piercing eyes. Copley emphasized the thinness of her face and body with shadows that pick up the hollow of her cheek and strong light that slims her forearm. Her slenderness was remarked upon by Abigail Adams, who in 1775 referred to her as "affable and agreable" but also "delicate." Mrs. Adams connected her physique to lack of children and noted: "I beleive Phyladelphia is an unfertile soil, or it would not produce so many unfruitfull women. I always conceive of these persons as wanting one addition to their happiness."[6]

Thomas Mifflin sits sideways on a Boston Chippendale-style chair, the back of which supports his crossed arms and divides the space between husband and wife. He has a slim book in his right hand and holds his place in it with his index finger. He too seems to have been distracted, but his attention has been caught by his spouse, whom he is admiring. His appearance in the picture accords with Abigail Adams's appreciation of him as a man of "easy address, politeness, complasance &c."[7]

Though Sarah makes decoration, there is little decoration in this picture. The only major ornament on her dress is a corsage. Thomas eschews a wig and wears a wool frock coat, and neither one flaunts loud colors or shows lace on the sleeve or cuff. Silhouetted sharply against a narrow and tall plain dark background that gives the picture a Neoclassical austerity, their bodies and gestures are converted into a statuesque tableau of a relationship. The hands, hovering over one another, cinch the composition—and the relationship—together. This relationship is unusual for a colonial double portrait, painted in an era in which marriage was often an economic arrangement, for it is Mrs. Mifflin who dominates the picture, while her husband is cast in the role of admirer. Together they form a strict architecture of vertical bodies and horizontal arms, all of which converge, along with Mr. Mifflin's eyes, on Sarah. John W. McCoubrey eloquently described the form of this relationship:

The two figures, though apparently casual in their pose, are of equal height, seated in a simple one-to-one relationship. An awkward heap of hands and book which the husband heedlessly points at his wife's throat, separate them. They have no place to sit; the husband seems to emerge suddenly from nothing, behind the table. They are drawn together in this strange union by a tall space, of the sort usually calculated to impress people: a space they neither use nor need. They bear no more relation to it than Mrs. Mifflin's small loom bears to the column in the background. Yet, as they sit low in this space, drawn toward its center, they gain a deeper relationship which transcends their graceless confrontation.[8]

The portrait was admired in its day. One Bostonian viewing the recently completed painting on August 24, 1773, declared that "this Town will have the Honour of furnishing Phila with one of the best Pictures it has to boast."[9] And Henry Pelham, visiting the Mifflins in Philadelphia in 1775, made a point of reminding his half brother, Copley, how much he admired the picture.[10] Evidently, it was and continued to be a milestone for Copley himself, for when he studied the work of Raphael in Rome in 1775 he observed that the Italian master "has painted with the same attention that I painted Mr. Mifflin's portrait and his Lady's. In that determined manner he has painted all the heads, hands, feet, draperies and background with a plain simple body of colours and great precision in his outline, all parts of it from nature."[11]

The making of fringe and embroiding at home, which were common activities for women in the eighteenth century, became politically charged in the years just before the Revolution.[12] In the wake of the Townshend Acts of 1767, radical Whigs protested English duties by boycotting English goods and, at the same time, encouraging American manufactures. American women, who were closed out of the public sphere, could nonetheless engage in political protest and the quest for cultural sovereignty by producing the kinds of handmade textiles that previously had been imported. Mercy Otis Warren of Boston, another of Copley's sitters, declared the new ethic of self-sufficiency: "We must at first indeed Sacrifice some of our Appetites. . . . Silks and Velvets and Lace must be dispensed with—But these are Trifles in a Contest for Liberty."[13] In such an environment, Mrs. Mifflin's homemade fringe, as well as the absence of lace on her and her husband's sleeves and collars, might be viewed as a political sign. Certainly her fringe making, which Copley placed in the foreground of the picture, would have been consistent with the radical politics of her husband, who seems to rise bodily out of the loom. Thomas Mifflin was a leader in the momentous nonimportation movement in Philadelphia, and in the summer of 1773, while he and Sarah were in Boston, he would have seen public reaction to the Tea Act and have prepared his own political position. This position he effected upon his return to Philadelphia, where he helped organize mass protests that led to the convening of the Continental Congress of 1774.[14]

PS

1. There is no modern biography of Mifflin. See James H. Peeling, "Mifflin, Thomas," in *Dictionary of American Biography*, ed. Dumas Malone, vol. 12 (New York, 1933), pp. 606–8; and Kenneth R. Rossman, *Thomas Mifflin and the Politics of the American Revolution* (Chapel Hill, 1952).

2. John Adams, letter to Abigail Adams, Oct. 7, 1774, in *Adams Family Correspondence*, ed. Lyman H. Butterfield (Cambridge, Mass., 1963), vol. 1, p. 166.

3. Rossman, *Thomas Mifflin*, p. 13.

4. S. Eliot, letter to William Barrell, Aug. 24, 1773, Miscellaneous Collections, Historical Society of Pennsylvania, Philadelphia.

5. Rembrandt Peale, "Reminiscences," *Crayon* 1 (May 9, 1855), p. 290.

6. Abigail Adams, letter to John Adams, Dec. 10, 1775, in *Adams Correspondence*, vol. 1, p. 336.

7. Abigail Adams, letter to John Adams, July 31, 1775, in *Adams Correspondence*, vol. 1, p. 271.

8. John W. McCoubrey, *American Tradition in Painting* (New York, 1963), pp. 17–18.

9. S. Eliot, letter to William Barrell, Aug. 24, 1773, Miscellaneous Collections, Historical Society of Pennsylvania, Philadelphia.

10. Henry Pelham, letter to Copley, Feb. 16, 1775, in Jones 1914, p. 293.

11. Copley, letter to Henry Pelham, Mar. 14, 1775, in Jones 1914, p. 301.

12. Edward S. Cooke Jr. et al., *Upholstery in America and Europe from the Seventeenth Century to World War I* (New York, 1987), p. 142.

13. Quoted in Alice Brown, *Mercy Warren* (New York, 1896), p. 51.

14. Lois Dinnerstein discusses the political dimension of weaving in "The Industrious Housewife: Some Images of Labor in American Art," *Arts Magazine* 55 (Apr. 1981), pp. 109–11. For Mifflin's role in the Philadelphia nonimportation movement, see Charles S. Olton, *Artisans for Independence: Philadelphia Mechanics and the American Revolution* (Syracuse, 1975).

81

Mr. and Mrs. Isaac Winslow (Jemima Debuke)

1773

Oil on canvas, 40½ x 48¾ in. (102.2 x 123.8 cm)

Museum of Fine Arts, Boston, Gift of Mr. and Mrs. Maxim Karolik for the M. and M. Karolik Collection of Eighteenth Century American Arts

39.250

Isaac Winslow (1709–1777) was an insatiable collector of his own likeness. An immensely prosperous man, he came from a family accustomed to the trappings of wealth and dedicated to the accumulation of portraits: other images were produced in London of previous generations of Winslows; his father, the goldsmith Edward Winslow, was painted by John Smibert; and his older brother Joshua was portrayed once by Smibert and twice by Joseph Blackburn.[1] Isaac himself early exhibited a predilection for luxury: a member of the Harvard class of 1727, he is described as "a normal college boy with either a large appetite or a taste for delicacies not found on the college menu. His first term bill was paid with two silver spoons and his second, with a necklace of gold beads."[2] After college he worked in the counting house of James Bowdoin, scion of another family intent on preserving likenesses of every generation of the family.

As a grown man Isaac Winslow ordered as many as five portraits of himself and his family, painted in turn by the man who was the leading artist in Boston at the time of each commission. The first of these was a likeness executed by Robert Feke shortly after Winslow's marriage, in December 1747, to Lucy Waldo of Boston (fig. 228); she also was depicted by Feke, probably at the same time.[3] The Winslows had resided in Boston and then in Milton, but in about 1756 a large inheritance enabled them to retire to Roxbury, where they acquired the Dudley Mansion. They documented their position as the most prominent family in Roxbury with another portrait, this one by Blackburn (fig. 229). Blackburn, just come to town, portrayed Winslow (with Lucy and their two children) affecting the languid, easy pose of a British aristocrat, in a formula derived from the latest London portraiture.[4]

Lucy Waldo Winslow died in 1768. Two years later Winslow married Jemima Debuke (1732–1790), daughter of Thomas and Jemima Reed Debuke of Boston; Winslow was twenty-three years her senior. In 1774, in keeping with his custom of documenting with portraits each significant change in family status, Winslow hired Copley to depict himself and his new wife in an intimate double portrait.[5]

The portrait is notable for its aura of geniality, domestic contentment, and calm; however, it commemorates a comfortable existence that was soon to end, for the months following the painting's completion were turbulent and painful for Isaac Winslow and his family. Like so many people of his station, Winslow had seen his pleasant way of life severely threatened by the events of the early 1770s. Winslow was a Loyalist, but without firmly held convictions, and for many years he resisted political office. However, the Boston Tea Party goaded him into taking a stand, for his nephew Joshua and his uncle, Richard Clarke, were among the consignees of the tea; in August of 1774 Winslow accepted an appointment to the Mandamus Council. However, his councillorship proved to be a mistake. Winslow's decade of philanthropy and his liberal views[6] were quickly forgotten by his Roxbury neighbors, who now derided him as "Farmer" Winslow.[7] Public pressure forced him to resign his seat on the council and to publish an apology in the *Massachusetts Gazette* in September 1774. For the next seven months he lived relatively undisturbed in Roxbury, a peaceful interlude that unfortunately was short lived. In the wake of the events of April 19, 1775, the Winslows were forced to flee Roxbury for Boston, and in July their mansion was burned to the ground. Finally, in March of 1776, after making a characteristically generous contribution to a fund for the distressed people of Boston, Winslow, his wife, and their family left with the British army for Halifax.

Little is known about Jemima Debuke or what she brought to the marriage in terms of property or social status, but in the painting of the Winslows, Copley showed his two sitters in a more nearly equal relationship than was customary in earlier American husband-and-wife portraits. Although Winslow is clearly depicted as the dominant partner—he is placed beside the table while she is

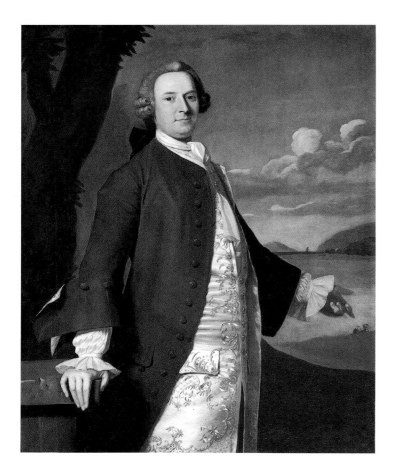

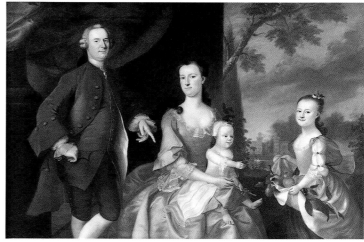

Fig. 228 Robert Feke. *Isaac Winslow*, ca. 1748. Oil on canvas, 50 x 40 in. (127 x 101.6 cm). Museum of Fine Arts, Boston, Gift in memory of the sitter's granddaughter (Mary Russell Winslow Bradford, 1793–1899), by her great-grandson, Russell Wiles 42.424

Fig. 229 Joseph Blackburn, *Isaac Winslow and His Family*, 1755. Oil on canvas, 54½ x 79½ in. (138.4 x 201.9 cm). The Museum of Fine Arts, Boston, Abraham Shuman Fund 42.684

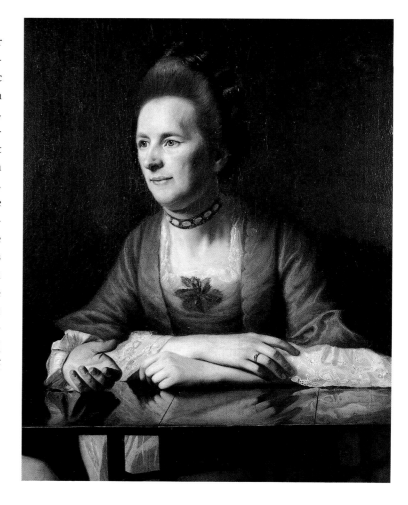

behind it, and the direction of their gazes and the nature of their gestures mark him as the more public member of the family—they are both seated, and their heads are on the same plane. Isaac Winslow looks toward the viewer; his open hand reaches out in a welcoming gesture. Jemima Winslow is somewhat deferential, gazing toward her husband with a fond, vaguely meditative expression. Her arms are crossed on the table. The Winslows do not touch, yet she leans toward him and her left hand and its reflection are very near his; the position of her hand echoes that of his, which is extended toward her, a harmonious parallelism of gesture that suggests intimacy. Their characterization as partners (in contrast to the hierarchy among family members immortalized in the Blackburn portrait of the Winslows) and the mood of tenderness reflect an increase in publicly expressed affection that has been documented in New England family life in the second half of the eighteenth century. Like Copley's *Mr. and Mrs. Thomas Mifflin* of 1773 (cat. no. 80), the Winslow painting also foreshadows a new fashion in husband-and-wife portraiture, in which man and woman would be shown as near equals and in which gestures of affection would be displayed clearly.[8]

Fig. 230 Detail (before treatment), *Mr. and Mrs. Isaac Winslow* (*Jemima Debuke*)

322

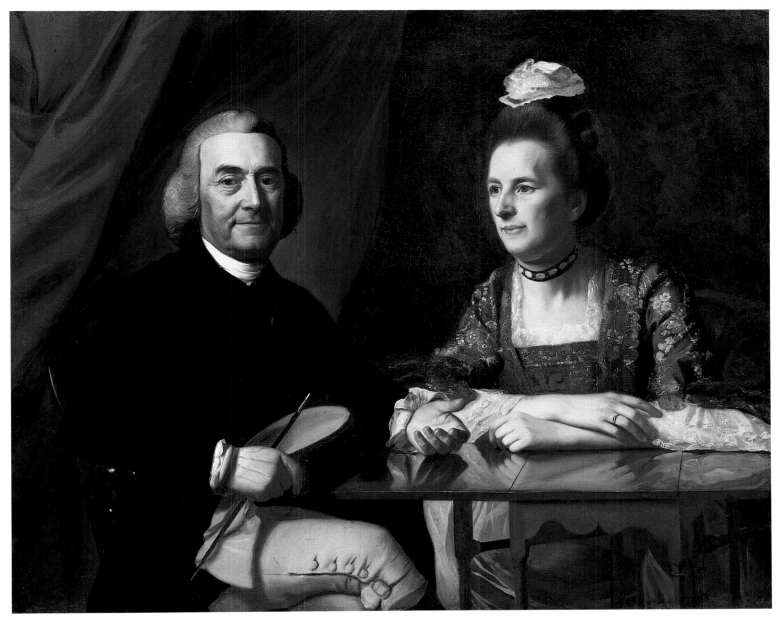

81

The innovations in pose and mood in the Winslow picture are matched by innovations in Isaac Winslow's rather unconventional attire. He is shown in riding costume: a blue frock coat, tight, butter-colored leather breeches, buckled just below the knee, and riding boots, just the top of which can be seen on his right leg. His right hand is gloved in elegant yellow kidskin and he holds a short riding crop and a soft, round hat with a brim on one side, probably a jockey cap. The custom of painting sitters in riding habit had become fashionable in England by the 1760s,[9] but Copley himself had used such a costume only once before, for a sitter shown out of doors (cat. no. 17). It is an odd artistic contrivance to present a subject in full riding gear, including jockey boots, seated indoors with his rather formally dressed wife at a delicate table, with a swag of drapery behind him, but it must have suited a man who already possessed two grand images of himself.[10]

By 1773 Winslow seems to have wanted to be shown as the man he had enjoyed being for the last ten years: a lover of country life, for whom riding was one of many outdoor pleasures. While the green Windsor chair and the somewhat old-fashioned gateleg table with which he is pictured occur in a number of Copley's portraits of the 1770s and were no doubt studio props, here they serve Winslow as attributes of ease. Without renouncing a bit of stylishness, Winslow appears quite natural, as though he were seated not among his best things but among the familiar, worn, and comfortable accessories of his household.

Mrs. Winslow wears an elegant gown of fine brocaded silk (a very expensive fabric, imported from England, whose floral pattern was actually slightly old-fashioned by the 1770s), with sleeve ruffles of broderie anglaise and a moonstone necklace at her throat. An extremely feminine lace cap floats on top of her towering hairdo, which was considered quite stylish in the 1770s. As Aileen Ribeiro notes, there is a disjunction in the degree of formality in Mr. and Mrs. Winslow's dress that their contemporaries might have found somewhat jarring, which may account for the subsequent fate of the painting.[11]

The Winslows managed to keep this portrait with them, despite extreme duress, when they fled from Boston to Halifax and then to New York (where Isaac Winslow died in 1777), and Mrs. Winslow was able to take it with her when she moved on to London. She is believed to have settled there by 1780, and not long after her arrival, she appears to have hired a painter other than Copley—even though he was in residence in London by then—to restore and rework the portrait, repairing the damage it had suffered since Mrs. Winslow's departure from Boston, and changing her floral silk to a simple gray-green dress, and her cap of lace, gauze, and ribbon to a more restrained braid (fig. 230). These alterations were more in accord with emerging Neoclassical taste and, especially to Londoners' eyes, might have seemed more in harmony with Winslow's rather soberly colored attire.[12] Yet it is possible that the Winslows' costumes even as they originally were painted (and, after removal of the later dress, as they are again) were not so discordant as they seem to modern viewers. By the 1780s jockey

boots were commonly worn indoors as well as out, and frock coats, which were initially designed as hunting garments, were accepted everywhere but in the most formal settings.[13] By wearing riding costume in the drawing room, Winslow once again showed himself to be at the vanguard of fashion.

C T

1. For a full listing of the Winslow family portraits, see *The Winslows: Pilgrims, Patrons, and Portraits* (exh. cat., Brunswick, Maine: Bowdoin College Museum of Art, 1974), pp. 15–20.
2. Clifford K. Shipton, *Sibley's Harvard Graduates*, vol. 8 (Boston, 1958), p. 333.
3. Robert Feke, *Lucy Waldo Winslow*, 1748 (The Brooklyn Museum, New York).
4. A portrait of about 1760, believed to be of Mrs. Winslow and daughter Hannah, attributed to Blackburn, is in the Bayou Bend Collection, Museum of Fine Arts, Houston.
5. Although the bill for this portrait is dated February 11, 1774, a much abraded signature and date recently discovered at the center right edge of the canvas appears to read 1773.
6. Winslow was a generous contributor to a number of public causes. He was a member of the progressive Sandemanian Congregation but also supported denominations other than his own.
7. Shipton, *Sibley's Harvard Graduates*, p. 337.
8. According to Margaretta Lovell, the few surviving husband-and-wife portraits made in America in the first half of the eighteenth century follow the British convention of showing the husband standing and the wife seated beside him to dramatize his dominance. By about 1760 the fashion began to change in England, and husbands as well as wives were posed seated; Copley's *Mr. and Mrs. Thomas Mifflin* and *Mr. and Mrs. Isaac Winslow* are among the first portraits painted in America that show both husband and wife seated. By the mid-1770s expressions of affection were a common feature of such pictures (Margaretta M. Lovell, "Reading Eighteenth-Century American Family Portraits: Social Images and Self-Images," *Winterthur Portfolio* 22 [Winter 1987], pp. 247–51). See also Gordon S. Wood, *The Radicalism of the American Revolution* (New York, 1992), p. 148.
9. See, for example, Joseph Wright of Derby's Markeaton group of portraits from the early 1760s (Judy Egerton, *Wright of Derby* [exh. cat., London: Tate Gallery, 1990], nos. 5–8).
10. In his portrait of 1748 Winslow had been shown in a velvet coat and an elaborately embroidered vest that represented the height of fashion of that era, gesturing in a proprietary manner toward a vast wilderness (his pose, after all, was derived from the Apollo Belvedere). In 1755 he had Blackburn render him as an aristocratic squire, the master of an extensive estate, and the head of a handsome family. There he wears a rich red-brown velvet suit, again quite a stylish costume at the time the portrait was completed.
11. See Aileen Ribeiro, "'The Whole Art of Dress': Costume in the Work of John Singleton Copley," in this publication.
12. See ibid. Numerous publications from 1969 and earlier show this painting prior to the removal of the green Neoclassical-style dress. This later dress was removed, and the original costume restored, at the Museum of Fine Arts, Boston, in 1975.
13. Aileen Ribeiro, costume notes for *A Gentleman with a Gun and Two Dogs*, in Elizabeth Mankin Kornhauser, *Ralph Earl: The Face of the Young Republic* (exh. cat., Hartford: Wadsworth Atheneum, 1991), p. 127.

Chronology

1738

Born July 3 in Boston, first and only child of Richard, a tobacconist, and Mary Singleton Copley, Irish immigrants to America in 1735.

mid-1740s

Father dies.

1748

Mother marries Peter Pelham, artist, engraver, and schoolmaster. Family moves from Long Wharf to Lindel's Row. Except for exposure to artistic techniques through Pelham, Copley would remain largely self-taught.

1749

Half brother, Henry Pelham, born.

1751

Stepfather dies.

1753

Produces first works, a mezzotint and three portraits (cat. no. 1; see figs. 65, 153).

1754

Paints first historical pictures (fig. 157; cat. nos. 3, 4), all derived from mezzotints.

1755

Produces first oil-on-copper miniature portraits (see fig. 97); he would begin to execute miniatures in watercolor on ivory in the early to mid-1760s (see fig. 102).

1756

Makes book of anatomical drawings (cat. no. 6) copied from European anatomy books. Begins to paint portraits in earnest, executing six three-quarter-length likenesses (see cat. no. 7).

1758

Makes first pastel portraits (see figs. 104, 105).

1762

Writes to Swiss pastelist Jean-Étienne Liotard, initiating contact with prominent European artists.

1763

Maintains studio near Orange Tree Tavern at Hanover and Court Streets.

1764

Paints first full-length portrait, *Nathaniel Sparhawk* (cat. no. 19). Moves studio to Cambridge Street.

1765

By February has a studio full of portrait commissions. Sends *Boy with a Squirrel (Henry Pelham)* (cat. no. 25) to exhibition at Society of Artists of Great Britain, London.

1766

Boy with a Squirrel garners praise from Sir Joshua Reynolds and Benjamin West, American artist resident in London, who begin to advise Copley and urge him to study in Europe. Elected fellow of Society of Artists. Paints full-length commemorative pendant portraits of Thomas Hancock and Thomas Hollis (figs. 1, 2) for Harvard College.

1767

Produces six portraits for prominent Boylston family (figs. 52, 186, 187; cat. nos. 30, 31, 33). Estimates annual income at about three hundred guineas, a handsome amount.

1768

Paints New York residents Thomas Gage, commander in chief of British forces in North America, and the Reverend Myles Cooper, president of King's College (cat. nos. 66, 47); these commissions begin to establish his reputation in New York.

1769

Marries Susanna (Sukey) Clarke, daughter of Richard Clarke, Tory merchant and principal agent for British East India Company, and Elizabeth Winslow. Acquires property on Beacon Hill. Executes self-portrait in pastel and in miniature, casting himself as an elegant, leisured gentleman (fig. 25; cat. no. 49).

1770

First child, Elizabeth, is born. Purchases property adjoining his Beacon Hill lot (transaction completed in 1773) to form an estate, Mount Pleasant, of about twenty acres, three houses, a barn, and an orchard. Sometime between Boston Massacre in March and 1772 paints *Samuel Adams* (cat. no. 62), a portrait rife with political significance.

1771

Lives and works in New York mid-June through December, with

two-week trip to Philadelphia in autumn, while his estate is landscaped and houses are remodeled. Paints numerous portraits at a faster rate and for higher fees than was his custom in Boston; reaches pinnacle of his financial success in America.

1772

Birth of first son, John Singleton Copley Jr. Moves into his Beacon Hill house. Begins planning trip to Europe.

1773

Daughter Mary is born. Intends to leave for Italy in spring but remains to paint at least eight portraits, including double portraits of Mr. and Mrs. Thomas Mifflin and Mr. and Mrs. Isaac Winslow (cat. nos. 80, 81). Vandals attack Richard Clarke's house, forcing Clarkes into hiding and compelling Copley to defend the family against charges of disloyalty to the revolutionary cause at a meeting of the Sons of Liberty and in private conversation with John Hancock and Joseph Warren.

1774

Mob threatens Copley and his family for allegedly harboring the Tory George Watson. Sails for England June 10, leaving his pregnant wife and three children in Boston. Arrives in London in early July and visits places of cultural interest. With English artist George Carter sets off for Rome via Rouen, Paris, Lyons, Marseilles, Toulon, Antibes, Genoa, Pisa, and Florence. Begins his first original historical painting, *The Ascension* (Museum of Fine Arts, Boston).

1775

Son Clarke is born in Boston. Visits Naples. Paints large double portrait of Americans Mr. and Mrs. Ralph Izard (fig. 82), whom he had met in Naples. Via Parma, Venice, the Tirol, Mannheim, and Cologne returns to London, where he joins his wife and three eldest children. (Clarke has remained in Boston with Copley's mother.) Receives invitation to become member of Royal Academy of Arts.

1776

Settles wife and children, along with Richard Clarke, into a house in Leicester Square. Son Clarke dies. Elected associate of Royal Academy and enters Izard portrait at academy's annual exhibition. Third daughter, Susanna, is born.

1777

Shows first of several large group portraits, *The Copley Family* (fig. 36), and *The Nativity* (location unknown) at Royal Academy, both of which are attacked in the press.

1778

Exhibits *The Pepperrell Family* and *Watson and the Shark* (figs. 11, 12), first in a series of large-scale history paintings he would execute in London, at Royal Academy; *Watson and the Shark* causes a popular sensation.

1779

Accepts full membership in Royal Academy and begins *The Death of the Earl of Chatham* (Tate Gallery, London), reportedly drawing portraits from life of some fifty-five noblemen.

1781

Displays *The Death of the Earl of Chatham* at Spring Garden, a critical and popular success that garners impressive profits from admission fees.

1782

Birth of son Jonathan. Belatedly presents *The Tribute Money* to Royal Academy as his diploma picture. Begins *The Death of Major Peirson* (fig. 10).

1783

Moves from Leicester Square to George Street near Hanover Square. Corporation of the City of London selects Copley over West to commemorate the recent British victory at Gibraltar; Copley begins to plan a monumental canvas on the subject.

1784

Exhibits *The Death of Major Peirson* at Haymarket to great acclaim.

1785

Paints and shows *The Daughters of George III* (Her Majesty the Queen, London), deemed a failure by the press. Daughter Susanna and son Jonathan die.

1786

Exhibition of *The Sitwell Family* (private collection) elicits negative reviews. Continues working on Gibraltar picture.

1787

Draws and paints portraits of officers for Gibraltar composition; travels to Germany in August for sitting with Hanoverian officers. Also visits Ghent, Flanders, Brussels, and Antwerp.

1789

Mother dies in Boston.

1791

Thousands of visitors view the immense *Siege of Gibraltar* (Guildhall Art Gallery, London) in tent in Green Park.

1792

Appeals for increase in fee for *The Siege of Gibraltar*. Loses election for Royal Academy presidency to West.

1793

Serves as member of Royal Academy council, its hanging committee, and committee to arrange its twenty-fifth anniversary

celebration. Exhibits *The Red Cross Knight* (fig. 7), his first literary subject.

1795

At Spring Garden shows *Charles I Demanding in the House of Commons the Five Impeached Members* (City of Boston), on which he had worked for fourteen years. Agent sells Beacon Hill estate at terms Copley believes are unfavorable.

1799

Displays *The Victory of Lord Duncan* (City of Dundee, Scotland) in tent in Lord Suffield's Albemarle Street garden, London, to favorable reviews.

1800

Accepts several important portrait commissions, including large group portrait of Sir Edward Knatchbull and family (destroyed).

1803

Becomes embroiled in dispute with Knatchbull that involves Royal Academy and results in litigation.

1806

Declines commission to commemorate death of Lord Nelson. Sells *The Death of the Earl of Chatham* by lottery for two thousand guineas to Alexander Davision; Davision subsequently commissions *The Offer of the Crown to Lady Jane Grey* (location unknown). Henry Pelham drowns.

1810

Exhibits *George IV (as Prince of Wales)* (Museum of Fine Arts, Boston) at the Royal Academy, where he serves as senior council member at the Royal Academy.

1811

American painter Samuel F. B. Morse, in London as a student, visits Copley in September and writes that "he is very old and infirm. . . . His powers of mind have almost entirely left him."

1815

Suffers a stroke August 11; dies September 9.

CR

ABBREVIATED REFERENCES

Amory 1882 Amory, Martha Babcock. *The Domestic and Artistic Life of John Singleton Copley, R. A., with Notices of His Works, and Reminiscences of His Son, Lord Lyndhurst, High Chancellor of Great Britain.* Boston, 1882.

Bayley 1915 Bayley, Frank W. *The Life and Works of John Singleton Copley.* Boston, 1915.

Dunlap 1834 Dunlap, William. *History of the Rise and Progress of the Arts of Design in the United States.* 2 vols. New York, 1834.

Jones 1914 Jones, Guernsey, ed. *Letters and Papers of John Singleton Copley and Henry Pelham, 1739–1776.* Boston, 1914.

Parker and Wheeler 1938 Parker, Barbara Neville, and Anne Bolling Wheeler. *John Singleton Copley: American Portraits in Oil, Pastel, and Miniature.* Boston, 1938.

Perkins 1873 Perkins, Augustus Thorndike. *A Sketch of the Life and Some of the Works of John Singleton Copley.* Cambridge, Mass., 1873.

Prown 1966 Prown, Jules David. *John Singleton Copley.* 2 vols. Cambridge, Mass., 1966.

Tuckerman 1867 Tuckerman, Henry T. *Book of the Artists: American Artist Life.* New York, 1867. Reprint of 2d ed., New York, 1966.

Bibliography

Abrams, Ann Uhry. "Politics, Prints, and John Singleton Copley's *Watson and the Shark*." *Art Bulletin* 61 (June 1979), pp. 265–76.

Adams, Charlotte. "The Belles of Old Philadelphia." *American Magazine* 8 (May 1888), pp. 31–44.

_____. "John Singleton Copley." *Art Interchange* 31 (August 1893), pp. 27–28, 30, 36.

Ahlander, Leslie Judd. "An Artist and His Era." *Christian Science Monitor*, September 25, 1965.

Allard, Joseph. "West, Copley, and Eighteenth-Century American Provincialism." *Journal of American Studies* 17 (1983), pp. 391–416.

Ambler, Louise Todd. "Faces from Harvard's Past." *Harvard Magazine*, March–April 1978, pp. 33–41.

"American Milestone Comes to Washington." *Art News* 64 (March 1965), pp. 35, 65–66.

"American Old Masters." *New York Times*, May 11, 1947, p. 7.

[American Portraiture.] *Collector* 3 (April 1, 1892), p. 161.

Amory, Martha Babcock. "John Singleton Copley, R. A." *Scribner's Monthly* 21 (July 1881), pp. 759–76.

_____. *The Domestic and Artistic Life of John Singleton Copley, R. A., with Notices of His Works, and Reminiscences of His Son, Lord Lyndhurst, High Chancellor of Great Britain.* Boston, 1882.

Andrus, Vincent D. "Copley's New York Visit." *Bulletin of The Metropolitan Museum of Art* 7 (June 1949), pp. 261–65.

"Art Notes." *New York Times*, December 30, 1902, p. 8.

B., C. H. "A Portrait by Copley." *Bulletin of the Detroit Institute of Arts* 9 (March 1928), pp. 69–70.

B., O. K. "Copley's Erskine Portrait." *Denver Art Museum Quarterly*, Summer 1949, pp. 10–11.

Barck, Dorothy C., ed. *Diary of William Dunlap*. 3 vols. New York, 1931.

Barker, Virgil. *American Painting: History and Interpretation*. New York, 1950.

Bayley, Frank W. *Sketch of the Life and a List of Some of the Works of John Singleton Copley*. Boston, 1910.

_____. *The Life and Works of John Singleton Copley*. Boston, 1915.

Belknap, Waldron Phoenix. "Mezzotint Prototypes of Colonial Portraiture." *Art Quarterly* 20 (Winter 1957), pp. 407–68.

Bell, Hamilton. "Early American Portraits at the Cleveland Museum of Art." *American Magazine of Art* 7 (October 1916), pp. 484–88.

Benjamin, Ruth L. "American Art Through Foreign Eyes." *Gazette des Beaux-Arts* 25 (May 1944), pp. 299–314.

Bewley, Marius. "The Colonial Vs. the National." *Partisan Review* 16 (February 1949), pp. 202–6.

Boime, Albert. "Blacks in Shark-Infested Waters: Visual Encodings of Racism in Copley and Homer." *Smithsonian Studies in American Art* 3 (Winter 1989), pp. 20–36.

Bolton, Theodore. Review of *John Singleton Copley*, by James Thomas Flexner. *William and Mary Quarterly* 6 (April 1949), pp. 322–27.

Bolton, Theodore, and Harry Lorin Binsse. "John Singleton Copley: Probably the Greatest American Portrait Painter, Here for the First Time Appraised As an Artist in Relation to His Contemporaries." *Antiquarian* 15 (December 1930), pp. 76–79.

"Boston Celebrates Founding with 100 Colonial Portraits." *Art Digest* 4 (July 1930), p. 32.

"Boston Exhibit Hails Copley's Bicentennial: Colonial Aristocracy Lives Again in Unusual Display at Museum." *Boston Evening Transcript*, February 18, 1938.

"Boston Gets Copley Picture." *New York Times*, December 30, 1902, p. 2.

Breen, T. H. "The Meaning of 'Likeness': American Portrait Painting in an Eighteenth-Century Consumer Society." *Word and Image* 6 (October–December 1990), pp. 325–50. Reprinted in *The Portrait in Eighteenth-Century America*, edited by Ellen G. Miles, pp. 37–60. Newark, Del., 1993.

Britton, James. "Copleys in Brooklyn." *American Art News* 14 (November 27, 1915), p. 9.

Brooks, Valerie F. "Tender Offers for Plain Jane." *Art News* 83 (May 1984), p. 20.

Brown, Wallace. "The Loyalists and the American Revolution." *History Today* 12 (March 1962), pp. 149–57.

Bryant, Lorinda Munson. *American Pictures and Their Painters*. London, 1921.

Burroughs, Alan. *Limners and Likenesses: Three Centuries of American Painting*. Cambridge, Mass., 1936.

_____. "Copley in Boston." *Magazine of Art* 31 (March 1938), pp. 164–66.

_____. "Young Copley." *Art in America* 31 (October 1943), pp. 161–71.

_____. "A Pelham Portrait?" *Antiques* 71 (April 1957), pp. 358–59.

Burroughs, Louise. "John Singleton Copley." *Bulletin of The Metropolitan Museum of Art* 31 (December 1936), pp. 252–58.

C., W. H. "Two Copley Portraits." *Brooklyn Museum Quarterly* 2 (October 1915), pp. 357–62.

The Cabinet Gallery of Pictures by the First Masters of the English and Foreign Schools. London, 1836.

Caffin, Charles H. *The Story of American Painting.* New York, 1907.

Canaday, John. "Art: Copley the Realist." *New York Times,* November 18, 1965.

———. "The Artist Who Lived Twice." *New York Times,* May 1, 1966, pp. 7, 32.

———. "A Vote for the Spirit." *New York Times,* October 8, 1972, p. 27.

———. "Yankee Honesty—the Strength of Copley's Portraits." *New York Times,* December 14, 1975, p. 39.

"Close to Fame." *New York Sun,* February 19, 1945.

"Colonial Dames Open Exhibition." *New York Times,* February 24, 1931.

"A Colonial Portrait by John Copley." *Bulletin of the Minneapolis Institute of Arts* 30 (October 4, 1941), pp. 118–21.

"Colonial Portraits [at Ehrich Galleries]." *New York Times,* April 15, 1905, p. 5.

Comstock, Helen. "Historical Portraiture at the Corcoran Gallery." *Connoisseur* 101 (January–June 1938), pp. 91–92.

———. "Drawings by J. S. Copley in the Karolik Collection." *Connoisseur* 109 (July 1942), pp. 150–53.

———. "Drawings by John Singleton Copley." *Panorama* 2 (May 1947), pp. 99–107.

———. "Some Unpublished Drawings by John Singleton Copley." *American Collector* 16 (July 1947), pp. 6–8, 20.

———. "American Painting in the Eighteenth Century." *Connoisseur* 134 (January 1955), pp. 295–300.

"Confessions of a Young Artist." *Putnam's Monthly* 3 (January 1854), pp. 39–45.

"Copley at His Best." *Art Digest* 15 (July 1, 1941), p. 8.

"Copley Bicentennial." *Time* 29 (January 4, 1937), p. 33.

"Copley, Early American-Born Master, Honored at Metropolitan." *Art Digest,* January 1, 1937, pp. 6–7.

[Copley Exhibition in New York.] *Revue de l'art ancien et moderne* 71 (April 1937), pp. 96, 98.

"Copley in New York." *New York Times,* November 29, 1914, p. 11.

"Copley—Our First Eminent Painter." In *Art in America from 1600 to 1865,* p. 18. Chicago, 1934.

"A Copley Portrait." *Antiques* 69 (January 1956), p. 74.

[Copley Portrait Found in France.] *New York Times,* July 19, 1936, p. 22.

"Copley Portrait on View." *New York Times,* February 14, 1932, p. 4.

"A Copley Returns to Boston." *American Artist* 29 (March 1965), pp. 4, 10.

"Copley Show to Open in Capital." *New York Times,* September 14, 1965, p. 36.

"Copley's American Portraits." *Magazine of Art* 43 (1950), pp. 83–88.

"Copley's Art in Great Display." *New York Sun,* December 21, 1936.

"Copley's Artistry Stressed at Sale." *New York Times,* April 19, 1934, p. 23.

"Copley's Dual Moods." *Connoisseur* 154 (November 1963), pp. 204–5.

"Copley's Painting of the Long Parliament." *New York Times,* July 20, 1859, p. 8.

"Copley's Picture of the Prince Regent." *Boston Transcript,* December 9, 1874, p. 4.

"Copley's Portrait of Joshua Henshaw." *Connoisseur* 126 (August 1950), p. 54.

"Copley's Portrait of Mrs. Gage." *Art and Auction* 6 (February 1984), pp. 46–48.

"Correspondence, 1762–1775, by John Singleton Copley." *American Art Review* 2 (May–June 1975), pp. 45–52.

Cortissoz, Royal. "The Art of Copley at the Metropolitan." *New York Herald Tribune,* December 27, 1936.

———. "The Traits of Our Early Portraiture." *New York Herald Tribune,* February 13, 1938, p. 8.

"Cosmopolitan Art Association." *Cosmopolitan Art Journal* 3 (1859), p. 184.

Cox, Kenyon. *Old Masters and New: Essays in Art Criticism.* New York, 1905.

Craven, Wayne. *Colonial American Portraiture: The Economic, Religious, Social, Cultural, Philosophical, Scientific, and Aesthetic Foundations.* Cambridge, 1986.

Crawford, Mary Caroline. *Old Boston Days and Ways.* Boston, 1924.

Cunningham, Allan. *The Lives of the Most Eminent British Painters and Sculptors.* 3 vols. New York, 1831. Later edition of 5 vols., New York, 1868.

Cunningham, Charles C. *John Singleton Copley (1738–1815): Loan Exhibition of Paintings, Pastels, Miniatures and Drawings in Commemoration of the Two Hundredth Anniversary of the Artist's Birth.* Exh. cat. Boston: Museum of Fine Arts, 1938.

———. "Copley Centenary in Boston." *Art News* 36 (February 12, 1938), pp. 7–9.

———. "John Singleton Copley." *Art in America* 26 (April 1938), pp. 77–78.

———. "The Karolik Collection—Some Notes on Copley." *Art in America* 30 (January 1942), pp. 26–35.

D., A. "Important Copley Portrait Goes West." *Art Digest* 17 (July 1, 1943), p. 10.

Dana, Mr. "The Vassall Portraits." *Massachusetts Historical Society Proceedings* 50 (March 1917), pp. 200–203.

Davidson, Ruth. "The First American-Born Master." *Antiques* 88 (September 1965), p. 270.

"Deaths." *Boston Gazette,* November 16, 1815, p. 2.

De Rochemont, Ruth. "Fashions in Feminine Portraiture." *Vogue* 67 (February 1, 1926), pp. 62–63, 102–4.

Deweese-Wehen, Joy. "Copley's 'Lady' Now in L. A." *Antiques Monthly,* January 1986.

"Died." *Columbian Centinel,* November 15, 1815, p. 2.

Dillenberger, Jane, and Joshua C. Taylor. *The Hand and the Spirit: Religious Art in America, 1700–1900.* Berkeley, 1972.

Dinnerstein, Lois. "Still Life in the Painting of John Singleton Copley." Seminar paper, Graduate School and University Center, City University of New York, 1972.

_____. "The Industrious Housewife: Some Images of Labor in American Art." *Arts Magazine* 55 (April 1981), pp. 109–19.

[Doll and Richards.] *Appleton's* 14 (August 21, 1875), p. 250.

[Doll and Richards.] *Nation* 21 (September 9, 1875), p. 166.

Dooley, William Germain. "Copley in Retrospect After 200 Years of American Art." *Boston Evening Transcript*, February 5, 1938.

Dorment, Richard. "Painting the Unpaintable." *New York Review of Books* 37 (September 27, 1990), pp. 54–56.

[Downes, William Howe.] "Boston Notes." *Art Interchange*, July 31, 1886, p. 1.

_____. "Boston Painters and Paintings." *Atlantic Monthly* 62 (July 1888), pp. 89–98.

"Drawings by American Masters, 18th–20th Centuries." *Bulletin of the Department of Art and Archaeology, Princeton University*, May 1943, pp. 3–16.

Drawings by Remington, Copley, Homer. Exh. cat. Boston: Childs Gallery, 1948.

Dresser, Louisa. "Attribution and Authenticity in American Painting." *Art in America* 33 (October 1945), pp. 193–209.

Dubuque, Robert. "The Painter and the Patriot: John Singleton Copley's Portrait of Paul Revere." *Revere House Gazette* 17 (Autumn 1989), pp. 1–5.

Dunlap, William. *History of the Rise and Progress of the Arts of Design in the United States.* 2 vols. New York, 1834.

"Early American Portrait Painters." *Art and Progress* 3 (February 1912), pp. 485–89.

"Early American Portraits, Miniatures, and Silver." *American Magazine of Art* 17 (February 1926), pp. 64–71.

"Early and Later Copleys." *Connoisseur* 96 (October 1935), pp. 233–34.

Edes, Henry H. [Biography of Martin Howard.] *Publications of the Colonial Society of Massachusetts* 6 (1900), pp. 384–401.

Eliot, Alexander. "The Art of History Painting." *Atlantic Monthly* 234 (December 1974), pp. 61–69.

"Exhibit Celebrates 200th Anniversary of John Singleton Copley's Boston." *American Collector* 5 (January 1937), pp. 1, 12–13.

"Exhibition at the Warner House, Portsmouth." *Connoisseur* 102 (October 1938), pp. 219–20.

"Extracts from Colonel Paul Revere's Day-Book." *Proceedings of the Massachusetts Historical Society*, October 1870, pp. 390–91.

Fairbanks, Jonathan L. *John Singleton Copley, 1738–1815, Gilbert Stuart, 1755–1828, Benjamin West, 1738–1820, in America and England.* Exh. cat. Boston: Museum of Fine Arts, 1976.

Fairbrother, Trevor J. "John Singleton Copley's Use of British Mezzotints for His American Portraits: A Reappraisal Prompted by New Discoveries." *Arts Magazine* 55 (March 1981), pp. 122–30.

Feld, Stuart P. *American Portraits by John Singleton Copley.* Exh. cat. New York: Hirschl and Adler Galleries, 1975.

"The Fine Arts: Vogue of Copley." *Boston Evening Transcript*, July 1, 1918.

"First Great American Painter Liked Women's Dress and Hands." *New York Sun*, January 5, 1937.

Fleischer, Roland E. "Emblems and Colonial American Painting." *American Art Journal* 20, no. 3 (1988), pp. 3–35.

Flexner, James Thomas. *John Singleton Copley.* Boston, 1948. Reprint, New York, 1993.

Foote, Henry Wilder. "When Was John Singleton Copley Born?" *New England Quarterly* 10 (March 1937), pp. 111–20.

Forbes, Esther. "Americans at Worcester—1700–1775." *Magazine of Art* 36 (March 1943), pp. 83–88.

Ford, Paul Leicester. "Some Copley-Pelham Letters." *Atlantic Monthly* 71 (April 1893), pp. 499–510.

Frankenstein, Alfred M. *The World of Copley, 1738–1815.* New York, 1970.

_____. "Copley Portraits—the Story of the Children." *This World*, May 9, 1971, pp. 27–28.

Frankfurter, Alfred M. "J. S. Copley, American Master." *Art News* 35 (December 26, 1936), pp. 11–12.

Freund, Frank E. Washburn. "Exploring the Art World of New York." *Travel* 68 (February 1937), pp. 44–45.

Freyer, D. C. "On Picture Restoring." *New York Times*, November 28, 1911, p. 12.

Gardner, Albert Ten Eyck. "A Copley Primitive." *Bulletin of The Metropolitan Museum of Art* 20 (April 1962), pp. 257–63.

Gavin, William. "Francis Wheatley and John Singleton Copley." *Source Notes in the History of Art* 1 (Fall 1981), unpaged.

Gerdts, William H. "Copley in Washington, New York, and Boston." *Burlington Magazine* 108 (May 1966), pp. 278, 280–81.

Gerry, Phillipa. "J. S. Copley." *Magazine of Art* 30 (February 1937), pp. 111–12.

Getlein, Frank. "Hand Across the Sea." *New Republic* 153 (October 9, 1965), pp. 32–33, 35.

Gibson, Eric. "First Corcoran Copley Is a Splendid Catch." *Washington Times*, November 23, 1989, p. 25.

Goodrich, Lloyd. "Our Greatest Colonial Artist." *Talks* 2 (1937), pp. 30–34.

_____. "What Is American—in American Art?" *Art in America* 46 (Fall 1958), pp. 19–33.

Gordon, Isobel. "John Singleton Copley." *Hobbies* 56 (August 1951), pp. 22–23.

Gottesman, Rita. "Copley Versus West." *Antiques* 78 (November 1960), pp. 478–79.

Graeme, Alice. "Exhibition of Copley Art: Tribute to Painter." *New York Evening Post*, January 31, 1937.

"Great Acquisitions." *Time* 79 (June 8, 1962), pp. 60–61.

Greenough, Horatio. "Remarks on American Art." *Crayon* 2 (September 19, 1855), pp. 178–79.

Greenwood, Isaac J. "Copley the Artist." *Magazine of American History* 2 (1878), pp. 116–17.

Gustafson, Eleanor H. "Museum Accessions." *Antiques* 137 (November 1990), p. 918.

Guttman, Allen. "Copley, Peale, Trumbull: A Note on Loyalty." *American Quarterly* 11 (Summer 1959), pp. 178–83.

H., A. D. "Portrait of Mrs. Samuel Phillips Savage." *Bulletin of the Worcester Art Museum* 7 (July 1916), pp. 2–4.

Hagen, Oskar. *The Birth of the American Tradition in Art.* New York, 1940.

Harris, Neil. *The Artist in American Society: The Formative Years, 1790–1860.* New York, 1966.

_____. "The Persistence of Portraiture." *Perspectives in American History* 1 (1967), pp. 380–89.

Hart, Charles Henry. "John Singleton Copley." *American Architect and Building News* 9 (April 8, 1882), pp. 161–62.

_____. "Thomas Mifflin and Sarah Morris Mifflin, Painted by John Singleton Copley, 1771." *Art in America* 5 (June 1905), pp. 200–205.

_____. Review of *Letters and Papers of Copley and Pelham*, edited by Guernsey Jones. *American Historical Review* 20 (April 1915), pp. 643–45.

Hartley, Marsden. "The Six Greatest New England Painters." *Yankee* 3 (August 1937), pp. 14–16.

Hartmann, Sadakichi. *A History of American Art.* 2 vols. Boston, 1901.

Harwood, Barry R. "A Copley Copyist at Princeton?" *Record of the Art Museum, Princeton University* 28 (1969), pp. 15–21.

Hayley. "West and Copley." *Boston Magazine* 2 (January 1784), pp. 112–13.

Heckscher, Morrison H., and Leslie Greene Bowman. *American Rococo, 1750–1775: Elegance in Ornament.* Exh. cat. New York: The Metropolitan Museum of Art, 1992.

"Here and Everywhere." *International Studio* 83 (March 1926), p. 94.

Hinton, Jack. "Little Girl Feature of New Art Stamp." *Long Island Press*, August 22, 1965.

[Historic Art Association.] *Collector* 3 (June 15, 1892), p. 251.

Hoagland, Clayton. "John Singleton Copley." *Pictures on Exhibit* 2 (November 1938), pp. 6–7.

Hobhouse, Janet. "America's First Great Artist." *Art in America* 63 (November–December 1975), pp. 74–75.

Hochfield, Sylvia. "John Singleton Copley's America." *Art News* 75 (February 1976), pp. 84–85.

Hoffman, Edith. "New York." *Burlington Magazine* 100 (December 1958), pp. 453–54.

Hogarth, Burne. "Outline of American Painting: The Revolutionary Era." *American Artist* 25 (December 1961), pp. 40–42.

"Honoring Copley, No Longer an Heirloom." *Art Digest* 12 (March 1, 1938), p. 6.

Howgego, James L. "Copley and the Corporation of London." *Guildhall Miscellany* 1 (July 1958), pp. 34–43.

Hudson, Andrew. "It Did Portraitist Copley Good to Work in England." *Washington Post*, September 19, 1965, p. 7.

Isham, Samuel. *The History of American Painting.* New York, 1905.

_____. "A Pastel by J. S. Copley." *Burlington Magazine* 11 (April–September 1907), pp. 58–59.

Jaffe, Irma B. "John Singleton Copley's *Watson and the Shark*." *American Art Journal* 9 (May 1977), pp. 15–25.

James, Henry. [Portrait of Mrs. Skinner at Doll and Richards.] *Nation* 21 (September 9, 1875), p. 166.

_____. *The Painter's Eye: Notes and Essays on the Pictorial Arts.* Edited by John L. Sweeney. Cambridge, Mass., 1956.

Jarves, James Jackson. *The Art Idea.* 1864. Reprint, Cambridge, Mass., 1960.

Jeffrey, Margaret. "A Painting of Copley's English Period." *Bulletin of The Metropolitan Museum of Art* 1 (December 1942), pp. 148–50.

Jewell, Edward Alden. "In the Realm of Art." *New York Times*, June 11, 1933, p. 6.

_____. "In the Realm of Art: High Spots of the Tercentenary." *New York Times*, September 8, 1935, p. 7.

_____. "In the Realm of Art: A Week Full to Overflowing; Past Eras; Old Masters' Work in the New Shows." *New York Times*, November 8, 1936, p. 9.

_____. "Copley Portraits to Be Shown Here." *New York Times*, December 21, 1936, p. 18.

_____. "In the Realm of Art." *New York Times*, December 27, 1936, p. 9.

"John Copley: Painter by Necessity." *Time*, August 13, 1956, pp. 58–59.

"John S. Copley Exhibit Opens at Metropolitan on Wednesday." *New York Herald Tribune*, December 21, 1936.

"John Singleton Copley." *Masters in Art*, December 1904, pp. 484–504.

"John Singleton Copley." *Newsweek* 66 (October 4, 1965), pp. 92–93.

"John Singleton Copley: America's First Colonial Portraitist." *Pictures on Exhibit* 29 (November 1965), pp. 12–13.

"John Singleton Copley As a Portrait Miniaturist." *Art in America* 18 (April 1930), pp. 207–14.

"John Singleton Copley to His Wife." *Boston Public Library Quarterly* 12 (April 1960), pp. 67–78.

"John Singleton Copley's Houses on Beacon Hill, Boston." *Old-Time New England* 25 (January 1935), pp. 85–95.

Jones, E. Alfred. "Lost Objects of Art in America. Part II." *Art in America* 8 (June 1920), pp. 187–92.

Jones, Guernsey, ed. *Letters and Papers of John Singleton Copley and Henry Pelham, 1739–1776.* Boston, 1914.

Jones, Karen M. "Three Copley Portraits." *Antiques* 117 (January 1980), p. 221.

Kent, Norman. "John Singleton Copley." *American Artist* 22 (April 1958), p. 53.

Kienitz, John Fabian. "A Parallel of American Styles." *Art in America* 34 (April 1946), pp. 91–105.

Klayman, Richard. "The Education of an Artist: The American Years of John Singleton Copley, 1738–1774." Ph.D. dissertation, University of New Hampshire, Durham, 1981.

L., H. M. "Early American Portraits." *Bulletin of the Worcester Art Museum* 6 (July 1915), pp. 2–14.

L., H. M., and P. J. G. "A Superb Copley." *Bulletin of the Worcester Art Museum* 6 (October 1915), p. 13.

"Lady Wentworth, the Wife of John Wentworth, Governor of New Hampshire." *Old-Time New England* 13 (October 1922), pp. 65–67.

La Follette, Suzanne. *Art in America: From Colonial Times to the Present Day*. New York, 1929.

———. "American Art: Its Economic Aspects." *American Magazine of Art* 28 (June 1935), pp. 337–45.

Lane, James W. "Notes from New York." *Apollo* 25 (February 1937), pp. 99–101.

Larkin, Oliver. *Art and Life in America*. 1949. Rev. ed., New York, 1960.

Ledes, Allison Eckhardt. "Drawings by John Singleton Copley." *Antiques* 137 (November 1990), pp. 898, 902.

Lee, Cuthbert. *Early American Portrait Painters*. New Haven, 1929.

Leeper, John, and Blanche Leeper. "American Processional." *National Geographic* 99 (February 1951), pp. 173–212.

Lidman, David. "American Painting Issue." *New York Times*, August 15, 1965, p. 19.

Life in America. Exh. cat. New York: The Metropolitan Museum of Art, 1939.

"Life of John Singleton Copley, R. A." *Magazine of Art* 2 (1879), pp. 94–96.

"Loan Exhibition of John S. Copley at Metropolitan." *New York Post*, December 26, 1936.

Lovell, Margaretta M. "Reading Eighteenth-Century American Family Portraits: Social Images and Self-Images." *Winterthur Portfolio* 22 (Winter 1987), pp. 243–64.

———. "To Be 'Conspecuous in the Croud': John Singleton Copley's Sir William Pepperrell and His Family." *North Carolina Museum of Art Bulletin* 15 (1991), pp. 30–43.

Low, Will H. "A Century of Painting in America: The Fathers of Art in America." *McClure's Magazine* 20 (February 1903), pp. 337–42.

Lucas, E. V. "Benjamin West, Stuart, and Copley." *Ladies' Home Journal* 42 (November 1925), pp. 10, 125–26.

Lyndhurst library sale. *Catalogue of the Valuable Library of the Rt. Hon. Lord Lyndhurst, Deceased: Also, a Few Engravings and Sketches by J. S. Copley, R. A.* Sale Catalogue, Christie, Manson and Woods, London, February 26–27, 1864.

Lyndhurst sale. *Catalogue of the Very Valuable Collection of Pictures of the Rt. Hon. Lord Lyndhurst, Deceased: Including Most of the Important Works of His Lordship's Father, That Distinguished Historical Painter, John Singleton Copley, R. A.* Sale Catalogue, Christie, Manson and Woods, London, March 5, 1864.

M., J. "Portrait of Joshua Henshaw." *Bulletin of the California Palace of the Legion of Honor* 1 (October 1943), pp. 59–61.

M., J. B. "A Portrait by Copley." *Bulletin of the City Art Museum of St. Louis* 14 (October 1929), pp. 42–43.

Mantz, Paul. "Exposition de Londres: École anglaise." *Gazette des Beaux-Arts* 13 (July 1862), pp. 97–125.

Mastai, M-L. d'Otrange. "The Connoisseur in America: John Singleton Copley, 1738–1815." *Connoisseur* 161 (January 1966), pp. 66–67.

Masur, Louis P. "Reading *Watson and the Shark*." *New England Quarterly* 67 (September 1994), pp. 427–54.

McBride, Henry. "Copley at the Metropolitan." *New York Sun*, December 26, 1936.

McCoubrey, John. *American Tradition in Painting*. New York, 1963.

McSpadden, J. Walker. *Famous Painters of America*. New York, 1907.

Mifflin, J. Houston. "The Fine Arts in America, and Its Peculiar Incentives to Their Cultivation." *Knickerbocker* 2 (July 1833), pp. 30–35.

Miles, Ellen G. *John Singleton Copley's* Watson and the Shark. Exh. pamphlet. Washington, D.C.: National Gallery of Art, 1993.

"Monthly Record of American Art" [Describes portrait of Mr. and Mrs. Izard]. *Magazine of Art* 11 (1888), pp. xlii–xliii.

Morgan, John Hill. "Some Notes on John Singleton Copley." *Antiques* 31 (March 1937), pp. 116–18.

———. "John Singleton Copley." *Walpole Society Notebook*, 1938.

———. *Foreword on Copley*. [New York: Walpole Society, 1939.]

Mount, Charles Merrill. "A Hidden Treasure in Britain, Part II: John Singleton Copley." *Art Quarterly* 24 (Spring 1961), pp. 33–54.

"Mrs. Harriman Buys Copleys." *New York Times*, January 19, 1912, p. 6.

"National Gallery Acquires Its 10th Painting by Copley." *New York Times*, July 19, 1968, p. 25.

Nearpass, Kate. "The First Chronological Exhibition of American Art, 1872." *Archives of American Art Journal* 23 (1983), pp. 21–30.

Nicolson, Benedict. "The Raft from the Point of View of Subject Matter." *Burlington Magazine* 96 (August 1954), pp. 241–49.

"Noted Canvas for Boston Museum." *American*, April 29, 1903.

"Noted Painting of Pitt's Death Lent to Metropolitan." *New York Times*, February 21, 1961, p. 37.

"Notes: Portrait of Mrs. John Winthrop by John Singleton Copley." *Bulletin of The Metropolitan Museum of Art* 27 (February 1932), pp. 52–54.

Novak, Barbara. *American Painting of the Nineteenth Century: Realism, Idealism, and the American Experience*. New York, 1969.

———. "Self, Time, and Object in American Art: Copley, Lane, and Homer." In *American Icons: Transatlantic Perspectives on Eighteenth- and Nineteenth-Century American Art*, edited by Thomas W. Gaehtgens and Heinz Ickstadt, pp. 61–91. Santa Monica, 1992.

"Obituary; with Anecdotes of Remarkable Persons." *Gentleman's Magazine* 118, part 2 (October 1815), p. 377.

O'Doherty, Barbara Novak. "Copley: Eye and Idea." *Art News* 64 (September 1965), pp. 22–26, 57–58.

Pach, Walter. "Quelque notes sur les peintres américains." *Gazette des Beaux-Arts* 1 (1909), pp. 324–35.

"Painting by Copley Goes to Kansas City." *New York Times*, April 1, 1934.

"Painting: The Man Who Left Home." *Time* 86 (October 29, 1965), pp. 74–75.

Parker, Barbara Neville. "Portraits of the Goldthwait Family of Boston." *Bulletin of the Museum of Fine Arts* 39 (June 1941), pp. 40–44.

_____. "Problems of Attribution in Early Portraits by Copley." *Bulletin of the Museum of Fine Arts* 40 (June 1942), pp. 54–57.

_____. Review of *John Singleton Copley*, by James Thomas Flexner. *New-York Historical Society Quarterly*, April 1949, pp. 106–7.

Parker, Barbara Neville, and Anne Bolling Wheeler. *John Singleton Copley: American Portraits in Oil, Pastel, and Miniature*. Boston, 1938.

_____. "The Copley Exhibition in Boston." *Parnassus* 10 (February 1938), pp. 10–12.

"A Pastel by Copley." *Bulletin of The Metropolitan Museum of Art* 3 (February 1908), p. 37.

Peale, Rembrandt. "Reminiscences." *Crayon* 1 (January 10, 1855), pp. 22–23.

_____. "Reminiscences." *Crayon* 1 (May 9, 1855), p. 290.

Pène du Bois, Guy. "Famous Boston Collections: The Collection of Herbert L. Pratt, Esq." *Arts and Decoration* 7 (September 1917), pp. 507–10.

Perkins, Augustus Thorndike. *A Sketch of the Life and Some of the Works of John Singleton Copley*. Cambridge, Mass., 1873.

"Personal." *New York Times*, May 26, 1859, p. 2.

"A Picture by Copley." *New York Times*, October 4, 1874.

Plate, Robert. *John Singleton Copley: America's First Great Artist*. N.p.: David McKay Company, 1969.

Preston, Stuart. "Art: Drawings by Copley." *New York Times*, November 9, 1962, p. 32.

Prown, Jules David. "Copley's 'Victory of Duncan.'" *Art in America* 50 (1962), pp. 82–85.

_____. "An 'Anatomy Book' by John Singleton Copley." *Art Quarterly* 26 (Spring 1963), pp. 31–46.

_____. *John Singleton Copley*. Exh. cat. Washington, D.C.: National Gallery of Art, 1965.

_____. "John Singleton Copley: A Balanced View." *Antiques* 89 (March 1966), pp. 380–83.

_____. "The Art Historian and the Computer: An Analysis of Copley's Patronage, 1753–1774." *Smithsonian Journal of History* 1 (1966), pp. 17–30.

_____. *John Singleton Copley*. 2 vols. Cambridge, Mass., 1966.

_____. "John Singleton Copley in New York." *Walpole Society Notebook*, 1986.

Prown, Jules David, and Peter Walch. "A Note on Copley's *Forge of Vulcan*." *Art Quarterly* 33 (1970), pp. 176–78.

Quick, Michael, and William H. Gerdts. *American Portraiture in the Grand Manner, 1720–1920*. Exh. cat. Los Angeles: Los Angeles County Museum of Art, 1981.

Rankin, William. "An Impression of the Early Work of J. S. Copley." *Burlington Magazine* 8 (October 1905), pp. 68–74.

Rathbone, Perry T. "A Pair of Portraits by John Singleton Copley." *Bulletin of the City Art Museum of St. Louis* 38 (1953), pp. 2–6.

_____. "Rediscovery: Copley's Corkscrew." *Art in America* 53 (June 1965), pp. 48–51.

"The Realm of Art: Chicago Unfurls Another Pageant." *New York Times*, June 3, 1934, p. 7.

"Remarks on the Progress and Present State of the Fine Arts in the United States." *Analectic Magazine* 6 (1815), pp. 363–76.

"Reminiscences: Exhibitions and Academies." *Crayon* 1 (May 9, 1855), pp. 290–91.

"A Resurrected Copley." *American Art News* 17 (October 26, 1918), p. 1.

Review of *The Domestic and Artistic Life of John Singleton Copley*, by Martha Babcock Amory. *Lippincott's Magazine*, May 1882, pp. 526–27.

Richard, Paul. "Corcoran Buys Copley Canvas." *Washington Post*, October 18, 1989.

Richardson, E. P. "*The Red Cross Knight* by Copley." *Art Quarterly* 5 (Summer 1942), pp. 267–69.

_____. "*Watson and the Shark* by John Singleton Copley." *Art Quarterly* 10 (Summer 1947), pp. 213–18.

_____. "Head of a Negro Boy by John Singleton Copley." *Detroit Institute of Fine Arts Bulletin* 32 (1952), pp. 68–70.

_____. *Painting in America: The Story of 450 Years*. New York, 1956.

_____. "Copley's Portrait of Mrs. Roger Morris." *Winterthur Portfolio* 2 (1965), pp. 1–13.

Roberts, Kenneth. *Northwest Passage*. Garden City, N.Y., 1936.

_____. "Elizabeth Browne, Joseph Blackburn, and 'Northwest Passage.'" *Art in America* 41 (Winter 1953), pp. 5–21.

Rogers, Alexander P. "Some Notes on Richard Clarke, of Boston, and the Copley Portraits of His Family." *Old-Time New England* 11 (April 1921), pp. 161–62.

Rothenstein, John. *American Painting from the Eighteenth Century to the Present Day*. Exh. cat. London: Tate Gallery, 1946.

Russell, John. "London Letter: Expatriates in Arcadia." *Art in America* 47 (Fall 1959), pp. 84–87, 131.

_____. "The Human Comedy of Copley Portraits." *New York Times*, December 5, 1975, p. 52.

_____. "A Portrait of a Lady Returns." *New York Times*, January 5, 1984.

Rutledge, Anna Wells. "American Loyalists—a Drawing for a Noted Copley Group." *Art Quarterly* 20 (Summer 1957), pp. 195–203.

S. "The Old Masters As Portrait Painters." *Dwight's Journal of Music* 24 (January 1865), pp. 371–72.

Saarinen, Aline. "Mr. and Mrs. Thomas Mifflin." *McCall's* 95 (October 1967), pp. 38–39.

Salisbury, William. "Colonial American Old Masters: The Work of Several of These Early Painters Stands Comparison with Rembrandt and Hals." *Antiquarian* 12 (April 1929), pp. 48–50, 121–22.

Saunders, Richard H. "Genius and Glory: John Singleton Copley's *The Death of Major Peirson*." *American Art Journal* 22 (1990), pp. 4–39.

Saunders, Richard H., and Ellen G. Miles. *American Colonial Portraits, 1700–1776*. Exh. cat. Washington, D.C.: National Portrait Gallery, 1987.

Schwartz, Marvin. "The Meaning of Portraits: John Singleton Copley's American Portraits and Eighteenth-Century Art Theory." M.A. thesis, University of Delaware, Newark, 1954.

Sewall, Darrel. *Copley from Boston*. Exh. cat. Philadelphia: Philadelphia Museum of Art, 1980.

Shank, J. William. "John Singleton Copley's Portraits: A Technical Study of Three Representative Examples." *Journal of the American Institute for Conservation* 23 (Spring 1984), pp. 130–52.

Sherman, Frederic F. "Portraits and Miniatures by Copley, Dunlap, Eichholtz, and Robert Street." *Art in America* 16 (April 1928), pp. 122–29.

———. "Recently Recovered Miniatures by John Singleton Copley." *Art in America* 23 (December 1934), pp. 34–38.

———. "John Singleton Copley's Portrait of Henry Pelham." *Art in America* 25 (April 1937), pp. 82–83.

———. "American Eighteenth Century Portraits." *Art in America* 27 (April 1939), p. 98.

Shirey, David L. "Montclair Offering 'Painting of the Month.'" *New York Times*, November 2, 1975, p. 111.

Siple, Ella S. "Art in America—Notable Mid-Winter Exhibitions in New York and Philadelphia." *Burlington Magazine* 70 (February 1937), pp. 92–93.

Sizer, Theodore, ed. *The Autobiography of Colonel John Trumbull*. 1841. Reprint, New Haven, 1953.

Smith, Martha Voley. "A Story of Two Portraits." *Daughters of the American Revolution Magazine* 61 (February 1927), pp. 116–22.

"Some Unpublished Drawings by John Singleton Copley." *American Collector* 16 (July 1947), pp. 6–8, 20.

Stebbins, Theodore E., Jr., Carol Troyen, and Trevor J. Fairbrother. *A New World: Masterpieces of American Painting, 1760–1910*. Exh. cat. Boston: Museum of Fine Arts, 1983.

Stein, Roger B. "Copley's *Watson and the Shark* and Aesthetics in the 1770s." In *Discoveries and Considerations: Essays on Early American Literature and Aesthetics*, edited by Calvin Israel, pp. 85–129. Albany, 1976.

———. "Copley in Italy." In *The Italian Presence in American Art, 1760–1860*, edited by Irma B. Jaffe, pp. 53–55. New York, 1989.

Sweet, Frederick A. "Mr. and Mrs. Daniel Hubbard, by John Singleton Copley." *Art Institute of Chicago Bulletin* 42 (February 1948), pp. 16–17.

———. *From Colony to Nation*. Chicago, 1949.

———. "From Colony to Nation." *Art Institute of Chicago Bulletin* 43 (April–May 1949), pp. 25–28.

———. "Mezzotint Sources of American Colonial Portraits." *Art Quarterly* 14 (Summer 1951), pp. 148–57.

"T. B. Clarke Gets a Copley." *New York Times*, October 17, 1920, p. 22.

"Three Portraits by Copley on Loan." *Bulletin of The Metropolitan Museum of Art* 3 (March 1908), p. 56.

Townsend, Gertrude. "Portrait by John Singleton Copley of a Lady 'Knotting.'" *Wadsworth Atheneum Bulletin*, Fall 1966, pp. 12–23.

Troyen, Carol. "John Singleton Copley and the Grand Manner: *Colonel Nathaniel Sparhawk*." *Journal of the Museum of Fine Arts, Boston* 1 (1989), pp. 96–103.

[Trumbull, Alfred.] "John Singleton Copley." *Collector* 3 (September 15, 1892), p. 295.

[Trumbull, John.] "American Academy of the Fine Arts." *New York Commercial Advertiser*, June 5, 1828, unpaged.

Tschudy, Herbert B. "John Singleton Copley." In *American Art Portfolios*, pp. 30–32. New York, 1936.

Tuckerman, Henry T. *Book of the Artists: American Artist Life*. New York, 1867. Reprint of 2d ed., New York, 1966.

Turpin, R. E. "Copley Keeps Alive Our Pre-Revolution Age." *New York Times Magazine*, February 13, 1938, pp. 19–20.

"$22,500 Paid for Two Copley Portraits Here." *New York Herald Tribune*, November 10, 1929.

"Two American Portraits with Historic Connotations." *Antiques* 16 (November 1929), p. 356.

"Two Copley Portraits." *American Magazine of Art* 7 (June 1916), pp. 319–21.

"Two Paintings by John Singleton Copley, R. A." *Connoisseur* 64 (September–December 1922), p. 187.

"Two Portraits by Copley." *New York Tribune*, December 3, 1916.

"Two Portraits Given: National Gallery Gets Art by Copley and Manet." *New York Times*, September 6, 1959, p. 44.

"Two Significant Boston Exhibitions." *New York Times*, September 14, 1919, p. 12.

Vaughan, Malcolm. "Copley from Windsor's Gallery to Be Shown at Metropolitan." *New York American*, December 21, 1936.

———. "Picture of Success." *Reader's Digest* 65 (November 1954), pp. 133–35.

Vendryes, Margaret Rose. "The Fashionably Dressed Sailor: Another Look at the Black Figure in John Singleton Copley's *Watson and the Shark*." *Athanor* 11 (1992), pp. 42–49.

Walker, John. "American Painters and British Critics." *Gazette des Beaux-Arts* 30 (October–December 1946), pp. 331–44.

Ward, Barbara M., and Gerald W. R. Ward. "The Makers of Copley's Picture Frames: A Clue." *Old-Time New England* 67 (July–December 1976), pp. 16–20.

Warden, G. B. "John Singleton Copley's Boston." *Apollo* 91 (January 1970), pp. 48–55.

[Warner House.] *Antiques* 34 (September 1938), p. 148.

Washburn, Gordon. "Old and New England: Comparative Analyses." *Art News* 43 (January 15–31, 1945), pp. 13, 18–19.

"Washington Gallery Buys Copley Painting in London." *New York Times*, February 23, 1965.

Watson, Forbes A. "My Country 'Tis of Thee." *Magazine of Art* 32 (June 1939), pp. 334–35.

_____. "Exhibition Reviews." *Magazine of Art* 32 (September 1939), pp. 532, 544.

Wayman, Dorothy G. "Copley's Portraits Part of Boston." *Boston Globe*, February 20, 1939.

Webster, J. Clarence. *Sir Brook Watson: Friend of the Loyalists.* Sackville, New Brunswick, 1924.

Wehle, Harry B. "Portrait of Brass Crosby, Lord Mayor of London, by Copley." *Bulletin of the Art Institute of Chicago* 16 (September 1922), pp. 66–67.

_____. "Copley's Portrait of Madam Bourne." *Bulletin of The Metropolitan Museum of Art* 19 (November 1924), pp. 270–73.

_____. *An Exhibition of Paintings by John Singleton Copley in Commemoration of the Two-Hundredth Anniversary of His Birth.* Exh. cat. New York: The Metropolitan Museum of Art, 1936.

Wertenbaker, Thomas J. *The Golden Age of Colonial Culture.* New York, 1942.

Whitley, William T. *Art in England, 1800–1820.* Cambridge, 1928.

_____. *Artists and Their Friends in England, 1700–1799.* 2 vols. London, 1928.

"The Widest Possible Range." *New York Times*, November 21, 1965, p. 25.

Williams, Hermann Warner, Jr. "Two Early Pastels by Copley." *Bulletin of The Metropolitan Museum of Art* 36 (June 1941), pp. 136–40.

Wilmerding, John, ed. *The Genius of American Painting.* New York, 1973.

_____. *American Art.* Harmondsworth, 1976.

Wilson, Rufus Rockwell. "America's First Painters." *New England Magazine* 26 (March 1902), pp. 26–44.

Winchester, Alice, and Helen Comstock. "American Painting in London: A Comment on the Tate Gallery Exhibition." *Antiques* 51 (February 1947), pp. 100–108, 127.

Wind, Edgar. "The Revolution of History Painting." *Journal of the Warburg Institute* 2 (1938), pp. 116–27.

Winsor, Justin, ed. *The Memorial History of Boston.* Boston, 1881.

Wiswell, George. "A Copley Rescued." *Art in America* 50 (1962), pp. 86–87.

"Worcester Seminar Uncovers a Copley." *Magazine of Art* 36 (March 1943), pp. 114–15.

Index

McArdell, James
 Duchess of Ancaster (after Thomas Hudson),
 106, *106*; fig. 89
 Mrs. Bonfoy (after Sir Joshua Reynolds), 107,
 107; fig. 91
 Helena Fourment (after Rubens), 68, 106
 Lady Caroline Russell (after Sir Joshua
 Reynolds), 107, *108*; fig. 92
 George Townshend (after Thomas Hudson),
 65, 200, *200*; fig. 176
McCoubrey, John, 15, 271
McEvers, Mary Verplanck, 294
 portrait by Copley, 303
McSparran, Reverend James, 309
medical profession, in American colonies, 309
Melville, Mrs. John (Deborah Scollay), portrait
 by Copley, 122, *122*; fig. 102
men
 Copley's portraits of, 111
 imaginary architecture shown in, 86
 indoor settings of, 238
 objects associated with, 62, 68, 86, 210, 256
 real, not fantasy, clothing worn in, 111
 dress and fashion, 111–13
 banyans (morning gowns), 113, 225
 waistcoats, 111–12
merchant and professional elite
 American Revolution's effect on, 43, 92
 artistic tastes of, 30–35, 42
 consumerism of, 94
 decline of, after 1760s, 90, 92
 portraits as providing identity to, 46–47,
 53–74, 94
 possessions and income of, 31
 radical attacks on, 214
merchants (small) and shopkeepers, 28–29
Merchants Club, 31
Mercier, Philip, *Handel*, 88
Mercury, statue of (in the Uffizi), 200
Merrett, John, 130
Metropolitan Museum of Art (New York), 13
 Copley exhibition of 1936–37, 11, 16
Meyer, Jeremiah, 123
mezzotints
 as models for artists, 105–6, 215
 as sources for Copley's work, 15, 33, 41, 66, 79,
 129–30, 190
 technique of, 29–30, 119, 128, 162
Mifflin, Thomas, 46, 318–20
 portrait by Copley (see *Mifflin, Mr. and Mrs.
 Thomas*)
 portrait by C. W. Peale, 318
 portrait by Stuart, 318
 portrait by Trumbull, 318, *318*; fig. 227
 portrait by West, 318, *318*; fig. 226
Mifflin, Mrs. Thomas (Sarah Morris), 46, 318–20
 portrait by Copley (see *Mifflin, Mr. and Mrs.
 Thomas*)
Mifflin, Mr. and Mrs. Thomas (double portrait by
 Copley), *2*, 5, 10, 19, 46, 55, 90, 110, 112,
 280, 318–21, *319*, 322; cat. 80
Miles, Ellen G., 18, 19
military portraits, 286–87, 300
miniatures
 Copley's, 117–24
 function of, as keepsakes, 117–18, 124, 252
 gold ground in, 120–21
 history and techniques of, 117–19, 120, 122
 oil on copper, 117, 118–21
 watercolor on ivory, 117, 118, 121–22

watercolor on vellum, 117–18
Moffatt, John, 129, 130
Montagu, Lady Mary Wortley, 68, 290
Montresor, James Gabriel, 302
Montresor, John, 302–3
 frame for portrait of, 157
 portrait by Copley, 113, 300–303, *301*; cat. 71
 works by
 *A Plan of the City of New York and Its
 Environs to Greenwich*, 302, 303; |fig. 216
 portrait of James Wolfe, 303
Montresor, Mrs. John (Frances Tucker), 303
 portraits by Copley
 (1771), 302, 303; fig. 217
 (ca. 1776–80), 302, 303; fig. 218
Morecock, Sarah. *See* Boylston, Mrs. Thomas
Morgan, John Hill, 11
Moroni, Giovanni Battista, "Titian's
 Schoolmaster," 81, *83*; fig. 69
Morris, Morris and Susanna, 318
Morris, Roger, 124, 298–300
Morris, Mrs. Roger (Mary Philipse), 124, 298–300
 portrait by Copley, 105, 291, 295, 298–300,
 299, 300, 314; cat. 70
 See also Philipse, Mary
Morris, Sarah. *See* Mifflin, Mrs. Thomas
Morse, Samuel F. B., 6
Mortier, Abraham, 297
Mortier, Mrs. Abraham, 297
Mount, Charles Merrill, 15, 295
Mount, William Sidney, 15
Mount Gulian, New York, 294
mounting, of pastels, 132
Mount Pleasant (Copley's estate and mansion),
 38, 61, 310–12
Muller, John, 300
Murray, Dorothy, portrait by Copley, 60
Murray, John, portrait by Copley, 91
Murray, Mrs. John, portrait by Copley, 91, 190
Murray, Reverend John (Universalist), 196
Museum of Fine Arts (Boston), Copley exhibi-
 tion of 1938, 11–13, 16
museums, American, work of Copley in, 9
Mytens, Jan, 176
mythological subjects of Copley, 29, 38, 79,
 166–70

Nash, Gary, 47
National Gallery of Art (Washington, D.C.), 13
Navigation Acts, 164
Neal, Daniel, 32
Neal, John, 6
Neoclassical style, 138, 200, 309, 324
Neoclassical-style frames, 156, 157–58
Newburyport, Massachusetts, 284
Newport, Rhode Island, 266
Newton, John, portrait by Copley, 57, *58*; fig. 44
New York City, 30
 art world of, 53, 130
 Copley in, 5, 38, 93, 95, 123, 151, 157, 251,
 287–307
Nicolson, Benedict, 15
Novak, Barbara, 16, 17–18, 19, 81, 94

objects
 absence of, in late portraits, 70–73

fictional, as stage props for portraits, 65–70,
 85, 86, 105
 iconography of, in Copley's portraits, 53–74,
 85–87
 See also children; iconography; men; profes-
 sions and occupations of sitters; women
occupations. *See* professions and occupations of
 sitters
Okey, Samuel, 128
Oliver, Andrew
 portrait by Copley, 120, *120*, 121; fig. 98
Oliver, Mrs. Andrew (Mary Sanford), portrait by
 Copley, 120, *120*; fig. 99
Oliver, Andrew, Jr., portrait by Copley, 120
Oliver, Elizabeth. *See* Watson, Mrs. George
Oliver, Griselda. *See* Waldo, Mrs. Samuel
Oliver, Mary Sanford, portrait by Copley, 120
Oliver, Peter, 208
 portrait by Smibert, 120
 portraits by Copley
 (miniature), 120, *121*; fig. 100
 (oil), 120
Oliver family, 119–21, 180
Orientalizing style, 67–68
Osborne, Catherine. *See* Sargent, Mrs. Epes, II
Osborne, John, 196
Osborne, Mrs. John (Sarah Woodbury), 196
Otis, James, 193, 224, 228
 portrait by Copley, 58, 87, *88*; fig. 76
Otis, Mrs. James (Mary Alleyne), 193
 portrait by Copley, 87, *88*; fig. 77
Otis, James, Jr., 90, 94
Otis, Mary. *See* Gray, Mrs. John
Otis, Mercy. *See* Warren, Mrs. James

Palmer, Mary, 182
paper, for painting pastels, 133
Parker, Barbara Neville, 13, 15, 16, 117, 170, 264
pastels, 127–38
 compared to other media, 138
 Copley's, 127–38
 popularity of, 127
 theory and technique of, 130
Peale, Charles Willson, 5, 79, 117, 157, 215
 political activities of, 47
 portraits by
 of John Beale Bordley, 46, 47; fig. 35
 of Thomas Mifflin, 318
Peale, Rembrandt, 6, 318–20
Pelham, Charles, 162–66, 218
 portrait by Copley, 84, 162–66, *165*; cat. 2
Pelham, first Mrs. Charles (Mary Tyler), 164
Pelham, second Mrs. Charles (Mehetabel
 Gerrish), 164
Pelham, Henry, 28, 38, 162, 218
 as artist, 46, 121, 123–24, 164, 218
 correspondence with Copley, 93, 105, 130, 132,
 138, 151, 157, 168, 172, 174, 218, 225, 268,
 291, 294, 303, 320
 emigration of, 92
 political views, 46, 47
 portraits by Copley, 83, 214, 215–16, *216*, 264;
 cat. 24, 25 (see also *Boy with a Squirrel*)
 works by
 Boston Massacre drawing (appropriated by
 Revere), 218
 The Finding of Moses, 218
 Edward Holyoke (after Copley), 218

Photograph Credits

Photographs were supplied by the owners of the works and are reproduced by permission of the owner, except as indicated in the following additional credits.

Courtesy Art Resource, New York: figs. 4, 10
Courtesy British Library, London: fig. 88
Will Brown: fig. 218; cat. no. 39
Del Bogart: fig. 178; cat. nos. 8, 34
David Bohl: cat. no. 17
Courtesy Christie's, New York: fig. 194
Courtesy English Heritage, London: fig. 94
Courtesy Kennedy Galleries, Inc., New York: fig. 172
A. F. Kersting: fig. 22
Benjamin Magro: cat. no. 75

Courtesy Marblehead Historical Society, Massachusetts: fig. 195
Courtesy Massachusetts Historical Society, Boston: fig. 16
Courtesy The Metropolitan Museum of Art, New York: figs. 5, 6
Courtesy Museum of Fine Arts, Boston: figs. 8, 9
Mary Northend, courtesy Society for the Preservation of New England Antiquities, Boston: fig. 21
Copyright © Steve Rosenthal: fig. 196
Bruce Schwarz: fig. 133; cat. no. 16
Courtesy Sandak, Inc., Boston: fig. 1
Courtesy Society for the Preservation of New England Antiquities, Boston: fig. 20
Courtesy Strawbery Banke Museum, Portsmouth, New Hampshire, Patch Collection: fig. 181